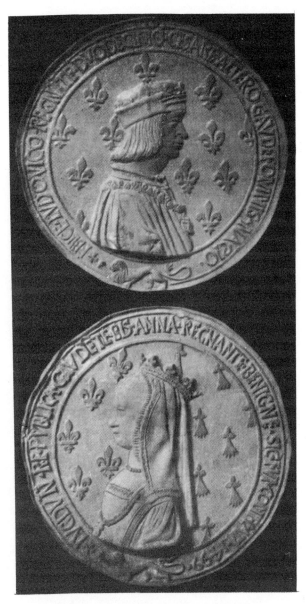

Medal of Louis XII and Anne of Brittany.
By Nicolas Leclerc and Jean de Saint Priest
(Fitzwilliam Museum, Cambridge)

THE DAWN

OF THE

FRENCH RENAISSANCE

THE DAWN

OF THE

FRENCH RENAISSANCE

BY

ARTHUR TILLEY, M.A.

FELLOW AND LECTURER OF KING'S COLLEGE, CAMBRIDGE

NEW YORK

Russell & Russell

TO FRANCE

FIRST PUBLISHED IN 1918
REISSUED, 1968, BY RUSSELL & RUSSELL
A DIVISION OF ATHENEUM HOUSE, INC.
BY PERMISSION OF THE CAMBRIDGE UNIVERSITY PRESS
L. C. CATALOG CARD NO: 68-10951
PRINTED IN THE UNITED STATES OF AMERICA

PREFACE

A SYMPATHETIC critic of my *Literature of the French Renaissance* pointed out that it lacked an introduction, and he suggested that with a view to remedying that defect I should revise and add to the *Introductory Essay* that I published thirty-five years ago. I recognised the justice of his criticism, but I was conscious that the Essay in question was too imperfect to serve the purpose. I therefore proposed to begin afresh and to write two or three chapters which might more worthily take its place. But in the course of thinking out the matter this modest undertaking assumed larger proportions. It seemed to me that to trace the beginnings of the French Renaissance, and to lay a sure and firm foundation for the study of it as an organic movement affecting the whole life and thought of the nation, a wide and thorough survey of the ground must be made. There must be an investigation of the first manifestations of the Renaissance spirit, not only in humanism and literature, but in architecture, sculpture, painting, and every form of art. Former histories of the Renaissance have suffered from a concentration of the vision on certain fields of activity to the exclusion of others equally important. The humanist has been inclined to identify the Renaissance with Humanism, the historian of art to lay undue stress on the particular art in which he was interested. Into the delicate and much debated question as to the relations between France and Italy a further hindrance to right judgment has been introduced by a natural but disturbing bias of patriotism. Good

Frenchmen have rejected without due examination any suggestion of the debt of France to Italy, and this attitude has provoked counter-attacks which go too far in the opposite direction.

It appeared to me then that a stranger, untouched either by patriotic impulses or by the desire to rise superior to them, might possibly hold the scales more evenly and survey the field with a mind that was at any rate free from prejudice. There was this difficulty that I was not an expert in any branch of art, and that in dealing with architecture and sculpture and painting I was likely, indeed sure, to blunder. But on the whole I thought that the attempt was worth making. I thought that if I abstained from pronouncing aesthetic judgments and confined myself to the more modest task of collecting data to speak for themselves, I might present a body of facts, not indeed complete, but sufficient to enable those who have more special knowledge than myself to form their own conclusions. Whatever mistakes I have made, there should at least be no difficulty in detecting them, for I have been careful to give the sources of my facts, and to state with candour my conclusions.

The writing of the book was nearly finished in May 1914, when I made a final visit to France in its interests. Little did my companion and I think as we rested on the grass at Chantilly, after inspecting the treasures of the château, that in three months from that day, within five miles of where we sat, the peaceful town of Senlis would be given up to murder, rapine, and destruction at the hands of an invading army broken loose from civilization and humanity. The Great War has swept other interests into the background, and the best energies of active men and women have been concentrated on the paramount task of repelling the common danger. Thus, though under normal conditions

this book might have appeared in the autumn of 1915, and though the printing, except for the introductory matter, was finished before the end of that year, it was thought advisable to wait for its publication till the close of the War. Two more years however have passed, and it has not yet pleased God, "who by his divine Word rules and moderates all," to crown the efforts of the Allies with final victory. My book therefore must appear under the shadow of war, and I can only hope that there may be a few persons who have leisure and inclination to direct their thoughts for a while from sterner issues to the arts of peace.

Fortunately all the buildings and works of art that fall within the immediate scope of this inquiry are intact. It is otherwise with some of the buildings to which a cursory reference is made. Everyone knows how the cathedral of Reims, so intimately associated with the historic greatness of France, has been defaced. It is worse with Soissons, which has been damaged almost beyond repair. Of secular buildings the Hôtel de Ville of Arras, a singularly beautiful example of Flamboyant architecture, has with the exception of one solitary corner been entirely destroyed. What will be the ultimate fate of its sister of Saint-Quentin it is impossible to say. Worst of all, because no shadow of a military excuse can be alleged in its justification, is the case of Coucy. It was in pure revenge that the finest existing example of a mediaeval château in France was deliberately blown into the air[1].

From these injuries to the sacred relics of her past, as from the devastation of her soil and from the sacrifice of so many of her heroic sons, who have died that she may live,

[1] An instructive account of the damage done to French buildings will be found in M. André Michel's "Ce qu' 'ils' ont détruit," in the *Gazette des Beaux Arts* for June 1916.

France, with her unconquerable spirit and her inexhaustible powers of recuperation, will rise triumphant. But her regeneration will not be merely material. Unless one has misread the signs of the times, we are nearing the dawn of a greater Renaissance than that which is the subject of these pages—greater, because, while the old Renaissance was chiefly intellectual in character, and its chief work was the emancipation of human intelligence from the chains of worn-out tradition and authority, the new Renaissance will be largely of the spirit. It will not be a sudden re-birth, it will not bring with it the millennium, there will be delays and hesitations and backslidings, but it will surely come, and it will bear the fruits of love and righteousness and peace.

A. T.

CAMBRIDGE,
Christmas, 1917.

AUTHOR'S NOTE
OF ACKNOWLEDGEMENT

FULL reference will be found at the beginning of chapters
III–XV to the sources of information for these chapters, but
I should like to make here special acknowledgement to the
Histoire de l'Art now in process of publication under the
direction of M. André Michel. Without its guidance, and
without that of Mr W. H. Ward's *Architecture of the Re-
naissance in France* and of M. Paul Vitry's *Michel Colombe
et la sculpture française de son temps* I should have been
greatly at a loss in dealing with the Third Part of my book.
To my friend Mr Ward, indeed, who combines with the pro-
fessional knowledge of an architect the habits and method
of a trained scholar, I owe a double debt, for he has kindly
read, wholly in proof and partly also in manuscript, the two
chapters on Architecture (XI and XII) and the chapter on
the French Occupation of Milan (IV). I must hasten to add
that he is no way responsible for the statements and opinions
that occur in them. My deep gratitude is also due to my
friend the Rev. H. F. Stewart, D.D., Fellow and Dean of
St John's College, who—not for the first time—has read the
whole of my proofs, and given me the benefit of his vigilant
criticism. My grateful thanks are also due to the Provost
of King's College, Dr M. R. James, who has always been
ready to place at my disposal the stores of his multifarious
learning. I am also indebted to Mr F. J. H. Jenkinson, Uni-
versity Librarian; to Mr C. E. Sayle, and to Mr H. G. Aldis
of the University Library; to Mr S. C. Cockerell, Director of

the Fitzwilliam Museum; to Mr G. F. Hill, Keeper of Coins
and Medals in the British Museum, and to Mr A. W. Pollard,
Assistant Keeper of Printed Books in the same Museum;
to Mr P. S. Allen, Fellow of Merton College, Oxford; to
M. Léon Dorez of the Manuscript department of the
Bibliothèque Nationale; to M. Louis Polain of the *Bibliothèque
Mazarine*; to M. Pierre Dufay, formerly Librarian of the
Blois Library; and to M. Pontier, Director of the Museum
at Aix-en-Provence; all of whom have shewn me great
courtesy and kindness in answering my inquiries or in dis-
playing the treasures committed to their charge. I must
add my thanks to Mme de Yturbe for graciously permitting
me to see her Portrait of a young girl (presumably Suzanne
de Bourbon) at her house in Paris; to Mr Charles Weld-
Blundell of Ince Hall, Liverpool, for allowing me to repro-
duce his fine picture of the Madonna with Saints and
Louis XII; to Messrs B. T. Batsford and Co. for permis-
sion to reproduce some of the illustrations in Mr Ward's
Architecture of the Renaissance in France; and to the editor
and publishers of *The Burlington Magazine* for the same
courtesy with regard to Plates XX, XXI and XXIII. The
negatives of the photographs which are reproduced in Plates
X and XI are the property of the *Commission des Monuments
historiques*.

Finally let me add a word of sincere gratitude to the
Syndics of the University Press for undertaking the publica-
tion of my book, and to the Secretary of the Syndicate, the
reader and other members of the staff, for unfailing courtesy
and patience.

A. T.

CONTENTS

PART I

FRANCE AND ITALY

CHAPTER I

THE ITALIAN RENAISSANCE

I

CHAPTER II

PREMONITIONS OF THE FRENCH RENAISSANCE

I

II

III

CHAPTER III
THE EXPEDITION OF CHARLES VIII

I

II

III

CHAPTER IV

THE FRENCH OCCUPATION OF MILAN

CHAPTER V

THE FRANCE OF CHARLES VIII AND LOUIS XII

PART II

THE RENAISSANCE IN LETTERS

CHAPTER VI

THE STUDY OF LATIN

I. *Robert Gaguin*

CHAPTER VII
JACQUES LEFÈVRE D'ÉTAPLES

CHAPTER VIII

THE STUDY OF GREEK

I. *Aleandro*

II. *Budé*

III. *Erasmus*

CHAPTER IX
HUMANISM IN THE PROVINCES

CHAPTER X
FRENCH POETRY AND PROSE

I

II

III

PART III

THE RENAISSANCE IN ART

CHAPTER XI

ARCHITECTURE I

I. *Introductory*

II. *Châteaux*

CHAPTER XII
ARCHITECTURE II
I. *Hôtels*

II. *Smaller town-houses*

III. *Municipal buildings*

IV. *Ecclesiastical architecture*

V. *Stained Glass*

VI. *Summary*

CHAPTER XIII

SCULPTURE I

I

II

CHAPTER XIV

SCULPTURE II

I

II

III

CHAPTER XV
PAINTING

I

II

III

CHAPTER XVI

RETROSPECT

LIST OF PLATES

* Reproduced by kind permission of B. T. Batsford and Co. from W. H. Ward, *The Architecture of the Renaissance in France.*

CORRIGENDA

p. 47, l. 23. *For* Cada Mosto *read* Ca da Mosto.

p. 64, l. 5. *For* brightening *read* blighting.

p. 74, n. 2. *For* 327 ff. *read* 527 ff.

p. 87, l. 20. *For* Varro *read* Valla.

p. 122, l. 23 and p. 128, l. 21. *For* Le Maire *read* Lemaire.

p. 126, l. 28. *For* Manuel Chrysoloras *read* Constantine Lascaris.

p. 145, l. 8. *For* Ambierlé *read* Ambierle.

p. 153, last line but two. *For* Forjat *read* Forjot.

p. 155, n. 1. *For* George *read* Georges.

p. 166, l. 11. *For* Giulio *read* Giuliano.

p. 168, l. 29. *For* Génèvre *read* Genèvre.

p. 168, last line but one. *For* Tarn *read* Tarare.

p. 190, l. 16. *For* by Verard *read* for Verard.

p. 392, l. 5. *For* Blois *read* Romorantin.

p. 397, l. 5. *For* nine miles north of Caen *read* seven and a half miles south-west of Caen.

p. 421, l. 11. *Del.* the old Hôtel de Ville, and in.

p. 421, l. 17. *For* a narrow building of *read* a third set of rooms consisting of

ADDENDA

p. 155, n. 3. Add a reference to M. de Montmorand, *Une femme poète au xvi^e siècle; Anne de Graville,* 1917.

p. 364, n. 4. The author, a Fellow of Trinity College, Cambridge, died in France on November 29, 1917, of wounds received near Cambrai two days previously.

p. 375. Add a reference to T. A. Cook, *Twenty-five great houses of France* (reprinted from *Country Life*), with an introduction by W. H. Ward (1916). It contains chapters on the house of Jacques Cœur and the châteaux of Langeais, Montreuil-Bellay, Amboise, Blois, and Maintenon, besides those of Josselin and D'O cited in my notes.

p. 381. For the château Du Moulin see *Country Life* for August 25, 1917 (by W. H. Ward).

p. 419. For the Hôtel Lallemand see *Country Life* for April 28, 1917 (by W. H. Ward).

PART I

FRANCE AND ITALY

CHAPTER I

THE ITALIAN RENAISSANCE

I

WHEN under the mighty impulse of the world-movement which we call the Renaissance men began to cut themselves adrift from the moorings of authority and tradition, they were not left wholly without a chart in their voyage across unknown seas. They had to guide them the wisdom of the ancients as recorded in the writings of their poets, philosophers, and historians. Yet there were some who preferred to shape their course by observation and experience, and it is an error to suppose that Humanism was the whole of the Renaissance. Leonardo da Vinci, the most perfect and complete embodiment of the Renaissance spirit, owed little, either in his speculations or in his manifold achievements, to the teaching of antiquity. The truth is that the Renaissance manifested itself in so many different forms, varying in quality and degree according to the soil which produced them, that in order to arrive at a just idea of the movement as a whole we must steadily keep in view all these manifestations. And this can be best done by starting from the man who was the real source of the Italian Renaissance. The little drawing which represents the Sorgues flowing out of a rock above Vaucluse, and which is presumably by Petrarch's hand[1], symbolises the whole movement. The stream is the Renaissance, the rock is Petrarch.

[1] P. de Nolhac, *Pétrarque et l'Humanisme*, 2 vols. 1907, II. 268.

For the Renaissance is the passage from the mediaeval to the modern world, and Petrarch under various aspects foreshadows the beginning of the modern world. He has been termed "the first modern man of letters," "the first modern writer of autobiography," "the first modern tourist," and all these aspects have been summed up in Renan's well-known phrase, "the first modern man." He inaugurated in fact most of the activities which we regard as characteristic of the Renaissance. He collected manuscripts, he studied ancient monuments and coins, he wrote Latin prose and verse. And if we penetrate beneath these outward manifestations and look for the spirit which prompted them, we find in the first place that he was essentially an individualist. He was the first articulate rebel against the mediaeval conception that man existed only for the sake of Church or Corporation—that he had no individual rights, no individual conscience, no individual aims and aspirations. In none of his writings is the character of his individualism more clearly brought out than in his *Secretum*, that intimate work in which he lays bare the recesses of his soul[1], and to which he has given the form of three dialogues between himself and St Augustine. Thus the first modern man is brought face to face with the man who inaugurated the mediaeval world, and the cultivated individualism of the Renaissance is contrasted with the ascetic self-suppression of the Middle Ages. In the first Dialogue St Augustine impresses upon Petrarch the duty of self-examination and urges him to meditate upon death. In the second he arraigns him for various sins and infirmities, love of money, ambition, vanity, unchastity, and above all for that species of melancholy which mediaeval theologians called *accidia*, and which is often found in men of Petrarch's self-centred temperament. On all these points the penitent recognises the justice of his confessor's accusations, and with evident sincerity promises amendment. In the third Dialogue the

[1] In the Basle editions it is called *De contemptu mundi*. It has been well translated into English by W. H. Draper under the title of *Petrarch's Secret*, 1911.

Father begins to probe deeper-seated diseases. He tells
Petrarch that he is held in bondage by two strong chains,
Love and Glory. "You call these chains? Do you want
to rob me of the noblest of passions? Do you wish to
darken the brightest region of my soul?" Then his inex-
orable monitor proceeds to examine him with regard to
his love for Laura. Petrarch makes a stout defence,
but at last he owns himself beaten and submissively
accepts the proffered medicine. The other chain remains.
"You desire more than is right", says his confessor,
"the glory conferred by men and immortal fame." "I
freely confess it," is the answer, "but this is a passion that
I cannot curb." Once more St Augustine drives him from
position to position, and urges him to abandon his studies.
But Petrarch's last word is that "though he sees the straight
path of salvation, he has not the strength to restrain his
heart's desire." Nominally the victory is with the mediaeval
ideal, and in fact the dialogues, which were written in 1342,
coincide with a marked amendment in Petrarch's moral and
spiritual health. From this time he rose

> On stepping stones
> Of *his* dead *self* to higher things.

Yet Koerting is right when he speaks of Petrarch as being
in his heart not altogether convinced. He will not, at any
rate, abandon his love of letters, or his desire for posthumous
fame. Truly, as Koerting says, the *Secretum* "may be
called the charter of Humanism and the Renaissance[1]."
So too in the treatise *On a solitary life*, written at Vaucluse
a few years later, the central thought is the duty of self-
culture and the development of the individual.

Yet Petrarch's individualism was far removed from the
intense self-absorption of a Jean-Jacques Rousseau. He
recognised to the full the claims of others to their individ-
uality. Above all he venerated with a glowing admiration

[1] G. Koerting, *Petrarca's Leben und Werke*, Leipsic, 1878, pp. 646 and
648. And see the whole chapter for an admirable summary of the
Secretum.

those who had devoted this individuality to noble and great ends. For him history was the record of the illustrious men who had made it. The *De viris illustribus*, which he originally planned to embrace the lives of the great men of action of all ages and countries, but which in its definite form he limited to Roman history from Romulus to Titus, was regarded by him as his *magnum opus* in prose, the masterpiece which with its pendant in verse, the epic poem of *Africa*, should win for him immortality. It was in a similar spirit of admiration that he wrote his letters to the great writers of Rome, to Cicero, Varro, Horace, Virgil, Livy, Seneca, Quintilian.

Individualism implies not only freedom of action, but, almost as a necessity, freedom of thought. And this in active natures leads to freedom of inquiry, which in its most elementary stage is " an honest curiosity for information about everything." Petrarch had a large measure of this curiosity. In the well-known letter[1] in which he describes his ascent of Mont Ventoux he finds fault with the *frigida incuriositas* of the generality of mankind. He himself had a love of travel unusual in his age. Indeed, during his later years, after he left Vaucluse, he had something of the restlessness which is so marked a characteristic of the Renaissance[2]. Three years before the ascent of Mont Ventoux, he had visited Paris, and had prolonged his journey through Flanders to Liège, Aachen, and Cologne. He knew all the chief cities of Italy—Rome, Florence, Naples, Venice, Milan, Pavia, Parma, Bologna, Ferrara, Verona, Mantua, Padua. In later life he was sent by his patrons the Visconti on a mission to the Emperor (Charles IV), and he found him in his camp at Prague " on the confines of the barbarians." Four years later he paid a second visit to Paris. His interest in travel and geography is further shown by his *Itinerarium Syriacum*, which traces the journey of a pilgrim to Jerusalem,

[1] *Ep. de rebus familiaribus*, IV. I (ed. Fracassetti).

[2] He says of his second visit to France that he went "non tamen desiderio visa millies revisendi, quam studio, more aegrorum, loci mutatione taediis consulendi " (*Ep. ad post.*).

giving a brief description of the places of interest on the
route, and by the numerous notes on geographical matters
which he made in his manuscript of Pliny[1].

A higher stage of free inquiry is reached with the critical
spirit, the spirit which takes nothing on trust, which makes
an independent examination of everything, irrespective of
tradition or authority. This spirit too Petrarch possessed
in a high degree. Nothing more clearly marks his position
as the parent of the Renaissance, as " the first modern man,"
than his antagonism to nearly all the branches of mediaeval
learning, to its astrology, its jurisprudence, its medicine, its
logic, and its theology. The opposition to Aristotle, which
runs through the *De sui ipsius et multorum ignorantia*, is
prompted rather by an orthodox churchman's antagonism
to the Averroist interpretation of Aristotle's writings than
by a critical examination of those writings, with which he
was necessarily only imperfectly acquainted, but it is highly
significant that, while Dante proclaims Aristotle as " the
master of those who know," Petrarch, only a generation later,
raises the standard of revolt against his infallibility, and by
asserting the superiority of Plato foreshadows the philosophic
thought of the Renaissance[2].

The same critical spirit takes another form in the preface
to the *De viris illustribus*, where Petrarch explains his method
of using his authorities. " I do not try to reconcile the
historians, nor to collect all their narratives ; I only follow
those whose greater credibility or superior authority com-
mands respect[3]." This is the true principle of historical
inquiry. So too in the second book of the treatise *On the
solitary life*, when he is dealing with the lives of those saints
who had led a solitary life, he does not content himself with
reproducing the hagiographical records, but tests them so
far as he can by independent investigation. " The founder
of modern criticism," to quote Koerting again, " could not

[1] Nolhac, I. 75.

[2] See Nolhac, I. 8 and II. 148 ff.

[3] Ego neque pacificator historiarum neque collector omnium, sed
eorum imitator, quibus vel verisimilitudo certior, vel auctoribus maior est.

refrain from applying the principles of free inquiry even to ecclesiastical writings ; even here he broke with the blind belief in authority of the Middle Ages."

Such was the new spirit which descended upon Petrarch and made him one of the most powerful agents of human progress that the world has ever seen. He is rightly termed the first humanist, for he was the first man to claim free play for human aims and aspirations. But he was also the first humanist in the narrower and historical sense of the term[1]. It was in the pages of the great writers of antiquity that he found nourishment for his belief in humanity. He prized literature as a form of intercourse with great men. He communed with Virgil and Horace, with Cicero and Seneca, as with wise and eloquent monitors[2].

[1] *Humanitas* was used by the Romans to signify a liberal education, the education befitting a man. "' Humanitatem ' appellaverunt id propemodum, quod Graeci ' παιδείαν ' vocant, nos ' eruditionem institutionemque in bonas artes ' (good conduct) dicimus.... Huius enim scientiae cura et disciplina ex universis animantibus uni homini data est idcircoque ' humanitas ' appellata est " (A. Gellius, XIII. 17). This passage is paraphrased by Battista Guarino in his educational treatise *De ordine docendi et studendi* (written in 1459) as follows : " To man only is given the desire to learn. Hence what the Greeks call παιδεία, we call *studia humanitatis*. For learning and training in virtue are peculiar to man ; therefore our forefathers called them *Humanitas*, the pursuits, the activities, proper to mankind. And no branch of knowledge embraces so wide a range of subjects as that learning [*i.e.* classical learning] which I have now attempted to describe." On a medal of Vittorino da Feltre, executed by Pisanello not long before 1446, the date of Vittorino's death, the great schoolmaster is described as *omnis humanitatis pater*. Similarly on a medal of Piero Candido Decembrio, made by the same artist in 1448, the inscription runs, *Studiorum humanitatis decus*, or, as we should say, the glory of classical scholarship (G. F. Hill, *Pisanello*, pp. 176 and 179, plates 54 and 56). For, as Guarino implies, the Italians of the fifteenth century regarded classical literature as supplying in a larger measure than any other subject that learning and training in virtue which were peculiar to man. Hence this literature was spoken of as *literae humaniores*, as the literature that was distinctively human, that was distinctively proper to man, and those who studied this literature were called humanists.

[2] Libri medullitus delectant, colloquuntur, consulunt et viva quadam nobis atque arguta familiaritate junguntur (*Ep. de rebus fam.* III. 18).

He found in their glowing pages a consecration of human aims, and a guide to human endeavour. But he also learnt from them the mystery of style, regarding it not as a trick to be slavishly copied, as did the Ciceronians of a later period, but as the expression of the individual man. This is the feature of Petrarch's own Latin style. Though it is defective from the point of view of Latinity, it has a charm which is wholly wanting to the correct compositions of most scholars from the Renaissance downwards ; it is the expression of the individual man ; it bears the impress of his idea of beauty. For Petrarch touched and retouched his writings many times before they satisfied his artistic sense. In 1341 he thought that he had almost completed his *Africa*, but he went on working at it for another dozen years. Finally he threw it aside, and it has come down to us in an incomplete state[1]. The same fate attended the *De viris illustribus*, for the pen dropped from his hand when he was working at the Life of Julius Caesar.

If in his Latin writings Petrarch's imperfect mastery of the language renders his artistic expression unequal and hesitating, it is otherwise with his vernacular poetry. No poet, not even Pindar or Virgil or Milton, has ever shewn a truer or a more watchful sense of style, and the form, at least of the *Sonnets*, is as impeccable as the style.

Koerting rightly sees in this careful attention of Petrarch to literary form a sign of the important part which art was destined to play in the whole culture of the Renaissance. But Petrarch was interested in other forms of art besides literature. He was a warm lover of music, and played on the lute with considerable skill. His friendship with the Sienese painter of the Papal Palace at Avignon, Simone Martini, is well-known, and few painters have had a subtler feeling than Simone for beauty of colour and outline, or greater skill in the expression of it[2]. Petrarch,

[1] There is almost certainly a gap of three and a half books between the present fourth and fifth books.

[2] B. Berenson, *The Central Italian Painters of the Renaissance*, pp. 45–47.

too, loved beauty in nature as well as in art. His descriptions of scenery, especially of his beloved Vaucluse, shew the precision and the warmth of a careful and loving observer. He was also an enthusiastic gardener, versed in the principles of horticulture and working with his own hands[1].

Between the solitary of Vaucluse and the sojourner in the courts of princes there seems a sharp contrast. Early in May 1353 he left Vaucluse, which had been his home for sixteen years, for ever, and immediately after crossing the Alps accepted an invitation from the head of the Visconti, Archbishop Giovanni, the "Great Viper." His eight years sojourn at Milan as the client of the Visconti, those most able and unscrupulous of despots, whose aim was the enslavement of Italy, was as perplexing to his friends as it is to us, and the explanation which he gave to Boccaccio can hardly have satisfied him better than it satisfies the modern reader[2]. Equally disconcerting is his affection for that treacherous adventurer, Azzo da Correggio, sometime lord of Padua, to whom he dedicated the most popular of his Latin treatises, the *De remediis utriusque fortunae*, and for Jacopo II da Carrara, whose able rule of Padua was inaugurated by murder and forgery. But here it is chiefly important to notice that in these episodes Petrarch once more reveals himself as the parent of the Renaissance. His ready acceptance of the patronage of Italian princes was the first step towards that shameless importunity for place and pelf which disgraced the humanists who came after him. His blindness to the vices of the tyrants who honoured and flattered him foreshadows that indifference to sin which was the ugliest feature of the Renaissance, and which was the chief cause of that long night which descended upon Italy. Power and energy, independently of their aims, had the same attraction for Petrarch as they had for the Italians of a later generation. His relations with Giovanni and Galeazzo Visconti mark the

[1] Nolhac, II. 260 ff.
[2] See *Epistolae variae*, xxv. (Fracassetti, III. 264 ff.).

beginning of that admiration for *virtù* which is so conspicuous in the later Renaissance[1].

II

The impulse which Petrarch gave to the study of Latin literature had momentous consequences. It produced a movement which found all the more ready acceptance because it appealed to Italian patriotism[2]. It was the writings of their ancestors that the Italians were called upon to study and honour. Two cities responded to the call with special alacrity, Florence, which should have been Petrarch's birth-place, and Padua, in whose neighbourhood he died. At Florence the torch was handed on by Coluccio Salutati, the genial Latin secretary of the republic, who had corresponded with Petrarch, and by Luigi de' Marsili, the Augustinian monk, to whom he had given shortly before his death the precious volume of St Augustine's *Confessions* which had been his constant companion for forty years. "It has grown old in its journeys with me," he says in the touching letter which accompanied the gift, " so old that it can only be read by an old man with great difficulty. And now it returns to the house of Augustine from which it set forth, and will doubtless be your travelling companion, as it was mine[3]."

At Padua the leader of the new movement was Giovanni Conversini of Ravenna, who after living for about three years with Petrarch as a copyist was so fired with enthusiasm for the great writers whom he was employed to copy

[1] The two most recent English works on Petrarch, both of much merit, are H. C. Hollway-Calthrop, *Petrarch ; his life and times*, 1907, and Maud F. Jerrold, *Francesco Petrarca, Poet and humanist*, 1909.

[2] The most important authorities for the general history of Italian Humanism in the fourteenth and fifteenth centuries are G. Voigt, *Die Wiederbelebung des classischen Alterthums oder das Jahrhundert des Humanismus*, 3rd ed. by Max Lehnert, 2 vols. Berlin, 1893, and J. E. Sandys, *A History of Classical Scholarship*, 3 vols. Cambridge, II. 1–123.

[3] *Ep. de rebus senilibus*, XIV. 7. The book had been given to Petrarch in 1333 by Fra Dionigi of Borgo San Sepolcro, an Augustinian friar.

that he resolved to become a scholar himself. He is an admirable type of those enthusiasts for learning who in the early days of Humanism reached their goal after a long and arduous pilgrimage. For more than twenty years he taught Latin—he never had an opportunity of learning Greek— at Florence, Belluno, Padua, Venice, Ragusa, Udine, and then he returned to Padua as chancellor to its lord, and as teacher of rhetoric in the University. Among his many pupils who afterwards became famous were Vittorino da Feltre and Guarino da Verona[1].

At Padua also lectured Piero Paolo Vergerio, the author of the *De ingenuis moribus*, the first treatise on humanistic education, which retained its position as an educational classic down to the middle of the sixteenth century. He also wrote a short Latin life of Petrarch, whom he may have seen at Padua in his student days[2]. In 1399, being then in his thirtieth year, he gave up his post at Padua to attend the Greek lectures of Manuel Chrysoloras at Florence[3]. It was a significant recognition of what the culture of his time needed most. Petrarch had been firmly convinced of the superiority of Latin literature to Greek, and though he had dimly recognised the poetical supremacy of Homer, and possessed a manuscript of his works, he could only read them in the miserable Latin translation which was made for him by the Calabrian impostor, Leontius Pilatus. Boccaccio, his most eminent disciple in Humanism, attained under the guidance of the same Pilatus to a rough know-ledge of the language. But the serious study of Greek in Italy dates from the appointment of Manuel Chrysoloras to a chair of Greek at Florence (1396)[4].

[1] See Voigt, *Wiederbelebung*, I. 212 ff.; T. Klette, *Beiträge zur Geschichte und Litteratur der italienischen Gelehrten-renaissance*, 3 vols. Greifswald, 1888–1890, I. *Johannes Conversanus und Johannes Malpaghini von Ravenna*.

[2] Vergerio was born in 1349, and Petrarch came there in 1369.

[3] See for the date R. Sabbadini in *Giornale storico della letteratura italiana*, v. (1885), 14.

[4] We first hear of him at Florence in February 1397, but he was apparently appointed in the preceding year.

Chrysoloras resided in Italy, save for occasional absences, till just before his death, which took place at Constance, while the Council was sitting, in 1415. In 1403 Guarino da Verona accompanied him to Constantinople, and lived in his house for five years, returning in 1408, the first Italian to become really proficient in Greek, and the possessor of over fifty Greek manuscripts. His example was followed by Giovanni Aurispa, a Sicilian, who travelled in the east, searching for manuscripts, from 1405 to 1413, and who, having undertaken a fresh journey to Constantinople in 1421, returned in 1423 with no less than 238 manuscripts, including the Laurentian Æschylus, Sophocles, and Apollonius Rhodius. Four years later Francesco Filelfo of Tolentino in the March of Ancona brought back from the Byzantine capital, where he had spent seven years as secretary to the Venetian ambassador and had married the great-niece of Manuel Chrysoloras, some forty manuscripts, and a knowledge of Greek beyond that of any of his countrymen.

In 1438 a fresh stimulus was given to the study of Greek in Italy by the arrival of 500 Greeks, including the Emperor and the Patriarch of Constantinople, to attend the Council of Ferrara, which had been summoned by Pope Eugenius IV with a view to the re-union of the Greek and Latin churches. Though the conference failed in its object, the residence of so many learned Greeks in Italy for eighteen months helped greatly to spread the knowledge of the Greek language. The most learned of the envoys, Georgios Gemistos Plethon, sowed at Florence[1] the seed from which sprang up the famous Florentine Academy, while another envoy, Plethon's most distinguished pupil, remained in Italy, and, as Cardinal Bessarion, became the leader of Greek scholarship in the country of his adoption. There were other Greeks, too, who by teaching, and by translating and copying manuscripts contributed to the diffusion of Greek learning in Italy before the fall of Constantinople. Among these were George of Trebizond, who is to be found at Venice and Padua before 1418 ; Theodore Gaza, the author of the well-known Greek Grammar,

[1] The Council was transferred to Florence in 1439.

who took part in the discussions of the Council of Ferrara ; Demetrius Chalcondyles (1424–1511) of Athens, the editor of the *editio princeps* of Homer, who in the course of his long life lectured successively at Perugia, Padua, Florence and Milan ; and Joannes Argyropoulos (1416–1486), who, though he paid his first visit to Italy in 1441, did not take up his abode there till after the fall of Constantinople. He lectured at Florence from 1456 to 1471, where Politian attended his lectures, and at Rome from 1471 to 1484, where he had Reuchlin for a pupil. Both he and Gaza had a high reputation as exponents of Aristotle, and Gaza was employed by Nicholas V in the great work, which he had so much at heart, of making Latin translations of the chief prose writers of Greece. Plato and Aristotle were allotted to Greeks ; Strabo, Thucydides, and other historians to Italian scholars.

The first sixty years of the fifteenth century may be regarded as the most flourishing period of Italian Humanism, as the period when the humanists occupied the highest place in public estimation. But it is important to notice that there is a marked difference between the Humanism of the earlier half of this period and that of the later half. If the older generation were inferior as scholars to their successors, their Humanism was of a broader and more generous type. Like Petrarch they ranged over the whole available field of ancient literature. Vittorino da Feltre (1378–1446) included Augustine and Lactantius and other theological writers in his curriculum of studies, and Leonardo Bruni (1369–1444) in his educational treatise, *De studiis et literis (circ.* 1405), claimed the fullest liberty in the choice of authors. This breadth of view operated in two ways. In the first place these older humanists found no difficulty in reconciling ancient learning with Christian conduct and ideals. Vergerio, whose long life—he died in his ninety-sixth year in 1445—carried on the immediate tradition of Petrarch to the close of the second generation, was a man of preeminently Christian spirit. So were the two schoolmasters, Vittorino da Feltre and Guarino da Verona (1370–

1460)[1]. Secondly, the older humanists, like Petrarch, wrote
Latin as a living language ; naturally, and with freedom,
not as a mechanical exercise. Even Gasparino Barzizza
(1370–1431), who definitely established the Ciceronian tradi-
tion, aimed only at reproducing the spirit of Cicero's style,
retaining his own individuality in the matter of vocabulary
and idiom.

The growth of a one-sided and exclusive devotion to
pagan literature cast a shadow over the labours of the
Camaldulensian monk, Ambrogio Traversari (1386–1439)[2].
His life in the peaceful monastery of Santa Maria degli
Angioli, just outside Florence, was spent in translating the
Greek Fathers, and though he was on terms of the most
friendly intercourse with all the Florentine humanists, he
regarded pagan literature with anxious disquietude. When
Cosimo de' Medici bade him translate into Latin the *Lives*
of Diogenes Laertius, he did so with reluctance and mis-
giving.

He lived long enough to see his fears fully justified.
With Poggio Braccolini (1380–1457)[3], Francesco Filelfo
(1398–1481)[4] and Lorenzo Valla (1407–1457)[5], we come
to a new and in some respects debased type of humanist.
In learning, as was only natural, they were superior to those
upon whose shoulders they stood, and each in his own way
did signal service to the cause of Humanism, Poggio by his
successful researches for manuscripts, Filelfo by his wide
and sound knowledge of pagan literature, and by his inspiring
energy as a teacher, Valla as the founder of historical criticism.
But all three alike contributed to the debasement of the
humanistic ideal. By their vanity, their self-importance,
their unchaste lives and still more unchaste writings, their

[1] See W. H. Woodward, *Vittorino da Feltre and other Humanist Edu-
cators*, Cambridge, 1905.
[2] He was general of the Order from 1431 to his death. See L. Mehus,
A. Traversarii Epistolae, Florence, 1759.
[3] W. Shepherd, *The life of Poggio Braccolini*, Liverpool, 1802.
[4] C. de' Rosmini, *Vita di Francesco Filelfo*, Milan, 1808.
[5] See *post*.

insatiable greed for money and reputation, their scurrilous
and ridiculous quarrels, they went far to belie the claim of
classical literature to be the most humane of studies. Even
more alarming to Ambrogio Traversari must have been their
attitude towards the Church. Poggio's was one of frivolous
malice, Valla's of cold and critical hostility, and though
Filelfo professed a zealous orthodoxy, he attacked the monks
and friars with no less acrimony than Poggio. His library,
unlike that of the earlier humanists, was composed entirely
of pagan authors.

Another characteristic of these humanists, at any rate
of Filelfo and Poggio, was the "traffic in immortality," to
borrow Voigt's expressive term, which they carried on with
the princes of Italy. It was founded on the belief, held
with equal credulity by both buyer and seller, that the
humanists could confer by their writings immortal glory or
everlasting shame. Thus in practice it resolved itself into
a foretaste of the more unabashed form of blackmail which
Aretino carried on with such successful effrontery a century
later.

In the year · 1450, when the jubilee was celebrated at
Rome with a splendour which had not been witnessed since
its institution in 1300, Humanism seemed to be at the
zenith of its popularity. Alfonso I of Naples, Federigo
Duke of Urbino, Cosimo de' Medici, and Pope Nicholas V
vied with one another in their liberal patronage of scholars.
Even Francesco Sforza, the great *condottiere*, who had just
been acknowledged as Duke of Milan, invited humanists to
his court from motives of policy.

In King Alfonso's romantic passion for antiquity there
was something extravagant and fantastic. If he saved Valla
from the clutches of the Inquisition, he extended his hospi-
tality to Antonio Beccadelli, known as Il Panormita, the
author of the infamous *Hermaphroditus*. When he entered
Naples in triumph, the procession was modelled on that
of a Roman *imperator*. Every day he had read to him
some pages of Livy, and when the supposed bones of the
great Roman historian were discovered at Padua, he sent

Beccadelli on a mission to the Venetian Republic to beg for an arm.

In solid learning and in shrewd commonsense he was surpassed by the Captain-General of his forces, Federigo of Montefeltro, Duke of Urbino. Though he was of illegitimate birth, it was characteristic of the age that on the assassination of his half-brother Oddantonio he succeeded to the Duchy with the entire good-will of the citizens (1444). He had been a pupil of the great humanist schoolmaster, Vittorino da Feltre, whose aim it was to make good men and good citizens, and he had learnt the art of war under the distinguished *condottiere*, Niccolo Piccinino. In 1450 his reputation as a commander was already so high that he was appointed Captain-General of the forces to Francesco Sforza, the new Duke of Milan, and soon afterwards to the King of Naples. Throughout his life military service provided him with a large and regular income, but a great part of the wealth that he derived from war was devoted to the arts of peace. The small court of Urbino became one of the most famous of Italy, until in the next generation, under Federigo's son and successor, Duke Guidobaldo, it served as a model to Europe, and Castiglione founded on it his famous book of *The Courtier*. At the outset of his work he speaks of Federigo as the "light of Italy," and praises his humanity, his justice, his liberality, his fortitude, and his military skill. He says that his palace, which was built for him by the Dalmatian architect, Luciano Laurana[1], was "in the opinion of many the fairest in the whole of Italy," and finally he mentions his library which he had collected at great expense, "believing it to be the supreme excellence of his great palace[2]."

Of this famous library we have a detailed account from the pen of the Florentine bookseller, Vespasiano da Bisticci, who had helped to make it. It had cost 30,000 ducats and had given employment to thirty or forty copyists for more than fourteen years. Vespasiano, who had compared its catalogue

[1] A native of Lo Vrana near Zara, in Dalmatia, and a Venetian subject.
[2] *Il Cortegiano*, lib. I. c. 2.

with those of the chief libraries of Italy, the Vatican, St Mark's at Florence, and that formed by the Visconti at Pavia, declared that it was more perfect than any of them, for it was more complete and more thoroughly representative. Every volume was richly illuminated, and bound in crimson with silver ornaments. " There was not a printed book among them ; he would have been ashamed of having one[1]." The Duke, says Castiglione, "regarded it as the supreme orna-ment of his great palace[2]." He himself was a well-read man, ranging over a variety of subjects, including theology, history, and Aristotle's philosophy. He had also studied architecture, geometry, and arithmetic, and "he had in his house a German professor, who was a very great philo-sopher and astrologer." He delighted in music, and had an excellent band of musicians ; he talked to sculptors as if he were himself a sculptor ; and he had a great knowledge of painting, and " not finding painters to his liking in Italy who could paint in oils, sent for one from Flanders." This was Justus of Ghent, who painted a large picture of the Last Supper into which he introduced portraits of the Duke and his wife and their son Guidobaldo at the age of about two[3].

The Duke was a bountiful patron not only of art but of letters, vying, says Vespasiano, with Nicholas V and the King of Naples. " No man of learning ever came to Urbino, or wherever the Duke was, without being shewn honour and hospitality." There is no more charming picture of

[1] *Vite di uomini illustri del secolo* xv, Florence, 1859, c. xxxi. A similar account is given by Giovanni Santi in cap. LIX. of his long chronicle of the Duke in *terza rima* (ed. H. Holtzinger, Stuttgart, 1893). See also J. Dennistoun, *Memoirs of the Dukes of Urbino*, ed. E. Hutton, 3 vols. 1908, I. c. viii., and J. Cartwright (Mrs Ady), *Baldassare Castiglione*, 2 vols. 1908, I. c. v.

[2] *Il Cortegiano*, I. 2. See for a comparison with the other great libraries of Italy the note at the end of this chapter.

[3] The best known portrait of Federigo is that in the Uffizi; it was painted by Piero della Francesca about 1469, when the Duke was forty-seven. The ugly but dignified face with its broken nose, five warts, and strong chin is here portrayed without malice or extenuation, a masterpiece of realistic portraiture.

the Renaissance than the account given by Pius II in his
Commentaries of his journey from Rome to Tivoli[1]. He
relates how Federigo came to meet him at the bridge over
the Anio, and how, as they rode together to Ponte Lucano
accompanied by a brilliant escort of men-at-arms, the great
captain, who had read much, questioned the Pope as to the
armour of the ancients compared with that of the moderns,
and how they were led to discuss first the Trojan War and
then the boundaries of Asia Minor, and how, when the Pope
reached Tivoli, he availed himself of a few days leisure to
write a description of that country[2].

But in 1450 Federigo of Montefeltro was still a young
man and had hardly begun to exercise any influence on art
and letters. At that date the most enlightened patron of
the humanists was Pope Nicholas V. In a striking page
Lord Acton[3] points out that he recognised how important it
was for the Church that the new learning and the new
criticism should be enlisted in her service, and that the
exposure of falsehood in her traditions should come not
from her enemies but from her own servants. It was also
part of the policy of this enlightened pontiff that Rome
should stand forth as the material and intellectual capital
of Christendom, and to this end he devoted his two strongest
passions, his passion for books and his passion for building.

His relations to the humanists are highly characteristic
of the age. In answer to a congratulatory letter from
Filelfo on his election, he invited him to Rome and offered
him a post at the papal court. But Filelfo dreamt of higher
things than a mere secretaryship. Some years before this,
on the death of his first wife, he had thought of taking orders
as a preliminary to being made a Cardinal or at least a

[1] *Commentarii*, Frankfort, 1614, lib. v. p. 136.

[2] *Historia rerum ubique gestarum, cum locorum descriptione non finita,
Asia Minor incipit*, Venice, 1477. It was reprinted at Venice in 1503, with
another treatise by Pius II, *In Europam*—historical rather than geo-
graphical in character—under the title of *Cosmographiae libri* II. These
are the only completed parts of a comprehensive work on history and
geography which the Pope had planned.

[3] *Lectures on Modern History*, pp. 77–79.

Bishop, and in this sense he had approached Eugenius IV. But the Pope did not answer his letter, and Filelfo letting the project drop married again. Now he was left for a second time a widower, and with a very considerable family. Again the idea of taking orders presented itself to him, but having been twice married there was a canonical difficulty. Accordingly he addressed two Latin poems to Nicholas V, in which he begged for the required dispensation. Again he received no answer, and again he consoled himself with a new wife[1]. Five years later, passing through Rome on his way to the court of Alfonso of Naples, he was sent for by the Pope, who asked him about his literary work, and hearing that he had just completed a volume of satires insisted on his remaining in Rome until he had read them. They were filthy in the extreme, but the Pope praised them highly and rewarded the author with 500 ducats, and the post of papal secretary[2]. Another papal secretary was Poggio, who had held the post under six preceding Popes. It was characteristic of Nicholas V that he urged him to learn Hebrew in order that he might revise the Vulgate translation of the Old Testament. But the Pope's most striking act in connexion with Humanism was the appointment of Valla to a post at his court. For Valla's remarkable powers of historical criticism had been directed against some of the most cherished traditions of the Church, the writings of Dionysius the Areopagite, the Donation of Constantine, and the composition of the Apostles' Creed.

This attitude of Nicholas V to men like Valla and Poggio and Filelfo, however much it may have been dictated by policy, lends no support to the theory of the two Renaissances—the true or Christian, and the false or pagan—which Dr Pastor puts forward at the outset of his *History of the Popes*, and which colours his whole narrative. Certainly no such antagonism was felt by the humanists themselves. It is

[1] By his three wives, all of whom he survived, Filelfo had twelve sons and twelve daughters. In his will he made provision for two illegitimate children.

[2] Voigt, *Wiederbelebung*, II. 95 ff.

doubtful whether even the most pagan-minded of them seriously cherished the desire to restore the spirit of paganism in life and thought. However widely their lives might deviate from the Christian pattern, they never, except perhaps in very rare instances, wholly abandoned the Christian faith, and on their death-bed they hastened to fortify themselves for the passage to eternity with the rites of the Church. In the true development of the Renaissance, in the emancipation of the human mind from the fetters of tradition and authority, in the assertion of the rights of the individual as against the tyranny of society, in the general striving after knowledge and truth and beauty, Valla and Poggio were fellow-workers with Vittorino da Feltre and Nicholas V.

It is true, however, that the Renaissance, like all great movements, contained elements of unreason and exaggeration. Excess of individualism led to licence, excess of the critical spirit to scepticism, exaggerated humanism to paganism. Especially the adoption of pagan ideals of thought and character constituted for about the space of a generation— roughly speaking, from the delivery of Filelfo's Greek lectures at Florence (1429) to the close of the pontificate of Nicholas V (1455)—a real danger to the whole movement of the Renaissance. But the very excesses and absurdities of the humanists brought about a reaction. The savage and indecent controversies between Poggio and Filelfo and between Poggio and Valla must have done even more than their greed for fame and money to disgust sober-minded men with Humanism. With the accession of Æneas Sylvius to the papacy (1458) the reaction definitely set in. But before describing this, it will be necessary to go back to the beginning of the *quattrocento* and to consider the Renaissance under an aspect which differs considerably from that of Humanism, and without which our whole conception of the Renaissance must needs be one-sided and imperfect.

III

The first half of the fifteenth century was not only the age of the humanists, it was also the age of Brunelleschi, Michelozzo and Alberti, of Jacopo della Quercia, Ghiberti, Donatello and Luca della Robbia, of Fra Angelico, Paolo Uccello, Andrea del Castagno, Domenico Veneziano, Masaccio, Filippo Lippi, Pisanello, and Piero de' Franceschi. All were Florentines[1] except four, and of these four Domenico Veneziano came to Florence at an early age, painted there for the rest of his life, and had for his pupil Piero de' Franceschi, who was born at Borgo San Sepolcro in the corner of Tuscany. Thus only Jacopo della Quercia, who was a Sienese, and Antonio Pisano, commonly called Pisanello, who was born at Verona, had no artistic connexion with Florence. The first thing to be noticed in these great artists is their versatility. Brunelleschi is thus described by an anonymous writer : " He was an unrivalled architect, an arithmetician and an excellent geometrician, a sculptor and a painter, though in these two arts he did little. He rediscovered the art of perspective, which had been for a long time lost. He was most learned in the Scriptures, and he had a marvellous comprehension of the *Commedia* of Dante, our Florentine poet." Michelozzo was equally in request as a sculptor and an architect. Donatello's architectural knowledge is shown in his niches and tabernacles, and in the buildings which form the backgrounds of some of his reliefs ; he copied antique gems for Lorenzo de' Medici, and he designed one of the stained-glass windows in the Duomo. Ghiberti, whose success in the competition for the Baptistery doors made his defeated rival, Brunelleschi, an architect, began his artistic career first as a goldsmith, and then as a painter. He designed the greater part of the windows in the Duomo, and he had a considerable reputation as an architect. Indeed, he complacently says in his *Commentaries* that few

[1] Alberti, the son of a Florentine exile, was born probably at Genoa.

important works had been carried out in Tuscany which had not been designed and executed by his hands[1].

Like Ghiberti and Brunelleschi and many others, Luca della Robbia was first a goldsmith, and at the height of his fame he worked in marble and bronze as well as in the famous glazed terra-cotta by which he is best known. Pisanello was a painter of considerable reputation before he became the greatest of medallists. A still better example of many-sidedness is afforded by Leon Battista Alberti. Eminent in the first place as an architect and a writer on architecture, he was also proficient in the arts of painting and sculpture, on both of which he wrote treatises ; and he was an accomplished musician. He was a classical scholar, a writer of both Latin and Italian prose, and for his time had considerable knowledge of mathematics, physics, and mechanics. Renowned too for his physical strength and activity, he was regarded by his contemporaries as a perfect example of what they called an *uomo universale*.

Alberti, however, was exceptional in his classical know-ledge. The majority of the Renaissance artists had little book-learning of any sort. As soon as they could read, write, and cypher, they began their artistic apprenticeship, which lasted for twelve years and included every kind of mechanical labour that was employed in the various arts. The thoroughness of their training made them extraordin-arily proficient in technique, but without stifling their intellectual faculties. For the most striking characteristic of the Florentine art of this period is the intellectual effort which sustained it. The majority of the artists, especially the greatest of them, were occupied with important and difficult problems—problems of engineering and mechanics, problems of perspective and light, problems arising out of the relations of the different arts to one another. One of

[1] Second Commentary. See *Vita di L. Ghiberti scritta da G. Vasari*, ed. C. Frey, Berlin, 1886. Frey prints, besides the complete Second Commentary, a few fragments from the Third. The First, which has never been printed, contains an account of Greek and Roman art, taken mainly from Pliny.

the most important of these problems was that of perspective, that is to say, of representing objects on a flat surface, or in low relief, so as to give the illusion of depth. As we have seen, the credit of having "rediscovered the art of perspective" was given to Brunelleschi. But it does not appear that either he or Ghiberti, who in the second pair of doors that he made for the Baptistery, worked almost like a painter, went beyond an empirical study of the subject. The same may be said of Paolo Uccello, whose naive enthusiasm led him to introduce figures into his pictures solely for the purpose of displaying his skill in foreshortening. It was Piero de' Franceschi who first studied the subject scientifically by the light of geometry. His results were embodied in an unpublished treatise, to which later research has added little except the theory of the vanishing point. The same painter paid close attention to problems of light and shade, as may be seen in the famous frescoes which he began at Arezzo in 1453, and especially in the Vision of Constantine. "The tent," says Vasari, "the armed men, and all the surroundings are illumined by the light which proceeds from the angel with the greatest skill. In this night-scene Piero shows the importance of copying things as they really are, and of taking nature (*il proprio*) for his model."

"Taking nature for his model"—that was the motto of the early Renaissance. "Remember," says Cennini in his *Treatise on painting*, "that the most perfect guide that you can have is the triumphal gateway of drawing from nature." So Ghiberti, speaking of his second doors, says that he strove to imitate nature as closely as possible. He had a special love for birds and animals and plants, and he has given exquisite effect to it in the framework of these doors. A similar style of decoration, though without the birds and animals, is used by Luca della Robbia for the borders of his terra-cotta reliefs of Madonnas, for his coats-of-arms on Or San Michele, and for his tomb of Bishop Federighi[1]. But he aims at decorative effect rather than accurate representation, and though his leaves and

[1] Now in Santa Trinità, Florence.

fruit (grapes, quinces, pine-cones) are fairly true to nature, his flowers either purposely or from insufficient observation are almost conventional. On the other hand Pisanello's pinks and columbines and butterflies in the portrait which Mr Hill conjectures to be that of Ginevra d'Este, and his birds and animals in the Vision of St Eustace in the National Gallery, are rendered with great fidelity, though without Luca della Robbia's sense of aesthetic fitness. His treatment has the defect of diverting the attention from the main interest of the picture, and is an inheritance from the naive naturalism of the mediaeval illuminators.

Donatello's unrivalled powers of imagination were concentrated upon Man, not merely upon the outward and physical Man, but upon the inner and spiritual Man. His chief aim was the expression of character. His St George is a type of youthful determination, concentrated energy, and modest confidence. On the other hand the Jeremiah, the Habakkuk, and the " Zuccone," which he made for the Campanile between 1416 and 1425, are individuals rather than types. Tradition has even named them, and, whether tradition is true or not, they are undoubtedly portraits.

In the year 1425, when Donatello was putting the last touch to his prophets, and Ghiberti was setting to work on his second doors, Masaccio was painting his celebrated frescoes in Santa Maria del Carmine. It is from Masaccio that Leonardo da Vinci in an often cited passage dates the revival of painting. " After Giotto the art of painting again declined, because everyone imitated the pictures that were already painted ; thus it went on from century to century until Tommaso the Florentine, nicknamed Masaccio, showed by his perfect works how those who take for their standard anything but nature—the mistress of all masters—weary themselves in vain." But if nature was Masaccio's chief mistress, he learned something from Donatello. He learned from him the importance of structure, and he learned to find an absorbing interest in character. But his treatment is that of the St George rather than that of the prophets of the Campanile. Masaccio gives us individuals who are also

types, and noble types. In portraying character he does not, like Filippo Lippi for instance, depend entirely upon expression. Gesture plays an equally prominent part ; every curve and line of the body has its significance. Moreover this strong impress of character is communicated not only to the individual figures but to the whole incident in which they are taking part. The Expulsion from Paradise, the central scene of the Tribute-money, the Distribution of Alms by St Peter, and the Healing of the Sick by St Peter and St John, are all represented at the most characteristic moment[1].

Note too, in the Tribute-money, the contrast between the calm dignity of Our Lord, and the energetic indignation of St Peter. Dignity in repose, and energy in action—these are the qualities which most impress us in the art of this period. In the frescoes of Piero de' Franceschi at Arezzo, for instance, what energy in the battle between the Emperor Heraclius and the King of Persia, and what dignity in the Visit of the Queen of Sheba to Solomon ! We see the same calm, almost impassive, dignity in one of the rare examples, a Madonna with Saints in the Uffizi, of Piero's master, Domenico Veneziano. We see the same energy, but with less dignity, in Andrea del Castagno's swaggering figures of celebrated Florentines, which are obviously influenced by Donatello. Donatello himself is an equal master of dignity and energy. Nothing can be more dignified than some of his Madonnas, and his statue of Gattamelata is a model of restrained energy and noble dignity. On the other hand in the four reliefs of St Anthony's miracles, which he executed at Padua before the great equestrian statue, and in the bronze pulpits of San Lorenzo, which he designed in his old age after his return from Padua, and which were executed in great part by his pupils, the prevailing note is one of animated energy. We find the same double note of energy in action and dignity in repose in Jacopo della Quercia. On the portal of San Petronio at Bologna the Expulsion

[1] Donatello is sometimes influenced by Masaccio ; compare, for instance, his Charge to St Peter in the Victoria and Albert Museum, executed at Rome in 1433, with Masaccio's Tribute-money.

from Eden and the Sacrifice of Isaac in their simple but
dramatic intensity proclaim the forerunner of the sculptor
of the tombs of San Lorenzo : in the Cathedral of Lucca
the figure of Ilaria del Carretto reposes with a serene dignity,
" which is not death nor sleep, but the pure image of both."
This feeling for human energy and human dignity is very
characteristic of the Renaissance. So also is the growing
love of portraiture, which corresponds to the craving for
posthumous fame. We have seen that three at least of
Donatello's prophets are evidently portraits, and it became
increasingly common with him and his successors to make
portrait busts of women and boys under the guise of Saints
and Holy Children.

Long before this there had been acknowledged portraits
of the dead, either in the form of an effigy on the tomb, or
as an adjunct to it. But the portrait bust of a living
individual was rare before the middle of the fifteenth century.
Painted portraits of the living were more common, but
Masaccio seems to have begun the practice of introducing
them into religious pictures. There are portraits of himself
and his master Masolino in his surviving frescoes at the
Carmine, and his vanished fresco of the consecration of that
Church contained the portraits of numerous citizens who
took part in the procession, including Brunelleschi and
Donatello. Filippo Lippi has smuggled the head and
shoulders of Roberto Malatesta into the corner of the
Nativity which he painted for the nuns of Annalena about
1430, and in his great Coronation of the Virgin, painted
in 1441, he has introduced numerous portraits[1]. Even Fra
Angelico fell in with the growing fashion. His great De-
position contains a portrait of Michelozzo, and Vasari tells
us that in his frescoes for the Chapel of the Holy Sacrament
in the Vatican (destroyed by Paul III), there were several
portraits including Nicholas V, the Emperor Frederick III
(whose coronation took place in 1452), Ferrante of Arragon, the
future King of Naples, and Flavio Biondo, the archaeologist.

[1] Not, however, his own portrait, as was formerly supposed (M. Car-
michael in the *Burlington Magazine*, XXI. 194 ff.).

Considerable impulse was given to portraiture by Pisanello's great series of portrait medals, the earliest to which a date can be assigned being that of John Palaeologus (1438). His medals had a considerable influence upon painters. For instance, Piero de' Franceschi's portrait of Sigismondo Malatesta, painted in 1451, bears a close resemblance to Pisanello's medals of the same prince, which were executed six years earlier.

This growing interest in Man, whether as type or as individual, introduced into Italian art, which had been hitherto almost exclusively religious, a considerable secular and realistic element. But Art, at any rate during the earlier Renaissance, did not thereby become pagan. Rather, since Christianity is essentially human, Art in becoming more human became more Christian. To say that nine-tenths of the painting and sculpture of this period drew their inspiration from the Christian story does not mean much, for it only implies that the Church was the best patron. But at any rate down to the close of the pontificate of Nicholas V (1455), Art, with some exceptions, remained religious in sentiment as well as in subject[1].

Luca della Robbia's work, if less mystical than Fra Angelico's, is hardly less religious. Donatello in his Madonnas and tombs, and especially in his beautiful relief of the Annunciation in Santa Croce, shows no want of devotional feeling. But it is true that Art ceased to be dominated by the two great arbiters of mediaeval thought and life, the Church and the Guild. Brunelleschi's successful completion of Santa Maria del Fiore was the triumph of individual genius over the pedantry and prejudices of the Florentine Guilds. If the painters and sculptors accepted the subjects assigned to them by their patrons, they treated them in their own way. Art ceased to be conventional and hieratic. Henceforth its sole aim was truth—truth of observation and truth of expression. Truth is the essential characteristic of

[1] Instances of religious themes treated in a purely pagan fashion are Mantegna's frescoes in the Eremitani at Padua (1454–1459) and Benozzo Gozzoli's Adoration of the Magi in the Palazzo Riccardi (1459).

Brunelleschi's architecture. He is sparing of all ornament
which does not fulfil a structural purpose. He is, above
all things, intellectual and practical. He is a great artist,
but he would have said with Boileau, *Rien n'est beau que
le vrai.*

Finally there is the question how far early Renaissance
Art was influenced by the classical revival. According to
the older view this influence was far-reaching, and may be
dated from that celebrated journey of Brunelleschi and
Donatello to Rome in the second or third year of the fifteenth
century, which Manetti and Vasari record with such pictur-
esque details. But when we come to examine this theory
by the light of sober fact we see that it rests on very insecure
foundations. In the first place, even by the middle of the
Quattrocento, or fifty years after the visit of Brunelleschi
and Donatello to Rome, very few important examples of
classical art, apart from buildings, were known to Italians.
Five or six bronzes, including the equestrian statue of
Marcus Aurelius and the Boy extracting a thorn (Spinario),
which throughout the Middle Ages had been in or around
the Lateran Palace, the colossal statues of Castor and Pollux
on Monte Cavallo (much mutilated) and some river-gods,
including the celebrated one known as Marforio, were prac-
tically all the antique sculpture of which Rome could boast.
Add to these the bronze horses at Venice, a few sarcophagi
at Pisa, Florence, and elsewhere, the collections of Niccolo
Niccoli, Cosimo de' Medici, Poggio, and other collectors,
which, so far as sculpture goes, seem to have consisted
largely of torsos and noseless busts, and you arrive at a sum
total which, however interesting, is far from imposing.
Especially is it to be noticed that it is impossible to
claim for the golden age of Greek sculpture any work that
was known in 1450.

It is true that these examples of classical art furnished
the artists of the early Renaissance with occasional motives.
Brunelleschi, for instance, in his competition panel of the
Sacrifice of Isaac for the Baptistery doors, gives a free
rendering of the Spinario from a marble copy which existed

at Florence, just as Niccolò Pisano 140 years before had
borrowed for his pulpit in the Pisa Baptistery some figures
from the sarcophagi in the neighbouring Campo Santo.
Again, classical details, apart from the architecture, will be
found occasionally in Donatello's work ; but it is only in
the pulpits of San Lorenzo, which he did not begin to design
till after his return from Padua in 1453, that they are at
all frequent. But even so, the classical influence is confined
to details and accessories, and very rarely affects the essential
spirit of his work. It is only in the horse of his Gattamelata
statue, the first bronze equestrian statue that was cast in
Italy since classical times, that he can be really said to have
been helped by the study of a classical model—the bronze
horses at Venice. Similarly with Ghiberti. He speaks in
his *Commentaries* with glowing enthusiasm of certain recently
discovered specimens of classical art, he was himself a col-
lector of antiquities, and he has introduced at least one
classical motive into his Baptistery doors. But what can
be more unlike classical art than the reliefs on these doors
with their four separate planes and their general pictorial
effect ?

Even in architecture the influence of antiquity during
the earlier Renaissance was not a preponderating one.
Brunelleschi is essentially an architect of transition, who,
guided by his genius for construction far more than by
classical sympathies, gradually feels his way with marvellous
originality and independence to new architectural methods.
The cupola with which he crowned Santa Maria del Fiore
is the triumphant solution of a constructive problem which
had been imposed on him by the plans and partial execution
of Arnolfo and his successors. The palazzo Pitti, for which
he received the commission in 1440, was, as he designed it,
more like a mediaeval fortress than a Renaissance palace.
Meanwhile he had been working out after his own fashion
the principles of classical architecture which he had studied
at Rome. But just as for his great double cupola he had
had in the neighbouring Baptistery a model to his hand far
more helpful than the Pantheon of Rome, so in his classical

churches he was largely influenced by the Romanesque work around him, such as the Santi Apostoli, San Miniato, and the old Badia of Fiesole[1]. In the sacristy of San Lorenzo, which he began about 1430, and in the little Pazzi chapel in the cloister of Santa Croce, which he completed a little later, the classical pilasters and entablature are merely decorative, and have no structural importance. In the portico of the latter he combines the lintel with the arch. "It resembles nothing," says Mr Statham, "either Roman or Gothic."

It was Alberti who turned the attention of the Renaissance architects to the classical buildings of Rome. Having followed Pope Eugenius IV to that city in 1443 he published about 1452 his famous *De re aedificatoria*, the first modern scientific work on the theory and practice of architecture. He took Vitruvius, who was then little known, for his groundwork, but corrected and largely supplemented him by the light of his own observations and studies. His work speedily acquired a position of great authority, and under its influence and that of Biondo's *Roma instaurata*, published a few years earlier (1446), younger architects like Francesco Georgio di Martini and Giuliano da San Gallo diligently filled their sketch-books with the buildings of ancient Rome.

It was the weaker men of the early Renaissance, such as Michelozzo and Filarete, who were most strongly affected by classical art. For instance, Filarete in the bronze doors which he made for the old basilica of St Peter's (1433–1445) has filled the borders round the panels with medallions of Roman emperors and subjects from ancient history and mythology, and has introduced Roman buildings and other classical reminiscences into the panels which represent the martyrdoms of St Peter and St Paul. But with all this

[1] See P. Fontana in *Arch. Stor. dell. arte*, III. 256–267 ; C. H. Moore, *The Character of Renaissance Architecture*, New York, 1905, pp. 26–32. Vasari says that the Church of SS. Apostoli was his model for San Lorenzo and San Spirito.

naive enthusiasm for antiquity he has but a superficial knowledge of it, and he has no perception of its true spirit[1]. Michelozzo's feeling for classical art is of a higher order. In his Aragazzi monument at Montepulciano (1427–1436) the nude children, the draperies and attitudes of the other figures, and the general art of grandeur and severity testify to his classical sympathies. But the execution betrays a certain awkwardness and lack of artistic harmony ; the figures are stunted, and the fusion between the ancient and the modern elements is incomplete. It is easier to imitate the forms and decorative details of classical architecture, and Michelozzo does this with considerable success in minor works, such as chapels, niches, and tabernacles. But he had neither the structural genius nor the artistic personality to carry out any real architectural change. His best work is the palace which he built for his chief patron, Cosimo de' Medici[2], and owing to his excellent workmanship and to his talent for the arrangement of interiors he was in great demand for domestic architecture.

On the other hand Luca della Robbia and Pisanello, without any visible help or hindrance from outside influences, achieved in the serenity of their own souls a consummate felicity of artistic expression. Both apprehend with unerring instinct the style and treatment most appropriate to the special branch of Art in which they are working. Pisanello's medals by their large style of portraiture, and by their "combination of convention and realism" equal, if they do not surpass, the best Greek coins[3]. Luca della Robbia, alike in his tomb of Bishop Federighi,

[1] Before he left Rome he made a small bronze reproduction of the equestrian statue of Marcus Aurelius, which is now at Dresden. It is fair to say that his work as an architect, which belongs to his riper years, is far superior to his work as a sculptor.

[2] Now the Riccardi palace.

[3] Glorious examples are the reverses of the medals of Cecilia Gonzaga, Malatesta Novello, and Leonello d'Este (the marriage medal), for which see Mr G. F. Hill's excellent book on Pisanello. On pp. 20–24 he discusses his debt to antiquity, and comes to the conclusion that it is very small.

in his Cantoria, in his bronze doors, and in his terra-cotta reliefs, shows the same feeling for his material, the same instinctive perception of the appropriate treatment. The simplicity of Bishop Federighi's monument is in perfect keeping with the calm repose of the reclining figure ; the dancing and singing children of his Cantoria combine close observation of nature with consummate skill in grouping and arrangement ; his bronze doors are no mere sculptured panels, but real doors which open and shut ; his terra-cotta Madonnas are at once perfect emblems of Motherhood and perfect Art. Thus in all his work he never sacrifices beauty to expression, he never loses sight of the composition in the details, he never forgets the universal in the particular. Like Pisanello, he has the restraint, the economy, the absolute rightness of the best classical work, and like Pisanello he lives in that serene region between the real and the ideal, between nature and artistic convention, which is the chosen atmosphere of Art. But, except in the possession of these highest artistic qualities, neither his art nor Pisanello's is in the least classical. Like Brunelleschi and Donatello and Masaccio they had " recovered for themselves the secrets of art-creation[1]."

IV

When Æneas Sylvius Piccolomini[2] was elected Pope in 1458 the humanists looked forward to a golden harvest. But they were destined to be grievously disappointed. When Filelfo, the one remaining veteran of Humanism—Valla died

[1] B. Berenson, *North Italian Painters of the Renaissance*, 1907. See pp. 31–37 for an excellent discussion *à propos* of Mantegna on the influence of the Antique. It is however an exaggeration to say that " specimens of debased Greco-Roman sculpture alone were accessible " to the early Renaissance artists.

[2] The latest biographer of Pius II is Miss C. M. Ady, *Pius II, the Humanist Pope*, 1913 ; her account is both sympathetic and critical. She says truly that Creighton's Essay (*Historical Essays and Reviews*, 1902) and his account in vol. III. of his *History of the Papacy* " can hardly fail to be the inspiration of all future work on the subject."

the year before the Pope's election, and Poggio the year
after—besieged Pius II for preferment, the Pope put him
off with courteous answers and a few small presents. He
could appreciate the wit and literary genius of Poggio, and
the historical acumen of Valla, but he had less sympathy
with Filelfo's scholarship. He himself was a man of letters
rather than a scholar. His busy life had left him little
leisure for continuous study. His knowledge of Greek never
went beyond the rudiments, and his Latin style, though
flowing and picturesque, was far from correct. But if he was
not a great humanist, he worthily represented the Renais-
sance in its best and widest spirit. It is a mistaken view
of him to say with Symonds that before he was Pope he
was "the mirror of his time," and that afterwards he was
"an anachronism." During the first forty years of his life,
indeed, his opposition and his pliability bore him along the
current of contemporary thought and fashion, but as Bishop,
as Cardinal, and above all as Pope, so far from lagging
behind on the intellectual march he strode forward under
the stimulus of responsibility and a growing sense of the
seriousness of life to the very forefront of the movement.
He represents the Renaissance on its critical side. " The
founder of freedom of speech in history," as Lord Acton
calls him, he wrote history in a critical and scientific spirit.
Like Petrarch he took a keen interest in geography ; his
Asia was read by Columbus, and was a favourite book in
the early days of geographical discovery[1]. Like Petrarch
too, he was a lover and observer of nature. When he
visited Viterbo in May 1462 he noted the fields of flax
" which imitate the colour of heaven[2]," and in recording an
excursion to Albano in the following year, he speaks with
delight of the clear waters of the lake, and of its groves of
ilex trees, and of the neighbouring lake of Aricia (Nemi),
the shores of which were planted with chestnuts and many
kinds of fruit trees[3]. He has left an equally charming

[1] Chapter II is entitled *an mare circumnavigari queat sententiae.*
[2] *Comm. lib.* VIII. p. 207.
[3] *Comm. lib.* XI. 307.

description of Siena and its beautiful neighbourhood, where he spent some time in the spring of 1460. From there he visited the baths of Petrioli about ten miles from the city, passing through the valley of the Mersa, "which is full of eels sweet in flavour though small." On the hills which circle the valley he notices the ilexes, the oaks, and the cork-trees[1]. Wherever he went he looked about him with a curious and intelligent eye ; in his faculty for observing the material world he was a true Italian.

In one respect he showed himself singularly in advance of his age. He had no belief in that science of astrology which had been so popular in Italy ever since the beginning of the thirteenth century[2], and which, even in the next generation, was patronised by Federigo of Urbino, Ludovico Sforza, Sixtus IV, and Innocent VIII, and, later still, in spite of the damaging attack of Pico della Mirandola, by Leo X and Paul III. Though he had little sympathy with the ordinary humanist, he showed favour to men of real learning. He made Niccolò Perotti archbishop of Manfredonia, and he treated with marked consideration a man who, lacking the graces of style, had been neglected by Nicholas V. This was Flavio Biondo (1388–1463), the founder of classical archaeology, who in his *Roma triumphans*, *Roma instaurata*, and *Italia illustrata* treated for the first time in a scientific spirit the topics of Roman antiquities, Roman topography, and Italian geography, and whose *Historiarum ab inclinatione romani imperii Decades*, a history of Italy from the invasion of Alaric down to his own times, "marks," in the words of Creighton, "an important epoch in historical writing[3]." Pius II, who has himself laid down admirable principles with regard to the weighing of authorities, showed his sense of its value by writing an epitome of it ; and it was possibly the influence of Biondo's *Roma*

[1] *Comm. lib.* IV. p. 101. See Creighton, *History of the Papacy*, III. 245 f., where the whole passage is translated.

[2] "Geomantibus et ceteris id genus nullam fidem attribuit" (Platina).

[3] There is an excellent appreciation of Biondo in T. Monnier, *Le Quattrocento*, 1901, pp. 266–274.

instaurata which led him to realise, as Nicholas V had so signally failed to do, the importance of preserving Rome's ancient monuments, and to issue his brief *Cum almam nostram urbem*[1].

The pontificate of Pius II marks the beginning of a new phase in Italian Humanism, when scholarship or the really critical study of antiquity definitely separated itself from Humanism as a mere patriotic cult. The founder of critical scholarship was Lorenzo Valla. He was a born critic, loving opposition, but loving truth still better. We have seen how he applied his critical axe to the traditions of the Catholic Church; and he carried his warfare into every field of knowledge. He attacked Aristotelian logic, especially as interpreted by the Arabian Commentators[2]; he wrote an invective against the celebrated *glossator* Bartolus, and, appealing from the mediæval to the ancient jurists, laid the foundation for the exact study of Roman jurisprudence[3]. In both these lines of attack, it may be observed, he was following in the footsteps of Petrarch. He even dared to lay hands on the Vulgate itself[4]. But it was in the sphere of Latin scholarship that his method was most fruitful. He was no stylist, and he never wrote a line of Latin verse, but he had made a scientific study of the Latin language. It was on this basis and not on an empirical imitation of models that he formulated his canons of correct Latinity, and he gave his results to the world in that abiding monument of his scholarship, the *Elegantiae latinae linguae*, a comprehensive treatise on grammar and style and textual criticism, which, first printed at Venice in 1471, went through fifty-nine editions between that date and 1536, and even at the present day may be consulted with profit[5].

[1] Pius II however plundered the ancient buildings for his Loggia of the Benedicite. See R. Lanciani, *The destruction of Ancient Rome*, 1899.

[2] *Dialecticarum disputationes*, lib. III.

[3] *Invectiva in Bartholi de insigniis et armis libellum.*

[4] *Annotationes in Novum Testamentum.*

[5] For Valla see especially I. Vahlen's masterly lecture, *Lorenzo Valla*, Vienna, 1864.

Valla's feud with Poggio (1451–53), was not, like that of Poggio with Filelfo, of a purely personal nature. It was primarily a controversy on style. Poggio wrote Latin with the individuality which makes for literature, but he took arbitrary liberties with grammar and construction. Valla had no pretensions to style in the higher sense of the word, but he knew to a nicety what was Latin and what was not. And his knowledge was based on reason, and not on mere instinct. Behind this was a larger issue, the issue between a synthetic but superficial reconstruction of antiquity, and a critical and analytical study of it. The controversy was carried on in the next generation, Valla's place being taken by his friend and disciple Niccolò Perotti (1430–1480), best known as the author of the first large Latin grammar of the Renaissance (1468).

On the other hand Humanism in its more superficial aspect, Humanism as a patriotic cult rather than as a key to knowledge and intellectual progress, was represented by the Roman Academy. Its founder indeed, Pomponius Laetus—both names were of his own invention—was a man of sound learning, as became a pupil of Valla. He was an authority on Roman antiquities, wrote a commentary on Virgil, and edited various Latin authors. But his enthusiasm for Rome—the Rome of the past and not of the present—was a narrow and all-absorbing one. He refused to learn Greek, for fear it should spoil his Latin style ; he professed himself a pagan in religion, and instituted a festival in honour of the birthday of the City of Rome ; and generally he despised the age in which he lived, and dreamed only of the glorious past. Thus, while the true spirit of the Renaissance was essentially progressive, this ardent humanist was a pure reactionary. Under his influence the Roman Academy became a centre of foolish protest against the Christian religion, and especially against the Pope, Paul II, who had given great offence by abolishing the College of Abbreviators, of which many of the humanists were members. These proceedings were very silly, and quite harmless. But the Pope took them seriously. He threw the leaders into prison

and suppressed the Academy[1]. It was revived under his successor, Sixtus IV.

The Academy of Naples, though it did not indulge in all the absurdities of its Roman sister, also represented Humanism in its less intelligent aspect. Founded by Antonio Beccadelli, Il Panormita, under the auspices of King Alfonso, it passed after his death (1471) under the sway of Giovanni Gioviano Pontano (1426–1503)[2], who, himself an admirable man of lettèrs impressed upon it a strong literary bent. In the battle between the stylists and the grammarians he fought on the side of the former, and in two of his dialogues attacked Valla with sharp satire. Yet he did not altogether disdain Valla's analytical method, and in his *De aspiratione* he investigated a purely grammatical question with minute and patient research.

On the other hand the bent of the Florentine Academy was philosophical. It was founded, as we have seen, by Cosimo de' Medici, to promote the study of Plato ; and under Cosimo's grandson, Lorenzo, its leading spirit was Marsilio Ficino, the translator of Plato and Plotinus into Latin, and the author of the *Platonic Theology on the immortality of souls*. Like the Roman Academy, it had its naive enthusiasms, commemorating the birth of Plato with a fitting ceremonial, as the other body commemorated that of Rome.

But at Florence Italian scholarship reached its high-water mark in Angelo Poliziano (1454–1494). The equal of Pontano in literary feeling and of Valla in critical analysis, he combined the merits of both schools of Humanism. Moreover, while Valla, though he had translated Thucydides,

[1] For Pomponius Laetus and the Roman Academy see Creighton, IV. 47–56 ; Voigt, II. 237–241 ; Sandys, II. 92–93. In the middle of the last century several inscriptions were discovered by G. B. de Rossi in the Roman Catacombs, which reveal the extreme silliness of their proceedings (see R. Lanciani, *Ancient Rome*, 1888, pp. 10–12 ; Rossi, *Roma Sotterranea Christiana*, I. 2–9). The story of the persecution is told with lively exaggeration by Platina in his life of Paul II ; a translation of part of his narrative will be found in Isaac Disraeli's *Curiosities of Literature*, 4th ed., IV. 339 ff.

[2] It being a rule of the Academy that every member should assume a classical name Pontano chose that of Jovianus.

modestly disclaimed any pretensions to higher Greek scholarship, Politian, in whom modesty had no part, boasted in a letter to Matthias Corvinus, the King of Hungary, that he was the first Latin for a 1000 years who equalled the Greeks in knowledge of their own language[1]. As a matter of fact, he had much less familiarity with Greek literature than with Latin ; but he was probably the best Greek scholar that Italy had yet produced, and at the age of sixteen he showed his confidence in his powers by beginning a translation of the *Iliad* into Latin verse. At any rate his range of knowledge and his whole conception of scholarship were singularly wide for his age. He lectured not only on Homer and Virgil, but on the Latin writers of the Silver Age, on Persius, Quintilian, Statius, Suetonius, and Juvenal. He translated such diverse authors as Herodian, Epictetus, and Hippocrates with his commentator Galen[2]. His edition of the *Pandects* remained the standard one for many years, and he lectured on Aristotle's logic. Not that he claimed to be either a jurist or a dialectician. As he said in his *Lamia* or introductory lecture to his course on the *Analytica Priora*, it was as a *grammaticus* or *litteratus* and not as a *philosophus* that he expounded Aristotle[3]. He was in short what in modern speech is called a philologist, or, to use the more common English expression, a scholar. That is to say he brought to the interpretation of ancient texts a combination of taste, insight, and critical method. The merit of his edition of the *Pandects* lay in the fact that it was based upon a systematic collation of the manuscripts.

His fame was spread abroad by his lectures, which he began to deliver in public in 1480. Students of all nations came to hear him, among them Grocyn and Linacre the pioneers of Greek scholarship in England. They were attracted, less by his learning, which few could really

[1] *Ep.* IX. I.

[2] The translation of Hippocrates and Galen is lost.

[3] Grammaticorum enim sunt hæ partes ut omne scriptorum genus, poetas, historicos, oratores, philosophos, medicos, iurisconsultos excutiant atque enarrent. *Opera*, Venice, 1498, Y vii, v°.

appreciate, than by the glowing inspiration of his rhetoric, the charm of his voice, and the fire of his delivery. The ungainly form and the ugly face, with its huge nose, thick lips, and squinting eyes[1], were forgotten under the spell of the lecturer's genius. A special feature of his lectures were the introductions to the various courses, which often took the form of a Latin hexameter poem. Four of these, *Manto*, *Rusticus*, *Ambra*, and *Nutricia*, have come down to us under the title of *Silvae*, and are among the most admired examples of his Latin verse.

In 1489 he published a selection of topics from his lectures under the title of *Miscellanea*. The volume made a great stir, and was read with avidity by all men of learning. Naturally, it found some detractors. The humanists of the school of Poggio cavilled at the elaborate investigations of minute points. Others found fault with the style. For Politian did not model his style on that of any one classical writer, but combined with the correctness of Valla the freedom of Poggio and Pius II. An amicable controversy which he had with a young scholar named Paolo Cortesi, the author of the dialogue, *De doctis hominibus*, on this question of style is the first note of the great Ciceronian controversy[2].

Thus both in his method and in his style, Politian stood for progress in scholarship. His death on September 28, 1494, twenty-six days after Charles VIII had crossed the Alps, may be said to mark the beginning of the decline of Italian Humanism. It is a significant fact that the learned and high-born Greek, Janus Lascaris (1445–1535), who had come to Florence in 1472 on the death of his patron, Cardinal Bessarion, and who had been twice sent by Lorenzo de' Medici on a mission to the East in quest of manuscripts, entered the service of Charles VIII. On the other hand his pupil Marcus Musurus (1470–1517), did good service as a

[1] See Niccolo Fiorentino's medal (C. von Fabriczy, *Medaillen*, Leipsic, p. 61).

[2] *Epp.* VIII. 16, 17; R. Sabbadini, *Storia del ciceronianismo*, Turin 1885; Sandys, II. 85.

successful teacher at Padua and Venice, and in helping Aldus Manutius to edit the many first editions of Greek authors which issued from his famous press. This work which went on from 1495 to 1514 was the principal contribution made by Italy to the cause of learning after the death of Politian. But it helped to destroy her primacy. The printed editions took the place of expensive manuscripts and made it more and more possible to study Greek out of Italy. Though Erasmus still found it necessary to spend three years in that country in order to perfect his knowledge of the Greek language, his rival Budé, his friends More, Vives, and Melanchthon all learned their Greek north of the Alps.

V

We have seen how Petrarch regarded his immortal Sonnets and *Canzoni* as of little account compared with his *Africa* and his *De viris illustribus*. So too Boccaccio in his old age was ashamed of having written " things in the vulgar tongue, fit for the ears of the populace." Small wonder then if the humanists of succeeding generations following these illustrious examples looked with contempt upon their own language, as at best the speech of a single people. Aspiring, as they did, to a world-wide fame not only after their death but in their lifetime, they wrote in that imperial language which their ancestors had used as the instrument of universal empire, and which they believed might once more become universal as the language of learning and letters. Thus, languishing under neglect, the speech of Dante and Petrarch and Boccaccio was employed only for humble uses, for such things as chronicles, and private diaries and letters, or for popular poetry such as the *strambotti* of the Venetian noble Leonardo Giustinian, or the satirical sonnets of the Florentine barber, Il Burchiello. Filelfo, for instance, declared that he employed it only for " such matter as he did not choose to transmit to posterity." The attitude of the humanists to the great triumvirate is especially instructive. At the very beginning of the fifteenth

century we find Coluccio Salutati writing with glowing enthusiasm of the transcendent merits of the *Divina Commedia*, and in Leonardo Bruni's Latin dialogue, *Ad Petrum Paulum Istrum*[1], the scene of which is laid in 1401, Salutati is made to say that if Dante had written in Latin he would rank even above the Greek writers. But Niccolò Niccoli, who with Leonardo represents the younger generation of humanists in the dialogue, takes a very different view, and ends by saying, " for these reasons, Coluccio, I shall banish your poet from the assembly of the learned and make him over to the wool-carders and bakers." Yet Leonardo, who in the dialogue is more or less in agreement with Niccolò Niccoli, wrote in 1436 excellent lives of Dante and Petrarch in the vernacular, while five years earlier (1431) the post of lecturer on Dante in the Florentine *Studium* was held by no less a humanist than Francesco Filelfo. However for many years after this the lectureship seems only to have been filled spasmodically, and in 1459 Giannozzo Manetti wrote Latin lives, prolix and pretentious, of Dante, Petrarch, and Boccaccio, in order to bring their merits to the notice of the learned, " who always despise and disparage writings in the vulgar tongue."

But a revival, a brilliant revival, of the vernacular literature was at hand. Its first champion was no less a man than Leon Battista Alberti, who, though a good Latin scholar and an eager student of antiquity, had a far wider range of sympathies than the ordinary humanist. In the prelude to the third book of his *Della famiglia*, a treatise on education which he began between 1432 and 1434, he defends the use of the vulgar tongue as being more generally understood than Latin, and as being equally rich in ornament. It was on his proposition that in 1441 a contest for poems in the vulgar tongue was held under the recently completed cupola of the Duomo. The style of the competitions revealed the depth to which the Tuscan Muse had fallen. The judges, who were the Pope's secretaries, finding

[1] Ed. T. Klette in *Beiträge zur Geschichte und Litteratur des Italienischen Gelehrtenrenaissance*, ii. Greifswald, 1889.

no competitor worthy of the prize awarded it to the church
of Santa Maria del Fiore, " a decision," says the Chronicler,
" which was blamed by everybody." In his efforts on
behalf of this neglected Tuscan speech, Alberti was warmly
seconded by his friend Cristoforo Landino (1424–1504),
a scholar of great ability, to whom, with Marsilio Ficino,
Cosimo de' Medici had committed the education of his
grandson Lorenzo. In his lectures on Petrarch (1460)
Landino pointed out the merits, existing and potential, of the
Tuscan language, and he mentioned the names of those who
in his time had cultivated it with success, first Alberti, and
after him Matteo Palmieri, who wrote a long poem in
terza rima entitled *La città di vita*, a treatise on education,
Della vita civile, and one or two others. " But," adds
Landino, " they are fewer in number than the gates of
Florence[1]."

But it was Landino's pupil, Lorenzo de' Medici, who gave
the chief impulse to the revival of Italian literature. Already
in 1466, when he was only sixteen, he sent to Federigo of
Arragon, the younger son of Ferrante, King of Naples, some
specimens of old Tuscan poetry, together with a remarkable
letter, in which he sketched for his friend a history of the
subject. From that time he was unceasing in his efforts
to spread the influence of Tuscan song, and, when the reins
of power fell into his hands, he impressed the same views
on the intellectual circle which he gathered round him. Thus
under the stimulus of his encouragement Luigi Pulci wrote
his *Il Morgante Maggiore*, and Politian his *Orfeo* and *Stanze*,
while Lorenzo himself produced the *Selve d' amore* and other
poems, which, if they lack Pulci's wit and creative power,
and Politian's exquisite finish, have a delicacy of feeling
and a range of interest which make them more perfectly
representative of their age. The work of all these writers
is largely based on the popular literature ; Pulci's on the
romances of chivalry, which in the second decade of the
century had found literary expression in the prose *I Reali
di Francia*, Lorenzo's and Politian's on the *strambotti*,

[1] *Poliziano*, ed. Carducci, Florence, 1863, pp. xviii–xx.

rispetti, and *canzoni a ballo* of rural Tuscany. In all alike we find the same variety, not to say, contrast of mood, which has so greatly perplexed the critics of Pulci, as he becomes by turn frivolous and serious, sceptical and religious, and under the influence of which Lorenzo de' Medici passes so easily from Carnival Songs to Spiritual Lauds ; the same freshness of observation, whether of nature or of humanity ; the same frank enjoyment of life ; and beneath it the same undercurrent of melancholy, born of the thought that all things must pass, including life itself.

> Di doman non c'e certezza.

The revival of the vernacular literature was not confined to Tuscany. At the martial and pleasure-loving court of Ferrara, the high-born Matteo Maria Boiardo (1436–1474), Count of Scandiano, the trusted friend of Ercole d'Este, treated the popular legends of chivalry in a different spirit from the *bourgeois* Pulci. Adventures and love are his only themes, and he seldom turns aside from his story to make a wise reflexion or a witty jest. The *Orlando innamorato* is the last great narrative poem that is frankly romantic, and almost frankly mediæval. Boiardo also wrote lyrical poetry, and he dramatised Lucian's *Timon* for the court theatre at Ferrara. For Politian's *Orfeo*, written for the court of Mantua and recited there in 1471, had introduced the fashion of plays in the vernacular, and they were performed not only at Ferrara, but at the courts of Ercole d'Este's two sons-in-law, Ludovico Sforza of Milan and Francesco Gonzaga of Mantua. Among the writers was Pandolfo Colleruccio, the author of the beautiful *Canzone alla Morte*, which he probably wrote during his imprisonment at Pesaro (1488–89).

The revival of Italian prose came more slowly. But before Lorenzo de' Medici's death Sannazaro at Naples had nearly completed his famous *Arcadia,* and it was due to Lorenzo's encouragement that the masterpieces of Machiavelli and Guicciardini were written in the vernacular. Not the least important member of Lorenzo's circle was Marsilio

Ficino, the head of the Florentine Academy. If his writings have little value as contributions to the serious study either of Plato or of theology, they exercised in their own day a very real influence. This was mainly due to the fact that they seemed to offer a basis of reconciliation between antiquity and Christianity. The mystical amalgam which Ficino compounded of Platonism, Neo-Platonism, and Christianity had a great influence on the humanists of the Renaissance. They came to regard the Platonic writings as containing the germs of Christian thought. Even Homer and Virgil and the other great pagan poets were thought to have an inner symbolical meaning and took their places in the scheme of Christian teaching. It was this idea, magnificent if visionary, of the essential unity of all thought that Julius II commissioned Raffaelle to illustrate in the *Camera della Segnatura*[1].

Further, it was no slight merit in Ficino's writings that in an age of increasing scepticism and materialism they contributed to the spread of spiritual thought. In this respect their influence was perhaps greater in France and in England than in Italy. In England they helped to form the theological opinions of Colet and More, and there were French editions of the *De Christiana religione* and the *De triplici vita*.

Ficino's disciple, Giovanni Pico della Mirandola, went even beyond his master in the mystical character of his thought, and had even a wider influence on the finer spirits of his own and the next generation. At least five editions of the *Golden Letters* were published in France from 1499 to 1510, and one of his treatises was translated into French by Robert Gaguin. He had a special fascination for both Colet and More, and the latter translated his Life by his nephew. His studies in the Cabbala powerfully attracted Reuchlin, and this became the starting-point of modern Hebrew scholarship. His weighty treatise against the Astrologers practically gave the death-blow to the almost universal belief in astrology. But his influence was due not only to his writings but to

[1] See F. X. Kraus in *The Cambridge Modern History*, II. 4–7.

his rare personality. "From his face shone something divine," says his friend Politian, and indeed his youth, his beauty, his learning, and his piety have invested him as it were with the halo of a saint. His learning was largely fantastical ; it was his attitude towards learning which was so admirable. Like Valla he accounted the substance of a work of learning of more importance than the style. " Quaerimus nos quidnam scribamus, non quaerimus quo-modo[1]." In the words of Burckhardt, " he defended the truth and science of all ages against the one-sided worship of classical antiquity." " He is a true humanist. For the essence of Humanism is that belief of which he never seems to have doubted, that nothing which has ever interested living men and women can wholly lose its vitality[2]."

We have seen that the scientific spirit was not wanting to the Italian Renaissance ; we have seen it manifested in Valla's critical researches, in Flavio Biondo's studies in the antiquities and history of Rome, in Politian's handling of manuscripts, and not least in the experiments of painters and sculptors. When we turn to actual science there is less to record. The Italians of the Renaissance were essentially men of action, and scientific investigation for its own sake had little attraction for them. But the tendency of recent research is to show that in this field as well as in others the services of Italy must not be ignored.

The most celebrated Italian man of science of the fifteenth century was Paolo del Pozzo Toscanelli, whose long life (1397–1482) extended over more than four-fifths of it. He was the friend of Nicholas of Cues and Regiomontanus, of Brunelleschi and Alberti, and he was one of the group of humanists who met in the cell of Fra Ambrogio at Santa Maria degli Angeli. He was famous as a geographer, and an astronomer ; he wrote treatises on perspective and meteorology, and he practised occasionally as a physician. But, except for some observations on the comets which

[1] Letter to Ermolao Barbaro in *Ang. Pol. Epist.* lib. IX.
[2] Pater, *Studies in the Renaissance.*

appeared during his life-time, including Halley's (1456), his writings have perished, and he is now chiefly known to fame for the encouragement which he gave to Columbus, assuring him that his proposed voyage " from the East to the West " was not only possible but certain, and sending him a map[1]. Some years before this he had written to a Canon cf Lisbon, Fernam Martins, asking him to bring his idea of a voyage to the Spice Islands by the West to the notice of Affonso V. When he died in 1482 he left a flourishing school of geography in Italy. Fra Mauro, a Venetian, made a planisphere of the world (1457-1459)[2], and Francesco Berlinghieri, a Florentine who belonged to the circle of Lorenzo, wrote a geography in *terza rima*. The text, which is chiefly based on Ptolemy and Flavio Biondo, is of no importance, but among the maps with which it is furnished there are four of great importance and interest, those of France, Spain, Italy, and Palestine. For they are the first modern maps that were ever printed and they mark an epoch in cartography[3]. The influence of Toscanelli may also be traced in Nicholas of Cues's map of Central Europe.

In other ways, too, Italy played a prominent part in the history of maritime discovery. Besides Columbus, she furnished eminent explorers in Cada Mosto, Giovanni Cabot, Amerigo Vespucci, and Giovanni Verrazzano. It was in the despatches of the Venetian Ambassadors to the Spanish and Portuguese courts, and in the letters written by the correspondents of Venetian or Florentine banking-houses that the results of the early voyages were generally recorded. The narrative of discovery which had the widest circulation

[1] A whole volume of the *Commissione Colombiana* (pt. v, vol. i. edited by Gustavo Uzielli) is given to Toscanelli. His two letters to Columbus were written between 1479 and 1482, the year of his death. For his observations of Halley's comet see *tav.* VIII.

[2] *Comm. Col. ib.* p. 549. His original map is in the library of San Michele at Murano ; there is a copy made in 1804 in the British Museum.

[3] For Berlinghieri, see *Comm. Colomb. ib.* 397 ff. and 522 ff. His work was finished in 1468 and printed at Florence, *circ.* 1400. The map of France is reproduced by Nordenskiold, who was the first to call attention to its importance, in his *Facsimile Atlas to the early study of Cartography*, Stockholm, 1889, p. 13.

was the Latin version of the letter written by Vespucci to Lorenzo di Pierfrancesco de' Medici (grandson of Cosimo's brother) describing his third voyage. The first collection of voyages, the well-known *Paesi novamente retrovati*, was published by an Italian editor, Fracanzio da Montalboddo, in 1507.

In pure mathematics the chief Italian name of this period is that of Luca Pacioli, a Franciscan friar, who was born at Borgo San Sepolcro. His *Summa de aritmetica geometria proportione e proportionalità* (1494) shews very little advance on the treatises written by Leonardo Fibonacci of Pisa at the beginning of the thirteenth century, parts of which he bodily incorporates. It is however the earliest printed book on the subject, for that of Regiomontanus did not see the light till 1534. Pacioli taught mathematics successively at Perugia, Rome, Naples, Pisa, and Venice, and later he settled at Milan, where he made friends with Leonardo da Vinci, who drew the figures for his *Divina proportione* (1509) and probably also assisted him with the text[1]. Another Italian mathematician of this period was the somewhat older and little-known Benedetto Aritmetico, who wrote numerous arithmetical treatises (*Trattati dell' abbaco*), which have never been published. He was a Florentine, and a fragment of the *Codex Atlanticus* possibly refers to a conversation which Leonardo had with him and Toscanelli and others[2].

As Morelli has noted, Leonardo consorted more readily with men of science than with artists at the court of Il Moro. Fra Pacioli was one of his few intimate friends. Most intimate of all was Giacomo Andrea da Ferrara, *suo quanto fratello*, an architect who was an ardent follower of Vitruvius and deeply versed in all the science of his art. In Bramante too he found another kindred spirit, with whom he could discuss difficult problems of architecture. Other

[1] For Pacioli, see G. Libri, *Histoire des sciences mathématiques en Italie depuis la Renaissance jusqu'à la fin du xviii*[e] *siècle*, 4 vols., 1840, III. 133 ff.; E. Solmi, *Leonardo*, Florence, 1900, pp. 110–115.

[2] Solmi, pp. 12, 13.

friends were Pietro Monti, an engineer and a writer on
military tactics, Fazio Cardano, father of the great Cardano,
and himself a mathematician as well as a physician[1], and
at a later date, Marc' Antonio dalla Torre, the greatest
anatomist of his day. Leonardo met him at Pavia, where
he held the chair of anatomy not long before his death in
1511 at the early age of twenty-nine. In fact, when
Leonardo went to Milan in 1482 or 1483[2], he had
acquired such facility in the arts of painting and sculpture,
and had solved with such apparent ease the problems to
which his predecessors had given so much thought and
labour, that there was nothing for him to learn from Foppa
or Bergognone, from Amadeo or Cristoforo Solari. In
architecture indeed, though, as he said in his famous letter
to Il Moro, he " believed he could give perfect satisfaction,
and to the equal of any other, in the composition of public
and private buildings," there were scientific problems of
great interest still waiting for solution. The transition from
mediæval to classical architecture, which had been begun
so admirably by Brunelleschi, had still to be completed. In
Bramante Leonardo found a fellow-worker, and possibly
a teacher, and in the church of San Lorenzo a model which
inspired him to fresh intellectual endeavour[3].

Until all Leonardo's manuscripts have been printed, the
full extent of his scientific knowledge cannot be accurately
determined. But enough is known at present to enable
us to wonder at the extraordinary range of his researches
and discoveries. Some of his greatest achievements were
in mechanics, " the Paradise," as he termed them, " of
mathematical sciences." Taking up the investigation of the
lever at the point where Archimedes had left it, he discovered
the principle of moments, from which it is only a simple
step to Stevinus's theory of the parallelogram of forces.

[1] Solmi, pp. 77–84.
[2] According to the Anonimo Gaddiano he went to Milan in his thirtieth
year, and Solmi accepts this date.
[3] For the influence of San Lorenzo on Leonardo and Bramante. see
Geymüller in J. P. Richter, *L. da Vinci*, II. 39 f.

A hundred years before Galileo made his famous experiments on the tower of Pisa he formulated the laws which govern falling bodies. A hundred years before Stevinus he rediscovered the principle of the equilibrium of fluids, which was known to Archimedes but since his day had been forgotten. It was by the light of these simple but far-reaching laws in statics, dynamics, and hydrostatics that he invented machines, and other labour-saving appliances of every kind and description, from a flying-machine to a self-revolving spit. He also occupied himself with astronomy, and a hundred years before Maestlin explained the dim illumination of the moon's disc when the bright portion is a mere crescent. In physics he was the first to discover the undulatory theory of light and sound.

The structure of Man interested him no less than the forces of Nature. In an age when dissection was exceedingly rare, he had dissected, he tells us, more than ten human bodies, and his wonderful skill as a draughtsman enabled him to record his observations in drawings which are as remarkable for their accuracy as for their beauty. By modern men of science he is recognised as the founder of scientific human anatomy. He is also the founder of comparative anatomy, for he studied animals with no less care and accuracy than human beings. And recognising the unity of all life, he extended his researches to plants, and thus became the founder of biology. From the structure of man he proceeded to the structure of the earth. He was deeply interested in physical geography, and made some admirable maps of certain districts of Italy, and he was the first to recognise in fossil-shells traces of the past history of the earth. Thus he is in a sense the founder of geology. It was formerly supposed that his discoveries " remained unknown and useless in his time[1]." But at any rate during the life-time of Francesco de' Melzi, to whom he bequeathed all his manuscripts, and who preserved them with reverent care in his villa at Vaprio near Milan, it is probable that

[1] Acton, *Lectures on Modern History*, p. 84.

they were available for consultation and study[1]. Moreover, though at most seasons he preferred solitude to society, he was noted for the singular charm and brilliance of his conversation, and he can hardly have failed to impart to those about him at least some faint glow from his own scientific ardour. For above all it is his scientific spirit that makes him so remarkable. More than a hundred years before Bacon he proclaimed, with no less confidence and with truer insight into its scope and application, the necessity of the experimental method. " Vain and full of error," he said, " are those sciences which do not spring from experience, the mother of all certainty." He believed that experience was the only test of truth, and that through the senses alone lay the road to scientific knowledge. He spoke of the eye " as the window of the soul," and he had achieved such perfect correspondence between hand and brain that he used his favourite art of painting as a method of studying natural phenomena, so that his exquisite drawings are not only records of observations but observations themselves. In his portrait of La Gioconda, no less than in his anatomical and biological experiments, he was urged by the same passionate desire to pierce through the visible to the invisible, to lift, so far as may be, the veil which hides the mystery of life.

I said at the outset of this chapter that Leonardo was not a humanist. " I well know," he says, " that the fact of my not being a man of letters "—and by " man of letters " he means a humanist—" may cause some presumptuous persons to think that they may with reason censure me, alleging that I am a man ignorant of books (*omo senza lettere*[2].)" But though he disclaimed any pretensions to learning, he was far from being, as his critics said, wholly ignorant of classical literature. He knew Latin, and to a certain extent, Greek, but he consulted the ancient authors

[1] *Leonardo da Vinci, Conferenze Fiorentine*, Milan, 1910, p. 226. Melzi died in 1570.

[2] Solmi, *L. da Vinci, Frammenti letterari e filosofici*, Florence, 1904, p. 82 ; E. McCurdy, *L. da Vinci's note books*, 1906, p. 45. The passage quoted is from the *Codex Atlanticus*.

as he consulted those of the Middle Ages, not as complete guides to knowledge and life, but as sources of information. Thus he read Archimedes for mathematics and mechanics, Aristotle and Pliny for natural history, Theophrastus for botany, Hippocrates and Celsus for medicine, Ptolemy for geography, Vitruvius and Frontinus for architecture[1]. But in physics he owed more to Albert of Saxony than to any ancient writer, in mechanics and metaphysics his chief literary debt was to Nicholas of Cues, while to his study of fossils he had probably been led by the writings of Albert the Great[2].

But he accepted the statements of no writer, ancient or modern, without testing them. For he recognised no authority save that of experience, and no experience save that of men who know how to use it[3]. " Consider now, O Reader, what trust can we place in our ancient writers, who have undertaken to define the nature of the soul and of life—things incapable of proof—whilst those things which can always be clearly known and proved by experience have for so many centuries remained unknown or have been falsely interpreted[4]."

This attitude towards antiquity was almost unique in Leonardo's day[5]. But it was the logical development, not the negation, of the spirit of the Renaissance. Petrarch, the first clear manifestation of this spirit, had escaped from the cloister of authority and tradition to found on free and independent lines the study of Man and Nature. Though he was keenly alive to the beauty of Nature and of the human body, he was interested before all things in the

[1] He also refers to Xenophon, Ammianus Marcellinus, Lucretius, Virgil, Horace. The books which he mentions in a passage in the *Codex Atlanticus* were presumably in his own library. (See Richter, II. 442 and *sqq.*)

[2] See P. Duhem, *Études sur Léonard de Vinci* Ire série, 1906, 2me série, 1909, 3me série, 1913.

[3] Solmi, *Frammenti*, p. 90.

[4] *ib.* p. 100 ; McCurdy, p. 210.

[5] The physician and Greek scholar Leonicenus (1428–1524) exposed Pliny's errors in medicine.

human mind, and in his quest after intellectual truth he found admirable guides in the great writers of antiquity. His successors of the first and second generation trod in his footsteps in a catholic and liberal spirit, though, as Italians, they overrated Latin culture as compared with Greek. Then, in the third generation, under the stimulus of the constant discovery of new manuscripts, which bred a fever only equal to that of the first discovery of Australian gold, there arose a desire to imitate, and even to recall antiquity. Happily this vain enthusiasm for an irrevocable past was guided into more profitable paths by the critical sense of a Valla, a Biondo, a Pius II. Meanwhile, among men who for the most part had little or no literary education, painters, sculptors, and architects, there was being slowly and silently developed the other half of the work inaugurated by Petrarch, the study of Nature and the human body. This work was mainly done by Florentines, and it was done in a spirit which was as much scientific as æsthetic, and in which the passion for knowledge had as large a share as the passion for beauty. It was the quintessence of this spirit which animated the whole life and work of Leonardo da Vinci. But its source was Petrarch. Leonardo was Petrarch's greatest successor, and Petrarch would have recognised him as such. For in Leonardo as in Petrarch the flame of the Renaissance burnt at its brightest, with intense and generating heat.

NOTE. ON THE NUMBER OF BOOKS IN THE PRINCIPAL ITALIAN
LIBRARIES OF THE FIFTEENTH CENTURY

1. *The library of Urbino.* The catalogue of this library
made by Duke Federigo's librarian, Federigo Veterano, has
been preserved[1]. It gives the titles of 772 manuscripts,
of which 73 are Hebrew, 93 Greek, and 604 Latin. The
remaining two are Dante's *Divina Commedia* and Petrarch's
Sonnetti and *Canzoni.* The writings of the Italian
humanists are fully represented, and there is a life of
the famous *condottiere,* Piccinino, who is described on
the title-page as "the Duke's first preceptor in the art of
war." The collection passed to Rome and was incorporated
in the Vatican library[2].

2. *The Vatican library.* In 1455 this contained 353
Greek manuscripts and 824 Latin ones. Twenty years later,
when Sixtus IV was Pope (1471–1484), the total number of
manuscripts had increased to 2527, of which 770 were Greek[3].

3. *The Visconti-Sforza library at Pavia.* The number
of manuscripts in 1459 was 880. Galeazzo Maria added
126 in 1469[4].

4. *The library of St Mark (Bibliotheca Marciana) at
Venice.* This was bequeathed to the republic by Cardinal
Bessarion. In 1468, four years before his death, it consisted

[1] Printed by C. Guasti in *Giornale storico degli archivi toscani,* VI.
127 ff., VII. 46 ff., 130 ff. When Duke Federigo died in 1482, 60 volumes
had been catalogued.
[2] See *Codices Urbinates Graeci,* recensuit Cosimus Stornajolo, Rome,
1895, and *Cod. Urb. Latini,* vol. I, Rome, 1902.
[3] E. Müntz and P. Fabre, *La Bibliothèque du Vatican au* xvᵉ. *siècle.*
1887 ; J. W. Clark in *Proceedings of the Cambridge Ant. Soc.* 1904, pp. 11–61.
In 1443, four years before the accession of Nicholas V, the number of manu-
scripts was only 340.
[4] *Indagine storiche sulla libreria Viscontea-Sforzesca del Castello di Pavia*
[by Marchese Girolamo d' Adda], Milan, 1875.

of 482 Greek and 264 Latin manuscripts. A certain number were added between 1468 and 1472[1].

5. *The Laurentian library at Florence.* The first inventory of this library that has come down to us is of a rather later date than those of the other great Italian libraries. It was made in 1495, when the collection of Lorenzo de' Medici was handed over to the convent of San Marco. It then contained 1039 manuscripts, of which about 460 were Greek. 35 manuscripts were found among Politian's books[2].

[1] H. Omont in *Rev. des Bibliothèques* for Jan. 1894, pp. 138–140. G. Valentinelli, *Bib. manuscripta S. Marci Venetiarum*, Venice, 1868.

[2] E. Piccolomini in *Archivio stor. ital.* ser. III. vol. XIX. (1824), pp. 101–129 ; XX. 51–94.

CHAPTER II

PREMONITIONS OF THE FRENCH RENAISSANCE

I

THE princes of the house of Valois, which in 1328 suc-
ceeded to the throne of France in the person of Philip VI,
were a pleasure loving race, passionately fond of display,
recklessly extravagant, and passably indifferent to moral
obligations. Endowed with a real taste for art, and in some
cases with a considerable tincture of learning, they were
munificent and discerning patrons of both art and literature.

The first two, Philip VI and his son John the Good,
were too feeble and frivolous to impress their own culture
upon their subjects, and they impoverished the resources
of the kingdom by their incompetence alike in war and
government. The close of Philip's reign was darkened
by Crécy and the Black Death ; the reign of John (1350–
1364) by Poitiers, the revolt of Paris under Étienne Marcel,
and the Jacquerie. On John's death in the Savoy he
was succeeded by his son, Charles V, who happily for
France lacked the chivalric temperament of his father
and grandfather. He loved peace, as they had loved war ;
he was prudent and sagacious, as they had been rash and
frivolous. But he shared their taste for pomp and spectacle,
and, though his expenditure was better regulated than theirs,
he was hardly less extravagant. He was a great builder ;
he transformed and embellished the Louvre, completed
the keep and the chapel of Vincennes, and rebuilt several
other royal palaces. But his chief creation was the vast
Hôtel Saint-Pol, which he made out of an irregular group
of existing mansions, setting them in a wide pleasance

of gardens and orchards. Within the precincts of the palace were a tilting-ground, a tennis-court, baths, colonnades, cages for bears and lions, and aviaries for exotic birds. Charles also incorporated in the royal domain the Church and Monastery of the Célestins, and he enriched them with so many works of art that they became veritable museums. His collections of jewellery and precious stones, and above all of specimens of the goldsmith's art, were probably the finest in Europe. He kept his greatest treasures in his palace at Melun, but each of his numerous places of residence had a rich collection. It is noteworthy that at that early date, before the great revival of gem-engraving and before ancient gems were seriously studied or collected, he possessed a certain number of gems, both intaglios and cameos[1]. He encouraged sculpture as liberally as architecture, and he shewed a true Renaissance spirit in the monuments which he erected to his predecessors, and in the numerous representations of himself which were destined to perpetuate his memory[2].

Above all he loved books. His library, which numbered about 1100 volumes, was regarded as one of the wonders of the world[3], and had been formed for the express purpose of encouraging learning. For Charles was a man of wide intellectual curiosity, interested alike in science—including astrology—and literature. The classical side of his library was represented by Latin versions of Plato's *Timæus* and the principal works of Aristotle, by nearly the whole of Seneca's prose works, by Ovid's *Heroides*,

[1] See *Inventaire du mobilier de Charles V* (made in 1379 and 1380) ed. J. Labarte, 1879 (*Doc. inédits*).

[2] In the very first year of his reign he ordered tombs for his grandfather, his father, his wife and himself.

[3] See L. Delisle, *Recherches sur la librairie de Charles V*, 2 vols. 1907. About 160 of the books described in Delisle's inventory are noted by him as having been added to the library after the death of Charles V. By far the greater part of the books were housed in three stories of one of the towers of the Louvre. In 1425 the library, which then numbered only 843 volumes, was bought by the Duke of Bedford for 1200 livres. After his death in 1435 it was irrevocably dispersed (Delisle, I. 138 ff.). Delisle has traced about 100 volumes as still existing.

Tristia, and *Epistolae ex Ponto*, by Lucan and Frontinus. The work of translating Latin authors into French had already been begun by John the Good, who commanded Pierre Bersuire to make a translation of Livy (*circ.* 1352–1356). It was continued with great energy by his successor, who employed Simon de Hesdin to translate Valerius Maximus, Jacques Bauchant to translate Seneca's *De remediis fortui-torum*, and above all Nicolas Oresme to give a French dress to the Latin versions of Aristotle's *Ethics, Politics, Economics, De cælo*, and *De mundo*. In Charles's library too there were French versions of Aristotle's *Meteorologica* and *Problemata*, of Seneca's *Moral Epistles*[1], of Ovid's *Metamorphoses*, of Vegetius and Boethius. Nor were the Latin writings of the great Italians neglected. Jean Daudin, a Canon of the Sainte-Chapelle, translated Petrarch's *De remediis utriusque fortunae*[2], and in the succeeding reign Laurent de Premierfait, the translator of the *Decameron*, made a French rendering of Boccaccio's *De casibus illustrium virorum* (1407). Two years previously he had performed the same service for Cicero's *De senectute* and *De amicitia*.

Charles V died in 1380 comparatively young. His brother John, Duc de Berry, had one advantage over him as a collector, that he lived to a ripe old age[3], and if his area of taxation was less extended than that of the King of France, he made up for it by greater rapacity. The unfortunate people of his government of Languedoc were shorn to the skin that his appanage of Berry and Auvergne might be adorned with palaces and chapels. At Bourges he completed the splendid façade of the Cathedral[4], and rebuilt the Palace, adding to it a Sainte-Chapelle which he destined for his mausoleum[5]. At Riom, which at that

[1] Delisle, *Recherches*, I. 82 ff.

[2] Delisle, *Notices et extraits des manuscrits de la bibliothèque nationale et autres bibliothèques*, XXXIII, p. 273 ff.

[3] He died in 1416, aged seventy-five.

[4] The towers were not added till the sixteenth century.

[5] The Sainte-Chapelle was barbarously destroyed in 1757 by order of the Archbishop of Bourges, François de la Rochefoucauld. It was larger than the Sainte-Chapelle of Paris, and of singularly graceful propor-

time was with Clermont the joint-capital of Auvergne, he erected another palace, and another Sainte-Chapelle, which still exists[1]. At Poitiers he restored on a magnificent scale the Palace of the Counts (which the English had burnt in 1345) and its adjoining keep, the Tour de Maubergeon[2]. But his favourite residence was the château of Mehun-sur-Yèvre, about ten miles from Bourges, which Froissart describes as one of the finest houses in the world[3]. Hardly inferior to it in reputation were the Duke's Paris residences, the château of Bicêtre and the Hôtel de Nesle, the former of which with its priceless treasures was burnt in his lifetime by a Paris mob[4].

The Duke's collections were not so large as those of his brother, Charles V, but they were formed with perhaps greater care and taste. His collection of precious stones was especially rich in rubies, at that time accounted the most valuable of all stones. Like his brother he had magnificent specimens of goldsmith's work. He had also embroideries from England and Florence, leathern hangings from Castile and Aragon, and huge tapestries from Paris and Arras. But his chief renown as a collector is due to his library. His three hundred manuscripts, having been collected, not for the promotion of learning, but to please his own taste as a lover of art and literature, were of a choicer quality than his brother's. About half were richly illuminated by the best artists of the day. The most famous of all was the great Book of Hours (*Les très riches Heures*), which

tions. See a reconstruction of the Chapel and Palace in G. Hardy and A. Gandilhon, *Bourges*, 1912, p. 47. The Palace was greatly injured by a fire and finally pulled down during the Revolution.

[1] The Palace was pulled down in 1830 and the present Palais de Justice was built on its site.

[2] Now the Palais de Justice, remarkable for its great hall (*Salle des pas perdus*) with its splendid fireplaces. The Duke originally had Poitou for his appanage, but it was ceded to the English at the peace of Brétigny.

[3] The ruin with its two towers may be seen from the railway. Charles VII died there.

[4] See for the Duc de Berry's buildings, A. de Champeaux and P. Gauchery, *Les travaux d'art exécutés pour Jean de France, Duc de Berry*, 1894 (with admirable illustrations).

Paul de Limbourg and his brothers were illuminating
for him at the time of his death, and which is now preserved
at Chantilly[1].

Owing to the quality of the manuscripts a much larger
proportion of them have been preserved than in the case
of the library of Charles V, and Delisle has succeeded
in tracing over a hundred. The library contained a
Terence, a copy of Virgil's *Eclogues*, and *un livre de Pline
richement historié*, all authors who are unrepresented in
the royal collection. It also contained *un grant livre ancien,
escript en grec*, but the cataloguer gives us no further informa-
tion as to its contents.

The remaining two sons of John the Good, Louis, Duke
of Anjou, and Philip the Bold, Duke of Burgundy, were
both collectors and art-patrons, especially the latter, who
by his marriage with the heiress of the Count of Flanders
not only became nearly as powerful as the King of France,
but greatly strengthened the already existing Flemish
element in French art. It was he who founded the great
Chartreuse of Champmol near Dijon, where the sculptures
of the portal of the Church, the *Puits de Moïse*, and above
all his own tomb, were the source of inspiration for the
sculptors of the fifteenth century throughout eastern and
southern France.

In the third generation the brilliant and witty but
volatile Louis, Duke of Orleans, younger son of Charles
V, imitated his more powerful uncles in extravagance,
rapacity, and patronage of the arts. His château of Pierre-
fonds, near Compiègne, begun in 1390, marks, as Renan
points out, a new departure in the construction of a fortress-
palace. Surrounded by fortifications so strong that they
resisted the artillery first of Henry IV, and later of Richelieu,
it was in itself a charming residence. It enabled its
possessor at once to defy his enemies and to gratify

[1] For the Duc de Berry's collections see Champeaux and Gauchery,
op. cit., and J. Guiffrey, *Inventaires de Jean, Duc de Berry* (1401–1416),
2 vols. 1894 ; and for the library L. Delisle, *Gazette des Beaux Arts*, xxix.
1884), 97 ff. ; 281 ff. ; 391 ff. ; and *Recherches*, ii. 318–331.

his taste for splendour and beauty. It was conceived in
the true spirit of a prince of the Renaissance[1]. At Ferté-Milon
the Duke began to build a palace on even a grander scale,
but it was never finished. He also repaired the existing
châteaux of Château-Thierry and Coucy[2]. These were
only a few of his numerous residences, for besides half-
a-dozen other princely mansions in the country he had
eight hôtels at Paris[3]. Like his father he was a lover of
books as well as of building, and at his death his library
numbered nearly a hundred volumes, many of them richly
illuminated, and the greater part in splendid bindings[4].

Finally among the princes of the blood who patronised
art and letters must be mentioned Louis II de Bourbon
(1337–1410), the hero of the war against the pirates of
Tunis in 1391, and a man of fine character, who during the
dissensions of the royal family which marked the minority
of Charles VI more than once intervened with success
in the interests of peace. It was he who established the
capital of the Bourbonnais at Moulins, and he maintained
there a court of considerable splendour. Christine de Pisan
says of him that " he took his pleasure in all good, subtle,
and beautiful things,". and it was at his command that
Laurent de Premierfait made the translations of Cicero's
De senectute and De amicitia referred to above.

All this patronage of art and literature by quasi-
independent princes, radiating from various centres, from
Paris, Blois, Bourges, Dijon, Moulins, Riom, gave France
at the close of the fourteenth century, at least upon a
superficial view, a somewhat similar aspect to that of
Italy. In fact in the year 1400, when Gian Galeazzo
Visconti was at the height of his power, Italy seemed more
likely than France to come under the domination of a single
ruler. At this time too there was considerable intercourse

[1] Pierrefonds has been restored by Viollet-le-Duc.

[2] These last three are all in the department of the Aisne. Coucy
is one of the finest existing examples of a feudal château.

[3] See P. Champion, *Vie de Charles d'Orléans*, 1911, pp. 24, 25.

[4] See P. Champion, *La libraire de Charles d'Orléans*, 1910, pp. x–xvi.

by various channels between France and Italy. The establishment at the Papal court at Avignon, prolonged as it was by the Anti-popes, Clement VII and Benedict XIII, whom France supported, the claim of Louis d'Anjou to the kingdom of Naples, and the marriage of Louis d'Orléans with Valentina Visconti, the daughter of Gian Galeazzo, were all channels by which the current of Italian culture was transmitted to France. Italian miniaturists worked for John, Duc de Berry, and we hear of him importing Italian ivories.

Another feature of this period was the increase of the secular element in art and art-patronage. It is true that the princes of the house of Valois were exceedingly pious and religious, and spent a great deal of the money which they wrung from their subjects on the building and embellishment of chapels to hold the monuments of themselves and their families. But on the whole civil architecture shewed greater vitality than religious, and the portrait, alike in painting and sculpture, was more in demand than the sacred subject. In all this we recognise true Renaissance characteristics. *On se croirait à deux pas de la Renaissance dont on est encore séparé par plus d'un siècle*; so aptly says Renan, speaking of the year 1396, in which Richard of England married with great pomp Isabella the daughter of Charles VI. What was the reason for this arrested development?

It is easy to find it in the terrible era of anarchy, civil war, and foreign dominion, which began early in the fifteenth century. This had been already foreshadowed during the minority of Charles VI by the rivalry of his ambitious and self-seeking uncles. Then came the King's madness (1392), which added to the discord and confusion. But it was the murder of the Duke of Orleans by John *sans-Peur* (1407) that plunged the kingdom into an abyss of misery. The deed was in a sense symbolical, for the victim, partly in his own person and partly as the husband of Valentina Visconti, represents the spirit of the Renaissance, while the assassin was the new head of that powerful state

which for sixty years and more was to dominate France not only in politics but in art. In 1410 open war broke out between the Burgundians and the Armagnacs, and it was soon followed by an appeal for assistance from both parties to the foreigner. The result was Agincourt, and the subjection of a large part of France to English dominion for nearly forty years. Anarchy and disunion were increased fourfold, and in their wake came pestilence and famine. During the years 1418 to 1422 the population decreased at an alarming rate.

It was in the first of these years that Perrinet Leclerc opened the gates of Paris to the Burgundians, and a terrible massacre of the Armagnacs took place. Among the victims was Jean Charlin de Monstereul[1], the Chancellor of Charles VI, whose death, like that of Louis d'Orléans, may be regarded as a symbol of the crushed Renaissance. For he was almost the only Frenchman of his day who was a humanist after the Italian pattern. His friends, Jean Gerson, Pierre d'Ailly, and Nicolas de Clamanges, with the latter of whom he was specially intimate, were all, it is true, interested in classical studies. But they were in the first place, theologians. Jean de Monstereul, though he was in orders and held several ecclesiastical benefices, was a humanist pure and simple. He was a great admirer both of Petrarch and Coluccio Salutati, and it was doubtless their writings that helped to inspire him with his ardent enthusiasm for Virgil and Cicero. Next to these his favourite author was Terence. But there were few Latin writers with whom he does not shew some acquaintance in his letters, and he was the first to introduce into France manuscripts of Plautus, Vitruvius, Cato's *De agri cultura*, and Varro's *De re rustica*. He paid a visit to Italy in 1395, and in 1412 he was sent to Rome on a mission to Pope John XXIII. There he made friends with Leonardo Bruni, one of the Papal secretaries, who gave him a letter of introduction to Niccolo de'

[1] For his name see A. Thomas in *Romania*, XXXVII. (1908), 594–601. His birthplace is uncertain, for Monstereul may be Montreuil, Montreux, or Montereau.

Niccoli at Florence. His greatest friend was the diplomatist Gontier Col, to whose teaching and encouragement he owed his classical sympathies. He too perished in the fatal massacre[1].

But this brightening of the early promise of the Renaissance was due to another cause than the unhappy state of the kingdom. It had no sufficient root. It neither struck down into the heart of the soil, nor spread out into numerous fibres. In Italy the leader of the movement had been a private citizen, not a great prince—Petrarch, not Galeazzo Visconti. In the generation after Petrarch's death the movement had owed more to the Universities of Pavia and Padua than to their Visconti or Carrara lords ; it had owed most of all to the republic of Florence, to the intelligence of her citizens, and to her care for their education. As for Humanism, though its popularity was due to the feeling of the Italians that they were entering into their own inheritance, it was by education that its foothold was firmly secured. The opening of Guarino da Verona's school at Venice (1412) and of Vittorino da Feltre's still more famous one at Mantua (1423) were of the greatest importance for the development of Humanism. It was otherwise in France. There the interest in art and learning was almost entirely confined to the princes of the House of Valois. The blossoms which the early Renaissance put forth in France withered not only under the frost of anarchy, but because the tree was not mature enough to ripen them. Even when the kingdom began slowly to recuperate, as it did in 1444, the year of the truce with the English, another half-century had to elapse before it was able to bear the fruit of the Renaissance.

[1] A. Thomas, *De Joannis de Monsterolio vita et operibus*, Paris, 1883 ; Voigt, *Die Wiederbelebung des classischen Alterthums*, 3rd ed. II. 344–349 ; Martène and Durand, *Amplissima collectio* II. 1311–1465 (a selection from Jean de Monstereul's letters).

II

During a great part of the fifteenth century, and especially throughout the long reign of Philip the Good (1419–1467), the dominant factor in French culture was Burgundy. For many years the Duchy and County of Burgundy had suffered less than any other part of France from the misery which had its main origin in the treacherous act of their lord. It was not till after the peace of Arras (1435) that the organised bands of brigands known as the *Écorcheurs* reduced the two Burgundies to the same pitiable condition as the rest of France. But Philip the Good paid little attention to the French portions of his vast heterogeneous possessions. It was Brabant and Flanders that were the main sources of his wealth, and it was at Brussels and Bruges that he preferred to hold his Court. That Court had the reputation of being the most splendid in Christendom. Like many others of that date, and even of a much later period, it combined senseless extravagance, puerile display, and a meticulous etiquette with a standard of comfort and decency far below that of an English labourer at the present day. Philip himself loved ostentation and luxury beyond even the measure of his race, and his Order of the Golden Fleece, which he founded in 1430, gave him many opportunities for indulging his taste. Among the famous festivities of his Court was the Banquet of the Pheasant held at Lille in February 1454, at which Philip and his nobles swore " by the pheasant " that they would take part in a crusade against the Turks[1].

But the Duke was not a mere splendour-loving barbarian. He had considerable taste in art, and a genuine regard for

[1] The Church in the form of a nun riding on an elephant—the part was represented by the chronicler, Olivier de la Marche—implored the assistance of the Duke and his nobles, while Toison d'Or carried in his arms a live pheasant. It does not appear that either the Duke or his courtiers, who vied with one other in the singularity of their vows, had any serious intention of fulfilling their engagement.

learning. He added greatly to his library, which in 1467 num-
bered nearly 900 volumes, many of them richly illuminated.
The art which flourished under his patronage is conveniently
called Burgundian, but like his kingdom it was composed
of many different elements, of which the Flemish strongly pre-
dominated. Its influence was greatest in sculpture. From
the very beginning of the fifteenth century the School
of Dijon was regarded as the chief School in France[1], and
the great tomb which Claus Sluter and his nephew Claus
van der Werve made for Philip the Bold (1411) became
a widely accepted model. In architecture indeed the
Flamboyant style, which prevailed over the whole of
France, was not of Burgundian origin, but in painting
the Flemish influence emanating from the Burgundian
Court was as powerful as it was in sculpture. For from
the day when Philip the Bold became Count of Flanders
by the death of his father-in-law (1384) he began largely
to employ Flemish painters, and the names of Melchior
Broederlam, Jean Malouel, and Henri Bellechose appear
frequently in the ducal accounts. Outside Burgundy
the native school still held its own for a time, the chief
foreign influence being Italian. Then a change took place
which was due to two causes, the increasing anarchy of
France, and the rise of the new school of painting in Flanders.
In the words of M. Hulin, " in the second quarter of the
fifteenth century France ceased to be the artistic centre
of Western Europe." The completion of the great picture
of the Adoration of the Lamb (1432) spread the fame
of the Van Eycks far beyond the borders of Flanders and
Burgundy, and after the death of Jan at Bruges in 1441
he had a successor in Roger van der Weyden who rivalled
him in reputation and surpassed him in actual influence.

Next to the Duke of Burgundy, though after a long
interval, the two most powerful of the great vassals of
France, were the Duke of Brittany, who was practically
an independent monarch, and the Duke of Bourbon, whose

[1] See above, p. 60.

dominions extended over the whole central plateau of France. At Nantes, the favourite residence of the Breton Dukes, François I, who died in 1450, and his successors gave considerable encouragement to art and learning, while at the court of Moulins Charles I (1434–1456), who was reputed the handsomest and most athletic Frenchman of his day, and his son Jean II (1456–1488), the victor of Fourmigny, surnamed *Le Fléau des Anglais*, carried on the traditions of Louis II[1]. Charles I added the *Chapelle Neuve* to the great church of Sauvigny, the burial-place of his race. It was built to contain the tomb of himself and his wife, which he had ordered in his lifetime from the sculptor, Jacques Morel[2]. He was also a great lover of music, and had in his service for a short time the famous Jan Van Okeghem. Jean II began in 1468 the Collegiate Church, afterwards the Cathedral, of Moulins. A frequent guest at the Court of Blois before his father's death, he brought to Moulins the love of art and letters which distinguished that Court[3].

Charles, Duke of Orleans, who was released from his long captivity in 1440, had to the full the artistic tastes of his race ; he was a skilful musician as well as a poet, and in his later years poetry became the chief business of his Court at Blois. He had, however, too slender a purse and too indolent a spirit to be an effective Maecenas, and he confined himself to the formation of a small but choice library[4], to the regulation of poetic contests, and to

[1] For Louis II see above, p. 61. His son, Jean I, was taken prisoner at Agincourt, five years after his accession, and died at London in 1434. He married Marie de Berry, who brought him as a dowry the Duchy or Dauphiné of Auvergne. His son, Charles I, married Agnes of Burgundy, and his grandson Jean II, Jeanne de France, daughter of Charles VII. See J.-M. de La Mure, *Histoire des Ducs de Bourbon*, 1868, vol. II (edited with copious notes from a MS. of 1675).

[2] The tomb of Louis II and his wife is in the *Vieille Chapelle*. Both tombs, especially the statues, were greatly mutilated during the Revolution.

[3] P. Champion, *Vie de Charles d'Orléans*, pp. 617–620.

[4] The library according to an inventory made about 1442 contained about 180 separate works. Latin classical literature is represented by

the entertainment and patronage of wandering poets. Among these was François Villon, who was attached to his household for a brief season in 1457, and who three years later contributed three pieces to his poetic album[1]. His near neighbour and cousin, René, King of Jerusalem and Sicily, Duke of Anjou and Bar, Count of Provence and Piedmont, had had a shorter but more varied experience of captivity, for he had been confined in nearly every fortress in Burgundy. After his final return from Italy in 1442 he resided principally at Angers till 1471, and from then till his death in 1480 chiefly at Aix in Provence. Though he was nearly as poor as the Duke of Orleans, he made his Court an important and artistic centre. Himself an amateur painter and goldsmith, as well as a writer of prose and verse, he directed in person the numerous works which he carried on at Angers and Aix and other places in Anjou and Provence, and upon which he employed numerous architects, sculptors, medallists and painters, both French and Fleming[2]. His most notable artistic undertaking was his own tomb in the Cathedral of St Maurice at Angers. It was begun in 1447, but chiefly owing to his poverty was not quite finished at the time of his death.

Besides these more or less independent princes there were also a fair number of great nobles who helped by their patronage the revival of art and letters during the last

Terence, Virgil, Horace, Statius, Juvenal, Sallust, Cicero, Valerius Maximus, and Macrobius. Ovid and Livy appear in translations. (See P. Champion, *La librairie de Ch. d'Orléans*).

[1] Two poems on Marie d'Orléans, and a ballad on the theme, *Je meurs de soif auprès de la fontaine*. See G. Paris, *F. Villon*, 1901, pp. 57–60 ; P. Champion, *Le Manuscrit autographe des poésies de Ch. d'Orléans*, 1907, pp. 25, 26, and *Vie de Ch. d'Orléans*, pp. 636–640.

[2] Among the painters employed by him were Barthélemy de Cler and Coppin Delf, both Flemings, and Nicolas Froment, a Provençal, who worked at Avignon ; among the sculptors, Jean Poncet of Anjou and his son, Pons Poncet, and Jacques Morel of Lyons. The Dalmatian, Francesco Laurana and the Italian, Pietro da Milano, who followed him from Naples to Provence, were architects, sculptors, and medallists. See A. Lecoy de la Marche, *Le roi René*, 2 vols. 1875, II, cc. ii. and v.

twenty years of the reign of Charles VII. Such were
Louis de Bruges, Seigneur de La Gruthuyse, whose fine
library, the best in Flanders after that of the Dukes of
Burgundy, passed into the hands of Louis XII[1], and Antoine
de Bourgogne, known as the "Great bastard of Burgundy,"
one of the numerous illegitimate children of Philip the
Good, who had a fine collection of illuminated manuscripts
at his château of La Roche in the Ardennes[2]. Then there
were Pierre de Brézé, the favourite of Charles VII, the patron
of Chastellain and the protector of Villon, and himself
a poet and a bibliophil; Louis de Beauveau, Seneschal
of Anjou and a great friend of King René, who wrote a
poem called *Pas d'armes de la bergère*, and translated Boc-
caccio's *Filostrato*; and the three Breton brothers, Prigent,
Alain, and Olivier de Coëtivy, of whom Prigent[3] was Admiral
of France, Alain was a Cardinal and Bishop successively
of Dol, Cornuailles, and Avignon, and Olivier, who married
Marie de Valois, the charming daughter of Charles VII and
Agnes Sorel, was an eminent soldier.

In addition to these noble patrons there were also a
few *bourgeois* who, having acquired wealth by mercantile
or financial transactions, vied with the nobles in luxury
and art-patronage. Chief among these were Nicolas Rolin,
the chancellor of Philip the Good, and Jacques Cœur the

[1] *Recherches sur Louis de Bruges, Seigneur de la Gruthuyse* [by Van
Praet] 1831. Van Praet describes 106 MSS.; judging by these it was
a typical mediæval library. In the exhibition of illuminated manuscripts
at the Burlington Fine Arts Club (1908) was a manuscript of the romance
of *Gilles de Trasignies*, written for Louis de Bruges in 1464. It had
passed with the rest of his books into the royal library at Blois. It is
now the property of the Duke of Devonshire (Cat. No. 160).

[2] See A. Boinet in *Bibl. de l'École des Chartes* LXVII. (1906), pp. 255 ff.
(with 3 illustrations); also M. Rondot, *Les medailleurs et les graveurs
de monnaies en France*, pl. X. 2, for a portrait-medal.

[3] Prigent de Coëtivy owned many fine manuscripts; one, *Livre du
trésor des histoires*, is in the Arsenal library (*Cat. des MSS. de l'Arsenal,*
v. 41); another, *Des Clercs et nobles femmes,* a French translation made
in 1401 from the Latin of Boccaccio, is in the collection of Mr H. Yates
Thompson. It had originally 105 larger miniatures, of which 48, in splendid
condition, survive. (Exhibition of Burlington Fine Arts Club, 1908
Cat. No. 159).

finance-minister of Charles VII, who began in the same year (1443) the famous buildings which have preserved their memories, the hospital at Beaune, and the great palace at Bourges. In 1425 Jan van Eyck had painted the picture now in the Louvre, of Nicolas Rolin (1376–1462) seated before the Virgin and Child. Twenty years later the same patron commissioned Roger van der Weyden, to paint for his hospital at Beaune the great picture of the Last Judgment. His son Jean (1408–1483), bishop and cardinal, followed in his footsteps, amassing great wealth, not too scrupulously, and spending it liberally on art and letters. The cathedrals of Châlon and Autun, his father's native town, of which sees he was successively bishop, bear witness to his munificence, and he contributed considerable sums of money to the support of Guillaume Fichet's printing-press in the Sorbonne.

The life of Jacques Cœur with its sudden vicissitudes, resembles a story in the *Arabian Nights*. But he is not only a romantic figure ; he is also a significant one. The son of a Bourges furrier, he made a large fortune by trading in the Mediterranean and the Levant, superintending from his counting-house, first at Montpellier, and then at Marseilles, a great fleet of trading vessels. His wealth and enterprise recommended him to the king, who had need of both. Appointed first to the office of royal silversmith (about 1440), which carried with it certain financial duties, and then to other administrative posts, he gradually became the king's most trusted adviser and the most powerful man in the kingdom. During the final struggle with the English in Normandy he lent the king 40,000 crowns, and when Charles VII made his triumphal entry into Rouen (November 10, 1449) he rode in the procession side by side with Dunois and Pierre de Brézé. Meanwhile his commercial activity went on expanding ; he traded not only with the Levant, but with Persia, Arabia, and the Far East. He had a silk manufactury at Florence, and he conducted numerous enterprises in France—paper-works, dying-works, salt-works, and mines. No wonder his fortune

made a deep impression upon the imagination of his con-
temporaries.

> Puis ay vu par mistère
> Monter un argentier,
> Le plus grand de la terre,
> Marchand et financier[1].

His rise had been rapid ; his fall was sudden. He had
many enemies among the nobles, who regarded with an
envious eye this upstart who had lent them money and
bought their lands, eclipsing them in display and luxury.
Nor was he difficult to trip up, for in building up his immense
fortune he had not been scrupulous, or even honest. In
1451 he was arrested on various charges ; two years later
he was condemned to perpetual banishment, to the confisca-
tion of his property, and, pending the payment of 400,000
crowns, to imprisonment. In 1455 he escaped from his
prison at Beaucaire, made his way to Rome, entered the
service of Nicholas V and his successor Calixtus III, and
died at Chios in command of a fleet which the Pope had sent
to help the Greeks against the Turks (November 1456).

He has left a proud memorial of his wealth and energy
in the princely house which he began to build at Bourges
in 1443, and which was still unfinished at the time of his
downfall. In this house we may read something of the
man's character, something too of the character of the
age. It is a house built mainly for comfort and display[2] ;
not according to any plan or preconceived design, but by
a process of gradual development, as convenience or artistic
improvisation suggested. Its huge reception-rooms are
worthy of a palace ; like a palace too, or the château of
some great noble, it has its *salle des gardes* and its chapel.
The roof of the latter is decorated with angels floating
in a blue firmament, an admirable work by an unknown
artist, whose science was equal to his artistic feeling. Two
features in the general decoration of the house impress

[1] Chastellain, *Recollections des merveilles.*

[2] The great height of the façade facing the *place de Berry*, which helps
to give it the appearance of a fortress on this side, is due to the irregularity of
the ground.

themselves on the beholder, first its secular character, as in the sculptured scenes above the great chimney-pieces, secondly the pervading presence of the owner, which shews itself in the representations of himself and his wife, and in the frequent introduction of his various mottoes and devices. " It announces an architecture," say MM. Hardy and Gandilhon in their work on Bourges, " which only reached its full development in the sixteenth century....it is the type of the private hôtel, destined for peaceful inhabitants who seek to lead an individual and refined life, sheltered from vulgar surroundings."[1]

This is very true : the house of Jacques Cœur took its place beside the other two great buildings of Bourges, the Cathedral and the Royal Palace. If the Cathedral and the Palace represented the two principal institutions of France, the Church and the Crown, the house of Jacques Cœur represented the individual. And Jacques Cœur himself, like his house, was a precursor. He was no humanist and he had little tincture of letters ; but in his energy, his enterprise, his love of luxury and display, his patronage of the arts, his very unscrupulousness, and, to sum up all, in his individualism, he was a true precursor of the Renaissance[2].

The gradual recovery of the kingdom which began in 1445, the year after the truce with England, was accompanied by a revival in literature as well as in art. The first forty years of the fifteenth century had been singularly barren. Froissart and Eustace Deschamps were still alive at its opening, but it is almost certain that neither of them were living in 1407, the year of the assassination of the Duke of Orleans. Christine de Pisan, except for her short poem in honour of Jeanne d'Arc, wrote nothing after 1413, and both she and Alain Chartier, whose eloquent and patriotic *Quadriloque invectif* and *Livre de l'Esperance* were produced during the darkest days of the English dominion, died between 1430 and 1440. But the twenty-two years from

[1] *Bourges*, p. 65.
[2] See Pierre Clément, *Jacques Cœur et Charles VII*, 2 vols. 1853.

1440, the year in which Charles d'Orléans returned to France, to 1462, the year after the accession of Louis XI, form a period of remarkable literary activity, all the more remarkable because it was followed by a long period, not so much of barrenness, as of dull mediocrity. Within these two and twenty years were produced Martin Lefranc's *Le Champion des Dames*, much of the poetry of Charles d'Orléans, and most of the prose and verse of Georges Chastellain, Arnoul Greban's *Mystery of the Passion*, Jacques Millet's *Mystery of the Destruction of Troy*, *Les Quinze Joyes de Mariage*, Antoine de La Sale's *Petit Jehan de Saintré*, Martial d' Auvergne's *Les arrêts d'amour* and *Les vigiles de Charles VII*, the whole of Villon's poetry[1], *Les Cent Nouvelles Nouvelles*, and probably the farce of *Patelin*[2].

Here again we find the Burgundian court making its influence powerfully felt. When at the beginning of this period Martin Le Franc presented his *Champion des Dames* to Philip the Good, it was merely a testimony to his reputation as a liberal patron. But the *Cent Nouvelles Nouvelles* were offered to the same Duke because they were largely inspired by him and his Court[3]. It would be unfair, however, to assume that the coarseness of these tales is specially characteristic of the court. They are rather the expression of a coarse age and of a society from which female influence was banished. Burgundian taste, or it may be the individual taste of Philip the Good, is chiefly reflected in the didactic works, the chronicles, and the prose-romances of chivalry, which were produced so abundantly during this period. The last class of literature was largely due to the passion for jousting which was so marked a feature of the Burgundian Court, and which was greatly stimulated by the creation

[1] All trace of Villon is lost after January 5, 1463, when the sentence of death passed on him by the Provost of Paris was commuted by the Parliament to banishment for ten years from "the town, provostship and viscounty of Paris."

[2] See *Romania*, xxx. 392.

[3] The Monseigneur to whom no less than 14 stories are attributed is the Duke, and nearly all the other thirty-four supposed narrators are connected with his Court.

of the Order of the Golden Fleece. It was under Philip the Good that Jean Wauquelin, a copyist from Picardy, turned into prose the *Histoire d'Alexandre, Girart de Roussillon,* and *La belle Hélène,* and that Daniel Aubert, another active copyist and a native of Artois, compiled the *Conquêtes de Charlemagne,* and transcribed, possibly at the same time refashioning, that encyclopædia of chivalry, *Perceforest.* It is to Raoul Le Fèvre, the Duke's chaplain, that we owe the prose form of the Romance of Troy, the *Recueil des histoires de Troie,* and that of the Romance of Jason, who shared with Gideon the honour of being the patron of the Golden Fleece. In the same reign were produced the prose stories of *Gilles de Chin* and *Gilles de Trasignies*[1], the former certainly and the latter probably being founded on earlier poetical versions, while to the first years of Charles the Rash (*circ.* 1470) belongs the biographical romance of *Le livre des faits de Jacques de Lalaing,* which relates the adventures of that well-known Don Quixote of the tournament-lists, and which has been attributed to various authors[2].

The other field of literature which received special encouragement from Philip the Good, was that of the chronicle or history. This was in continuation of the work of Froissart, himself a native of Hainault, whose last patron, Albert of Bavaria, Count of Hainault, was grandfather of that Jacquelin, whom Philip the Good dispossessed. But neither Enguerrand de Monstrelet, Provost of Cambray (d. 1453), who calls himself the continuator of Froissart, nor the King-at-arms of the Golden Fleece, Jean Le Fèvre de Saint-Rémy, had a spark of Froissart's genius for narrative and picturesque description. " Toison d'Or" was an old man, nearly seventy, when he began to

[1] See Gaston Paris, *La légende du mari aux deux femmes* in *La poésie du moyen âge,* 2me série, 1895, pp. 109 ff.

[2] It is printed by M. Kervyn de Lettenhove in the *Œuvres* of Chastellain (vol. VIII.), but the style is not in the least like Chastellain's. M. Raynaud (*Romania,* XXXI. 327 ff.) attributes it to Antoine de La Sale, that convenient repository of unclaimed literary baggage, while M. Bayot and M. Liègeois ascribe it with *Gilles de Trasignies* and *Gilles de Chin* to one and the same author.

write his chronicles (*circ.* 1463). Nearly ten years before this Georges Chastellain, already in high repute as a writer of prose and verse, received from Philip the Good a pension of 650 livres, and the title of *indiciaire* or historiographer, on condition of writing a history of his time. He faithfully carried out his task, working at it at Valenciennes, the birthplace of Froissart, where he went to live probably in 1456, till his death in 1475. But it was not by his *Chronique*, which is often admirable both in style and matter, that he was known to his contemporaries. It was by virtue of his dull poems and highly rhetorical treatises, with their constant striving after effect[1], that he achieved the primacy of literature. Moreover, since he survived all the writers who have been mentioned as illustrating this period, except Martial d'Auvergne, by several years, it was he who set the pattern to the next generation, founding the school of the *grands rhétoriqueurs*, which flourished for half a century after his death. Thus when one speaks of the Burgundian influence on French literature, one thinks chiefly of Georges Chastellain[2].

In all this literature there is little sign of the Renaissance. Whether we turn to the Burgundian Chastellain, or the Provençal La Sale, or the Picard Le Franc, or the Parisian Villon, or the Valois prince, Charles d'Orléans, we find the same clinging to the old ways. They write *ballades* and *rondeaux* according to the metrical rules prescribed by Eustace Deschamps in his *Art de dictier* (1392) and they cling to the allegorical personifications of the *Roman de la Rose*. Villon, it is true, rejected allegory as too artificial for his profound realism, and made the *ballade* a vehicle for passion and self-analysis. But, with all his rare genius, Villon is just as mediæval as the rest. We see it in his

[1] Such as the *Exposition sur vérité mal prise*, the *Entrée du roi Louis en nouveau règne, Le Temple de Boccace,* and the very popular poem, *Oultré d'amour.*

[2] For the whole subject of Burgundian literature see G. Doutrepont, *La littérature française à la cour des Ducs de Bourgogne,* 1909, where it is treated very fully, and G. Gröber, *Grundriss der romanischen Philologie,* II. part i. pp. 1126–1159.

attitude towards antiquity. His knowledge of classical literature was that of the ordinary university student of his day. The only writer whom he knew at all intimately was Ovid, he had read some Virgil, he had a smattering of Roman history, and he cites Aristotle, Valerius Maximus, Vegetius, and Macrobius. But, as Gaston Paris says, he and his contemporaries were "completely incapable of deriving any profit from Latin classical poetry for the form of their own verse. They found in it material for interesting narrative, or elements of moral instruction, but they did not perceive its beauty[1]." And M. Thuasne, after quoting some verses by Martin Le Franc, another student of the University of Paris and a much more learned one than Villon, points out that they fully confirm Gaston Paris's observation. For though they are directly inspired by Juvenal, they have nothing of the energy and dignity of his verse[2]. Even less than Fouquet, Villon and the rest found in the great monuments of antiquity subjects for their pencil, but not inspiration for their art. On the other hand, it may be said that Chastellain, like his predecessor in the primacy of French literature, Alain Chartier, had learnt from the classical models which he had studied at the University of Louvain the importance of style and dignity and sustained utterance, in a word, of eloquence. But in the writings by which he was chiefly known to his contemporaries he employs methods which are the very reverse of classical—over-emphasis, unusual or manufactured words, and a laborious pedantry. Yet with all these obvious defects he is often weighty and eloquent, while in his observant curiosity, his independence of thought, his realistic grasp of men and events, he is a true herald of the Renaissance[3].

[1] *François Villon*, pp. 83, 84.
[2] *Gaguini Epistolae* (1903), II. pp. 468–469. Prof. Söderhjelm in *La nouvelle française au XIV*e *siècle*, 1910 takes a different view of the literature of this period, and sees in La Sale a type of the Renaissance.
[3] It is also to Chastellain's credit that he is the first writer to make French prose a vehicle for speculative thought, and to attempt the long phrase which this demands. If he fails in this, if his sentences wind like

If we turn from the writers of the last twenty years of the reign of Charles VII to the Universities in which some of them were trained, we find much the same condition of things, that is to say, a marked revival of activity, but little or no real intellectual progress. No less than three new Universities were founded, Valence by the Dauphin in 1452, Nantes by the Duke of Brittany in 1460, and Bourges by Louis XI (as the Dauphin had now become) in 1464. At Paris the College of Navarre, the largest and most important in the University, had so many students that a new college was founded in 1460 to provide for its overflow. In 1463 the college of Coqueret was re-organised. But this renewed activity of University life did not bring with it any change in the system of education. The new Statutes which Cardinal D'Estouteville promulgated in 1452 for the University of Paris only affected discipline and the methods of teaching and examination. Logic still continued to be the staple of University education, absorbing all the energies of both professors and students, and becoming more and more arid and hair-splitting. In such an atmosphere there was little likelihood that the new learning would find anything but a chilly welcome.

Yet an attempt was made at the beginning of the year 1458, when Gregorio of Citta di Castello (Gregorius Tifernas), a humanist of considerable distinction, who had been residing in France since the close of 1456, was appointed to a chair of Greek in the University at a yearly salary

wounded snakes, it must be remembered that it is only a great artist like Montaigne who can make his prose reflect the sinuosities of his mind, and that it was not till more than a hundred and fifty years after Chastellain's death that the art of the well-balanced sentence was perfected in France. In his *Chronique* Chastellain tells a plain narrative in a simple and forcible style, which not unfrequently, as in the account of the disturbances at Ghent, rises to dramatic intensity. Moreover, when he is heated by moral fervour, as in the chapter on the " conditicn des princes de la terre," he is not only really eloquent, but perfectly clear and unaffected. But the *Chronique* was never printed till the nineteenth century, and if we may judge by the fragmentary condition in which it has come down to us, and by the small number of the manuscripts, it was little known to Chastellain's contemporaries, except by reputation.

of a hundred crowns. He was to lecture twice a day, once on Greek, and once on rhetoric. But like so many of the Italian scholars of his day he was of a restless disposition, and, after pining among " the barbarians " till the end of the summer term of 1459, he returned to Italy[1]. Robert Gaguin, who fourteen years later was to become the leader of the humanistic circle at Paris, attended his lectures, and learnt from him to appreciate the beauties of Latin poetry. Of Greek he acquired nothing but the bare rudiments. Yet the seed sown by Tifernas did not fall on altogether barren ground, for when Reuchlin was at Paris in 1473 he learnt, he tells us, the elements of Greek from pupils of Tifernas[2].

The times, in fact, were not yet ripe. They may be characterised in the following words of M. Petit-Dutaillis : " If there were Frenchmen in the days of Charles VII who were capable of reflexion, who knew how to observe nature and humanity, they were independent spirits who owed little to their education."

III

Louis XI had not the time, even if he had had the inclination, to play the part of art-patron. He did not care to spend money on illuminated manuscripts, and when he confiscated the possessions of rebels and traitors, he seems to have spared their libraries. But he was far from unlettered ; he was, indeed, fond of literature, and, like his friend Francesco Sforza, he was too shrewd and intelligent not to encourage learning and art. He founded, as we have seen, a new University at Bourges, and he gave his support to the new art of printing. He

[1] Born in 1414, he was at Naples in 1447, where he taught Pontano Greek. He translated the last seven books of Strabo and various other Greek prose writings for Nicholas V. See Bulaeus, *Hist. Univ. Pav.* v. 875 ; G. Naudé, *Addition à l'histoire du roi Louis XI* in Commynes, ed. Lenglet Du Fresnoy IV, 305 ; L. Delaruelle in *École franç. de Rome, Mélanges d'archéologie et d'histoire*, XIX (1899), 9–33 ; *Gaguini Epistolae et orationes*, ed. L. Thuasne I, 9–13.

[2] *Briefwechsel* ed. L. Geiger, Tübingen, 1875, No. clxxi, p. 199.

ordered pictures from Fouquet, upon whom he conferred the title of " peintre du roi," and works of sculpture from Michel de Colombe, while his superstitious piety bore fruit in the Churches of Notre-Dame de Cléry, and Notre-Dame de Béhuard.

The names of these artists and churches point to a service which Louis XI, rather by accident than by design, conferred on French art. He helped to concentrate its energies in the neighbourhood of the Loire. Though he never remained long in one place, his favourite residences were Amboise and the château which he built at Plessis-les-Tours. Cléry is only three miles from the Loire, about the same distance above Plessis as the Ile de Béhuard is below it. Fouquet was a native of Tours, and lived and died there ; Michel Colombe spent the greater part of his life there ; and it was for many years the home of the great musician, Jan van Okeghem, Louis XI's master of the chapel.

Cléry and Notre-Dame de Béhuard suggest another train of thought. As M. Petit-Dutaillis has pointed out, the devotion of Louis XI to certain shrines had a practical advantage besides that of ensuring him the good-will of Our Lady and the Saints. It enabled him on the pretext of a religious pilgrimage to see what was going on in the states of his vassals. Thus Cléry is conveniently placed between Orleans and Blois, both in the territory of the Duke of Orleans, while the island of Béhuard is eight miles from Angers, the capital of Duke René, and twenty from the borders of Brittany. To break the power of the great vassals, to abolish all hindrances to the action of the central government as concentrated in the hands of the King of France, was the great aim of Louis's statesmanship. Against the fatal system of royal appanages, which had brought the kingdom to the verge of dissolution, he set his face from the outset. It is true that he was forced to invest his brother Charles, first with Normandy—which he soon took from him—and later with Guyenne, but in the end, thanks to his good fortune and to the promptitude with which he took advantage of it, his policy of centralisation

completely triumphed. His brother died without heirs in 1472. The great power of Charles of Burgundy was shattered at Nancy on January 5, 1477. In the same year Jacques, Duc de Nemours, the last surviving male of the house of Armagnac, paid the penalty of treason on the scaffold. The death of René of Anjou in 1480 was followed by that of his nephew a year later, with the result that the appanages of Anjou and Maine reverted to the Crown, and together with Provence were added to France. Mary of Burgundy, Charles's heiress, died opportunely in 1482, and, as the result of the treaty of Arras, the Duchy and Picardy, which Louis had overrun immediately after Charles's death, remained in his hands. The Duke of Bourbon was childless, and his brother and heir, Pierre de Beaujeu, was Louis's son-in-law and most trusted supporter. The meeting of the States-General at Tours in 1484, to which every province except Brittany sent representatives, was, in the words of M. Petit-Dutaillis, "a striking manifestation of the unity of France." This unity was scarcely interrupted either by the Mad War of 1485 or by the ineffectual coalition which was defeated at Saint-Aubin-du-Cormier in 1488, while it was greatly strengthened by the marriage of Charles VIII with Anne of Brittany in 1491. It was a condition precedent to that return of domestic peace and order without which the advent of the Renaissance would have been impossible.

The Italian policy too of Louis XI helped to prepare the way for the Renaissance. It was one of the signs of the renewed vitality of France that she began to interest herself in the affairs of Italy. But during the reign of Charles VII there was no consistent policy. The King of France, the Duke of Anjou, and the Duke of Orleans each pursued independently his own aims, and these often proved to be conflicting. For the first wanted Genoa, the second the two Sicilies, and the third Milan. As Dauphin, Louis XI had often fished in these troubled waters, but when he became king he wisely preferred the part of peacemaker. He proved himself a staunch and valuable ally alike to

Francesco Sforza, for whom he cherished a warm admiration, and to Piero and Lorenzo de' Medici.

This policy naturally necessitated much diplomatic intercourse between France and Italy. On Louis's accession to the throne, Milan, Venice, and Florence all sent ambassadors, Florence being represented by a Medici, a Pitti, and a Pazzi[1]. Before long Milan and Florence appointed permanent ambassadors to the Court of France, and throughout the reign missions were constantly passing between France and the principal Italian Courts. Except at Rome, however, it was not till the time of Louis XII that permanent French embassies were established in Italy[2].

Contrary to the usual practice of his day, Louis XI preferred laymen to ecclesiastics as diplomatic agents, but among his envoys we find Jean de Beauvau, Bishop of Angers, Louis de Rochechouart, Bishop of Saintes, and three Cardinals, Jean de Villiers de La Groslaye, Bishop of Lombez and Abbot of Saint-Denis, who gave Michelangelo the commission for his *Pietà*, Raymond Peraud, and Jean Jouffroy, Bishop of Albi, all of whom were more or less in sympathy with the new learning. The last-named, Jean Jouffroy, formed a close link between France and Italy. In his youth he had studied law at Pavia, and for three years (1435–1438) was lecturer in canon law at that University. Between 1448 and 1468 he paid several visits to Italy, and on one occasion he resided there for a couple of years or more. He had a fairly wide, if superficial, knowledge of Latin literature, his favourite authors being Cicero, Caesar, Livy, and Plautus. In his discourses he cites a certain number of Greek authors, but he only knew these through Latin translations. He speaks with enthusiasm of Homer, and, like Rabelais, found Plato "divine." In this cult of Plato he was doubtless influenced by his

[1] For this and other Florentine embassies see A. Desjardins, *Négociations diplomatiques de la France avec la Toscane* (Doc. inédits), vol. I. 1859.

[2] R. de Maulde La Clavière, *Hist. de Louis XII*, 2ᵐᵉ partie, *La Diplomatie*, 1893, I. 306–7. For the whole Italian policy of Louis XI see the admirable *Relations de la France avec Venise*, 2 vols. 1896, by P.-M. Perret, a young *savant* of great promise, who died in 1893 in his thirty-second year.

fellow Cardinal, Bessarion, who was carrying on his controversy with Theodore Gaza at the time of Jouffroy's sojourn in Italy in 1458–1459[1].

To the diplomatic agents of Louis XI must be added those of the Duke of Burgundy—Philibert Hugonet, Bishop of Tournay, and his successor Ferry de Clugny, both Cardinals, the latter being also Chancellor of the Golden Fleece, and Guillaume de Rochefort, who spent a whole year in Italy as envoy successively to the Pope, the Duke of Milan, and Venice. Clugny possessed illuminated service-books, and it was either for him or his brother Guillaume, who was translated in 1479 from Térouanne to Poitiers, that Roger van der Weyden painted the Annunciation which once figured in the collection of Lord Ashburnham[2].

Apart from these diplomatic missions the Church supplied a natural avenue of communication between France and Italy. Bishops, especially those who were Cardinals, and other Church dignitaries made journeys to Rome on business connected with their sees and Orders, and as they were nearly always men of education and wealth, indeed, sometimes of vast wealth—for, though at this time pluralism in the matter of sees was the exception, a bishop often enjoyed the revenues of several rich abbeys—they were not only in a position to profit by intercourse with Italian humanists, but they had the means as well as the inclination to dispense a liberal patronage. The French Cardinals of this period included besides those already mentioned, Philippe de Levis de Caylus, Bishop successively of Auch and Arles; the two Normans, Richard Olivier de Longueil, Bishop of Coutances, and Guillaume d'Estouteville of the family of Harcourt, Archbishop of Rouen, who narrowly missed the Papacy when Pius II was elected; Pierre de Foix, a pluralist, who held Aire and other sees; André d'Epinay, Bishop of Bordeaux; the well-known

[1] See Ch. Fierville, Le cardinal Jean Jouffroy et son temps, 1874; L. Delaruelle, Guillaume Budé, 1907, pp. 7–8.

[2] It passed into that of Rodolphe Kann. See J. Weale in Burlington Mag. VII. 141.

Jean de La Balue, who was Bishop, first of Evreux and then of Angers; and Charles de Bourbon, Archbishop of Lyons, a thoroughly mundane prelate, but an excellent patron of letters. Thomas James, Bishop of Dol, never became a Cardinal, but in the pontificate of Sixtus IV (1471–1484) he resided for some time at Rome as procurator of the Duke of Brittany, and Governor of the Castle of St Angelo. Nor must we forget the learned Bishop of Chartres, Miles d'Illiers, whom Guillaume Tardif calls his *benefactor eximius*, and whose love of law-suits has gained him a place in Rabelais's great narrative and one of Desperiers's stories[1]. He was sent by Charles VII on a mission to Milan in 1446, and on one to Florence and Rome in 1458, but he was not employed by Louis XI.

But Churchmen were not the only class who travelled on the road from France to Italy. The Italian Universities attracted a certain number of French students. Padua, which served as the University of Venice, was at this time one of the two or three leading Universities of Europe. Pavia, which occupied the same relation to Milan, and Bologna, also held high rank. The reputation of Ferrara had declined since the days when it was made illustrious by the teaching of Guarino (1436–1460)[2]. Students were now drawn there chiefly by the facility with which its degrees could be obtained. During the sixty years before 1495 only forty-seven Frenchmen, less than one a year, are recorded among its students[3]. As for those to whom a degree was no object, their choice was determined rather by the fame of great teachers or great libraries. Thus Florence, Rome, and Venice were more important centres of Humanism, and attracted more foreign students than any University town, not excepting Padua.

On the other hand, Italian ecclesiastics, humanists, men of letters, and artists came to seek their fortunes in France

[1] Rabelais, *Le Tiers Livre*, c. v; Desperiers, *Nouv.* xxxiv.

[2] Nearly all the earliest English humanists, Tiptoft, Grey, Free, Fleming, Gunthorpe, studied at Ferrara.

[3] E. Picot in *Journal des Savants*, 1902, pp. 80 ff. and 146 ff.

as a country which was richer than their own, and in which second-rate learning and second-rate art were more likely to impose upon uncritical patrons. Some of these ecclesiastics were appointed to French bishoprics. Cibos and Della Roveres occupied the sees of Agen and Mende for half a century[1]. Niccolò Fieschi was Bishop, first of Agen, and then of Fréjus. Federigo da San Severino, one of the twelve sons of the well-known *condottiere*, Roberto da San Severino, was Bishop of Maillezais, and later (from 1508) Archbishop of Vienne. A former occupant of this latter see was Angelo Cato, a Neapolitan by birth, who, having been physician successively to Jean, Duke of Lorraine and his son Nicolas, Charles, Duke of Burgundy, and Louis XI, was elected Archbishop of Vienne in 1482. It is perhaps his chief title to fame that the memoirs of Commynes were written at his request, but he was highly esteemed as a man of learning by his contemporaries, and was also in repute as an astrologer[2].

Among the Italian humanists who settled in France during the last years of the reign of Louis XI and the minority of his successor, were Paolo Emilio of Verona, the historian, who came to Paris in 1483 in order to study theology; Domenico Mancini, of a noble Roman family, the author of the popular *Libellus de quatuor virtutibus*, who entered the household of his friend Cardinal San Severino about 1480; Michele of Pavia, who, having joined the College of Navarre, and served as Rector of the Paris University in 1492--1493, was appointed Dean at Cambray in 1506[3]; and Ludovico Ricchieri of Rovigo, better known as Coelius Rhodiginus, whose *Antiquarum lectionum libri XVI* (Venice, 1516; Paris, 1517) became a favourite

[1] Innocent VIII held the see of Comminges from 1467 to 1471, Julius II that of Mende from 1478 to 1483.

[2] He was born at Supino near Benevento. He wrote a Latin treatise, *De cometa*, on the comet of 1472, which was printed in 1473 (N.S.), probably at Naples. See Hain, n°. 4706; Brunet, v. 594; Commynes, *Mémoires*, ed. Mandrot, book y. cc. iii. v.; vi. c. vi.; vii. c. iv. and vol. i. p. l, n¹.

[3] Launoi, *Navarri gymn. hist.* p. 217; Bulaeus, v. 924; *Gallia Christiana*, iii. 72.

hunting-ground for those in search of miscellaneous information[1]. To these must be added two humanists of a very inferior stamp, pushing, vain, quarrelsome, and licentious, Gicolamo Balbi of Venice, and Fausto Andrelini of Forli. We shall meet with them again.

Banishment was a favourite form of punishment for political offences with the Italian states, especially with Florence, and it is a tempting conjecture to attribute to this cause the presence of a Florentine named Francesco Florio in the household of Jean V, the last Count of Armagnac. We also find him living for a short time at Tours, where he dwelt in the house of a master-mason named Guillaume Larchevesque, and where he made the acquaintance of Guillaume Tardif, afterwards a professor at Paris and reader to Charles VIII. It was to Tardif that Florio dedicated his Latin novel, *De amore Camilli et Aemiliae Aretinorum*[2], which was printed by Keysere and Stoll in 1473[3]. We hear of him again from 1478 to 1480, when he was employed in copying a manuscript of Gratian for Tristan de Salazar, the Archbishop of Sens[4].

It has already been said that Italian artists were employed by King René, chief among them being Pietro da Milano and Francesco Laurana, both architects, sculptors, and medallists, and both formerly in the service of King Alfonso of Naples and his son Ferdinand. Another medallist, Giovanni di Candida, of the noble Neapolitan ·family of Filangieri, entered the service, first of Charles of Burgundy,

[1] He returned to Italy in 1491, and after a wandering and chequered career was appointed by Francis I in 1575 to the Greek chair at Milan. He died at Rovigo in 1525. Montaigne mentions him with approval in his *Journal de Voyage* and probably gleaned some passages from his book. Rabelais certainly used him.

[2] *Liber editus in domo domini Guillermi Archiepiscopi Turonensis prid. kal. ianuarii anno dom.* 1467. His host was at one time supposed to be the Archbishop of Tours.

[3] Without a date, but printed with their earliest type; it was reprinted by the same printers in the same year, and again about 1483 by a printer who has not been identified. (Proctor, 7891, 7892, 8475.)

[4] According to a note signed *Florius ille infortunatus* it was begun July 9, 1478, and finished March 12, 1480.

and then of his daughter and her husband Maximilian. He came to France in 1482 or 1483, and rose to high honour under Charles VIII[1].

The influx of Italians into France was greatly encouraged by the wise and liberal measures taken by Louis XI to promote the increase of population and the revival of trade. He established a colony of Italian silk-workers, first at Lyons, and then at Tours, and relieved them from the ordinary restrictions imposed on corporations. He also abolished the *droit d'aubaine*, by which the property of all foreigners who had not received rights of naturalisation passed on their death to the crown, for the whole of Languedoc and for the towns of Rouen and Bordeaux. In Provence too foreigners were permitted to settle, and to inherit and dispose of property with complete freedom. The same rights were granted by treaty to the Swiss in 1484, the year after Louis's death. As the result of this policy, not only Italians, but Spaniards, Flemings, Lorrainers, Scots, Piedmontese, Savoyards, Germans, and Swiss, settled in France[2]. It was a Savoyard and a German who with the help of German workmen—the Germans were at this time the best mechanics in Europe—introduced into France the new art and industry which did so much to propagate the ideas of the Renaissance.

The initiator of this far-reaching movement was Guillaume Fichet. A Savoyard by birth, he studied for some years at Avignon, where he read Petrarch's works, and transcribed his *De vita solitaria*. Then in 1459, at the age of twenty-six, he came to Paris, was admitted a *socius* of the Sorbonne in 1461, and received the licence and doctorate of theology in 1468[3]. It is a well-known story how in 1470 he and Jean Heynlin, another member of the Sorbonne, who had been a professor at Basle (1463–1467), induced Michael Friburger, a Master of Arts of that University, and two working-printers, Ulrich Gering of Constance and Martin Krantz

[1] I shall return to these medallists in a later chapter.
[2] See Imbart de la Tour, *Les origines de la Réforme*, 1909, I. 287–292.
[3] J. Philippe, *Guillaume Fichet, sa vie, ses œuvres*, Annecy, 1892.

to set up the first French printing-press within the precincts of the Sorbonne[1]. With few exceptions the books issued from this press were of a humanistic character. The first was *Gasparini Pergamensis Epistolarum Opus*, a collection of model Latin letters by Gasparino Barzizza, the Italian humanist who did so much to promote the study of Cicero, and who, though he was far from being a slavish imitator of his style, may fairly be called the first Ciceronian[2]. Next followed his *Orthographia*, a copy of which was presented by Fichet as a New Year's gift to Robert Gaguin. It was accompanied by a letter, in which the writer expressed his satisfaction at the flourishing condition of Latin poetry and rhetoric in Paris. The twenty other works which are known to have been issued from the Sorbonne press down to the removal of the three associates to a house in the Rue Saint-Jacques included eight editions of Latin classical authors[3], a volume containing the *De officiis* of St Ambrose (an imitation of Cicero) and the *De quatuor virtutibus* falsely attributed to Seneca, three works on rhetoric, namely Varro's *Elegantiae*, Agostino Dati's *Eloquentiae praecepta*, and Fichet's *Rhetorica* (a summary of the lectures which he had delivered at the Sorbonne), and the *De miseria curialium* and *De duobus amantibus* of Pope Pius II. Only one publication was a *livre de circonstance*, and that was the *Orationes* of Cardinal Bessarion, who had come to France in July or August of 1472 on a mission from Sixtus IV to promote a crusade against the Turks. Fichet, who had corresponded with him, was his devoted admirer, and helped the cause which he had so much at heart by the publication of his speeches. The mission, however, was a failure—it is difficult to imagine Louis XI as a crusader—and before the end of the year, Bessarion

[1] In 1470 Heynlin was prior and Fichet librarian of the Sorbonne, both being elected on Lady-day of that year. Fichet had previously been prior (an annual office), and both had served as Rector of the University.

[2] See above, p. 15.

[3] No copies of two of these, Cicero's *Orator*, and Valerius Maximus are known to exist.

returned to Italy, taking Fichet with him. Bessarion died of fever at Ravenna on his way to Rome, and Fichet remained in Italy, but probably did not survive beyond 1480. It was doubtless Fichet's departure that caused the removal of the press from the Sorbonne to the neighbouring Rue Saint-Jacques in 1473. But soon afterwards two other presses were set up in the same street, one by Pieter de Keysere of Ghent and Johann Stoll, two of the Sorbonne workmen[1], and the other at the sign of the *Soufflet-Vert* or Green Ball[2]. So far nothing had been printed except Latin works, but in January 1477 (N.S.), Pasquier Bonhomme, one of the four principal booksellers of the University, issued *Les Croniques de France* in three volumes—the first French book printed at Paris[3]. At the beginning of 1478 Gering's two associates, Friburger and Krantz, left France, and from about that time the character of the books completely changed. The publication of Latin classics and works on rhetoric now became the exception, and for the next fifteen years the chief productions of the Parisian press were romances, treatises on chivalry, devotional works, and the text-books of the old learning. It was a question of supply and demand. The press had been introduced into Paris in the interests of Humanism, and had been supported by a few ardent humanists. It was now worked on business lines, and Humanism did not pay. Still, for a few years after Fichet's departure an effort was made to carry on his work. When Reuchlin was at Paris in 1473, he attended lectures on rhetoric by Gaguin at the Sorbonne, and by Tardif at the College of Navarre. From 1476 to 1478 Filippo Beroaldo the elder, a scholar of wide learning, who for the last twenty-four years of his life (1481–1505) was a highly successful professor in his native city of Bologna, lectured at Paris. An edition of Virgil (now lost) and

[1] The date of their first book is 1474, but their press was probably set up in the preceding year.

[2] 1475.

[3] See for the early Parisian press A. Claudin, *Hist de l'imprimerie en France*, I. and II.

a commentary on Lucan seem to have arisen out of these lectures[1]. In 1476 too there came to Paris a native of Greece, George Hermonymos. According to the almost unanimous testimony of his pupils—Erasmus, Budé, Beatus Rhenanus—he was an incompetent teacher, but he did good service as a copyist of Greek manuscripts[2]. He remained at Paris till at least as late as 1508.

The sanguine expectations expressed by Fichet in his letter to Gaguin were unfulfilled—partly owing to the defection of Fichet himself. But the lamp which he had helped to light was not allowed to flicker out altogether. His friend Gaguin, as we shall see when we come to our main story, became the leader of the small band of Paris humanists, who kept that lamp burning, and waited for better days.

[1] See L. Delaruelle, *G. Budé*, 1907, p 21, n. 4.

[2] See H. Omont, *Georges Hermonyme de Sparte, maître de grec à Paris* 1885 ; L. Delaruelle, *op. cit.* pp. 69 ff.

CHAPTER III

THE EXPEDITION OF CHARLES VIII[1]

I

On the 2nd of September, 1494, Charles VIII at the head of his army crossed the Alps by Mont Genèvre, and on the following day entered Susa in the territory of the Duke of Savoy. On the 5th he reached the capital, Turin, where he was received with great pomp and splendour. It was the first of the many magnificent " Entries," which

[1] The two contemporary sources of information upon which all other accounts of the whole expedition are based are the *Compendium de Francorum origine et gestis* of Robert Gaguin, which appeared in 1495, and the *Le Vergier d'honneur* of André de La Vigne, of which the first edition, without date or place of publication, is to be assigned to the years 1498–1502. Gaguin's *Compendium*, which is very brief, contains nothing that is useful for the purpose of this chapter. La Vigne's work is a detailed account of the expedition, evidently by an eye-witness of its chief events. It is in the nature of a diary, though it is not written up day by day. The first part, down to the middle of Charles's sojourn at Naples, is in verse, of a more or less doggerel type ; the rest is in prose interspersed with verse. The author was at one time secretary to the Duke of Savoy, and was probably a Savoyard by birth. At the time of the expedition he was Court poet to Charles VIII. His narrative will be found in the *Histoire de Charles VIII* by Denis Godefroy, 1684, pp. 114–189, but with the verse turned into prose. Portions of it, also in prose, are printed in Cimber and Danjon's *Archives curieuses*, Sér. 1. vol. 1. but with many alterations and omissions. It is therefore indispensable to consult the original work. I have used an edition printed and published by Philippe Le Noir (without a date, but to be assigned to the year 1520), a copy of which is in the British Museum, catalogued under the name of Octovien de Saint-Gelais, who was formerly supposed to be joint-author of the work. It is now known that he only contributed to it a single piece of verse.

To these two principal sources must be added Marin Sanuto's *La spedizione di Carlo VIII in Italia* (ed. R. Fulin, Venice, 1883), which

are so characteristic a feature of the later Middle Ages and the Renaissance both in Italy and France, that he was to make during his progress through Italy. The fronts of the houses were hung with cloth of gold and rich tapestry, while at intervals were erected scaffolds for the representation of mysteries from the Old and New Testament. Charles was met at the gates by a long procession of nobles, ecclesiastics, and University officials, and by his aunt Blanche de Montferrat, mother of the reigning Duke (who was a boy of five), resplendent with cloth of gold, the fashionable material for dress in Italy at this period, and blazing jewels. Thus brilliantly escorted, the King rode through the streets to the castle, erected by Duke Amadeo VIII (the anti-Pope Felix V) in 1416, where lodgings had been prepared for him. Under the name of the Palazzo Madama it still impresses the modern traveller with its four massive red brick towers, the one solitary relic of mediaeval Turin.

On the 9th of September Charles reached Asti, being escorted for the last two miles by Ludovico Il Moro. This was his first meeting with the man who had been the chief instrument in bringing him to Italy. Ludovico Sforza, Duke of Bari, commonly known as Il Moro, uncle of the reigning Duke of Milan, who was practically a prisoner in the Castle of Pavia, was a characteristic type of the Italian Renaissance in its decadence. We know his outward appearance from his numerous portraits. In the altar-piece

was written by the well-known Venetian diarist from good sources of information soon after the expediton. J. de La Pilorgerie, *Campagnes et Bulletins de la grande armée d'Italie commandée par Charles VIII* (Nantes, 1866) gives a certain number of original documents, including some letters. Those by Charles VIII will also be found in vol. IV. of *Lettres de Charles VIII*, edited by P. Pélicier for the *Soc. de l'hist. de France*. The *Mémoires* of P. de Commynes should also be consulted, especially in the new edition by B. de Mandrot (vol. II. 1903), which has full and admirable notes. The chief modern account of the expedition is that of F. Delaborde, *Expédition de Charles VIII en Italie*, 1888 ; its effects on the French Renaissance are dealt with in the companion work of E. Müntz, *La Renaissance en Italie et en France à l'époque de Charles VIII*, 1885. See for the whole question of authorities H. Hauser, *Les sources de l'histoire de France, xvie siècle* (1494–1610), I. (1906), esp. pp. 16–18.

painted by an unknown artist in this very year 1494[1], and in the miniature by Ambrogio di Predis in the so-called *Libro del Jesu*[2] we see the sleek fat face of the voluptuary with its incipient double chin. A similar portrait by Boltraffio is remarkable for its air of perfect self-complacence[3]. Nothing in fact contributed more to Il Moro's final downfall than his extraordinary confidence in himself and his star. There is more intellectual power in the effigy, now in the Certosa of Pavia, which Cristoforo Solari made (probably in 1497 or 1498) for his tomb in Santa Maria delle Grazie. He was, in fact, a man of active and keen intelligence, but he was too subtle to be really effective as a statesman. It wanted a man who could act as well as plot, a man of courage as well as of intelligence, to dominate a divided Italy and to unite her various states in a defensive alliance against the foreigner. Unfortunately Il Moro was a coward, and in times of danger his finely-spun webs of diplomacy collapsed from sheer panic[4].

Nevertheless he governed the Duchy of Milan and his other possessions, first as regent and then as Duke, in an enlightened spirit. Above all, as we shall see later, he was a generous and intelligent patron of art and letters. It is from the arrival of Charles VIII at Asti and his meeting with Ludovico that Guicciardini with characteristic penetration dates the beginning of " the innumerable calamities," which descended upon his unhappy country. We might also date from the same dramatic moment the beginning of the French Renaissance. At any rate it was at Asti,

[1] In the Brera. See the catalogue by F. Malaguzzi Valeri, pp. 186 ff.

[2] A MS. in the library of Prince Trivulzio at Milan. The portrait is reproduced in Lermolieff, *Die Galerien Borghese und Doria Panfili*, 1890, p. 239.

[3] In the possession of Prince Trivulzio : reproduced in *The story of Milan*, by E. Noyes, 1908, p. 176. We see the same characteristic in the medal by Caradosso, who knew him well (Fabriczy, *Medaillen der italienischen Renaissance*, p. 83).

[4] Commynes says of him, "Le dit seigneur Ludovic était homme très sage, mais fort craintif et bien souple, quand il avait peur (j'en parle comme de celui que j'ai connu et beaucoup de choses traité avec lui), et homme sans foi s'il voyoit son profit pour la rompre."

where Charles was detained for nearly a month by a slight attack of small-pox, and where many attempts were made to dissuade him from his expedition, that the final resolution was taken.

On the 6th of October Charles renewed his march, and on the following day came to Casale on the Po, the capital of the Marquisate of Montferrat. On the 11th he slept at Vigevano in the fourteenth century castle of the Sforzas, which Ludovico had recently restored at great cost. Among the additions was a loggia on the third story, which experts have agreed in assigning to Bramante. Thus for the first time the French beheld the work of the man who was to exercise so powerful an influence upon architecture in France. Il Moro received his guest with every mark of honour, but he could not persuade him to visit Milan. On the 13th Charles, saying that he had no time to lose, turned towards Pavia. Here he was met by the usual procession and conducted to the Castello, the splendid palace and fortress of Galeazzo Visconti, where Petrarch used to visit him, and which he described to Boccaccio as "the most stately of modern buildings." It was remarkable not only as a building but for the magnificent collections which it contained. Here Charles visited his aunt Bona of Savoy, whose portrait by Ambrogio di Predis may be seen in the National Gallery, and his unfortunate cousin Gian Galeazzo Maria, the reigning Duke, who, as we have seen, was practically a prisoner. On the 16th he dined at the Certosa[1], and on the following day he set out for Piacenza. On October 22 Gian Galeazzo died, and Ludovico, who was of course believed to have poisoned him—modern enquiry shews that there was no ground for this belief—was proclaimed Duke in his stead at Milan. Charles remained five days at Piacenza, chiefly employed in diplomatic negotiations. We are told that he heard Mass at San

[1] Sanuto, *Spedizione*, p. 672. Leonardo da Vinci was at Pavia at the time of Charles's entry (*Burlington Mag.* xxi. 61, notice of an article by E. Solmi in *Boll. della Soc. Pavese di storia patria*, fasc. i, ii, 1911).

Sisto[1], the church which was later to be rendered famous by Raffaelle's great Madonna.

Leaving Piacenza on the 23rd of October he followed the great Roman road, the Via Aemilia, as far as Parma, where he turned to the south-west to cross the Apennines. He reached their foot at Fornovo, the spot which on his return was to become memorable as the scene of the one pitched battle of the expedition, and crossing them at the Col de la Cisa descended through the beautiful chestnut woods to Pontremoli, the key of the passes between Lombardy and Tuscany. On the 30th he reached Sarzana in the Lunigiana, and after remaining there seven days marched by Marsa and Pietra Santa to Lucca, where he was met by another procession of clergy, nobles, and citizens. The majority of the latter, notes André de La Vigne, were clad in velvet and cloth of gold. For Lucca *la industriosa*, thanks to its silk manufactures, was a prosperous commercial city. On the following day, which was Sunday, Charles heard Mass, doubtless in the Cathedral. If so, he was probably shown the Tempietto, the little octagonal marble temple of pure Renaissance work which Matteo Civitali, a native of Lucca, completed in 1484 as a shrine for the *Volto Santo*, Lucca's most treasured relic[2]. In the same church are numerous other works by the same artist, executed from 1472 to 1484—a statue of St Sebastian, two kneeling angels of great charm, the altar of St Regulus, and the tomb of Pietro da Noceto, secretary to Pope Nicholas V. The last-named work (1472) is inspired in about equal degrees by two famous Florentine tombs, that of Carlo Marsuppini by Desiderio da Settignano in Santa Croce, and that of the

[1] Sanuto, *ibid.*

[2] It was a wooden crucifix, probably a work of the sixth century, which according to tradition was made by Nicodemus with the help of an impression of Our Lord's face taken on linen immediately after the crucifixion. "By the face of Lucca" was the favourite oath of William Rufus (Freeman, *William Rufus*, II. 503). The Volto Santo was known in France, and is probably the origin of the colossal crucifix of La Bourgonnière in Anjou, a fine work of about 1515 (Vitry, *Michel Colombe*, pp. 438–441).

Cardinal of Portugal by Antonio Rossellino in San Miniato. The sarcophagus closely resembles that of the latter work. But the artistic jewel of the Cathedral is the effigy of Ilaria Guinigi, all that civic hate has left of the rich monument which Jacopo della Quercia, the great prototype of Michelangelo, made for her and her husband, the lord of Lucca for thirty years.

From Lucca, instead of taking the direct road to Florence, Charles crossed the hills to Pisa, where he visited the Duomo and the Campo Santo. An eye-witness describes him as " a man of very little stature, with a small reddish beard, a large thin face and an aquiline nose[1]." The next morning he began his march up the fertile valley of the Arno, past Pontedera and Empoli to Signa, where he spent six days in preparation for his entry into Florence.

The entry into the fair city by the Arno which was at this time the intellectual and artistic capital of Italy has been described by several eye-witnesses, including Francisco Gaddi, the writer and diplomatist[2], who played a not inglorious part in the pageant, receiving Charles with a few words in French, when the public orator, Messer Luca Corsini was prevented by the confusion from delivering his Latin speech, and by Luca Landucci, a partisan of Savonarola who had an apothecary's shop at the Canto de' Tornaquinci near the Palazzo Strozzi[3]. Probably also the Florentine historian, Jacopo Nardi, then a youth of eighteen, whose account is on the whole the most complete, was present

[1] *Memoriale di Giovanni Portoveneri* in *Archivio storico ital.* VI. pt. 2, p. 288. Probably the portrait of Charles VIII which most faithfully represents his features is one that was discovered between the boards of the binding of a Book of Prayers in the Bibliothèque Nationale (MSS. Lat. 1190). Its artistic merit is slight, and it makes Charles look absurdly old. There is a similarly realistic portrait of Anne of Brittany at the end of the volume. See H. Bouchot, *Gazette archéologique* (1888), XIII. 103, pt. xvii. C. Couderc, *Gaz. des Beaux Arts*, 1907 (I.), p. 469 and *Album de Portraits d'après les collections du département des manuscrits* [1909], No. cx.

[2] See *Archivio storico italiano*, Iᵐᵃ serie. IV. pt. 2, pp. 45–48 (an extract from the Priorista or records of the Gaddi family).

[3] *Diario Fiorentino dal 1450 al 1516 di Luca Landucci*, ed. Jodoco del Badia, Florence, 1883.

on the occasion[1]. It was on the 17th of November, two hours before sunset[2], that the French king with 8000 horse and 4000 foot[3] arrived at the Porta San Frediano. Here he was met by the Signoria, and by a procession of clergy, the latter somewhat disordered by the surging crowd and an untimely shower of rain. After a little delay the march through the streets began. Among the striking features of the procession were the Swiss in their gay parti-coloured dresses, reputed the first infantry in Europe, the huge mounted archers from Scotland and other northern countries, the men-at-arms, the flower of the French nobility, riding powerful horses with docked tails and ears after the French fashion, the royal guard composed of a hundred archers and two hundred knights, all on foot[4], and lastly the king himself, riding a magnificent black charger, named Savoye (a present from the Duchess of Savoy[5]), and sheltered by a rich *baldacchino* or canopy, the bearers of which were members of the two Florentine Colleges. Amid cries of *Viva Francia*! the procession passed along the present Via San Frediano and its continuations, then over the Ponte Vecchio and by the Via Por Santa Maria and the Via Vacchereccia to the Piazza della Signoria. It was just sunset when the king dismounted at the western door of Santa Maria del Fiore. "When the people saw him on foot," notes Landucci, "his prestige was somewhat diminished, for he was a very little man." After hearing Mass he re-mounted his horse, and—no longer under the *baldacchino*, for that according to custom had been pillaged by the mob —rode to the palace of the Medici (now Palazzo Riccardi), where he was to lodge.

[1] J. Nardi, *Istorie della Città di Firenze*, 2 vols., Florence, 1838–41.

[2] Landucci and Rinuccini, also an eye-witness. Nardi says three hours before sunset.

[3] Gaddi.

[4] See André de La Vigne, E. i. r⁰.–E. iii. v⁰. and cf. Jovius's account of the entry into Rome (*Hist. sui temporis*, book II.).

[5] Savoye aussi le coursier du roy Charles
 Que meilleur neust de Rome jusqu'a Arles.
 JEAN LEMAIRE, *L'amant vert*, IV.

On the two following days he heard Mass at San Lorenzo, the church which is so closely associated with the Medici family, and which is also of great significance in the history of Renaissance art. For with the comparatively unimportant exception of the lower portion of the portico of the Ospedale degli Innocenti, the old Sacristy of San Lorenzo (1421–1428) was the first building which Brunelleschi, the parent of Renaissance architecture, completed in the new style[1]. Moreover it contains several works, including the bronze doors, by his friend Donatello. And in the body of the church, which was still unfinished at Brunelleschi's death in 1446, is Donatello's last work, the two bronze pulpits, also unfinished when he died in 1466. He lies in front of the high altar beside his friend and patron, Cosimo, Pater Patriae.

The Medici palace, built for Cosimo by Brunelleschi's pupil and rival, Michelozzo, filled Charles VIII and his courtiers with wonder and admiration. Commynes describes it as " the finest house of a citizen or merchant that I have ever seen[2]." Begun in 1444, it was among the first of those severe and stately fortress palaces which are the glory of Florence and the early Renaissance, buildings in which architecture depends for its effects more on proportion and on harmony of line than on ornament and external decoration. It had been preceded by the Palazzo Pitti and the Palazzo Pazzi (later Quaratesi), both designed by Brunelleschi about 1440[3], and it was followed by the less severe but equally harmonious Palazzo Rucellai (1460). Here the classical tastes of Leo Battista Alberti expressed themselves in the pilasters of the façade, which are used as mere ornament, without serving any structural purpose. Of a later date are three beautiful specimens of the work of the three chief Florentine architects who were living at the time of

[1] See Marcel Reymond in *Gazette des beaux arts*, XXIII. (1900), pp. 89 ff. ; 425 ff.

[2] Book VIII. c. ix. ; La Vigne says that its walls were made of marble !

[3] The order for the design of the Palazzo Pitti was given by Luca Pitti in 1440. The Palazzo Pazzi was finished by Giuliano da Maiano.

the French expedition, the Palazzo Gondi, near the Bargello, by Giuliano da San Gallo, the favourite architect of Lorenzo de' Medici, and a keen student of antiquity; the Palazzo Guadagni, close to San Spirito, a smaller palace with an open loggia, the work of Simone Pollaiuolo, nicknamed Cronaca from his love of telling long stories; and, most beautiful of all, the Palazzo Strozzi, which was still in process of building, having been begun in 1489 for Filippo Strozzi by Benedetto da Maiano. On his death in 1497 it was completed by Cronaca.

Immediately on his arrival at the Palazzo Medici, Charles asked to see the famous collection of coins, cameos, and porcelain, but, " he could not have them, because they had been already carried off and concealed in the monasteries[1]." After the flight of Piero de' Medici on November 9 the populace had plundered the gardens of San Marco and the house of Cardinal Giovanni, the future Leo X, but the Palazzo Medici itself had been protected by the Signoria[2]. Piero, however, previous to his flight had deposited part of his treasures in various monasteries, and had handed over some of his jewels for safe keeping to a friendly jeweller. Moreover when the palace was first assigned to Charles VIII as his residence, Robert de Balsac, Seigneur d'Entragues had pillaged it on the plea that he was owed a considerable sum by the Lyons branch of the Medici bank, and others followed his example[3]. The rest of the collection was soon afterwards sold by order of the Signoria, Ludovico Sforza, through his agent Caradosso, becoming a considerable purchaser[4].

II

It was on the 28th of November, eleven days after his arrival, that Charles left Florence and slept at the Certosa of the Val d' Ema. Marching by San Casciano, where he

[1] Sanuto, *Spedizione*, p. 146.
[2] Jovius, lib. I. (Basle edition, p. 33); Nardi, *op. cit.* p. 40.
[3] Commynes, bk VII. c. XI. and see Mandrot's notes.
[4] E. Müntz, *Les précurseurs de la Renaissance*, 1882, pp. 211–219; and for the collection itself see pp. 133–197.

spent Sunday, and Poggibonsi, he reached Siena on the
2nd of December. Three miles from the city he was met
by the customary procession, which after the inevitable
Latin speech conducted him to the Porta Camollia, where
two temporary triumphal arches had been erected, then to
the Duomo, and finally to the episcopal palace, where he
was to lodge. Two days later he set out on his march
towards Rome. At Acquapendente and the other towns in
the Papal territory he was received with the same respect and
submission that had been accorded to him throughout his
march. At Viterbo, where he spent five days, he paid
several visits to the shrine of Santa Rosa, the patroness of
the city, who died in 1261, and whose embalmed body is
still venerated by the faithful. On the 15th of December
he dined at Ronciglione and slept at Nepe. On the 19th,
he took up his quarters in the grim castle of the Orsini at
Bracciano, twenty-three miles from Rome, and there he
opened negociations with the Pope, and discussed the
arrangements for his entry into the Papal city.

This took place at nightfall on the last day of the year.
In the early morning the Pope's Master of the Ceremonies,
Johann Burchard, whose well-known diary[1] here becomes
our authority, rode out from Rome to acquaint him with the
order of the proposed ceremonial, and to receive his com-
mands. But, before the Pope's emissary had ridden much
more than half-way to Bracciano, he met Charles, who had
set out twenty-four hours before he had intended, and who
now informed him that he wished to enter the city without
any procession. Accordingly, escorted only by the Cardinal
Ascanio Sforza, brother of Ludovico, and a few other cardinals
of the French faction, he crossed the Mulvian Bridge, and
entering the city by the Porta del Popolo rode to the Palazzo
di San Marco, the residence of Lorenzo Cibo, Cardinal of San
Marco and nephew of Pope Innocent VIII. Along the latter
part of the route, from San Lorenzo in Lucina to the palace,
the Corso was ablaze with torches and flambeaux, while

[1] J. Burchardi *Diarium*, ed. L. Thuasne, 2 vols. 1883–1884, II. pp. 216 ff.
and appendix, pp. 656 ff.

from every window came cries of *Francia! Colonna! Vincula!*
All through the night the soldiers poured into the streets.
The keys of the gates were delivered up to the Maréchal
de Gié, and on the next morning, the first of the year 1495,
Rome for the first time since its capture by Totila
in 549 wore something of the aspect of a conquered
city.

The Palazzo di San Marco, better known by its later
name of the Palazzo di Venezia[1], formed with the smaller
palace adjoining it and the Church of San Marco a group
of buildings of considerable importance and interest in the
history of Renaissance architecture. The work was begun
by Pope Paul II in 1455, when he was still Cardinal of
San Marco, and was finished during his pontificate (1464–
1471). The chief architect of the larger palace seems to have
been Giacomo da Pietra Santa, a Florentine, and among his
assistants were two other Florentines, Meo del Caprino,
who, at the time of the expedition, was building the Duomo
at Turin, and Giuliano da San Gallo, then quite a young
man, but in high favour with Paul II. Externally the
larger palace is a fortress of more or less mediæval type,
but the court (which was never finished) with its two-storied
arcades and its engaged columns of three Orders and the
somewhat similar portico of the church are purely classical
in design, having evidently been modelled on the Colosseum.
In this palace Paul II, who loved magnificence and beauty
as few men have loved them, had formed a superb collection
of bronzes, pictures, mosaics, tapestries, embroideries,
ivories, cameos, intaglios, coins, medals, gold and silver
plate, and above all precious stones, but after his death
they had all been dispersed[2].

It was not till the 12th of January that Charles, having
practically completed his negociations with the Pope,

[1] In 1564 Pius IV ceded it to the Republic of Venice in exchange for
a residence for the Papal Nuncio at Venice.

[2] See E. Müntz, *Les arts à la cour des Papes pendant le xv^e et le xvi^e
siècles*, 2^{me} partie, *Paul II*, 1879 (*Bibl. des écoles franç. d'Athènes et de Rome*,
fasc. 9).

ventured to cross the threshold of his lodgings. On that and
the following days he rode out to see the sights of Rome.
On the 13th he heard Mass in the Dominican Church of
Santa Maria sopra Minerva. In this solitary representative
of Gothic architecture among Roman churches the French
visitors might have seen not a few interesting examples of
Renaissance art, especially in the Chapel of St John the
Baptist. Here was the tomb of young Francesco Tornabuoni
(d. 1480), Mino da Fiesole's last and best work in Rome,
inspired like that of Pietro da Noceto at Lucca[1] by the
tomb of Carlo Marsuppini at Florence[2]. Here too was the
monument which Verrocchio had made soon after 1480 for
Francesca Tornabuoni, the wife of Francesco's uncle, Giovanni
Tornabuoni[3], and here were the frescoes painted by Ghir-
landaio in 1482. Another chapel was adorned with frescoes
representing events from the life of St Thomas Aquinas,
which Filippino Lippi had executed for Cardinal Caraffa[4].
In the Triumph of St Thomas the visitors might have noted
the classical architecture and classical symmetry which are
characteristic of Filippino, and which here appear for the
first time in Florentine art[5]. But the attention of the
Frenchmen must have been specially directed to the portrait
of Eugenius IV in the sacristy, for it was the work of their
own countryman, Jean Fouquet. On the 15th, the French
king visited the Colosseum, and we also hear of visits to the
Capitol and to the church of the Araceli, where Pintoricchio

[1] See above, p. 94.

[2] All that is left of the tomb, which is now in a dark corner in the left
aisle, are the sarcophagus with the reclining figures and the panels behind it.

[3] This tomb has been removed and broken up. It is difficult to accept
the bas-reliefs in the Bargello as belonging to it. See Maud Cruttwell,
Verrocchio, pp. 140–157.

[4] Some of these frescoes have been destroyed, and the rest have been
restored.

[5] "No other painter who employed, as he did, the forms of the
fifteenth century departed so far from the artistic spirit of that epoch.
He was, in fact, a precursor of the æsthetic confusion of the Seicento.
He had all its sentimentality, all its indiscriminate profusion of ornament,
all its fondness for empty display." B. Berenson in *The Study and
Criticism of Italian Art*, second series, 1902, p. 90.

was employed in decorating the Buffalini Chapel with frescoes of the life of St Bernardino of Siena. Here also was the fine tomb, massive and simple, of the French Cardinal D'Albret, completed in 1465, and generally attributed to the Lombard sculptor Andrea Bregno, who worked at Rome from about this date to the close of the century[1].

On the 16th, the treaty having been signed on the previous evening, the French king paid his first visit to the Vatican. On his ride he may have passed the finest Renaissance palace, rapidly approaching completion, that had yet been built in Rome. This was the palace of Cardinal Raffaelle Riario, now the Cancellaria, of which the noble court with its two-storied loggia is known to all visitors to Rome[2]. Charles took up his quarters at the Vatican in the *Stanze Nuove*, a part of the palace of Innocent VIII which was generally assigned to distinguished guests. It was not far distant from the Pope's apartments[3], a suite of six rooms, of which four dated from the time of Nicholas V, while the remaining two had just been added by Alexander himself, forming the first story of the Torre Borgia. With the exception of the largest, the Sala de' Pontefici, all had been recently decorated from the designs of Pintoricchio, though probably only three, the *camerae secretae*, or private apartments, by his own hand[4]. Experts differ as to the merits of Pintoricchio as a painter, but no one has questioned his genius for decoration, and Charles and such of his

[1] See G. S. Davies, *Renascence Tombs of Rome*, 1910, pp. 86 (with an illustration) and 246.

[2] The palace was well in progress in 1489—there is an inscription of that date over a window of the first story. It was completed in 1495, and inhabited by the Cardinal in 1496. The architect is unknown. (See D. Gnoli in *Archivio storico dell' arte*, Rome, 1892, pp. 176 ff.)

[3] "Il n'y a entre les deux logis qu'une petite gallerie, par où le roy va voir nostre dit Saint Père bien souvent." (Letter of Louis de Luxembourg, cited by La Pilorgerie, *op. cit.* p. 154.)

[4] A. Taja, *Descrizione del Vaticiano*, Rome, 1750, pp. 83 ff. ; P. F. Ehrle and H. Stevenson, *Les Fresques de Pintorricchio dans les salles Borgia du Vatican*, Rome, 1898 ; A. Schmarsow, *Pinturicchio in Rom*, Stuttgart, 1882, pp. 34 ff.

followers who were privileged to visit the papal apartments may well have been impressed by the glowing colours and decorative effect of these frescoes. Possibly too they were taken across the valley (as yet unspanned by Bramante's Loggie) to the Belvedere or garden-house of Innocent VIII (said to have been designed by Antonio Pollaiuolo) and were shewn the tiny chapel, about eight feet square, which Mantegna had recently (1488–1490) decorated with such minute elaboration that, according to Vasari, the work seemed like miniature-painting rather than fresco[1].

No Italian painter had a greater reputation or a greater following at this time than Mantegna. His passion for antiquity, to which he gave free play during the last 20 years of his life (1485–1506), appealed to the humanist sympathies of his patrons, while his close observation of nature, his scientific study of perspective, and his consummate skill as a draughtsman made a profound impression upon younger artists. Unfortunately the Chapel of the Belvedere[2] was destroyed by Pius VI to make room for the Museo Pio-Clementino, and all that we know of its decorations is derived from Vasari's account, and from the descriptions of it by Taja (1750) and Chattard (1767). Of the miniature-like character of the work we can judge from Mantegna's two pictures in the Uffizi, the *Madonna of the Quarries*, and the triptych. As for the scheme and method of the decoration, Herr Kristeller is doubtless right in his conjecture that they were similar to those employed by the artist in the little chapel of San Andrea at Mantua, which he endowed and decorated for his burial-place[3].

A little earlier in date than the frescoes of the Belvedere Chapel and the Borgia apartments are those of the Sistine

[1] See P. Kristeller, *A. Mantegna*, English edition by S. A. Strong, 1901, pp. 297 ff.

[2] It was on the site of the present Stanza de' Busti.

[3] The frescoes of this chapel, though not finished by Mantegna, were certainly designed by him. The spandrils of the vault are filled with figures of the four Evangelists, just as they were in the Chapel of the Belvedere. For reproductions of three of them see Kristeller, *op. cit.* pp. 146, 337, 413.

Chapel, to paint which Sixtus IV had bidden to Rome four of the leading painters of the day, three Florentines—Ghirlandaio, Botticelli and Cosimo Rosselli—and Perugino[1]. The last named, who executed four of the frescoes, was at the time of the French invasion the equal of Mantegna in reputation. Municipal corporations, ecclesiastical chapters, princes, and cardinals competed for his services, and he received many more commissions than he could execute. His merits and his defects are both of the kind to exercise a wide influence upon artists. His sense of space[2] (nowhere better shewn than in his only remaining Sistine fresco, Christ giving the keys to St Peter)[3], his feeling for composition, his refined drawing, his glowing colour, were all qualities from which intelligent disciples could learn much ; while, on the other hand, his stereotyped attitudes and expressions were bound to lead weaker men astray, and all the more because they were often embodied in such beautiful figures as his St Johns and his St Sebastians. Perugino returned to Rome in 1490, and painted several works for Cardinal Giuliano della Rovere (afterwards Julius II), but all have perished except the beautiful altar-piece in six compartments now in the Villa Albani.

No two artists were ever more dissimilar in their temperament and in their works than the Florentine painters, Domenico Ghirlandaio and Sandro Botticelli. Ghirlandaio keeps within the well-worn round of sacred subjects, but treats them chiefly as opportunities for the realistic representation of Florentine life. He is supremely interested in all that relates to the material and visible world, and he portrays it with unimaginative fidelity and unfaltering execution. He is never troubled by ideas or spiritual

[1] By a contract dated October 27, 1481, the four painters agreed to paint ten frescoes by March 15, 1482. Only Ghirlandaio's work—two frescoes—seems to have been finished by this date.

[2] I need hardly refer to Mr Berenson's admirable pages on space-composition in his *Central Italian Painters of the Renaissance*.

[3] His three other frescoes were destroyed to make room for Michelangelo's Last Judgment.

aspirations. He never rises above the common-place, but the dignity with which he invests ordinary persons and ordinary events redeems his work from triviality. On the other hand Botticelli's sensitive and emotional temperament easily responds to the stimulus of ideas and emotions. Humanism, politics, the poetry of Poliziano and Lorenzo de' Medici, the preaching of Savonarola, all in turn aroused his sympathies, and furnished subjects for his brush. His execution, both as regards colour and drawing, is uncertain, but it is always intensely individual. He is dominated, apparently under the influence of Antonio Pollaiuolo, by a passion for rhythmical curves, and the rendering of vivid movement. But while Pollaiuolo's art was almost scientific in its aim, that of Botticelli was the true expression of his spiritual imagination[1].

But in the frescoes of the Sistine Chapel, to which Botticelli contributed three (besides 28 figures of the Popes between the windows), and Ghirlandaio two (one of which has practically perished), both alike had to conform to the imperious will of their patron. Scenes from the lives of Moses and Jesus with plenty of figures, for the most part portraits of contemporaries, these were the conditions imposed upon all the artists of the Sistine Chapel.

In the Vatican Library, which was at that time on the ground-floor of the palace of Nicholas V, and therefore immediately under the Appartamento Borgia, the French visitors might have seen the most remarkable and interesting example of portraiture in Rome, namely the celebrated fresco by Melozzo da Forli which commemorates the opening of the library by Sixtus IV[2]. Painted in 1477, three years after Mantegna had finished the frescoes of the Camera degli Sposi at Mantua, which contain the groups of Ludovico Gonzaga and his family, it is one of the earliest examples

[1] There is an excellent appreciation of Ghirlandaio and Botticelli by Mr E. Armstrong in his *Lorenzo de' Medici*, 1896.

[2] See J. W. Clark, *The Vatican Library of Sixtus IV* in *Proceedings of the Cambridge Antiquarian Society*, x. 11 ff (1904). The fresco has been transferred to canvas and is now in the Vatican Gallery.

of a true portrait group, in which the artist not only gives a faithful rendering of each individual, but brings them into relationship with one another. Melozzo da Forli had died at Rome less than two months before the arrival of the French. His great master, Piero de' Franceschi, whom he survived by two years, was also represented in the same building, namely in the rooms immediately above the Appartamento Borgia; his frescoes were destroyed to make room for the work of Raffaelle[1].

On the 20th of January a special mass was celebrated by the Pope in St Peter's in honour of the French king. Externally the Basilica of Constantine, with its plain brick façade and plain round-arched windows, must have presented a mean appearance to the Frenchmen, accustomed to the glorious sculptures and rich tracery of their own cathedrals. But when once they entered the venerable building which for more than eleven centuries and a half had been the chief church of Christendom, they cannot fail to have been impressed. Covering an area more than half as large again as that of Amiens or Bourges, it was divided into five aisles, of which the central one, about twice the width of an ordinary Gothic nave, was separated from the others by two rows of twenty-three antique Corinthian columns. The walls above the columns were covered with paintings, the space between the entablature and the level of the windows being filled with scenes from the Old and New Testament, while between the windows were single figures of saints and angels. One of the angels was in mosaic, and was by the hand of Giotto, and according to Vasari several of the paintings were the work of the same great artist. In front of the sanctuary was a portico supported by two rows of six twisted white marble columns, which were said to have once adorned the temple at Jerusalem and to have been brought to Rome by Constantine the Great. The sanctuary itself was approached by two flights of seven porphyry steps. Over the high altar was a ciborium of white marble, which had been erected by Pope Paul II. The walls of the apse were covered with

[1] According to Vasari they were in the Stanza dell' Eliodoro.

marble below, and with frescoes and mosaics above. The principal mosaic represented Our Saviour with St Paul on his right hand, and St Peter on his left[1].

Of the numerous tombs of Popes and Cardinals which lined the walls of the aisles the most striking was the superb tomb of Sixtus IV which the Florentine painter and sculptor, Antonio Pollaiuolo, had completed about eighteen months previously. The bronze figure of the dead Pope is a wonderful piece of realistic portraiture. It is surrounded by bronze reliefs of the seven Virtues, while the concave sides of the tomb are adorned with ten other female figures, representing the Arts and Sciences. Among these Perspective is represented for the first time, a significant tribute to that scientific character of Florentine art which was so markedly represented in the artist. It is especially in these latter figures, which are in higher relief than the Virtues, with their restless variety of attribute and gesture, their crumpled and diaphanous draperies, that Pollaiuolo shews his unsurpassed knowledge of the human form, and the freedom and certainty of his execution. Yet as a whole the work is not altogether satisfying; the absence not only of all religious sentiment but of all emotion beyond the joy of execution leaves the spectator cold and unmoved[2].

Of the tombs of the immediately preceding Popes, Eugenius IV, Nicholas V, Callixtus III, Pius II, and Paul II, only those of the two last were remarkable as works of art. One cannot say with any certainty what the tomb of Pius II was like when it was in its original position and without

[1] For a description of old St Peter's see Bunsen and Plattner, *Beschreibung der Stadt Rom*, 1832, II. 113 ff. There are representations of it in Fouquet's *Grandes Chroniques* (Crowning of Charlemagne), Fra Angelico's St Laurence distributing alms, and Pintoricchio's Election of Pius II. The last shews the ciborium and the principal mosaic above it.

[2] In its present form the tomb has a flattened look; probably M. Reymond is right in his conjecture that originally it was raised on a slab of marble. It is now in the Chapel of the Sacrament. The tomb of Innocent VIII was not finished till 1498, the year of Pollaiuolo's death. See Maud Cruttwell, *Antonio Pollaiuolo*, 1907, pp. 189 ff; G. S. Davies, *op. cit.* pp. 157–161.

its present additions, but apparently it was of simple and dignified design, and chiefly noticeable for being in four horizontal tiers[1]. That of Paul II, by Mino da Fiesole and Giovanni Dalmata, so far as we can judge from an engraving in Ciaconius[2] and from the surviving fragments now in the crypt of St Peter's[3], was the most ambitious monument that had yet been attempted in Renaissance art. It included in its composition several statues and reliefs, of which the most important was a large relief of the Resurrection, immediately above the tomb, by Dalmata. We are not told whether any of these monuments were pointed out to Charles VIII and his suite, but we know that they were shewn the Sacred Lance, the head of the spear with which Our Saviour was pierced. It had been presented by the Sultan Bajazet to Innocent VIII, and its reception on May 31, 1493, was almost the last public act of that Pontiff.

III

On the 25th of January Charles VIII accompanied the Pope to San Paolo fuori Mura which was very similar to St Peter's in size and design. Three days later, January 28, he left Rome by the Latin way, and marching by Velletri and San Germano, "the first town of my kingdom of Naples[4]," whence he visited the celebrated monastery of Monte Cassino, reached Capua on February 14. After resting there for five days he set out again on the 19th, and on the 22nd made his entry into Naples. In spite of the ease with which his march had been conducted, and of the few obstacles which he had encountered, he had taken nearly six months to reach the goal of his expedition. At Naples he remained for nearly

[1] See Davies, pp. 125 ff. and p. 198 and C. M. Ady, *Pius II*, p. 340, for an illustration. The tomb is now in S. Andrea della Valle, and is evidently placed higher than was originally intended.

[2] *Vitae pontificum*, II. 1093, 4. See Davies, pp. 96, 97 ; Michel, *Hist. de l'art*, IV. 213.

[3] There are two fragments in the Louvre.

[4] Charles to Pierre de Beaujeu.

three months, spending most of his time in enjoyment. *Depuis qu'il entra à Naples jusques il en partit, ne pensa que à passer temps,* says Commynes, a hostile but not unfair critic of the expedition. But for the first month there was a certain amount of fighting to be done, and it was not till the 22nd of March that the last fortress, the Castel d' Uovo, surrendered. Naples seems to have made considerable impression upon Charles as a city of pleasure. Writing to Pierre de Beaujeu he describes it as *belle et gorgiase en toutes choses autant que ville peut estre*[1], and in another letter he dwells on the beauty of its gardens which he says " only want an Adam and an Eve to make a terrestrial Paradise." And he adds that he had found some excellent painters of ceilings, whom he intended to bring with him to Amboise[2].

He was lodged in the Castel Capuano close to the Capuan gate, designed in excellent taste by the Florentine architect, Giuliano da Maiano, who died at Naples in 1490. Between two and three miles distant from the gate was the same architect's masterpiece, the palace of Poggio Reale, which marked the final evolution of the palace from the fortress in Italy[3]. Nothing in Naples, or even in the whole of Italy, seems to have impressed and delighted the French more than this palace with its deer-park, fountains, statues, orchards, flower gardens, poultry and other domesticated birds. The Maréchal de Gié wrote an enthusiastic description of it to a friend[4], and even the doggerel verse of André de La Vigne calls up an enchanting vision of a " terrestrial Paradise."

Perhaps the most impressive monument at this time in Naples—at any rate to a casual observer—was the Triumphal Arch of Alfonso I, erected in memory of his entry into the city, after the expulsion of King René, in 1443. The architect, who was almost certainly Pietro di Martino, has produced a work which must have appealed strongly to his patron, and was doubtless largely inspired by

[1] *Lettres missives de Charles VIII*, IV. 177. [2] *op. cit.* IV. 187.
[3] It is now only known from the sketch by Serlio. See M. Reymond in Michel, *Hist. de l'Art*, III. (2), 498.
[4] La Pilorgerie, *op. cit.* p. 196.

him. For from the river-gods which crown its fourth
story to the *amorini* which sport on its base it is full of
reminiscences of antiquity. The attica of the first story is
supported by Corinthian columns, and that of the third by
Ionic ones, the second represents Alfonso borne in triumph
like a Roman *imperator*, while the fourth is treated like
a sarcophagus, with niches between Corinthian pilasters, in
which are statues of the Virtues. According to Vasari the
architect was Benedetto da Maiano, but this is impossible ;
he may however have executed some of the sculptures[1].
The details have great charm, but the whole is wanting in
unity, and would be improved by the omission of the top
story. One of its most remarkable features are the bronze
gates, which according to an inscription were cast by
Guglielmo da Monaco of Paris in 1462. Close to the arch,
and within the precincts of the palace, is the Church of Santa
Barbara with a beautiful portal by Giuliano da Maiano.

During his stay in Naples Charles, as his custom was,
heard Mass in numerous churches. On the first Sunday
in May he went to the Cathedral of San Gennaro, and saw
the head of the Saint in its massive silver case—*qui est
une moult riche chose à veoir, digne et saincte*—and wit-
nessed the liquefaction of his blood[2]. Other noteworthy
churches which he visited were San Giovanni a Carbonara,
with the rich but inartistic tombs of King Ladislaus and
Gian Caracciolo, both by the Neapolitan sculptor, Andrea
Ciccione, and the far superior altar-chapel of the Mirabolli
family with sculptures of about the same date as those of
the Triumphal Arch ; the great Carthusian convent of San
Martino (now a museum) ; and, most important of all for
its examples of Renaissance sculpture, the church of Mont-
oliveto. In the Mastro-Giudici Chapel is a work of Benedetto
da Maiano, the Annunciation with seven small reliefs below
it[3]. The chief panel lacks simplicity ; there is too much

[1] Vasari, ed. Milanesi, II. 484.

[2] So says André de La Vigne ; it now takes place on the first *Saturday*
in May.

[3] Reymond, III. 139.

display of perspective, and the attempt to render movement in the figure of the angel is not a success. Immediately opposite, in the Chapel of the Piccolomini, is the tomb of Mary of Arragon (d. 1470), the wife of Antonio Piccolomini, Duke of Amalfi, by Antonio Rossellino and Benedetto da Maiano. Except for the figure, it is a replica of the well-known monument to the Cardinal of Portugal in San Miniato[1]. In the same chapel there is a beautiful Nativity by Rossellino with a charming garland of oak-leaves and acorns beneath it. Both chapels are closely modelled on Brunelleschi's Sacristy of San Lorenzo.

But the work of art in the Church of Montoliveto to which we can with certainty point as having really made an impression upon Charles VIII is a group of life-size figures in terra-cotta coloured to resemble bronze, representing Nicodemus, St John, St Joseph of Arimathea, the Virgin Mary, Mary Magdalene, and the two other Maries kneeling round the Body of Our Lord. St John is a portrait of Alfonso II, while in St Joseph of Arimathea and Nicodemus are portrayed the two most distinguished humanists then living at Naples, Giovanni Pontano and Jacopo Sannazaro. The author of this crude but not unimpressive example of realistic portraiture was Guido Mazzoni, called Paganino, a native of Modena[2], who had come to Naples probably in 1491, and who had received the commission for the work from Alfonso II in 1494[3]. Charles VIII shewed his appreciation of it by knighting the artist on the day of his solemn entry into Naples (May 12, 1495), and by inviting him to France[4].

Giovanni Pontano, the St Joseph of Mazzoni's group,

[1] Vasari says that the Duke was so pleased with this tomb that he ordered the artist to make a similar one for his wife.

[2] There is a similar *mortorio* in painted terra-cotta in the Church of San Giovanni Decollato at Modena, which is generally regarded as Mazzoni's masterpiece. M. Vitry suggests that the portrait of Charles VIII in the Bargello at Florence is by him.

[3] Alfonso after his abdication intended to join the Olivetan order, but died before he could carry out his intention.

[4] *Arch. de l'art franç.* I. 126 ff.

who succeeded Il Panormita as the head of the Neapolitan
Academy, and who is perhaps better known by the Latinised
form of his name, Jovianus Pontanus, is a highly charac-
teristic figure of the Italian Renaissance, uniting domestic
tenderness with vagabond sensuality, and lofty sentiment
with vulgar self-seeking[1]. He was loaded with favours by
King Ferrante I, Alfonso's successor, and for ten years was
his chief minister. Yet he betrayed his grandson Ferrante II
to the French, and in the Latin speech which he delivered
at Charles's coronation heaped insult and outrage upon the
house of Aragon. But he was an admirable man of letters,
and had he written in Italian instead of Latin might have
held a high place in the history of Italian literature. As it
is, he is the best writer of Latin verse and prose of his century,
handling the language with extraordinary ease and versa-
tility, and uniting a lively faculty of observation with
considerable feeling and wit.

His fellow humanist, Sannazaro, his junior by more than
30 years, whom he had introduced to the Neapolitan Court
and Academy, also played a part in public affairs, but,
unlike Pontano, he remained faithful to the house of Aragon.
When his protector and friend, Federigo, who succeeded to
the throne of Naples on the death of his nephew Ferrante II
in 1496, was driven from his kingdom in 1501, he followed
him to France and remained with him till his death in
September, 1504. Then he returned to his own country,
and employed himself with correcting and editing Pontano's
works. Meanwhile he had completed his famous *Arcadia*,
which was published at Naples in a correct and complete
form in March, 1504. The first ten parts indeed were already
written in 1489 or 1490, and an incorrect and unauthorised
edition of the whole had appeared at Venice in 1502. Besides
these two leading representatives of Neapolitan letters there
were a crowd of minor writers of miscellaneous verse and
prose, chief among them being Il Cariteo, who was Secretary
to Ferrante II, and who founded a school of poetry of which
more will be said in the next chapter.

[1] See above, p. 38.

Charles left Naples on the 20th of May, and returning
by the same route reached Rome on the 1st of June. At
Siena, where he had spent only two nights on his march
southwards, he now remained for four days. As on the
former occasion, he was the guest of the Cardinal Archbishop,
Francesco Todeschini de' Piccolomini, nephew of Pius II[1],
who eight years later was to succeed Alexander VI as Pope,
and to die twenty-six days after his election. With regard to
the artistic impressions of the French visitors in Siena we are
left absolutely to conjecture. Doubtless they admired the
stately palaces, which recalled those of Florence, being built
for the most part from the designs of Florentine architects.
Thus the Palazzo Spannocchi (ascribed conjecturally to
the Sienese architect, Francesco di Georgio), except for
the absence of pilasters, bears a strong resemblance to the
Palazzo Rucellai, and the two Piccolomini palaces, the
delle Papesse, later Nerucci, and now the Banco d'Italia[2],
and the de' Papeschi, now the Palazzo del Governo[3],
were probably built from the designs of Bernardo Rossellino.
Opposite the last palace was the graceful Loggia del Papa,
which Pius II built as a meeting-place for the members
of his family. The whole city, indeed, is in a large measure
a monument to the honour and glory of the Piccolomini
family. We may picture to ourselves the Cardinal of Siena
pointing out with honourable pride to his royal guest the
various buildings with which his uncle and his other relations
had embellished the city.

When Charles visited the Duomo, he cannot fail to have
been struck by the famous marble pavement. Many of
the designs had been executed not very long before his visit,
namely the Seven Ages of Man (1475) by Antonio Federighi,
the architect of the Loggia del Papa, the Massacre of the
Innocents (1481), from the design of Matteo da Giovanni, the
chief Sienese painter of the fifteenth century, the ten Sybils

[1] He was the son of Laodamia Piccolomini, the wife of Nanni Todeschini.
[2] Built for Caterina Piccolomini, sister of Pius II, but never finished.
[3] Built for two of Pius II's nephews, brothers of Francesco de' Picco-
lomini.

(1482–1483), the story of Jephthah (1482–1484), the Expulsion of Herod (1484–1485) and Hermes Trismegistus (1488)[1].

After the pavement the most striking work of art in the Duomo was the pulpit by Niccolò Pisano and his pupils, begun in 1266, and marking that return to the study of nature which heralded the re-birth of Italian art. The Duomo too possessed two works in bronze by the great sculptor who contributed so effectually to that re-birth. Donatello's slab-tomb of Bishop Pecci, trampled on by the feet of two generations, cannot have been a conspicuous object, but in the Chapel of St John the austere emaciated form of the Baptist[2], clad in his camel's-hair tunic, might have seemed to Charles and his followers another Savonarola calling sinners to repentance[3]. Donatello also had a share in the execution of the bronze reliefs and figures on the celebrated Font of the Baptistery, designed by the great Sienese sculptor, Jacopo della Quercia[4].

Charles's next halt of any duration was at Pisa, where he stayed from June 20 to 23. He is said, though I know not on what authority, to have lodged in the Palazzo Medici (now Pieracchi) on the right bank of the Arno, one of the finest palaces in Pisa. A little lower down was the fifteenth-century palace of the Lanfranchi (now Palazzo Toscanelli)[5]. On his former visit, as we learn from André de La Vigne, Charles visited the Duomo and the Campo Santo. In the latter he would have seen the remarkable series of wall-paintings with which the facile and genial Benozzo Gozzoli had recently (1469–1485) decorated the whole north side of the cloisters. Nominally scenes from Old Testament history, they are really idyllic representations of Florentine

[1] With the exception of the last these form a continuous series along the aisles as far as the middle of the transepts. See R. H. Hobart Cust, *The Pavement Masters of Siena*, 1901.

[2] A late work, executed in 1457.

[3] The Duomo also contains the exquisite tomb, with a beautiful entablature supported by classical columns with arabesque decoration, of Tommaso Piccolomini, who died in 1483.

[4] See Reymond, II. 39.

[5] Byron lived here for a short time.

life, with rich architecture, lovely landscape, and numerous contemporary portraits. The artist was still living at the time of Charles's visit ; he died at Pistoia two years later, at the age of seventy-seven. With the rest of Charles VIII's return march we need not concern ourselves. It partook too much of the nature of a retreat to allow time for artistic impressions. The Apennines were crossed in the face of a formidable coalition commanded by Francesco Gonzaga, and at the bottom of the descent the French had to fight the battle of Fornovo (July 6), in order to secure their further retreat down the valley of the Taro. The situation continued to be difficult, nearly two months being spent in marching to and fro between Chieri and Turin. It was not till October 22 that Charles finally left Turin. On the 23rd he crossed the Alps and slept at Briançon ; on November 7 he made his triumphal entry into Lyons.

Much of the spoil which Charles had collected in what he was pleased to call " his kingdom of Naples " was lost at Fornovo in the plunder of the baggage, while the bronze gates of the Castel Nuovo, and the bronze statue of Alfonso I, which had been sent by sea from Naples, were captured by the Genoese. But the French king was not left altogether without visible mementos of his conquest. In December 1495 the royal treasurer paid for the transport by sea from Naples to Lyons and by land from Lyons to Amboise of manuscripts, tapestries, pictures, and marbles to the weight of about 87,000 pounds[1].

Such was the memorable expedition of Charles VIII to Italy. Ill-advised in conception, and feeble in execution, it was politically a failure. But its consequences to the intellectual and artistic culture of France were momentous. It did not indeed create the French Renaissance, for as we have seen, the germs of that movement already existed, and would doubtless have matured even without this quickening impulse from without. But it impregnated France with a strong Italian influence, which without stifling the national

[1] *Archives de l'art français*, I. 305.

genius sensibly altered its direction. The very lack of thoroughness with which the military operations were conducted increased the opportunities for intellectual and aesthetic impressions. It may be true that for the great majority of the nobles who accompanied Charles VIII these impressions were of a vague and general kind. But there were a few who had at any rate sufficient appreciation of Italian art to introduce it on their return into their own country. Such were Gilbert de Bourbon, Comte de Montpensier, the Captain-General of the army, who was married to Clara di Gonzaga, the daughter of Mantegna's patron[1]; Pierre de Rohan, Maréchal de Gié, the commander of the vanguard at Fornovo, who built the château of Le Verger ; Louis de La Trémoille, whose new hôtel at Paris was to shew the influence of his Italian impressions ; Raoul de Lannoy ; and Louis de Luxembourg, Comte de Ligny, who bid fair to be a liberal Maecenas, but who was cut off by an early death. Among the civilians were Guillaume Briçonnet, Bishop of Saint-Malo, Charles's most trusted adviser, and his brother Pierre ; Jean de Ganay, the Chancellor ; Florimond Robertet, secretary of the finances, and his fellow financier, Thomas Bohier ; all of whom were patrons of art or letters. Lastly there was Georges d'Amboise, who in the next reign was to be the most active agent for the diffusion of Renaissance art. Nor was Charles himself the ignoramus that Guicciardini represents him to be in his unfriendly portrait. So far from being " without any knowledge of liberal arts and scarcely acquainted with the characters of letters," he had in his unbalanced and ill-regulated fashion a considerable enthusiasm both for art and literature[2].

Such being the disposition of the king and not a few of his courtiers, it has seemed worth while to follow his movements with some care, and to point out the churches and palaces which he visited. For nearly all of these we have definite information, but in one or two cases we are

[1] He was appointed Viceroy of Naples, and died at Pozzuoli in 1496.

[2] Gaguin says, "Scriptos gallice libros libenter legit, tentavitque atine scire."

only told that he heard Mass in a certain city, and the actual church is a matter for conjecture. Of course it must not be supposed that the French visitors, like modern tourists with their Baedeker in hand, conscientiously inspected every work of art. As was said above, their impressions were doubtless for the most part of a very general character. Judging from the commissions which they gave on their return to their own country, it may be inferred that what made the greatest impression on them were the spacious palaces with their stately fronts, the beautiful sepulchral monuments, and the increasing fashion for portraiture. All these appealed strongly to that sentiment of individualism which was so vital a characteristic of the Renaissance.

As regards individual cities it must be borne in mind that only in one—Naples—was Charles's stay of any duration. Eleven days at Florence, six at Siena and twenty-five at Rome, of which only the last twelve were spent in sightseeing, did not allow much opportunity for admiring all the artistic treasures of these storehouses of Renaissance culture. As a matter of fact, the direct influence of Florentine art upon the French Renaissance is exceedingly small. Where we do find unmistakeable traces of such influence, it generally comes either through some other Italian city, or, even less directly, by way of Flanders. It was at Naples that Charles VIII gathered his plunder, and it was fron Naples that he recruited the majority of the Italian artists whom he invited to France.

CHAPTER IV

THE FRENCH OCCUPATION OF MILAN

CHARLES VIII spent barely fourteen months in Italy, and in no city except Naples did he remain for a whole month. The occupation of Milan by Louis XII lasted for twelve years and a half. If the impression made on the invaders by the first expedition had the force of novelty and variety, in the second they came under the prolonged influence of a single city—a city which was second only to Florence as a centre of art and culture.

Already as Duke of Orleans the new king had nursed the project of claiming the Duchy of Milan by virtue of his descent from Gian Galeazzo Visconti. He had no sooner ascended the throne than he proceeded to put his project into execution. After carefully paving the way by treaties and other diplomatic arrangements, all made with the object of isolating the Duke of Milan, and having obtained the active support of Venice, he was ready to take the field in the summer of 1499. On July 18 his commander-in-chief Gian Giacomo Trivulzio, the bitter enemy of Il Moro, crossed the frontier with the vanguard, and by the capture of Rocca d' Arazzo (August 3) and Annona (August 17), followed by a general massacre, struck terror into the hearts of his opponents. On September 2 Il Moro fled from his capital without striking a blow in its defence, and a fortnight later his favourite, Bernardino da Corte, to whom he had intrusted the command of the Castello, one of the strongest fortresses in Europe, with instructions to hold it for at least a month, sold himself and his troops to the French.

The triumphal entry of Louis XII into the city took place on October 6. We have interesting accounts of it from the official chronicler Jean d'Auton, who accompanied the expedition, and from Baldezar Castiglione, the author of *Il Cortegiano*, who as a youth of twenty rode in the procession in attendance on Francesco Gonzaga, Marquis of Mantua[1]. After a brief ceremony in San Eustorgio, the king made his entry at the Porta Ticinese, a noble memento of the days when the free city, risen from her ashes, defied the might of Frederick Barbarossa, and routed him in the field of Legnano. Close to the gate the procession passed the five Corinthian columns which stood in front of San Lorenzo, the only relic *in situ* of the Roman city. The church itself was the oldest in Milan, being contemporary with San Vitale at Ravenna (526–547), and possibly, as Signor Rivoira suggests, the work of the same architect[2]. Though it was twice seriously damaged by fire, first in 1071 and again in 1123, it preserved its original form of an octagon surmounted by a lofty dome down to the last quarter of the sixteenth century, when it was almost entirely rebuilt by order of Cardinal Borromeo. From San Lorenzo the procession made its way past San Georgio in Palazzo (built in the eighth century on the site of an Imperial Palace) along the Corsia della Palla and the Corsia della Lupa, streets now swept away and replaced by the modern Via Torino. Leaving to the right the Church of San Satiro with its *campanile*, the oldest in Milan, and, a little further off, but plainly visible, the beautiful *campanile* of San Gottardo, it reached the Duomo, the lantern of which was fast approaching completion. Here Louis entered to hear Mass, after which the procession started again for the Castello. It must have passed through what was once the heart of republican Milan, the Broletto

[1] Jean d'Auton, *Chronique de Louis XII*, ed. R. de Maulde La Clavière for the Soc. de l'hist. de France, 4 vols. 1889–1895, I. 92 ff. His narrative goes down to Easter, 1508. He also accompanied the king to Genoa and Milan in 1502, and to Genoa in 1507. See also J. Cartwright (Mrs Ady), *Baldassare Castiglione*, 2 vols. 1908, I. 18 ff.

[2] G. T. Rivoira, *Le origine dell' architectura lombarda*, 2nd ed. Milan, 1906, pp. 83–85.

Nuovo with its group of twelfth and thirteenth century buildings, all dedicated to the business of free government, of which the Palazzo della Ragione alone remains, solitary memorial of vanished glories.

Milan, when the French first saw it, must have been a singularly picturesque city. The brick churches with their *campanili* and their domes, the stately public buildings and private palaces with their noble portals and windows enriched with deep terra-cotta mouldings, the smaller houses with their wrought iron balconies, these must have presented a picture, varied in form and glowing in colour, which could not fail to have impressed the strangers, as they rode in triumph through the streets.

But their first enjoyment of their triumph was short-lived. In the following February (1500) Ludovico Sforza, having obtained assistance from the Emperor and the Swiss, recovered his Duchy, and the work of conquest had to be done over again. It was soon accomplished by Cardinal d'Amboise, whom Louis XII had appointed lieutenant-general beyond the Alps, with Louis de La Trémoille as commander-in-chief. Il Moro was deserted by his soldiers at Novara (April 1500), and the victory was rendered decisive by his own capture. He was sent to France, where he spent the remainder of his days in an underground dungeon at Loches, his only solace being to decorate his prison with paintings and inscriptions, which may be seen to this day[1].

In June the Cardinal returned home, leaving behind him as Governor of Milan his nephew Charles de Chaumont d'Amboise. In July 1502, Louis and his minister were again in Lombardy, and on August 26 the king made a triumphal entry into Genoa. On the 29th, the feast of the Beheading of St John the Baptist, he went to hear Mass in the Cathedral church of San Lorenzo. Here he was shewn the *Sacro Catino* or Holy Grail, said to be made of a single emerald, which the Genoese brought from Caesarea after the capture of that city in 1101, and which was believed

[1] He died in 1508.

to be the vessel used by Our Lord at the Last Supper[1].
The Cathedral possessed another priceless relic in a shrine
which contained the ashes of St John the Baptist, and which
was preserved in the recently rebuilt Chapel of the Saint
(1496). The chapel also contained a Madonna by Andrea
Sansovino, and six statues by Matteo Civitali, which he had
just completed before his death in 1501[2]. A native of
Lucca, where he lived till he came to Genoa about 1498,
and influenced to some extent by Jacopo della Quercia, he
belonged on the whole to the Florentine school, and was in
close relations with Antonio Rossellino[3]. Since the death
of Donatello (1468) very few large statues had been made
by that school, and Civitale's work at Genoa is of great
historical importance as heralding that of Michelangelo.
In these statues—Adam and Eve, Isaiah and Habakkuk,
Zacharias and Elizabeth—we see a real endeavour to
express character—the character rather of a situation than
of an individual. If the result is not altogether successful,
except in the noble group of Elizabeth and the Virgin, it
at least represents a high aim, and thus on the very eve of
the sixteenth century not unworthily inaugurates the heroic
period of Florentine sculpture[4]. The exterior of the
Cathedral with its alternate courses of black and white
marble was greatly admired by the chronicler Jean d'Auton.
He also dwells upon the famous mole with its marble
terrace, and he describes the city generally as "an earthly
paradise."

On August 18, 1503, the Pope, Alexander VI, died
unexpectedly, and no sooner had the news reached France
than Cardinal d'Amboise, warmly backed by his sovereign,

[1] Jean d'Auton, III. 70. In 1507 Louis XII was advised to carry
off the Sacro Catino for the Sainte Chapelle, but he refused. Napoleon
was less scrupulous, and it was taken to Paris in 1809. On its return
in 1815 it was broken, when it was found that the supposed emerald
was only glass.

[2] Jean d'Auton, III. 74.

[3] For his work at Lucca see above, p. 94.

[4] For illustrations of the Adam, the Habakkuk, the Zacharias, and the
Elizabeth see Reymond, La sculpture florentine, III. 122–125.

began his candidature for the Papacy. The election at first seemed a very open one, but on September 22, the Cardinal Archbishop of Siena, Francesco Piccolomini, whom we have met already as the host of Charles VIII, was elected. He was a man of high character, but it was the belief that he had a mortal disease that determined his rivals Amboise and Ascanio Sforza to support him. Their hopes were fulfilled, for he died on October 18. But the French Cardinal's chances had by this time evaporated, and on November 1, Cardinal della Rovere was elected Pope, and took the name of Julius II.

The personal ambition of Cardinal d'Amboise had cut across his Italian policy, and the candidate for the Papacy had hampered the action of the Minister of Louis XII. The French army, which instead of defending the kingdom of Naples had wasted three months in the neighbourhood of Rome, was defeated on the Garigliano, and had to fall back on Gaeta. Its surrender to the superior force of Gonsalvo de Cordova (January, 1504) ended the struggle. Naples was lost to France. In February 1507, Genoa revolted, but was recaptured in the following April, an exploit which called forth many poems from the Court poets, from André de La Vigne, Jean Le Maire, and Jean Marot in French, and from Fausto Andrelini, an Italian domiciled at Paris of whom we shall hear more hereafter, in Latin. On April 28 the victorious monarch made another triumphal entry into the city. From Genoa he marched into Lombardy; on May 18 he entered Pavia and on May 24, Milan. His entry into the capital was the occasion for a splendid triumphal display. From the Porta Ticinese to the Cathedral, and from the Cathedral to the Castello the streets were decorated with " hedges of verdure," above which floated red and yellow bunting. The fronts of the houses were hung with tapestry, and every window and doorway was filled with ladies in cloth of gold or crimson velvet. At the head of the procession marched three hundred of the celebrated armourers of Milan, followed by the Lombard cavalry. Then came the archers of the

French guard, and the mounted men-at-arms, French and
Lombard. These were followed by four hundred children,
in violet-blue (*perse*) doublets, covered with fleurs-de-lis.
They bore on their shoulders imitations of towers and towns,
of swords and armour, " in order to show by these emblems
the effect of the king's victory." After these came a grand
triumphal car, within which were seated the four cardinal
Virtues, and Mars, holding in his right hand a spear
and in his left a palm-branch. Behind the car marched
the physicians and doctors of the various faculties ; then
a hundred German guards. Then came the trumpeters,
blowing their trumpets unceasingly, followed by the
king, riding on a white horse and sheltered by a *baldac-
chino*, which was borne by six of the greatest nobles of
Milan. He was attended by Cardinal d'Amboise and four
other French cardinals, by his chief captains, Charles
d'Amboise, Gian Giacomo Trivulzio, Louis de La Trémoille
and others, and by many Italians who had either, like
Cardinal della Rovere, belonged to the French party from
the first, or had found it politic to range themselves on
the side of the conqueror. Among these latter were
Ercole d' Este, Duke of Ferrara, the father-in-law of the
fallen Duke, Francesco Gonzaga, Marquis of Mantua, the
husband of his sister-in-law, Isabella d' Este, Galeazzo di
San Severino, the husband of his daughter Bianca, and
Niccolò da Correggio his wife's cousin. They had all
feasted and revelled at his Court, and San Severino and
Niccolò da Correggio, had been among its most conspicuous
ornaments. Now they rode in the train of the French
King.

Louis XII remained in Milan till June 10. During his
stay he gave an entertainment in the Rocchetta, the inner
fortress of the Castello, where Beatrice d' Este had had her
apartments. He danced with her sister Isabella, who made
a great impression upon him, for he paid her three visits
of two or three hours each at her lodgings[1]. Of the many

[1] See a letter from Isabella to her sister-in-law Elisabetta Gonzaga,
the Duchess of Urbino. (J. Cartwright, *Isabella d' Este*, 1. 298.)

entertainments that were given in his honour the most
famous was the banquet given by Gian Giacomo Trivulzio,
at which more than six hundred persons were present,
including a hundred ladies, who sat together at separate
tables. A much larger number, including over twelve hundred
ladies, all richly dressed so that "they seemed to be queens
or princesses," attended the preliminary reception, and took
part in the dancing which preceded the banquet. For this
part of the entertainment a temporary building, 120 paces in
length, was erected in the Corso della Porta Romana in front
of Trivulzio's palace ; its decoration alone was said to have
cost over 50,000 ducats[1].

In the spring of 1509 Louis XII, in pursuance of the
treaty of Cambrai, again crossed the Alps and reached
Milan on May 1. On May 14 he gained a decisive victory
over the Venetians at Agnadello on the Adda, and on July 1
he returned to Milan, his entry, says the chronicler, being like
a Roman triumph. His stay at Milan lasted till August 25,
when he returned to France[2]. In the following February
Venice came to terms with the Pope, who, having humiliated
that republic with the help of the French, was now burning
to expel his ally from Italy. It was not, however, till
the autumn of 1511 that open hostilities broke out. The
French troops were commanded by Gaston de Foix, who,
on the death of Charles d'Amboise in the preceding February,
had succeeded him as governor of the duchy and city of
Milan. In April 1512 he gained a brilliant victory over the
Pope's Spanish allies at Ravenna, but the victory was
dearly purchased by his own death. It was the last French
success. In the following summer they evacuated Milan,

[1] J. d'Auton, IV. 307 ; *Le loyal serviteur*, ed. J. Roman, p. 136 ; Jean
Marot, *Voyage de Gênes* in *Œuvres*, 1723, pp. 28–32 ; Giovanni Andrea
Prato, *Storia di Milano*, 1499–1519, in *Archivio storico italiano*, III. (1842),
pp. 260–264 ; Ambrogio de Paullo, *Cronaca milanese*, 1476–1515, ed.
A. Cerruti in *Miscellanea di storia italiana*, XIII. Turin, 1871. The last-
named chronicler, who was major-domo of the ducal palace, tells us that
Louis XIII *abbrazo et baxo tutte le damixelle erano a la festa*, adding, *oh Dio,
come erano belle et bene ornate, come ai inteso.*

[2] See Prato, pp. 269 ff. for the events of 1509.

with the exception of the Castello. A year later (1513) they were routed by the Swiss at Novara, and, on November 19, they surrendered their last foothold in Italy.

For a hundred and fifty years and more the Court of Milan had been one of the most splendid in Europe, and the city had not only rivalled all European capitals in wealth and luxury, but had been an important centre of civilisation and culture. The marriage of Violante, daughter of Galeazzo Visconti, with Lionel, Duke of Clarence, son of Edward III, was celebrated in 1368 with extraordinary magnificence. Milan was at this time under the joint administration of Galeazzo and his brother Bernabò, but Galeazzo had set up a special Court of his own at Pavia, where he founded the University and the famous library, and built the splendid Castello, which, as has been said, Petrarch declared to be " the most stately of modern buildings." His son, Gian Galeazzo, whose active brain aspired to the union of all Italy under his rule, and who was as devout as he was ambitious and unscrupulous, founded the two great religious centres of his state, the Cathedral of Milan, and the Certosa of Pavia. In his youth an eager student at the University of Pavia, and a warm admirer of Petrarch, whom he had known as the honoured guest of his father, he cherished a deep regard for learning, and shortly before his death he secured for his University the services of Manuel Chrysoloras, the learned Greek who had first brought to Italy a scholar's knowledge of that literature which was to be the corner-stone of the Renaissance. He was an equally judicious patron of architecture and sculpture and painting, and it was he who initiated the splendid decorations of the Castello of Pavia.

The forty-eight years which elapsed between his premature death in 1402 and the proclamation of Francesco Sforza as Duke of Milan were years of anarchy, faction, and struggle. Gian Maria, Gian Galeazzo's elder son, was little better than a ferocious maniac. His younger brother and successor, Filippo Maria, who ruled from 1412 to 1447, was a man of considerable ability, but timid, secretive, and misanthropic.

Though he had little leisure for the arts of peace, being entirely occupied in maintaining his independence against the neighbouring states, he kept up the family traditions as a patron of art and learning. For thirty years the distinguished humanist, Pier Candido Decembrio, was his Latin secretary.

The great *condottiere*, Francesco Sforza, retained to the close of his life his simple and primitive tastes, but he had the respect for learning common to his age, and he was a great builder. His most notable works were the Castello of Milan, which had been destroyed by the fury of the Ambrosian Republic, and the Ospedale Maggiore. His son by Bianca Visconti, Galeazzo Maria, was more Visconti than Sforza, for he had the unrestrained passions and the unbalanced temperament of his mother's race. His passion for display and luxury became almost a mania, and the pomp of his visit to Lorenzo de' Medici (1471) made as great an impression on the beholders as the marriage festival of Violante Visconti a century earlier[1]. He carried on the work of decorating the Castello of Pavia, and he began the even more splendid decorations of the Castello of Milan, employing a whole army of painters. But his greatest passion was for music, and he procured singers for the ducal chapel in the Castello from all parts of Europe. A pupil of Filelfo, he had a genuine love of learning, and under his auspices a printing-press was established at Milan, which had the honour of issuing the first Greek book printed in Italy. It was the Greek Grammar of Manuel Chrysoloras.

The fame of the Milanese Court was carried to still greater heights by Il Moro. If he lacked the solid learning and polished culture of Guidobaldo of Urbino, and the fine taste of his father-in-law, the Duke of Ferrara, and his sister-in-law Isabella, Marchioness of Mantua, he brought to the work of glorifying his Duchy and his capital great energy, a quick intelligence, and abundant wealth. And he was

[1] See for a description of it Bernardino Corio (Milan, 1503), fo. cccxviii ; Ammirato, *Istorie Fiorentine*, pte sec. lib. xxiii. 3 vols., Florence, 1641, iii. 108.

not only a liberal patron, but he was a judicious one, for he recognised genius and gave it a free hand. Chief among the many distinguished strangers whom he attracted to his service were Leonardo and Bramante, but there were also to be found at his Court the architects Giacomo Andrea of Ferrara and Giuliano da San Gallo of Florence, the mathematician Fra Luca Pacioli of Borgo San Sepolcro, the learned Greek, Demetrius Chalcondyles, and the Tuscan poets, Bernardo Bellincioni and Antonio Cammelli. With the visit which the Emperor Maximilian paid to him and his Duchess at Vigevano in September 1496, his prosperity reached its climax, and it is with a fine eye for dramatic effect that the historian of Milan, Bernardino Corio, begins his last book, which closes with the Duke's downfall, with a graphic picture of the splendours of his Court. Two months after the Emperor's visit the first presage of evil came with the sudden death of Bianca Sforza, the Duke's natural daughter. Six weeks later (January 3, 1497), the Duchess herself died in childbirth. Her husband felt her death profoundly, for, in spite of his infidelities, he was really attached to her, and she had been his untiring and staunch companion alike in his political schemes and in his pleasures[1]. It was the beginning of the end. In a little more than two years came the final catastrophe, and in Leonardo's laconic phrase " the Duke lost state, possessions, and liberty, and left all his works unfinished."

Unfinished, in spite of all his efforts, were the great works which he had inherited from his predecessors, the Certosa, the Cathedral of Milan, and the Castello ; unfinished were his own foundations, the Cathedral of Pavia, and the monastery of San Ambrogio ; unfinished was his favourite Church of Santa Maria delle Grazie, where Beatrice d' Este lay buried. Unfinished too was Leonardo's own work, the great equestrian statue of Francesco Sforza, the completed model for which had been standing in the Piazza

[1] Cp. Guicciardini, " Che gli era assiduamente compagna non manco alle cose gravi, che alle dilettevoli." (*Istoria d' Italia*, lib. II.)

d' Armi of the Castello ever since the marriage of Bianca Maria with the Emperor Maximilian (1493).

Leonardo himself had gone to Venice with Luca Pacioli; Bramante had gone to Rome, where he was soon followed by his friend Caradosso; Ambrogio di Predis had accompanied the exiled Sforzas to Innsbruck. The splendour of the Court of Milan had vanished as a dream. The French conquerors seemed to the cultured Italians mere barbarians —*sporcha zente*, as the Venetian, Marin Sanuto, records in his diary after a conversation with one fresh from Milan[1]. Yet many of them were not incapable of appreciating the artistic treasures of Milan. Several of them, including Cardinal d'Amboise, Florimond Robertet, Louis de La Trémoille, and Louis de Luxembourg, Comte de Ligny, had been in Italy with Charles VIII. Ligny was the youngest son of the Comte de Saint Pol, who was beheaded in 1475 by order of Louis XI. He found favour with Charles VIII, who restored to him his patrimony. He was equally in favour with Louis XII, but he died on the last day of the year, 1503, and his secretary Jean Le Maire, who had only just entered his service, deplored his early death—he was barely 38—in an interesting poem, entitled *La plainte du desire*[2], from which we learn that he had a great reputation as a lover and patron of literature and art.

Of Cardinal d'Amboise and Florimond Robertet, the two chief Maecenases of their day, more will be said in the next chapter. The governor of Milan was, as we have seen, the Cardinal's nephew, Charles d'Amboise, while the office of Treasurer was held by Jean Grolier, the distinguished bibliophil. Above all Louis XII himself shewed from the first an eager interest in Milanese art and architecture. According to Paolo Giovio, he greatly admired Leonardo's Last Supper, and wanted to carry it off to France. At any rate he made great efforts to induce Leonardo to work for him. From a letter of April 14, 1501,

[1] *Diarii*, III. 31 (October 13, 1499).
[2] *Œuvres*, ed. Stecher, III. 157 ff.

we learn that the great painter was under an engagement to him, and that at the same time he was painting a picture for Florimond Robertet[1]. Since the captivity of Il Moro, Leonardo, save for an interval of about six months, during which he was chief engineer to Cesare Borgia, had been living at Florence, where he had made the cartoons for the Madonna with St Anne and the Battle of Anghiari, and had painted the portrait of Monna Lisa, the wife of Francesco del Giocondo. But he had been chiefly occupied with the study of geometry and with practical problems of hydraulics and mechanics, such as the canalisation of the Arno and his famous flying-machine[2]. In June 1506, having obtained three months' leave of absence from the Signoria, he returned to Milan, and lodged with the Governor in the Palazzo Carmagnola. His stay was prolonged until the arrival of the French king on May 24, 1507[3]. From that moment Louis wholly ignored the claims of the Signoria, and treated Leonardo as his own servant, styling him *peintre du roi* or *peintre et ingegneur ordinaire*. However, in July he gave him leave to go to Florence on private affairs, and he was absent from Milan till about Easter, 1508. Then he returned once more, and resided either in the city itself, or at Vaprio, in the villa of Girolamo de' Melzi, the father of his young friend Francesco, till September 24, 1513. He seems to have painted no pictures during this period, but to have confined himself to giving advice and perhaps also assistance to his disciples. On the other hand he carried on his scientific studies with ardour. One of his great designs was to make the Martesana navigable from Milan to the Lake of Como, but he could not persuade the French to carry this into effect. He had greater success with the *Naviglio grande*, which connects Milan with Lake Maggiore,

[1] See a letter to Isabella d' Este (J. Cartwright, *Isabella d' Este*, I. 321).

[2] Early in 1505 he paid a flying visit to Rome in order to present to Julius II certain proposals in connexion with the Pope's monetary reforms (E. Solmi in *Arch. stor. lomb.* XXXVIII. (1911), 390 ff.).

[3] See A. Desjardins, *Négociations de la France avec la Toscane* (Doc. inéd.) II. 210–214; Gaye, *Carteggio*, II. 94–96.

for by constructing a lock and a large reservoir he obviated all danger of inundation to the city[1].

Next to Leonardo the painter most in repute at the Court of Il Moro was Ambrogio de Predis, who appears in 1482 as official painter to the house of Sforza[2]. It was chiefly as a portrait-painter that he was celebrated. Among his finest extant portraits are those of the Emperor Maximilian at Vienna, of Francesco Brivio in the Poldo-Pezzoli Gallery at Milan, and of the young woman of the house of Sforza in the Ambrosiana[3]. But, as we have seen, Ambrogio de Predis had accompanied the Sforza exiles to the Court of Innsbruck, and there is no trace of his having been employed by any French patron[4].

It was otherwise with Andrea Solari, a member of the well-known family of architects and sculptors which had settled in Milan in the first half of the fifteenth century. He painted the portrait of Charles d'Amboise, and when Cardinal d'Amboise wanted a painter to execute the decorations of his château of Gaillon, his nephew sent him Solario as the best substitute for Leonardo. He was engaged on the work for two years, from 1507 to 1509. Though like most Milanese painters of this time he came under the spell of Leonardo, his work also shews Venetian influence, especially that of Alvise Vivarini and of Antonello da Messina. His fine portraits of Charles d'Amboise in the Louvre and of a Venetian senator in the National Gallery are, as Mr Berenson says, " more Venetian than Milanese," and the same may be said of his Crucifixion (1503) in the

[1] Solmi, *Leonardo*, pp. 180, 181.

[2] *Dipintore de lo Ill. Sforza*. This may mean that he was painter to Il Moro, or he may have succeeded Antonello da Messina, who died in 1479, as painter to the reigning Duke.

[3] Formerly called Beatrice d' Este and attributed to Leonardo. It has recently been conjectured with some probability to be Bianca Sforza, the natural daughter of Il Moro, whose death in 1496 was the first presage of his impending doom.

[4] See J. Lermolieff (Morelli), *Die Galerien Borghese und Doria-Pamphili in Rom*, Leipsic, 1890, pp. 230–242 ; B. Berenson, *North-Italian Painters of the Renaissance*, pp. 160, 161.

Louvre[1]. But he is an unequal painter, his work being often feeble in conception and inharmonious in colour[2].

As for Vincenzo Foppa, who for thirty years had been the leading painter in the Duchy of Milan, and whose influence made itself felt over the whole of North Italy, his star had paled before that of the great Florentine, and in 1490 he had returned to his native Brescia. But his best pupil, Ambrogio Fossano, known as Bergognone, continued to paint throughout the French occupation pictures of deep religious feeling which shew little or no traces of Leonardo's influence.

Gothic architecture never took real root in Italy, because its spirit was wholly alien to the Italian temperament. Its soaring character, its suggestion of awe and mystery, its symbolism, its humour, its love of diversity, all these qualities made no appeal to the Italian, who " thought of nothing but space, proportion, and order[3]." The only Italian building of importance that is at all Gothic in feeling is Milan Cathedral, the design for which is undoubtedly due to a northern mind. With this solitary exception the spirit of Gothic architecture was no better apprehended in the Lombard capital than elsewhere in Italy. But the Lombard architects, though they failed to grasp the true character of Gothic, developed in their treatment of it a genius for decorative detail, to which their materials, brick and terra-cotta, lent themselves with admirable effect[4].

[1] See Gaye, *Carteggio*, II. 94 ff. ; Lermolieff, *op. cit.* pp. 216–224. The *Vierge au coussin vert* (Louvre) was probably painted in 1507, either just before his departure for France, or just after his arrival at Gaillon. The Virgin and Child in the National Gallery, from the Salting collection, is reminiscent of Giovanni Bellini. An Annunciation, dated 1506 (the year after the Venetian Senator), belonging to Mr A. Kay, was exhibited by the Burlington Fine Arts Club in 1908. (See *Cat.* pp. lx–lxii. and pl. VIII.)

[2] He is at his worst in the Poldo-Pezzoli Gallery.

[3] B. Berenson, *Italian Art*, II. 64 (" The Dome in Renaissance Architecture ").

[4] For the architecture of the city and duchy of Milan see F. Malaguzzi Valeri, *Milano*, Bergamo, 1906 ; E. Noyes, *The Story of Milan*, 1908 ; A. G. Meyer, *Oberitalienische Frührenaissance*, 2 parts, Berlin, 1897–1900 ; T. U. Paravicini (a Milanese architect), *Die Renaissance-Architectur der Lombardei*, Dresden, 1877–1878 ; H. Strack, *Central- und Kuppelkirchen der Renaissance in Italien*, Berlin, 1882 (illustrations and plans only) ;

The most perfect and charming example of this style at Milan is the Campanile of San Gottardo, erected about 1330 by Azzo Visconti, who during his short rule did so much to embellish the city. The architect was a native of Cremona, which boasted of the loftiest tower (Il Torraccio) in Italy, but the immediate source of his inspiration was the great Cistercian church of Chiaravalle, three miles from Milan. He surpassed his model alike in beauty of design and in restraint of execution. The terra-cotta cornices of intersecting arches, the white marble columns in the fifth and seventh storeys, the conical roof covered with red tiles, combine to form a matchless harmony of line and colour. Moreover, though the windows and the greater part of the arcading have round and not pointed arches, the vertical character of Gothic architecture is secured by the long shafts at each angle which run up to the top of the fifth storey[1].

This national Lombard style, ever increasing in richness of decoration, reigned supreme at Milan until the close of the Visconti rule. It was Francesco Sforza who introduced the new style. In 1456 he commissioned Antonio Filarete, the sculptor of the bronze doors of St Peter's[2], to build the Ospedale Maggiore. The materials, brick and terra-cotta, are Lombard, but the style is Florentine. Filarete's work shews the stately simplicity and the restraint in the use of ornament characteristic of his great master, Brunelleschi[3]. But in 1465, when he had only completed the lower storey of what is now the southern wing of the building, together with the colonnades of the inner court, he was succeeded by the Lombard, Guiniforte Solari, who in the upper storey substituted the pointed arch for the round one,

L. Gruner, *The terra-cotta architecture of North Italy, from drawings and restorations by F. Lose* (illustrations in colour), 1867 ; L. Beltrami, *Guida storica del castello di Milano*, Milan, 1894, and *La Certosa di Pavia*, Milan, 1907.

[1] The first clock which struck the hours was placed in the tower.

[2] See above, p. 31.

[3] See W. von Oettinger, *Antonio Averlino genannt Filarete*, Leipsic, 1888, pp. 20–33.

and the luxuriant ornamentation of Lombardy for Florentine austerity. Thus we may see here in striking juxtaposition admirable examples of the two styles.

On the other hand we find them blended in two buildings of about the same date, the Medici Bank, and the Chapel of St Peter Martyr annexed to the Church of S. Eustorgio. In 1455 Francesco Sforza presented a palace in the Via de' Bossi to Cosmo de' Medici, who placed there as his representative Pigallo de' Portinari, and to mark his appreciation of the gift had the palace rebuilt and decorated on a magnificent scale. Filarete gives an elaborate description of it at the close of his *Trattato dell' architettura*, saying that, " it was more beautiful than anything in Milan[1]." The interior was decorated with frescoes by Foppa, among the subjects being episodes from the life of Trajan. But of all this magnificence nothing remains save the charming fresco in the Wallace Collection of a child reading Cicero, which formed part of the decoration of the parapet in the cortile, and the marble portal now in the Museum of the Castello[2].

Unfortunately Filarete does not tell us the name of the architect, and we have only Vasari's authority for naming Michelozzo. To the same architect has also been assigned, on the strength of some striking analogies with his known work, the beautiful Chapel of St Peter Martyr which Portinari erected on an area adjacent to the apse of S. Eustorgio[3]. But in the absence of documentary evidence all that can be said for certain is, either that the design is Florentine and the execution Lombard, or that the Florentine architect, whoever he was, was strongly influenced by his environment. For in its gaiety and exuberance, its harmonious colouring, and its wealth of decoration, to which Foppa's frescoes greatly contribute, this little building, Florentine

[1] Ed. W. von Oettinger in *Quellenschriften für Kunstgeschichte und Kunsttechnik*, Vienna, 1890, pp. 679–686.

[2] C. J. Ffoulkes and R. Maiocchi, *Vincenzo Foppa*, 1909, pp. 42–56 (with illustrations).

[3] It was begun in 1462 and was probably completed soon afterwards, at any rate before 1468, the year of Portinari's death.

in conception, and revealing in parts Florentine treatment, is thoroughly Lombard in sentiment[1].

It was under Galeazzo Maria Sforza, at latest in 1474 and possibly as early as 1472, that the great master of the new style, who was to develop it on more thoroughly classical lines, came to Milan and remained there for a quarter of a century. Born in 1444 in a village near Urbino, Donato Bramante[2] began his artistic career as a painter, and some frescoes of single heroic figures, which once decorated the *casa* Panagirola at Milan and are now in the Brera, testify to his affinity with Melozzo da Forli[3]. But from the first he must have been strongly attracted towards architecture, and of this art he had an admirable example to his hand in the palace of Urbino, the work of the great Dalmatian architect, Luciano Laurana[4]. This is a truly noble and dignified building, more classical in design and richer in decorative treatment than the Florentine palaces, in which critics recognise the beginning of the fully developed classical Renaissance. Noteworthy features are the charming *cortile* and the doorway of the *salone,* which is exquisitely

[1] Ffoulkes and Maiocchi, pp. 57–70 (with illustrations); L. Beltrami, *La Capella di San Pietro Martire* in *Arch. stor. dell' arte,* v. 267 ff. and *The Chapel of St Peter Martyr (Italian Wall Decorations of the 15th and 16th centuries,* Victoria and Albert Museum Art Handbooks), 1901 ; A. Melani in *Architectural Review,* v. 194 ff. ; VIII. 25 ff. There is a model in the Victoria and Albert Museum.

[2] See Baron H. von Geymüller, *Die ursprünglichen Entwurfe für Sanct Peter in Rom,* Vienna and Paris, 1875, pp. 18–63 (in German and French) ; H. Semper, *Donato Bramante,* in Dohme's *Kunst und Künstler,* 2nd part, vol. I. Leipsic, 1878 ; W. von Seidlitz in *Jahrbuch der Preussischen königlichen Sammlungen,* VIII. 183 ff. ; *I capi d' arte di Bramante nel Milanese,* dal Dott. C. C[asati], Milan, 1870.

[3] According to Vasari he was a pupil of Fra Carnevale of Urbino, but he may also have had lessons from Piero de' Franceschi, Fra Carnevale's master, who worked at Urbino from 1468 till about 1472. The connexion of Melozzo da Forli, six years Bramante's senior and also a pupil of Piero, with Urbino is doubtful. But even if he, and not Justus of Ghent, is the painter of the pictures representing the Liberal Arts (as Schmarzow holds), he did not come to Urbino till the autumn of 1473, when Bramante had almost certainly left it.

[4] He was appointed engineer and *capo-maestro* of the works in 1468, but he had been at work two or three years before this.

decorated and has pilasters adorned with arabesques[1]. There were other influences too at work. At no great distance from Urbino were the Roman triumphal arches of Ancona and Rimini, and in the latter city Bramante could study Alberti's application of a triumphal arch to a Christian church. There is evidence too from his work that he had travelled across the Apennines to Florence.

In spite of Bramante's long activity at Milan, there is only one complete building there that can be assigned to him with practical certainty, and that is the charming octagonal Sacristy—or Baptistery—of S. Satiro. It is admirable in construction and simple in design, but the design is carried out with a great wealth of decorative detail. The shell ornament over the semi-circular arches and the arabesques on the main pilasters are features which never found favour with the more austere Florentines, but they were among the first elements of Renaissance decoration to be introduced into France. So were the medallions framed in garlands, which flanked by groups of *putti* form the decoration of the frieze.

Bramante's exact share in the rebuilding of the Church of S. Maria delle Grazie (1492) has not been definitely determined, but all are agreed in assigning to him the beautiful portal, the lofty sacristy, and the charming cloister with its slender columns. Even more certainly by him is the unfinished cloister of the Canonica of S. Ambrogio, for which Ludovico gave him the order in 1492. It consists only of a single side, but this is remarkable for its graceful and noble proportions. The arches spring not from the columns themselves, but from an entablature block[2], as they do in Brunelleschi's Churches of San Lorenzo and San Spirito at Florence. The capitals, instead of being classical,

[1] See E. Calzini, *Urbino e suoi monumenti*, 2nd ed. Florence, 1899 ; J. Cartwright, *Baldassare Castiglione*, I. 55–66 ; Dennistoun, *Memoirs of the Dukes of Urbino*, ed. E. Hutton, I. 154 ff. ; Schmarzow, *Melozzo da Forli*, pp. 72–80.

[2] A similar arrangement may be seen in the entrance of Somerset House, though here the entablature is supported by a pair of columns.

are decorated with arabesques, each after a different pattern, while charming *putti* adorn the keystones of the arches.

Other colonnades assigned to Bramante by Geymüller are the court-yard of the Archiepiscopal Palace (1493–1497) and one side of the Rocchetta, that to the right on entering, while the two cloisters of S. Pietro in Gessate (1506–1511) and S. Antonio are evidently inspired by the Canonica of S. Ambrogio. Similar in character, though with the arches springing directly from the columns, are the court-yards of the Palazzo del Verme and the Casa dei Castani[1].

These graceful and airy colonnades evidently made an impression on the French nobles, as did the use of portrait-medallions in the spandrels between the arches, a favourite form of decoration in the Lombard architecture of this period[2]. These represented sometimes the Dukes of the house of Sforza, but more often Roman emperors. For Milan, like the rest of northern Italy, shared in the antiquarian enthusiasm which radiated from Padua, and which shewed itself also in the decorative use of inscriptions, mottoes, and devices.

Another conspicuous feature of Milanese architecture was the variety of domes that arose about this time. The *tiburio* or lantern of the Cathedral was completed on September 28, 1500. A mixture of Renaissance and Gothic, it closed a long controversy which had been marked by many discussions and many rejected designs, including those of Bramante and Leonardo da Vinci. But a more effective and attractive dome is that of S. Maria delle Grazie, which Geymüller attributes to Bramante. Noteworthy examples also are S. Maurizio (also known as the Monastero maggiore), and S. Maria *presso* S. Celso, both by Bramante's pupil Dolcebuono, who died in 1506, and S. Maria della Passione, the work of Cristoforo Solari. It

[1] To these may be added the now demolished colonnade of the Lazaretto outside the Porta Orientale, which was founded in 1489.

[2] We have seen the use of medallions in the Sacristy of San Satiro; they are also freely used on the exterior of S. Maria delle Grazie.

is characteristic of these Lombard domes that their shape is masqued externally by a polygonal or conical structure of masonry and columns. The dome had always been popular in Italy. Even a building like the Duomo at Florence, which was ostensibly Gothic, received its crown and glory in Brunelleschi's dome. It is not surprising then that the Renaissance ideal was a church with a dome, and that Leonardo da Vinci studied this form of architecture with his accustomed energy and thoroughness. While all these domes were being planned and executed at Milan, he was filling his note-books with designs of churches and other domed buildings of every conceivable plan. Among them is a group which is evidently inspired by the noble dome of S. Lorenzo[1].

In other towns too of the Duchy of Milan there were admirable new specimens of both civil and ecclesiastical architecture to attract the attention of the French occupants. Such were Bramante's façade at Abbiategrasso, his *loggia* at Vigevano, and S. Maria di Canepanova at Pavia, which he designed in 1472. Such, too, were S. Maria Incoronata at Lodi, begun by Giovanni Battaggio in 1488, and completed by Dolcebuono, and the Palazzo dei Tribunali at Piacenza, which was wholly the work of Battaggio.

But the most striking architectural work outside Milan was the Certosa near Pavia, in which Il Moro had taken a special interest. The foundation stone of Gian Galeazzo Visconti's monastery was laid on August 27, 1396, but after his death in 1402 the works were stopped until the days of Francesco Sforza. Then in 1453 Guiniforte Solari was appointed architect, and the original plan of the church having been modified under the influence of the classical revival, the work proceeded at first slowly and then more rapidly, till by about 1473 the whole church, with the exception of the façade, was nearly completed. To this period belong the beautiful terra-cotta decorations of the two cloisters. In 1473 the Prior determined to take in hand the

[1] See *The Literary Works of Leonardo da Vinci*, ed. J. P. Richter, II. 38–59.

façade, and Guiniforte Solari's design being thought too simple, he entrusted the work to Cristoforo and Antonio Mantegazza, and in the following year associated with them Giovanni Antonio Amadeo. The latter had already done some admirable work for the monastery, especially on the richly decorated doorway leading from the church to the small cloisters, and his reputation at this time stood very high. But partly owing to his numerous engagements little progress was made, and it was not till 1491, after various designs had been considered and rejected, that the façade was really begun in earnest.

It is supposed that the design finally adopted was the joint work of Dolcebuono and the painter Bergognone, but the design was little more than a framework for the display of the sculptor's art. Upon this part of the work a whole army of sculptors were employed, with Amadeo at their head. When the church was consecrated on May 3, 1497, rather more than a century after the laying of the foundation stone, the façade had been completed as far as the triforium[1]. In 1498 Amadeo, probably owing to the pressure of engagements—for he was architect to the Cathedrals of both Milan and Pavia—resigned his post and was succeeded by Benedetto Briosco, who in 1501 undertook to make the central portal. He had already been working on the façade, and he had collaborated with Cristoforo Romano, a son of Isaia da Pisa, in the execution of Gian Galeazzo's magnificent tomb, which was completed just before the ceremony of consecration. Thirteen years later (1510) the body of Isabelle de Valois, Gian Galeazzo's first wife, was transported with great pomp from the Church of San Francesco at Pavia to the Certosa. Meanwhile Briosco with his numerous assistants had been engaged on the central doorway. But the work was stopped in 1507, and was not resumed till after the treaty of Bologna,

[1] The state of the façade at the time of the consecration is shown in a bas-relief on one side of the central doorway, in a picture by Bergognone of Christ bearing his cross followed by Carthusian monks, now in the Museo Civico of Pavia, and in a picture by the same artist in the National Gallery.

which established the Spanish dominion in Lombardy (1530).

Exquisite in its details, the façade as a whole lacks dignity and repose and that impression of unity which comes from a nobly imagined plan. To enjoy the full beauty of the great Carthusian church you must see it from the cloisters. Here the red roofs and white marble columns, rising tier above tier and glowing with the rich tints of the terra-cotta mouldings, offer an enchanting vision, which disarms criticism.

As one might expect in this transitional period, and in the hands of men like Amadeo, who were first sculptors and then architects, the new style, apart from the façade, shews itself chiefly, if not entirely, in the decorative parts of the work—in the tomb of Gian Galeazzo Visconti by Cristoforo Romano, in the choir-stalls by Bartolommeo de' Polli, in the doorway leading from the small cloister to the refectory, and above all in the richly ornamented doorway of the old sacristy by Amadeo and Alberto da Carrara[1].

Ever since Amadeo as a young man of three and twenty had been commissioned in 1470 by the celebrated *condottiere*, Bartolommeo Colleone, to make the tomb for his daughter Medea, he had been inundated with more orders than even his prolific genius could find time to execute. If he was a sculptor before he was an architect, he was first and foremost a decorator, and it is in his charming reliefs and medallions far more than in single figures that he excels. Such indeed was the character of the whole school. But two figures by a Milanese sculptor deserve special mention. They are those of Ludovico Sforza and his wife, which Cristoforo Solari, called Il Gobbo, executed in 1497, the year of Beatrice's death, and which were destined to form part of a great sepulchral monument in S. Maria delle Grazie. But during the troubles of the French occupation the monument was broken up, and in 1564 the two figures were

[1] This doorway (1475–1490) has evidently inspired the magnificent south doorway (Porta della Rana) of the Cathedral of Como (1491).

transported to the Certosa. Here in their calm and dignified simplicity they form a worthy memorial of those sincere lovers and generous patrons of every art[1].

Il Moro's confidential agent for the purchase of works of art was Cristoforo Foppa, known as Caradosso. A many-sided artist like so many of his contemporaries, he was chiefly famous as a worker in gold and other metals[2]. Cellini praises him enthusiastically. His medals of Francesco Sforza, Il Moro, Julius II, and Bramante shew the minute and highly finished execution of a goldsmith. He was also noted as an engraver of gems and coins, though his share in the beautiful productions of the Milanese mint cannot be determined[3]. It is more important for our purpose to notice that this mint took the initiative in the revival of the monetary art, and that, save for some coins struck in Sicily, the first modern coins with portraits are those of Francesco Sforza (1463). The art continued to flourish under his successors and the pieces which bear the heads of Gian Galeazzo on the obverse and Il Moro on the reverse are justly celebrated[4]. From Milan this new form of portraiture spread to other cities, and Louis XII, when he was still Duke of Orleans, had struck at Asti gold ducats and silver testons bearing his head on the obverse[5]. After 1500 ducats and testons were also struck at Milan with his portrait[6].

[1] The beautiful recumbent statue of Gaston de Foix by Agostino Busti, called Il Bambaia, perhaps the *chef-d'œuvre* of Lombard art (now in the Museum of the Castello), was not ordered by Francis I till 1515.

[2] See A. Venturi, *Storia dell' arte italiana*, VI. 128 ff.

[3] The crudely realistic Deposition from the Cross in coloured and gilded terra-cotta in one of the chapels in S. Satiro, and the frieze in the baptistery of the same church are no longer supposed to be by his hand (see F. Malaguzzi Valeri, *Milano*, pp. 134–136).

[4] F. and E. Gnecchi, *Le monete di Milano*, Milan, 1884, plates XV. 7 and XVI. 1.

[5] D. Promis, *Monete della zecca d' Asti*, Turin, 1853, pl. IV. 4–6. In 1498 a bronze medal was struck with the head of Louis XII on one side and that of Il Moro on the other (*Misc. di stor. ital.* XIII. 709, pl. II).

[6] H. Hoffmann, *Les monnaies royales de France*, 1878, plates XLVIII and XLIX.

Il Moro was far less successful as a patron of literature than as a patron of art. Bernardo Bellincioni, whom he invited to his Court from Florence, was a sycophant and a buffoon, and none of his numerous sonnets, the best of which are satirical and burlesque in charater, rise above mediocrity. His fellow-countryman, Antonio Cammelli, whose family, like Leonardo's, came from Vinci in the territory of Pistoia, and who was nicknamed from his birthplace Il Pistoia, was attached to the Court of Ferrara in much the same capacity as Bellincioni to the Court of Milan, and after the union between the houses of Este and Sforza was frequently employed on missions between the two capitals. He was an even more prolific sonnet-writer than his rival and enemy, Bellincioni, and he devoted himself more exclusively to the satirical and burlesque type, in which he shews himself akin to Burchiello, and a forerunner of Berni. Many of his sonnets are political, the best known of all being the fine one beginning,

Passò il re Franco, Italia, a tuo dispetto,

in which he bitterly reproaches his countrymen for having allowed Charles VIII to leave Italy unscathed.

The making of sonnets and other occasional verse was a favourite pastime at the court of Il Moro. Among the exponents of the art were Niccolò da Correggio, in whose service Il Pistoia had spent four years, Antonio Fregoso, a Genoese noble, and Gaspare Visconti, the friend and patron of Bramante[1]. But for our purpose the most interesting poet connected with the Court of Milan was Serafino Ciminelli of Aquila, who first came there with Ascanio Sforza in 1490, and remained till 1493. He returned with Francesco Gonzaga, Marquis of Mantua, in 1495, and was present at the investiture of Il Moro on May 26. In September of the same year he accompanied the Duke and Beatrice to the camp of the league before Novara, and it was during the negotiations with Charles VIII that he charmed the French king and his courtiers with a specimen of his improvising powers. After the death of Beatrice he

[1] See R. Renier in *Arch. stor. lomb.* XIII. (1886) pp. 509 ff., 777 ff.

left Milan for Mantua, and died soon afterwards in 1500 at the age of thirty-four.

In his youth he had been a close student of Petrarch[1], but at Milan he came under the influence of Il Cariteo, a native of Barcelona, who lived at Naples as secretary to Ferdinand II of Aragon. It was from Il Cariteo that he learnt to write *strambotti*, for which he was especially famous, and which he turned from a popular into a Court love-poem[2]. It was mainly, too, from Il Cariteo that he learnt to stuff his poems with conceits and to employ other tricks for producing unexpected effects. He had another master in Antonio Tebaldeo of Ferrara, tutor to Isabella d' Este, who carried exaggeration and the abuse of rhetorical figures to an even greater pitch than Il Cariteo ; and he had an admiring imitator in Pamfilo Sassi, a much older man, who was living at this time at his native Modena.

All these poets, it will be seen, were connected with one or more of the closely-allied Courts of Naples, Milan, Ferrara, and Mantua. Thus there arose a poetical school, which strayed from the Petrarchian fold into a jungle of rhetorical artifice and bad taste. Its interest for us is that it was much admired by some of the French sixteenth-century poets, notably by Maurice Scève, Mellin de Saint-Gelais, and Desportes[3].

[1] Il Cariteo or Chariteo (son of the Graces) was the name which he assumed in the Academy of Naples.

[2] The *strambotto* consisted of eight lines on two rhymes.

[3] See A. d' Ancona, *Studi nella letteratura italiana de' primi secoli*, Ancona, 1884, pp. 151 ff. (*Del seicentismo nella poesia cortegiana del secolo XV*): A. Luzio and R. Renier, *Mantova and Urbino*, Turin and Rome, 1893, pp. 89 ff. (*Serafino dall' Aquila*) ; J. Vianey, *L'influence italienne chez les précurseurs de la Pléiade* in *Bull. ital.* II. (1903), 85–117, and *Le Pétrarchisme en France du xvi^e siècle*, Montpellier, 1909.

CHAPTER V

THE FRANCE OF CHARLES VIII AND LOUIS XII

" CENTRALISATION was in process of accomplishment, the feeling for unity was developing; but France was neither completely centralised, nor completely unified. The different countries which composed it preserved their own usages, institutions, privileges, and mental habits. This accounts alike for the facilities and for the hindrances which the diffusion of the Renaissance...encountered[1]." It would be impossible to better this statement of M. Lemonnier's as to the condition of France during our period from the point of view of its effect on the Renaissance. The France which acknowledged the suzerainty, if not the actual sovereignty, of the French king at the opening of the sixteenth century, except that it lacked Lorraine, Franche-Comté, Bresse, and Savoy, was very much the same as the France of to-day. But it embraced a considerable number of fiefs which still possessed various degrees of independence. The majority of these were held by princes of the blood, of whom by far the most powerful from the point of view of territorial possessions was the Duke of Bourbon. His possessions became greater still when Suzanne, the heiress of Pierre and Anne de Beaujeu, married in 1505 her cousin Charles de Bourbon, who as the head of the branch of Bourbon-Montpensier had for his appanage the County of Montpensier and the Dauphiné of Auvergne. Thus almost

[1] *Histoire de France*, ed. Lavisse, v. pt. i. 136.

the whole of that district which is known as the central plateau of France passed into the hands of a single individual. The territory of the house of Orleans was very small in comparison with this ample domain, and when its Duke became king in the person of Louis XII the greater part of it passed to the crown. If the fiefs of Bourbon and Orleans retained some measure of independent government, Brittany, at any rate as regards the management of its internal affairs, was still practically an independent kingdom. Neither Charles VIII or Louis XII ventured to unite it formally to the crown, for not only were the Bretons extremely jealous of their privileges, but they were backed up by Anne of Brittany, who was a Breton of the Bretons. Of the non-royal houses the most powerful was that of Albret, whose chief, Alain the Great, having married his son to Catherine, heiress of Navarre, Foix, and Béarn, controlled a considerable territory in the neighbourhood of the Pyrenees.

The existence of these semi-independent states had, as M. Lemonnier says, at once a retarding and an accelerating effect on the Renaissance. On the one hand their patriotic attachment to their local privileges and institutions tended to foster a conservative spirit, and to check the diffusion of new ideas and new forms of art ; on the other, the Courts of their princes formed centres of culture and patronage for artists and men of letters. Of these Courts the most brilliant at the opening of our period was that of Moulins, where Pierre and Anne de Beaujeu fully maintained the love of art and letters traditional in their house[1]. Pierre succeeded his brother Jean II in 1488, and about the same time he and Anne de Beaujeu began to play a less important part in the government of the kingdom ; thus they were able to devote themselves to the affairs of their own Duchy[2]. Among the arts which profited by their patronage those of painting and

[1] See above, p. 67; also P. Champion, *François Villon*, 2 vols. 1913, II. 99, for a view of Moulins in the fifteenth century.

[2] Their influence ceased altogether after 1491. See P. Pélicier, *Essai sur le gouvernement de la Dame de Beaujeu*, Chartres, 1882, pp. 202–206.

stained glass were conspicuous. It is from Moulins that the chief French painter of our period, pending the discovery of his identity, provisionally takes his name. The great triptych that now hangs in the sacristy of the Cathedral is the one picture of the period which bears the unquestionable impress of the Renaissance spirit. In the windows too with which the Bourbon family enriched the Cathedral, and in others at Ambierlé in Le Forez and at Beaujeu, the little capital of the Beaujolais, we see the early stages of a new development in the art of stained glass, when it was beginning to abandon its old association with architecture and sculpture, and to enter into closer relations with painting.

At Moulins too there was a considerable library. Several of the Dukes had been collectors, and they had been fortunate in their wives. Marie, the daughter of Jean, Duc de Berry, had brought to her husband, Jean I de Bourbon, forty-one manuscripts from her father's priceless collection and their son, Jean II, had married as his second wife Catherine, second daughter of Jacques d'Armagnac, Duc de Nemours, and the inheritor of his admirable library[1]. Pierre de Beaujeu not only collected books but he patronised men of letters. Jean Lemaire de Belges held a post in his service, and on his death in 1503 composed in his honour the poem entitled *Le Temple d'honneur et de vertus*.

Auvergne, the appanage of the Montpensier branch of the Bourbons, had for joint capitals Clermont and Riom, situated at either extremity of the fertile plain of the

[1] The famous Josephus with Fouquet's miniatures seems to have passed directly into the hands of Pierre de Beaujeu after the Duc de Nemours's death. (See L. Delisle in *Journal des Savants*, 1903, pp. 265 ff.). The Moulins library was confiscated in 1523 by Francis I with the rest of the Constable de Bourbon's possessions. Sixty of Jacques d'Armagnac's MSS. are in the *Bibliothèque Nationale* (L. Delisle, *Cabinet des Manuscrits*, I. 165 ff.). The greater part of the château of Moulins, which was built by Louis I and largely added to by Louis II, was destroyed by fire in 1755. All that now remains are the underground portions (Louis I), the tower (Louis II) and the pavilion (now a museum) added by Anne de Beaujeu, but considerably more was standing in 1833. (See A. Allier, *L'ancien Bourbonnais*, Moulins, text, 1833, plates, 1837.)

Limagne. Judging by the examples that still remain, both must have had a fairly vigorous artistic life at the dawn of the Renaissance. Aigueperse, too, ten miles north of Riom, the capital of the county of Montpensier, could boast of a small library, while pictures by Mantegna and Benedetto Ghirlandaio in its church of Notre-Dame testify to an interest in Italian art on the part of some prince of the house of Bourbon-Montpensier[1].

Of the two chief towns of Brittany, Rennes ranked as the capital, but ever since the days of Jean V, who succeeded to the Duchy as a boy in 1399, Nantes had been the habitual residence of the Dukes. The château was rebuilt by the last Duke, François II, who was a liberal patron of art and letters[2], and three years after his death the nave of the Cathedral was completed (1491). Its greatest ornament is the beautiful monument by Michel Colombe which the Duke's daughter, Anne of Brittany, erected to her father and mother.

Finally, in considering the influence of these Courts on the development of the Renaissance in France we must not forget two foreign but French-speaking Courts on the borders of France, which shewed a good deal of patronage to French artists and men of letters. These were the Court of the Dukes of Lorraine at Nancy, and that of Margaret of Austria at Malines. At Nancy both René II[3] (grandson of King René) and his son, Antoine, were liberal patrons, the former chiefly of art, his successor of both art and letters. René II was a collector of illuminated manuscripts, and we know the names of three illuminators who worked at his Court[4]. The ducal palace was begun by him in 1502 and completed by his son in 1512. It is in the Flamboyant style of Gothic, but the entrance-portal is an

[1] The picture by Mantegna is now in the Louvre.

[2] Considerable remains of the château still exist, but its chapel, in which Anne of Brittany was married to Louis XII, was destroyed in 1800 by the explosion of a powder-magazine.

[3] He succeeded to the Duchy in 1473 and died in 1508.

[4] *Histoire de l'Art*, III. ii. 747; and see *Cat. Didot*, 1879, p. 58, for a *Horae* executed soon after 1476.

interesting example of transitional work. Among the men of letters who enjoyed the patronage of Duke Antoine were Pierre Gringore, the playwright, and one who was much more in sympathy than Gringore with the Renaissance, Symphorien Champier of Lyons.

Margaret of Austria during the seventeen years of peace which she gave to the Netherlands encouraged every form of art and letters, and made her Court at Malines one of the most brilliant of her day. Though she hated the French as a nation, she patronised French artists. She employed Jean Perréal to design her famous church at Brou, and Michel Colombe to execute the model for her husband's tomb. Herself a poetess, whose verse has at least the merits of simplicity and sincerity, she attracted men of letters as well as artists to her Court. Jean Lemaire de Belges, who, if not a Frenchman, had an important influence on French literature, was in her service for eight years from 1504 to 1512[1].

Finally we come to the chief source of patronage for French artists and men of letters, the Court of the King of France. Unlike the lesser French Courts it was not located in a single town, but moved from place to place with the king. Thus it distributed the fertilising waters of its patronage over a wide area, but more especially over the district comprised between Paris, Tours, and Lyons. For the Italian policy of Charles VIII and Louis XII entailed much coming and going between the capital, Lyons, and their châteaux on the Loire.

Charles VIII had many residences, but it was his birth-place, Amboise, that he selected for enlargement and embellishment. Already before the expedition to Italy he had begun to make additions to it, and on his return he at once employed upon the work the Italian artists and workmen whom he had brought with him from Italy. After his death it was assigned to Louise of Savoy, who lived there with her children, Margaret and Francis,

[1] See F. Thibaut, *Marguerite d'Autriche et Jean Lemaire de Belges*, 1888.

educating them on more or less humanistic lines[1]. Francis, indeed, preferred athletic exercises to books, and learnt next to no Latin, but his first tutor, a priest of Poitou named François De Moulins,translated for him the *Cyropaedia* of Xenophon and for a brief space (1508) he had as professor Christophe de Longueil, who, though he was now only twenty, had already given promise of his future distinction as a humanist[2].

Louis XII made his ancestral château of Blois his favourite place of residence, and soon after his accession began to add to the existing building. In 1508 the jurist Ludovico Beloguini, ambassador from Bologna to the French Court, celebrated in a Latin poem the château and library of Blois as two of the most remarkable features of the kingdom[3]. The library had risen to fame during the ten years which had elapsed since the accession of Louis XII. The collection left by Charles VIII was only a small one. It comprised a few Greek and Latin manuscripts, which he had brought from Italy, and the library which Anne of Brittany had inherited from her father[4]. It was moved by Louis XII to Blois to join the books of his father, Charles d'Orléans, amounting to some 200 volumes[5]. His first great acquisition was made in 1500. It consisted of the

[1] Margaret was born in April, 1492, Francis in September, 1494. They resided at Amboise from 1499 to 1509.

[2] R. de Maulde La Clavière, *Louise de Savoie et François I^er* (1485–1515), 1895, pp. 237–240. C. Longolii Parisiensis, *Oratio De laudibus Ludovici...habita Pyctavii*, 1510 (dedicated to François d'Angoulême, September 5, 1510).

[3] *De quatuor singularibus in Gallia repertis* (the other two were the town of Lyons and the general prosperity of France), printed in Symphorien Champier's *De triplici disciplina*, Lyons, 1508.

[4] There seems to be no truth in the story that 1140 volumes were brought from Naples and presented to Anne of Brittany by Charles VIII. Delisle has shewn that a considerable portion of the royal library at Naples was taken to France by Federigo III, who sold 140 volumes to Cardinal d'Amboise—these came later to the royal library—while after his death at Tours in 1504 his widow sold a considerable number to Louis XII. (Delisle, *Cabinet des Manuscrits de la Bibl. Imp.* I. 97, 217 ff.)

[5] P. Champion, *La librairie de Charles d'Orléans*, 1910.

noble Visconti-Sforza library in the Castle of Pavia, which
in 1469 contained over a thousand manuscripts, including
twenty-three that had belonged to Petrarch[1]. The next
important addition was the small but precious collection
of Louis de Bruges (d. 1492) consisting of about 150
illuminated manuscripts, all exquisite specimens of Flemish
art[2]. It is not known how Louis XII became possessed
of it. To these collections were added the manuscripts
that were bought by Louis himself or by Anne of Brittany,
and those that were copied for them. Among the former
were about forty which Lascaris brought to France in 1508.
Presumably these were all or nearly all Greek manu-
scripts. But, apart from these, the library does not seem
to have been strong on the classical side. In the hundred
or so volumes which now represent the Sforza-Visconti
collection in the *Bibliothèque Nationale* Latin classical
literature is only moderately well represented, and Greek
not at all. Virgil, Horace, and Ovid are all absent[3]. In
the library of Charles d'Orléans there were three copies
of Virgil, and three of Terence, and single copies of Horace,
Juvenal, and some of the works of Cicero, and Seneca, but
few other classical writers were represented, except in
translations[4].

Anne of Brittany probably had a more genuine en-
thusiasm for art and letters than either of her husbands.

[1] Francesco Sforza added largely to the library, and the catalogue
of 1459 enumerates 880 MSS. Galeazzo Maria added 126 in 1469. Many
of the volumes now in the *Bib. Nat.* are inscribed, *De Pavye, du roi Loys XII*[e].
See L. Delisle, *op. cit.* pp. 125 ff. ; *Indagine storiche sulla libreria Viscontea-
Sforzesca del Castello di Pavia* [by Marchese Girolamo d'Adda], Milan,
1875. For Petrarch's books see P. Nolhac, *Pétrarque et l'Humanisme*,
I. 103.

[2] [J. van Praet], *Recherches sur Louis de Bruges*, 1831. There is
an excellent portrait of him in a MS. of a Latin translation of Ptolemy,
dated 1485 (*Bib. Nat. fonds lat.* 4804, fo. iv). It is reproduced by C. Coudere
in his *Album de Portraits*, No. CVI.

[3] Delisle, *ibid.* pp. 126, 127.

[4] P. Champion, *op. cit.* p. xlvii. When Francis I moved the Blois
library to Fontainebleau it consisted of 1891 volumes, of which the printed
books numbered only 109.

At any rate she seems fully to have realised how much dignity and charm they impart to life, and as during both reigns she retained her separate establishment, she not only stimulated her royal consorts to munificence but she dispensed a great deal of patronage on her own account. The Breton *rhétoriqueur* poet, Jean Meschinot, who died in 1491, and whose allegorical poem, *Les Lunettes des princes*, retained its great popularity down to nearly the close of the reign of Francis I, was her *maître d'hôtel*. Jean Marot was one of her *valets de chambre*. Her secretaries included André de La Vigne, Jean Lemaire de Belges, Fausto Andrelini, and Germain de Brie, better known as Germanus Brixius. Among the artists employed by her were Jean Perréal, who designed her father's tomb, Michel Colombe who executed it, and the illuminators, Jean Bourdichon and Jean Poyet. The inventory of her possessions includes pictures, tapestry, gold and silver work of every description, ivories, and precious stones[1]. Some of the tapestry came from Milan and several of the pictures from Milan or Naples[2]. Among these latter were numerous portraits, one of which according to the inventory was said to represent Ludovico Sforza, while on two others was inscribed the name of Filippo Maria (Visconti).

She also loved books and manuscripts. The *Bibliothèque Nationale* has several presentation copies, printed on vellum, and adorned with illuminated woodcuts of works, which that astute and enterprising publisher, Antoine Verard, had executed for her, and for which, judging by one extant bill of his, he doubtless charged pretty heavily. They include *Les louanges du Roi Louis XII*[3] by Claude de Seyssel, *Les epistres de Saint-Paul glosées*, of which the translation

[1] Brantôme, *Vie des dames illustres* (a charming life); Le Roux de Lincy, *Anne de Bretagne*, 4 vols. 1860–1861.

[2] *E.g.* Ung autre grant tableau d'environ quatre piedz en carré richement paint en son estuy, apporté de Naples. See Le Roux de Lincy, *op. cit.* IV. 153–157.

[3] Van Praet, *Catalogue des livres imprimés sur vélin dans la bibliothèque du roi*, 6 vols. 1822–1828, V. 112.

and notes were the work of the king's Dominican confessor, Antoine Dufour, Bishop of Marseilles[1], Bocacce, *Des Clercs et nobles femmes*[2], and Aesop's fables in Tardif's translation[3]. Among the fifteen manuscripts which are known to have been either ordered by her or presented to her are Jean Marot's *Voyage de Gênes*[4], the third book of Jean Lemaire's *Illustration de Gaule*, which was dedicated to her, a history of Brittany by her almoner, Pierre Lebaud[5], and translations into French by Antoine Dufour of the Old Testament and St Jerome's letters[6]. But the most famous of Anne's manuscripts is the *Book of Hours* in the *Bibliothèque Nationale* with its sixty-three full-page illustrations by Jean Bourdichon, of which more will be said in a later chapter.

In addition to these royal and semi-royal patrons there were a considerable number of wealthy individuals, holding for the most part high office, who, whether from a genuine interest in art and letters, or from mere vanity and love of display, acted the part of a Maecenas in the district in which they resided. As a large proportion of them had been in Italy either with Charles VIII or Louis XII they proved important agents for the diffusion of the Renaissance in France. To begin with the First Estate, Jean d'Auton records the names of no less than four French Archbishops, seven Bishops and an Abbot, who were at Milan in June 1507[7]. Of these, Federigo da San Severino, Bishop of Maillezais, who became in the following year Archbishop of Vienne, and Tristan de Salazar, Archbishop of Sens, have already been mentioned in these pages[8]. Salazar was one of the most enlightened patrons of his day. During his long tenure of his see (1475–1519) he enriched his Cathedral with numerous additions and embellishments—the

[1] Van Praet, I. 60. [2] *Id.* v. 160.
[3] *Id.* IV. 239.
[4] *Bib. Nat.* MSS. *franc.* 5091 (formerly 9707) ; Le Roux de Lincy, IV. 219.
[5] *Livre des croniques des Ducs et Princes de Bretaigne Armoricaine*, Brit. Mus. Harl. MSS. No. 4371, on vellum.
[6] Le Roux de Lincy, IV. 216 ff. The manuscript of the translation of the Old Testament is lost.
[7] Jean d'Auton, *op. cit.* IV. 325. [8] See above, pp. 84 and 85.

transepts with their magnificent stained glass, part of the south-west tower, and the great tomb for himself and his parents. He also added a new wing to the Archbishop's Palace, and built at Paris the Hôtel de Sens, which may be seen at the present day in a side street[1] near the Quai des Célestins, the only remaining specimen, besides the Hôtel de Cluny, of Gothic domestic architecture in that city[2].

Louis II d'Amboise, Bishop of Albi, and Antoine Bohier, Abbot of Fécamp and Saint-Ouen, and afterwards Archbishop of Bourges and a Cardinal, were both instrumental in introducing specimens of Italian workmanship into France. The former, who, though he had been a bishop for six years, was only two-and-twenty in 1507, imported Italian artists for the decoration of his Cathedral of Albi[3], while Antoine Bohier, besides completing the noble Church of Saint-Ouen, ordered from a Genoese sculptor a whole series of works in marble for La Trinité at Fécamp[4].

Guillaume Briçonnet, the powerful minister of Charles VIII, was represented at Milan by his son, the Bishop of Lodève and future Bishop of Meaux. He himself was living in retirement at Rome, but he still held the sees of Saint-Malo, Nimes, and Reims, the latter of which he exchanged for Narbonne in 1507. At Reims he began to build a *grande salle* for the archiepiscopal palace, which was completed by Robert de Lenoncourt[5]. His immediate successor was a Genoese, Carlo da Carretto, who under the title of the Cardinal da Finale, figures in Jean d'Auton's

[1] Rue du Figuier. Close by is the Rue des Jardins, where Rabelais is said to have died.

[2] See Thuasne, II. 132, n.[1]; E. Vaudin, *Fastes de la Sénonie*, 1882, pp. 273–277 and pl. XXXI (Hôtel de Sens).

[3] Bishop of Autun 1501–1503, of Albi 1503–1510. His uncle and predecessor, Louis I, erected the choir-screen and the rood-loft.

[4] He held the see of Bourges from 1515 to his death in 1519, and here too he shewed his love of building and restoring. He was made a Cardinal in 1517. For Fécamp see Le Roux de Lincy, *Essai historique et littéraire sur l'abbaye de Fécamp*, Rouen, 1840, p. 339.

[5] He was Archbishop of Tours from 1484 (when he was only twenty-five) to 1508, but he does not seem to have resided there much. He held the see of Reims till his death in 1532.

list. He only held the see for a year, and then exchanged
it with Lenoncourt for Tours, to which he afterwards added
Cahors. Though he had done much for the churches in
his native district of Finale, he does not appear to have
shewn the same activity at Tours. The lantern of the
northern tower of the cathedral was finished before his
election, and that of the other tower was not begun till
many years later. One Archbishop who was at Milan,
Louis de La Trémoille, died in that city, and was succeeded
at Auch by François-Guillaume de Castelnau, Cardinal de
Clermont-Lodève, a nephew of Cardinal d'Amboise, who
gave the order for the magnificent stained-glass windows
in that cathedral[1]. Not far from Auch, Jean d'Orléans-
Longueville, grandson of Dunois, and nephew of Louis XI
—his mother was Agnes of Savoy—roofed the Cathedral of
Saint-Étienne at Toulouse and built the bell-tower. As how-
ever he was only eighteen when the work was begun (1502),
the merit of it should rather be ascribed to the Chapter[2].

It is certainly to the Dean and Chapter of Amiens and
not to the Bishop, François de Halluin, who chiefly occupied
himself with hunting and other pleasures, that the noble
stalls of their cathedral (1508–1522) were due. The Dean,
Adrien de Hénencourt, also decorated at his own expense
the Chapel of Saint-Éloy with frescoes of the Sibyls (1506).
Other ecclesiastics who deserve honourable mention as
embellishers of their churches or palaces are René d'Illiers,
Bishop of Chartres from 1493 to 1507[3], who just had time
before his death to lay the first stone of the spire on the
north tower; Louis de Crevant, Abbot of Vendôme from
1488 to 1522, who adorned his fine Church of La Trinité
with stall-work which is justly celebrated ; Nicolas Forjat,
Abbot of Saint-Loup and Prior of the Hôtel-Dieu de Comte
at Troyes, who enriched his churches and chapels with various

[1] He was Archbishop of Narbonne from 1503 to 1507.
[2] He died in 1533, just after receiving a cardinal's hat. Louis XII,
who appointed him to his see, was his guardian.
[3] Erasmus dedicated to him his translation of Lucian's *Pseudomantis*
(Allen, I. no. 199).

works of art[1]; and Guillaume Gueguen, the *protégé* of Anne of Brittany, who rebuilt his palace at Nantes in 1502[2]. After his death in 1506 his memory was perpetuated by a tomb for which Michel Colombe made the recumbent figure. About the same time the nephews of Thomas James, Bishop of Dol, employed the Italian sculptor, Giovanni Giusti, to commemorate his memory in the same fashion[3].

One ecclesiastical Maecenas remains to be noticed, and that the most influential of all. As a patron of art and learning, Georges, Cardinal d'Amboise, was more active than either Charles VIII or Louis XII, or even than Anne of Brittany. As Archbishop of Rouen and Governor of Normandy, he contributed greatly to the artistic and intellectual development of that city[4], and he made some notable benefactions to its cathedral, repairing the roof of the nave, rebuilding the façade, and presenting the great bell which bore his name. He died (1510) a year after the façade was begun, but it was continued by his nephew and successor, Georges II d'Amboise, who proved himself hardly less liberal than his uncle. But it is chiefly by the work on his palace at Gaillon, of which a full account will be given in a later chapter, that the first Cardinal d'Amboise ranks as the chief promoter of the introduction of Renaissance art into France. He also had a small but well-chosen library of 190 volumes, which included two copies of Herodotus and Strabo, presumably in Latin, and various works of Petrarch, Valla, Filelfo, Baptista Mantuanus, Fausto Andrelini, and Ludovico Heliano[5].

[1] See for Forjat R. Koechlin and J.-J. Marquet de Vasselot, *La sculpture à Troyes*, 1900, p. 37.

[2] Gueguen's election to the see encountered great opposition from Rome. Anne had a clause inserted in her marriage-contract with Louis XII to the effect that he must insist on the appointment. (A. Guépin, *Histoire de Nantes*, 2nd ed. 1839, p. 185.)

[3] The Bishop died in 1504. The date of 1507 is repeated several times on his tomb. (P. Vitry, *Michel Colombe*, p. 206.)

[4] He was elected Archbishop in 1493 and made his entry into Rouen as Archbishop and Lieutenant-Governor on September 20, 1494. In 1498 he succeeded the Duke of Orleans, now Louis XII, as Governor.

[5] See A. Deville, *Comptes de Gaillon*, 1850, pp. 521–528.

The Cardinal's nephew, Charles de Chaumont d'Amboise, the King's Lieutenant-General for the Duchy of Milan, in which capacity he acquired considerable wealth, was also a builder and a patron of art. His château of Meillant in Berry, which still exists, will be noticed hereafter[1]. Near it was the château of Louis Brémond d'Ars who served with great distinction in the Italian campaigns of Charles VIII and Louis XII. A friend of Bayard's, he only survived him a year, being killed at Pavia in 1525. Charles d'Amboise married Jeanne, daughter of Louis Malet de Graville, admiral of France (1441–1516) another art-loving noble, who decorated his château of Marcoussis, eighteen miles south of Paris, with paintings by Italian artists, and collected tapestry and jewels[2]. His other daughter, Anne, was a lover of books, especially of illuminated ones, and a reader of Italian literature. She was also herself a poetess, and translated into French verse the *Teseide* of Boccaccio[3].

Cardinal d'Amboise had a powerful rival in Pierre de Rohan, Maréchal de Gié, a cadet of the family of Rohan-Guemené[4], whose great wealth enabled him to make his

[1] Pierre d'Amboise, Seigneur de Chaumont, chamberlain to Charles VII and Louis XI, had nine sons and eight daughters by his wife, Anne de Beuil :

Pierre								
Charles I	Jean B. of Langres	Aymery Grand Prior	Louis I B. of Albi	Jean Seigneur de Bussy	Pierre B. of Poitiers	Jacques B. of Clermont and Abbot of Cluny	George I Archb. of Rouen and Card.	Hugues
Charles II Governor of Milan	Louis II B. of Albi and Card.		George II Archb. of Rouen and Card.		Geoffrey Abbot of Cluny			

[2] He was descended from Robert Malet, who came to England with William the Conqueror. See V.-A. Malte-Brun, *Histoire de Marcoussis*, 1867, and P.-M. Perret, *Notice biographique sur L. Malet de Graville*, 1889 ; Le Roux de Lincy, *Anne de Bretagne*, II. 132 ff. Marcoussis was built at the beginning of the fifteenth century by Jean de Montaigu, the favourite of Charles VI, who was executed in 1409. His daughter married Graville's grandfather. The château was destroyed in 1800.

[3] In 1509 she made a run-away match with her cousin, Pierre de Balsac d'Entragues, and had eleven children, of which one, Jeanne, married Claude d'Urfé, the father of Honoré d'Urfé, the author of *L'Astrée*. See Maulde La Clavière, *op. cit.* pp. 291–296.

[4] This is the older and correct way of spelling the name ; *Guéménée* is modern. (See Sainte-Beuve, *Les Cahiers*, p. 141.)

château of Le Verger between Angers and La Flèche vie with Gaillon as a home of art and luxury. In 1506, as the result of an impeachment, due to the concerted action of the Cardinal d'Amboise with Anne of Brittany and Louise of Savoy, neither of whom ever forgave a real or supposed injury, he was deprived of the governorship of Angers and Amboise and the guardianship of the Comte d'Angoulême, and was banished from the Court. But he was acquitted of the main charge of high treason, and as moreover he was not condemned to pay the costs of the trial, he continued to enjoy his wealth and his art-treasures at Le Verger till his death in 1513[1]. One artistic loss, however, he suffered by reason of his disgrace. A bronze statue of David by Michelangelo, which the Signoria of Florence had ordered at his request in 1502, was, when completed six years later, given to Florimond Robertet, who placed it in the courtyard of his château of Bury, near Blois.

In thus altering the destination of the David the Signoria of Florence shewed remarkable foresight. A month later (October 1508) Robertet was appointed Treasurer of France, and at the beginning of the following year, when Cardinal d'Amboise was seriously ill, the foreign ambassadors looked upon him as the Cardinal's destined successor, and began to approach him with the customary presents[2]. They were not wrong in their forecast, for after the Cardinal's death in May 1509 the whole foreign policy of the kingdom passed into Robertet's hands. The new minister was a son of Jean Robertet, who was secretary to three Dukes of Bourbon and two Kings of France, and who enjoyed considerable fame as a poet and prose-writer of the *rhétoriqueur* school. Florimond had in his turn been secretary, first to Anne of Brittany, and then to Charles VIII, to whom he had commended

[1] Maulde La Clavière, *op. cit.* pp. 128–192, and Introduction to *Procédures politiques du règne de Louis XII* (Doc. inéd.), 1885; Lavisse, *Hist. de France*, v. pt. i. 139–141.

[2] The Florentine envoys writing on January 2, 1509, speak of "La mancia consueta...la quale accetto graziosamente" (A. Desjardins, *Négociations diplomatiques de la France avec la Toscane*, II. 258.)

himself by an extraordinary capacity for work and the knowledge of four foreign languages, Italian, Spanish, German, and English. Besides his château of Bury, he had a town house at Blois known as the Hôtel d'Alluye, part of which shews the unmistakeable hand of an Italian architect. His receptivity of Renaissance ideas is also shewn by the humanistic education which he gave to his two sons. They profited sufficiently to be able to carry on a correspondence with the great Budé, who was a friend of their father's, in both Greek and Latin[1].

By his marriage at the age of fifty with Michelle, daughter of Michel Gaillard, one of the four Generals of the Finances[2], and Jaquette Berthelot, Florimond Robertet became connected with that remarkable group of families, the Gaillards, the Berthelots, the Beaunes, the Briçonnets, and the Ruzés, which, allied to one another by numerous intermarriages, controlled the financial affairs of the kingdom for a period of eighty years[3]. The four last-mentioned families, says M. Spont, formed the *élite* of the Tours *bourgeoisie*, and it is to Tours and its neighbourhood that we must look for the memorials of their wealth and artistic tastes. Chief among these are the hôtel which Jacques de Beaune de Semblançay began in 1507, and the beautiful fountain which he erected in front of it. Ten years before this he had acquired the estate of La Carte, about six miles from Tours, but nothing remains

[1] See G. Robertet, *Les Robertet au XVIe siècle*, 1888 ; H. Guy, *Histoire de la poésie française au XVIe siècle*, I. 51 ff., 1910. Budé corresponded with Claude and François Robertet from 1521 to 1525 (L. Delaruelle, *Répertoire de la correspondance de Guillaume Budé*, 1907). In the *Deploration de Messire Florimond Robertet*—he died in 1527—Marot writes :

> Cessez vos pleurs, cessez, Françoys et Claude,
> Et en latin, dont vous savez assez,
> Ou en beau grec, quelque œuvre compassez
> Qui après mort vostre pere collaude.

[2] The four Generals (of Languedoc, Languedoïl, Outre-Seine-et-Yonne, and Normandy) and the four Treasurers formed the Council of the Finances.

[3] A. Spont, *Semblançay*, 1895, a work of great interest. The first Mayor of Tours (1462) was Jean Briçonnet the elder, and among the first sheriffs were a Berthelot, a Ruzé, and a Poncher (E. Giraudet, *L'Histoire de Tours*, 2 vols. Tours, 1873, I. 234).

of the château which he built there except the keep[1].
It was not till the next reign, when he reached the zenith
of his prosperity, that Louise of Savoy bestowed on him
the barony of Semblançay. His execution in 1527, made
memorable by Marot's well-known epigram, marks the close
of the long *régime* of the great financial families. In his fall
were involved Gilles Berthelot, President of the *Chambre des
Comptes*, the builder of Azay-le-Rideau, a son of Thomas
Bohier, the builder of Chenonceaux[2], and Jean de Poncher,
brother to the Bishop of Paris, who shared the fate of
Semblançay. Both Thomas Bohier, who was a brother of
Antoine Bohier, the Archbishop of Bourges, and Jean de
Poncher, were Generals of the Finances ; and both were
connected with the Briçonnets, the former through his wife,
the latter through his mother[3].

Another bourgeois family of Tours was that of Cottereau,
several members of which held the office of mayor. A frag-
ment of their hôtel, dating from the early Renaissance, but
rather later than our period, is still visible[4]. It was Jean
Cottereau, a Treasurer of France under four reigns, who
bought that estate of Maintenon, between Rambouillet and
Chartres, which gave its name to Scarron's widow, and

[1] Spont, pp. 107, 108. His wife was Jeanne Ruzé, whose mother was
a Berthelot.

[2] Azay-le-Rideau was begun in 1518, and Chenonceaux about the
same time.

[3] The following pedigree, compiled from Spont, includes those members
of the Briçonnet family whose names occur in these pages, and shews
their relationship with the other financial families :

Jean Briçonnet d. 1447

Jean *l'aîné* = Jeanne		Jean le *jeune* = Catherine de Beaune	André
Gen. of	Berthelot		
Languedoïl		Perrine = Jean de Poncher Catherine = Guillaume	
d. 1493			Ruzé
		Jean	

Guillaume = Raoulette	Guillaume	Robert	Pierre	
Card.	de Beaune		Archb. of	Gen. of
d. 1514		Michael	Reims	Languedoïl
		B. of Nimes	d. 1497	d. 1509

| Guillaume | Catherine = Thomas Bohier | Marie = Morelet de Museau |
| B. of Meaux | | |

[4] P. Vitry, *Tours*, p. 92.

who built on it a château of which the round towers and
chapel are still standing[1].

At other towns than Tours there still exist houses which
owe their origin to some wealthy *bourgeois*, who having
married into one of the great financial families was admitted
to a share in their good things. At Angers, for example,
is the hôtel of Olivier Barrault[2], Treasurer of Brittany, who
married a Briçonnet. At Amboise is the house of Pierre
Morin[3], one of the Treasurers of France, whose wife was
a sister of Jacques de Beaune, and whose mother was the
sister-in-law of Jean Berthelot.

At Bourges Jean III Lallemand, General of the Finances
for Normandy, who was heavily fined as the result of the
above-mentioned inquiry, completed the building of the
charming hôtel which bears his name. As his wife was
a Gaillard, he too was connected by marriage with the
leading financial families. His own family had been settled
at Bourges since the thirteenth century, and had become
considerable in the fifteenth. Both his grandfather and his
father before him were Generals of Normandy. The grand-
father, Jean I, received his appointment from Louis XI, and
is a good example of that characteristic feature of that astute
monarch's policy which consisted in confiding the govern-
ment and administration of the larger towns (*les bonnes villes*)
to a few well-to-do *bourgeois*, whose attachment to himself
he secured by the bestowal of lucrative offices and hardly
less lucrative privileges. By this means he created a *bour-
geois* aristocracy, which following the example of Jacques
Cœur vied with the nobles in the display of luxury and the
patronage of art. It is significant that the Lallemand who
began the hôtel in 1487 was known as Jean II, and his sons,
who completed it after his death in 1494, as Jean III and

[1] Jean Cottereau died in the reign of Francis I at the age of 72. Marot
wrote three epitaphs for him, and one for his widow (*Œuvres*, ed. P. Jannet,
II. *Cimetière*, VIII–X and XXIII).

[2] Now the museum and library; it was built 1486–1495 and is a
purely Gothic building.

[3] Now the *hôtel de ville*; it shews no traces of the Renaissance.

Jean IV. The great financiers had their dynasties as well as the nobles and the ecclesiastics. The hôtel was in place of an earlier one built by Jean I, which had been destroyed by the great fire of that year. Among the many buildings which rose from the ashes was a new *hôtel de ville*[1]. About the same time the north tower of the Cathedral collapsed (December 31, 1506) and the work of rebuilding it was carried on with great vigour, masons and sculptors being summoned for the purpose from all parts of France[2]. The Lallemand family had relations with Italy; one of them held an administrative post at Milan under Louis XII, and a daughter of the house married Giovanni Rucellai, an Italian merchant settled at Lyons. There were also Italian financiers at Bourges, and it was for one of these, Durante Salvi, a Florentine, that the hôtel, which now bears the name of Cujas, was built[3].

It will be noticed that Angers, Poitiers, and Bourges are all closely connected with Tours by their geographical position. Angers is easily reached by the Loire, Poitiers by the Roman road which passes through Châtellerault, and Bourges by another Roman road along the valleys of the Cher and the Yèvre. Thus they not only had an artistic activity of their own, but they were in touch with the vigorous artistic life of the capital of Touraine. Now Tours is of the greatest importance in the history of the French Renaissance. In 1436 Bourges ceased to be the capital of Charles VII, and during the next half century it is hardly too much to say with M. Vitry that Tours was " the moral and political centre of the kingdom." Charles VII lived chiefly in one of his châteaux on the Loire; the favourite residence of Louis XI was at Plessis-les-Tours. It was at Tours in 1484 that the Estates were held which crowned the work of Louis XI and testified to the unity of the

[1] L. Raynal, *Histoire du Berry*, 4 vols. Bourges, 1844–1847, III. 267. Marot's *Cimetière* contains an epitaph on Des Allemans de Bourges (No. XI, *Œuvres*, II. 226.)

[2] *Archives de l'art français*, 2e sér. I. 226 ff.

[3] P. Vitry, *Michel Colombe*, p. 219.

kingdom. It was also a manufacturing centre; it was the chief home of the silk industry which Louis XI established there in 1470, and it was of considerable importance in the woollen trade. Merchants from Rouen and other Norman towns, from Poitiers, Angers, Saumur, and Saint-Malo, might be seen daily in its market[1].

Partly by reason of these advantages Tours became the artistic centre of France. From about 1450, when Fouquet became famous, its supremacy was uncontested, not only in painting, but also in the other arts. The nave of the Cathedral was finished about 1440, and the western façade with its triple portal and twin towers was in process of erection. The tombs of Jeanne de Bueil (d. before 1456) and Agnes Sorel (d. 1449) testify to the fame of the Tours sculptors. Michel Colombe established his *atelier* there, and gathered round him a school not only of sculptors, but of architects, decorators, and painters. Fouquet's traditions were carried on by his two sons and other disciples, who lacked however the master's genius, while Jean Bourdichon, painter to Charles VIII and Louis XII, and Jean Poyet, were names of great renown. Painting on glass and embroidery also flourished, and music was nobly represented by Jan Okeghem, one of the greatest of musical teachers. At the opening of our period he had resigned the Treasurership of St Martin, to which he had been appointed by Louis XI, and was living in retirement, an old man between seventy and eighty[2].

Okeghem, who was a Hainaulter, was by no means the only native of the Low Countries who shed lustre on the artistic life of Tours. Coppin Delf, the painter employed by King René, was commissioned in 1482 to decorate the Chapel of the Dauphin in St Martin[3]. In the municipal

[1] E. Levasseur, *Hist. des classes ouvrières en France*, 2 vols. 1859, I. 552.

[2] He died in 1513, when he was between ninety and a hundred (*Dictionary of Music and Musicians*). Guillaume Cretin wrote a *Déploration sur le trépas de Jean Okeghem*, which has been reprinted in modern times (ed. E. Thoinan, 1864).

[3] P. Vitry, *Michel Colombe*, p. 229. The Dean of St Martin from 1471 to 1491 was Thomas de Lendas, of a noble family of Tournay.

accounts between 1480 and 1498, we find the name of a painter called Lallement *dit le Liégeois*. Jean Clouet, who was certainly a foreigner and almost certainly a native of the Low Countries, settled at Tours before the close of the reign of Louis XII[1]. Moreover manuscripts illuminated by Flemish miniaturists were in much demand throughout Touraine[2]. Side by side with these Flemish artists were Italians. The first Italian colony was that of the silk-workers whom Louis XI had transported from Lyons. Though the industry had proved a failure in the southern city, it prospered greatly at Tours, in spite of the initial ill-will of the citizens. Among these Italian colonists may well have been some of superior cultivation with drawings and engravings in their possession, from which Tours artists may have derived their first knowledge of the Renaissance. After the expedition of Charles VIII Italian artists, as we shall see later, settled at Tours, the most notable being Girolamo Pachiarotti, Girolamo da Fiesole, and the family of Giusti Betti.

It was natural that Tours should be the meeting-point of northern and southern art, for Touraine, as Michelet has pointed out, forms a connecting link between northern and southern France, and Tours, which lies on the great highway between Paris and the south-west, is warmed by an almost southern sun[3]. Thus in Tours the Fleming and the Italian, the northerner and the southerner, worked beside the French-man who was half northerner and half southerner. Down to 1495 it was the Flemish influence which prevailed; after 1495 it was the Italian. But throughout both periods, though French art profited by its intercourse with rivals who were in some respect more accomplished, it never ceased either in its outlook on life or in its conception of art to be funda-mentally French.

From Tours a third road led to Le Mans, that ancient

[1] He was official painter to Louis XII.

[2] Vitry, *op. cit.* p. 230.

[3] The spring vegetation along the Loire from Tours to Saumur is five days in advance of Orleans (Lavisse, *Hist. de France*, I. pt. i, p. 47).

and picturesque city which rises abruptly above the Sarthe, and is crowned by the noble Cathedral of St Julian[1]. But its affinity is rather with Angers than with Tours, for the Sarthe which connects the capital of Maine with the similarly situated capital of Anjou is a navigable river[2]. Moreover, ever since the latter part of the thirteenth century, Maine had been united to Anjou as an appanage of the French Crown. In 1440 King René had ceded it to his brother Charles, who shared his love of art, and whose beautiful tomb, of pure Italian workmanship, is to be seen in the Cathedral of Le Mans. The narrow streets which run from the Cathedral to the lower parts of the town still preserve their old houses of the fifteenth and sixteenth centuries. The name of *Vieille Rome*, which one of these streets (now Rue des Chauvines) bore till recently, and the remains of the old fortifications, recall the Gallo-Roman city, Vindinum, of the Cenomani.

Half-way between Le Mans and Angers is the Abbey-Church of Solesmes, where the well-known Entombment of 1496 offers an unsolved problem as to its authorship. Five miles below Angers the Maine[3] falls into the Loire, which, here a broad stream, serves as a water-way to Nantes. From Bourges a road, which existed in pre-Roman times, led by Argenton, the home of Philippe de Commynes, to Limoges, situated on the lower slopes of the great central plateau. Thanks to its position on this southern road at the point where it was crossed by that from Clermont to Saintes, Limoges was an important place both in Roman and mediaeval times. It was not only a commercial centre, but it enjoyed a precocious artistic life, being especially famous for goldsmith's work and enamelling. At the close of the fifteenth century however, though it had quickly recovered from the terrible punishment inflicted on it by

[1] See Freeman, *History of the Norman Conquest*, III. 203–205, for a good description of the city.

[2] The Sarthe, after receiving Le Loir, joins the Mayenne just above Angers.

[3] The Maine is formed by the junction of the Mayenne with the Sarthe.

the Black Prince in 1370, its commercial importance had considerably diminished. But the art of enamelling was revived, and in the hands of Nardon Pénicaud and his successors acquired fresh glory. The road from Limoges to Saintes passed through Angoulême, finely situated on a hill above the Charente. At Saintes with its Roman arch and amphitheatre it met that from Poitiers to Bordeaux[1]. Bordeaux was one of the towns which owed the revival of its commercial life to the far-seeing and practical wisdom of Louis XI. The termination of the long English dominion, which had lasted for three centuries, and under which the whole province of Guyenne had greatly prospered, was followed by a dark period of decline, during which Charles VII from animosity to the English ruined the trade of his own subjects. But Louis XI, realising the importance of Bordeaux as a port which connected the Atlantic with the Mediterranean, removed all the restrictions on its trade, and did everything in his power to encourage its return to commercial prosperity. Among other signs of his favour he created a University, which was not, however, a success.

From Bordeaux there were roads to Périgueux and Agen, both on the great southern road which led through Auch and Saint-Bertrand de Comminges to Spain. Périgueux, on the side of a hill which slopes down to the Isle, commands a wide view over the surrounding country. It has some picturesque houses of the late fifteenth and early sixteenth centuries[2].

Though Bordeaux and Toulouse both lie on the Garonne they have lived, as has been said, different lives. For the Garonne is very difficult of navigation, and Toulouse from

[1] When Clement V returned to Bordeaux after his coronation at Lyons (1305) he passed through Macon, Cluny, Nevers, Bourges, and Limoges. On his journey to Lyons his route had been by Agen, Toulouse, Beziers, Montpellier, and Nimes.

[2] See an interesting and highly instructive account of Périgueux in E. A. Freeman, *Historical Essays*, fourth series, 1892, pp. 131 ff.

Roman times was in easy communication with Narbonne on the Mediterranean by a road which followed the line of the modern Canal du Midi. Like Bordeaux, Toulouse profited by the liberal policy of Louis XI, who abolished the *droit d'aubaine* for the whole of Languedoc, and thus encouraged a considerable number of Spaniards, for the most part engaged in commerce, to settle in both province and city. But Toulouse, which before the rise of Lyons was the intellectual capital of the south of France, had enjoyed ever since the eleventh century an artistic life that was too vigorous and too individual to be much affected by foreign influences. It had a flourishing school of sculpture, a corporation of painters on glass[1], and a distinctive architecture, the style of which was largely determined by the prevalent use of brick. Albi on the Tain, about forty miles north-east of Toulouse, is also a city of brick, and has an imposing Gothic Cathedral of that material. Beyond Albi on a spur of the central plateau, surrounded on three sides by the Aveyron, a tributary of the Lot, stands Rodez, the unfinished Cathedral of which, conspicuous for its lofty bell-tower, was begun five years after that of Toulouse[2].

Montpellier, where Jacques Cœur had his principal counting-house, was a decaying place in the reign of Louis XI, who tried in vain to revive its trade. But when Provence fell to the Crown, he recognised at once the far superior position of Marseilles, and turned his attention to that city. The only French port on the Mediterranean accessible to large vessels, it soon monopolised the Mediterranean and Levant trade, and was one of the main channels of communication between France and Italy. Twenty-five miles from Marseilles was Aix, the capital of Provence, where King René, with his artistic tastes and cosmopolitan patronage of artists, had

[1] Arnaut de Moles, the great artist who executed the windows at Auch, was not a native of Toulouse, as was formerly supposed, but he seems to have worked there.

[2] The Cathedrals of Toulouse and Narbonne were founded in 1272, and that of Rodez in 1277.

established an artistic tradition. Though now the general aspect of the town, with its fine houses on the Cours Mirabeau and elsewhere, mainly recalls the seventeenth and eighteenth centuries, there are still to be found, especially in the doors of the Cathedral, some interesting examples of early Renaissance work. Similar in interest is Papal Avignon, where King René had an hôtel, and where numerous other patrons from that city and from various towns in Provence brought together a colony of painters, which is sometimes described as a school. Later it owed much to its active and art-loving Bishop, Cardinal Giulio della Rovere, afterwards Pope Julius II.

From Avignon it is about eighty miles by road, and rather more by river, to Valence, the seat of a University, and the capital of the district which Louis XII erected into a duchy for Caesar Borgia. About fifty miles further up the Rhone lies Vienne. Chief town of the Allobroges, second only to Narbonne in the Roman province of Narbonensis, seat of an archbishopric which down to the Revolution maintained its claim to the primacy of all the churches of Gaul, second capital of the first kingdom of Burgundy, one of the chief cities of the kingdom of Arles, Vienne had a glorious past, but its glory had departed long before the close of the fifteenth century. Yet it preserves a striking memorial of its pristine splendour in the temple of Augustus and Livia, the only classical temple besides the *Maison Carrée* of Nimes that is left in France. It was Grenoble on the Isère, the most beautifully situated town in France, and not Vienne, that became the residence of the Dauphins of the Viennois and the capital of Dauphiné when that province was united to France. Its *palais de justice*, formerly the palace of the Dauphins, shews in its façade, dating from the early years of the sixteenth century, the first beginnings of the new style.

One reason for the decline of Vienne was the superior position at the junction of the Saône and the Rhone of its neighbour and rival Lyons. That city, which had made so splendid a start as metropolis of the three Gauls, had been

slow in recovering from the terrible punishment inflicted on it by Septimius Severus, and it was only towards the close of the fourteenth century that, inheriting the prosperity which Troyes and Reims had lost, it began to regain its importance. Charles VII increased the number of its fairs from two to three ; Louis XI added a fourth, and issued stringent regulations to the prejudice of its rival Geneva[1]. The result was that these fairs became the most important centre of international trade in France, and Lyons served as a clearing-house for the traders of various nations. Moreover the liberal treatment which Louis XI shewed to foreigners who settled in France, attracted a large number of Italians, so that in 1528 the Venetian envoy, Andrea Navagero, could report that half the inhabitants were foreigners, and nearly all of these Italians. The most important class were the bankers who came chiefly from Florence—Medici, Strozzi, Pazzi, Salviati, Guadagni, Rucellai, Albizzi, Nasi, Buondelmonti, Capponi, Altoviti—but also from Genoa, Lucca, Siena, and Milan[2].

Lyons was at this time a picturesque city of narrow streets and lofty houses, one half of it being hemmed in between the heights of Fourvières and the Saône, and the other half being confined to the northern end of the peninsula between the Saône and the Rhone. The Cathedral of Saint-Jean was only completed towards the close of the fifteenth century ; its Chapel of Saint-Louis was built by Cardinal Charles de Bourbon and his brother Pierre de Beaujeu soon after the appointment of the former to the see in 1485. It is in connexion with the Cardinal's entry into the city as archbishop that we first hear of that enigmatical person Jean Perréal. The same artist was employed to organise

[1] Sée, *Louis XI et les villes*, 1891, pp. 325–326 ; Montfalcon, *Hist. de la ville de Lyon*, 2 vols. Lyons, 1847, I. 536 ff. (prints in a note to p. 540 the letters-patent of Louis XI) ; Levasseur, *op. cit.* I. 444–446.

[2] Colonia, *Hist. litt. de la ville de Lyon*, 2 vols. 1728–1730, II. 459–517 ; E. Picot, *Les Italiens en France au XVI^{me} siècle*, I. 1906 ; Spont, *op. cit.* p. 122. Evelyn says that Lyons " abounds in rich merchants ; those of Florence obtain greater privileges above the rest " (*Journal*, September 2, 1643).

the entry of Charles VIII in 1490, that of Anne of Brittany in 1494, and those of Louis XII in 1499 and 1507.

One effect of Louis XII's forward Italian policy was to give increased importance to Lyons. The city on the Rhone was not only the gateway to Italy through which the armies of France passed and repassed, but it was also the post of observation from which the king and his ministers watched the shifting fortunes of war and the tangled web of diplomacy. Thus Lyons became temporarily, if not the capital of the kingdom, at any rate the centre of government and the chief residence of the Court. The magnificence of the entries planned by Jean Perréal called forth all the artistic resources of the city, which were considerable. The tapestry-weavers, wood-carvers, and goldsmiths all enjoyed considerable renown. In 1496 the painters, sculptors, and painters on glass presented a petition to the king for a charter, which was accordingly granted to them. As at Tours, there was a considerable sprinkling of Flemings and Italians among the Lyons artists, and as at Tours, while the Flemings outnumbered the Italians in the fifteenth century, in the sixteenth the Italians began to gain the upper hand. The artistic character of Lyons at this period also shewed itself in its printing-press, which was remarkable not only for its activity, but for the artistic merit of its productions. A good many of the printers were Germans, and of the booksellers, Italians.

The only available carriage road from Lyons to the Alps led through Chambéry, Grenoble, Vizille, Gap, Embrun and Briançon to the pass of Mont Génèvre, whence it descended to Susa. This was the road taken by Charles VIII in 1494, and by Louis XII in 1502 and 1507. The old Roman road over the Little St-Bernard to Aosta seems to have been used at this time chiefly for merchandise, and there was no carriage road over the Mont Cenis.

Lyons was connected with Toulouse by a road through Le Puy and Aurillac. The most direct road to Paris crossed the central plateau at Tarn by a pass of about 3000 feet, and reached the Loire at Roanne, where it first becomes

navigable[1]. Thence it passed by Moulins on the Allier to rejoin the Loire at Nevers. The County of Nevers had been for nearly a century in the possession of the house of Burgundy, serving as an appanage for a younger son of Philip the Bold and his descendants. On the defeat of Charles the Rash it passed to the French Crown without any protest from its last Count, Jean II de Clèves, who was the Duke's nearest relation in male descent[2]. It was he who built the ducal château, now the *palais de justice*, a stately building in the Flamboyant style. From Nevers the road proceeded to Cosne, where it met the road from Bourges, which was known as "the road of Jacques Cœur." Thence it reached Paris by Gien (where it left the Loire) Montargis, Fontainebleau, and Melun. A somewhat longer route from Lyons to Paris followed the Saône to Beaune, and thence proceeded by Dijon, Troyes, and Sens to Fontainebleau. Another road led from Dijon to Langres and so to Toul and Nancy. There was also a Roman road which left the Saône at Châlon, and passed through Autun to Auxerre, whence you could go either by Sens to Paris, or by Troyes and Châlons-sur-Marne to Reims. But neither of these was any longer a main route.

Of the two routes from Paris to Lyons the more direct one by Nevers and Moulins was certainly the favourite. The result was that the towns of Burgundy and Champagne —Autun, Dijon, Auxerre, Troyes, and Reims—were left outside the main line of communication between the capital and Italy. Autun still preserved its noble Roman gates,

[1] Evelyn on his return from Italy in 1646 in company with " the great poet Mr Waller, and some other ingenious persons " took boat at Roanne, and reached Orleans by river on the third day, and the first night they came to Nevers, " early enough to see the town," and the principal sights.

[2] There was probably a secret agreement between him and Louis XI. He continued to reside at Nevers and died there in 1491. His grandson Enguilbert de Clèves received from Charles VIII the County of Auxerre. He commanded the Swiss at the battle of Fornovo, and, though a foreign prince, had the County of Nevers conferred on him *en pairie* in 1505. He died in the following year, and was succeeded by his son, Charles de Clèves.

but it had greatly shrunken since the days when it was a seat of liberal studies for the noblest youth of Gaul[1]. Dijon had been neglected by the last two Dukes of Burgundy for Brussels and Bruges, and it was not till the middle of the reign of Francis I that it began to play a prominent part in the development of the Renaissance in France. Troyes under the rule of the Counts of Champagne, in the days of its celebrated fairs, had been an important centre of international trade, but it had been ruined by the wars of the fourteenth and fifteenth centuries, and owing to the growth of Lyons had never recovered its commercial prosperity. Its artistic life, however, began to shew renewed vigour. The façade of the Cathedral, begun in 1506, and the rood-screen of La Madeleine, which dates from 1508, are Flamboyant of the decadence, but in the same two churches we see the successful beginnings of the new school of stained glass, which rivalled that of the thirteenth century in productiveness, if not in merit, and which was nowhere more productive than in Champagne. In the department of Aube alone there are at least sixty churches that have preserved some of their sixteenth-century glass, all of which was produced in the Troyes *ateliers*. It was Troyes artists, too, who executed the windows in the south transept of the neighbouring Cathedral of Sens, for the two cities maintained close artistic relations, and as soon as Martin Chambiges had completed the transepts of Sens he set to work on the façade of Troyes. Châlons-sur-Marne was another active centre of stained glass. But here, as at Troyes, all the earlier productions are purely Gothic in treatment, while the subjects that they represent are taken from French or German sources. It was not till about 1530 that the glass painters of Champagne began to seek inspiration from the Italian Renaissance[2].

Reims, the meeting-place of several Roman roads—to Autun, Metz, Trèves, Tournai, Amiens—and once a great

[1] Tac. *Ann.* III. 43. See Freeman, *Hist. Essays*, fourth series, pp. 94 ff.
[2] E. Mâle in *Hist. de l'Art*, IV. ii. 795.

political, commercial and religious centre, had, like Troyes, lost its political and commercial importance. But it remained the religious capital of France, and it is meet that its Cathedral, with its historical associations and its noble façade, the noblest, perhaps, in Christendom, should bear the proud title of " the most French " of French Cathedrals[1]. The three neighbouring cities, Laon on its lofty hill, Soissons, and Noyon, shared the fate of Reims. Once of considerable political importance, they had at the opening of the sixteenth century receded from the main stream of progress, and could only boast of their fine Cathedrals and their historical past.

The old Roman road from Lyons to Reims was continued to Boulogne by Soissons, Noyon, and Amiens. With the latter city we return to the mid-stream of civilisation. The celebrated stalls of its Cathedral, executed from 1508 to 1522, are for the most part purely Gothic in character, but there are traces of the Renaissance in the arabesques and small figures of the elbow-rests. They were the work of an important nature school of wood-carving, which in 1494 numbered two hundred members. Amiens had also a Confrérie of St Luke, which included painters, illuminators, painters on glass, and embroiderers, and which received its first statutes about the year 1500[2]. The road from Amiens to Paris led through Beauvais, where there was also a school of glass-painting. That to Rouen crossed the table-land which separates the valley of the Somme from that of the Bresle.

The capital of Normandy is another city which greatly profited by the foresight of Louis XI. Situated at the lowest point of the Seine where it is narrow enough to be easily crossed, it commanded the passage between High and Low Normandy. It is also near enough to the sea to serve as a sea-port, and Louis XI so treated it. He transferred to it the two fairs held at Caen, and otherwise encouraged

[1] Lavisse, I. i. 107.

[2] See G. Durand, *Notre-Dame d'Amiens*, 1901–1903. Except for the Cathedral, Amiens is now a featureless modern manufacturing town.

its commerce[1]. As a result Rouen became next to Paris the principal town in the kingdom[2]. We have seen how Cardinal d'Amboise contributed to its embellishment, and strove to make it a capital worthy of the province of which he was governor.

In 1820 Rouen, which, except in a few side streets, now wears the aspect of a prosperous modern city, was one of the most picturesque towns in Europe. But to the classical taste of that age all Gothic art seemed barbarous, and even that of the Renaissance found no favour. From 1820 to 1830 the citizens of Rouen in the name of good taste pulled down houses of the greatest beauty and interest, and made their city a hunting-ground for enlightened amateurs, especially English ones. To get an idea of the wealth of mediæval and Renaissance architecture which it once possessed, one must turn to Delaquérière's fascinating volumes, the first of which was published in 1821[3]. In 1860 another epoch of destruction set in. Rouen was "haussmannised" after the Paris pattern. Modern hygiene and the legitimate demand for light, air, and space no doubt made this necessary ; but the work was carried out with a stupid disregard for the glorious past. It was then that the broad Rue Jeanne d'Arc was driven through the city from north to south, ruthlessly cutting in two the Rue du Gros-Horloge, once the main artery of Rouen and lined with noble and picturesque façades[4].

[1] Sée, *op. cit.* pp. 322 ff.

[2] Marino Cavalli, Venetian ambassador in 1546, gives the principal towns in the following order—Paris, Rouen, Lyons, Bordeaux, Toulouse (Tommaseo, *Récits des ambassadeurs Vénitiens*, I. i. 225).

[3] *Description historique des maisons de Rouen les plus remarquables*, 2 vols. 1821–1841. See also Jacques Le Lieur's remarkable *Livre des Fontaines de Rouen*, with numerous water-colour sketches of the city (1524–1525), integrally reproduced under the editorship of V. Sanson, Rouen, 1911.

[4] See C. Enlart, *Rouen* (*Les Villes d'art célèbres*), 1910, pp. 11–14. He reproduces on p. 15 an engraving of the Rue du Gros-Horloge as it was at the beginning of the nineteenth century. See also E. Mâle, *L'art réligieux de la fin du moyen âge en France*, 1908, p. 170. William Morris who first visited Rouen in 1854, when he was an Oxford undergraduate,

But there are still some picturesque streets left, notably the Rue Eau-de-Robec with its numerous wooden houses—which the laws of sanitation will soon condemn—and generally the whole quarter between the Churches of Saint-Ouen and Saint-Maclou ; the Rue de la Vicomté, the Rue aux Ours[1], and the Rue de l'Épicerie[2]. Especially there survive some important memorials of the early Renaissance—the Bureau des Finances (now a shop), the oak ceiling, said to have been designed by Fra Giocondo, of the Grand Chambre of the Palais de Justice, and the vaulted gallery of the old Chambre des Comptes.

The arts were in a flourishing condition at Rouen during our period. It possessed distinguished master-masons in Jacques Le Roux and his nephew Roulland Le Roux, and sculptors of equal distinction in Raymond des Aubeaux and his son Pierre, the latter of whom executed the Tree of Jesse for the tympanum of the great central portal of the Cathedral and, with other Norman artists, the twenty large statues of archbishops which once adorned the façade[3]. The *huchiers*, or workers in wood, were also in high repute, and we have good examples of their work in a beautiful retable of the Crucifixion from the Church of Pasquienne near Pavilly, and in other objects preserved in the Musée des Antiquités. Rouen was also an important centre of stained-glass production, supplying workmen not only for its own churches, of which there were seventy-seven before the Revolution, but for many towns and villages in

writes, " Less than forty years ago I first saw the city of Rouen, then still in its outward aspect a piece of the Middle Ages : no words can tell you how its mingled beauty history and romance took hold of me : I can only say that looking back on my past life I find it was the greatest pleasure I ever had : and now it is a pleasure which no one can ever have again : it is lost to the world for ever."

[1] The Rue de la Vicomté leads from the Place de la Pucelle to the river ; the Rue aux Ours runs out of it.

[2] Leads from the Cathedral to the Place de la Haute-Vieille-Tour.

[3] They were destroyed or mutilated by the Huguenots. See Le Chanoine Porée in *Bull. de la soc. des Antiquaires de Normandie*, XXI. (1900), p. 234.

Normandy. It also had a school of illuminators, which received much encouragement from Cardinal d'Amboise[1].

The two sea-ports nearest to Rouen, Honfleur and Dieppe, had like the other Atlantic ports—Boulogne, Saint-Malo, La Rochelle, Nantes, Bordeaux, and Bayonne—benefited largely by the partial diversion of trade from the Mediterranean to the Ocean, caused by the progress of geographical discovery and the increased importance of Lisbon and Cadiz. From Honfleur and Dieppe and Saint-Malo numerous expeditions were sent out to Labrador, Newfoundland, and the East Indies. At Dieppe the elder Ango established the shipowning business which in the hands of his son, Jean Ango, became so prosperous. The latter is buried in a chapel of the Cathedral, which was not completed till the sixteenth century, and of which the later work—the western tower and portal, and especially the screen and carvings of the aforesaid chapel—furnishes characteristic examples of Flamboyant Gothic. The houses of the younger Ango—his hôtel at Dieppe, and his château at Varangeville, four miles from the town—were not built till the reign of Francis I, nor was it till that reign that Florentine exiles began to settle at Dieppe as bankers and shipowners.

Between Rouen and Paris the Seine runs a peaceful but extremely circuitous course, making the distance by river nearly double that by road. There were two roads, one, of Roman origin and more direct, through Magny and Pontoise, and the other, keeping close to the Seine, through Vernon and Mantes. Another road from Rouen, this also Roman, led by Evreux[2] and Dreux to Chartres, where, as we have seen, the northern tower of the Cathedral was crowned with a spire in 1514, partly at the expense of Louis XII. As soon as it was finished, the architect, Jean Texier, generally known as Jean de La Beauce, took in hand the elaborate screen which separates the choir from the ambulatory.

[1] Michel, *Hist. de l'Art*, IV. ii. 748.

[2] Or rather by Vieil-Evreux, the site of Mediolanum, four miles to the south-east of Evreux.

From Chartres it is sixty miles across the corn-land of La Beauce to Orleans, another town which owed the foundation of its commercial prosperity largely to Louis XI. Situated at the northernmost point of the Loire, and therefore at the point where that river approaches nearest to Paris and the Seine, it forms a natural link between Paris and the south. But during our period its affinities were rather with Tours than with the equidistant capital. For the road to Paris lay first through the vast forest of Orleans[1], and then after crossing the plain of La Beauce through the smaller forest of Rambouillet. Nor was there a canal in those days to connect the Loire with the Seine. Still there was a fairly close connexion between the two cities. As the University of Paris had no Faculty of Civil Law, Parisians habitually pursued their legal studies at Orleans, which had the first Law School in the north of France, if not in all France. It was to Orleans too that foreign students at Paris betook themselves, when the visitations of the plague became more than ordinarily alarming. The hand of the modern improver has lain heavily upon Orleans, and before long few relics of Renaissance architecture will be left to it, but in the former *hôtel de ville*, now the *Musée de peinture*, we have one of the earliest buildings in France which shews Renaissance details.

These provincial capitals—for nearly all the towns that we have noted in our survey can claim this distinction—had a similar effect, whether in promoting or in retarding the spread of the Renaissance, to that of the semi-royal Courts. As Freeman has pointed out in his essay on *French and English Towns*[2], " no town in England has been a capital for many ages in the same sense that these old French towns still are capitals," and he goes on to shew that in various ways " the old French city is more of a capital, more of a centre than the English county-town." It is

[1] It is the largest existing forest in France, occupying about 100,000 acres, and being one-third larger than the forests of Rambouillet and Fontainebleau together.

[2] *Op. cit.* pp. 25 ff.

this sense of historical importance in the French provincial
capitals that has called forth so many useful histories,
whether of province, or town, or cathedral, from patriotic
local antiquaries. And if " after all the havoc of revolution
and the worse havoc of fussy mayors and prefects," the
towns of France still retain in various degrees their attrac-
tiveness and individuality, what must they have been at
the opening of the sixteenth century when France had
hardly attained to unity, much less to centralisation ?

In spite of the wise measures taken by Louis XI to
promote the commercial prosperity of the towns, the almost
uninterrupted condition of civil war and the drastic punish-
ment which he inflicted upon rebellious towns effectually
prevented any marked improvement during his reign. It
was already drawing to its close when he confided to
Commynes his intention to make peace with Maximilian
and to devote himself to the unification and pacification
of his kingdom[1]. " Had God granted him five or six years
of health," says Commynes, " he would have done much
good to his kingdom[2]." As it was, he weighed heavily
upon his people, increasing the taxation from 1,800,000 to
4,655,000 livres, and the paid troops from 1700 to over
4000. During the reigns of Charles VIII and Louis XII
there was little internal warfare. The Guerre Folle (1485)
was ended nearly as soon as it was begun, and with hardly
a blow struck. The final struggle with Brittany, which
was concluded by the defeat of Duke François and his allies
at Saint-Aubin-du-Cormier (1488), brought great distress to
the disaffected province, but left the rest of France un-
scathed. Thus the towns had a whole generation in which
to reap full benefit from the wise measures of Louis XI,
and to display the wonderful recuperative power of France.
It was not till the last years of the reign of Louis XII that
the growing expenses of the Italian wars, aided by the
venality of the financial administrators, weighed down the
country with burdensome taxation, and put an end to that

[1] Commynes, ch. cxxv.
[2] Id. ch. cxxix.

popularity which had earned for Louis XII the name of
" Father of the People."

It is a sign of this prosperity on the part of the towns
that several *hôtels de ville*—Lyons, Tours, Compiègne,
Riom—were wholly built during our period, while those of
Orleans and Noyon were completed. Of the same date are
the Bureau des finances and the Cour de l'exchiquier (now
the Palais de Justice) at Rouen. The old palace of the
Dauphins at Grenoble, which became the Palais du Parle-
ment, received, as we have seen, a new façade about 1515.

In considering the channels by which the Renaissance
penetrated the various local centres of French civilisation
it must be borne in mind that the means of communication
at this time were extremely limited. The great majority of
the roads dated from Roman times, and were in no great state
of repair. Indeed about the only important road which was
not of Roman origin was that portion of the great road from
Paris to Lyons which ran between Montereau and Roanne.
Something, however, was done at this period, especially under
Louis XII, to make communication easier. Bridges were
repaired and rivers made more navigable[1]. For, in the
absence of good roads, the rivers were of great importance
for the purpose of transit, and the merchants who used
them formed themselves into corporations. The rivers
varied considerably in their usefulness for navigation. The
Garonne, as has been said, was very difficult to navigate,
and the stream of the Rhone was so rapid that while the
navigation down stream required great care and experience,
up stream it was practically impossible. The Loire has al-
ways been subject to violent inundations, and a modern writer
says of it that in spite of time-tables " it is not seriously
navigable[2]." But in the sixteenth and seventeenth centuries
it was much used for the transport of travellers and materials.
La Fontaine in the account of his journey from Paris to
Limoges (1663) compares the river at Orleans with its

[1] Imbart de La Tour, *op. cit.* i. 243–245 ; Pigeonneau, *Hist. du commerce
de la France*, 2 vols. 1889, ii. 37.

[2] Joanne.

numerous sailing-vessels to a miniature Bosphorus[1]. Evelyn on his journey from Paris to Tours in 1644 went by boat most of the way from Orleans to Amboise, and on his return from Italy two years later used the same means of transit from Roanne to Orleans. Moreover, on his outward journey he hired a boat at Lyons to take him to Avignon. Of the four great French rivers the Seine alone is "without being inoffensive, amenable to discipline." Yet from time to time it has produced memorable inundations, such as those of 1658 and 1740, and the recent one of 1910, though these are not to be compared with the fury of the Loire or the Rhone. Nor does it ever fall so low at Paris as the Loire at Orleans or the Garonne at Toulouse. It becomes navigable a little below Troyes. At Montereau, where it receives the waters of the Yonne, its volume is tripled and its breadth doubled, and shortly before it reaches Paris it is further increased by the addition of the Marne. Thus Paris by the water-way alone is in easy communication in one direction with Montereau on the main road to Lyons and Italy, and in the other with the capital of Normandy.

But, as M. Vidal de la Blache says in the note to his map of the Paris basin, "the position of Paris owes its importance not only to the convergence of the rivers, but to the neighbourhood of the Valois and the Vexin, plains unbroken by forest, which open routes to Flanders and Rouen respectively[2]." That to Flanders leaves Paris by the gap between the heights of Chaumont and Montmartre, and from an early period was a much frequented highway. But when Paris after the expulsion of the English in 1436 began slowly to recover its prosperity, it felt more and more the attraction of the half-Italian city at the junction of the Saône and the Rhone, which was on its way to become a great centre of international trade. And the attraction was reciprocal. The main line of traffic no longer went

[1] *Lettres de La Fontaine à sa femme.*
[2] Lavisse, I. ii. 125.

from the Rhone to the North Sea, from Italy to Flanders, passing through Troyes and Reims to Arras and Bruges. It was diverted to Paris, either at Lyons by the direct road from that city over the pass of the Tarare, or at Troyes by the road through Sens. We have seen too[1] how in the reign of Charles VII political relations which had been dormant during the long period of civil war began to be resumed with Italy, and how under Louis XI these relations took the form of friendly diplomacy. Thus when Charles VIII, breaking with the wise policy of his fathers, embarked on his ill-advised expedition of conquest, his army marched along a road which had for some little time been frequented by more peaceful agents of intercourse between the two countries. Neither, however, the light-hearted undertaking of Charles, nor the more serious and more lasting expedition of his successor put an end to the peaceful side of the relations between France and Italy. Owing to the clash of factions and the lack of Italian patriotism there were plenty of Italians who, either from the stress of exile, or from the attractions of a land that was richer than their own, were ready to take service in France. It was the continuation of a practice, which, as has been pointed out in a former chapter, had begun even before the accession of Charles VIII[2].

Of the more distinguished Italians, whether in art or letters, who came to France before the Expedition, Francesco Laurana, the sculptor and medallist, Michele of Pavia, Dominico Mancini, Fausto Andrelini, and Paolo Emilio were still living there in 1495. The last-named was generally respected as a man of high character and sound learning. He was on friendly terms with both Lefèvre d'Etaples and Budé, and it was Badius Ascensius who published the first instalment of his history. The medallist, Giovanni di Candida, seeing that he was a Neapolitan and in high favour, probably accompanied Charles VIII to Italy, but we have no certain knowledge of his movements between 1494 and 1503. If he went to Italy with Charles VIII, he almost certainly

[1] See above, p. 80.
[2] See above, pp. 83–84.

returned with him, for as a partisan of the French he could not safely have remained in Naples after its re-capture. In any case this Neapolitan noble, who was a diplomatist and man of affairs by profession, but who also enjoyed a considerable reputation as an historian and orator, and more especially as a sculptor and medallist, was a prominent person at the French Court, and an important agent in the introduction of Italian culture to France[1]. It has been seen that his defection from the service of Burgundy to that of France probably took place in 1482 or 1483[2]. On the accession of Charles VIII he offered to the young king a Compendium of French history from its earliest beginnings[3]. He was rewarded by being made a member of the Council, and in 1491 he took part in an important embassy to Pope Alexander VI. He had formed close relations with the powerful financial family of Briçonnet, and it was doubtless by their advice that in 1504 he began to pay court to the young Count of Angoulême, now the next heir to the throne, and his mother, Louise of Savoy. But he did not live to reap the fruits of his policy, for he died soon after this date.

After the Expedition of Charles VIII the small band of eminent Italians resident in France received notable accessions in the sculptor, Guido Mazzoni, the architects, Fra Giocondo and Domenico da Cortona, and the eminent Greek scholar, Janus Lascaris.

Finally, among the Italians who took service with Charles VIII must be mentioned the Neapolitan, Michele Ricci or Rizzi. Of considerable repute as an orator, he filled in the next reign several important posts, and was employed on various diplomatic missions. He was a member of the Great Council, President of the *Parlement* of Provence, and a Councillor of the *Parlement* of Paris. Two Latin treatises from his pen met with some success. One was a compendious account of Christian monarchs in

[1] See H. de La Tour, *Jean de Candida*, 1895.
[2] See above, p. 86.
[3] It begins in fact with Priam.

general, *De regibus Christianis*[1]; the other dealt in an
equally summary fashion with the Kings of France, Spain,
Jerusalem, Naples and Sicily, and Hungary[2]. He also
wrote a Latin apology for the conquest of Naples by
Charles VIII, which has never been printed[3].

The Italians whom Louis XII introduced to France
were of no particular eminence. Gianfrancesco Quinziano
Stoa of Brescia was a Latin scholar and poet of considerable
pretensions, but slender merit[4]. Ludovico Heliano of
Vercelli, another poet, was a doctor of canon and civil
law, and represented Louis XII at the Diet of Augsburg in
1510, when he delivered an harangue against the Venetians.
In fact it was as " orators " that these Italians were chiefly
found useful, for at this date there were few Frenchmen
capable of making a Latin speech which would pass muster
with the critical audiences of Italy. Another service which
Heliano performed was to write a treatise, *De optimo principe
instituendo*, for the benefit of François d'Angoulême[5].

The king was not the only patron who invited distin-
guished Italians to France. It was to decorate Cardinal
d'Amboise's château at Gaillon that Andrea Solario came
from Milan, and it was at Gaillon that the sculptor, Antonio
Giusti, first found employment in France. A little before this
his brother Giovanni executed the tomb of Thomas James,
Bishop of Dol, by order of his nephews. Next to nothing
is known about the sojourn of Benedetto Ghirlandaio in
France, but he evidently worked for some prince of the
house of Bourbon. Lastly the illustrious humanist and

[1] Badius, 1507.

[2] Basle, Froben, 1517.

[3] See Jean d'Auton, *op. cit.* I. 273 a^1; La Croix du Maine; Struve,
VI. i. 117, and VII. i. 4.

[4] His writings include *Christiani Opera, Disticha in omnes fabulas
Ovidii*, a tragedy on the Passion, and *Orphei libri tres*.

[5] The MS. is in the library at Bourges (Giraudot, *Cat. des manuscrits
de la bibliothèque de Bourges*, 1859, p. 90). For Heliano see *Bull. de la
soc. des Antiquaires de France*, 1864, pp. 149–153. He lost all his property
in the war with Naples. One of his patrons was Gilbert, Comte de
Montpensier.

author of the *Arcadia*, Jacopo Sannazaro, came to France in 1501. He came at the invitation of no patron and with no thought of professional advancement, but in order to share the exile of his master, Federigo III, the ex-King of Naples. He lived with him, first in Anjou, and then at Tours, till his death in 1504, when he returned to Naples.

PART II

THE RENAISSANCE IN LETTERS

CHAPTER VI

THE STUDY OF LATIN [1]

I. *Robert Gaguin* [2]

WHEN Charles VIII returned from his Italian expedition in November 1495, the recognised leader of Humanism in France was Robert Gaguin, General of the Order of the Trinitarians or Mathurins [3]. He had just published his most important work, a Latin *Compendium* of French history from the earliest times to the close of the reign of Louis XI. He was now an old man, and in failing health,

[1] For this and the next three chapters P. S. Allen's monumental edition of Erasmus's letters, *Opus Epistolarum Desiderii Erasmi*, 3 vols. (in progress), Oxford, 1906–1913 ; Ph. Renouard, *Josse Badius Ascensius*, 3 vols. 1908 ; and L. Delaruelle, *Guillaume Budé*, 1907, have been of the greatest service. The last-named volume contains the best existing sketch, *Les précurseurs*, of the first beginnings of Humanism in France.

[2] The chief authority for this section is *Roberti Gaguini epistolae et orationes*, ed. L. Thuasne (with very full and admirable notes), 2 vols. 1904. Another contemporary authority of a general character is Trithemius [Johann of Tritheim or Trittenheim (1462–1516)], *De scriptoribus ecclesiasticis*, Basle, 1494 ; Paris, Rembolt, 1512, with a supplement (*additis nonnullorum ex recentioribus vitis*), which according to the 1546 edition was written in Paris ; Cologne, 1531 ; Cologne, 1544, with a second supplement (*Additio II*), by Balthazar Werlin of Colmar. I have chiefly used this last edition. Trithemius's information is by no means always accurate, and must be recieved with caution. For Gaguin's life see also P. de Vaissière, *De R. Gaguini vita et operibus*, Chartres, 1906, and *Gallia Christiana*, VIII, col. 741 (a notice by Jacobus Burgensis, Principal of the Trinitarian order for Picardy). For the bibliography of Gaguin, Pierre de Bur, and Pierre van der Brugge (Petrus de Ponte) see *Bibliotheca Belgica*.

[3] *Quo uno litterarum parente antistite principe Francia non iniuria gloriatur* (Erasmus to Henry of Bergen, November 7, 1496—Allen, I. 262).

but his zeal for learning and his devotion to the interests of his Order and his University had in no way diminished. Born in Artois at Calonne-sur-le-Lys, of French descent, his first studies were carried on in the Monastery of Préavin, a Flemish house of the Trinitarians. He was twenty-four years of age and in priest's orders when in 1457 he became a student of the University of Paris, and it was soon after this that he attended the lectures of Gregorio of Città di Castello on Greek and rhetoric[1]. As far as Greek was concerned he learnt little more than the alphabet, but the lectures on rhetoric taught him to appreciate the merits of Latin classical style. His interest was further stimulated by the arrival in Paris at the close of 1459 of Guillaume Fichet, who, though just his own age, became his teacher as well as his friend. His classical studies suffered many interruptions, for his practical gifts caused him to be frequently employed on the affairs of his Order. But he found time to make copies of the *Aeneid*, Suetonius, and Cicero's *Verrines*, and he assisted with his encouragement and advice the work of establishing the Sorbonne press. In 1465 he paid a visit to Northern Italy[2], Germany, and Spain on business connected with his Order, and it was probably similar business which took him to Rome in 1471, where Cardinal Bessarion, to whom Fichet gave him a letter of introduction, received him with great kindness. In the following year, as we have seen, Fichet's mantle descended on his shoulders, and in 1473 he began definitely to carry on Fichet's work by lecturing on rhetoric.

For the first four centuries after the schools of Charles the Great had revived the study of classical Latin in France, grammar and rhetoric had formed an integral part of education. Grammar included, besides the learning of grammatical rules, the reading of classical Latin authors by way of illustration. Rhetoric meant the study of the rules of Latin composition, generally with the help of some formal treatise, such as the *Topica* or the *De inventione* of Cicero or the

[1] See above, p. 89.
[2] Apud Ligures Tuscosque (Thuasne, I. 181).

spurious *Rhetorica ad Herennium*[1]. As the result of these studies the writing of Latin gradually improved, and by the twelfth century there were not a few writers living or educated in France who could express themselves in correct and forcible Latin. Their style was not classical either in construction or in vocabulary, but this was not because they did not study classical authors. It rather arose from the nature of the subjects that they handled, which were chiefly theological and philosophical, and partly because being great writers they strove to express their own personality. Such men were Hildebert of Le Mans, Abélard, Hugo of Saint-Victor, Bernard of Clairvaux, Alain of Lille (Alanus de Insulis) and John of Salisbury[2].

But already in the middle of the twelfth century we find the last-named writer attacking certain Paris teachers who neglected the Latin poets for dialectic and philosophy. The reign of the Schoolmen was fatal to Latin composition. Forced to express highly abstract ideas, for which the genius of the Latin language is not too well suited, and no longer sustained by a natural sense of literary form, or by the study of classical models, Latin style rapidly deteriorated. The great Schoolmen of the thirteenth century, above all, Thomas Aquinas, wrote at any rate with lucid dignity, but in the hands of Scotus and Occam, largely owing to the increased prominence which they gave to logic, Scotus by exalting it above all other philosophical studies, Occam by excluding metaphysics from the field of speculation, style became obscure as well as bald. Finally when Occam's death, which took place shortly before 1350, brought the great age of Paris scholasticism to a close, and no fresh movement took its place, Latin composition was more and more neglected. Grammar was reduced to the mere learning by rote of

[1] See J. B. Mullinger, *The Schools of Charles the Great*, 1877 See also, John of Salisbury, *Metalogicus*, lib. I. c. xxiv, for an account of the teaching of Bernard of Chartres.

[2] See H. O. Taylor, *The Mediaeval Mind*, 2nd ed. 1914, II. c. xxxi. As Hildebert was born about 1055 and Alain de Lille died in 1202 or 1203 these names between them cover the whole twelfth century.

grammatical rules, and rhetoric practically disappeared[1]. Thus Latin writing became as barbarous in style as it was feeble in thought.

The revival of Latin style was not the least important of the aims of the humanists. It was one of those obvious reforms which are most readily communicated from one mind to another, and from one country to another. It therefore naturally formed the starting-point of French Humanism. Though grammar and rhetoric still bore in the strict sense the meaning ordinarily attached to them, in the humanistic scheme of education they easily shaded into one another, and lectures on classical authors in the University of Paris might be indifferently termed lectures on grammar or lectures on rhetoric. Both subjects were preliminary to, and not part of the course in Arts, and those who lectured on them were termed either "grammarians" like their pupils, or "poets."

That Gaguin's lectures were especially concerned with Latin composition we may infer from the fact that under the influence of Fichet he was much interested in the improvement of the style of Latin prose, and that in the same year (1473) in which he began to lecture he published a short treatise on Latin versification[2]. It is worthy of notice that in the list which he gives of Latin classical poets the only absentees are Calpurnius Siculus, Valerius Flaccus, Claudian, and Rutilius, and that he includes in it various Christian poets from Prudentius to Petrarch. He, however, advises that pupils in their tender years should be imbued with the best authors[3].

Soon after the completion of this treatise he was elected General of his Order (May 16, 1473), which left him still less time for study. Moreover, his reputation as an orator, and his conciliatory temper and manners led to his

[1] Under the name of rhetoric students learnt how to address letters to persons of title.

[2] Keysere and Stoll, c. 1474.

[3] This treatise was reprinted six or seven times before the end of the century. It is variously called *Ars versificandi*, *Ars versificatoria*, and *De arte metrificandi*.

employment in the larger arena of the state. Louis XI sent him to Germany in 1477, but, this mission proving a failure, he did not employ him again. In the next reign, however, his services as a diplomatist were in constant demand. In 1484 he formed part of a mission to the new Pope, Innocent VIII, and in 1486 he was one of the ambassadors sent to Florence and Rome to support the claims of René II of Lorraine to the kingdom of Naples[1].

In 1489 he was one of three ambassadors sent to Henry VII with proposals for a treaty of peace and alliance. For Charles VIII was already meditating his campaign against Naples, and was anxious to secure the neutrality of England. Though Gaguin was "third in place," says Bacon in his *History of King Henry the Seventh*, he "was held the best speaker of them." Bacon gives a translation of his speech. The negociations which followed these overtures brought more work to Gaguin, and in May 1490 he was sent to Tours as one of the French plenipotentiaries for the ratification of a truce for some months between France and England. Among the English ambassadors were Bishop Fox, the founder of Corpus College, Oxford, and William Tilley of Selling, Prior of Christ Church, Canterbury, the parent of English Humanism. Gaguin struck up a friendship with the latter, and sent him two years later a copy of his Latin poem on the Immaculate Conception of the Virgin[2].

His next mission brought him into relations with the German humanists, for in January 1492 he was sent to the Elector Palatine at Heidelberg to justify the marriage of Charles VIII with Anne of Brittany. This was no easy task, for the French King had repudiated the Emperor's daughter as well as robbed him of his bride. This double insult had aroused great indignation in Germany, and Jacob Wimpheling, who was an ardent patriot as well as a humanist, expressed this feeling in a Sapphic ode, which he sent to Gaguin. Nor was his wrath softened by a personal

[1] Thuasne, I. 58 and 64.
[2] *Id.* I. 383.

visit which the French ambassador paid him at Speyer[1]. On his way home Gaguin visited another German humanist, the illustrious abbot of Spanheim, Johannes Trithemius. He was coldly received by Charles VIII on his return, and in a letter to his friend the Chancellor, Guy de Rochefort, he complains that the gout is his only reward for all his labours[2].

This was the prelude to a long illness, which kept him more or less a prisoner for the next eighteen months, but which also gave him leisure for literary work. Seven years before this he had made a translation of Caesar's *De bello gallico*, and had presented it with a dedication to Charles VIII[3]. He now translated the third decade of Livy, prefixing to it another dedication to the king, most of which is repeated from the earlier one[4]. A French translation of Livy already existed, namely that made by Pierre Bersuire in 1356, and had been printed by Verard in 1486–1487. It was perhaps for this reason that Gaguin's new version of the third decade, which was entrusted to the same publisher, did not appear till 1498[5].

In making translations of Roman historians Gaguin was training himself for a more important work which he had been meditating for nearly twenty years, and for which he had long been collecting materials. In a letter to the then Chancellor, Pierre Doriole, which M. Thuasne assigns with some plausibility to 1476, he regrets that no Frenchman had been found to write a history of his country in the Latin

[1] See *Disceptatio oratorum duorum regum Romani scilicet et Franci super raptu illustrissime ducisse britannie* (printed, probably at Heidelberg, soon after the date of the contents, February 12–14, 1492). It contains Gaguin's reply, and a second letter with an elegiac poem from Wimpheling.

[2] Thuasne, I. 379.

[3] Printed by Pierre Levet, probably soon after the presentation to Charles VIII in 1485. See Claudin, *Hist. de l'imprimerie en France*, I. 417–424.

[4] For the dedications see Thuasne, II. 299 ff. and 310 ff.

[5] Gaguin presented an illuminated copy on vellum to Charles VIII (Van Praet, v. 55). The work, therefore, must have appeared before the king's death, but as it was published by Verard *devant notre dame de Paris*, the date cannot be earlier than 1498, the year in which Verard went to live in the Rue du Marché-Palu.

tongue, so that the memorable deeds of their ancestors might be made known to other nations, and he calls on the Chancellor to urge the king (Louis XI) to select some man for the task[1]. Nothing, however, came from this suggestion, and it was left to Gaguin to carry out the work on his own initiative. It appeared in 1495 under the title of *De origine et gestis Francorum Compendium*, the printer being Pierre Le Dru[2]. At the end of the volume was a laudatory epistle from Erasmus, who had quite recently come to Paris, and who was no doubt glad of an honourable occasion to make known to the world his learning and his Latinity. For this was the first product of his pen to appear in print. In flowing and well-turned commonplaces he praises the author's trustworthiness and learning (*fides et eruditio*), and the purity of his style, which, he says, combines " the elegance of Sallust with the felicity of Livy." As a matter of fact, the style cannot be described as pure, for Gaguin was far from being a finished Latinist, but it shews a careful study of the chief writers of Latin prose, of Cicero, Caesar, Livy, and Sallust. Gaguin's ideal is evidently the concision of Caesar and Sallust rather than the rhetorical amplitude of Cicero or the flowing abundance of Livy. Indeed in his efforts to be concise, though he is often nervous and forcible, he is sometimes obscure. This latter defect, however, is partly due to his incorrect Latin.

But, whether deserved or not, he must have been gratified by Erasmus's praise of his style, for, like all the humanists of his day, he attached great importance to the cultivation of a good Latin style. In a letter to Erasmus, written apparently on October 1495, not many days after the publication of the *Compendium*, he says that those only have acquired literary fame who have united eloquence with learning[3],

[1] Letter no. 23 (Thuasne, I. 252 ff.).

[2] It was written *anno uno a me graviter egrotante* (Thuasne, II. 39), and *noctu maxime, cum quieti non daretur locus* (*ib.* 41). The colophon has *nonagesimo nono*, but *nono* is corrected to *quinto* in the *Errata*.

[3] Thuasne, II. 10; Allen, I. 152. The month-date given by M. Thuasne is, he informed Mr Allen, obtained from a manuscript note in a contemporary hand in a copy of Bocard's edition of Gaguin's *Epistolae*.

and in his earlier letters he frequently expresses similar views, regretting that in the University of Paris the study of rhetoric was overshadowed by that of scholastic philosophy[1].

Gaguin's *Compendium* was the first attempt to write a history of France in a more critical spirit and in a more elevated style—*cum aliqua maiestate* is Gaguin's own expression—than that of *Les grandes chroniques*. But the greater part of his work is little more than an abridgement of its predecessor, with a few additions and corrections from other sources[2]. From the reign of Charles VI onwards the narrative is told at greater length, and that of Louis XI derives interest and importance from the fact that it treats of events within the writer's memory. Though Gaguin does not sufficiently appreciate the statesmanship of that astute monarch, he is in other respects not unfair to him. Finally it says something for his critical faculty that after relating the universally accepted tradition of the Trojan origin of the Franks he proceeds to throw doubt upon it.

The first edition of the *Compendium* was so badly and incorrectly printed that Gaguin determined to publish a new one, and entrusted the printing of it to Jean Trechsel of Lyons. It appeared in June 1497, the work having been supervised by Josse Badius Ascensius, who was at this time manager at Trechsel's press, and already of considerable repute as a scholar. A third edition was issued at Paris by André Bocard in March 1498[3]. In the summer of the same year Gaguin brought out a collected edition of his speeches and letters[4]. Again the work was so badly done that it had

[1] *E.g.* in a letter to Beroaldo (Thuasne, I. 282 ff.).

[2] *Feci ex longa hystoriarum serie epythoma* (Gaguin to Laurent Bureau, Thuasne, II. 41).

[3] March 31, 149$\frac{7}{8}$. This explanation of these two editions, put forward by D. Clément (in *Bibliothèque curieuse*, IX. 10–13, Leipsic, 1760), and adopted by Mr Allen (I. 148), is clearly the right one. In a letter to Pierre de Bur (Thuasne, II. 42) Gaguin refers to the publication of a third edition, but the letter is only dated June 27, without the addition of the year.

[4] *Epistole et orationes Gaguini.* Printed for Durand Gerlier by Felix Baligault after July 18, 1498.

to be done over again, and a new edition was issued in November, which also included some Latin poems and other pieces[1].

This volume may be regarded as a recognition of Gaguin's merits as a humanist, or, at least, as his claim to such recognition. It will, therefore, be well at this point to consider how far the claim was justified. He was certainly neither a man of profound learning, nor an accurate scholar. Indeed, he was quite conscious of his own defects, and recognised that his busy life, his constant employment on the affairs of his Order, his University, and the State, had left him little leisure for his favourite studies. His most important literary undertaking, the *Compendium*, had been written during the forced inaction of an illness, and chiefly at night when he could not sleep. Beatus Rhenanus, who came to Paris in 1503, says of him that "being much employed in embassies to foreign powers, and not being perfect in his scholarship, he did not teach publicly." By this he means that Gaguin had ceased to lecture on rhetoric, for he continued to lecture on canon law till nearly the end of his life.

But if Gaguin was not a great scholar, he rendered great services to Humanism in France. For five and twenty years he was the leader of the small band which kept alive the flame of Humanism in the University of Paris. His reputation as a diplomatist, his proved capacity for affairs, and his high character, gave dignity and stability to the cause. His cautious and conciliatory bearing, his enthusiasm and warmheartedness, and above all his ready kindness to younger men, especially to those who were promising scholars, extended and strengthened his influence. It was no small advantage to French Humanism at this early stage of its development that its chief representative, not only in Paris, but in France, should have been a man of sense and character, a man of wide interests and sympathies, and, not least, a patriot. If his own learning and scholarship were deficient, his ideals were sound, and his conception

[1] Printed for Gerlier by André Bocard.

of Humanism was no narrow one. It is true that, like all the humanists of his day, he exaggerated the value of writing Latin verse and prose, but he was very far from limiting his aims and interests to this accomplishment. We have seen that he attached great importance to history. He was interested also in philosophical questions. We find him writing to Marsilio Ficino and telling him that his name was beloved and honoured in the Paris schools by both professors and students, and that his works were read and highly valued[1].

This was not merely the language of compliment, for editions of Ficino's *De triplici vita* were printed about this time at Paris and Rouen[2], possibly at the instigation of Germain de Ganay, who had requested Ficino to send him copies of his works[3]. Gaguin had doubtless made Ficino's acquaintance on the occasion of his embassy to Florence in 1486. He was already known to one member of the Florentine Academy, namely Pico della Mirandola, who had been in Paris from July 1485 to April 1486, and had made many friends there. Mindful of this friendly reception, when he was condemned by the Papal Bull in the following year, Pico turned his steps again to Paris, but having been arrested *en route* by the Pope's orders, he arrived at the French capital as a prisoner, and was detained for a month in the keep of Vincennes[4]. Gaguin evidently cherished a warm admiration for Pico. He translated his well-known letter to his nephew and biographer[5], and in the very brief account of the Expedition to Italy that is given in the

[1] September 1, 1496 (Thuasne, II. 20).

[2] Paris for Jean Petit, s.d.; G. Wolff [*circ.* 1495] (Camb. Univ. Lib.); Rouen, Regnault, Violette, and Harsy. See Pellechet, 4795–4797.

[3] Delaruelle, *G. Budé*, p. 88.

[4] L. Dorez and L. Thuasne, *Pic de La Mirandole en France*, 1897.

[5] *Conseil profitable contre les ennuis et tribulations du monde*, Paris, Guy Marchand (Proctor, 8006). Gaguin's preface is dated April 19, 1498. Brunet mentions an edition by J. Trepperel of 1498, and the *Bib. Nat.* has a copy of a third edition (see Harrisse, *Excerpta Colombiniana*, p. 148). Pico's letter was translated into German by Wimpheling in 1509, and into English by Sir T. More about 1510 (reprinted from the original edition of W. de Worde by J. M. Rigg, 1890).

Compendium he finds room to record his sudden death, describing him as " an illustrious philosopher, a most famous orator, and a learned scholar in several languages."

Unlike the great majority of the Italian scholars and of the French scholars of the next generation, Gaguin did not disdain to write in his native language. If his French poems shew no more feeling for classical beauty of style and form than those of the ordinary fifteenth century poet, they have a certain power of forcible and picturesque expression and one, at least, *Le debat du laboureur, du prestre et du gendarme*, which is probably to be assigned to the close of Louis XI's reign, gives, in the form of a debate between a labourer, a priest and a soldier, a remarkable picture of the condition of the kingdom at a time when it had not yet recovered from the devastating effects of foreign conquest, civil war, and anarchy[1].

As regards Gaguin's prose style his translation of Livy shews an improvement on that of Caesar. It is true that there is more pretension to style in the latter, but the sentences are longer and more complicated. Livy, on the other hand, is rendered into simple and clear language without any attempt at grandiloquence or rhetoric.

Among the services which Gaguin rendered to his Order and at the same time to the cause of Humanism in Paris was the construction of a library over the cloister of the Mathurin monastery with money which he had obtained by subscription from the Sorbonne and other bodies. The collection of manuscripts and books grew to considerable proportions, and was extremely useful to Paris students[2]. As General of the Order Gaguin seems to have had power

[1] Thuasne, II. 350 ff. from the only known copy, which passed from the Sunderland library to that of Baron James de Rothschild. It was printed about 1490. The longer, but less interesting, poem, *Le passetemps d'oysivité*, was written in London at the close of 1489 when Gaguin was ambassador to this country. It is also in the form of a debate, the disputants being the author and the Chester (Sestre) Herald (Sir Thomas Whiting), and the subject being the comparative merits of war and peace. It is printed by M. Thuasne (II. 366 ff.), from the only known copy, which is in the library of the Arsenal.

[2] Thuasne, I. 30.

to lend the books at his pleasure. We have two letters
from Erasmus, written in March 1500, just before he
brought out the first edition of his *Adagia*, in one of which
he asks for the loan of a Macrobius, and in the other for a
Quintilian and a treatise on rhetoric by George of Trebizond.
" I do not ask," he says, " whether you have the book, as I
know that no good authors are absent from your shelves[1]."

It is in the circle of Gaguin's friends that we must look
for the chief supporters of Humanism in France. One of
the most intimate was the king's confessor, Laurent
Bureau. Like Gaguin he had risen from humble beginnings,
having received his first education in a Carmelite convent
at the expense of a lady whose interest he had aroused.
After making his profession at Paris, he acquired a high
reputation for learning, and travelled in Italy. It was
from his copy of Beroaldo's *Orationes* that Trechsel printed
at Lyons in 1492 the first work which Badius edited for his
press. On the death of Charles VIII he became confessor
to his successor, and in the following year (1499) Bishop of
Sisteron. He died in 1504[2].

Gaguin also counted among his friends and supporters
Angelo Cato, the Archbishop of Vienne, of whom mention
has been made in an earlier chapter[3], and Louis de Roche-
chouart, Bishop of Saintes, who was something of a Latin
poet and the possessor of a library of two hundred volumes,
but who is chiefly notable for his learned account of a journey
to the Holy Land which he made in 1461[4]. To these must
be added Louis de Beaumont de La Forêt, Bishop of Paris,
and Tristan de Salazar, Archbishop of Sens, who was Gaguin's
colleague at Tours on the occasion of the ratification of the

[1] Allen, I. 283–284, and cp. p. 195.

[2] Thuasne, II. 40, n. I. Badius dedicated to him an edition of Baptista
Mantuanus's *Parthenica Mariana* (1490), and in the preface to the same
writer's *De calamitatibus* refers to him as *fautor noster praecipuus* (Renouard,
II. 158 ff., 101 ff., 107).

[3] See above, p. 84.

[4] See C. Couderc, *Journal de voyage de Jerusalem de Louis de Roche-
chouart*, 1893; Thuasne, I. 228, n. I. Three of Gaguin's letters, nos. 13–15,
are addressed to him.

truce with England. Both these prelates shewed their interest in Humanism by ordering copies of Greek manuscripts from George Hermonymos[1].

Passing from the Church to the Law, we find among Gaguin's friends and correspondents the Chancellor, Guillaume de Rochefort, who died in 1492. Of an old Burgundian family, he had, like so many others, left the service of Charles the Rash for that of Louis XI. He ranked high as an orator, was a man of literary tastes, and a good patron of artists and scholars[2]. His younger brother, Guy de Rochefort, who was Chancellor from 1497 to 1508, was also a man of learning and a friend of Gaguin's. Balbi and Andrelini dedicated works to him, and Budé in his *De Asse* writes a warm panegyric on his attainments[3]. Another lawyer, Pierre de Courthardy, First President of the *Parlement* of Paris from 1497, and of considerable reputation as an orator, though he does not figure in Gaguin's letters, was in friendly relations with several of his brother humanists. Charles Fernand, Andrelini, and others addressed to him dedications and verses, and Andrelini wrote his funeral elegy (1505)[4].

He was succeeded as First President by Jean de Ganay, who was keenly interested in various branches of learning, and was himself of some distinction as a humanist and mathematician. He accompanied Charles VIII on his expedition to Italy, and rendered considerable service by his knowledge of Italian geography. In 1508 he was appointed Chancellor in succession to Guy de Rochefort. Budé dedicated to him his first important work, the *Annotations to the Pandects* (1508), and Guillaume Cop his edition of Hippocrates's *Prognostics*

[1] For Salazar as a patron of art see above pp. 151-152.

[2] Thuasne, I. 292, n. I. See letters 34, 40, 45, 50, 60, 63.

[3] Thuasne, II. 63, n. I. He died January 15, 150⅞ (see *Anciennes poestes françaises*, II. 157), Robert Briçonnet, Archbishop of Reims, and Chancellor between the two Rocheforts (1495–1497), if not a man of learning himself, was at any rate a patron of it.

[4] [Dom Liron] *Singularités historiques et littéraires*, I. 275–283 ; Delaruelle, *G. Budé*, p. 15, n. I. Budé dedicated to him his Latin translation of Plutarch's *De placitis*. See also H. de La Tour, *op. cit.* pp. 100–104, *à propos* of a medal of Courthardy by Giovanni di Candida.

(1511)[1]. His brother, Germain de Ganay, began his career as a lawyer and was made a councillor of the Paris *Parlement*. Then, having taken Orders, he became successively Canon of Bourges, Bishop of Cahors (1509), and Bishop of Orleans (1514). He took an interest in Neo-Platonic philosophy and in the mystical science of numbers, corresponding on these subjects with Ficino and Trithemius. He was also a liberal patron of learning, accepting numerous dedications and shewing open hospitality. Among those who profited by his liberality were Lefèvre, Budé, Josse Badius, and Geofroy Tory[2].

Another distinguished patron of Humanism who left the Law for the Church was Étienne Poncher. Beginning his career as President of the Court of Inquests, he ended it as Archbishop of Sens. He was made Bishop of Paris in 1503, and shortly afterwards accompanied Louis XII to Milan, where for a year he filled the posts of President of the Senate and Chancellor of the Duchy. During the two years' interregnum in the Chancellorship of France which followed the death of Jean de Ganay he was Keeper of the Seals. He made excellent use of his position as Bishop of Paris to further the cause of learning, and Erasmus, Budé and the other French humanists are never weary of singing his praises. "Happy and thrice fortunate would France be," says Germain de Brie, "if she had ten such Maecenases[3]." Yet another lawyer who favoured the new studies was Charles de Guillart, one of the Masters of Requests, and Fourth President of the Paris *Parlement*. He was in Milan at the time of the surrender of the city to the French[4].

These patrons played an important and useful part in the encouragement of Humanism. One of their functions was to accept the dedications and poems that were addressed

[1] Delaruelle, p. 95, n. 3.

[2] In the preface to an edition of Petrus Crinitus's *De honesta disciplina*, Badius speaks of Germain de Ganay's dinner-parties, *honestissimo cuique patentia*, at which every kind of learned topic was discussed (Renouard, II. 351). See also Dom Liron, *op. cit.* III. 45; Delaruelle, *G. Budé*, pp. 87, 88.

[3] Allen, II. 531 and cp. Budé's praise, *ib.* 447.

[4] Hauréau, *Hist. litt. du Maine*, VI. 45–50.

to them, and to reward the writers either with a present of money, or better still, with a post in their household. Often they were men of learning themselves, though it must be admitted that in some cases the evidence for their learning rests chiefly on the above-mentioned dedications and poems. But at any rate the business of patronage was carried on in France with decency and dignity, and there was none of that sordid traffic in immortality, that mixture of panegyric and blackmail which characterises the Italian Renaissance, and which Filelfo and his fellows practised with such abominable skill.

We must pass on to those among Gaguin's friends and correspondents who were actual workers in the cause of Humanism. His correspondence has something of an international character. Some of it, indeed, is concerned purely with the business of his Order, but among his private correspondents, besides Trithemius and William Tilley of Selling, of whom mention has already been made, we find Roger de Venray, a native of the Low Countries, who had become an Augustinian Canon in a monastery near Worms[1], and Arnold Bost, a Carmelite monk at Ghent, to whom four letters are addressed. Bost had a great reputation, both for learning, and as a writer of Latin verse and prose. But he was chiefly remarkable for his stimulating effect on others. Like Roger de Venray, he corresponded with scholars of all nations, and in the words of their common friend Trithemius "incited many to the study of literature[2]."

Among Gaguin's Paris friends one of the most intimate was Charles Fernand, a professor at the college of Boncour. He was a native of Bruges, and came of a noble Spanish family. He edited Seneca's *Tragedies*[3], and had a considerable reputation as a writer of Latin prose. In 1491 he dedicated

[1] Thuasne, II. 49.

[2] Thuasne, I. 312 ; Trithemius, *De script. eccl.* and *Carmelitana Bibliotheca* (Florence, 1593). Bost was born in 1450 and died in 1499.

[3] Dedicated to Pierre de Courthardy ; printed by Higman, Hopyl and Probst, *circ.* 1488. There is a copy of this rare volume in the Cambridge University Library.

to Gaguin a collection of his letters[1]. It was reprinted in
1500, and again in 1506. He was a musician as well as a
scholar, and held the post of first musician to Charles VIII.
But about the year 1492, when he was a little over thirty, he
resigned his professorship at the University, and retired to
the Benedictine monastery of Chezal Benoît near Bourges[2].
His example was followed in 1494 by his brother Jean, who
was also a professor in the University and a musician of the
Chapel Royal. We hear of his lecturing on Terence, and of
his introductory lecture being attended by Gaguin, Guy de
Rochefort, and Angelo Cato[3].

The two Fernands had been moved to enter the Bene-
dictine Order and to quit the University for the cloister
by the influence and example of their friend and colleague
Guy Jouennaux, better known as Guido Juvenalis. Born
of poor parents at Le Mans, he entered the University of
Paris at an early age, and after taking his degrees made for
himself a considerable name as a lecturer on rhetoric. His
commentary on Terence, first published in 1492, went through
at least five other editions before the close of the century[4],
and his abridgement, with a commentary, of Valla's *Ele-
gantiae* (1490) became a favourite text-book in several
Universities[5]. He also published (1499) *Epistolae*, or models
of Latin epistolary style with French translations, which
was re-issued in 1500 and again in 1516[6].

In the reformed statutes which Cardinal d'Estouteville
made for the University of Paris in 1452, he urged that
greater attention should be paid to the writing of Latin
verse. Partly perhaps as the result of this stimulus, but

[1] *Caroli Fernandi brugensis musici regii ad doctissimum virum dominum Robertum gaguinum—Epistolae familiares* [Antoine Caillaut].

[2] In 1512 he published *De animae tranquillitate libri duo*, a justification of monastic life. In 1509 he moved to Le Mans and died there in 1517.

[3] For Charles and Jean Fernand see *Biog. Nat. de Belgique*; Thuasne, I. 327, n. 10, and 387, n. 4; Delaruelle, *G. Budé*, p. 18; Renouard, II. 437–442. Their family name is said to have been Frenand, which they changed to Fernand.

[4] Lyons, 1493, 1495, 1497; Strassburg, 1496, 1499.

[5] Reprinted, 1492, 1497, 1498, 1500.

[6] See P. Hauréau, *op. cit.* VI. 186–191; Dom Liron, III. 41 ff.

chiefly, no doubt, in imitation of the Italian humanists, Gaguin and his friends cultivated the art with considerable assiduity. Their chief poet was Pierre de Bur or Burry, whom his admirers proclaimed to be almost the equal of Horace. His family came from Noyon in Picardy, but he was born at Bruges. After taking his degrees at Paris, and spending seven years (1468–1475) in Italy, he returned to Paris and became in great demand as a tutor in noble families. He was a Canon of Amiens, but he seems only to have resided there occasionally. He was an old and intimate friend of Gaguin, who dedicated to him his *Compendium*. A very large proportion of his Latin verse that has been printed is of a religious character, consisting of hymns, canticles, moral poems, and paeans in honour of the Virgin. None of it appeared in print till a year before his death, when Badius Ascensius brought out a volume entitled *Moralium Carminum Libri novem* (1503). The manuscript was furnished him by Bur's friend Pierre Joulet, who professed to have stolen it, but who was doubtless forgiven for his "pious theft," as Badius calls it, when the author saw his verses in the glory of print and provided with summaries and notes by the learned publisher. Of the nine books, four consist of odes written in a great variety of metres, one of hexameters, one of apologues (in elegiacs), two of elegies, and one of epigrams, of which the third is addressed to Gaguin[1].

Gilles de Delft (Aegidius Delphus) also was a prolific composer of Latin verse and prose. But his fluency, which

[1] For P. de Bur—this is the form of the name adopted in the Catalogue of the *Bibliothèque Nationale* (1430–1504)—see Trithemius, *De script. eccl., Additio I*, who gives the title of 30 of his works ; Foppens, *Bibliotheca Belgica*, Brussels, 1739, II. 959; Paquot, *Mémoires pour servir à l'hist. litt. des Pays-Bas*, 14 vols. Louvain, 1763–1768, XIV. 256 ff; Thuasne, I. 258, n. 3; Renouard, II. 241–253, III. 469. In the last Stanza of his last Ode (fo. XCII, V°) written for January 1 (1502, or at latest 1503), he gives his age as 75, and I see no reason for doubting this. I quote the stanza, which will serve also to illustrate his Muse.

> Si noles aeuum numerare nostrum
> Septuaginta cumulato messes :
> Iis tamen lustrum superadde, vixi
> (Crede) tot annos.

enabled him to write paraphrases in verse of the Epistle to the Romans and the seven penitential Psalms, was attained at the price of carelessness. He was a doctor of the Sorbonne (1492), and produced numerous works bearing on the studies of the University, while a commentary on Ovid's *De remedio amoris*, testifies to his interest in the lighter and more profane side of literature[1]. He must not be confused with Martin de Delft, who, like his compatriot, was a doctor of the Sorbonne, and, like him, filled the offices of Procurator of the German Nation and Rector of the University. He had a considerable reputation as a theologian, and he wrote a treatise on the Art of Oratory, which has been lost, but to which Gaguin refers in a letter addressed to him. Both he and Gilles died in the same year, 1524[2].

There are no extant letters from Gaguin to his friend Nicolas Ory, Canon of Reims[3], but two from Ory to Gaguin are included in the latter's correspondence. Ory's printed work consists of seven books of verse and fifteen books of prose, of which five books of the verse and nearly all the prose, except the letters, are of a religious character. The verse is full of elementary mistakes both in language and prosody. The two books of secular verse contain poems addressed to Gaguin, Tardif, and Balbi, and what is more interesting, to Guillaume Coquillart, the poet and ecclesiastical lawyer, who was, like Ory, a Canon of Reims. There are letters to Jean de Ganay, Pierre de Courthardy, Charles Guillard, Fausto Andrelini, and, as has been said, to Gaguin[4].

[1] Gyraldi, *De poetis nostrorum temporum*, ed. K. Wotke, Berlin, 1894, pp. 26, 95 ; Foppens, I. 29 ; Renouard, *op. cit.* II. 376 ; Claudin, I. 97 ; Allen, I. 234, II. 323. His Dutch name was Gillis van Delft (*Biographisch Woordenbook der Nederlanden*). Erasmus says of him: *Totum ferme divinae Scripturae corpus carmine complexus est* (Allen, II. 323).

[2] Thuasne, I. 379, n. 2, and letters nos. 64 and 65.

[3] *Quam sim canonicus ipse receptus ego* (to Coquillart, fo. III. r°).

[4] *Nicolai horii Remensis praefecti auxiliaris Poemata noua. In laude sanctae fidei catholicae edita in septem partita libellos* and *Opus in quindecim dispartitum libellos*, Lyons, Jacques Sacon, 1507. The first book of the prose, *De Gloriosa Virginis Mariae Assumptione liber*, was published separately

Another friend of Gaguin's, who was a poet of some merit, Guillaume de La Mare, will be noticed at greater length in connexion with Humanism in the provinces. But a brief mention should be made here of his *Sylvae*[1], as most of the poems were written between 1492 and 1500, during which period he was secretary successively to the two Chancellors, Robert Briçonnet and Guy de Rochefort, and to Guillaume Briçonnet, the Cardinal of Saint-Malo[2]. Among those to whom the poems are addressed are Gaguin, Lefèvre d'Etaples, Gilles de Delft, Fausto Andrelini, Paolo Emilio, Charles Guillard, and Cardinal d'Amboise. As an ecclesiastic La Mare figures in the appendix to Trithemius, so do the " renowned poets and orators," Antoine Forestier and Guillaume Castel. Of Forestier—if that is the right rendering of Sylviolus—the writer of the supplement to Trithemius speaks in the most laudatory terms, praising his skill as a writer in Latin, Italian, and French. His Latin verse includes sacred elegies, a long poem on the victory of Agnadello, and another on the death of his patron, Cardinal d'Amboise. He also wrote comedies in French, which unfortunately have not survived[3]. Castel, who was born at Tours in 1468, obtained a bursary at the College of Navarre, and having pursued his studies with marked success, became a professor, first at the college of Burgundy, and then at his old college. Having taken orders and his doctor's degree, he retired to Tours with a canonry and an archdeaconry, and was living there when Trithemius wrote[4].

Guy de Fontenay, Sieur de La Tour de Vesvre in Berry, Canon of Nevers, was from 1509 a professor at the college of Sainte-Barbe, of which his elder brother was Principal.

at Paris by Guy Marchand in 1500. In answer to some critic who had found fault with *praefectus auxiliaris* (as well he might), Ory paraphrases it by *Qui sum praefectus principis auxiliis*. I understand by this some post in connexion with the *Aides*.

[1] *Sylvarum liber quatuor*, Badius Ascensius, 1513.

[2] *Sylvas...inter curiales procellas...olim composui.*

[3] Trithemius, *De script. eccl.*, *Add. I*; La Croix du Maine; Brunet.

[4] Trithemius, *op. cit.*; Renouard, ii. 262 f. On the title-page of his poems he calls himself Castellus *seu* Castalius.

He published various humanistic text-books for the benefit
of his pupils, including a little book on synonyms with
precepts for writing prose and verse[1]. His own verse,
which is of little merit, included, besides some short occasional
pieces[2], a long poem entitled, *De multifario vivendi ritu
hominum praesentis saeculi*[3].

A somewhat older man, who did similar work to Guy
de Fontenay, but whose reputation was considerably
greater, was the blind professor, Pierre van der Brugge or
Petrus de Ponte. Born at Bruges about 1475, he began to
teach at Paris about 1505—it does not appear whether he
was attached to any college—and continued teaching there
till his death, which took place after 1539. He published
several volumes of Latin verse, including *Opera poetica*
(1507), of which the last piece, *De sunamitis querimonia*, is
dedicated to Jacques Lefèvre; a poem on the life of St Bertin
(1510) ; and *Decem Aecloge* (1513). He also edited Lucan
(1512) and wrote treatises on grammar and versification[4].

In the same year (1507) as Petrus de Ponte's *Opera
poetica* there appeared a volume of Latin verses, entitled
Varia opuscula, by Michel l'Anglois, another migrant from
the Low Countries, who, in spite of his name, was born at
Beaumont in Hainault about 1470. He came to Paris to
learn Latin and Greek, and having lost his fortune had a
hard struggle to earn a livelihood as a teacher. Eventually
he found patrons in Pierre de Courthardy, Geoffroy Bous-
sard and Cardinal Philippe de Luxembourg, the last of

[1] *Synonymorum...liber...adiectumque opusculum rem domesticam
latinitate donans cui olla patella nomen inditum est*, Rouen [1500 ?]; Paris,
Senant [after 1505]; *noviter correctus et emendatus, ib.* Badius, s.d.

[2] *De Obitu Mauri Ludovici ; De septem virtutibus ; Epithalamium
super connubio Caroli et Margaritae principum (i.e.* Charles, Duc d'Alençon,
and Margaret of Angoulême, 1509). All these, as well as his principal
poem, were printed by R. de Gourmont.

[3] J. Quicherat, *Hist. de Sainte-Barbe*, 3 vols. 1860, 1. c. xii. Guy de
Fontenay was related to Octovien de Saint-Gelais through the latter's mother.

[4] *Prima ac secunda grammatice artis isagoge*, 1514; *Ars versificatoria*,
1520 See Dom Liron, III. 241 ff ; Paquot, III. 34 ff ; P. H. Peerlkamp,
*Liber de vita doctrina et facultate Nederlandorum qui carmina latina com-
posuerunt*, Haarlem, 1838, p. 26 ; *Biogr. Nat. de Belgique.*

whom he followed to Italy in 1498. Having studied law at Pavia for several years, he returned to Paris in 1507 and became a professor in that subject. His *Varia opuscula* had appeared at Pavia in 1505 before being published by Badius. The verse is chiefly of a grave character. The usual testimonies to the author's learning include a *iudicium* by Baptista Mantuanus[1].

A good deal of the Latin verse of this period was of a patriotic character. Thus Valeran de Varanes, a native of Abbeville, who in 1507 was living at Paris in the Collège des Cholets, produced an epic in four books on Jeanne d'Arc[2], while a monk of Vendôme, named Humbert de Montmoret, began a similar poem on a larger scale, for it embraced the whole war with the English under Charles VII. Only the first part, however, which carried the narrative down to the siege of Orleans, ever appeared. It was dedicated to Louis de Crevant, Abbot of Vendôme, and the author dubs himself on the title-page *poeta et orator clarissimus*[3]. But the majority of these patriotic poems related to contemporary events, and every success of the French arms was celebrated by some needy poet in quest of patronage. The battle of Fornovo and the capture of Genoa fell to Valeran de Varanes[4], the defeat of Maximilian by the Venetians and French in March, 1508, to Martin Dolet, a Parisian[5], and the victory of Ravenna, so dearly purchased by the death of Gaston de Foix, to Humbert de Montmoret[6]. The last "illustrious poet" also wrote a poem in hexameters to celebrate

[1] Dom Liron, III. 251–260 ; Paquot, I. 68 ff ; Peerlkamp, *op. cit.* p. 25 ; *Biog. Nat. de Belgique.*

[2] *De gestis Ioanne Virginis..libri quattuor*, 1516. See L. Geiger, *Studien zur Geschichte des französischen Humanismus* in *Vierteljahrsschrift für Kunst und Litteratur der Renaissance*, II. (1887) 297 ff.

[3] Badius Ascensius, 151⅔.

[4] *De inclyta Caroli VIII in agro Fornoviensi victoria...carmen*, 1501 ; *Carmen de expugnatione genuensi*, 150⅞. The latter poem contains two dedications, one to Raoul de Lannoy, *Bailli* of Amiens, and Governor of Genoa, and the other to Adrien de Hénencourt, Dean of Amiens.

[5] *De parta...in Maximilianum ducem victoria*, J. de Gourmont (*Bib. Nat.*).

[6] *Bellum Ravenne*, 1513.

the heroic combat which took place off Brest on August 10, 1512, between the *Cordelière*, commanded by Hervé de Portzmoguer, and the English ship, the *Regent*, which ended in the destruction of both vessels by fire[1]. The same event found another bard in Germain de Brie (Brixius), whose poem entitled *Chordigerae navis conflagratio*, owing to its reflexions on the good faith of English statesmen, involved him in an acrimonious poetic controversy with Sir Thomas More[2].

The writer of occasional and patriotic Latin verse who was most in repute at the Court and in the University at this time was the Italian professor, Fausto Andrelini, whose name has already been mentioned several times in this chapter. He arrived at Paris in 1488, three years after his countryman, Girolamo Balbi, whom he found engaged in a literary feud worthy of Filelfo and Poggio with the University professor, Guillaume Tardif, a native of Le Puy, who had been one of the first to encourage the study of rhetoric at Paris.

Tardif's lectures at the college of Navarre were attended, as we have seen, by Reuchlin, when he was at Paris in 1473. Two years later he published a manual on the subject under the title of *Rhetoricae artis ac oratorie facultatis compendium*[3]. He also published about the same time a short treatise on grammar, *Compendiosissima grammatica*[4], and an edition of Solinus[5]. These were printed at the *Soufflet-Vert*, but by a different press from that of Keysere and Stoll[6]. Later Tardif became reader to Charles VIII,

[1] *Herveis*. The *Cordelière* was set on fire by one of her gunners; only six of her crew escaped. See La Roncière, *Hist. de la Marine française*, III. (1906), 93 ff; A. Spont, *The War with France*, 1512–1513, 1897, pp. xxii–xxvi (Publications of Navy Records Society, x).

[2] *Philomorus*, 2nd ed. 1878, pp. 74–78; L. Geiger in *Vierteljahrsschrift für vergleichende Litteratur*, II. 213 ff. See generally for these patriotic poems, H. Hauser, *Les sources de l'hist. de France, xvi siècle*, I. 1906.

[3] Hain, 15241; Proctor, 7898.

[4] Proctor, 7898A (Additions).

[5] Proctor, 7897. It is not quite clear from the Latin lines at the end of the volume whether Tardif was the editor or only the proof-corrector; probably he filled both functions. See Ph. Renouard, *Imprimeurs parisiens*, 1898, p. 348.

[6] This has been established by Proctor.

and it was for the entertainment and profit of the young king that he wrote a treatise on hawking and hunting[1], and translated Poggio's *Facetiae* (*le plus pudiquement que j'ay peu*)[2] and Valla's *Facetiae morales,* which is itself a Latin translation of thirty-three of Aesop's fables[3]. Poggio's coarse and not very entertaining jests might have been left with advantage in their original Latin, but the translation of Valla is of high excellence. Tardif has expanded the Italian humanist's faithful rendering of Aesop with its dry brevity into little stories which have all the freshness and charm of original work. In his hands five lines of Valla become a page, and his bald narrative a living drama. For if Tardif lacks the grace and the feeling for nature of La Fontaine, he has something of his talent for lively dialogue, and even a touch of his dramatic power. One of the best specimens of his art is The Ass and the Wolf[4], which it is instructive to compare on the one hand with Valla's version of Aesop and on the other with La Fontaine's rendering of the same fable[5]. One would like to cite it, but there is nothing either in the turn of the thought or in the style to suggest the Renaissance.

The most prominent incident in Tardif's peaceful life was his quarrel with Girolamo Balbi, a Venetian humanist, who came to Paris in search of employment in 1485. He met with a favourable reception from Gaguin's circle, but after the manner of Italian humanists he made an apparently unprovoked attack upon Tardif, first calling upon the

[1] *Cest Le liure De l'art De Faulconnerie et Des chiens De chasse,* 149⅔. It was often reprinted. The presentation copy, printed on vellum, is in the *Bib. Nat.* See Van Praet, III. 59 ; J. Macfarlane, *Antoine Verard,* 1900, p. 11.

[2] See A. Tilley, *Literature of the French Renaissance,* I. 98, n. 2.

[3] *Apologues et fables de Laurent Valla,* printed for Verard about 1490. The only known copy—the magnificent presentation one printed on vellum, with an illuminated frontispiece representing Verard kneeling before Charles VIII and Anne of Brittany—is in the *Bib. Nat.* (Van Praet, IV. 239, no. 357 ; Macfarlane, *op. cit.* p. 53). There is a modern reprint edited with an introductory life of Tardif by Charles Rocher, Le Puy, 1877.

[4] No. XII.

[5] v. 8 (Le cheval et le loup).

University to appoint a committee to examine the errors in his Grammar (1486), and then pelting him with epigrams and abuse. Tardif treated him for some time with silent contempt, but finally retorted with a short pamphlet entitled *Antibalbica*. Balbi followed with his *Rhetor gloriosus*, and Tardif replied with a second *Antibalbica* (1487). Here the quarrel ended, but, paltry though it was, it excited the interest of a great many distinguished people, including all the Paris humanists. Balbi's attack was probably prompted by a desire for self-advertisement, and as he proved himself superior to his antagonist in wit and learning, he doubtless attained his object. He remained for five years more at Paris, lecturing with great success not only on the humanities, but on civil and canon law, on moral philosophy, and even on the Sphere of Proclus[1]. Then at the end of 1492, or at latest in the spring of 1493, he left Paris in considerable haste[2].

His flight was the occasion for a Latin poem[3] from his countryman and rival, Fausto Andrelini of Forli, who had come to Paris, as we have seen, towards the end of 1488, and with whom he had been engaged in another Thersitean contest. Rid of his rival, Faustus (as he called himself, and was habitually called by others) gradually pushed himself into prominence. His lectures on rhetoric, and on the Latin poets, old and new, obtained great popularity. "He was a perfunctory lecturer," says Beatus Rhenanus, who attended his lectures, "seeking the applause of his inexperienced hearers by making jokes that were more lively than

[1] Trithemius's praises may be regarded as evidence of his reputation.

[2] The best account of the quarrel between Balbi and Tardif is by P. S. Allen in the *English Hist. Rev.* xvii. (1902), 417 ff. I have followed his chronology in preference to that of Thuasne, I. 87 ff. and 342 ff. Balbi lectured with success both at Vienna and then at Prague, but had to leave both cities on a charge of vice. Afterwards he held various important posts, was employed on several missions, and died Bishop of Gurck. See Giov. degli Agostini, *Notizie intorno le vite e le opere degli scrittori Viniziani*, 2 vols. Venice, 1752–1754, II. 240–280 ; Mazzuchelli ; Allen, I. 105.

[3] It was printed in 1495, two years after it was written, with a dedication to Robert Gaguin.

learned[1]." But he imposed upon the University, which regarded him as a miracle of learning[2]. "I have long wondered," says Erasmus, writing to Vives soon after Faustus's death, "at the simplicity and courtesy of the University of Paris, in tolerating Faustus for so many years, nay, not only tolerating him, but even holding him in high honour. His name must recall to your mind many things which I should not like to put in a letter. How imprudently used he to rage against the Theological Faculty! How indecent were his lectures! And everybody knew what sort of life he led. But the French condoned all these failings on account of his learning. Yet that was never more than mediocre[3]." Erasmus himself was among those who were imposed on by Faustus; indeed, during his first residence at Paris Faustus seems to have been the only humanist with whom he was really intimate. The explanation is that at this stage of his career he had not enough learning to enable him to detect the want of it in his friend, who had for him, as he had for others in Paris, the glamour of an Italian humanist. Moreover, he liked the man's ready wit, and liked it none the less because it was often directed against the Paris theologians, *quorum cerebellis nihil putidius, lingua nihil barbarius, ingenio nihil stupidius, doctrina nihil spinosius*. So he wrote to his friend and pupil, Thomas Gray, in 1497, when he was attending theological lectures at Paris with a view to his Bachelor's degree[4].

Faustus's chief business was the writing of Latin verse. It is poor stuff, alike in subject-matter and style, but it brought him credit, not only with the University, but with the Court. His poem on the expedition to Naples gained for him the favour of Charles VIII, who conferred on him the title of *poeta regius* and a pension. Louis XII added a canonry of Bayeux (*circ.* 1505) and letters of naturalisation

[1] Preface to *Erasmi opera*, 1540 (Allen, I. 58).

[2] *Solus fuit qui Galliam ex ieiuna saturam, ex inculta tersam, ex sicca viridem, ex barbara latinam fecit*, quoted by Mazzuchelli from a letter written by Faustus's pupil, Jean Cordier, to the University.

[3] *Opera*, III. Ep. 489. [4] Allen, I. 192.

(1502). In return for these benefits Faustus celebrated each success of his adopted country over his old one in fluent and servile verse[1]. Besides these official poems, his verse includes *Bucolica, Elegiae, De moralibus et intellectualibus virtutibus, De influentia siderum : et querela parisiensis pavimenti,* and *De gestis legati,* a panegyric on Cardinal d'Amboise, who, next to Pierre de Courthardy, was his principal private patron. He also wrote as a school-book some specimens of Latin prose, entitled *Epistolae proverbiales et morales.* He died at Paris in 1518[2].

Such was the small circle of humanists, who, living for the most part at Paris, and looking up to Robert Gaguin as their leader, studied Latin classical authors and practised the writing of Latin verse and prose about the time of the expedition of Charles VIII to Italy. Their leader only just survived the opening of the new century. In November, 1498, he had been elected to the annual office of Dean of the Faculty of Canon Law, and in the words of the official record " though he was broken by age, a martyr to gout, and absorbed by the countless affairs of his Order, he would not yield either to age or disease, preferring the honour of the Faculty to his own interests." He served again in the following year, and also lectured. Then on November 13, 1500, he resigned his office, recording the act with his own hand in the register, and adding that it was also the year of his jubilee, for he had completed the twentieth year of his regentship. In the following January he published the fourth edition of his *Compendium,* revised and continued down to 1499, and beautifully printed by Thielman Kerver[3].

In the preface he refers to the criticisms of an *externus*

[1] *De neapolitana victoria. De neapolitana Fornoviensique victoria. De captivitate Lodivici Sphorciae. De secunda victoria neapolitana. De regia in Genuenses victoria.*

[2] See Mazzuchelli; Knod, pp. 87–109 ; Allen, I. 220. L. Geiger's account in *Vierteljahrsschrift für Kultur und Litteratur der Renaissance,* I. (1886), requires much correction.

[3] For Gerlier and Petit, January 13, 150⅑. On the last leaf but one is a fine full-page woodcut with figures of St Denis, head in hand, and St Remy. See Copinger, 7413, Proctor, 8392, Pellechet, 4972.

calumniator, and it has been suggested with a good deal of probability that he is alluding to Paolo Emilio[1]. It was said in the last chapter that this Italian humanist, unlike his compatriots, Balbi and Andrelini, was generally respected by his Paris compeers as a man of high character and sound learning. But he was Gaguin's rival as a historian, and in 1495 he had begun to collect materials for a Latin history of France modelled on the pattern of the classical historians. The first instalment, consisting of four books, did not appear till 1577, but it is conceivable that he may have paved the way for the success of his own work by criticising that of his rival's[2].

Four months after the publication of the fourth edition of his *Compendium* Gaguin died (May 22, 1501). Of the general character and value of his work, and of his services to Humanism enough has been said. But with regard to his friends and followers who formed the humanistic circle at Paris, two features suggest themselves for comment. In the first place it will be noticed that they include a good sprinkling of Flemings and other natives of the Low Countries —Charles and Jean de Fernand, Pierre de Bur, and Pierre van der Brugge from Bruges, Michel l'Anglois from Hainault, Gilles and Martin from Delft, and lastly Arnold Bost, who in his Carmelite convent at Ghent kept in close touch with the Paris humanists. Finally Gaguin himself, though a Frenchman by descent, was, as we have seen, born in the Flemish province of Artois.

Secondly we notice that the great majority of the elder generation, that is to say, of those who were more or less Gaguin's immediate contemporaries, were theologians in the first place, and humanists only in the second. Laurent Bureau, and Arnold Bost were Carmelites, Gaguin was a

[1] Thuasne, II. 287 ff.

[2] For Paolo Emilio see Thuasne, I. 151–4 and II. 290 n. ; Allen, I. 316 ; Delaruelle, *G. Budé*, p. 24, n.[2] ; A. Tilley, *Literature of the French Renaissance*, I. 239. See also Erasmus, *Ciceronianus* (*Op.* I. 1010 E). For the publication of his History see Renouard, II. 2–3, and a letter of Erasmus dated January 16, 1518, and cited *ib.* p. 426. P. Emilio was made a Canon of Notre-Dame in 1511, and died in 1529.

Trinitarian, Guy de Jouennaux and the two Fernands left
the University to become Benedictines, Gilles de Delft and
Martin de Delft were Doctors of Theology. And these were
not men who had taken orders solely with a view to prefer-
ment, but men who had a genuine religious vocation.

This theological bias is not surprising in the atmosphere
of a University like Paris, whose fame rested largely on
her Theological Faculty, and whose degree of Doctor in
Theology was the most coveted degree of Western Europe.
And this brings us to the question of the attitude of the
University generally towards Humanism. It was certainly
not a hostile one. Rather it was one of guarded toleration,
developing as time went on into a gradually increasing
sympathy. The favour shewn to a third-rate humanist
like Fausto Andrelini, the warm reception given, as we
shall see later, to a humanist of the first rank, Girolamo
Aleandro, are evidence of this. It was not till the great
Reuchlin controversy, of which the real point of dispute
was whether all branches of learning and science were to be
subordinate to theology, that the theologians of the Paris
University began actively to oppose Humanism[1].

But from the first the new studies were under the dis-
advantage of being outside the University curriculum for the
Arts degree. Grammar and rhetoric, under which names
were comprised every branch of humanistic study, had no
place in the Arts course. They were confined to the "gram-
marians," or those who were not sufficiently advanced to
proceed to the Arts course. That course consisted entirely
of logic, natural philosophy, and moral philosophy. When
therefore the Italian humanists, Balbi, Andrelini, and Cornelio
Vitelli, petitioned the University in 1488 that they might be
allowed to give public lectures it was not very surprising that
the required permission, which was extended to all the *poets*
(*i.e.* lecturers on Latin poetry and rhetoric) without distinc-
tion, was granted on the condition that they should lecture
for one hour only after dinner (when all "extraordinary"

[1] The University of Paris condemned Reuchlin's *Speculum Oculare* in
1514.

lectures were given), and on lines laid down by deputies of the
University. It was also a natural corollary from the nature
of the studies of the University that Masters of Arts who
taught grammar and rhetoric were not admitted as Regents,
and that a proposal to admit them, which was made in the
German Nation in 1490, was not carried.

In spite, however, of the subordinate position occupied
by rhetoric in the University, this Cinderella of studies
began rapidly to find favour in many quarters. This is
shewn by the records of the press. Before the close of the
fifteenth century only two Frenchmen, Charles Fernand
and Gaguin, ventured to print their Latin compositions.
Even the poems of Pierre de Bur, the French Horace of his
day, remained in manuscript until a year before his death,
when by the "pious theft" of a disciple they came into the
hands of Badius. But after 1500 the publication of Latin
verse and prose by French humanists became more and more
common. Moreover, those compositions began to be less
religious, and more secular in character. We have seen how
the victories of French arms provided a useful theme for
budding poets. There was also a constant demand for
prose dedications and complimentary verses. One has
only to look through M. Renouard's volumes on Josse Badius
Ascensius to see that not a book was issued from his press
without a long prose dedication, either by the author or by
Badius himself, to some distinguished patron, followed by
one or more pieces of verse from the pen of some brother
humanist, which served as a double advertisement for the
learning of the author and the poetical skill of his friend.

The quest for patronage also entailed a good deal of verse-
making. Poems were addressed to existing or prospective
patrons, and the patron, when he died, had to be mourned
in a funeral poem, in which his deeds and virtues were
becomingly celebrated. A rarer opportunity for the display
of rhetoric was offered by diplomatic missions to foreign
countries. Unless one of the envoys themselves, like
Gaguin, was skilled in Latin prose, the mission was accom-
panied by an *orator*, who introduced the deputation to the

foreign court in a highly rhetorical harangue. Thus, as is
so often the case with University studies, rhetoric thrived
under the aegis of the Paris University largely on account of
its practical advantages.

II. *Josse Badius Ascensius*

The great advance made by rhetoric, or the study and
practice of Latin composition, at Paris in the years which
immediately succeeded Gaguin's death was due partly
to the impulse which he had given to it during his
long leadership of French Humanism, but also to the
energy and industry of a single individual—Josse Badius
Ascensius. Setting up his famous printing-press within
less than two years of Gaguin's death, he may be
said to have succeeded him, as Gaguin had succeeded
Fichet, as the chief promoter of Latin rhetoric at Paris. It
is true that, lacking Gaguin's position and authority, he was
far from exercising the same influence, but, with the exception
of Lefèvre d'Étaples, he was at Gaguin's death the most
distinguished humanist in Paris, and he had this advantage
over his more illustrious predecessor, that he was better
equipped as a scholar. For not only had he a greater
mastery of Latin, and more especially of Latin style, but he
had a competent knowledge of Greek. His services to
humanistic education as an editor of Latin classics and as a
reformer of text-books were very considerable, but perhaps
his greatest service consisted in the impulse which he gave
to the printing of humanistic literature, whether of Latin
classics, or of Latin translations from Greek classics, or of
works in prose and verse by Italian humanists.

We have seen that it was in the interests of Humanism
that Fichet and Heynlin set up the first press in the Sorbonne,
and that the productions of this press were all of a human-
istic character[1]. But there was little or no market for
them, and had it not been for the financial support of
Fichet and his friend, Cardinal Rolin, the work must have

[1] See above, p. 87.

stopped. After Fichet's departure, Gering, who was a well-to-do bachelor, and his two partners continued for a few years to print books which did not pay. But when Krantz and Friburger also departed, Gering seems to have lost heart, and during the fifteen years from 1479 to 1493 inclusive only six impressions of Latin classics are recorded by Panzer as issuing from Paris presses. But in the year 1494, the year of the expedition to Italy, a change took place. In that year were printed Virgil, Juvenal, and Seneca's *Epistles*, besides six works, all of a more or less educational character, by Italian humanists. During the next eight years a considerable number of the principal Latin classics were printed in whole or in part—Terence, Virgil, Horace, Ovid's *De remedio amoris* and *Metamorphoses*, Propertius, Seneca's Tragedies, Lucan, Persius, Valerius Flaccus, Statius, Juvenal; and in prose, Sallust, Cicero's *De officiis*, *De senectute*, *De amicitia*, *Paradoxa*, and *Tusculans*, Justin with Florus, and the *Epitomes* of Livy. Of these Virgil was by far the most popular. The whole works were printed twice (once with the commentary of Servius), the *Eclogues* five times, the *Georgics* three times, the *Eclogues* and *Georgics* together twice, and the *Aeneid* once. Another sign of the times was the printing of school-books, such as grammars and aids to Latin composition, by Italian humanists, which gradually superseded the time-honoured favourites of the Middle Ages, Donatus, the *Doctrinale*, and the *Grecismus*. This was a reform in which Badius took special interest.

Josse Badius Ascensius, according to his own testimony, was born at Ghent. Ascensius therefore represents not his birth-place—for Asche is in Brabant and not in the neighbourhood of Ghent—but his family name, which was possibly Van Asche. As for Badius, which eventually superseded Ascensius and was used as the family name by his sons, it seems reasonable to regard it as either an additional name or a nickname[1]. He was born in the

[1] Trithemius calls him Gandensis. An additional reason for regarding Ascensius as his name is that, if it were an adjective, he would not have formed from it a second adjective, Ascensianus. This is the view of

year 1461 or 1462[1], and studied first at Ghent, in the school of the Brethren of the Common Life, and then at the University of Louvain. After that he went to Italy, where he learnt Greek from Battista Guarino at Ferrara. In 1488 he was already known as a good Latinist. In 1492, after holding a Professorship at Valence[2], he migrated to Lyons where he published through Trechsel an edition of Beroaldo's *Orations*[3], and in the following year he became manager of Trechsel's press. In 1497 he visited Paris, where matters of business brought him into relations with Gaguin, and early in 1499, Trechsel having died in May 1498, he took up his permanent abode in the city. Here he became general adviser to Jean Petit, who a few years previously (apparently in 1495) had founded the great house which for nearly a century was at the head of the publishing and bookselling trade of Paris.

At the same time Badius carried on his work as editor and commentator. Before leaving Lyons he had edited, with notes for the use of young students, Boethius, Baptista Mantuanus, Juvenal, and Persius[4]. He now produced editions, with a "familiar commentary" on the same lines, of Cicero's *De officiis*, *De amicitia*, and *De senectute*, Horace, Ovid's *Epistles* and *Metamorphoses*, Virgil, and Sallust. All of these were chosen for their educational value, for Badius was first and foremost an educationalist. He had doubtless imbibed his zeal for education from his first teachers, the Brethren of the Common Life, to whom he addressed in tones of grateful affection the preface of his edition of Acron's Commentary on Horace's *Epistles*[5]. In

M. Renouard and it is insisted on, but not more than it deserves, by Prof. Roersch in the *Rev. des Bibliothèques* for July and September 1909.

[1] Trithemius says that he was thirty-two in 1494.

[2] Preface to Persius of 1499 (Renouard, III. 146).

[3] He says in his preface addressed to Laurent Bureau that he had attended a few of Beroaldo's lectures at Mantua. The volume was printed from a copy of the Bologna edition which Bureau had sent him. (See above, p. 196.)

[4] The Juvenal and Persius are in the Cambridge University Library.

[5] Renouard, II. 500.

his prefaces he invariably lays stress on the suitability of the work in question for young students, and the preface prefixed to the third part of his Virgil is addressed to the sons of Jean Petit and two other booksellers[1]. All these school-editions, as they may be called, had great popularity, and were often reprinted both in and out of France.

In 1503, under the auspices of Jean Petit, he set up a printing-press in the Rue des Carmes, opposite to the Collège des Lombards. In 1507 he moved to the sign of the Three Pikes in the Rue Saint-Jacques, nearly opposite to the Church of Saint-Benoît, and it was to this house that he gave the name, which was to become so famous in the annals of printing, of *aedes Ascensianae*[2]. The first production of his press was an edition of the *De Calamitatibus* of Baptista Mantuanus. In the following year (1504) he printed for the first time in France the *Epitome* of Aurelius Victor[3]. But down to the close of 1507, though he issued several editions of Latin classics, he made no other addition to the list of those printed in France for the first time. Nor during these five years was much added by other printers. The most important novelty was Ovid's *Fasti* by Gilles de Gourmont (*circ.* 1510) ; others were Calpurnius Siculus (edited and annotated by Badius), Orosius, and the geographers, Pomponius Mela and Solinus.

In 1508 Badius made a beginning on Cicero, publishing in partnership with Jean Petit the *De inventione* and the *Rhetorica ad Herennium*, the latter of which is not by Cicero but probably by one Cornificius. The *De Fato* followed in 1509. Then towards the close of 1511 he and Petit made a splendid contribution to the study of the great Roman orator by publishing his complete works in four volumes, containing respectively his philosophical, his rhetorical, his oratorical, and his epistolary writings.

[1] Renouard, III. 363.

[2] Renouard, I. 40. The site is now occupied by one of the outbuildings of the Collège de France.

[3] *Libellus de vita et moribus imperatorum.*

Badius's communion with Cicero helped to form his Latin style, and he is mentioned by Erasmus in his *Ciceronianus* (1528) as one who, if he had had more leisure, might have written really well[1]. In fact by discussing his claims before Budé's Erasmus gave much offence to the latter's friends[2], and, as a result of the controversy, a coolness arose even between Badius and Erasmus.

Other authors added to the list of novelties by Badius were Valerius Maximus (1510), Valerius Flaccus (1513), Lucretius with the voluminous commentary of Giambattista Pio (1514)[3], and Macrobius (1515). Valerius Flaccus was edited by Gervasius Amoenus of Dreux, who had been a servant-pupil of Erasmus[4].

Meanwhile other Latin authors were printed for the first time in France by other Paris presses. In 1512, Louis Hanken, a Cologne printer who had a press at Paris during this and the preceding year, issued Suetonius and the *Metamorphoses* of Apuleius. In the same year 1512, or at any rate before 1513, Plautus was printed by Guillaume Le Rouge for Denys Roce. It was edited by Simon Charpentier of Paris, who dedicated it to Fausto Andrelini[5].

One is surprised to find no Paris edition of Caesar, except in French, earlier than 1528, but his works were printed at Lyons in 1508. Tacitus was not printed at all in France till 1541 (Gryphius, Lyons), nor Martial till 1518. Catullus, Propertius, and Tibullus, first appeared at Lyons in pirated copies of the Aldine edition of 1502[6]. The first *bona fide* French edition was published at the same place in 1518[7]. There was no Paris edition till 1529. The omission of these amatory poets was no doubt due to the disfavour with which the French humanists regarded them in the interests of education.

[1] *Opera*, I. 1011 N.
[2] *op. cit.* III. 1115–1119 (Erasmus to Brixius).
[3] See Munro's *Lucretius* (Cambridge, 1866), I. 4–5.
[4] See Allen, I. 442.
[5] *Nec cis Alpes impressae.* There is a Lyons edition of 1513
[6] One about 1503, and another about 1510.
[7] By Bartolommeo Trotti.

The only contribution made by Badius to the study of the Roman Law was an edition of the *Digestum vetus* (1513). But numerous editions of the *Digest* and one of the whole *Corpus Juris* (1509–1514) were printed at Lyons. The *Institutes* were printed both at Lyons and Paris, and also at Valence (1514).

History, other than that of Rome or Greece, was not held in much account by the Italian humanists, and Flavio Biondo is a solitary instance of one who studied in a critical spirit the history of his own country. It was left to France and Badius to produce the first editions of Paulus Diaconus, the historian of the Lombards, and of Liutprand, the historian of Italy in the tenth century (1514). In the same year Badius issued the *editio princeps* of the History of Denmark by Saxo Grammaticus[1]. Diaconus and Liutprand were printed on the initiative and at the expense of Guillaume Petit, the King's Dominican confessor. He was an intimate friend of Budé's, who in a letter to Erasmus describes him as a sagacious hunter of rare books, and one hardly to be trusted in a library. But, he says, he was as good-natured in lending books to his friends as he was greedy in collecting them[2]. Through his liberality and love of learning the chroniclers of his own country as well as those of Italy saw the light. In 1512 Badius printed under his auspices the first edition of Gregory of Tours, and in 1514 the *Historia Francorum*, a summary and uncritical chronicle of little value, of the Benedictine monk, Aimoin. To the same initiator were due editions of Sigebert of Gembloux, another Benedictine chronicler of little importance (1513), and of the excellent and well-written Life of St Martin of Tours by his disciple Sulpicius Severus (1511)[3].

The Italian humanists had shewn considerable activity

[1] *Danorum regum heroumque historiae.*

[2] Allen, II. 522, 1123–1128 and n.[67]. See also Quetif and Échard, *Script. Ord. Praed.* II. 100–102.

[3] It was accompanied by Fortunatus's versified version, and by other treatises relating to St Martin ; the publisher was Jean Petit.

in translating into Latin the masterpieces of Greek literature, and Badius played no inconsiderable part in republishing them in France.. Thus in the very first year of his press (1503) he printed the Latin version of Theocritus by Martino Filetico[1], accompanying it with a commentary of his own. In 1506 he printed Erasmus's translation of the *Hecuba* and *Iphigenia in Aulis*, and in 1510 that of nine books of the *Iliad* by Niccolò Valla. The latter was dedicated to Jacques Lefèvre d'Étaples, "the glory of Philosophy and my good friend (*compari meo*)[2]," who had brought the work from Rome. Then turning to Greek prose, he printed in three successive years Polybius on the *First Punic War* in the version of Leonardo Bruni (1512), Thucydides, in that of Valla (1513), and the *Lives* of Plutarch in the translation made by Filelfo, Guarino da Verona, Leonardo Bruni, and other Italian scholars (1514)[3]. The great folio of nearly 800 pages was fitly dedicated to the man who had done so much for the study of Greek in France, Girolamo Aleandro. His pupil, Gérard de Vercel, was responsible for the text. Badius also printed versions by his friends Budé and Erasmus of a few of Plutarch's moral treatises. Politian's translation of Herodian was included in the edition of his *Works* (1512). That of Herodotus by Lorenzo Valla was published by Petit in 1510.

As has been already said, Badius had especially at heart the introduction of improved grammars. When Valla made war on mediaeval Latin and mediaeval methods of learning Latin, he naturally condemned the favourite grammar of the Middle Ages, the *Doctrinale* of Alexander de Villa Dei. His *Elegantiae linguae latinae*, the fruit of his critical knowledge of Latin, was a comprehensive, but quite unsystematic, treatise on grammar, syntax, and textual criticism[4], and it was left to his friend

[1] Dedicated to Federigo, Duke of Urbino. Giraldi calls Filetico a mediocre poet (W. Wotke, p. 23).

[2] He also published a Latin version of the *Batrachomyomachia*.

[3] First printed in Rome by Ulrich Hans, *circ.* 1470 (Proctor 3348).

[4] See above, p. 36.

and pupil, Niccolò Perotti, to produce the first and best Latin grammar of the Renaissance. Written in 1468, it was printed at Rome by Sweynheym and Pannarz in 1473 under the modest title—for it was a goodly folio—of *Rudimenta grammatices*. It was followed by the *Brevis grammatica* of the Venetian priest Francesco Nigri (Venice, 1480), and the grammar of Giovanni Sulpizio of Veroli (Rome, 1481)[1], which, though its author was among the loudest in his complaints against the *Doctrinale*, owed a good deal to that despised work. A decade later Antonio Mancinelli of Velletri published his *Spica*—a short treatise in verse on declensions, genders, participles, and supines—at Venice (1492)[2], and followed it up with other grammatical treatises—*Epitoma seu Regulae constructionis* (1492), *Donatus melior* (1493), *Carmen de floribus* and *De poetica virtute* (1493), *Scribendi orandique modus* (1493)[3], *Elegantiae portus* and *Lima in Vallam* (an epitome and a criticism of Valla's *Elegantiae*) (1494), and *Thesaurus de varia constructione*.

All these grammatical treatises, except some of Mancinelli's, were printed in France before the close of the fifteenth century. Perotti's grammar appeared as early as 1479, and again in 1484 and 1488. Badius, however, with his habitual caution and tact regarded the *Doctrinale* as too long established a favourite to be dispossessed all at once. The fact of its being in verse was a great advantage for students whose knowledge was largely acquired by means of the memory. Badius accordingly prepared a new edition, making various omissions, additions, and corrections, and supplying explanatory notes. The book, thus revised, became extremely popular. It was pirated on all sides, and Badius, who was himself a respecter

[1] *De arte grammatica opusculum compendiosum.* D. Reichling (No. 1401) gives a Venice edition of about 1480, and Brunet says that a Perugia edition of 1475 is cited by bibliographers.

[2] August 20, 1492. A prefatory letter to Mancinelli is dated July 23, 1491, and there may be an edition of that year.

[3] See generally for these grammars : D. Reichling, *Das Doctrinale des Alexander de Villa-Dei* (*Monumenta Germaniae Paedagogica*, XII.) Berlin, 1893.

of copyright[1], inveighed against the pirates in the following distich :

Gens ignava et iners fruges consumere nata
Falces in messem mittit ubique meam[2].

Numerous editions must doubtless have disappeared, but Renouard enumerates eleven that were printed in France alone between the date of the first edition and 1515.

Badius next turned his attention to the grammars of the Renaissance, and edited in succession the two principal ones, Sulpizio[3] (1502) and Perotti (1504). Here again he proceeded with caution. Fearing lest students might be deterred by a grammar written in prose, he wove into the text, paragraph by paragraph, a versified grammar of his own, which he called the *textus Ascensianus*. He also wrote some short grammatical treatises, two of which were printed, though probably not for the first time, in the third part of the *Doctrinale*, while one was appended to the grammar of Sulpizio.

In 1505 he edited the various grammatical works of Mancinelli in three parts. Then seven years later, having pretty well exhausted the Italian field, he began to publish the works of the Flemish grammarian, Jan van Spauteren, better known by his Latin name of Despauterius, printing the first part of his grammar in 1512, and his *Syntaxis* and *Ars epistolica* in 1513. In spite of the severe attack which his countryman and rival grammarian, Petrus de Ponte[4], made on it, his grammar obtained a firm foothold in France. Its epitomised form, known as *Despauterius minor*, was the recognised grammar for beginners till the days of Port Royal, and did not cease to be printed in France till after the middle of the eighteenth century[5].

[1] See Allen, II. p. 271.

[2] One of the most active pirates among the Paris booksellers was Denys Roce, by descent a Scot of the family of Rosse (Claudin, II. 530, from information supplied by Mr E. Gordon Duff).

[3] The grammar of Sulpizio was printed in England by Pynson in 1494 and 1498, and by Wynkyn de Worde in 1499 and 1504.

[4] See above, p. 204.

[5] *C'est du Latin, Madame, et la première règle de Jean Despautère* (Molière, *La Comtesse d'Escarbagnas*, Sc. VII).

Besides these regular grammars Badius edited the work which had done so much to promote the critical study of Latin, the *Elegantiae* of Valla. His edition, which included Mancinelli's *Lima* and an epitome made by himself, appeared in 1501, and was so successful that it was reprinted five times before the end of 1510[1].

After the Renaissance grammars it was the turn of the Renaissance dictionary. Accordingly in 1509 Badius edited the dictionary of Ambrogio Calepino, first printed at Reggio, under the title of *Cornucopiae*, in 1502[2]. His edition was reprinted in 1510 (the year before the author's death), 1513, and 1514. Three years previously he had printed the great encyclopaedia of the Middle Ages, the *Catholicon* of John of Genoa.

Perotti in his manual had defined grammar as "the art of speaking and writing correctly," thus making grammar nearly equivalent to rhetoric. In a strict sense, rhetoric meant composition, or the acquirement of a good style in Latin prose. Its importance in the eyes of the humanist schoolmaster, as a passport alike to a literary, a public, or a professional career, has often been pointed out[3]. At an early stage, therefore, of their education, students were introduced to the writing of Latin, which generally began with letter-writing.

Two popular treatises for beginners were Nigri's *Opusculum scribendi epistolas* (Venice, 1488) and Sulpizio's *De componendis et ornandis epistolis* (Venice, 1489). But the earliest and most popular was that of Agostino Dati[4], who

[1] Some fifteen years before the publication of Badius's edition Erasmus recommended the *Elegantiae* to a schoolmaster as the best book from which to teach boys Latin, and at the schoolmaster's request made an epitome of it. This was published at Cologne, without Erasmus's sanction, in 1529, and became rapidly successful. Thereupon Erasmus, with the help of a much fuller paraphrase, which he had made at Paris in 1496, prepared a new version, and the work thus revised was published at Freiburg in 1531. Within the next 20 years 40 editions of one version or the other were printed (Allen, I. p. 108, note).

[2] It owed a good deal to Perotti's *Cornucopia* and Valla's *Elegantiae*.

[3] See W. H. Woodward, *Vittorino da Feltre*, pp. 230–234.

[4] 1420–1478.

held the office of Public Orator at Siena. He had written
it in haste without any thought of immediate publication,
but some friends to whom he lent the manuscript had it
printed at Venice by Adam of Ammergau in 1471 (or possibly
1472), under the title of *Elegantiolae*[1]. Under the title of
Isagogicus libellus in eloquentiae praecepta Dati's treatise
soon became popular at Paris. It was printed by the
Sorbonne press, possibly in the very year in which it appeared
at Venice, by Keysere and Stoll, by Gering (twice), and at
least four times more before 1498, in which year it was
edited by Josse Clichtove with the similar work of Nigri.
His edition, which included a familiar commentary, was
re-edited by Badius, first in 1501, when he gave to both
treatises the title of *Regulae elegantiarum*, and added to
them his own *De recte scribendi ratione*, and again in 1502
with the addition of Sulpizio's *De componendis epistolis*
and of a compendium on the same subject by himself.

These treatises on Composition generally contained a
certain number of model letters composed by the author as
specimens of various epistolary styles. But students were
also encouraged to read the collected letters of distinguished
humanists. The very first book printed in France was, as
we have seen, the Epistles of Gasparino Barzizza, and it
was reprinted four times before the close of the fifteenth

[1] See J. V. Bandiera, *De Augustino Dato libri duo*, Rome, 1733,
pp. 233 ff. Bandiera's statement as to the publication is confirmed by
the following distich appended to the second of the two editions printed
by Adam of Ammergau:

Presserat hoc primo : placuit formare secundo
Ne desit, quamvis sit breve, doctus Adam.

Both editions (of which the first is in the Bodleian and the second in the
Brit. Mus.) are printed in Adam's first type, and therefore not before
1471 and not later than 1472 (Proctor 4148, 4149). The first edition has
32 leaves, and the second 34. Other early editions are those of Ulrich
Zell, Cologne, 48 ll., of which Mr Jenkinson says that it is not earlier than
1471, and that of the Sorbonne press, which is ascribed, on not very good
evidence, to that year. The title of Zell's edition is *De variis loquendi
regulis, sive de poetarum praeceptis*. Dati also wrote a treatise with the
title of *De variis loquendi figuris sive de modo dictandi* [Zell], 24 ll. There
is, however, a Ferrara edition of 1472 (*Bib. Nat.*) with this title, but with
the text of the longer and better known work.

century. Among the earliest publications of the Sorbonne press was also Bessarion's *Epistolae et orationes de arcessendis Turcis a Christianorum finibus*[1]: it was reprinted in 1500[2]. The letters of Aeneas Sylvius were printed at the *Soufflet-Vert* in 1477, and at Lyons in 1497, the *Aureae epistolae* of Pico in 1499 and 1500, and the letters of Filelfo, which were especially popular, in 1498. In the following year Badius, before leaving Lyons, edited a volume of letters collected by Politian and entitled *Illustrium virorum Epistolae*[3]. It consisted of two hundred and forty-seven letters, of which the last eighteen were written by Ermolao Barbaro, and the great majority of the remainder either by or to Politian. From this volume Badius extracted the letters of Pico, and edited them separately in 1502. These were reprinted in 1508, and again in 1510, the former edition being revised by Nicolas Du Puys, surnamed Bona Spe, of Troyes[4]. In 1503 Badius printed Filelfo's *Epistles*, and in the following year his *Orations*. In 1512 he further honoured Politian by printing an edition of his complete works; the first volume was dedicated to Nicole Bérault, and the second to Louis Berquin. From other presses came two editions of Dati's *Orations*.

But Badius's favourite author among the Italian humanists was Beroaldo. We have seen that he had begun his literary career with an edition of his *Orationes* published by Trechsel at Lyons. In 1505 he printed at his own press a new edition under the title of *Orationes, praelectiones, praefationes* (many of the *orationes* were really *praelectiones* or introductory lectures), which also included the *Varia opuscula*. This became popular and was reprinted by Badius or other printers five times before 1515. There were also separate editions of the *Varia opuscula*, and of individual

[1] There is a copy in the library of King's College, Cambridge.

[2] By Guy Marchand (Camb. Univ. Lib.).

[3] Lyons, Nicolas Wolf (Camb. Univ. Lib.). The volume became popular.

[4] Badius's name does not appear on the title-page of this edition, which was printed by the piratical Scot, Denys Rosse or Roce. Du Puys was a friend of Pietro Rossetti.

works, such as the *De felicitate* (the most admired of
Beroaldo's treatises), the *De optimo statu*, the *Symbola
Pythagorae*, the *De septem sapientum sententiis*, and the
Carmen lugubre de dominicae passionis die. The popularity
of Beroaldo at Paris may have been partly due to the fact
that he had lectured there, but it was also due to his pre-
occupation with moral questions, and to his wealth of
illustration and quotation drawn from a wide range of
classical literature. It is also a sign that the French
humanists were not superstitious admirers of Cicero. For
Beroaldo cultivated the simple non-periodic structure and
the other archaic effects by which Fronto and Apuleius had
dealt the final death-blow to Ciceronian prose as a living style.

If Beroaldo was Badius's favourite prose author among
the Italians, he shared to the full the admiration of his
countrymen and of all his contemporaries for the poems
of Beroaldo's friend, Baptista Mantuanus. While he was
still at Lyons he edited one of his prose works, the
De patientia (1498), and on his arrival at Paris his first task
was to edit with a familiar commentary four volumes of his
verse, the *Contra poetas impudicos scribentes*, the *De calami-
tatibus temporum*, the *Parthenice Mariana* and the *Parthenice
Catharinaria* (poems on the life of the Virgin, and St
Catharine of Alexandria), all in 1499[1]. The *Eclogues*, the
most popular of all Mantuanus's writings, followed with a
similar commentary in 1502, and were reprinted eight times
at Paris alone before 1515[2]. Two of these editions came from
the Ascensian press, which also issued the *Sylvae*, the *Par-
thenice tertia* (containing the lives of four more Virgin
Martyrs), and a volume entitled *Opuscula moralia*, which,
furnished with a commentary, became only less popular than
the *Eclogues*. But the most striking evidence of the esteem
in which Mantuanus was held in France is furnished by the
two great editions of his *Works* which Badius issued, the

[1] There are copies of the two latter volumes in the library of King's
College, Cambridge.

[2] They have been recently edited with an excellent introduction by
W. P. Mustard, Baltimore, 1911.

first in five parts, from 1507 to 1510, and the second in four parts in 1513. Neither was complete, for the General of the Carmelite Order, as Mantuanus became in that same year 1513, never ceased writing, and at his death in 1516 left works still unpublished. These were printed at Lyons in the same year, another instance of his popularity in France.

It was doubtless largely owing to the chastity and general moral excellence of his Muse that his facile verse, with its Virgilian echoes, excited the uncritical admiration of his contemporaries. Beroaldo with the partiality of friendship ranked him second only to Virgil, while Trithemius, whose praise is always of the superlative order, considered him as at least the equal of Virgil in verse, and of Cicero in prose. Erasmus in the early days of his residence at Paris, when his taste in literature was still unconsciously affected by his theological training, prophesied that in the future, when time had silenced the tongue of envy, Baptista's fame would be only a little lower than that of his fellow-citizen[1]. It was an unfortunate prophecy. During his lifetime "the other Mantuan" received his full meed of praise, but, though his *Eclogues* were used as a school-book in all countries for two centuries after his death, his fame as a writer dwindled in less than two generations. Yet if his verse is forgotten, his virtues have received their reward. In the Roman Church he is now the Blessed Battista Spagnoli[2], but to the countrymen of Shakespeare he will continue to be known as the "good old Mantuan."

In the same year (1502) in which Badius edited the *Eclogues* of Mantuanus he also edited those of Petrarch, and in the following year he published two editions, of which the second was accompanied by a commentary and a preface, of the *De coetu poetarum*, of Francesco Octavio, surnamed Cleophilus, of Fano, who taught for several years at Viterbo, and also at Ferrara and Rome[3]. This popular work, on which Fausto Andrelini lectured at Paris, and

[1] Allen, I. Ep. 49, ll. 96–104; and see Mustard, p. 31.
[2] He was beatified, December 17, 1885.
[3] 1447–1490. See Giraldi, p. 20.

which he edited in 1499, is a catalogue of Latin poets in elegiac verse[1]. Badius reprinted his edition in 1505, and there were four pirated editions. He also printed the Latin verse of another Italian, Pietro Rossetti. His publications of Latin verse by French humanists have been noticed in the preceding chapter. Early Christian poetry was represented by editions of Juvencus (1505; 1506), Sedulius (1505), and Avitus (1510).

It was natural that Badius with his keen interest in education should print some of the treatises on that subject written by Italian humanists. He was not the first in the field. In 1494 Guy Marchand published three educational treatises which are often found together in manuscripts, Vergerius, *De ingenuis moribus*, Guarino's version of Plutarch's *De liberis educandis*, and Leonardi Bruni's version of St Basil's *De libris lectitandis*[2]. Badius's first venture was the *editio princeps* of Francesco Barbaro's *De re uxoria*[3], with a chapter on education edited by Rabelais's friend, André Tiraqueau (1513)[4]. He also printed two editions of Mancinelli's *De parentum cura in liberos*[5]. The most popular educational treatise in France at this time was Maffeo Vegio's *De educatione liberorum clarisque eorum moribus*, which curiously enough was printed several times under the name of Filelfo (1500; 1505; 1508), until Rembolt and Waterloes restored it to its true author in 1511[6]. It was translated into French under the title of *le Guidon des parents* by Jean Lodè, a schoolmaster of Orleans. Equally popular was Domenico Mancini's elegiac poem, *De quattuor virtutibus*, which treats of good manners. It was printed at Paris some half-a-dozen times from 1484 to the close of the

[1] See Thuasne, II. 137; Delaruelle, *G. Budé*, p. 41.

[2] Hain 15995. There is a copy in the library of the University of Paris (see E. Chatelain, *Cat. des incunables de la bibliothèque de l'Université de Paris*, 2 vols. 1902—1905, pp. 252—253).

[3] It was first circulated in 1428.

[4] See *Rev. des études rabelaisiennes*, III. 139 and 271.

[5] First printed at Milan in 1504. The colophon of Badius's edition of 1515, which is the earliest known, has "*rursus* in aedibus Ascensianis."

[6] First printed at Milan in 1491.

century[1]. The same writer's hexameter poem, *Carmen de passione Christi* was also printed there several times during the same period. Little seems to be known about the author. He was born about 1424 and entered the household of his friend Federigo di San Severino, Bishop of Maillezais, about 1480[2]. Bulaeus makes him a member of the University of Paris[3], and according to Trithemius he was living in 1494[4].

The same educative aim is shewn in a class of book which began to appear early in the sixteenth century, and which became very popular not only in Italy, but in other countries where an interest was taken in classical literature. With considerable differences in character and merit, these books, which were known as *Lectiones antiquae* or *Exempla*, were alike in containing anecdotes, memorable events, and other interesting matter from ancient literature, with the addition of commentaries by their compiler. The earliest was the *De honesta disciplina* of Pietro Ricci (Petrus Crinitus), printed at Florence in 1504. In his preface the author tells us that he has taken as his models Valerius Maximus, Aulus Gellius, and Macrobius, and that it was his object "to collect everything that might shew the virtuous character of learning, and give pleasure to the noblest minds[5]." Three years later Marcantonio Coccio, best known by the Latin name of Sabellicus which his master, Pomponius Laetus, conferred upon him, published at Venice (1507) a similar work entitled *Exemplorum libri x*. It was followed in 1509 by the *De dictis factisque memorabilibus*[6]—the title is borrowed from Valerius Maximus—of Battista Fregoso, the deposed and banished Doge of Genoa, who was spending his latter days at Lyons in the tranquil pursuit of learning.

[1] The full title is *De quattuor virtutibus et omnibus officiis ad bene beateque vivendum*. In one edition (149⅘) the title is altered to *De quattuor fontibus honestatis*.

[2] The *De quattuor virtutibus* is dedicated to him.

[3] v. 871.

[4] *De scriptoribus ecclesiasticis*, f. 139. See also Thuasne, II. 214 ff.

[5] *Quae et honestatem eruditionis probarent ac meliora praesertim ingenia iuvarent.*

[6] Printed at Milan.

Badius printed the *De honesta disciplina* in 1508, and again in 1511 and 1513, while the compilation of Sabellicus was published by Poncet Le Preux in 1508, and that of Fulgosus by Galiot du Pré in 1518. The only work of Sabellicus printed by Badius was his *Rapsodiae historiarum enneadum*, an uncritical sketch of general history down to the year 1503, which was received with great applause by his contemporaries. Badius printed it in 1509, with a dedication to Guillaume Petit. He also printed (1511) the equally uncritical and equally popular work entitled *Commentariorum urbanorum libri xxxviii*, which Raffaelle Maffei of Volterra had published at Rome in 1506. It is a sort of encyclopaedia, of which the first twelve books deal with geography.

Finally, to complete the tale of Badius's publications of humanistic works, mention may be made of the *Opuscula* of Pomponius Laetus with his life by Sabellicus (1511), the *De triplici vita* of Ficino (1506), a favourite work, as we have seen[1], in France, and the famous forgeries of Annius of Viterbo (*Antiquitatum variarum volumina xvii*, 1511; reprinted 1515). One volume somewhat surprises us as coming from the press of a man who was before all things a moralist and an educationalist. It is Valla's *De voluptate*.

If we add to the books mentioned in this chapter (1) the Latin verse written by Frenchmen and printed by Badius which has been mentioned in the previous chapter, (2) a certain amount of patristic literature, which will find a place in the next, and (3) some of the writings of Erasmus, which will also be referred to later, we shall have a fairly complete record of the output of the Ascensian press before 1515. Thus the work of Badius, as a printer, an editor and commentator of Latin and neo-Latin authors, and a writer of manuals of grammar and rhetoric, fully substantiates his claim to be regarded as the chief promoter of Latin studies in France during the reign of Louis XII. As we have seen, he did not altogether turn his back on the old learning. Twice he printed the popular paraphrase of Ovid's *Metamorphoses* with the moral commentary made in the fourteenth

[1] See above, p. 194.

century by Pierre Bersuire, but ascribed by Badius (following Colard Mansion) to Thomas Walleys (of Wales). He also published the well-known commentary on the *Sentences* by the Scottish Professor, John Major, who was to become later the stoutest defender of the old learning at Paris[1].

In most of his larger undertakings he went shares with Jean Petit, who, as publisher and bookseller—for he was not a printer—served Humanism as zealously as his friend. Not a few volumes which were printed for him alone have been recorded in these pages. In 1510 died Ulrich Gering, one of the printers of the Sorbonne press. After the departure of his two original associates, Krantz and Friburger, he had successive partners in Guillaume Maynial, Jean Higman, George Wolf[2], and Berthold Rembolt. But it was only after Rembolt became his partner (1494) that his press resumed its former activity, and from this time, though it issued a certain number of humanistic works, such as Perotti's *Cornucopia* (1494; 1496), the sympathies of the partners seemed to have been rather in the direction of mediaeval and scholastic theology[3]. For one great mediaeval writer, Gregory the Great, the founder of the mediaeval Papacy, Gering had a special predilection. With the exception of his letters, which were issued by another press, he printed nearly all his writings, and the last publication of his partner and successor Rembolt was an edition of his complete works (1518).

One name, the most illustrious in the annals of French printing, remains to be mentioned, that of Estienne. It was in 1502 that Henri Estienne the elder, the scion of a noble family of Provence, having been disinherited by his father, came to seek his fortune in Paris, where he married the

[1] He took his M.A. degree from the College of Montaigu in 1496, and joined the Sorbonne, where he began to lecture, in 1505. Badius published his *Historia maioris Britanniae* in 1521.

[2] At first Higman and then Wolf printed in Gering's house with his types. They may have been managers of his press, or they may have rented his business.

[3] He left part of his property to the Sorbonne, and part to the poor scholars of the College of Montaigu (Renouard, *Imprimeurs parisiens*, p. 149).

widow of the printer, Jean Higman, and succeeded to his
business. In that year he only shared in a single publication
with Wolfgang Hopyl, but in 1503, the same year in which
Badius set up his press[1], he began to print on his own
account. From this time, carrying on the traditions of his
predecessor Higman, he was closely associated with Jacques
Lefèvre d'Étaples, most of whose numerous writings issued
from his press. It is to the work of this remarkable man
that we must now give our attention.

[1] In 1526 Robert Estienne, the second son of Henri, married Perrette,
the daughter of Josse Badius.

CHAPTER VII

JACQUES LEFÈVRE D'ÉTAPLES

At the head of Sainte-Marthe's *Elogia* on "Frenchmen illustrious for learning who have flourished within our memory or those of our fathers[1]," stands Jacobus Faber Stapulensis. "He came forth," says his panegyrist, "like the rising sun to dissipate the darkness and arouse the youth of France from its deep lethargy. He was the first to shed the light of purer learning on liberal studies and to raise them from their fallen state to a place of honour." But it was especially with the study of Aristotle that his name was connected. He was for his contemporaries "the restorer of philosophy." In the rhetorical phrase of Sainte-Marthe "he opened for posterity by his lectures and his writings an easy approach to the whole doctrine of Aristotle and to every department of learning."

He was born at Étaples in Picardy, probably about the year 1455[2], when Picardy was in the hands of the Duke of

[1] *Gallorum doctrina illustrium qui nostra patrumque memoria floruerunt elogia*, Poitiers, 1602.

[2] The best account of him is still K. H. Graf, *Jacobus Faber Stapulensis* in *Zeitschrift für die historische Theologie*, Hamburg and Gotha, 1852, pp. 3–86 and 165–237, which is a revision of the same writer's *Essai sur la vie et les écrits de J. Lefèvre d'Étaples*, Strasbourg, 1842. This account, however, chiefly deals with him as a theologian and reformer. For his work as a humanist see J.-A. Clerval (l'Abbé), *De Judoci Clichtovaei vita et operibus*, 1894; L. Delaruelle, *G. Budé*, pp. 46–54; Imbart de La Tour, *Les origines de la réforme*, 1905 (in progress), II. 382–395; A. Renaudet, *Rev. d'hist. moderne et contemporaine*, XII. (1909), 266–270 (reviews the former work and corrects some errors); A. Lefranc, *Grands écrivains français de la Renaissance*, 1914, pp. 70–72, 158–163. The older biographers give the date of his birth as about 1435, but this is merely based on a literal interpretation of a line in Salmon Macrin's Ode on his death (in 1536),

<p style="text-align:center">Aevi peracto jam prope saeculo.</p>

When we consider that nothing is heard of him before 1490 it is difficult to

Burgundy[1]. He took his degree of Master of Arts at the University of Paris, but we hear nothing of him till the year 1490, when we find him lecturing in the college of Cardinal Lemoine[2]. In 1492 accompanied by his servant-pupil, Guillaume Gontier, he made his first journey to Italy, visiting Florence, where he made the acquaintance of Ficino, Politian, and Pico della Mirandola, Rome, where he met Ermolao Barbaro, and Venice[3]. On his return to Paris he resumed his lectures at the College of Cardinal Lemoine, and for the next fourteen years devoted himself with untiring energy and industry to the task of reforming the study of Aristotle.

It was a reform that was much needed. The Aristotle whom the University had so blindly worshipped for two hundred and fifty years was an Aristotle deformed and mutilated, alike by translation, abridgement, and commentary. The translation of the *Organon* ascribed to Boethius, but only in part by him[4], and his translation of Porphyry's

suppose that he was born much before 1455, which would make him over eighty at his death. This is Graf's view: M. Delaruelle suggests 1445.

[1] The towns on the Somme, or, in stricter parlance, Picardy beyond the Somme, were ceded to the Duke of Burgundy by the treaty of Arras in 1435. Louis XI availed himself of the right of ransoming this territory in 1463, but had to cede it again in 1465, after the battle of Montlhéry. On the death of Charles the Rash (1477) he re-annexed it.

[2] Jean d'Abensberg attended his lectures in that year (Herminjard, *Correspondance des réformateurs*, p. 20, n. [1]).

[3] The date of the journey to Italy is given by the following passage from the preface to the *Dialectica* of George of Trebizond, written in 1508: *hunc sextus decimus agitur annus quod viguit adhuc Hermolaus Barbarus.....Romae peregrinus agebam.* And it is confirmed by another passage written in 1512 (Graf, p. 8, n. [10]). It may further be inferred that Lefèvre did not start for Italy until after the publication of the *Paraphrase to the Physics* in 1492. As his (apparently) next work, the *Introduction to the Metaphysics*, did not appear till February 1494, and is a short work of only 84 pages, he may have stayed in Italy till the summer or autumn of 1493. I agree with Graf that Beatus Rhenanus must be mistaken in saying that Argyropoulos, who died in 1486, was Lefèvre's teacher. Lefèvre never speaks of him as such, and never refers to an earlier journey to Italy..

[4] *Nullam Boetii interpretationem habemus praeterquam Porphyrii et Praedicamentorum* [the Categories] *et Perihermenias librorum* [*Interpretationes*], L. Bruni, *Epistolarum libri viii*, ed. L. Metrus, 2 vols,

Isagoge or Introduction to the *Categories*, were in the hands of every Arts student, but neither Boethius nor Porphyry were thorough-going Aristotelians, and each wrested the sense of the Master to suit his own interpretation. Equally indispensable was the *Summulae* of Petrus Hispanus, but the last of the seven treatises into which it is divided (the *parva logicalia*) contains much that has little in common with Aristotle. The work of disfigurement was carried still further by the commentators. The overwhelming preponderance which logic had acquired in the Paris University had led not only to the *Organon* being studied to a much greater extent than Aristotle's other works, but to the introduction of dialectical subtleties into every field of interpretation. Among the commentators who were most in repute during the concluding years of the fifteenth century, Buridan still held a high place, but his authority was shared by others of more recent date, by Thomas Bricot[1] and George of Brussels, by Martin Lemaistre (1432–1482), better known as Magister Martinus, who first as a professor at the College of Navarre, and then as Principal of the College of Sainte-Barbe, had an enormous success as a lecturer and teacher[2], and by Pierre Tartaret (d. 1494), who taught at the College of Reims[3].

Florence, 1741, II. 89. See E. Moore, *Studies in Dante*, First Series, 1896. The rest of the *Organon* was translated by Jacopo di Venezia in 1128.

[1] Wrote *Textus abbreviatus totius logices* (1489), *Textus abbreviatus Aristotelis super octo libros Physicos et totam naturalem philosophiam* (1494), which was continued by George of Brussels, and numerous *quaestiones* such as *Cursus optimarum quaestionum super Philosophia Aristotelis cum interpretatione textus* (1490) and *Logicae quaestiones subtiles ac ingeniosae super duobus libris posteriorum Aristotelis profitentibus in doctrinam nominalium usque ad apicem eius plurimum commodatissimae* (1494; 1504), in which the commentary, as might be expected from the title, is of a highly dialectical character.

[2] Wrote *Quaestiones morales*, of which the first part, *De fortitudine*, was especially popular at Paris, and *Quaestiones super viii politicorum libris Aristotelis*.

[3] Wrote *Quaestiones, Expositiones*, and *Commentarii*. Badius wrote prefaces for two editions of his Questions on the Ethics, and his *Quaestiones morales* retained their popularity till well into the sixteenth century. It

Such was the condition of things with regard to the teaching of Aristotle which Lefèvre d'Étaples set about to reform. Proceeding in the same cautious and conservative spirit as his friend Badius, he retained the old methods of introduction, commentary, and paraphrase. His first contribution to a purer Aristotle, so far as we know—for probably some of the early editions of his text-books have vanished—was a Paraphrase of all the Physical works of Aristotle, followed by two dialogues between professors and pupils on the same subject[1]. This work, which formed a stout volume of 620 pages, was published in 1492 before his journey to Italy. After his return he followed it up by printing an Introduction to the first six books of the *Metaphysics*, followed by four dialogues[2], and in the preface, addressed to Germain de Ganay, he says that he had adopted this method of dialogue in place of a continuous commentary at the suggestion of Guillaume Gontier[3]. The idea was not altogether new, for Boethius had written two dialogues on Porphyry's *Isagoge*. A good deal of the subject-matter of the dialogues was borrowed from Nicholas of Cues[4].

After the *Physics* and *Metaphysics* he turned to the *Ethics* and published under the title of *Ars moralis* (1494) a short introduction to the *Magna Moralia*. Like that to the *Metaphysics* it consisted of short definitions, followed by *quaestiones, elementa*, and *apophthegmata*. In 1496 he published an introduction to the *Nicomachean Ethics* in the form of a tabulated summary, which he entitled *Artificialis introductio*, and also introductions to all the logical works.

may be remembered that imaginary works by Tartaret and Bricot appear in Rabelais's burlesque catalogue of the library of S. Victor.

[1] See for the bibliography of this and Lefèvre's other works on Aristotle and the other subjects of the Arts *curriculum* the Appendix at the end of Part II.

[2] See for these dialogues L. Massebieau, *Une acquisition de la bibliothèque de Musée pédagogique* (fasc. No. 2 of *Mémoires et documents scolaires publiés par le Musée pédagogique*), 1885.

[3] February 149¾. It was written in 1490. See edition of 1515 appended to Bessarion's translation of the *Metaphysics*.

[4] P. Duhem, *Études sur Léonard de Vinci*, 2ᵐᵉ série, 1909, p. 103.

Other contributions which he made to the study of logic were an *Ars suppositionum*, with notes by his pupil, Charles de Bouelles (1500), and an edition of the *Dialectica* of George of Trebizond (1508), an eclectic manual which was much used in Universities, including those of this country.

His next step was to publish the translations made by Italian humanists. A beginning had already been made. Argyropoulos's version of the *Nicomachean Ethics*, with Gilles of Delft for editor, was printed by Higman in 1488, and by Wolf in 1493, Leonardo Bruni's rendering of the *Politics* and *Economics* by Wolf in 1489, and that of the *Rhetoric* by Keysere and Stoll about 1475. In 1497 Lefèvre edited a volume containing three translations (*tres conversiones*) of the *Nicomachean Ethics*, the first being that of Argyropoulos, the second that of Leonardo Bruni, and the third an "old translation" attributed to Henry Kosbein of Brabant[1]. The volume also contained Georgio Valla's translation of the *Magna Moralia*, which Lefèvre dedicated to Guillaume Budé, and an introductory dialogue by Leonardo Bruni. The *Organon* in the version ascribed to Boethius appeared in 1503, and the *Politics* and *Economics* in that of Bruni in 1506[2].

Bruni's translation was accompanied by commentaries from the pen of Lefèvre, and by seven books of what he

[1] In the letter referred to above (p. 234 n. [4]), to which Dr Moore's attention was called by Dr Henry Jackson, Leonardo Bruni says that there were two translations of the *Ethics* before his, one made from the Arabic by Michael Scot and known as the *translatio vetus*, the other made by a *Britannus quidam*, whom he says in another letter was a Dominican. This latter is the *nova traductio* made by William of Moerbeke or William of Brabant— Bacon calls him William the Fleming—for St Thomas Aquinas, completing it in January 128½. In the fifteenth century it had become in its turn the *antiqua traductio*, and a commentator of that century attributes it to a Dominican, named Henry Kosbein (perhaps = Henry of Brabant). But whether he is to be identified with William de Moerbeke—who surely has enough *aliases* already—or whether he collaborated with him, or whether the commentator is wholly in error, is a moot question (see Quetif and Échard, *Script. Praed.* I. 388; *Biog. Nat. de Belgique*, IX. 216).

[2] Bruni's translation of the *Politics* was made at the request of Humphrey, Duke of Gloucester.

called *Hecatonomia*, being a collection of precepts or *leges* from the works of Plato. The first hundred, forming the first book, were called *Socraticae leges*, and the remaining six hundred *Platonicae leges*. This addition is interesting as shewing that Lefèvre was interested in Plato as well as in Aristotle. Finally in 1515 the series of translations from Aristotle was concluded with the publication of Bessarion's translation of the *Metaphysics*, which had come into Lefèvre's hands through the kind offices of Pico della Mirandola.

Lefèvre's efforts in the cause of University education were not confined to Aristotle. He also turned his attention to the four subjects of the *Quadrivium*. In his preface to the *Introductio in Metaphysicos libros* of 1494 he refers to an *Arithmeticum opus* which he had dedicated to Jean de Ganay. I cannot trace this volume, but it is apparently an earlier edition of a treatise which stands first in a composite volume published in 1496[1]. This is a treatise on arithmetic by Jordanus Nemorarius, a German mathematician of the thirteenth century, which Lefèvre edited. The volume also contains a treatise on music by Lefèvre himself, and an epitome of Boethius's work on arithmetic. Lefèvre also published the time-honoured *Sphaera* of Ioannes de Sacro Bosco (John of Holywood) with a commentary, and in 1503, with the co-operation of Clichtove and Charles de Bouelles, a volume on arithmetic, geometry, and astronomy. The treatise on astronomy was by Lefèvre himself. Students were thus furnished with text-books on all the four subjects of the *Quadrivium*.

Of Lefèvre's life apart from his books we know very little. Having some private means[2], he was able to travel occasionally, and in 1500 he paid his second visit to Italy, going to Rome for the jubilee. In 1504 he became secretary to Guillaume Briçonnet, Bishop of Lodève and afterwards of Meaux, a connexion from which sprang results of great importance to

[1] See Appendix to this Chapter, No. 6.

[2] *Patrimonium non contemnendum* (Trithemius). Sainte-Marthe says *Avitum patrimonium (quantulum idcumque erat) fratribus fratrumque filiis utendum fruendum reliquit.*

the history of Protestantism in France. Briçonnet was the
younger son of the Cardinal of Saint-Malo, and, though only
two and thirty, had held his see for seventeen years. In
February 1507 Lefèvre, probably in performance of his
duties, was with the Court at Bourges[1], and soon afterwards
he took up his residence in the Abbey of Saint-Germain de
Près, which had just been conferred on his patron. With
its rich library it must have been a paradise to the inde-
fatigable student.

From this time Lefèvre began to devote himself more and
more to theological studies, but it is a mistake to separate
the two phases of his career, the Aristotelian and the theo-
logical, by too rigid a dividing line. As we have seen, he
published Bessarion's translation of the *Metaphysics* as late
as 1515. On the other hand, as early as 1499 he edited a
Latin version, probably by Ambogio Traversari, of the sup-
posed works of Dionysius the Areopagite, and he joined to
this the Epistle of Polycarp, and the much interpolated text
of the Epistles of Ignatius known as the Long Recension.
To the whole volume he gave the title of *Theologia vivificans*.
In 1504 he edited another composite volume, which begins
with the Lausiac history of Palladius (here called *Paradisus
Heraclidis*), and also contains the spurious Second Epistle and
Recognitions of Clement (the latter in the Latin version of
Rufinus), and a spurious epistle of Anacletus. His last con-
tribution to the Apostolic Fathers was the *Shepherd* of
Hermas, which he edited with other visions in a volume
entitled *Liber trium virorum et trium spiritualium virginum*
in 1513. Nor did he content himself with editing the versions
of others, for in 1507 he translated at Bourges " among the
turmoils of the Court" the *De fide orthodoxa*, or, as he called
it, the *Theologia*, of John Damascene, the last of the Greek
Fathers[2].

Lefèvre was not alone in making Greek Christian literature
accessible by means of Latin translations. Of the four chief

[1] See his preface to the *Theologia* of John Damascene.

[2] Dedicatory letter addressed to Gilles of Delft, dated February 150⁷⁄₆
(Camb. Univ. Lib.).

works of Eusebius of Caesarea, the *Ecclesiastical History* in the version of Rufinus was edited in 1497 by Geoffroy Boussard, who had served the University of Paris as Rector in 1487, and who represented it at the Council of Pisa in 1511, while the *Cronicon* was published conjointly by Badius and Henri Estienne in 1512. But Badius's most important work in connexion with the Christian writers was the publication in 1572, with Petit and Kelch as partners, of four stately volumes of Origen. They were edited by Jacques Merlin of Saint-Victurnien (Haute Vienne), a professor of theology at the College of Navarre[1]. Before this Badius had published Basil's popular treatise, *De libris lectitandis* in Leonardi Bruni's version (1508)[2] and his *De vita solitaria* in a translation by Budé (1505). In 1513 he dedicated to a pupil of Lefèvre's, Beatus Rhenanus, a volume containing some of the writings, not only of Basil, but also of the other two great Fathers who adorned the Church in the second half of the fourth century, Gregory of Nyssa, and Gregory Nazianzen. Their contemporary Cyril of Alexandria was edited in part by another pupil of Lefèvre's, Josse Clichtove. the Commentary on the Gospel of St John in 1509, and the *Thesaurus* and the Commentary on Leviticus in 1514. For the two former works he used the Latin version of George of Trebizond. I cannot find that anything of Chrysostom's was printed in France at this period, and Athanasius is only represented by a single treatise[3].

Of the Latin Christian writers the one that stood highest in the estimation of the humanists was Lactantius, whom they hailed as a Christian Cicero. Cyprian too, who like Lactantius, was a professor of rhetoric before he became a Christian, found favour for his chaste and

[1] On the last page is a commendatory letter addressed by Badius to Guillaume Cop. There is a copy of the work in the library of Queens' College, Cambridge. See A. Horawitz, *Michael Hummelberger*, Berlin, 1875, p. 38, for a letter from Badius referring to this edition. For Merlin see Launoy, *op. cit.* pp. 666 ff.

[2] See Delaruelle, *G. Budé*, p. 40.

[3] *Athanasius de homousia contra Arium cum aliis opusculis*, Bocard, 1500 (Pellechet 1414).

polished style. Besides these Ambrose, Jerome, and Augustine, the first an eloquent orator and the other two ardent students of rhetoric in their youth, were regarded as worthy of study by the earlier and more broad-minded humanists[1]. Lactantius was edited by Badius with a commentary in 1504[2], and Cyprian by Robert Dure, or Duré, surnamed Fortunatus[3], Principal of the Collège Du Plessis and a former pupil of Lefèvre's, in 1512. The only work of Ambrose that appeared at Paris before the edition of his *Opera* in 1529 was his *De officiis ministrorum*, written in imitation of Cicero. It was printed twice by the Sorbonne press, and again in 1494 and 1504. Jerome's Letters were published at Lyons in 1508 and at Paris in 1513. At one time Erasmus thought of entrusting to Badius the publication of his recension of the Letters, but it eventually formed part of the great Amorbach-Froben edition of 1516[4]. The *Vitae patrum* appeared at Lyons in 1502, and at Paris in 1507 and 1512.

As regards St Augustine, one is surprised to find that his *De civitate Dei*, which was printed more often in Italy and Germany during the fifteenth century than perhaps any other work, was only once printed in France in the original text before 1500, namely, at Toulouse in 1488. Two years before this, however, it had appeared in French at Abbeville—one of the finest specimens of early typography. Various of his smaller works were printed at Lyons from 1497 to 1500, and after 1500 Badius printed a volume of his *Opuscula*. But there was no further edition of the *De civitate Dei* till 1520, when it was printed at Lyons. His complete works were printed at Paris in 1515[5]. Hilary of Poitiers, another converted pagan, who may be said to mark the beginning

[1] See L. Bruni in Woodward, *Vittorino da Feltre*, p. 125.

[2] Printed by Gilles de Gourmont, but probably, says M. Renouard, this is not the first edition. Petit published another edition in 1509.

[3] Fortunatus was the name of Cyprian's principal opponent at Carthage. Had this anything to do with the editor's surname?

[4] See Badius to Erasmus, May 19, 1512 (Allen, I. Ep. 263).

[5] Bib. Nat.

of Latin Christian literature, was edited by Guillaume Petit in 1510–1511.

We must now go back a little in our survey of Lefèvre's multifarious labours and give a short account of his work in the field of mystical literature. His interest in mysticism was probably first aroused by the writings of Nicholas of Cues, with which, as we have seen, he was acquainted as early as 1490. A year later he read the *Contemplations* of the marvellous many-sided Spaniard, Ramón Lull, a work which he was to edit fourteen years later. Then came the visit to Italy, when his interest must have been further stimulated by Marsilio Ficino, whose Latin version of the *Liber de potestate et sapientia Dei* or *Pimander* of Hermes Trismegistus he edited after his return[1]. It was presumably at his instigation that his friend and patron, Germain de Ganay, wrote to Ficino to ask him for copies of his writings[2]. A few years later, as we know from his own lips[3], Lefèvre came under the influence of the Augustinian mystic, John Mauburn of Brussels, who arrived in Paris in 1490 with a mission to reform certain abbeys in the city and its neighbourhood. Among these was that of Livry, of which he was appointed Abbot in April, 1501. He died at Paris in the following December[4].

We have seen that in 1499 Lefèvre edited the writings of the Neo-Platonist mystic of the fifth century who wrote under the name of Dionysius the Areopagite. In the same year he published his *Clericus* and *Phantasticon*, and two short religious treatises by Lull. In 1505 he gave to the light the first part of the Spaniard's *Contemplationes in Deum* under the title of *Contemplationes Remundi*[5]. In the same

[1] Paris, Hopyl, 1494 (Brit. Mus.). We learn that Lefèvre edited the work, *tum amore Marsilii (quem tamquam patrem veneratur) tum Mercurii sapientiae magnitudine promotus* (fo. e iii b). [2] See above p. 194.

[3] In the preface, dated November 1, 1505, to the *Contemplationes Remundi*.

[4] See Allen, I. 166. Mauburn's *Rosetum exercitionum spiritualium* was printed by Badius in 1511.

[5] For Lull see *Hist. littéraire*, XXIX. 1–386, and for the *Contemplationes ib.* pp. 220–235; this occupies vols. IX. and X. of the Maintz edition of his works.

year he re-edited the *Pimander* of Hermes Trismegistus in Ficino's version, adding to it the *Asclepius*.

In 1509 Lefèvre went to Germany, spending July at Maintz, and visiting the house of the Brethren of the Common Life at Cologne, as well as several monasteries on the Rhine. The main object of his journey was to hunt for manuscripts, especially those of a mystical character. In the following year he edited the *Opus theologicum* of Richard of Saint-Victor, who with his master Hugo and his fellow-pupil Adam made the Augustinian abbey of Saint-Victor famous in the twelfth century as a school of contemplative and symbolic philosophy[1]. Then he turned to the mystics of the Low Countries and Germany, and with the help of the manuscripts which he had brought back with him from Germany published the *De ornatu spiritualium nuptiarum* (1512) of Jan van Ruysbroeck, the spiritual father of Gerard Groot, the founder of the community of the Brethren of the Common Life, and the volume, already mentioned, entitled, *Trium virorum et trium spiritualium virginum* (1513). It included, besides the *Shepherd* of Hermas and the short and unimportant "visions" of Uguenin, a Benedictine of Metz, and Robert of Uzès, a Dominican of Avignon[2], the writings of three remarkable representatives of German mysticism in the twelfth and thirteenth centuries, St Elizabeth of Schönau, St Hildegard of Bingen, and St Mechthild (Matilda) of Magdeburg[3]. Finally in 1519 he published through Henri Estienne, under the title of *Contemplationes idiotae*, the mystical writings of Raymond Jordan, an Augustinian Canon, who became Provost of Uzès and Abbot of Selles-sur-Cher.

The most important of Lefèvre's finds in Germany were

[1] Richard was a Scot. One of Hugo's works *De institutione novitiorum*, was edited by Lefèvre's pupil, Josse Clichtove, in 1506.

[2] For Uguenin and Robert see Fabricius.

[3] See W. Preger, *Geschichte der deutschen Mystic*, 3 vols. Leipsic, 1874–1893, I. 29–43 and 96–112; H. O. Taylor, *The Mediaeval Mind*, 2nd ed., 1914, I. 458 ff.

some unpublished writings of the great Cardinal, Nicholas of Cues (1401–1464)[1]. Some of his works had been published in the fifteenth century[2], but Bishop Briçonnet had expressed to Lefèvre his desire for a more complete edition[3]. It appeared in three volumes in 1514, printed by the Ascensian press[4]. Among the novelties were the *Excitationes* and the *De concordantia catholica*, which fills the whole of the third volume[5]. Representing as it did the ideals of the reforming party of the Church, it has been described as "the text-book of the Council of Basle." The edition contained nine other unpublished works, and Lefèvre mentions six of which he could not find traces. As a man of multifarious learning, as a conservative reformer, and above all as a mystic, Nicholas of Cues must have had a peculiar attraction for his editor. As we shall see presently from a passage in his commentary on the *Politics*, written in 1505, he at that time regarded the Cardinal of Cusa and the pseudo-Dionysius as the two greatest mystics. But before long, without abandoning his interest in mysticism he turned to the Scriptures as the worthiest object of a man's study. In the preface to the *Quintuplex Psalterium* he says that the study of divinity alone brings the highest bliss, and adds, with an apparent touch of regret, that for many years he has been occupied with profane studies and has hardly tasted those that are divine.

This first achievement in the field of Biblical criticism, of which the printing was finished on July 31, 1509, consisted of five Latin versions of the Psalms, (1) the second version of Jerome from the Septuagint, the one adopted by the Churches of Gaul (*Gallicum*), (2) Jerome's first version, the one adopted by the Church of Rome (*Romanum*), (3) his

[1] See J. M. Düx, *Nicolaus von Cusa*, 2 vols., Regensburg, 1847; Creighton, *History of the Papacy*, III. 46 and VI. 8; A. Lefranc, *op. cit.* pp. 147–164.

[2] Hain, 5893.

[3] In the preface addressed to Briçonnet Lefèvre gives as his chief reason for the publication, *Quod tu ipse vel avidissime ea percuperes.*

[4] Bib. Nat. Rés. Z, 280 (vols. I. and III. only). This copy has the signature of Jacques Corbinelli, the tutor of Henri III.

[5] The text was revised by Michael Hummelberger.

version from the Hebrew (*Hebraicum*), (4) the version
generally adopted before those of Jerome (*Vetus*), (5)
Lefèvre's version of the Gallican text (*Conciliatum*). The
first three were printed in three parallel columns, and the
remaining two, in smaller type, in two columns. His next
work in this field was a revised Latin version of St Paul's
Epistles, which was printed by the side of the Vulgate, and
was accompanied by a commentary (1512). The latter had
this remarkable feature, that it anticipated two of the
cardinal doctrines of Luther's theology, asserting that there
is no merit in works without grace, and denying, though in
less precise language, the doctrine of Transubstantiation.
But at the time of their publication these views attracted
little attention. There was as yet no idea of revolt
against the Church, and no one had less thought of it than
Lefèvre himself. For he was no rebel, but a humble and
single-minded inquirer after truth. How he became the
leader of the Evangelical party in France and the object of
persecution from the Sorbonne and the *Parlement*, and how
he himself, though he prepared the way for others, remained
within the fold of the Catholic Church, is a story which
belongs to the history of the Reformation. His attitude
towards the Church was the result of the double thread
which runs through his character, mysticism and the love
of truth, and it is in this double thread that we shall find
a clue to his attitude towards the Paris University.

In his commentary on the *Politics* he has himself sketched
for us his educational ideal. He says that in the first place
good authors must be read in the texts themselves without
the addition of fantastic glosses, and as good authors he
recommends Virgil, Baptista Mantuanus, and Prudentius
in verse, Cicero, the younger Pliny, and Filelfo in prose.
When the student has completed his studies in the *Trivium*
and the *Quadrivium* "let him drink from the source itself
the pure streams" of the *Physics*, the *Ethics*, and the *Politics*.
"But he who wishes to reach the higher peaks of blissful
tranquillity" must study the metaphysical works of Aristotle.
"From these he will be led to handle with reverence the

pages of Holy Writ...and let him take as companions, Cyprian, Hilary, Origen, Jerome, Augustine, Chrysostom, Athanasius, Nazianzen, Damascene and the like. Then when his mind has been purged and his senses put under subjection by these studies...if his generous soul aspires to still loftier heights of contemplation, let him rise by degrees with the help of the works of Cusanus and the divine Dionysius."

Thus in the light of this programme all Lefèvre's labours as an editor and commentator appear as part of a single consistent design. From Grammar and Rhetoric to Aristotle, from Aristotle to the Scriptures and the Fathers, from the Fathers to the mystical writers, and so upward to a beatific contemplation of the Divine Essence—this for the really generous soul is the true ladder of education.

It will be seen that with the study of the *Metaphysics* mysticism begins to play a part in Lefèvre's programme. The same mysticism which enabled Ficino to read Christianity into Plotinus, and an amalgam of Christianity and Neo-Platonism into Plato, led Lefèvre to regard Aristotle as a transcendental and almost as a Christian philosopher. "Those who predicate ideas," he says in the preface to his introduction to the *Metaphysics*, "are Platonists; those who follow the divine and eternal doctrines are Aristotelians." It is a surprising view of Aristotle, and would have surprised no one more than Aristotle himself, but it explains why this ardent Aristotelian was able to pass without effort to Neo-Platonism and Platonism, or rather to be at one and the same time a follower of Aristotle, Plotinus, and Plato.

Mysticism, it has been said, first appeared in the Mediaeval Church as the protest of practical religion against the predominance of the dialectic spirit[2]. If this is true of the

[1] *Politicorum libri octo*, H. Estienne, 1506. Book VIII. vi. (quoted by Clerval, pp. 55, 56).

[2] Professor Pringle-Pattison in the *Encyclopaedia Britannica*, art. "Mysticism."

twelfth century, how much more was such a protest needed at the close of the fifteenth! Lefèvre was himself a logician, but he protested with all his soul against the sophistical quibbles and puerilities which degraded the logic of his day, and against the intrusion of the dialectical spirit into every field of learning, and being, like so many mystics, a man of practical intelligence, he set himself to combat the methods of a decadent scholasticism in a practical way. He realised that the introduction of printing had made a potential change in the whole method of instruction. It had made possible the substitution to a large degree of text-books for oral teaching. But some one had to write the text-books. This is what Lefèvre did for Aristotle. Instead of the cumbrous commentaries of Bricot and Tartaret, which were too expensive for students to buy and too difficult for them to understand, he wrote short introductions and simple commentaries. He also provided them with improved text-books for the four subjects of the *Quadrivium*.

But this was for beginners. More advanced students must "drink the pure streams from the source itself." Hence, as they could not read Greek, he gave them improved Latin versions, made by Italian scholars. Thus, so far as he was able, he lectured on Aristotle from the sources, just as at Meaux a quarter of a century later, to use his own expression, he "preached Christ from the sources." In this going back to the sources he was guided by a simple love of truth. Unfortunately his equipment for his task was insufficient. In the first place, his knowledge of Greek and Latin was very inferior to that of the best humanists. His acquaintance with Latin classical literature was far from wide, and his taste was uncritical. As we have seen, he ranks Prudentius with Virgil, and Filelfo with Cicero. Though he wrote Latin with facility, his style is wholly unclassical.

But it was Greek that he specially needed for his chosen task. How and when did he learn it? Apparently his first teacher was George Hermonymos, of whom he speaks in a tone of veneration very different from that of Budé and

Erasmus[1]. He also had lessons from Lascaris, but this must have been after his first visit to Italy. How much he learnt during that visit it is impossible to say. Cuthbert Tunstall, who came across him in Italy on his second visit in 1500, speaks slightingly of his scholarship. In a letter to Erasmus he says that he had never heard of Lefèvre's knowing Greek until he published his Commentary on St Paul's Epistles[2]. But this is the tone of partisanship. Three years before the publication of the Commentary, Lefèvre had translated the *Theologia* of John Damascene. It is true that the latter's Greek is easy and straightforward, and makes no great demand on scholarship. But Lefèvre's version, so far as I have tested it, is quite accurate. M. Delaruelle has pointed out that he sometimes ventures to correct Leonardo Bruni's version of the *Politics*[3]. But Bruni was by no means a faithful translator, and a good scholar would have found many more opportunities for correction. Even Erasmus, who, when he tried to restore part of the Apocalypse by translating it into Greek from the Vulgate, made thirty mistakes in six verses[4], detected numerous errors in the Commentary on St Paul. Lefèvre, in short, knew Greek up to a certain point, but he was incapable of dealing with any real difficulties of construction, or of appreciating the niceties of the language.

He has been accused of timidity in his attitude towards Humanism, as in his attitude towards Reform. He was not indeed a bold thinker nor had he a rebellious spirit. He was a conservative reformer; he wanted to mend the old ways, not to end them. His aim was to purify Aristotle and the other studies of the University, just as later his aim was to purify the Church. But it does not follow that this conservatism was due to moral timidity. Just as there was nothing in his theological views, which were at bottom those

[1] G. *Hermonymum, cuius familiaritas mihi quam gratissima est.* It was at his instigation that he applied himself to the study of Mathematics.
[2] Erasmus, *Opera*, III. 266 F. (Sept. 1517). For the date of Tunstall's visit to Italy see P. S. Allen in the *English Hist. Review*, XVIII. 916.
[3] G. *Budé*, p. 53.
[4] Acton, *Lectures on Modern History*, p. 87.

of a practical mystic, to drive him from the Catholic fold, so there was nothing in his views on education to make him abandon the *Trivium* and the *Quadrivium*. His dislike of scholasticism, his devotion to learning, and his love of truth, made him sympathise with the best of the humanists, especially with those who studied philosophy. But he took little interest either in philology or in literary form, and his whole attitude towards pagan antiquity was rather mediaeval than humanistic. He vaguely admired it, but he also feared it. He tried to see in its literature an allegory of Christianity; he did not frankly accept it for what it was. Thus, though the humanists in all countries revered him as the restorer of philosophy, he was never quite a humanist any more than he was ever quite a Protestant.

Lefèvre's amiable and blameless character endeared the little man, whose stature was as small as his heart was large[1], to all who came in contact with him, while his enthusiasm and overflowing energy inspired his pupils with a love of learning similar to his own. They were of all nations, and many of them in their turn became distinguished. Among the foreigners were Bruno Amorbach, son of the famous Basle printer, Beatus Rhenanus and Michael Hummelberger from Alsace, Johannes Solidus of Cracow, and Volgatius Pratensis. It was partly through the agency of his pupils that Lefèvre's works were printed in many lands —at Venice, Nuremberg, Leipsic, Strassburg, Freiburg, Basle, Deventer, and even Cracow. Some of them wrote or edited books under his inspiration; others helped him in his own labours. Chief among the latter were Josse Clichtove and Charles de Bouelles.

Josse Clichtove[2] was born at Nieuport in Flanders in 1472 or 1473, and came to Paris in 1488, where, as was the habit with Picards and Flemings, he entered the College of Boncour, and became the pupil of Charles Fernand. Two years

[1] *Statura fuit supra modum humili, vultu modesto et moribus plane aureis* (Sainte-Marthe).

[2] J.-A. Clerval, *op. cit.*; Vander Haeghen, *Bibliographie des œuvres de Josse Clichtove*, Ghent, 1888; Launoy, *Nav. Gymn. Hist.* pp. 668 ff.

later he migrated to the College of Cardinal Lemoine, possibly attracted by the fame of Lefèvre's lectures, and in due course took his Master's degree in 1492. Then proceeding to the study of Theology he took his Bachelor's degree in that faculty in 1498, joined the Sorbonne in the following year, and finally, having completed the usual fourteen years course, was admitted Doctor in 1506.

While he was still studying for his degree of Bachelor in Theology, he began to help Lefèvre in the preparation of his text-books, and later he gave more substantial assistance, either by acting as editor of new editions, or by providing a commentary. This he did not only for the introductions to Aristotle but also for Boethius's work on Arithmetic. Meanwhile he edited on his own account the rhetorical manuals of Nigri and Dati, and wrote one or two logical treatises. After taking his Doctor's degree he confined himself almost entirely to theology, and, as we have seen, edited some of the works of Cyril of Alexandria and of Hugh of Saint-Victor. He also provided with a commentary new editions of the *Theologia* of John Damascene (1513) and the *Theologia vivificans* of the pseudo-Dionysius (1515). From 1506 to 1513 he had as pupils François and Geoffroy d'Amboise[1]. For the former, who became a soldier, he wrote a treatise, *De vera nobilitate* (1512) which received some years later (1533) the honours of a French translation. In the double controversy which Lefèvre had with the Sorbonne with regard to the identity of Mary, the sister of Lazarus, with Mary Magdalene and the "woman who was a sinner," and with regard to the number of times that St Anne, the Mother of the Virgin, was married, Clichtove sided with his old master on the first question, and with the Sorbonne, after considerable vacillation, on the second[2]. In 1520 he

[1] Clerval describes these young men as nephews of the Bishop of Clermont. Geoffroy, who was a son of Jean d'Amboise, Seigneur de Bussy, succeeded his uncle as Abbot of Cluny, and died in 1518. I cannot find in the genealogical tables of Père Anselme any brother of Geoffroy named François, or any nephew of the Bishop of Clermont of that name except one, and he is too old and was a priest, not a soldier.

[2] The orthodox view was that St Anne was married three times, and

was classed by Noel Beda, the champion of the Sorbonne, with Lefèvre, Erasmus, and Luther as a supporter of the new opinions. But when towards the close of the year Lefèvre went to Meaux to preach the Gospel, Clichtove remained at Paris in the College of Navarre, and in April of the following year published under the title of *Determinatio theologicae Facultatis Parisiensis super doctrina Lutherana* a detailed criticism of Luther's doctrines. From this time he became a warm adherent of the Sorbonne and scholastic theology. He died at Chartres, where he held a Canonry, in 1543.

Charles de Bouelles was a year or two younger than Clichtove, having been born in the neighbourhood of Amiens about 1475[1]. He began to study philosophy under Lefèvre in 1495, and his first literary work was to write notes for his professor's *Ars suppositionum* (1500). In 1503 he contributed a manual of Geometry to the reprint of Lefèvre's edition of Boethius's Epitome of Arithmetic. In the same year he travelled in Switzerland, and visited Maintz and Sponheim, where he made the acquaintance of Trithemius. In 1507 he was in Italy and not long afterwards in Spain. Apart from the assistance which he gave to Lefèvre, he does not seem to have published anything before 1510, but from that year till his death in about 1553 his pen was seldom idle. His numerous works were concerned with mathematics, philosophy and theology. His treatise on Physics was published by Badius and Petit in 1512. The most popular of his mathematical works was a treatise on Geometry, the French translation of which, *Art et science de Géométrie*, went through many editions. The first edition (1514) was the only French book that Henri Estienne ever condescended to publish. He had learnt from his master to take an interest in mysticism, and under the influence of Trithemius (whom he regarded as a magician) he became an adept in the

that Mary the wife of Cleopas, and Salome (originally also called Mary), the wife of Zebedee, were half-sisters of the Virgin.

[1] Niceron, *Mémoires*, xxxix.; J. Dippel, *Versuch einer systematischen Darstellung der Philosophie des C. Bovillus, nebst einer kurzen Lebensabrisse* Würzburg, 1865.

mystical science of numbers, and wrote *De numeris perfectis* and *De mathematicis rosis*. His philosophical treatises, most of which were written in 1509, were collected and published by Henri Estienne in the following year[1]. In later life he became a Canon of Saint-Quentin and Noyon; he died about 1553.

Among the more distinguished pupils of Lefèvre was a young Alsatian, who under his latinised name of Beatus Rhenanus achieved honourable distinction in the field of scholarship as the editor of numerous texts, including the *editiones principes* of Velleius Paterculus and Tertullian. He was the devoted friend of Erasmus, and wrote the life prefixed to Froben's edition of his works (1538–40). By a singular piece of good fortune his library, of about a thousand volumes, has been preserved almost intact in his native town of Schlettstadt; and as it throws very considerable light on the studies of the Paris University, the teaching of Lefèvre, and the production of the Paris press, a brief account of it will form an appropriate epilogue to this chapter.

Beatus Rhenanus was born in 1485[2]. His family name was originally Bild, but the *cognomen* of Rinow was conferred on his father, who had come to Schlettstadt from the neighbouring village of Rinow or Rheinau, and the son latinised it into Rhenanus. After receiving his early education at Schlettstadt, he joined the University of Paris in 1503, and remained there till 1507. At the age of fifteen he began to buy books, and as he had the excellent practice of noting in each book the year in which he bought it, we can construct from his library a continuous history of his studies. The school at Schlettstadt had been re-organised a little before the middle of the fifteenth century by Ludwig Dringenberg, a pupil of the Brethren of the Common Life, and both he and his successors, Arato Hofmann and Hieronymus

[1] For a description of this volume (*Liber de intellectu*, etc.) see *Catalogue of the Library of C. Fairfax Murray*, I. No. 63.

[2] See for what follows G. C. Knod, *Aus der Bibliothek des Beatus Rhenanus*, Strassburg, 1889; P. S. Allen, *The Age of Erasmus*, pp. 154–158.

Gebwiler, had pronounced humanistic sympathies. We find, in consequence, that among the books which Rhenanus bought in his native town the Latin classical writers are well represented. Of Plautus and Virgil he had two copies. Moreover in company with Donatus and Cato and the *Doctrinale* there appear the grammars and rhetorics of Italian humanists—Perotti, Mancinelli, Dati, and Nigri. Italian Humanism is also represented by Battista Guarino's *De modo et ordine docendi et discendi*, Ficino's *De triplici vita*, a short treatise by Beroaldo the elder, and a volume of verse and prose by another Bologna professor, Urceo Codro. It was on the ninth of May, as he carefully records in one of his books, that our student set foot in "the celebrated city of Paris." As he took his Bachelor's degree in Lent of the following year (1504), he must have plunged at once into the work of preparing for the examination, which began at the end of the year.

Among his purchases of 1503 we find the Latin text of Aristotle's Works in the translations of Argyropoulos, Leonardo Bruni, and Giorgio Valla[1], a commentary on Aristotle and Porphyry by the Englishman, Walter Burley, treatises on logic by Buridan and Bricot, Ermolao Barbaro's Latin version of Themistius's *Paraphrases*[2], and above all Lefèvre's edition of the translation of the *Organon* ascribed to Boethius[3]. This last bears witness to repeated study, pen in hand. It was doubtless the text upon which its editor founded his lectures. But Beatus Rhenanus did not confine himself to the logical studies which were necessary for his Bachelor's degree. He provided himself with Egidio Colonna's commentaries on some of Aristotle's physical treatises, and with the text-books on the four subjects of the *Quadrivium* which Lefèvre had prepared with the assistance of Clichtove and Bouelles. He also bought the fantastic treatise of Martianus Capella on the seven liberal arts[4], which

[1] Venice, 1496.
[2] Venice, 1499. It was first printed at Treviso in 1481.
[3] Hopyl and H. Estienne, 1503 (see above p. 237).
[4] Vicenza, 1499. This is the *princeps*.

had such a remarkable popularity during the Middle Ages, and Lefèvre's *Paraphrases* of Aristotle's Natural Philosophy. The latter volume cost a crown[1]. His purchases in 1504 include most of the recognised commentaries and text-books of the old learning—Buridan, Bricot, George of Brussels, Magister Martinus, Tartaret.

During the year of his preparation for the Licence (Lent 1504 to Lent 1505) his chief study would have been natural philosophy, with a smattering of mathematics and astronomy. For the Master's degree, which he took, as was usual, six months after the Licence, he would have continued the study of natural philosophy with the addition of moral philosophy[2]. For this latter subject he provided himself with Lefèvre's introductions to the *Ethics* and the *Magna moralia,* and with Argyropoulos's translation (edited by Gilles of Delft) of the *Ethics.*

After taking his degree he became proof-reader to Henri Estienne, and revised the proofs of Lefèvre's edition of Leonardo Bruni's translation of the *Politics* and *Economics*[3]. This work was now added to his library, as was Lefèvre's *Tres conversiones.* With the various commentaries on Aristotle which he bought before leaving Paris in the late autumn of 1507 we need not trouble ourselves, except to notice that they include two volumes by Arab commentators. It is more to our purpose to note the various works of a humanistic character which he acquired during his residence at Paris. Beginning with classical authors, he added to the collection which he had already formed at Schlettstadt, Quintilian, Petronius, Macrobius, Censorinus, Pomponius Mela, and eleven volumes of Latin historians. The only representatives of Latin poetry are Terence, of whom he

[1] Hopyl, 1501 (see above p. 236). Rhenanus hardly ever records the price of his books.

[2] I owe the dates of Beatus's degrees to Mr P. S. Allen, who transcribed them from the MS. *Registres de la Sorbonne,* No. 85, *Liber receptoris nationis Alamanice,* 1494–1530. Owing to his attainments, no doubt, Beatus proceeded to his Bachelor's degree in less than a year, instead of the ordinary two and a half years.

[3] 1506 (see above, p. 237).

already possessed a copy, and Ausonius. Lucretius, Juvenal, Catullus, Propertius, Tibullus, and above all Ovid, are absent from his library. Their place is taken by the Christian poets Prudentius, Juvencus, and Sedulius[1]. In this preference for Christian authors and in this avoidance of Ovid and the elegiac poets we may trace the influence of Lefèvre. The presence of Petronius may surprise us, but the fragments of this writer contained in the Venice edition of 1499 form less than forty pages. Beatus's purchases also include a few Latin translations from the Greek—the *Tabula* of Cebes, Erasmus's translations of Euripides and Lucian, and Budé's of Plutarch.

Italian Humanism is fairly well represented. Among the more noteworthy examples are a complete edition of Politian's works (Venice, 1502), which Beatus bought soon after his arrival at Paris, a Paris edition of Pico's *Golden Epistles*, and the same writer's *Commentationes* and *Disputationes* (Bologna, 1496), the *De honesta disciplina* of Petrus Crinitus, Paris editions of Valla's *Elegantiae* and Filelfo's *Orations*, and a copy of Poggio's *Facetiae*,—in which Beatus has written, *Liber hic non est legendus iuvenibus*. As might be expected, he took a warm interest in the nascent Humanism of Paris. He bought Tardif's *Compendium*, Gaguin's *Epistolae et Orationes* and *Ars versificatoria*, and several volumes of Latin verse—four by Pierre de Bur, the same number by Gilles of Delft, and one each by Jean Fernand, Valeran de Varanes, Guillaume Castel, Guy de Fontenay, and Michel l'Anglois. Fausto Andrelini, whose lectures Beatus attended, is represented by no less than fourteen volumes. The translations of Budé and Erasmus have already been noticed. Erasmus is also represented by three other volumes, the *Lucubratiunculae*, the panegyric addressed to the Archduke Philip on the feast of the Epiphany, 1504, and the *Epigrammata*. Other purchases were Fra Giocondo's Latin translation of Amerigo Vespucci's letter to Lorenzo di Pierfrancesco de' Medici, printed at Paris

[1] Cp. a letter from Rhenanus to Beatus Arnoaldus (*Briefwechsel*, p. 18).

about 1503 by Jean Lambert, and the *Theologia naturalis* of Raymond de Sebonde, printed at Nuremberg in 1502.

Under the influence of Lefèvre, Beatus bought several books of a mystical character—a volume containing Iamblicus, *De mysteriis*, and other Neo-Platonist writings (Aldus, 1497), the works of Hugh of St Victor, Lefèvre's editions of Hermes Trismegistus and the *Contemplationes* of Lull, and his translation of the *Theologia* of John Damascene. The proofs of the last two volumes had been corrected by Beatus for Henri Estienne. Some of his books were presents. Lefèvre gave him the *Quintuplex Psalterium* and the works of Nicholas of Cues, Badius the *Opuscula* of Avitus and those of Michel l'Anglois, his friend Michael Hummelberger the *Batrachomyomachia* and Hesiod's *Works and Days*, both from the new Greek press of Gilles de Gourmont. The last must have been a farewell gift, for the printing was only finished on October 28, 1507, shortly before Beatus's departure. In the case of each of these Greek books he has written out the Latin version between the widely spaced lines of the Greek text[1]. He had learnt little Greek at Paris, where his only teacher was Hermonymos[2]. In the next chapter we shall see how, under better teachers, the study of Greek began in earnest, and how Gourmont with his Greek press greatly contributed to its progress.

[1] Knod, p. 81.

[2] See Beatus to Hervagius in A. Horawitz, *op. cit.* p. 16.

CHAPTER VIII

THE STUDY OF GREEK

I. *Aleandro*.

WE have seen that neither Robert Gaguin nor any of his humanist friends at Paris knew Greek, and that, though Lefèvre d'Étaples had learnt some Greek in Italy, his scholarship was very imperfect. The serious study of Greek in France may be said to date from the year 1496, when the distinguished Hellenist Janus Lascaris entered the service of Charles VIII. He was not, indeed, a professional teacher like his predecessor, Gregorio of Città di Castello. He was a busy official, and his employment upon affairs of state left him little leisure for other work. Of his life before he came to France we know little. He is said to have been born in Constantinople about 1445, and to have been a near relative of Constantine Lascaris, the founder of Greek studies in Italy. Coming to that country as a youth, he found a patron in his compatriot, Cardinal Bessarion, at whose expense he studied for some years at Padua. On Bessarion's death in 1472 Lorenzo de' Medici made him his librarian and sent him twice to the East in search of manuscripts. During the second of these missions (1491–2) Lorenzo died, but Lascaris was continued in his post by his son Piero. He now applied himself to the establishment of a Greek press at Florence, designing the types, which at first consisted wholly of capitals. Five *editiones principes*—the *Anthology* (August, 1494), four plays of Euripides (no date, but 1494), Callimachus (no date, but 1495), Apollonius Rhodius (1496) and Lucian (1496)— and three other works, all printed within two years, testify to his industry and to that of his printer, Lorenzo de Alopa.

On the downfall of the Medici he was glad to accept an offer from Charles VIII, whom he followed to France towards the end of 1496[1]. He remained in the service of Louis XII, and he probably accompanied him to Milan, as we find him in that city in April, 1500. In the summer of 1503 he was sent on a diplomatic mission to Venice, and in the autumn of the following year he was appointed ambassador to that republic, a post which he held till the outbreak of the war between France and Venice in April, 1509. In January, 1510, he writes to Budé from Milan, and in the following June we find him with the French Court at Lyons[2]. In 1513 he was sent for by Leo X to help in the founding of a Greek College at Rome, and he did not pay another visit to France till the year 1518[3].

Though the circumstances of Lascaris's life prevented him from giving regular and continuous instruction, he was always ready to do what he could for students of his native language. For he was of a kindly disposition and his amiable character endeared him to all. Lefèvre d'Étaples refers to him in one of his prefaces as his teacher and particular friend (*singularis amicus*). The Swiss physician, Guillaume Cop, who came to Paris in 1495, and who had learnt the rudiments of Greek in Germany from Conrad Celtes and Mithridates, had lessons from him[4]. But the most interesting testimony comes from Guillaume Budé. "Lascaris," he says, "for all

[1] It appears from the royal accounts (*Archives de l'art français*, I. 94 ff.) that he was paid wages at the rate of 400 *livres* a year for two years ending Dec. 31, 1498. It is evident that Lascaris's work must have kept him at Florence till near the close of 1496. The text of Callimachus is printed in capitals and the *scholia*, which follow, in small letters. In the Apollonius Rhodius the *scholia*, printed in small letters, are on the same page as the text. The Lucian is printed throughout in small letters. See R. Proctor, *The Printing of Greek in the Fifteenth Century*, Oxford, 1900, pp. 78–80.

[2] See L. Delaruelle, *Répertoire de la correspondance de G. Budé*, 1907, p. 3.

[3] See E. Legrand, *Bibliothèque hellénique*, I. (1883), cxxxi–clxii.

[4] Igitur graecarum literarum prima rudimenta, quae iam pridem in Germania sub Mithridate et Conrado Celte degustaveram, sub utriusque linguae doctissimis praeceptoribus Joanne Lascari atque Erasmo Rotero-damo in Parisiorum academia excolere tentavi. (Preface to translation of Paulus Aegineta, April 4, 151$\frac{9}{1}$, quoted by Knod, *op. cit.* p. 45.)

his goodwill could not give me much assistance, seeing that
he was generally with the Court many miles away from
Paris, and that I spent most of my time at Paris and was
seldom with the Court. But being a man of the most
obliging nature, he gladly did what he could, so that he
gave me some twenty lessons, and when he was absent from
Paris entrusted me with the custody of his books[1]."

Meanwhile Budé's future rival in Greek scholarship was
struggling under the same difficulties to the same goal.
Erasmus had learnt little more than the Greek characters
at Deventer, and during his first residence at Paris does not
seem to have made much progress[2]. But when he returned
to Paris from England in February 1500, he began to work
at Greek in real earnest. He had now thoroughly realised
the importance of Greek literature as a key to knowledge,
and the great debt which Latin literature owed to it. He
expresses this in a letter to Anthony of Bergen, Abbot
of St Bertin at Saint-Omer, which evidently belongs to the
first quarter of 1501. "Formerly I amused myself with
Greek literature, but only in a superficial fashion. Now that
I have gone rather deeper into it I realise the truth of what
I have often read in writers of authority, that a knowledge
of Latin, however extensive, loses half its value without a
knowledge of Greek[3]. For in Latin authors you find only
rivulets and muddy pools, but in Greek authors pure
fountains and rivers of gold." Then he dwells on the
supreme importance of Greek for the study of theology[4].
But with all this ardour he was hampered by the want of
teaching. He had taken some lessons with Hermonymos,
but had found him useless. Still, he persevered and by
September 1502, when he was at Louvain, he could report
that he was immersed in Greek literature and that he could

[1] Budé to Tunstall (*Epistolae*, 1531, f. 1; *Luc.* 363 A; Allen, II. 572).

[2] For Erasmus's Greek studies see Allen, I. 592.

[3] For instance, Guarino in his *De Ordine Docendi et Studendi* (1459)
says that "without a knowledge of Greek, Latin Scholarship itself is in any
real sense, impossible." (Woodward, *Vittorino da Feltre*, p. 166.)

[4] Allen, I. Ep. 149 (p. 352).

write the language fairly well. In the following year he translated into Latin three declamations of Libanius and two plays of Euripides. During his next visit to Paris (1504–5) he gave Greek lessons to Cop, Pyrrhus d'Angleberme, and others[1]. His departure in the spring and summer of 1505, following as it did that of Lascaris in the previous autumn, must have been severely felt by the Paris humanists, especially by those who were endeavouring to learn Greek[2].

It was the lack of books as well as of teachers that made that study such uphill work. Greek books even in Italy were very expensive according to our notions. Aldus's edition of Thucydides cost a gold ducat, or eight and a half French *livres*. The price of Herodotus was the same, of Euripides in two volumes a ducat and a half, of Theocritus four Venetian *livres*, or five and a half French *livres*, of Sophocles three Venetian *livres*[3]. But the Paris booksellers sometimes asked more than three times the original price. "That usurer of a Jean Pierre (Zanpietro)," writes Aleandro to Aldus soon after his arrival at Paris, "sells your books here at the price of a man's eye, so that they do not go off easily, and many are thus deterred from learning Greek. They nickname him the Jew. He sold a copy of your edition of the *Epigrammata Graeca* to a French gentleman for two ducats and ten *soldi* of our Venetian money[4]." Then he adds, "there is beginning to be much talk of a Frenchman who knows Greek, and of setting up a press. My arrival has ruined his plans, and I believe he has stopped his lectures. I only know him by name; it is, I think, François Tissard[5]."

[1] He writes to Colet soon after his arrival at Paris, Iam triennium ferme literae Graecae totum me possident, neque mihi videor operam omnino lusisse (Allen, I. Ep. 181, l. 35).

[2] After this Erasmus paid only two or three short visits to Paris.

[3] Renouard, *Annales de l'imprimerie des Alde*, 3rd ed., pp. 332–334.

[4] The volume is priced in Aldus's catalogue at 4 Venetian *livres*. The price asked by Jean Pierre was equivalent to 12 Venetian *livres* and 18 *soldi*.

[5] H. Omont, *Essai sur les débuts de la typographie grecque à Paris*, 1892 (from *Mémoires de la Société de l'histoire de Paris*, XVIII. 1892), pp. 68 ff.;

François Tissard of Ambrose, to whom Aleandro, scenting a possible rival, refers in these contemptuous terms, had recently returned to France after several years spent in Italy. Before this, he had studied at Paris and Orleans. In Italy he had been a pupil of Battista Guarino and Demetrios Moschos of Sparta at Ferrara, of Beroaldo at Bologna, and of Giovanni Calphurnio at Padua. At both Ferrara and Bologna he had studied canon and civil law as well as the humanities, and he had taken a doctor's degree *utriusque iuris* in the latter University. As the result of his Greek studies he translated into Latin the *Medea*, the *Hippolytus*, and the *Alcestis*, three of the five plays of Euripides edited by Lascaris[1]. It was perhaps that scholar's example which led him, on his return to Paris in 1507, to associate himself with the printer Gilles de Gourmont[2] in setting up a Greek press. For though Greek type, probably imported from Venice, had been used by Gering and Rembolt for Perotti's *Cornucopia* as early as 1494 and by Jean Philippi for the first edition of the *Adagia* in 1500, no Greek book had yet been printed at Paris[3]. The first production of Gourmont's press was a little volume entitled Βίβλος ἡ γνωμαγυρική. It consisted of the Greek alphabet, some rules of pronunciation, and a few short treatises. It was followed by the *Batrachomyomachia* and the Greek Grammar of Chrysoloras (both dedicated to Jean d'Orléans, Archbishop of Toulouse), Hesiod's *Works and Days* (dedicated to Jean Morelet de Museau), and Theocritus, all in the same year, 1507. Early

E. Jovy, *François Tissard et Jérôme Aléandre*, Vitry-le-François, 1899–1900, fasc. 2, p. 59. These are the principal authorities for what follows.

[1] This translation, which has never been printed, was dedicated to the future Francis I. (see P. de Nolhac in *Mélanges Henri Wiel*, 1898, 299 ff.).

[2] Gilles de Gourmont began his honourable career as a printer in 1506. His elder brother, Robert, had preceded him in 1498, and his younger brother, Jean, followed him in 1507. Their family came from Saint-Germain de Varreville in the Côtentin.

[3] In 1492 Tissard's Greek type had been used by Trechsel at Lyons for Badius's *Silvae morales* (Proctor, *op. cit.* pp. 140–142). There are some well-printed Greek words in the notes to Badius's edition of Horace printed for Roce in 1503.

in the year 1509 appeared the first Hebrew book printed in France, a Hebrew grammar, the work of Tissard himself. Meanwhile Aleandro had arrived at Paris, and soon afterwards he succeeded Tissard as the director of Gourmont's press.

Girolamo Aleandro[1] was born at Motta, a small town in the neighbourhood of Venice, where his father practised as a physician. With little help from teachers he made himself a considerable Latin, Greek, and Hebrew scholar, and learnt something of Arabic and Syriac. He was only twenty-four when Aldus Manutius paid him the honour of dedicating to him the Aldine Homer (1504)[2]. He was at that time at Padua, where he spent four years (1503–1507) in the study of Greek under Marcus Musurus, and of philosophy under Pietro Pomponazzi. In the early months of 1507 he took up his abode at Venice, and became one of the most prominent members of Aldus's Academy. When Erasmus came to Venice in April 1508 for the purpose of publishing through Aldus a new edition of his *Adagia*, he became intimate with Aleandro, to whom he was much attracted, and he suggested to him that Paris offered great opportunities for a humanist teacher. Fired by his words, Aleandro decided to try his fortune on French soil, and on the following 4th of June he arrived at Paris, bearing letters of recommendation from Erasmus[3].

A thoroughly competent scholar, writing Latin and Greek with ease and correctness, full of energy and enthusiasm and confidence, hardworking and ambitious, this brilliant young humanist of eight and twenty was admirably suited to be the founder of Greek studies at Paris. Acting on the advice of Budé and Lefèvre d'Étaples, to whom as the two leading Greek scholars at Paris Erasmus had doubtless

[1] *Journal*, ed. H. Omont in *Notices et Extraits des Manuscrits de la Bibliothèque Nationale et autres bibliothèques*, XXXV. 1 ff. (1896); J. Paquier, *Jérôme Aléandre*, 1900, and *Lettres familières de J. Aléandre* (1510–1540), 1909; E. Jovy, *op. cit.*

[2] See the preface to the *Iliad*.

[3] Paquier, pp. 27–28; *Journal*, p. 16; Allen, I. Ep. 256 (Aleandro to Erasmus), esp. ll. 86 ff.; Erasmus, *Opera*, III. 544 C.

given him letters, he abstained at first from lecturing, and contented himself with giving private lessons to a few distinguished pupils[1]. It was not till October 8, 1509, that he began his first course, choosing for his subject three short treatises of Plutarch which he had recently edited for Gourmont's press[2], and upon which he had already lectured at Venice. In an interesting preface to the Paris edition he dwells on the dearth of Greek and Hebrew books at Paris. Apart from his own small collection, which he had formed with great difficulty and at great expense, there were barely two or three Hebrew books in all Paris. As for Greek books, far from sufficing for the thousands of students— this must be a greatly exaggerated estimate—there were scarcely enough to satisfy a few enthusiasts. Even if more books were procured from Italy, it was doubtful whether they would find purchasers, as the majority of the students were too poor to buy them. It was therefore his intention to reprint at Paris a series of selections from Greek authors[3]. The Plutarch was followed by two speeches of Isocrates (1509)[4], some dialogues of Lucian (1510?), and a Greek and Hebrew alphabet (1510)[5].

Before the end of the year 1510, owing to the outbreak of an epidemic at Paris, Aleandro migrated to Orleans, where he lectured and taught with great success till the following June[6]. On his return to Paris he began to prepare a new edition of Chrysoloras's Grammar; but being prevented by ill-health from finishing it, he handed it over to his pupil, François Vatable. It appeared in July 1512. Meanwhile, with the assistance of six other pupils, he had been engaged on a much larger work, a new edition of the

[1] Letter to Aldus. (See above, p. 260.)

[2] *Virtue and Vice, Fortune*, and *The manner in which children should study poetry*. They are all contained in the Aldine edition of the *Moralia* (1509), which Aleandro had helped to edit. There is a copy of Gourmont's edition in the Cambridge University Library.

[3] Paquier, pp. 65–66.

[4] Camb. Univ. Lib.

[5] Brit. Mus. 621, g. 40 (1).

[6] *Journal*, pp. 18–20.

Greek-Latin lexicon of Giovanni Crastone of Piacenza, first published at Milan not later than 1478, and frequently re-edited[1]. Aleandro's edition was finished on December 13, 1512, the third and fourth parts being printed from new and greatly improved types, in which the accents on the capitals were cast in one piece with the letters. Aleandro had taken as the basis of his work the Aldine edition of 1497, with which his first part, the Greek-Latin vocabulary, is identical. But the Latin-Greek part is much fuller, and is superior in general arrangement. Aleandro was therefore justified in claiming that his edition was an improvement on all preceding ones. The dictionary was closely followed by a collection of Greek texts entitled *Sentences of the Philosophers*, and by an enlarged and revised edition, under the title of Γνωμολόγια, of Tissard's Βίβλος ἡ γνωμαγυρική[2]. Three new treatises of Plutarch, taken like the former three from the Aldine edition of the *Moralia*, and the First Book of the Greek Grammar of Theodore Gaza[3] probably belong to the same year. Finally, early in the year 1513 Aleandro published a small elementary work of a few pages containing the Greek alphabet followed by some remarks on pronunciation, breathings, accents, and syllables[4]. It had considerable success, for there were three editions of it by Gourmont, and it was reprinted at Strassburg, Louvain, and Cologne.

Meanwhile Aleandro had been carrying on his work of teaching and lecturing with brilliant success. On his return to Paris he took up his abode in the college of La Marche, and so great was his fame that the number of pensioners rose from twenty-five to a hundred and forty[5]. His public

[1] Published, but not printed, by Bonus Accursius (Proctor 5962; Hain 5812).

[2] Brit. Mus. 832 n. 1.

[3] Brit. Mus. 621 g. 40 (2).

[4] *Tabulae sanae quam utiles Graecarum musarum adyta compendio ingredi cupientibus*, Brit. Mus. 621 g. 40 (3), four leaves of a curious *format*, the page being much broader than it is long; Brit. Mus. G. 7485 (2), four leaves of ordinary *format*. Neither edition is dated, but in the preface Aleandro refers to the Dictionary and Gaza's Grammar as recently printed.

[5] *Journal*, pp. 20, 21.

lectures on Greek and Latin authors drew large and distin-
guished audiences. "On the 30th of July 1511," he writes
to Michael Hummelberger, "I began to lecture on Ausonius.
You know how impatiently these lectures were awaited.
There was such a crowd that the cloisters and the two
courts of the college could not contain it. And what a
distinguished audience! Receivers-general, councillors, king's
advocates, rectors, theologians, jurists, heads of colleges,
professors of every faculty—the number is estimated at two
thousand. Never, either in Italy or France, have I seen
a more august or more numerous assembly of educated men.
As I had more or less foreseen this, I had prepared
a discourse which was of some merit. I know this by the
fact that though the lecture lasted two hours and a half,
and the heat was suffocating, none betrayed the least
weariness. Indeed, when I had finished my peroration they
remained in their places as if they expected someting
more[1]."

Aleandro in this and other letters[2] draws such glowing
pictures of his triumphs that one might suspect him of
exaggeration. But his account of the opening lecture is
confirmed by a letter from one of the audience to Hummel-
berger. "I wish you could have seen the crowd," writes
Johann Kierher, "it was like an immense army[3]." On the
following days the attendance was as large and even larger.
At eleven o'clock, two hours before the lecture began,
every seat was occupied. The college of La Marche could
not hold the audience, so the lecturer transferred his chair
to the more spacious courts of the college of Cambrai.

These successes brought Aleandro fame and distinction.
He was made Principal of the College of the Lombards or
Italians; twice he filled the office of Proctor of the German
nation; and finally on March 18, 1513, though he was a

[1] Horawitz, *M. Hummelberger*, p. 33.

[2] In a letter to Erasmus dated February 19, 1512, he says that he
hears on all sides that no professor at Paris was ever more admired, or
more pointed at in the streets (Allen, I. Ep. 256, 99–104).

[3] *Op. cit.* p. 30.

Master of Arts of less than a year's standing, he was elected Rector of the University, an office which no Italian had held since Marsiglio of Padua in 1312.

The lectures on Ausonius shew that Aleandro's teaching was not confined to Greek. It was partly for the purposes of his lectures that he reprinted texts of Sallust, of the *Sylvae* of Statius, and of the *De Divinatione* and four speeches of Cicero. His work on Ausonius bore fruit in two editions of that author, published by Badius in 1511 and 1513. The first was edited by Hummelberger under Aleandro's supervision, and was a decided improvement on the two editions immediately preceding it, those of Ugoletus (Parma, 1499) and Avantius (Venice, 1507). The edition of 1513 made some further corrections in the text, which were furnished by a pupil of Aleandro's, but did not differ materially from that of 1511[1]. Aleandro also edited for Jean Petit, again with the assistance of Hummelberger, a new edition of Landino's *Camaldulenses disputationes* (1511), in which the numerous Greek words were printed in Greek characters, and, when necessary, translated into Latin.

In spite of his success as a teacher, and of the great reputation and popularity which he had acquired, Aleandro began to grow dissatisfied with his position and prospects. So long as his lectures were free they drew an immense audience, but when he demanded a fee the crowds vanished. The remuneration too from private pupils was extremely uncertain. If in one month he earned seventy *livres* or more, for the next two he got hardly enough to provide him with dry bread. Nor was there any hope of a pension from the king, whose exchequer was being rapidly drained by his Italian campaigns.

But the real source of Aleandro's discontent lay deeper. He longed for a more active life and for a larger theatre for his abilities. In spite of his gift for languages and his faculty of rapid assimilation he was not a real student. His

[1] See Ausonius, *Mosella*, ed. H. de La Ville de Mirmont, Bordeaux, 1889, pp. xxxvii ff.; Renouard, *op. cit.* II. 63, 64.

mission was to stimulate and popularise, rather than to produce original work. So recognising his true vocation, he accepted in December, 1513, the post of secretary to the Bishop of Paris, Étienne Poncher, who as Keeper of the Seals had to be in constant attendance at the Court. This introduced him to a larger life, but he still lacked an assured income. Accordingly in November, 1514, in spite of all Poncher's efforts to retain him, he accepted the very favourable offers of Évrard de La Marck, Prince-Bishop of Liège, and entered his service.

Though the stimulus of his presence was withdrawn, Aleandro left behind him disciples to carry on his work. His "best and favourite pupil" was Charles Brachet, who had followed him from Orleans and who, probably at his suggestion, had edited in 1513 some of Lucian's dialogues[1] from the Aldine text of 1503. Other pupils were the two brothers Louis and Gaillard Ruzé, both of whom rose to distinction in the law, the former being also of high repute as a humanist[2], Claude de Brillac, nephew of the Bishop of Orleans, a youth of brilliant prospects, to whom Aleandro dedicated his *Gnomologia*, François Vatable, the future Hebrew professor, Gérard de Vercel, the editor of several Latin classics, Salmon Macrin, the French Horace of the next generation[3], Guy de Breslay, a future President of the Great Council[4], and Adrien Amerot of Soissons, who while Aleandro was in Poncher's service, was appointed professor of Greek in the Collège du Lis at Louvain[5]. His most distinguished German pupil was Michael Hummelberger, of whom mention has already been made, and he had an English pupil who afterwards attained distinction as a Greek scholar in Richard Croke, a Bachelor of Arts of King's College, Cambridge. He

[1] See above, p. 264.
[2] Both were intimate friends of Budé's; Louis became judge of civil causes at the Châtelet, Gaillard a Councillor of the *Parlement* and Archdeacon of Langres (see Delaruelle, *G. Budé*, pp. 88, 89).
[3] Delaruelle, *G. Budé*, p. 91.
[4] 1539–1543.
[5] See a letter from him to Aleandro (*Lettres familières*, p. 21).

came to Paris in 1511, and stood godfather with Aleandro to a son or nephew of the printer, Gilles de Gourmont[1].

Aleandro's influence was not confined to his own pupils. His amiability won him many friends, and his tact saved him from making enemies. In spite of his being a Hebrew scholar he took no part in the thorny controversy with Reuchlin[2]. We have seen how on his first arrival at Paris he put himself under the guidance of Lefèvre d'Étaples and Budé. Writing to Hummelberger in 1511, he sends a special greeting to Lefèvre, for whom, he said, he had " the greatest esteem and affection[3]." And these feelings remained un-altered in later days, when Lefèvre had become conspicuous as an evangelical teacher. He dedicated to Guillaume Cop his edition of Cicero's *De divinatione*, reminding him that it was partly due to his encouragement that he lectured at Paris[4]. He was also on very friendly terms with Petrus de Ponte, for whom he wrote an *Epithalamium*, and with the three printers, Bertrand Rembolt, Gilles de Gourmont and Josse Badius, of whom the last, as we have seen, dedicated to him his edition of Plutarch's *Lives*. Other friends were the two Dominicans, Cyprian Benet, a native of Aragon, and Guillaume Petit, the king's confessor, whose services to Greek have been mentioned in a previous chapter, Michel Boudet, who became Bishop of Langres, and Celse Hugues Descousu, who edited Theocritus under his auspices.

Thus the five and a half years during which Aleandro resided and taught in France were all important for the development of Humanism in that country. The crowd of distinguished men who attended his lectures was a tribute not only to the brilliant qualities of the lectures, but to the spell which he exercised as a representative of the Italian Renaissance. Of special moment was the impulse which he gave to the study of Greek. Men of his own age or senior to

[1] See J. Paquier, *Erasme et Aléandre*, and *Une lettre de G. de Gourmont à J. Aléandre* in *Rev. des bibliothèques*, 1898, p. 206. Croke was admitted to King's on April 4, 1506. He began teaching Greek in the University in 1518, and was Public Orator from 1522 to 1528.

[2] Paquier, p. 85.

[3] Horawitz, *M. Hummelberger*, p. 28. [4] Paquier, p. 87.

him, Cop, Badius, Guillaume Petit, Descousu, owed much, as we have seen, to his help and encouragement. Pupils like Brachet and Amerot and François Vatable were trained to carry on his work.

After his departure the enthusiasm for Greek visibly slackened, and especially there was a marked diminution in the activity of Gourmont's press. In the years 1514 to 1517 it only issued seven volumes; and though from this time most of the Paris presses possessed a certain amount of Greek type, the average issue of Greek books in all Paris down to 1528 was not more than one a year.

II. *Budé.*

When Aleandro left Paris, there was no one to take his place as an inspiring lecturer and teacher. But there was a Frenchman who, if he lacked the graces of style and the instinctive feeling for language of the best Italian humanists, was in solid learning and sound critical judgment the equal of any Italian. Five months after Aleandro's arrival in Paris he had published a work which had made his name known to the whole humanistic world. When Aleandro quitted France he was on the eve of publishing another work, which was to raise him to the first rank of European humanists and reflect much glory on his native land.

Guillaume Budé[1] was born at Paris on January 26, 1468, being thus three months younger than his friend and rival, Erasmus. His father, Jean Budé, held a lucrative post in the royal chancery and was a man of considerable wealth, possessing an *hôtel* at Paris and three estates in the neighbourhood. His mother, Catherine Le Picard, was connected with the powerful family of Poncher, and his father's sister was the wife of the well-known treasurer of France, Étienne Chevalier. His father was a great lover of books (*librorum emacissimus*), but his library did not contain a single classical

[1] *Gulielmi Budaei Vita* per Ludovicum Regium (Louis Le Roy), Paris, 154$\frac{0}{1}$; R. Rebitté, *G. Budé, restaurateur des études grecques en France*, 1846; E. de Budé, *Vie de G. Budé*, 1884; L. Delaruelle, *Guillaume Budé, les origines, les débuts, les idées maîtresses*, 1907. This work of real scholarship practically supersedes all the foregoing for Budé's life down to 1519.

author[1]. Guillaume was destined for a legal career, and accordingly when he had acquired a sufficient smattering of mediaeval Latin as a "grammarian" at Paris, he was sent to the University of Orleans to study Civil Law[2]. Here he remained for three years, playing tennis and otherwise enjoying himself, but studying to very little purpose. On his return home he continued to lead an idle life for some years, his chief occupations being hunting and falconry. Then all of a sudden he bade farewell to hawks and hounds[3], and applied himself with marvellous energy and patience to the study of Civil Law. He began, according to the usual practice, by diligently reading all the commentators. From these he was led to the texts themselves, and the passion for antiquity seizing him, he determined to learn Greek. For this purpose, he had recourse to the only Greek teacher at Paris, the incompetent George Hermonymos.

I found an old Greek—or rather, he found me, for I paid him a large fee[4]—who could do little more than converse in literary language. I cannot tell you how he tried me by teaching me things one day which I had to unlearn the next. But he pronounced and read excellently, and as I heard he was the only Greek in France, I thought him extremely learned. Moreover he succeeded in exciting my ardour for study by introducing me to Homer and to the names of some other famous writers. I further made the mistake of regarding what was pure ignorance on his part as a crafty means of retaining me as a pupil, bound to him, as it were, by my thirst for learning. At last intercourse with Italy having aroused a feeling for literature in France, and Greek and Latin books gradually finding their way here, I spared neither money in buying books, nor labour in studying them, in my efforts to make up for the time which I had lost, and without ever taking a holiday I did in a day the work of a day and a half[5].

[1] See H. Omont, G. Hermonyme . . . suivi d'un notice sur les MSS. de Jean et Guillaume Budé, 1885 (Bull. de la Soc. de l'hist. de Paris et de l'Ile de France, XII.).

[2] Cum hiscere Latine vix coepissem, ad iuris studium transivisse, ut assolet, aut transiluisse potius (Budé to Tunstall, May 19, 1517); Erasmus, Opera, III. 249; Budaeus, Epist. (1531), l. 112 b; Allen, II. 560.

[3] Accipitrariis et venatoribus salute dicta (Budé to Tunstall). This took place in 1491. [4] The fee was 500 crowns.

[5] Budé to Tunstall (Allen, II. 571, 572). See also Delaruelle, p. 72. There are two MSS. of the Gospels in Hermonymos's writing in the Cambridge University Library, one of which was copied for Budé.

It must have been about the year 1494 that Budé began his Greek studies. Towards the end of 1496 Janus Lascaris arrived at Paris, and, as we have seen, gave him from time to time some valuable help. But even before this he had made sufficient progress for Fausto Andrelini, in dedicating to him his *De influentia siderum* in 1496, to be able to speak of him as distinguished in both Greek and Latin scholarship. But he had to encounter opposition from his own father, who, while he had encouraged him in his legal studies, had no sympathy for his Greek ones. In the hope of diverting him from these he obtained for him an appointment as one of the royal secretaries, but Budé gave more time to study than to the copying of letters. The fame of his learning reached the ears of Charles VIII, who sent for him to the Court, but died before he had done anything for him. In 1501 Louis XII employed him on a mission which took him to Venice. Again in 1505, when the usual mission was sent to Pope Julius II after his election to make profession of the French King's obedience, Budé was appointed secretary and ambassador[1]. The "orator" of the mission, which was chiefly composed of bishops, was the Neapolitan, Michele Ricci[2].

On his way through Florence Budé made friends with Pietro Ricci (Petrus Crinitus), the author of the *De honesta disciplina*, and inspected the famous manuscript of the Digest which the fortune of war had transported from Pisa to Florence in 1406[3]. At Rome he visited the remains of the ancient city and the Vatican library, but he had little leisure or opportunity for the things which lay nearest to his heart, the examination of manuscripts and intercourse with learned men.

[1] It was the French practice to give the secretary the rank of ambassador. The Italians objected to Budé having this rank (Maulde la Clavière, *La diplomatie au temps de Louis XII*, p. 370).

[2] See above, p. 180. His *oratio* on this occasion was printed by Badius, 1505 (the only known copy is at Schlettstadt). Another edition, without date or printer's name, is recorded by Delaruelle, *G. Budé*, p. xxxi.

[3] Nos cum essemus Florentiae Pandectas Pisanas (quas archetypos esse putant) in palatio vidimus, sed raptim (*Annotationes in Pandectas*).

His father had died early in 1502. Half his possessions
went to the eldest son, and Guillaume had to share the
remaining half with eleven brothers and sisters. This
portion, however, together with his share of his mother's
property—she died in 1506—was sufficient to enable him to
continue his career of laborious and unremunerative study[1].

He had already given proof of his scholarship by some
Latin translations from the Greek. The first of these was
a translation of Plutarch's *De placitis philosophorum*, which,
at the request of his friend Lascaris, who had been too busy
to do the work himself, he had made for Germain de Ganay.
It was completed on January 1, 1502 (? N.S.), but was not
printed till 1505[2]. Two more treatises of Plutarch, *De
fortuna Romanorum* and *De fortuna Alexandri*, followed in
1503, and a fourth, *De tranquillitate animi*, in 1505[3].

Budé's studies and reputation naturally brought him into
relations with other humanists. Among the older generation
he numbered among his friends and patrons Guy de Roche-
fort, Pierre de Courthardy, and Germain de Ganay. With
Lefèvre d'Étaples he was on intimate terms, and a dedicatory
preface of 1505 from the older to the younger scholar speaks
of the friendship as being of ancient date. It extended to
Lefèvre's pupil, Charles de Bouelles. But among the younger
humanists his closest friend was his colleague in the royal
chancery, Jean Morelet de Museau, who was also a member
of the Paris *Parlement*. He had spent some time at Padua
and other Italian universities, and in 1507 Tissard dedicated
to him his Hesiod describing him as a man very familiar
with ancient literature[4]. It was probably to the exhortations

[1] Budé to Tunstall (Allen, II. p. 273). [2] Allen, IX. 252 n.

[3] These last three treatises, together with another translation by Budé,
the letter of St Basil to St Gregory Nazianzen *De vita eremitica*, were
printed by Badius in 1505. The Bib. Nat. has a MS. of all four pieces in
the writing of Hermonymos (Omont, *G. Hermonyme*, p. 21, No. 25). Another
MS. of Plutarch in the same library, which opens with the *De placitis phil.*,
followed by the *De fortuna* pair, these being in Hermonymos's writing,
has notes by Budé (Omont, *op. cit.* No. 24). See for all these translations
Delaruelle, *G. Budé*, pp. 77–80.

[4] I have adopted M. Delaruelle's conjecture that the king's secretary
to whom Hermonymos dedicates the MS., No. 25, referred to in the last

and encouragement of another intimate friend, François Deloynes, that the execution of his first considerable work was due[1]. Fired by Valla's praise of the *Pandects* in his *Elegantiae*, he set to work to read them carefully, and finding the text in a corrupt state, he conceived the idea of correcting it and supplying a commentary. We have seen that he had a hasty glimpse of the principal manuscript at Florence, and he consulted another in the Vatican. But when, on his return to France, he began to think seriously of his project and to collect his materials, he came to realise more and more its difficulties, and had it not been for the protests of his friends would have abandoned it altogether. At last in the spring of 1508 he began to write out his book for the press, and completed his task with such rapidity, that by November 17 the printing was finished[2]. It appeared with a dedication to Jean de Ganay, who in the previous January had been appointed Chancellor of France, and with the title of *Annotationes in quattuor et viginti Pandectarum libros*. The printer and publisher was Badius Ascensius[3].

A commentary without a text above it is apt to run to a considerable length. In Budé's case it ran to nearly 300 folio pages, or (in Gryphius's edition) to 735 octavo pages with over 300 words to the page. Some idea of its scope and range may be given by saying that it provides materials for a dictionary of Roman law, a Latin lexicon, and a dictionary of Roman antiquities. Some of the subjects are treated at considerable length: the account of the Roman Senate occupies sixty pages[4]; the word *athletae* calls forth a note of nineteen pages on the Greek and Roman public games[5].

note, saying that the pieces had been translated by "his Pylades," is Morelet de Museau (M. Omont reads the name as Mar. . . . o). See *G. Budé*, p. 88, n.[6].

[1] This is M. Delaruelle's conjecture. See *Ann. in Pand.* pp. 40–42.

[2] "Nam cum abhinc septem plus minus menses. . . . Annotationes quasdam in Pandectas scribere coepissem" (the date of the dedication is November 4). This must refer to the final writing out of the book, not to its composition.

[3] My references are to the edition of Gryphius, Lyons, 1541.

[4] pp. 194–254. [5] pp. 342–61.

Budé, in short, might have said with J. E. B. Mayor in the preface to his *Juvenal* that he had "endeavoured to supply new materials for the grammarian, lexicographer, and historian." Nor does he confine himself to the provinces of language, law, and antiquities. He wanders into interesting bypaths, such as the primacy of Homer[1], the praise of poetry[2], the defence of ancient literature[3]. The account of the Roman senate is followed by a sketch of the Paris *Parlement*[4]. A long note on *iusta haereditas* leads by gradual stages to an attack on the public morals of the day[5]. The word *calamitas* suggests an eloquent reprobation of those who turn a deaf ear to the sufferings of the common people[6].

Probably the first thing that strikes the reader, as he turns over the pages of Budé's commentary, is the wide extent of his reading. His Latin authorities range in point of time from Plautus to Boethius. As a jurist he naturally has Cicero at his fingers' ends, but he is hardly less familiar with technical writers, such as Celsus, Columella, and Vitruvius. He does not confine himself to pagan authors, for he cites Tertullian, Lactantius, and St Augustine; nor to Latin writers, for he quotes from Homer and the chief masters of Greek prose. The Greek passages he generally translates, a fact which, as M. Delaruelle points out, must have been of great advantage to those of his readers who, under considerable difficulties, were studying Greek.

It is a sign of his piety that many of his illustrations are taken from the Old and the New Testament, and in one of his most interesting digressions—it starts from the word *Centumviri*, which suggests the seventy translators of the Septuagint—he boldly criticises the Latin Bible[7], adducing several instances of mistranslation from the Gospel of St Luke. He returns to the subject later, and after referring to another error in the same gospel, which he believes to be due to the printer, he significantly adds: "This will cause those to

[1] pp. 547–548. [2] p. 549.
[3] pp. 443–449. [4] pp. 254–267.
[5] pp. 522–530 (*Digressio in mores praesentes invehens*).
[6] pp. 601–605. [7] pp. 149–154.

smile who, because our translation is received by the whole Western Church, think that the Greek Gospels are of no authority[1]."

Of the importance of Greek Budé was just as firmly convinced as Erasmus, saying in similar words to those used by the great Dutchman, that Latin scholarship was maimed and feeble without a knowledge of Greek[2]. Then he goes on to point out that Greek is absolutely necessary for a right understanding of the *Pandects*, and this leads to a severe attack on the study of the civil law as it was then carried on in France, with its substitution of the authority of the gloss for that of the text, its blind idolatry of Accursius and Bartolus, its ignorance of the language and history of the Roman people. In taking this line Budé was following the lead not only of Valla, but also of Politian, who had made an incomplete collation of the famous *codex florentinus* with a view to an annotated edition of the Pandects. All however that has reached us of his work are a few short notes, dealing with points of language or textual criticism, in his *Miscellanea*[3], and two or three passages in his *Letters*. These notes bear out Politian's statement in his *Lamia* that in dealing with philosophers, priests, and medical writers, he does not pretend to be anything but "a grammarian[4]." Budé's method is the same as Politian's in spirit. He writes his commentary not as a jurist but as a philologist, or, as we should say, a scholar. He does not seek to expound Roman law either as a historical growth, or as a philosophical system. His object is to make the *Pandects* intelligible to readers who were imperfectly acquainted with the Latin language, and who were still more ignorant of classical

[1] p. 608. [2] p. 554.

[3] Chapters 41, 78, 82, 93, 95. In the first and longest of these he refers to his study of the *codex* in the Medicean library. See Mähly, *A. Politianus*, pp. 61–67; Savigny, *Gesch. des römischen Rechts im Mittelalter*, 1st ed. VI. 375 ff. The second century of the *Miscellanea* which, says Mähly, was "rich in juristic inquiries," is lost. Budé tells us that he saw some notes of Politian's on the famous manuscript at the house of Pietro Ricci. There are some chapters on the *Pandects* in Ricci's own work, the *De honesta disciplina*.

[4] See above, p. 39.

antiquity. His conception of his task as a "grammarian" is far more ambitious than Politian's. Indeed no Italian humanist had studied the Roman world in so comprehensive a spirit as this Frenchman. The two great schoolmasters, Vittorino and Guarino, had viewed antiquity with a wide and liberal outlook, but they had neither the information nor the critical sense of a later age. Flavio Biondo had brought a true critical sense to the investigation of the geography of Italy and the institutions and buildings of Rome, but he had not included in his survey either law or language. Moreover Budé's attitude towards classical antiquity was as sensible as it was comprehensive. While fully recognising the lessons that were to be learnt from the great writers of Rome and Greece, he studied them in no spirit of blind worship. He regarded them as a critic and a Christian, not with the pagan sentimentalism of Pomponius Laetus and the Roman Academy.

Budé's book was very favourably received by scholars, and before long his name began to be coupled with that of the German scholar, Ulrich Zasius, as the restorer of the study of Roman law in his native country[1]. He was urged to continue his task, and for the next three or four years, in spite of bad health, he worked at the remaining books of the *Pandects*. But he was diverted from his task by a new undertaking. The growing interest in the ancient world led men to speculate how the Greeks and Romans compared with the moderns in the matter of wealth and luxury. Unfortunately they were pulled up short in their speculations by their ignorance of the value of Greek and Roman money and of the method of reckoning it. Budé, thinking the

[1] Ius Caesareum instaurat Lutetiae G. Budaeus, apud Germanos Udalricus Zasius (Erasmus to Capito, Feb. 151♀). Zasius was born at Constance in 1461, and became professor of law at Freiburg in Breisgau a little before 1500. He was more conservative in his attitude towards the Glossators and more of a practical lawyer than Budé. Alciati, the restorer of Roman Law in Italy, was a much younger man, being born at Milan in 1492. He was made professor of law at Avignon in 1518 and at Bourges in 1529. See Delaruelle, *Répertoire*, pp. 67–71, for letters from Budé bearing on the subject.

inquiry would be a pleasant relaxation from his more serious task, promised to write a book on the subject. The result was the *De Asse*, but it took him between three and four years to write it[1], and, when it was finished, it was four times as long as he had originally contemplated. The publication took place in March, 1515, when Francis I was on the throne. It falls therefore outside my period, and I shall not attempt the task, which has been performed so admirably by M. Delaruelle[2], of giving an account of it. It will be sufficient to say here that this work, which established Budé's reputation as one of the leading humanists of Europe, has in an increased measure all the qualities of the *Annotations to the Pandects*. Its range was even wider, its aim even more ambitious. It aspired to interpret the whole ancient world more completely than it had ever been interpreted before, and in so doing to bring glory to France. For the whole book is inspired by a tone of lofty patriotism, which anticipates Joachim Du Bellay's *Deffence et illustration de la langue françoyse*. Just as Du Bellay claims that the French language is as well fitted as the Italian for the production of noble literature, so Budé exhorts his countrymen to vie with the Italian humanists in the study of antiquity. The *De Asse* was more than a call to arms; it was an earnest of victory. By the adoption of a rigorously scientific method it triumphantly solved a problem over which the greatest Italian humanists had bungled.

But Budé's patriotism is revealed not only by this spirit of generous rivalry with Italy, but by the interest which he takes in the affairs of his own country. One of the most important sections of M. Delaruelle's analysis is that in which he deals with this feature of the *De Asse*[3]. The criticism of the Italian policy of Cardinal d'Amboise, both in its conception and in its execution, the arraignment of his incompetent successors, the lamentation over the

[1] In a letter to Nicole Bérault, dated March 25, 1511, Budé makes no reference to this new project. As Bérault had urged him to continue his annotations on the *Pandects*, he would have spoken of it had it assumed serious dimensions.

[2] *G. Budé*, cc. III. IV. and V. [3] v. ii. 166–180.

economic condition of the country burdened by imports to
the verge of bankruptcy, the warm sympathy with the
sufferings of the peasantry at the hands of tax-collectors
and plundering soldiers, all testify to Budé's intelligent
patriotism.

Finally, we find in the *De Asse* the same Christian tone
that marks the *Annotations to the Pandects*. Only here it
is accompanied by a vivid expression of the need for Church
reform. Especially, the wealth, the worldliness, and the
non-residence of the bishops struck Budé as it did the best
observers of his day. That in his opinion was the *fons et
origo mali*. Reform must begin at the top and Budé looked
hopefully to the new Pope, Leo X, to begin it[1]. Such was
Budé's interest in the world of his own day. We must
dismiss the legend that makes him a mere Dryasdust,
immersed in antiquarian study and with no eyes save for
the world of Greece and Rome.

I have referred to Budé's intimate friendship with
Jean Morelet de Museau and François Deloynes. That with
Deloynes, who was some twelve to fifteen years his senior,
if we are to take literally the expression *ab incunabulis et
crepundiis* (from the cradle and the rattle), dated from very
early days. But possibly, as M. Delaruelle suggests, it only
began at Orleans, when Budé was supposed to be studying
law[2]. For Deloynes, whose father was *bailli* of Beaugency,
was a law professor at Orleans, and it was not till the year
1500 that he came to Paris, having been appointed a member
of the *Parlement*. He was connected with Budé by marriage,
his wife's mother being a Chevalier[3]. He was a warm
partisan of the new studies, and had some reputation as a
writer of elegant Latin. His tastes and talents were shared
by Louis de Ruzé, Seigneur de Lépine, another councillor of
the Paris *Parlement*, who became *lieutenant civil*, or judge of
the civil court of the Provost of Paris[4]. A member of one
of the great financial families, he belonged to the same social

[1] Delaruelle, v. iii.
[2] He was made president of the Court of *Enquêtes* in 1522.
[3] Delaruelle, p. 66; Allen, II. 405.
[4] In their Latin letters Erasmus and Budé call him *suppraefectus*.

milieu as Deloynes and Budé. His elder brother was married to a sister of Budé's wife[1]. Erasmus, writing to him in the spring of 1520, speaks of the three friends as a triumvirate[2], and this is confirmed by Budé himself in a letter to Erasmus of an earlier date, in which he says that Ruzé is as much at home in his house as Deloynes, and that he does not know which of the two he visits most often. He praises Ruzé as a fluent and elegant composer, and adds that, though owing to his office he was chiefly employed in the study of laws, his natural bent was towards literature (*literae amoeniores*)[3]. He was not only a scholar, but the patron of scholars, and both Longolius and the future Royal Professor of Greek, Jacques Toussain, owed much to him. The latter, when he came to Paris in 1517, lived in his house[4].

This small society of humanists received a welcome addition about the year 1510 in the person of Germain de Brie (Germanus Brixius), a native of Auxerre, who had the advantage over his friends of having studied in Italy for five years. Though we have no positive information as to the date or manner either of his going to Italy or of his return, we may infer from the known facts of his life[5] that he went to Venice in 1504 in the suite of Janus Lascaris, who initiated him into the study of Greek, that he studied under Marcus Musurus at Padua[6], and that when that University was closed in 1509 he went to Rome. Before leaving Italy he was attached to the household of Cardinal Louis d'Amboise, the Bishop of Albi, who afterwards conferred on him

[1] His mother was Pernelle Gaillard. See Marot, *Œuvres*, ed. Guiffrey, III. 718.

[2] *Opera*, III. 420 (March 16, 15¹⁹⁄₂₀).

[3] Erasm. *Opera*, III. 210; Allen, II. 402 (November 26, 1516—I adopt the correction of *Novembres* to *Decembres*).

[4] See Delaruelle, *Répertoire*, p. 10, n.[4]. Robert Dure dedicated his edition of Cyprian (Rembolt, 1512) to him as *literatorum omnium Maecenas*.

[5] Some information may be gleaned from Brixius's preface to his translation of Chrysostom's dialogue, *Quam multe quidem dignitatis sed difficile sit episcopum agere*, Badius, 1526.

[6] At Venice he made friends with Aleandro, and at Padua with Erasmus (Erasmus to Aldus Manutius, Allen, I. Ep. 212).

the Archdeaconry of that see. On his return to France about 1510 he entered the service first of Jean de Ganay, the Chancellor, and then of Anne of Brittany, who made him one of her secretaries. He owed this last appointment[1] to his Latin poem, *Chordigerae navis conflagratio*, which, cele-brating, as it did, the heroism of a Breton sailor, was appropriately dedicated to the Queen[2]. At the close of the reign of Louis XII he was regarded as one of the chief Latin poets in France, and as second only to Budé as a Greek scholar. In the following reign he became a canon of Notre-Dame and one of the royal almoners, and he translated some of Chrysostom's works into Latin[3].

In 1513, if not earlier, another humanist from Orleans, Nicole Bérault, migrated to Paris, and was at once intro-duced by his countryman, François Deloynes, to the humanist circle. A native of Orleans or the neighbourhood, he had studied law as well as the humanities in that University[4]. Erasmus, whose host he was in 1506, when he passed through Orleans on his way to Italy, says in a letter to Deloynes, "methinks I hear that smooth and fluent tongue, that sweetly musical and gently resonant voice, that pure and polished discourse; methinks I see that friendly face so full of human kindness, so free from pride, those charming manners, so affable, so easy, so unobtrusive[5]." At the end of 1510, or early in 1511, he wrote to Budé warmly con-gratulating him on his revival of the study of Roman Law, and he was inspired by his great work to give a course of lectures on similar lines[6]. In 1511 he attended Aleandro's

[1] Non immerito igitur tuum munus admirata Regina Anna te sibi adscivit a secretis (*Chordigera*, fo. a 2(6), prefatory letter by Alexander). Mr Allen kindly called my attention to this letter.

[2] See above, p. 206.

[3] He died in 1538. The date of his birth is not known, but as he speaks of himself as *paene adolescens* in 1508 he was probably born about 1488.

[4] The fullest account of Bérault is by L. Delaruelle in *Rev. des biblio-thèques*, 1902, pp. 420–445.

[5] Allen, II. No. 535, ll. 38 ff.

[6] Bérault's letter is lost, but we have Budé's answer, dated March 25, 151¹⁄₇ (Delaruelle, *Répertoire*, p. 3).

Greek classes, and is described in the latter's journal as *ludi magister* or master of a grammar-school[1]. In 1512 Badius dedicated to him the first volume of the *Works* of Politian[2]. In the following year he was at Paris, lecturing on Quintilian and the *Rusticus* of Politian. The latter lectures, which were delivered at the Collège de Tréguier, were published in the summer of 1514[3], and in the same year he edited for Badius Giambattista Pio's *Lucretius*, introducing some changes into the text. For the next three years he gave himself up to the study of Greek[4], with the result that he ranked with Germain de Brie as second only to Budé in knowledge of that language.

Of Guillaume Cop of Basle I have already spoken[5]. His brother physician, Jean Ruel, was a native of Soissons, and, according to Sainte-Marthe, had, like Budé, taught himself Greek. He was Dean of the medical faculty of Paris in 1508 and 1509. His knowledge of the Greek and Latin medical writers was extensive, but the first of the many translations by which he made his reputation, that of Dioscorides, was not published till 1516, and the work by which he is now chiefly known, the *De natura stirpium*, not till twenty years later[6].

Other Frenchmen at this time besides Germain de Brie laid the foundations of their Greek and Latin scholarship in Italy. Jean de Pins, of whom more will be said in the next chapter, spent ten years (1497–1507) at Bologna under Urceo Codro and the elder Beroaldo. Geofroy Tory of Bourges, the author of *Champfleury*, was also a pupil of Beroaldo, returning to France shortly before his death (1505). He established himself at Paris, and became press-corrector first to Gilles de Gourmont and then to Henri Estienne. For the former he edited Pomponius Mela (1508), and for

[1] Aleandro, *Journal*, pp. 20, 21.

[2] See above, p. 225; there is nothing to suggest that he edited the volume.

[3] Delaruelle, *loc. cit.* pp. 424 and 435.

[4] *Ib.* p. 424.

[5] See above, pp. 258, 260, 269.

[6] 1474–1537. See Sainte-Marthe, *Elogia*.

the latter the *Cosmographia* of Pius II (1509), a work of considerable popularity. Other editions followed with great rapidity, one of these being a collection of short Latin pieces (1510), of which the chief was a treatise on the abbreviations used by Latin writers, entitled *De interpretandis Romanorum literis opusculum*, and attributed (wrongly) to the grammarian, Valerius Probus. The volume also contains some Latin poems from the pen of Tory, one of which is of special interest for its mention of the palace of Jacques Coeur[1]. Of far greater importance was a volume which appeared in 1512. This was a new edition of Alberti's *De re aedificatoria*, to which reference will be made in a later chapter. The preface is dated from the Collège de Coqueret, where Tory was now a professor. Before this he had been for four years (1508–12) a professor at the Collège Du Plessis, and later in the year 1512 he became Professor of Philosophy at the Collège de Bourgogne. At the same time he began with great ardour to learn drawing and engraving, and so fascinating did he find them, that in 1515 or 1516 he threw up his appointment and paid a second visit to Italy chiefly in order to study classical architecture. He returned to Paris about 1518, but his later career in all its varied activity lies outside the scope of this volume[2].

Among the humanists who had relations with Tory were Robert Dure and Gérard de Vercel. Dure furnished him with the manuscript of Alberti's *De re aedificatoria*, and Vercel wrote some introductory Latin verses for his edition

[1] *Monitor* Quae domus illa rubris excellens cordibus una,
 Memnonis anne ipsa est aedificata manu ?
 Biturix Hanc Jacobus homo Cordatus condidit olim,
 Dives opum ; nobis quem abstulit invidia.
 A. Bernard, *G. Tory*, p. 102.

The *rubra corda* are the hearts, which with pilgrims' cockle-shells, emblems of the owner, figure conspicuously in the external decoration of the palace.

[2] For Tory (*circ.* 1480–1553) see A. Bernard's excellent *Geofroy Tory*, 2nd ed., 1865. I have referred to his *Champfleury* and to his work as a translator in my *Literature of the French Renaissance*, I. 32, 33, and 36.

of the *Itinerary* of Antoninus. The latter, who was a native of the County of Burgundy[1], has already been mentioned as a pupil of Aleandro and an editor of Latin texts[2]. He did useful work for Badius and Petit, editing for them Cicero's rhetorical works (1511), Livy (1513), Lucan (1514), and the Latin translation of Plutarch's *Lives*. He also had a hand in Badius's edition of Seneca's *Epistles* (1514).

Another humanist professor of the University was Denys Lefèvre, a native of Vendôme, who, after taking his Master's degree in 1504, at about the age of sixteen, lectured with great success, first at the Collège de Coqueret, and then at the Collège d'Harcourt. His lectures at the latter college on Valerius Maximus attracted such large audiences that the hall could not hold them. After a year he was recalled to the Collège de Coqueret, where he lectured on Cicero's *Rhetoric*, Quintilian, Lucan, Filelfo's *De educatione puerorum*, and the Greek grammar of Theodore Gaza. Bulaeus, who has an unusually full notice of him, says that his lectures on Gaza were almost the first Greek lectures to be given in the University. If this is true, they must have been given either before or soon after Aleandro's first course in October, 1509. In June of this year Lefèvre contributed a preface to a long poem in Latin hexameters, entitled *Peregrinatio humana*[3], written by his pupil, Guillaume Du Bellay, who had spent three years at the Collège de Coqueret. It is significant of the trend of University studies at this period that this promising scion of a distinguished family, who was to become one of the leading men in the kingdom, should at the early age of eighteen have made his *début* in literature with a Latin poem on a semi-religious subject. From the Collège de Coqueret Lefèvre passed to that of Mignon, but about the year 1514

[1] Vercel is at the foot of the Jura, about 25 miles west of Besançon.

[2] See above, pp. 220 and 267.

[3] The poem is founded on Guillaume de Digulleville's *Pèlerinage de la vie humaine*. The volume, which is printed by Gilles de Gourmont, contains also six short pieces.

he was, like Guy Jouennaux and the two Fernands seized
with a passion for monastic life, and in consequence quitted
the University for the Celestine monastery of Marcoussis,
where, having attained to the highest dignities of his Order,
he died in 1538[1].

Another humanist connected with the University of
Paris was Olivier of Lyons, who, in Budé's words, introduced
into the Collège of Navarre "a more polished method of
studying Latin[2]." He was born, not at Lyons, as his
appellation seems to indicate, but at Montluçon, and he
held the post of "Hypodidasculus," or assistant teacher, of
the grammarians at the Collège of Navarre[3]. In 1507
François Tissard addressed to him a Latin couplet, in which
he speaks of him as learned both in Greek and Latin. In
1514 he edited for Badius Beroaldo's Commentaries on
Lucan. In 1516 he was Proctor for the Nation of France,
and in 1518 Rector of the University[4]. He died either
at the close of 1522 or early in the following year[5].

Finally it should be mentioned that Maturin Cordier,
who was to do so much for the introduction of Humanism
into the University, left Rouen, the capital of his native
province, to return to Paris in 1514, and began to give Latin
lessons to the younger students[6].

This practically completes the tale of those humanists
who at the close of the reign of Louis XII were lecturing or
working at Paris and had already attained to distinction.

[1] Bulaeus, *Hist. Univ. Par.* VI. 928, 929; E. Jovy, *op. cit.* pp. 13–14;
V.-L. Bourrilly, *G. du Bellay*, 1905, p. 7.

[2] *G. Budaei ... Lucubrationes* (Basle, 1557), I. p. 392; Delaruelle,
Répertoire, p. 233. There is no date to the letter.

[3] Launoy, *Hist. Gymn. Nav.* p. 644. I do not know when he was
appointed to this post, but, according to Launoy, Ravisius Textor, who
was born in 1480, was his pupil.

[4] Delaruelle, *op. cit.* p. 233, n.[4].

[5] Badius in a letter to Joannes ab Lugduno Acrolucio, dated Feb. 20,
1523, prefixed to an edition of Persius by the latter, speaks of his brother
as recently dead. (Renouard, III. 153–4.)

[6] See A. Tilley, *The Literature of the French Renaissance*, I. 17, and
add to the authorities there given W. H. Woodward, *Studies in Education*,
1906.

Salmon Macrin, the future French Horace, whom we have met as a pupil of Aleandro, did not publish his first volume of Latin verse till the eve of the reign of Francis I[1]. Lazare de Baïf, whom Macrin, in some lines addressed to his patron, Guillaume Du Bellay, ranks with Budé, Christophe de Longueil and Simon de Villeneuve as one of the champions of Humanism in France, was not born till 1496.

Christophe de Longueil, better known as Longolius, was born at Malines (1488), but he was of French parentage on one side, being the illegitimate son of Antoine de Longueil, Bishop of Saint-Pol de Leon. He came to Paris as a boy of nine. but all we know of his studies is that one of his teachers was Robert Dure[2]. In 1510 he was appointed to a law-professorship at Poitiers[3], and in the same year he delivered an oration on St Louis which was printed by Badius. In 1512 he was sufficiently distinguished to be included in the supplement to Trithemius's *De scriptoribus ecclesiasticis*, where various writings, not yet published, including Commentaries on the elder Pliny, of whom he had made a special study, are put to his credit. In that year he resigned his professorship and returned to

[1] In 1515 Jean de Gourmont printed for him *Six Hymns on the Virgin*, but this is described as *iterum impressa*. Macrin's first printed verses appeared in 1514 in the work of Quinziano Stoa. See J. Boulmier in *Bull. du Bibliophile* for 1871, pp. 498 ff.

[2] Life by Cardinal Pole, prefixed to *Orationes duae* and other works, including his letters, Badius, 1533; Trithemius, *De script. eccl.*; Foppens, *Bibl. Belg.* I. 178; *Biog. Nat. de Belgique* (by L. Roersch); Th. Simar in *Musée belge*, XIII–XV. (1909–11); Allen, III. 473. His parentage is stated in a brief of Leo X granting him the diploma of Roman citizenship (see V. Cian, *Duo breve di Leone X in favore di C. Longolio* in *Giorn. storico della lett. ital.* XIX. 373–388). The date of his birth is sometimes wrongly given as 1490.

[3] A story which he tells of his opening lecture is interesting as an illustration of the manners of the time, and as the source of a well-known incident in Boileau's *Lutrin* (v. 200–16). His lecture-room was suddenly invaded by a band of young Gascons, friends of a disappointed candidate for the professorship, who advanced upon him sword in hand. His only available weapons were three ponderous volumes of the *Infortiatum* (the second part of the Digest), but these he discharged at his foes with such effect that they beat a retreat.

Paris[1], but soon afterwards went to Valence, where he studied law under Filippo Decio, and took his Licence in 1514.

Returning once more to Paris he practised as an advocate with marked success, and two years later was made a Councillor of the *Parlement*. Meanwhile he had not neglected Pliny, and it was chiefly with a view to the better understanding of this author that he determined to travel, and to learn Greek. Louis de Ruzé provided the necessary funds, and with Lazare de Baïf as his companion he arrived at Rome in 1516. Here the two friends became students at Leo X's new Greek college, being cordially received by Lascaris to whom Budé had given Longolius a letter of introduction[2]. He also met with great kindness from Cardinals Bembo and Sadoleto. Under their influence he deserted Pliny for Cicero, and before long became an eminent and ardent Ciceronian. Finally, after a temporary visit to France (1519), when his patron, Louis de Ruzé, and several of his friends tried in vain to keep him in that country[3], he settled at Padua in 1520 and died there two years later.

Le Roy has a story that Longolius asked Budé to teach him Greek, but that the great man refused on the plea that he was too busy, and that it was from pique at this refusal that Longolius went to Italy. The second part of the story is clearly untrue. The first part may be true, but whether Longolius applied to Budé or not, the fact remains that he went to Italy partly in order to learn Greek. We have seen too that the other younger men who had acquired some competence in Greek by the close of the reign of Louis XII, such as Tory, and Germain de Brie, had studied in Italy. For great difficulties still hampered the Greek student in France, where there were few books, few manuscripts, and, except during

[1] Nuper ex Pictaviis Parhisios adveniens (G. Tory, in the preface to *Antonini Itinerarium*, dated August, 1512). Longolius had lent him the MS. in 1508.

[2] This letter is summarised by M. Delaruelle in his *Répertoire*, p. 61 but he gives the date as 1519. It should clearly be 1516.

[3] Budé pleaded Longueil's cause with Ruzé, and thought that the dearth of patronage from which Humanism suffered in France justified his return to Italy (Delaruelle, *Répertoire*, pp. 105–107).

the presence of Aleandro at Paris, practically no teachers. In the early years of the new reign Budé must have relaxed his rule, for Danés and Toussain, the first royal professors of Greek, were his pupils, but in the days of Charles VIII and Louis XII the aspiring student who lacked Budé's untiring industry and indomitable perseverance had to look to Italy for his instruction. We shall see in the next section how Erasmus, having worked hard at Greek, first at Paris, and then at Louvain, carried out at last his long-cherished dream of visiting Italy "chiefly for the sake of Greek[1]."

III. Erasmus.

If, remembering Leonardo da Vinci, we hesitate to say with Lord Acton that Erasmus was "the greatest figure in the Renaissance," we must at any rate recognise him as the greatest figure in the Renaissance north of the Alps. When he returned from Italy in 1509, after publishing the third edition of the *Adagia*, he was the first man of letters in Europe, and until Luther appeared on the scene, he was its chief intellectual force. Keenly interested in every manifestation of the human mind, he was quick to receive ideas and eager to communicate them. A citizen of no country, he was a welcome guest in all. His influence was international, and it had far-reaching effects beyond his own control. By insisting on morality as the true basis of religion, and by breathing into theology the critical spirit of the Renaissance, he laid the axe to the authority of the Roman Curia, and thus prepared the way for a Reformation which was not his.

But these are large issues. We are only concerned here with his work and influence so far as it affected Humanism in France before the reign of Francis I. His connexion with Paris began in August 1495, and from that date he resided there continuously, save for one or two short absences, till May, 1499. His next residence in the capital lasted from February, 1500 to May, 1501, with an interval of ten weeks, which he spent at Orleans. His subsequent visits were of

[1] He writes from Bologna, "Italiam adivimus Graecitatis potissimum causa" (Allen, I. Ep. 203).

shorter duration. The longest was in 1504–5, when he remained at the most eight months[1]. He also spent two months there in the summer of 1506, and made two flying visits in April and June, 1511. It was at Paris that his first composition appeared in print, the complimentary letter to Gaguin, which, as we have seen, was printed at the end of the latter's *Compendium*[2]. It was at Paris that the greater part of his earlier volumes first saw the light, the *Adagia*, the *Annotations of Valla*, the translations of Euripides and Lucian, the *Moriae Encomium* and the *Copia*. When he first came to Paris, he was an unknown student of twenty-eight. During his second visit in 1500 he published his *Adagia*, which attracted some attention. In 1505 and 1506 his rising reputation enabled him to publish several volumes through the press of the distinguished printer and humanist, Badius Ascensius. In 1511, when he paid two visits to Paris in connexion with the publication of his *Moria*, he had become famous through the Aldine edition of the *Adagia*. The *Moria* was to make him even better known. He was now at the height of his reputation as a humanist and a man of letters. From this time he made theology his chief study, and for the next few years he was mainly occupied with his editions of the New Testament and the Letters of St Jerome.

For the period after 1515 there is no question as to the veneration and affection with which the leading French humanists regarded Erasmus. There was not one among the younger generation who, like Rabelais some years later, was not prepared to address him as *pater mi humanissime*. To realise this one has only to turn to the letters which Budé[3] and Deloynes[4] wrote to him in November, 1516, and to those from Budé and Cop in February, 1517, when they were pressing him in the name of Francis I to return to Paris as director of the proposed Royal College for languages. Not only do they express their own admiration and affection

[1] There was possibly also a very short visit in July or August, 1502 (Allen, I. p. 380).

[2] See above, p. 191. [3] Allen, II. Ep. 493.

[4] *Ib.* Ep. 494, with a postscript of greeting by Nicole Bérault.

for him, but they tell him in what high estimation he is held by Guillaume Petit the King's confessor, and by Étienne Poncher, the Bishop of Paris[1]. Then in April Germain de Brie follows in the same strain, quoting at length the laudatory remarks of Poncher, who had just returned from an embassy to the Emperor at Brussels, and having met Erasmus in that city was full of his praises, the sum of which was that Erasmus was the first humanist on either side of the Alps, eclipsing all other luminaries by the brilliance of his learning and eloquence[2].

But for the earlier period our information is very scanty. In fact from 1505, when Erasmus began really to make his mark, to 1515 we have only three letters addressed to him by Paris humanists, two by his publisher Badius, and one by Lefèvre d'Étaples. There is no extant letter to him from Budé before 1516.

When Erasmus first came to Paris, with the object of taking a Doctor's degree in Theology, he took up his residence in the College of Montaigu, which from a state of complete decay had been raised to a flourishing condition by its Principal, Jean Standonck. One object of his reforms was to enable poor students to join the University, and it was in the *Domus Pauperum* that Erasmus resided. He has depicted the hardships which he endured there in his well-known Colloquy, the *Ichthyophagia*, with much eloquence, and doubtless some exaggeration. At any rate the fare was too Spartan for his delicate stomach, and in the spring of 1497, if not earlier, he moved into a boarding-house, where he taught two Englishmen, Thomas Grey and Robert Fisher, who were living there with their guardian. During his first residence at Paris, which lasted, as we have seen, nearly four years, one does not gather that he became very intimate with his brother humanists. His chief friend among them was Fausto Andrelini, and he also had friendly

[1] Budé to Erasmus (*ib.* Ep. 522); Cop to Erasmus (*ib.* Ep. 523); and see A. Lefranc, *Histoire du Collège de France*, 1893, pp. 39–60.

[2] *Unus profecto Erasmus Transalpinis ac Cisalpinis omnibus palmam praeripit, unus Erasmus omnia lumina eruditionis ac fecundiae fulgore praestringit* (Allen, II. Ep. 569, ll. 78–80).

relations with Paolo Emilio[1], Gaguin, and Cop. But we hear nothing of Lefèvre d'Étaples, or Budé, with both of whom one would have expected him to be acquainted. For Lefèvre was the best-known professor in the University, and was moreover a friend of Paolo Emilio, while as early as 1496 Andrelini had, as we have seen, dedicated to Budé a Latin poem, as to one " distinguished in both Greek and Latin." In the first letter that we have from Lefèvre to Erasmus, dated October, 1514, he writes to him as an old friend, and so does Budé in May, 1516. Moreover we know that when Aleandro came to Paris in 1508 he brought letters of recommendation from Erasmus, and that the chief persons whom he consulted about the advisability of lecturing were Lefèvre and Budé. If Erasmus then did not make their acquaintance during his first residence at Paris, which seems unlikely, he at any rate must have done so either in 1500–1 or in 1504–5. It is surprising too that, so far as we know, he did not make the acquaintance of Janus Lascaris till he met him at Venice in 1508, for Lascaris would gladly have helped him, as he helped Budé, in his Greek studies.

On the whole then, Erasmus, partly perhaps owing to his poverty, does not seem to have taken much part in the humanistic life of Paris during his first residence there, or to have made the most of his opportunities, especially as regards the study of Greek. Indeed the intellectual atmosphere of Paris seems to have been distasteful to him. He hated the theological lectures, and the whole tone and character of the theological teaching. In the well-known letter to Andrelini, written just after his arrival in England from Paris, in which he refers to the English practice of kissing on every occasion, he speaks in contemptuous terms of the country that he had left, and wonders that so intelligent a man as Andrelini could spend his life there[2].

[1] Allen. I. Ep. 136, 1.

[2] *Ib.* I. Ep. 103. It must be borne in mind that there is often a vein of playful exaggeration in Erasmus's letters, and that he had the faculty of adapting his remarks to the character of his correspondent.

From May, 1499, to the end of January, 1500, Erasmus was in England, and he spent part of this time—at most the months of October and November—at Oxford. The influence which John Colet, who was then residing at Oxford, had upon his future studies was first pointed out by Seebohm, and has been dwelt on by subsequent writers[1]. It was Colet who urged him to turn his attention to theology, and to help him in breaking through the web of dialectical sophistry that had been woven round it. In a letter written to Colet from St Mary's College Erasmus promises him that "he will give him his whole-hearted encouragement and applause, and further that, when he is conscious of sufficient strength, he will join him in the work, and will take an active, if not an illustrious, part in the enfranchisement of theology[2]."

But before Erasmus could feel "conscious of sufficient strength," it was necessary to improve his knowledge of Greek. Accordingly on his return to Paris, which he reached on February 2, 1500, he applied himself with all his energies to Greek. "My Greek studies almost break down my courage," he writes in March to his friend James Batt[3], and in April he says to the same correspondent in a memorable sentence, "The moment I get some money, I will buy, first Greek books, and then clothes[4]." He was busy at this time compiling his collection of *Adagia*, the first edition of which appeared in July under the title of *Adagiorum Collectanea*[5].

Early in September the plague drove him from Paris, and he spent the next two months and a half at Orleans, where he made the acquaintance of Deloynes, returning to Paris in the middle of December. Here he remained till the following May, more than ever convinced of the

[1] Seebohm, *The Oxford Reformers*, 3rd ed., 1887, pp. 97–136.

[2] *Caeterum ubi mihi conscius ero adesse robur et vires iustas, accedam et ipse tuis partibus et in asserenda theologia, si non egregiam, certe saedulam operam navabo* (Allen, I. Ep. 108, 109–111).

[3] Allen, I. Ep. 123, 23. [4] *Ib.* Ep. 124, 63–65.

[5] *Veterum maximeque insignium paroemiarum id est adagiorum collectanea.* Paris, Jean Philippi, 1500 (Camb. Univ. Lib.).

necessity of Greek, especially for the purpose of theological studies[1]. It was at this time that he had some lessons from George Hermonymos, that "ever hungry Greek who charges exorbitantly for his lessons[2]." Again the plague drove him from Paris, and, except for a possible flying visit in July or August of 1502, he did not set foot again in the French capital till the autumn or winter of 1504. He had now become a passable Greek scholar, and, as we have seen gave Greek lessons to Cop and others. It was during this visit to Paris that he first entered into relations with Badius in his character of publisher. He had found in a monastery just outside the walls of Louvain a manuscript of Lorenzo Valla, consisting of Notes on the Latin version of the New Testament, and being urged by the Papal Protonotary, Christopher Fisher, with whom he was lodging, to publish it, he entrusted it to Badius[3]. It was the firstfruits of his promise to Colet that he would labour in the field of theological study.

In the summer of 1505 Erasmus visited London, and on his return to Paris on his way to Italy in June, 1506, he placed in Badius's hands some translations from Euripides and Lucian. The *Hecuba* and *Iphigenia* were published in September, and the dialogues of Lucian, together with others translated by More, in November[4]. In the following December Badius printed a new edition of the *Adagia* with twenty new adages, and with a supplement, dated January 8, 1507, entitled *Varia epigrammata*. This last volume included, besides other poems already published, a poem on Old Age, written in the Alps during the journey to Italy, and addressed to Guillaume Cop[5]. Nearly two years before this Erasmus had published through Thierry Martens of Antwerp a volume of prose writings entitled *Lucubratiunculae aliquot*[6]. It included his *Enchiridion militis Christiani,*

[1] See above, p. 259.　　　　[2] Allen, I. Ep. 149, 65–68.

[3] The printing was finished, April 13, 1505.

[4] See F. M. Nichols, *The Letters of Erasmus*, 2 vols. 1901–1904, I. 414 and 422. The Aldine edition of Lucian had appeared in 1504.

[5] Nichols, I. 414. The poem was also printed in the volume of Lucian.

[6] February 15, 150¾ (Camb. Univ. Lib.).

which, though it attracted little attention when it was first published, became later one of his most popular works, and was translated into nine languages[1].

Erasmus's reputation in the world of letters was now steadily increasing. During his visit to London the University of Cambridge passed a Grace enabling him to take the degree of Doctor of Theology[2]. He did not, however, avail himself of the permission, but later in the year, when he had crossed the Alps, he accepted the same degree from the University of Turin (September 6). Early in the following year (1507) he received a Latin letter from the future Henry VIII, then a lad of fifteen, in which the prince says that Erasmus's skill in Latin composition is known throughout the world[3]. A more solid testimony to his reputation came from Aldus Manutius, who arranged to reprint his translations from Euripides as the first production of the Aldine Press after its forced inactivity[4].

But it was the Aldine edition of the *Adagia*, which Erasmus saw through the press while he was living at Venice under Aldus's roof, that made him really famous. It appeared in September, 1508, and was practically a new work. While the second edition, that of Badius, contained only twenty new adages, in that of Aldus the original number of 823 was increased to 3,260, and the original title was correspondingly changed to *Adagiorum chiliades tres ac centuriae fere totidem*. With its splendid type and 550 folio pages it was very different from the humble volume of 152 small octavo pages which Jean Philippi had published eight years earlier. Its increased size was due not only to the new adages, but to the much larger space which Erasmus gave to his accompanying commentaries. These were not the least striking part of the work[5]. Besides

[1] It was not reprinted till 1509 (Antwerp) with the rest of the *Lucubratiunculae*.

[2] Grace Book B, Part I, ed. Mary Bateson (Cambridge, 1903).

[3] Allen, I. Ep. 206. [4] *Ib*. I. p. 437.

[5] The commentary on two of the proverbs in this edition attains to the dimensions of an essay, viz. on *Festina lente* and *Herculei labores*. Other long essays, such as *Sileni Alcibiadis*, were added in later editions.

furnishing a wealth of illustration to the adages, they included references to contemporary affairs, and notably some pungent criticisms on theologians, dialecticians, and monks, which were a foretaste of what was to come in the *Moria*.

The original edition contained very few adages derived from Greek literature, hardly any at first hand. Even in the new edition Latin literature contributed the lion's share, for Erasmus was much more widely read in Latin than he ever became in Greek. Moreover a good many Greek works, including some of special importance for his purpose, had not yet been printed. But Aldus and the members of his Academy—Lascaris, Musurus, Aleandro—came to Erasmus's assistance, and lent him manuscripts of Plutarch's *Moralia*— of which the Aldine edition, the *princeps*, did not appear till 1509—Athenaeus, Pausanias, and Pindar[1]. It was not the least service afforded by the work that Erasmus appended to all his Greek quotations a Latin translation, and thus provided students with a convenient method of learning Greek. According to the title page, about 10,000 lines from Homer, Euripides and other Greek poets, were literally translated in the metres of the original[2].

Copies of the new edition of the *Adagia* must have reached Paris before the end of the year 1508. Illustrated by a man who to warm feeling and lively wit united a rare faculty of expression, and whose never-failing interest in humanity was preserved from becoming mere curiosity by an intense conviction of the moral basis of life, this fine flower of the ancient world, this epitome of ancient wisdom at its ripest and brightest, could not fail to impress its readers with the singular worth and dignity of the best ancient literature.

When Erasmus first set foot on Italian soil, he was still climbing the ladder of literary fame, and he was uncertain of his reception by the humanists of that country. When he came to Rome in 1509, he must have realised that he had reached the topmost rung of the ladder. For in the capital

[1] See the first Adage of Chilias II (*Festina lente*).

[2] Drummond, *Erasmus*, 2 vols. 1873, I. p. 272, and see the whole chapter for a good account of the *Adagia*.

of Christendom he was received as an equal not only by eminent scholars but by the princes of the Church. He finally left Rome in the summer of 1509, and travelling by more or less rapid stages to England, took up his residence in the house of his friend, Sir Thomas More. There, being kept to his room for a few days by an attack of lumbago, he wrote the *Moriae Encomium*. Nothing is known of his movements during the next eighteen months. In April and June, 1511, he paid two flying visits to Paris to see the *Moria* through the press. The printer was Gilles de Gourmont[1]. Of all Erasmus's writings this was the most immediately popular. It was reprinted in August, 1511[2], at Strassburg, in January, 1512, at Antwerp, in July, 1512, by Badius at Paris, and in October, 1512, again at Strassburg. Nor did its popularity diminish. 1200 copies of the new edition published by Froben in March, 1515, were sold in a month[3].

The title of Erasmus's satire was no doubt suggested to him by the famous *Narrenschiff* or *Ship of Fools* of Sebastian Brandt, one of the most popular books that was ever printed. Published at Basle in 1494, an additional popularity was given to it by the Latin verse translation of Brandt's disciple Jacob Locher, which appeared in 1497 with woodcuts of remarkable spirit. It was reprinted several times in the course of that year and the next. Its popularity was great in France from the first, and a translation in French verse by Rivière was published in 1497, and in French prose by Jean Drouyn (made from the verse translation) in 1498. In the latter year the printer Badius

[1] The volume has no date, except that the preface addressed to More is dated *Ex rure quinto idus Junias* (June 11). Mr Allen suggests that this was written, not in More's house, but in the neighbourhood of Paris, possibly at the Abbey of Saint-Germain-des-Près, the home of Lefèvre d'Étaples, to whom Erasmus certainly paid a visit about this time. The year, Mr Allen points out, must be either 1510 or 1511, for in June, 1509, Erasmus was still at Rome. But as, according to Erasmus (Letter to Martin van Dorp, Allen, II. Ep. 337, l. 140), the *Moria* was printed more than seven times within a few months, and we know of no edition of an earlier date than August, 1511, the date must be 1511.

[2] The first edition with a date (Camb. Univ. Library).

[3] Allen, II. Ep. 328, l. 47.

wrote in his turn a *Stultiferae naves*, and sent it to a French publisher to have it translated and printed. The French version, which was by Drouyn, had considerable success, and in 1501 Badius published the original Latin. Then in 1505 he made and printed a new Latin version of Brandt's *Narrenschiff*, and accompanied it with the old woodcuts of Locher's translation. This was again successful, and he had to reprint it in 1507[1].

Thus the way was prepared for a favourable reception of Erasmus's work, which, different though it was in aim and character from Brandt's popular satire, bore a similar title. Of the various classes of mankind upon whom he lays the lash of his satire, the scholastic philosophers and the theologians must have had most interest for his humanist friends at Paris. "They are happy in their self-esteem," he says of the dialecticians, "for armed with those syllogisms they are ready to engage with anybody on any topic[2]." Then he passes on to the philosophers who "though they know absolutely nothing, yet profess that they know everything; and though they do not know themselves... yet declare that they can see ideas, universals, separate forms, first matter, things so fine that Lynceus could not discern them any better than they do." The turn of the theologians comes next, and at this point the attack becomes more developed and the satire keener. After giving various examples of the absurd and trivial quibbles which they introduced into the most holy mysteries of religion, he says that "their most subtle subtleties are rendered even more subtle by the various scholastic sects, so that it is easier to make your way out of a labyrinth than out of the wrappings of Realists, Nominalists, Thomists, Albertists, Occamists, Scotists, and others." Finally he ridicules their pride in the title of *Magister*. "They think themselves second only to the gods, when they are addressed as *Magistri Nostri* ...and so they say it is a sin to write it in other than capital letters. And if any one transposes it and says

[1] See Renouard, II. 73–84.
[2] I quote from the Strassburg edition of 1511.

Noster Magister, there is an outcry that he has outraged the whole majesty of the theological title."

The publication of this outspoken satire must have tended to accentuate the breach between the partisans of the old and the new studies at Paris. The humanists must have smiled approvingly at the onslaught on scholastic philosophy and theology. What the attacked thought of it may be gathered from the letter which a young Dutch theologian named Martin van Dorp, who was on the eve of taking his Doctor's degree in the University of Louvain, was instigated by his brother theologians to write to his dear friend Erasmus. He tells him that his *Moria* has greatly disturbed even those who were formerly his greatest admirers. "Everybody admired you and eagerly read your works; the leading theologians and jurists longed for your company, when all of a sudden this unlucky *Moria* upsets everything." And he puts forward the flimsy plea, which has so often served to screen authority from criticism, that to revile theologians, whom it is so expedient that the common people should regard with reverence, was a highly dangerous proceeding[1].

In May, 1512, Badius received from Erasmus several of his writings, published and unpublished, for publication, including the *Moria*, the *Copia*, some new dialogues of Lucian with the old ones revised, and the materials for critical texts of the tragedies of Euripides and Seneca[2]. The letter in which he acknowledges their receipt is of much interest from the light that it throws on the relations between Erasmus and his publisher. The upshot of their negociations was that for some reason or other Badius deferred the publication of the Lucian and Seneca till 1514, but at once printed the *Copia* (July 15) and reprinted the *Moria* (July 27). He would also gladly have published a proposed new edition of the *Adagia*, and the long contemplated editions of the

[1] Allen, II. Ep. 304. Erasmus's answer, which was printed with the *Moria* in all the early editions from that of 1516 (Froben) onwards (Allen, II. Ep. 337), is an admirable composition, but it is far from ingenuous.

[2] Allen, I. Ep. 263, and see A. Horawitz, *Michael Hummelberger*, Berlin, 1875, I. 15.

Letters of St Jerome. But owing to the fraud of a printer's agent both the *Adagia* and the Letters passed into the hands of Froben at Basle, and the Letters appeared in 1516 as part of the great Amorbach-Froben edition of Jerome.

Erasmus had conceived the idea of the *Copia*, or, to call it by its full title, the *De duplici copia verborum ac rerum commentarii duo*, as early as 1499, but he only worked at it at intervals, and it was not completed till he went to Italy. His manuscript, however, was left at Ferrara, so when he was at Cambridge in the autumn of 1511, at Colet's request he wrote the treatise afresh, as a text-book for St Paul's school[1]. It is, in the words of Mr Woodward, "a storehouse of material for rhetorical uses[2]," its aim being to provide the beginners in Latin composition with a stock of synonymous words and phrases used by classical authors and generally to initiate him into the higher art of classical composition[3]. In the same volume as the *Copia* was included the little treatise, *De ratione studii*, the manuscript of which had also been left at Ferrara, and which falling into dishonest hands had been printed at Paris without Erasmus's knowledge in the previous year[4].

The *Copia* out of hand, Erasmus turned to a far more important task—an edition of the New Testament in Greek, with notes. The text was completed in the summer of 1513[5], and the notes a year later[6]. Some years before this he had nearly finished a kindred undertaking, a new Latin version of the New Testament. It was apparently the result partly of his work on Valla, and partly of the suggestions of Colet.

[1] Allen, I. Ep. 260, and see Epp. 237 (In absolvenda Copia mea nunc sum totus—October 29, [1511]) and 241.

[2] *Erasmus concerning Education*, p. 20.

[3] See also for the *De copia* Forbes Watson, *The English Grammar Schools to* 1660, Cambridge, 1908, p. 437.

[4] It was printed as an appendix to the *Epistolae* of Dati by Georges Biermant of Bruges (an obscure printer) for Jean Granjon (see Allen, I. p. 193). In the Leyden edition of Erasmus's works it only occupies 5½ pages.

[5] *Absolui collationem Novi Testamenti* (Allen, I. Ep. 270). Mr Allen seems to me to be right in assigning this letter to Colet to the year 1513 instead of to 1512. Mr Nichols adheres to 1512.

[6] Allen, II. Ep. 300, l. 31 (August, 1514).

For when he came to London in the summer or autumn of 1505, after the publication of Valla's *Annotations*, he found Colet installed in the Deanery of St Paul's, and his version was made with the help of two Latin manuscripts from the Chapter Library[1]. By October, 1506, the translation of the Epistles was copied out by Colet's amanuensis, Peter Meghen of Brabant[2], and on May 8, 1509, the same scribe wrote his colophon to the copy of the Gospels[3]. It was not, however, till August, 1515, that the work of printing the completed Latin version together with the Greek text and Erasmus's notes was taken in hand by Froben's press. The work appeared in March, 1516. The *Annotations of Valla* had been dedicated to the Papal Protonotary; the *Novum Instrumentum* with bold adroitness was dedicated to the Pope himself[4].

Although this publication of the first printed Greek Testament falls outside our period, the fact that Erasmus was at work on some comprehensive revision and criticism of the Vulgate text was well known to the learned world long before. It does not appear that the *Annotations of Valla* had had a wide circulation. At any rate a second edition was not called for till 1526. But the volume can hardly fail to have made an impression on those French humanists who took an interest in theological studies. Erasmus was fully aware of the boldness of the step he had taken, of the odium which attached to the name of Valla as a critic to whom nothing was sacred, and of the outcry which would be made by conservative theologians at a mere grammarian presuming to suggest changes in the received text. In an elaborate letter of dedication to Christopher Fisher he defends his action in editing Valla's criticisms[5]. It met with the full approval of at any rate one French humanist, the printer Badius, who wrote to Erasmus while the

[1] Allen, II. p. 164.

[2] See Allen, *The Age of Erasmus*, pp. 141–142.

[3] Mr Allen thinks that Erasmus had finished his translation of the Gospels before he left England in June, 1506 (II. p. 183).

[4] Allen, II. Ep. 384. [5] *Ib.* I. Ep. 182.

volume was going through his press, "I cannot but subscribe to your candid and weighty opinion about Valla[1]." What its influence was on Lefèvre d'Étaples and Budé is only a matter for conjecture, but it may well have emboldened Budé to insert in his *Annotations on the Pandects* his own criticisms on certain passages of the Vulgate[2], and it may possibly have dropped a seed in the brain of Lefèvre which was to bear fruit seven years later in the *Commentary on St Paul's Epistles* (1512).

The publication of Lefèvre's volume evidently caused Erasmus some annoyance. In the letter which he wrote in answer to Martin van Dorp's expostulations he says that it was very unfortunate that it did not occur to either of them in the course of their very intimate conversations to mention the work that each had in hand. But he adds that he warmly approves of Lefèvre's undertaking[3]. Seven months earlier (October, 1514) the French theologian had written to him a charming little letter in his quaint Latin, in which he compares him to the sun diffusing its light for the benefit of all men. Then he adds "Who is there who does not look up to, love, and revere Erasmus? Everyone who is good and a lover of learning.... Live for us and our age, and love him who reveres and loves you[4]." It is pleasant to find Lefèvre writing to Erasmus in this strain. It was not long before the two friends were engaged in a somewhat heated controversy on some points of Biblical interpretation.

It is clear from the foregoing sketch of Erasmus's relations with Paris that his influence on the Humanism of that city must have been quite inconsiderable up to 1506, the last occasion when he resided there for any length of time. At that date Lefèvre, Badius, and Budé had long been engaged on their special field of labour. Lefèvre had nearly completed his task of purifying Aristotle, and was editing mystical

[1] Allen, I. Ep. 183. [2] See above, pp. 274–275.
[3] Allen, II. Ep. 337, ll. 844 ff. The conversations *must* have been held in 1511. Mr Allen's "probably" is not strong enough. See above, p. 295, n.[1].
[4] Allen, II. Ep. 315 (October 23, 1514).

texts and preparing to devote himself to theology. Badius had for nearly ten years been writing familiar commentaries and grammatical treatises for schoolboys and printing Latin classics for mature students. Budé had realised before Erasmus the paramount importance of Greek for the undertaking even of Latin antiquity, and was preparing with the help of his new instrument to write a commentary on the Digest which should also be a survey of a large portion of Roman life. It must have been in the hands of Paris readers about the same time as the Aldine edition of the *Adagia*.

Of the works of Erasmus published before 1515, the only two for which a direct and immediate influence on French Humanism can be claimed are the *Adagia* and the *Moria*. But upon the younger humanists, at any rate, the general attitude towards antiquity of the man who had now become the first man of letters in Europe must have had an appreciable effect. Like all humanists, Erasmus idealised the ancient world, but, unlike some of the Italian humanists, he had not the slightest wish to revive it. In an important letter to Capito of February, 1517, he expresses a fear "lest under the cloak of the revival of ancient literature paganism should endeavour to rear its head[1]." It was one of his greatest merits that he kept the balance even between Christian and pagan antiquity. He clearly distinguished between the range of reading suitable for young students preparing for a professional life, whose chief object was to learn to read and speak classical Greek and Latin, and that suitable for their teachers and other mature students. In his earlier days he recommended his former pupil, Thomas Grey, to read Lactantius and Jerome along with Virgil, Lucan, Cicero, Sallust, and Livy[2], and he shared the preference of Lefèvre for Christian poets like Prudentius and Juvencus to Ovid and Catullus[3]. Five years later in the *Enchiridion* (written in 1501) he says that the writings of pagan poets and philosophers are a good preparation for Christian

[1] Allen, II. Ep. 541, ll. 633–635.　　[2] *Ib*. I. Ep. 63, ll. 40–42.
[3] *Ib*. Ep. 49, ll. 85–90.

warfare, provided they are read in moderation. But in 1519 he declares that Prudentius and Juvencus, Lactantius and Cyprian, are not for boys[1]. With teachers and men who aspire to learning it is different. He had no wish to confine them to pagan literature. He would have laughed at Filelfo, who had nothing but pagan authors in his library. The New Learning was for him an instrument of life. This clear conception of the uses of pagan literature for a Christian society was of the greatest service to France. For, as we have seen, a large proportion of the early French humanists, under the influence of their theological training, had an uneasy misgiving as to the fitness of pagan literature for the education of a Christian. Some, indeed, found relief in the theory that ancient literature was an allegory. But Erasmus taught them a truer view, that it is the moral seriousness of the best pagan literature that makes it a fitting instrument of Christian education. A humanist of the broad type of Vittorino da Feltre and Guarino da Verona, and like them a born educationalist, he held with Guarino that Humanism is "a training in virtue[2]." His chief aim in education was, like theirs, at once practical and moral. A knowledge of ancient proverbs, he says in his introduction to the Aldine edition of the *Adagia*, has a fourfold use. It is useful for philosophy (by which he means the conduct of life), for oratory, for rhetoric, and for the understanding of the best authors. Had he been asked the uses of a humanistic education, he would have answered in identical words.

[1] *Op.* IX. 93 C; and see Woodward, *Erasmus concerning Education*, p. 114.

[2] See above, p. 14.

CHAPTER IX

HUMANISM IN THE PROVINCES

THOUGH Paris was by far the most important centre of Humanism in France during the period which we are considering, it was not the only one. Other Universities, and at least one other large town which did not boast of a University, had their share in the diffusion of the new studies. Of the Universities Orleans decidedly ranks next to Paris in its favourable reception of these studies. It was one of the older Universities, having developed spontaneously in the thirteenth century from an ancient Cathedral School into a University[1]. It was as a School of Civil and Canon Law that it became celebrated, its prosperity being largely due to the prohibition of the Civil Law at Paris in 1219 and to the temporary dispersion of the Paris students in 1229. It indeed claimed to be the first School of Law in France, the only one, according to its patriotic historian, François Le Maire, which vied with Pavia, and Padua, and Bologna[2]. No other Faculty than that of Law is mentioned in the archives of the University, but we hear of Grammarians who were allowed to enjoy University privileges[3]. Reuchlin was a law-student there from 1478 to 1480, and supported himself by giving lessons in Greek and Hebrew[4]. In 1488 Jean Lodé of Nantes opened a school, in which the education was of a humanistic character, and which flourished

[1] F. Le Maire, *Histoire et antiquitez de la ville et duché d'Orléans*, Orleans, 1646; J.-E. Bimbenet, *Histoire de l'Université de lois d'Orléans*, Orleans, 1653; C. Cuissard, *L'étude du grec à Orléans* in *Mémoires de la Société archéologique et historique de l'Orléanais*, XIX. 645 ff.; H. Rashdall, *The Universities of Europe in the Middle Ages*, Oxford, 1895, II. part I. pp. 156 ff.

[2] p. 63. [3] Rashdall, p. 147. [4] Bimbenet, p. 351.

for a considerable period. Among his pupils was Gentien Hervet (1499–1584), the well-known controversialist and translator of Greek authors, who became a professor in the University. Lodé shewed his interest in education by translating Vegio's *De educatione liberorum* into French under the title of *Le Guidon des parens* (1513). He also wrote dialogues in Latin hexameters, and edited a Greek-Latin text of Plutarch's popular treatise on marriage (*Praecepta coniugalia*), which he had previously translated into French from the Latin[1].

A stimulus was given to humanistic studies in the University by the presence of Erasmus, who, driven by the plague from Paris, spent three months at Orleans from September to December, 1500. Among the friends that he made there was Pierre d'Angleberme, a practising physician, whose son Jean Pyrrhus[2], then a man of thirty to thirty-five, was pursuing his classical studies at Paris. Erasmus promised to assist him on his return to the capital, and fulfilled his promise. When Pyrrhus returned to Orleans to become a law-professor in the University (1506), he took an active part in promoting the new studies[3]. It was during his Rectorship, and at his invitation, that Aleandro, alarmed in his turn by the plague, came to Orleans at the close of 1510, and taught there till the following June with great success. Among his pupils were Arnoul Ruzé, the *scholasticus*—he corresponded to the Paris Chancellor—of the University, and his brother and son, Jean Lodé, Nicole Bérault, and Charles Brachet[4].

Other law professors at Orleans of humanistic proclivities were Pierre de L'Estoile, grandfather of the well-known diarist, who was appointed professor in 1512 at the age of thirty-two, and became one of the pioneers of the new jurisprudence in France, and François Deloynes, Budé's

[1] 1535; 1536; 1547. [2] Allen, I. Ep. 140, l. 34.

[3] Angleberme held his professorship till 1515, when he was appointed by Francis I a member of the Council at Milan. He died about 1520. Charles Dumoulin was his pupil (see Bimbenet, *op. cit.* pp. 352–354; *Les hommes illustres de l'Orléanais*, 2 vols. Orleans, 1852; Allen, I. 324).

[4] *Journal*, p. 20.

friend and connexion, who, as we have seen, went to live at Paris in 1500[1]. The University also had a distinguished *alumnus* in Louis Berquin, the future martyr of Protestantism. He was an intimate friend of Bérault, with whom as we have seen, he shared the dedication of Badius's edition of Politian's Works (1512).

The University of Angers, like that of Orleans, grew out of a Cathedral school, and profited similarly by the prohibition of the Civil Law at Paris and the dispersion of the Paris students[2]. In the fifteenth century it was hardly less famous than Orleans as a school of practical law, and in the latter half of the sixteenth century it rivalled Bourges as a school of scientific jurisprudence[3]. Faculties of Theology, Medicine, and Arts were added to that of Law in 1432, but none of them attained to any distinction. The first book printed at Angers (147$\frac{6}{7}$) was a classical work, the *Rhetorica nova* (or *ad Herennium*), which formerly passed as Cicero's, but it does not seem to have had any successors for a long time. In the next century we come upon a volume of Mantuanus published by Jean Alexandre, who was an agent for various printers at Paris, Rouen, and Poitiers[4]. The students of Angers were divided into six Nations. These in order of importance were Anjou (which included Touraine and all foreign countries), Brittany, Maine, Normandy, Aquitaine (embracing the episcopal dioceses of Bourges, Bordeaux, Narbonne, Toulouse, and Auch), and France (embracing the archiepiscopal

[1] See above, p. 278. Deloynes had Colet for a fellow-student (Deloynes to Erasmus, Allen, II. Ep. 494, ll. 14 ff.). Colet was absent from England from about 1493 to 1496, but we do not know whether he stopped at Orleans on his outward or his return journey (see J. H. Lupton, *John Colet*, 2nd ed., 1909, p. 45).

[2] L. de Lens, *L'Université de l'Anjou du XVIe siècle à la Révolution française*, Angers, 1880, vol. I. (no more published); Fournier, pp. 135 ff.; Rashdall, pp. 148 ff.

[3] Éguinaire Baron took his doctor's degree there in 1538, but the first distinguished professor was François Baudouin (1570–3). William Barclay, the Scottish jurist, and father of John Barclay, the author of *Argenis*, was a professor from 1605 to his death in 1608.

[4] L. H. Labaude, *L'Imprimerie en France au XVe siècle*, Mainz, 1900, p. 10.

provinces of Lyons, Sens, and Rheims), which was very sparsely represented. Thus, like all the French Universities, not even excluding Paris whose students came mainly from the North and North-East of France[1], Angers was a more or less local University, dràwing its students chiefly from Anjou, Touraine, Brittany, and Maine[2]. Even when a University in all the Faculties was founded at Nantes in 1461 by Duke François II, Brittany continued to send students to Angers.

Nantes prospered under its founder, but after his death in 1488, when the Bretons were making their last struggle for independence, it rapidly declined. In 1494 it was revived, chiefly as a School of Law, but I cannot find any trace of humanistic studies being carried on there.

Another University which like Nantes was almost purely local in character, but which had a much more successful career, was Caen, founded by Henry VI of England in 1431[3]. Thanks to Léopold Delisle's admirable record of the books printed and published in the Norman city from 1480 to 1550, we can in some measure trace the progress of Humanism in the University[4]. For, as Delisle points out, there was during this period a close connexion between the printing and bookselling trades and the University. If during the years before 1515 the progress was not great, a beginning at any rate was made. Classical literature is represented by Horace's *Epistles* (1480)[5], Ovid's *Metamorphoses* (1496) and *Remedia amoris* (1501), Terence (*circ.* 1505, and 1509), Virgil's *Eclogues* (1507 and 1509), *Georgics* and complete Works (1511), and Aesop's *Fables* in Latin (*circ.* 1504;

[1] The four Nations at this time were France, Germany, Picardy, and Normandy.

[2] See De Lens, pp. 47–52.

[3] L'Abbé de La Rue, *Essais historiques sur la ville de Caen*, 2 vols. Caen, 1820; Rashdall, pp. 194–8; H. Prentout, *Renovatio ac Reformatio in Universitate Cadomensi*, Caen, 1901; A. Tilley in *Fasciculus Joanni Willis Clark dedicatus*, Cambridge, 1909, pp. 378 ff.

[4] *Catalogue des livres imprimés ou publiés à Caen avant le milieu du XVI^e siècle*, 2 vols. (*Bull. de la Société des Antiquaires de Normandie*, XXIII. and XXIV.), Caen, 1903 and 1904.

[5] This edition has blank spaces for manuscript notes between the lines.

before 1507; 1512). These were followed towards the close of our period by a few text-books, such as Petrus de Ponte's *Ars versificatoris* (1514?), Perotti's Latin Grammar (*circ.* 1513), and an abridged edition of Valla's *Elegantiae* by Guy Jouennaux. The first book on the list was printed at Caen, but we hear nothing more of its printers, Durandas and Guijoue, and no other book was printed there till Laurent Hostingue of Rouen set up a press in 1508 and printed the *Eclogues* in the following year. Meanwhile books printed at Rouen or Paris were sold by the Caen booksellers, Pierre Regnault, Robert Macé and his son Richard, Michel and Girard Angier, most of whom were formally appointed booksellers to the University[1].

Among the University professors was a humanist of considerable distinction. Guillaume de La Mare, who has already been mentioned in these pages as a writer of Latin verse[2], began his studies at Caen, but owing to the plague migrated to Paris, where he took his degree in Arts[3]. Then returning to Caen he gave several years to the study of law and the humanities, and made himself a name as a writer of Latin prose and verse. But desiring a more active and a more remunerative career he became secretary successively to the two Chancellors, Robert Briçonnet, and Guy de Rochefort, and to Guillaume Briçonnet the Cardinal of Saint-Malo. In 1503 or 1504 he returned once more to Caen, took his degrees in Canon and Civil Law, and was chosen Rector of the University in 1506. In 1511 he was appointed Canon and Treasurer of the Cathedral of Coutances, and there he died in 1525[4]. We have seen that his volume of occasional verse entitled *Sylvae*, though nearly all of it was written before 1500, was not published till 1573[5]. Before this he had published a poem of a satirical character entitled

[1] Delisle, ii. xi ff.　　　　　　　　[2] See above, p. 203.

[3] He was born in 1451.

[4] See a brief sketch of his life in the preface to his *Chimera*; also Trithemius, *De script. eccl.* Add. i., and Ch. Fierville, *Étude sur la vie et les œuvres de G. de la Mare* in *Mémoires de l'Académie de Caen*, 1892, pp. 42 ff.

[5] *Sylvarum libri quattuor*, Badius Ascensius, 1513.

Tripertitus in chimeram conflictus[1], and he had written, if not published, a paraphrase of Musaeus in hexameters[2]. The *Chimera*, which is divided into three books, *Superbia*, *Libido*, and *Avaritia*, shews considerable power both of thought and expression, and La Mare's verse generally is distinguished by that quality of movement which gives vitality to all poetry. According to the preface to the *Chimera* he was no less celebrated for his prose than for his verse[3], and in 1513 he sent to the press a volume containing ten orations and a selection from his correspondence[4]. In spite of La Mare's example the new studies made but slow progress in the University of Caen. As late as 1530 one David Jore, who held the office of Rector in the following year, complained that "while good literature flourishes in Britain and Germany, with us a Latin scholar is far to seek[5]."

Many of the books sold at Caen were printed at Rouen, for the capital of Normandy was at this time a very important centre of the printing trade. Notably it produced a large number of liturgical books for the English market. But works of a humanistic character formed a very small porportion of its output. In addition to those already mentioned as sold at Caen, I can only find a Persius, a Terence, and a volume of Baptista Mantuanus[6].

South of the Loire the first two Universities that we

[1] Badius, 1513. But Trithemius in his notice (1512) mentions the *Chimera*, and the La Vallière catalogue II. No. 2635 records an edition without place or date, but with a dedication by the author dated from Caen University, Christmas Day, 1510.

[2] Badius, 1514. This work is also mentioned by Trithemius.

[3] Ut eo nullus in arte vel oratoria vel poetica celebrior haberetur.

[4] *Epistolae et orationes*, Regnault, 1514. He also published a short prose work of a moral and satirical tendency, made up of citations from Greek and Latin authors, and entitled *De tribus fugiendis, ventre, pluma et venere, libelli tres* (H. Estienne, 1512; S. de Colines, 1521).

[5] Delisle, *op. cit.* II. 52.

[6] E. Gordon Duff, *Westminster and London Printers*, Cambridge, 1906, pp. 205-7. Richard Pynson was a native of Normandy and probably learnt his trade there (*ib.* p. 55). So did Adam Miller, the first printer in Scotland (*ib.* p. 175).

encounter are Bourges and Poitiers. In both we find the Faculty of Law divided into the four Nations of France, Berry, Touraine, and Aquitaine, and the comparatively local character of both Universities is shewn by the fact that while at Bourges the order of the Nations was as above, at Poitiers Aquitaine ranked second and Berry last. Bourges was founded in 1464 on the petition of Louis XI, who wished to honour his birthplace, and his brother Charles, Duke of Berry. Mainly a University of Law, it met for some years with much opposition from Paris, Orleans, and Angers[1], and it was not till Margaret of Angoulême, who received the Duchy of Berry as her appanage in 1517, took it under her fostering care, that it began really to flourish. As we have seen, Geofroy Tory was a student there in the last half decade of the fifteenth century. Among his teachers was Guillaume de Rycke, a native of Ghent, who wrote a short poem in Latin elegiacs on Our Lord's Passion[2], which was printed more than once, sometimes in the same volume with Mancini's *De quattuor virtutibus*.

Poitiers was founded by Charles VII in 1431 as a counterpoise to the University of Paris, which was then in the occupation of the English. Reuchlin took his Licentiate's degree there in 1481; André Tiraqueau, the well-known jurist and friend of Rabelais, and Mellin de Saint-Gelais, the poet, were law-students there in the first decade of the sixteenth century; and Longolius was, as we have seen, a professor there from 1510 to 1512. Saint-Gelais had followed the Arts course before becoming a student in Law, but Poitiers, like all the French Universities except Paris and Montpellier, was mainly a Law-School. Though the University made no figure as a poineer in humanistic studies, the city itself was throughout the sixteenth century a literary centre of some importance, and the records of its press shew that even during our period there was some

[1] Rashdall, pp. 204, 205.
[2] Published first in 15$\frac{99}{10}$ by Badius with a dedicatory preface by Herverus de Berna of Saint-Amand-Montrond, a fellow-student of Tory's, and a commendatory dialogue in elegiacs by Tory.

demand for classical authors and the works of Italian humanists. During the last five years of the fifteenth century we find Jean Bouyer, a native of Saintes and a priest, printing in partnership with Guillaume Bouchet[1] Argyropoulos's translation of the *Ethics*, Valerius Maximus, Lucan, Statius's *Achilleis*, Aesop's *Fables* in Latin, several works of Mantuanus, a volume by Fausto Andrelini (*Carmina varia*), Mancini's *De quattuor virtutibus* and (under the name of Filelfo) Vegio's *De educatione liberorum*. In 1508 Jean Mesnage of Paris set up a press there, and between that date and 1515 issued a volume of Latin verse and prose by Julianus Pius, a professor at the College of Sainte-Marthe[2], a volume of Epigrams by Beroaldo, and an edition of Cicero's *De officiis, De amicitia, De senectute,* and *Paradoxa,* with notes by Erasmus[3]. Other presses contributed an edition of Lucan (151$\frac{2}{3}$)[4], and Dati's *De componendis epistulis (circ.* 1505). The Paris publishers Enguilbert, Jean, and Geoffroy de Marnef, with whom Badius Ascensius had close business relations, had a branch establishment there, as well as at Bourges, Angers, and Tours.

At Bordeaux there was only a small unendowed University, founded in 1441 during the English domination, which never became prosperous[5]. Nor were things much better at the older University of Cahors, which also belonged to the Duchy of Aquitaine[6]. The most flourishing University in the South of France was Toulouse, whose Law School held the same position South of the Loire as that of

[1] Uncle of the author of *Les Serées*. There is no evidence of any relationship between their family and Jean Bouchet, the attorney-poet and friend of Rabelais. See A. Richard, *Notes typographiques sur les Bouchet*, Poitiers, 1912 (notice in *Rev. des études rabelaisiennes*, x. 498 f.).

[2] *Juliani Pii Maseriensis Biturici epigrammata necnon moralia opuscula* [1509]. The author was a native of Mézières-en-Brenne in Berry. One of his poems is addressed to Longolius.

[3] See for the Poitiers presses A. de La Bouralière, *Les Débuts de l'Imprimerie à Poitiers*, 2nd ed. 1893; *Nouveaux documents sur les Débuts de l'Imprimerie à Poitiers*, 1894; *L'Imprimerie et la Librairie à Poitiers pendant le XVIe siècle*, 1900; A. Claudin, *Monuments de l'Imprimerie à Poitiers*, 1897. [4] Panzer, *Ann. Typ.*

[5] Rashdall, p. 198. [6] Rashdall, p. 179.

Orleans North of it. Indeed Toulouse would certainly have disputed the claim of her rival to be the chief Law University in France. But the southern University, which was founded for the repression of heresy, retained its severely theological and orthodox character. Its fourteen well-endowed colleges were, says Mr Rashdall, "of an even more distinctly ecclesiastical type than those of Paris." Most of them were governed by two Chaplains instead of a single Head[1]. As the result of this atmosphere, the attitude of the University to the new studies was extremely conservative. Among the earliest productions of the Toulouse press[2] was a treatise by Jasone de Maino, the famous Italian jurist and orator, one of the last representatives of the old school of jurisprudence, who, except for an interval of four years when he was first at Padua and then at Pisa, lectured at Pavia for fifty-two years. In 1507 Louis XII with five cardinals and a hundred members of his court attended one of his lectures. His most famous pupil was Alciati, so that he forms a link between the old school and the new[3].

Toulouse had, however, one distinguished representative of the new learning in Jean de Pins, afterwards Bishop of Rieux. Born in 1470, of an illustrious family of Languedoc, he studied successively at Toulouse, Poitiers, and Paris. Then he went to Bologna, where he learnt Latin from Beroaldo and Greek from Urceo Codro. After taking Orders in 1497, he spent eleven more studious years in Italy, writing the life of Beroaldo (1505), and helping to edit the works of Urceo Codro. In 1508 he was appointed Clerk to the Toulouse *Parlement* and resided in that city till 1515, when Francis I sent him to Milan as a senator. He had a considerable reputation as a writer of pure Latin[4].

The printing-presses at Toulouse were fairly numerous and active, and several Lyons publishers—Barthélemy

[1] Fournier, pp. 209 ff.; Rashdall, pp. 157 ff.

[2] Printing was introduced at Toulouse in 1476.

[3] Savigny, *Gesch. des römischen Rechts im Mittelalter*, 2nd ed. Heidelberg, 1834–51, VI. 397 ff.

[4] See R. C. Christie, *Étienne Dolet*, pp. 60–73; Thuasne, I. 374 and note (letter from Gaguin to J. de Pins dated 1493?); Allen, III. 510–511.

Buyer, Jacques Huguetan, Simon Vincent, Pierre Maréchal and his partner, Barnabé Chaussard—had branches there. So had the celebrated Nuremberg printer, Antoine Koberger, who also had a branch at Lyons[1].

At Montpellier there were separate Universities of Medicine, Law, and Arts, but it was chiefly the first that was famous. In the twelfth century it ranked as a world-renowned Studium with Paris and Bologna and Salerno. Then in the middle of the fourteenth came a decline, and it was not till the days of Charles VIII that a revival took place[2]. But neither the University of Arts nor that of Law profited by this revival. Aix was equally undistinguished as regards humanistic studies, and all that need be said about it here is that Provençal students were compelled to study there, and that its three Nations (as at Montpellier) were called Burgundian, Provençal, and Catalan[3].

Avignon had some reputation as a Law School in the fourteenth century, but after the Popes ceased to reside there it rapidly declined in importance. Thanks, however to the exertions of the Cardinal Giuliano della Rovere, the future Julius II, who was first Bishop and then Archbishop of the see, and to the foundation by him and other munificent patrons of four new colleges, it enjoyed some revival of prosperity[4]. It was at Avignon that Alciati was appointed to his first professorship in 1518[5]. But in the welcome given to the new jurisprudence, Avignon was outstripped by Valence, where the renowned Milanese jurist, Filippo Decio, found an asylum and a professorship. He had been driven from Pavia, where, on its capture by the Papal troops[6], he had accepted a professorship in 1505 from Louis XII. So great was his fame that before long he attracted an audience of four hundred students[7]. It included Longolius, who as we have seen took his Licentiate's

[1] A. Claudin, *Les enlumineurs, les relieurs, les libraires, et les imprimeurs de Toulouse* (1400–1530), 1893, pp. 9–10.

[2] Rashdall, p. 135.　　　　　　[3] Rashdall, p. 187.

[4] Fournier, pp. 588–602; Rashdall, pp. 175–177.

[5] Mazzuchelli, *Gli scrittori d' Italia*.

[6] He lost his library of 500 volumes.　　　[7] Savigny, *op. cit.* VI. 372 ff.

degree at Valence in 1514. After our period its Law School continued to increase in activity and importance, and numbered among its professors Jean de Coras, François Duaren, Antoine de Govea, Jacques Cujas, and François Hotman[1]. Nor were the humanistic sympathies of the University confined to the Law School, for, as has been already mentioned, Badius Ascensius lectured there for a short time on the humanities.

Ascending the Rhone and passing Vienne, about which there is nothing to record (except that printing was introduced there at a fairly early date, namely about 1478), we come to Lyons, which of all the provincial towns of France came nearest to Paris in the activity of its intellectual life. Indeed, at a later period, when Rabelais took up his abode there (1532) for a season, it was hardly, if at all, inferior to the capital, either in the number of humanists and men of letters who resided there, or in the productions of its numerous printing-presses. But during our period, at any rate as regards Humanism, it distinctly lagged behind the capital. It had no University, but there was a college frequented by the sons of nobles, of which one Henri Valluphinus was Principal[2], and where Badius was professor of Latin from 1492 to 1499. It was for these pupils that Badius, as we have seen[3], began to publish his editions of Latin authors with familiar commentaries, but he was soon absorbed by the work of managing Trechsel's press.

It was not till the year 1497 that the humanistic productions of the whole Lyons press (so far as I can gather from necessarily imperfect records) reached the number of seven, and it was not till 1506 or even later that the average output was as high as this. The range of classical authors was limited, the favourites being Juvenal, Persius, Terence, Sallust, Ovid (*Metamorphoses, De arte amatoria, Remedia*

[1] L'Abbé Nadal, *Histoire de l'Université de Valence*, Valence, 1861; Rashdall, pp. 200–201. The University was founded in 1459.

[2] Badius dedicated to him his edition of Juvenal with a "familiar commentary" (Renouard, II. 535 ff.)

[3] See above, p. 216.

amoris, and *Heroides*) and Cicero. The first four were much used as school-books. Ovid appears to have been in greater request at Lyons than at Paris, especially the *Heroides*, which was printed there six times from 1500 to 1514. Virgil, on the other hand, who at Paris was the most popular Latin author, was only printed twice (1492; 1499) at Lyons. Cicero's *Epistolae Familiares* were also printed twice (1496; 1499) and his *De officiis* with the *De amicitia* four times (1506; 1507; twice in 1512). Of three Latin authors Lyons furnished the first French editions, namely Caesar (1508), Pliny the elder (1510), and Silius Italicus (1513). Italian Humanism was represented by Perotti's Latin Grammar and *Cornucopia*, Mancinelli's *Works*, Dati's and Valla's *Elegantiae*, a poem of Baptista Mantuanus, Beroaldo's *Orations*, the *Letters* of Pius II, and the *Works* of Poggio. A striking feature is the number of editions of the *Digest*, which was printed either in whole or in part no less than nine times from 1482 to 1514. During the same period it was only printed once at Paris[1]. Lyons also produced two editions of the *Institutes*, one of the *Codex*, and, as we have seen, one of the whole *Corpus Juris* (1509–14).

Of the Lyons booksellers who published works of a humanistic character during our period, the chief were Jean Trechsel, Martin Boillon or Bullion[2], Barthélemy Trott (Trotti) of Pavia, Jacques Sacon or Zacon (Zaccone?) of Ivrea, who was also a printer, Jacques Huguetan, who had a branch establishment at Paris, Étienne Gueynard, and Simon Vincent. It will be noticed that out of these seven two were Italians and one, Trechsel, a German[3]. There were in fact a large number of Germans and Italians engaged in the printing and publishing trades at Lyons, a considerable proportion of the printers, as in many other towns in the south and east of France, being Germans. The centre of the trade was the Rue Mercière, a street near the river

[1] The *Digestum vetus* with a preface by Badius, Bocard, 1513.

[2] Baudrier, *Bibliographie lyonnaise*, III. 57 ff.

[3] See A. Péricauld l'aîné, *Bibliographie lyonnaise du XVᵉ siècle*, 4 parts, Lyons, 1851–9.

Saône, which though situated in what is now the finest quarter of Lyons, where many new streets and squares have been laid out, still retains many of its sixteenth-century houses[1].

The most distinguished man of letters living at Lyons at the beginning of the sixteenth century was. Symphorien Champier, who had a considerable reputation in his day as a physician and a writer on various subjects[2]. Born in 1471 or 1472 at Saint-Symphorien-le-Château in the Lyonnais, he studied at Paris under Jean Fernand, Guy de Jouennaux, and Fausto Andrelini. He took his medical degrees at Montpellier, and at about the close of the fifteenth century settled at Lyons as a practising physician. But about the year 1506 he left Lyons to enter the service of Duke Antoine of Lorraine, with whom he made the Italian campaign of 1509, fighting under his banner at Agnadello. On his return to France after Marignano he again settled at Lyons, where he lived for the remaining twenty and odd years of his life[3].

His chief service to his adopted city was the foundation of Trinity College (1529), which owed much to his initiative and exertions, and which contributed greatly to the spread of Humanism. For besides being an excellent physician and writer on medical subjects, a keen and patriotic antiquary, an editor of ancient chronicles and records of chivalry, and a dabbler in philosophy and mysticism, he was a warm sympathiser with the new studies. Two volumes, which he entitled respectively *Liber de quadruplici vita* (1507) and *De triplici disciplina* (1508), give one a good idea of the variety of his interests. Philosophy is represented by the treatise which gives its name to the earlier volume and by

[1] It runs out of the Place des Jacobins between the Rue de l'Hôtel de Ville and the Saône. It is in part parallel with the Quai Saint-Antoine, which preserves the name of a vanished church, near which many of the printers lived.

[2] See P. Allut, *Étude sur S. Champier*, Lyons, 1859; Père de Colonia, *Hist. littéraire de la ville de Lyon*, Lyons, 1730, pp. 478–491; P. A. Becker, *Jean Lemaire*, Strassburg, 1893, pp. 85–87.

[3] He was living in 1537, but died soon afterwards.

three books on Plato's philosophy in the second volume; medicine, by a dictionary and by the Fourth Book of Isidore's *Etymologies*; theology by treatises on Hermes Trismegistus and the Orphic mysteries; history by an abridged history of France down to the reign of Louis XII (*Tropheum gallorum*); and Antiquities by a list of ancient inscriptions found at Lyons and in the neighbourhood[1].

It must be admitted that these writings, apart from those which deal with medicine, are of very slender value. The historical treatises, in particular, are superficial and wholly uncritical. But in the multiplicity of Champier's interests—that in Plato is especially noteworthy—his enthusiasm for antiquity, his astonishing industry—between 1489 and 1534, though he was a practising physician of much repute, he had published a hundred and five separate treatises in over forty volumes—his practical energy, and his naive vanity, he is an interesting meridional type of that enthusiastic but uncritical curiosity which was one of the characteristics of the early French Renaissance.

The *Liber de quadruplici vita* is dedicated to François de Rohan, Archbishop of Lyons. To the same prelate Badius dedicated editions of Horace (1503) and Sallust (1504). He was a son of Pierre de Rohan, Maréchal de Gie, and was still a youth when he was elected to the Archbishopric in 1501[2].

Others centres of Humanism besides the Universities and the half-Italian city of Lyons were Cathedral towns which did not possess an University. As we have seen, several of the Bishops were favourable to the new studies and in several ways contributed to their encouragement. Either they formed a library, or they provided some promising young humanist with a place in their household and eventually endowed him with a Canonry, or, if they resided

[1] See Allut, *op. cit.* pp. 149–156. There is a copy of the *De quadruplici vita* in the Brit. Mus., and of the rarer *De triplici disciplina* in the Cambridge University Library.

[2] He already administered, that is to say, received the revenues of the see of Angers. He was consecrated in 1504, and made his entry into Lyons in 1506 (*Gallia Christiana*).

in their see, they exercised a general personal influence in favour of Humanism.

Sometimes it was the Dean and not the Bishop who was the leading patron. This was the case at Amiens, where we find Adrien de Hénencourt, well known for his liberal encouragement of the arts[1], sharing with Raoul de Lannoy, the *bailli* of the city, who had similar tastes[2], the dedication of Valeran de Varanes's poem on the capture of Genoa. Valeran, a native of Abbeville, perhaps owed his introduction to these patrons to his fellow-poet, Pierre de Bur, who, as we have seen, was a Canon of Amiens[3]. Among the Canons of Chartres was Robert de Val, born at Rouen about 1450, who published *Prologus in sequentem difficilium Plinii explanationem*[4] and an Epitome of Valerius Maximus, which was translated into French by Michel de Tours[5]. Guillaume Castel was a Canon of Tours and Antoine Forestier a Canon of Nevers. Guillaume Coquillart and Nicolas Ory were both Canons of Reims[6], but Champagne had a younger and better equipped representative of provincial Humanism in Louis Budé (1470–1517), Archdeacon of Troyes, a brother of the great Budé. He had several Greek books in his library, and he corresponded with his brother in that language[7].

In the south-west Rodez could boast of a Canon who had visited Italy and who had written treatises inspired by the philosophical mysticism of the Renaissance. Born at Montauban, Alain de Varènes had been a pupil of Lefèvre d'Étaples at Paris[8]. In 1502 he went to Italy, and in the

[1] See above, p. 153.	[2] See above, p. 205.	[3] See above, p. 201.

[4] Printed by Gerlier, *circ.* 1500 (Hain, 15837).

[5] Brunet, v. 1052. R. de Val (*ob.* 1529) must not be confused with a younger man of the same name who was born at Rugles and became a professor at the College of Lisieux at Paris. See A. Tougard in *Mém. de l'Académie de Caen*, 1906, and especially the note at the end.

[6] See above, p. 202.

[7] See Omont, *G. Hermonyme.* He lived in a house near the Cathedral, known as the Hôtel de la Montée-Saint-Pierre, which still exists. The fine entrance, however, with its rich mouldings, is of rather later date, probably later than the fire of 1524.

[8] See *Bull. de la Soc. Arch. de Tarn-et-Garonne*, XXIII. (1895), 311–321.

following year published at Bologna two short treatises in
the form of dialogues, *De amore,* and *De luce intelligibili.*
He was back at Montauban in 1505, took a Doctor's degree
at Cahors, and became a Canon of Rodez and later Vicar-
General. It was under his auspices that Salmon Macrin,
the future French Horace, published his first volume.

The above attempt to estimate how far Humanism had
spread through France before the accession of Francis I is
obviously incomplete. In the first place I am far from
pretending to have collected all the available evidence,
and in the second there must be a good deal of evidence
which is no longer forthcoming. There must have been
humanists living quiet lives in provincial towns who died
without leaving any record of their studies. There must
have been editions of classical authors and educational
text-books which have either vanished entirely or still
await discovery. But, so far as our evidence goes, it cannot
be said that Humanism had made much progress outside
Paris. At Caen and Valence, indeed, it appears that a
beginning had been made, and that the younger students or
"grammarians" were being educated on humanistic lines,
and probably this was the case in other Universities. At
Lyons too, where there was no University, there was a
school of a humanistic type. But only at Orleans and
Poitiers can the study of Latin be said to have reached
beyond an elementary stage. Here and there, too, we find
an isolated humanist, such as Jean de Pins at Toulouse, or
Louis Budé at Troyes, both of whom were not only Latin
but also Greek scholars. But on the whole the provinces
add little to the picture. For our estimate of the progress
of Humanism during our period and of its condition at the
close we must trust mainly to Paris.

In 1494, the year in which Charles VIII set out for
Italy, the Paris press definitively began the publication of
books of a humanistic character, a movement which points
to the beginning of a corresponding demand on the part
of readers. During the next eight years a small band of

humanists, under the leadership of the veteran, Robert Gaguin, devoted themselves to Latin rhetoric, or, in other words, to the study of Latin authors and to the practice of Latin composition in verse and prose. They were for the most part ecclesiastics and members of the University, for the Church offered them the most promising career, and members of an University had very considerable advantages in the matter of ecclesiastical preferment. As the result of this connexion with the humanists, the University, though it cannot be said to have shewn any marked zeal for the new studies, at any rate tolerated them in its midst. The favour and forbearance which it shewed to a third-rate humanist of indifferent character like Fausto Andrelini was, as we have seen, a matter of surprise to Erasmus. The attitude of the Colleges, as distinguished from that of the University, naturally varied with the sympathies of their Principals and Professors, but it is worth noticing that the great College of Navarre, which was regarded as a pillar of orthodoxy hardly less steadfast than the Sorbonne, was not unfriendly to the new studies. Among its Professors were Geoffroy Boussard and Jacques Merlin, editors of Eusebius and Origen respectively[1], Olivier of Lyons, the Master of the Grammarians[2], Jean Tissier of Ravisi, better known as Ravisius Textor, author of the *Officina* (1520), Josse Clichtove, who took his Doctor's degree there in 1506 and lectured there for a few years[3], and Louis Pinella, who was Principal from 1497 to 1505, and to whom Badius dedicated Beroaldo's Commentaries on Lucan[4].

The death of Gaguin in 1502 may be regarded as closing the first phase of the revival of classical studies in France, the phase of Latin rhetoric. A new phase in the study of Latin begins in the following year when Badius Ascensius set up his famous press. Thanks to his enterprise and that of his friend Jean Petit, the leading Paris publisher and bookseller, the production of Latin classical authors greatly increased. At the same time Badius continued the work

[1] See above, p. 240. [2] See above, p. 284.
[3] Clerval, *op. cit.* pp. 13–16. [4] Renouard, iii. 24, 25.

which he had already begun of promoting the cause of humanistic education, by writing his "familiar commentaries," and by editing and printing improved grammars and other manuals.

Meanwhile a work of a different character had been carried out with striking energy in the College of Cardinal Lemoine by Jacques Lefèvre d'Étaples. By lectures, commentaries, and the publication of improved translations he had reformed the whole study of Aristotle. He had also introduced great improvements into the study of Mathematics and the other subjects of the *Quadrivium*. His weak point was his imperfect knowledge of Greek. Greek was inevitably a plant of slower growth than Latin at Paris. It was not till the year 1496 that a really competent scholar settled there, in the person of Janus Lascaris, and he was not a regular teacher, but a busy man of affairs. Profiting, however, by his occasional help and constant encouragement, Guillaume Budé, with indomitable energy and perseverance, succeeded in overcoming all difficulties in the way of learning Greek at Paris, and by 1504, when Lascaris left France for a long residence in Italy, he was already a sound scholar.

The year 1507 is memorable as the year in which the first Greek press was set up at Paris, and for the next six years Greek studies made real progress. The year 1508 is marked by three events which greatly contributed to this progress, the arrival of Aleandro (June), the publication of the Aldine edition of Erasmus's *Adagia*, copies of which must have arrived at Paris in October or November, and the publication of Budé's *Annotationes in Pandectas* (November). The volumes of Erasmus and Budé, besides stimulating the general interest in classical antiquity, were particularly helpful to students of Greek by reason of the numerous translations which they gave of passages from Greek authors. But it was the coming of Aleandro that gave a real impetus to the movement. In the following October (1509) he began to give public lectures, and, except for the half-year which he spent at Orleans, sowing there

the same fruitful seed, he lectured at Paris for three years with the greatest success. At the same time, by his direction of Gourmont's Greek press he helped to meet the other great difficulty, besides the lack of teachers, which stood in the way of learning Greek at Paris, the lack of books.

But even at the very moment of Aleandro's triumph, when in July 1511 he was lecturing to large and distinguished audiences, the note of opposition was sounded. In the previous June had appeared the *Moriae Encomium*, and the susceptibilities of the professors of theology were at once aroused. They began to look with suspicion on the humanists, and the breach thus begun went on ever widening. In the same year broke out the controversy between Reuchlin and the Dominicans at Cologne. In the following year (1512) Lefèvre d'Étaples published his *Commentary on St Paul's Epistles*, and, though it aroused no storm of disapproval, it did not pass unnoticed by the theologians. Reuchlin had resisted the claim of theology to dominate over all other sciences. Now an ordinary Master of Arts, who had taken no Theological degrees, was presuming to comment on the Sacred Text of the Vulgate, and even to revise it![1] Two years later (1514) Reuchlin's book, the *Speculum oculare*, out of which the controversy had arisen, was censured by the Theological faculty at Paris.

Not long afterwards, in November, 1514, Aleandro left France, having ceased to lecture at the end of the previous year. One of his reasons was that the Archbishop of Paris, Étienne Poncher, refused to give him a regular salary. For in spite of the goodwill which Poncher and a few other leading men shewed to learning, their patronage was more or less fitful and uncertain. It was for this reason that Budé

[1] L'Abbé Humbert says with some truth: "La publication de l'*Encomium Moriae* est en effet le point du départ des résistances que vont opposer les partisans de la théologie, telle qu'on l'entendent jusqu'alors, aux tentatives des novateurs. Les poursuites contre Colet, contre Reuchlin, contre Erasme lui-même datent de ce livre célèbre et s'expliquent par lui' (*Les origines de la théologie moderne*, I. 194, 1911). Colet was charged with heresy in 1512.

in one of the interesting digressions of his *De Asse* takes a somewhat gloomy view of the prospects of Humanism in France[1]. He protests with eloquent indignation against the vaunted superiority of the Italians in learning, and sounding the same patriotic note that was to be heard a generation later in Du Bellay's *Deffence*, he declares that the French have as much natural aptitude for eloquence and letters as the Italians[2]. But he adds that, owing to the ignorant prejudice of the French nobles, who regard learning and noble birth as incompatible, classical studies languish from lack of encouragement[3]. However, in another place he is more hopeful. "Of late," he says, "owing to the happy revival of Greek and Latin the zeal of our youth has been wonderfully kindled. For a few ardent lovers of learning have by their perseverance in study excited general emulation. At the same time, thanks to the industry of Italian scholars, who are every day publishing new books, ancient literature, which not long ago was unknown and neglected, is now praised and honoured in France[4]."

It was, indeed, by the "perseverance in study" of a few lovers of learning, and above all of Budé himself, that Humanism was established in France. Lascaris was right when he told Lazare de Baïf that Budé had done as much for Greek in France as Cicero in Italy. But the hopes which the accession of a youthful and generous monarch, who though far from learned himself was reputed to be well-disposed to learning and letters, had roused in the breasts of the humanists were destined to suffer some disappointment. Before long the situation was profoundly complicated by the spread of the Lutheran doctrines in France, and by the sympathy with which the majority of the humanists at first received them. The breach between the new studies and the old,

[1] If we may judge by the *Annotationes in Pandectas*, Budé did not begin the actual writing of the *De Asse* till 1514, so that his observations on the condition of Humanism may be referred to that year.

[2] *Opera* (Basle, 1557), I. 32 ff. [3] *Ib.* 23 ff.

[4] *Ib.* p. 226. See also Delaruelle, *G. Budé*, pp. 160–166.

between Humanism and the Sorbonne, which had begun
with the publication of the *Moriae Encomium* and the
controversy with Reuchlin, inevitably widened. Greek was
henceforth regarded by the more ignorant of the orthodox
as the language of heresy. For the next ten years
after the outbreak of the Lutheran trouble Humanism in
Paris had to fight a hard battle against prejudice and
calumny and opposition. It was not till the year 1529
that Budé and his cause triumphed with the foundation of
the Royal Professorships.

CHAPTER X

FRENCH POETRY AND PROSE

I

In a previous chapter I briefly referred to the last efflorescence of French mediaeval literature, which, beginning with the return to France of Charles d'Orléans in 1440, ended in 1462 with the last poems of François Villon. Of the other writers who contributed to the comparative brilliance of this final display nearly all disappear from our view in the year in which Louis XI ascended the throne (1461). This is the last year in which we hear of Antoine de La Sale and the brothers Greban. It was in this year that Martin Lefranc made his will, probably dying soon afterwards. The death of Charles d'Orléans followed in 1465 and of Georges Chastellain in 1475. Martial d'Auvergne alone survived all his contemporaries and died a very old man in 1508.

Of these men I pointed out that Georges Chastellain shewed himself on the whole to be the truest precursor of the Renaissance spirit, partly because he recognised the importance of dignity and sustained utterance in literary style, and partly by reason of his observant curiosity and his clear comprehension of men and events[1]. Unfortunately the work in which these qualities were most fully displayed, his *Chronique*, was hardly known to his contemporaries and successors except by reputation. As is so often the case, it was his defects rather than his merits that were copied and exaggerated by those who professed to be his disciples.

[1] See above, p. 76.

The schools and *cénacles* which from time to time have played so conspicuous a part in French literature have no doubt produced much that is puerile and grotesque. But no school or *cénacle* was ever so foolish, so dull, or so pretentious, as that school of the *grands rhétoriqueurs*, which for more than sixty years dominated French literature. It was on poetry that its effect was the most desolating, and well may Petit de Julleville exclaim, "Du *Grand Testament* aux premières *Épîtres* (of Marot) quelle pauvreté! quel désert!" Already, at the opening of the fifteenth century French poetry was suffering from the abuse of allegory, and from the over-cultivation of fixed forms of verse. The delicate talent of Charles d'Orléans was cramped by both these fashions. Alone the genius of Villon avoided the allegorical whirlpool by steering clear of court poetry, while he triumphed over the fixed form of verse by making it his servant instead of his master. On the top of these two symptoms of disease Chastellain in his verse developed a third, that of bombast and over-emphasis.

These were the three symptoms which shewed that French mediaeval literature, and especially poetry, was sinking into a final decline. Of the first, the abuse of allegory and the treatment of abstractions as living personages, one can have no better instances than Octovien de Saint-Gelais's *Séjour d'Honneur* and André de La Vigne's *La Ressource de la Chrestienté*, both completed in the year 1494. As M. Guy points out, *Les uns et les autres* of the former poem have a worthy companion in *Je ne sais qui* of the latter. The second symptom, which in its first stage had appeared merely as a too exclusive devotion to fixed forms of verse like the *rondeau*, the *ballade* and the *chant-royal*, now assumed a far more alarming aspect. The merit of a poem now chiefly consisted in the successful accomplishment of metrical feats. *Rimes annexées, rimes couronnées, rimes enchaînées, rimes batelées, rimes équivoques*, these and other examples of metrical jugglery[1] degraded poets to the

[1] See for examples L. E. Kastner, *A History of French Versification*, Oxford, 1903, pp. 57 ff. See also E. Langlois, *Recueil des arts de second*

level of acrobats, and served to conceal their inherent poverty of thought and expression[1]. The third symptom, the love of bombast and emphasis, was, except in the case of Chastellain, more apparent in prose than verse.

These symptoms, which chiefly disfigured the poets of the *rhétoriqueur* school, all point to the general malady from which the whole of French poetry, whether that of the *rhétoriqueurs*, or that of a more popular character, was suffering. It was hopelessly prosaic, and it cultivated these artificialities and puerilities as the only means known to it of making prose look like poetry. In the more homely kinds of verse, in farce, and satire, and didactic poetry, there was less affectation and greater vigour. But whenever writers attempted a higher flight, their failure was ignominious and grotesque.

To make a comprehensive survey of French literature during our period is no part of my intention. It has been done for poetry in a thoroughly competent fashion by M. Guy in the first volume of his *Histoire de la poésie française au XVIᵉ siècle*[1]. His condemnation of the *rhétoriqueurs* as a school is not a whit too severe, and so far as the individual poets share in the faults of that school they deserve the same condemnation. With some, however, he might have dealt more mercifully. Amid the arid reaches of their dull and pretentious verse we come here and there upon natural and graceful lines, blossoming like flowers in the desert. But my task is not to rectify M. Guy's judgments or to search for literary merit in forgotten writers, but simply to

rhétorique (Collection des documents inédits), 1502. His collection includes an *Art de rhétorique* which was first printed in the last decade of the fifteenth century (acc. to Pelléchet, I. 1376, 1490 (?); acc. to Brunet *circ.* 1500). There is an inferior text in vol. III. of *Recueil de poésies françoises des XVᵉ et XVIᵉ siècle*, edd. A. de Montaiglon and J. de Rothschild. Another *Art de rhétorique* has been reproduced in facsimile by the Société des Anciens Textes Français, 1910, from the first edition printed for Verard *circ.* 1501 (*Le Jardin de Plaisance et Fleur de Rethorique*, pp. a 11 vᵒ–c 11 rᵒ).

In fairness to the *rhétoriqueurs* we ought not to forget that some of them rendered real service to the technique of French versification. (See P. Laumonier, *Ronsard, poète lyrique*, p. 644.)

[1] *L'École des Rhétoriqueurs*, 1910.

look at the literature generally in its relations to the
Renaissance and to see what signs of its influence can be
detected in its pages.

M. Guy recognises one virtue in the *rhétoriqueurs.*
"These ridiculous versifiers," he says, "prepared the way
for the Renaissance." For "they loved antiquity with
passion, and in their eyes every Greek or Latin book was
a second Bible[1]." But it is doubtful whether even this
virtue can be allowed them. It is true that "they loved
antiquity with passion," but they loved it ignorantly and
superstitiously. Poets and prose-writers had no more
intelligent comprehension of it in 1500 than they had in
1450. Some of them, indeed, knew Latin fairly well, but
a knowledge of Latin by no means implies that they were
touched by any breath from the Renaissance spirit. We
can see this by the example of our own Alexander Barclay,
who was a contemporary of Cretin's, both having been born
about 1475. He knew Latin well, translated Sallust's *Bellum
Jugurthinum,* and wrote English *Eclogues,* borrowing the
form from Baptista Mantuanus, and the substance from
that writer and Aeneas Sylvius. But "as a scholar he
represented mediaeval rather than renascence ideals," and
in *The Ship of Fools* "in spite of his learning, his point of
view is entirely mediaeval[2]." Even John Skelton, who was
some fifteen years older than Barclay, "whose knowledge
of classical literature, particularly Latin, must have been
very extensive," and who translated Cicero's *Familiar
Letters* and Diodorus Siculus, the latter from Poggio's
Latin version, shews no trace of classical influences in
his poetry[3].

With these examples before us we need not be surprised
if we find that among the *rhétoriqueurs* a knowledge of
Latin is no infallible sign of the Renaissance spirit. For
instance, Jean Molinet, who succeeded Chastellain in 1475,

[1] Guy, *op. cit.* p. 381.

[2] A. Koelbing in *The Cambridge History of English Literature,* III. c. iv.
(Cambridge, 1909). See also J. M. Berdan in the *Modern Language Review,*
VIII. 289 ff.

[3] A. Koelbing, *ibid.*

not only as historiographer to the Duke of Burgundy but also as the recognised head of the *rhétoriqueur* school, was a student at the University of Paris, held the post of secretary and registrar at the College of Cardinal Lemoine, and knew Latin, as they knew it in those days, well. But he is mediaeval to the marrow of his bones, and his knowledge of Latin is only betrayed by his love of adjectives tastelessly coined from that language[1].

But Molinet was an old man in 1495—he was born in 1435—and we are more likely to find traces of the Renaissance spirit among the younger members of his school. Shall we find them in André de La Vigne who accompanied Charles VIII to Italy and who after his death became secretary to Anne of Brittany? But we have already seen from his *Vergier d'Honneur*, that humble chronicle of the Italian expedition, how trivial were the impressions which Italy made upon him. Then there is Jean Marot, the father of Clément Marot, who became secretary to Anne of Brittany in 1506, and who in his turn wrote versified chronicles of the French successes in Italy, *Voyage de Gênes* and *Voyage de Venise*. He makes no pretence at being a Latin scholar—*clerc ne suis*—and from the point of view of the Renaissance he is of no more account than André de La Vigne. He is, in fact, a typical mediaeval poet; how typical, may be judged from the long poem on the favourite subject of the merits of the fair sex which he presented to Anne of Brittany in 1506 soon after his appointment as her secretary. Marot, writing for his august patroness, naturally took the side of women, and his poem is entitled *La vray disant Advocate des Dames*. It is written, like his *Voyages*, in a great variety of metres, and includes a *rondeau*, a *chant-royal*, a *rebus de Picardie*, and a ballad in the form of an acrostic, of which the first letters of each line make "Anne de Bretagne, royne de France." Allegory is employed with moderation, but we meet with *Jalousie, Male Bouche, Faux Semblant* and *Faux Rapport*. There are some very occasional scraps of Latin

[1] See Guy, *op. cit.* pp. 158 ff.
[2] *Recueil*, x. 225 ff.

from the Psalms and other obvious sources. The knowledge that is displayed of classical history and antiquity is of the most superficial kind. It consists solely of bare references to Caesar, Hector, Jason and Medea, Hercules, Penelope, Lucretia, Tomyris, who is travestied as Thanaris, Penthesilea the queen of the Amazons, who appears as Panthasitée, and the two historians, Valerius Maximus and Orosius, both of whom existed in French translations.

Another *rhétoriqueur* who followed Louis XII to Italy was Jean d'Auton, *grand orateur*, according to his friend Jean Bouchet, *tant en prose qu'en rime*. His prose is not nearly so bad as his verse, but his impressions of Milan and Genoa shew that he had as little appreciation of the Renaissance as Andre de La Vigne or Jean Marot[1]. The same must be said of Pierre Gringore, another supporter of the Italian policy of Louis XII. Whatever his merits as a dramatist, the author of *Le jeu du prince des Sotz et mere Sotte* is purely mediaeval in his outlook and his sympathies. Bourgeois, practical, opportunist, constant to his device of Raison Par Tout, he had no feeling for nature or art or for any manifestation of the ideal. He knew enough Latin to translate or rather paraphrase, often incorrectly, the *Hours of Notre Dame*, but he had no deeper knowledge of Latin history and literature than the great majority of his contemporaries[2]. His non-dramatic poems, which were highly popular when they first appeared, are thoroughly representative of the literature of his day. Excluding the purely political poems, allegory is represented by *Le Chasteau de labour* (1499), the most popular of all his poems, satire by *Les folles entreprises* (1505) and *Les Abus du Monde* (1509), didactic poetry by *La complaincte de trop tard marié*, written towards the end of the reign of Louis XII[3]. In *Les folles entreprises* Gringore, in order to give an air of learning to his work, has inserted

[1] Charles Oulmont, *Pierre Gringore*, 1911. He takes a much more favourable view of Gringore than M. Guy (*op. cit.* pp. 278 ff.).

[2] Oulmont, pp. 68–70.

[3] An English version of this is printed by J. P. Collier in his *Illustrations to Early English Popular Literature*, vol. I. 1863.

in the margin quotations, often incorrect, from various
Latin writings. One may accept without hesitation M.
Oulmont's opinion that, so far as the classical authors are
concerned, the quotations are taken not from the authors
themselves, but from some easily accessible arsenal. But
they have an interest for us, by reason that they throw some
light on the relative popularity of the authors cited. Ovid
easily heads the list. He is followed by Seneca, Juvenal,
Virgil, Cicero, Horace, and Terence (who is cited five times)
in the above order. Suetonius and Sallust are cited twice,
Vegetius, Ennius, Propertius, Lucan, and Claudian only once.
There are four quotations from Aristotle, and three from
Hesiod. There are also five from Baptista Mantuanus, and
one from Fausto Andrelini, which may possibly be the result
of Gringore's own reading[1].

Jean Bouchet, the respectable Poitiers attorney who,
except during the years 1497 to 1507[2], spent his whole life
in his native town, belongs just as little to the Renaissance
as the writers already mentioned. Though he did not die
till between 1557 and 1559—he was born in 1476—he
remained obstinately faithful to the literary traditions of
his youth. He was neither a fool nor an ignoramus—his
Annales d'Aquitaine (1524), are not wholly without merit—
but in the intervals of business he wrote reams of dull verse
without the slightest glimmering of what constitutes the
difference between prose and poetry. In one of his rhymed
Epistles he calculates that in thirty years he has been able
to dedicate 10,950 hours to Dame Rhetoric. *Il y a de
quoi frémir*, says M. Guy, who has had to read the result of
these communings with the Muse, but after all it only
represents just an hour a day[3].

[1] *Œuvres complètes*, ed. Ch. d'Héricault and A. de Montaiglon, 2 vols.
1858–1877 (Bib. Elzévir.), I. 1–144. This edition was never completed.

[2] He was at Lyons in 1497, when he offered his poems to Charles VIII.
In that year he entered the service of Florimond Robertet and went to
Paris, where he remained continuously till about 1504. He settled finally
at Poitiers in 1507.

[3] Guy, *op. cit.* p. 301 and, for Bouchet generally, pp. 298–314; see also
A. Hamon, *Un grand rhétoriqueur poitevin; Jean Bouchet*, 1901.

Guillaume Du Bois *dit* Cretin (?1472–1525), though very little of his work was printed in his lifetime, had a great contemporary reputation, and on the death of Molinet (1507), if not before, he was regarded as the head of the *rhétoriqueur* school[1]. It was his deft juggling with rhymes, and especially with punning rhymes, which roused the admiration of his contemporaries. He was less given to moralising than most of the *rhétoriqueurs*, and his language is simple and unaffected. Unfortunately it is also unutterably prosaic. This, as we have seen, was the fatal malady from which the whole poetry of the period was suffering; only, in the case of most of the poets, it is disguised under an artificial mask of stilted and allegorical language. Cretin, apart from his ridiculous rhymes, was a simple soul, and his poetical baggage consists of the ordinary *rondeaux, ballades, chants-royaux*, and *épîtres* of the mediaeval poet. It also includes a *déploration* on the musician Okeghem, and, what is more interesting for our purpose, a species of Eclogue which takes the form of an interchange of song between Gallus and Galathée, but in which these Virgilian names, together with those of Damon and Menalcas, appear side by side with the mediaeval ones of Franc Gontier and Hélène[2]. This poem however, in which Cretin may be said to represent the transition between Mediaeval and Renaissance literature, was not written till 1517, its occasion being the birth of the Dauphin. Like the majority of the *rhétoriqueurs*, he aspired to be a historian as well as a poet, and he began in 1515 a rhymed *Chronique* or history of France, which he carried down to the accession of Hugh Capet. It was continued after his death but was never printed. It shews very little knowledge of Roman history, and only a slight acquaintance with Latin classical authors, its chief humanistic feature being the introduction of

[1] In 1504 Lemaire de Belges calls him *chef et monarque de la rhétorique*. See for Cretin generally, Guy, *op. cit.* and in *Rev. d'hist. litt.* x. 553 ff.

[2] A short poem of the fourteenth century called *Les dits de Franc Gontier*, by Philippe de Vitry, Bishop of Meaux, gave rise to a mass of pastoral literature about Franc Gontier and his *compagne* Hélène, which provoked Villon's well-known *ballade* of *Contredictz de Franc Gontier*.

speeches[1]. On the strength of it, however, Cretin had a considerable reputation for learning among his contemporaries.

Of Octovien de Saint-Gelais[2], who died in 1502 at the early age of thirty-four, M. Guy says that it is right that he should "have seen the dawn of the sixteenth century, for by some traits of his character he seems really to belong to it." The scion of an ancient family of the Angoumois, he went as a boy to Paris and was a student of the College of Sainte-Barbe when it was under the highly successful rule of Magister Martinus[3]. At the age of twenty-five he was thrust upon the unwilling Chapter of Angoulême, which had already elected one of its own canons, as the successor in the see to Robert de Luxembourg. In 1494 he put the finishing touches to a long allegorical poem, *Le séjour d'honneur*, which he hoped would confer on him immortality, and which, interspersed here and there among the cold and faded abstractions of the *Roman de la Rose*, contains a few natural and graceful passages[4]. In this poem he is purely mediaeval, but the choice of his next work shews that he was at any rate conscious of the incoming tide of Humanism. To please his patroness, Louise of Savoy,—perhaps also to please himself—he made a translation of Ovid's *Heroides*. Completed in 1497[5] with a dedication to Charles VIII, and printed for Verard in 1500, it was one of the most successful works of the period, going through fifteen editions before 1550. It was followed by a translation of the *Aeneid*, which was offered to Louis XII in 1500, and published by Verard in 1510[6]. A translation of

[1] See Guy in *Rev. des langues romanes*, 1904, 385 ff.; 1905, 324 ff. 530 ff. for an analysis and extracts.

[2] Guy, *op. cit.* pp. 135 ff.; Maulde La Clavière, *Louise de Savoie et François I^er*, pp. 39–56; L'Abbé H.-J. Molinier, *Essai biographique et littéraire sur Octovien de Saint-Gelays*, Rodez, 1910.

[3] See above, p. 235.

[4] See Guy in *Rev. d'hist. litt.* xv. (1908), 193 ff. The poem was published by Verard in 1499.

[5] There seems no reason for following Paulin Paris's view that the date of February 16, 149$\frac{6}{7}$, which is given in one of the MSS. of the translation, is that of the transcription and not of the composition.

[6] April 6, 15$\frac{0}{10}$.

Terence in prose and verse, printed for the same publisher between 1500 and 1503, is also generally assigned to him, at least as regards the verse part of it. As for certain books of the *Odyssey*, which according to the general testimony of the older historians of French poetry he rendered into verse, they have completely disappeared[1]. If the quality of the translation was on a level with that of the *Aeneid*, the world has suffered no loss. For nothing shews more clearly how little Octovien de Saint-Gelais was capable of appreciating the style of the great classics than his version of Rome's masterpiece, which opens as follows:

> Je chante icy les horribles faicts d'armes.
> Je chante icy le premier des gendarmes[2].

The fact is that the Renaissance touched him, not as a spiritual awakening, but merely as the breeze of a new fashion. His own personal note is akin to that of Charles d'Orléans, a graceful and direct simplicity with a touch of melancholy. But he was hardly any nearer to a real understanding of classical literature than the writers of the days of Charles VII. In choosing the *Aeneid* and the *Heroides* for translation he selected two works which had been popular in France throughout the Middle Ages, and which from the twelfth century onwards had, together with the *Metamorphoses* and the *Ars amandi*, exercised an immense influence on French poetry[3]. If he did good service by introducing them to a wider circle of readers, on the other hand by the prosaic and almost burlesque character of his translations he gave a very unfaithful idea of the true classical spirit[4].

II

At last we come to a writer who, alike in his temperament, his tastes, and his writings, shews unmistakeably the influence

[1] See Molinier, *op. cit.* 239–244.

[2] *Gendarme* is used by Ronsard in the sense of a warrior.

[3] See W. P. Ker, *English Literature (Medieval)*, pp. 95–98.

[4] Henri Baude (*circ.* 1430–*circ.* 1495) and Guillaume Coquillart (1421–1510) are purely mediaeval poets. Moreover most of Coquillart's literary work was done between 1477 and 1482.

of the Renaissance. Jean Lemaire de Belges[1] was a native of Belges or Bavai[2] in Hainault, a town which, as the meeting place of four main roads, had been of some importance in Roman times under the name of Bagacum Nerviorum, but which in Lemaire's day was already deserted and decayed, with nothing but the remains of a circus and an amphitheatre to testify to its former greatness. He was born in 1472 or 1473—he speaks of himself as being twenty-seven in 1500[3]—and was therefore four or five years younger than Octovien de Saint-Gelais, and almost exactly contemporary with Guillaume Cretin. He had an influential relation in Jean Molinet, the historiographer to the Court of Burgundy, and it was under his guardianship, probably at Valenciennes, that his boyhood was spent. He was destined for the Church and he received the tonsure from Henry of Bergen, Bishop of Cambrai, with whom Erasmus lived five years as secretary. It was doubtless Molinet who sent him to study at the University of Paris[4]. But the first definite date in his career is the year 1498, when we find him established at Villefranche, the capital of the Beaujolais, as a clerk in the treasury of Pierre de Beaujeu. Villefranche being only

[1] *Œuvres*, ed. J. Stecher, 4 vols. Louvain, 1882–1891. This edition is nearly complete, but it is badly arranged, and the text, which is based on the edition of 1549, has no pretentions to be a critical one. By far the best account of his life and writings is P. A. Becker, *Jean Lemaire, Der erste humanistische Dichter Frankreichs*, Strassburg, 1893 (trustworthy, appreciative, and discriminating). The same writer gives some supplemental information in *Zeitschrift für romanischen Philologie*, XIX. 254 ff. and 542 ff. See also Pinchart, *Les Œuvres de Jean Lemaire au point de vue de l'histoire artistique*, Brussels, 1866; F. Thibaut, *Marguerite d'Autriche et Jehan Lemaire de Belges*, 1888; Guy, *op. cit.* pp. 174–206; P. Laumonier, *Ronsard, poète lyrique*, 1909, pp. 647–652; C. H. Conrad Wright, *A History of French Literature*, New York, 1912, pp. 146–149 (an appreciative notice, which shews that Lemaire's importance is at last recognised).

[2] Between Mauberge and Valenciennes, 9 miles from the former, and 14 from the latter; 15 miles south-west of Mons.

[3] Prologue to bk 1. of *Les Illustrations de Gaule*.

[4] *Mere et maitresse des estudes de tout le monde plus que jadis nulles Athenes ne nulles Rommes. Delaquelle jay principallement suce tout le temps (combien que peu) du laict de litterature qui vivefie mon esprit* (*Les Illustrations de Gaule*, 1. cxvi).

twenty miles from Lyons, he was brought into relation
with the literary and artistic circle of that city. He became
friends with the literary physician, Symphorien Champier[1],
and with the distinguished painter, Jean Perréal. It was at
Villefranche too that he made the acquaintance of Guillaume
Cretin, to whose persuasion he says it was due that he
embarked on a literary career[2]. His first work of any
importance was called forth by the death of his patron,
Pierre de Beaujeu (October 10, 1503). It was printed at
Paris in 1504 under the title of *Le temple d'honneur et de
vertus*, and Lemaire describes himself on the title-page as
disciple de Molinet[3]. Cretin provided a commendatory poem.
The allegorical form of the work, which is partly in verse
and partly in prose, proclaims the author's connexion with
the *rhétoriqueur* school. There is also a large infusion of the
pastoral element, and it is to be noted that the names of
all the seven shepherds and shepherdesses who take part in
the proceedings, with the single exception of Argus, are to be
found in Virgil's *Eclogues*[4]. From the poetical point of view
the chief merit lies in the musical character of the verse and
the easy skill with which Lemaire performs the metrical feats
incumbent upon every true *rhétoriqueur*. And though he
occasionally indulges, as in the song of Meliboeus, in a mere
acrobatic display, his efforts as a rule are controlled by good
taste and a true poetical sense. Here is a good example of
a combination of the *rime batelée* with the *rime renforcée*
from the song of Amyntas:

> Pan a manteau de couleur purpurine
> Fort riche et digne ainsi quun corps celeste,
> Tout parseme de mainte estoille fine
> Noble et insigne. Et par grace divine
> Tient en saisine une riche holette.
> Sur lherbelette est mainte brebisette
> Qui na disette en son parc plantureux:
> Pan est le dieu des bergers bien eureux[5].

[1] See above, pp. 315–316. [2] *Œuvres*, II. 255.
[3] Printed by Michel Le Noir [4] See *Eclogues*, I. v. and VI.
[5] *Œuvres*, IV. 197.

A noticeable feature is the use of *terza rima*, which Lemaire in a later poem claims to have been the first to introduce into French poetry[1]. By the advice of Jean Perréal Lemaire presented his work, while it was still in manuscript, to Louis de Luxembourg, Comte de Ligny, who happened to be at Lyons, with the request that he would bring it to the notice of the Duchess of Bourbon[2]. Ligny gave him a friendly reception, and took him into his own service[3], but he was suffering from a mortal illness, of which he died a few days later (December 31, 1503).

It was the occasion for a new poem, and the theme was more inspiring than the death of Pierre de Beaujeu. For Ligny was a man of great promise, cut off at the early age of thirty-five. He had distinguished himself in the Italian campaigns, and was well known as a lover of art and literature[4]. The plan of the poem, which was entitled *La plainte du desire*[5], is ingenious but simple. The poet described how one December day he was awoken by a sound of loud weeping, and how he beheld Dame Nature speechless from grief, with her two most trusted handmaids, Painting and Rhetoric, dissolved in tears by her side. Each in turn takes up her parable and calls on her nurslings to comfort Nature with the help of their art. The execution of the poem shews a decided advance on that of the preceding one. Not only is it inspired by more real feeling, but the movement of the verse is less monotonous, and better suited to the

[1] *La premiere* [partie] *contiendra la description du temple de Venus. Et sera rhythmée de vers tiercets à la façon Italienne ou Toscane et Florentine. Ce qui nul autre de nostre langue Gallicane ha encores attente d'ensuivre, au moins que je sache* (Prologue to *La Concorde des deux langages*). As a matter of fact *terza rima* had been employed by Adam de la Halle in his *Le Jeu de la feuillée*, and by Rutebeuf in his *Mariage* (Faguet, *Seizième siècle*, p. 274). [2] The work was dedicated to her.

[3] *Il me retint entre ses plus privez et secretz domestiques.* See Becker, *op. cit.* p. 29, n. 1.

[4] See above, p. 128; Becker, *op. cit.* pp. 29, 30.

[5] *La plainte du desire. Cestadire la deploration du trespas de feu monseigneur Loys de Luxembourg.* Printed with *La legende des Venitiens* at Lyons [1509] (see J. Babelon, *La bibliothèque française de Fernand Colomb*, no. 106 in *Rev. des bibliothèques*, Supp. x. 1913). *Œuvres*, III. 157–187.

subject. The tone is not merely graceful but at times eloquent and impressive. A passage from the speech of Peinture may serve as a specimen:

> Faites broyer sur vos polis porphyres
> Couleurs duisans a mon intention:
> Toutes de noir et de diverses tires,
> Pour exprimer les douleureux martyres
> Que Nature ha per grieve infection.
> Faites mesler paste carnation.
> Ne destrempez que noir de flambe ou bistre:
> C'est la couleur qui de deuil est ministre.
>
> Laissez a part synople[1], et azur d'acre,
> Lacque, verdgay, toutes hautes couleurs:
> Gardez les bien, pour quelque image sacre,
> Pour estoffer statue, ou simulacre,
> Qui soit de prys, et de riche valeur,
> Icy ne faut que touches de douleur:
> Car d'or moulu Nature ne se pare
> Quand quelque grief de ioye la separe.
>
> Voyez la bien, et remarchez[2] son estre:
> Notez son œil couvert dun sourcil triste:
> Que ne bransle a dextre ne a senestre,
> Dessus son pis[3] ne bouge sa main dextre,
> En regardant le defunct en son giste.
> Bien est il vray que les souspirs vont viste:
> Mais plus ne sont les levres coralines,
> Veu qu'elle ha tant d'angoisses si malines.
>
> Ne peignez point Nature rubiconde,
> Mais toute ombreuse, et pleine de soucy:
> Ne la monstrez fertile ne faconde,
> Mais tout ainsi que povre, et vereconde,
> Quand elle void son fruit mort, et transi,
> Son noble fruit qu'elle avait fait, ainsi
> Comme un miracle en humain personnage,
> Et mort la prins en la fleur de son aage[4].

Of special interest are the two stanzas in which Peinture calls upon the living painters of renown to come to the assistance of Nature.

[1] Green.
[2] =remarquez.
[3] breast.
[4] Œuvres, III. 162–163.

Toy Leonard, qui as graces supernes,
Gentil Bellin, dont les loz sont eternes.
Et Perusin, qui si bien couleurs mesle:
Et toy, Jean Hay, ta noble main chomme elle?
Vien voir Nature avec Jean de Paris
Pour luy donner ombrage et esprits.

These, she says, have attained even greater renown than
Simon Marmion of Valenciennes[1] or Jean Fouquet, "qui
tant eut gloires siennes," or Jean Poyet, or Roger, or Hugo
of Ghent, or Jan van Eyck. It will be noticed that for
living painters Lemaire turns first to the great Italians,
Leonardo, Perugino, and Gentile Bellini[2], and that the only
names which he adds to these are those of Jean Hay[3], a
Fleming, and his friend Jean de Paris, otherwise Jean Perréal.

Next it is the turn of Rhetoric, as Poetry was called by
the *rhétoriqueurs*. She regrets the loss of the great elegiac
poets of old, of Virgil[4], Catullus, Alain Chartier, Jacques
Millet, and Simon Greban, and, of those who had died more
recently, Jean Robertet[5], and Octovien de Saint-Gelais.

Pleurant son Roy, plus cher que nul antique.

But, she adds, there are still left Molinet and Cretin and
Jean Danton (d'Auton), and a second Robertet[6], and these
she summons "to assist their humble friend Jean Lemaire"
with lamentations. Finally she turns to the musicians,
Josquin des Prez, Alexander Agricola, and other pupils of
Okeghem, and bids them help with their compositions[7].

After the death of the Comte de Ligny, Lemaire found
a new patron in Margaret of Austria, daughter of the
Emperor Maximilian and Mary of Burgundy, and wife

[1] The miniature painter.

[2] Gentile Bellini died in 1507, not in 1501 as Becker (p. 33, n.[1]) says.

[3] Jean Hay or Hey, as we now know from an Ecce Homo dated 1494
and signed, was a *pictor teutonicus* (F. de Mély, *Rev. archéologique*, 1911,
pp. 315–319).

[4] Two elegies on the death of Maecenas, discovered in the thirteenth
century, were supposed to be by Virgil.

[5] Wrote *Complainte de la mort de maistre George Chastellain*.

[6] Probably François Robertet.

[7] Okeghem and Josquin or Jost des Prez were, like Lemaire, natives of
Bavai.

of Philibert, Duke of Savoy, in whose service he remained
for eight years. Once more his first literary task was to
compose a memorial elegy, for Philibert died in the following
September (1504). *La Couronne Margaritique*, partly in
verse and partly in prose, is one of the most ambitious of
Lemaire's works, but it is also the one in which his natural
grace and simplicity are most overburdened by the pedantry
and artificiality of his school[1]. On the other hand, the death
of the Duchess's favourite parrot at her château of Pont
d'Ain, where she had resided since her husband's death, was
the occasion for one of his most successful poems, *L'Epistre
de l'amant vert*, in which he gives full rein to his sportive
humour and talent for description[2]. Written in 1505, it
had a great success while still in manuscript, and definitely
established its author's fame. In the following year he was
sent by his patroness to Rome on business connected with
her great memorial church at Brou.

In March, 1507, Margaret was appointed by her father
Governor of the Netherlands, and Lemaire followed her
from Savoy to the Low Countries, where she rewarded
him with a prebend at Valenciennes. In the same year
he succeeded Molinet, who died in August, as historio-
grapher to the house of Austria, Castile, and Burgundy.
In the summer of the following year (1508) he paid a second
visit to Rome, remaining there for some six months. In
July 1509 he was entrusted by the city of Lyons with the
task of organising the entry of Louis XII on his return from
Italy[3]. While he was superintending the preparations, he
gave another proof of his versatility by publishing a political
pamphlet entitled *La Légende des Vénitiens*, in which he
supported the joint cause of the German Emperor and
the French King by a detailed exposure of all the crimes
committed by the Venetian Republic since the days of

[1] It was not printed till 1549. *Œuvres*, IV. 15 ff.

[2] *Œuvres*, III. 3–16. Printed with a second epistle (*ib.* 17–37), written
in 1509 or 1510 as a sequel to the first book of *Les Illustrations de Gaule*,
Lyons [1510]. The two epistles were dedicated to Jean Perréal.

[3] Jean Perréal, who had for some years organised the various entries
into Lyons, was now in Italy with Louis XII.

Charlemagne[1]. Two years later he gave similar assistance to Louis XII by attacking Julius II and the Papacy in general in a pamphlet entitled *On the difference between schisms and councils*[2]. It was hurriedly written and of no great merit, but the bitterness and outspokenness of its tone made it highly popular. Six thousand copies were sold within a year. It is as the adversary of the Papacy that Lemaire figures in Rabelais's nether world, where he is represented as personating the Pope and making the poor Kings and Popes kiss his feet[3].

The publication of *La Légende des Vénitiens* was shortly followed by that of the First Book of Lemaire's most important prose work, *Les Illustrations de Gaule et Singularitez de Troye*, upon which he had been engaged for ten years[4]. But he had not abandoned poetry, for in the following year (1511) he completed the work which perhaps represents the high-water mark of his poetical genius, and which at any rate is of peculiar interest to us as shewing to what extent he was penetrated by the spirit of the Renaissance, and what were his views as to the literary and artistic relations between France and Italy. *La concorde des deux langages*[5]— so was the piece entitled—is partly in prose and partly in verse, the prose, as is usual with Lemaire, serving as a framework to the verse. The author represents himself as overhearing a dispute between two persons as to the relative superiority of the two languages, French and Tuscan. The one puts forward Jean de Meung, Froissart, Alain Chartier, the two Grebans, Millet, Georges Chastellain, "and others whose memory is, and long will be, on the lips of men, not to mention those who are still living and

[1] Printed at Lyons by Jean de Vingle. The dedication is dated August 12, 1509. *Œuvres*, III. 361 ff.

[2] *La traictie intitule de la difference des scismes et des concilles*, Lyons, Estienne Baland, May 1511; Paris, G. de Marnef, January 1512. It was dedicated to Louis XII. *Œuvres*, III. 231 ff.

[3] *Pantagruel*, I. c. 30.

[4] Lyons, Estienne Baland [1510].

[5] Printed in *Lepistre du Roy a Hector de Troye. Et aucunes aultres œuvres Assez dignes de veoir*, G. de Marnef, August 1513; F. Regnault, 1528.

flourishing, of whom Master Guillaume Cretin is the prince."
The Italian champions are Dante, Petrarch, Boccaccio
Filelfo, and Serafino. The appearance of the last two in
such company is surprising, but I have already pointed out
in an earlier chapter how highly Serafino was esteemed in
France. As for Filelfo, who wrote no vernacular poetry, his
poetical fame rested solely on his Latin verse.

The disputants then turn to the poet and request him to
put on paper a record of their friendly controversy (*le
tumulte amoureux de leur debat*), and to suggest how they may
come to some agreement. He readily accepts the task, being
a lover of the French language, and also for the reason that
many Frenchmen at that time delighted in the practice of
the Tuscan speech and that the Italians paid the same
honour to that of France. Further he is moved by a desire
to bring about a perpetual peace and union between the two
nations. But this cannot be effected in the temple of
Venus, who is too great a friend of Mars, the god of battles,
but rather in that of Minerva, the goddess of prudence, peace,
and concord. Then follows a description of the two Temples,
that of the Temple of Venus being written in *terza rima*, and
that of the Temple of Minerva partly in prose and partly
in Alexandrine verse. These descriptions form the main
portion of the work, but the connecting narrative which tells
how the poet visited the Temple of Venus in his youth, and
how he is now striving to be worthy of admission to the
Temple of Minerva, the goddess of study and learning, of
virtue and peace, must not be lost sight of.

It is a little unfortunate that, this being our poet's
virtuous and laudable aim, the description of the Temples
of Venus should be not only three times as long as that of
the Temple of Minerva, but also superior to it in execution.
Lemaire handles the decasyllabic *terza rima* with much greater
effect than the Alexandrine, and he appears to be more at his
ease in the pleasant courts of Venus than in the austere pre-
cincts of her rival. The description of the Temple, and above
all the sermon of the Archpriest Genius, with its insistence on
the theme that youth is the season for love, is inspired by

the Renaissance in its most pagan mood. But the allegory
does not end here. The poet is driven out of this pleasant
temple, and after long wanderings over land and sea comes
to a vast desert, from which rises a lofty rock reaching to
the clouds. Upon its summit stands the Temple of Minerva,
where, according to an inscription, "many a noble spirit
contemplates the virtuous achievements of chronicle and
history, of moral science and oratorical art, and where the
Tuscan and the French languages dwell together in peace
and harmony." The inscription is carved on the northern
face of the rock, where, in a shady hollow, the parched
traveller quenches his thirst from cooling streams. "The
place is called labour and study and diligence," and here
the pilgrim to the Temple of Minerva must wait till Honour,
the just awarder of riches and virtues, comes to guide him.
The poet here falls into a deep sleep, and sees in a vision an
old man with a long white beard, whom he recognises as
Labeur historien. From him he learns that the inscription
was written by Jean de Meung, "who was the first to bring
fame to our language just as Dante did to Tuscan." Finally
the old man promises him two heavenly guides, Repose and
Reward, who will lead him to the desired vision of the
Concord of the two languages.

Meanwhile Repose, at any rate, did not come to Lemaire's
assistance. Since the year 1509 he had been entrusted by
Margaret of Austria with the superintendence of the proposed
Church and monuments at Brou, and in connexion with this
work he had been in active correspondence with Jean
Perréal and Michel Colombe. In the late autumn of 1511
he went to Tours to visit the latter artist, stopping on the
way at Blois, where he found the French court. There he
wrote a poem entitled *Lepistre du Roy a Hector de Troye*[1],
which was supposed to be an answer to Jean d'Auton's
Lepistre du preux Hector au roy Lous XII. Its poetical
merit is slight, but it served to draw its author still nearer
to the French court. In 1512 he entered the service of
Anne of Brittany as *indiciarius* and historiographer, perhaps

[1] See above, p. 340, n.[5].

in the hope of finding that repose for which he yearned. This act naturally gave umbrage to Margaret of Austria, who had always regarded France with a jealous eye, and whose father, Maximilian, was preparing to join the league of Julius II. She appointed a new historiographer, and though her wrath was appeased, a letter from Lemaire dated May 14, 1512, in which he asks permission to retain his post as superintendent of the alabaster quarries for the tombs at Brou, is the last, so far as we know, that passed between them.

Shortly before this letter was written the writer had dedicated to Claude de France, the daughter of Louis XII and Anne of Brittany, the Second Book of *Les Illustrations de Gaule*. The printing was finished in August of the same year, and the Third Book, dedicated to the Queen herself, followed in July 1513. Six months later Anne of Brittany died, and in a *Virelai* of some pathos Lemaire deplored the persistency with which death robbed him of his patrons:

> Du bon Bourbon le trespas survenant
> Me fit plourer, et puis tout d'un tenant
> J'ay deploré la perte de Ligny,
> Savoye apres, et Castille[1] plaigny,
> Vecy la suite et le pis avenant,
> Quand il te plait, o haut Altitonant.

With this poem Jean Lemaire disappears from our sight. The date of his death is unknown, but it must certainly have taken place before February 1526, when Galiot Du Pré published a selection from the works of the deceased masters of the *rhétoriqueur* school, in which Lemaire is represented by *Les trois contes de Cupido et d'Atropos*[2]. The first of these is a narrative poem founded on a sonnet of Serafino dall' Aquila, the second is a continuation, purely of Lemaire's invention, and the third is not by him at all, but by some

[1] Philip of Castile, the son of Maximilian, died in September 1506. In the preceding year he had promised Lemaire the succession to Molinet.

[2] Printed February 152⅚; Becker wrongly gives the date as 1525. *Œuvres*, III. 39–55.

unknown poet whose device was *cœur à bon droit*. It was written in 1520, being probably added to the manuscript before it came into Galiot Du Pré's hands[1]. As it is unlikely that the addition was made in Lemaire's lifetime, we may put his death before 1520, and probably Becker is right in supposing that he died soon after 1514.

The first Renaissance characteristic that we notice in Jean Lemaire is his versatility. He is not only a writer of verse and prose, but he superintends important artistic undertakings, organises a royal "entry," and forms part of a mission to the Pope on a matter of ecclesiastical business. The three months in the summer of 1506 which he spent in Italy on the occasion of this mission had a great influence on his development, which was deepened by a second and longer visit two years later. In the libraries of Rome and Venice he collected fresh material for *Les Illustrations de Gaule*, and brought back with him many new books, including works in Italian, which he proposed to translate into French. It was of greater importance that he made himself acquainted with the language of Dante, Petrarch, and Boccaccio, and with the recent publications of the Italian humanists. Above all his love of art and beauty must have guided him to a just appreciation of the masterpieces of Italian painting, sculpture, and architecture. When he visited Venice in 1506, Giorgione was transforming Venetian art with his subtle and sympathetic portraits, and his idyllic scenes in which figures and landscape are fused together in a sensuous harmony. In 1508 Michelangelo was decorating the Sistine Chapel, and a whole army of painters, Perugino, Piero de' Franceschi, Signorelli, and others were at work on various rooms of the Vatican, all to be superseded in this very year by the youthful Raffaelle. Like his contemporary Ariosto, who began his *Orlando Furioso* in 1506 and visited Rome in 1509, like our own Spenser, Lemaire had a strongly sensuous imagination, and he excels in the description of natural scenery and of works of art. Two pictures of

[1] See Becker, *op. cit.* pp. 254–269.

Flora, one in verse and the other in prose, may be taken as
examples.

> Printemps joyeux feit venir cent charrees
> De fueille verde et d'herbette jolie,
> Dont Zephyrus ha les landes parees.
> Puis vint Flora qui son tresor deslie,
> Parestendant ses beaux tapis semez
> De mainte rose, et de mainte ancolie[1].

Car alors Flora la gracieuse nymphe, campaigne de zephyrus
sentremist de tapisser la noble montaigne de fresche verdure et
de plantes aromatiques, et flairans violettes diaprees de maintes
couleurs: dont son mari le gentil zephirus fils de Atreus et de la
belle Aurora lui faisoit fourniture.

Then follows a list of flowers, including the roses and
columbines of the preceding picture[2].

It will be noticed that in the passage written in verse
Lemaire composes his picture not by the accumulation of
details, but by selection and suggestion. He has the true
poetic touch, which makes things visible to the inward eye
of the imagination. It is this quality which distinguishes him
from all his brethren of the *rhétoriqueur* school. It was their
vital defect that they did not know the difference between
prose and poetry. They believed their bare imaginative
statements of fact to be poetry because they were in verse.
Even their ingenious juggling with rhyme and metre did not
avail them, for they lacked the poet's feeling for movement
and music. Now these Lemaire possessed in a high degree.
His verse is always musical, and it nearly always has that
variety of movement, that quickening and slackening of the
pace in response to the underlying emotion which is of the
essence of true poetry, and without which even meritorious
verse becomes wearisome and monotonous.

But while he thoroughly understood the essentials of
verse harmony, he also shewed by his experiments in metre
that he was as good a virtuoso as his fellows. He revived
the use of the Alexandrine and the *terza rima* and in the
words of M. Laumonier "wrote a large number of strophic

[1] *La concorde des deux langages.*
[2] *Les Illustrations de Gaule* (F. Regnault, 1528), 1. c. 29.

poems remarkable for the suppleness and variety of their rythmical structure[1]."

Not that the disciple of Molinet and the friend of Cretin altogether escaped from the *rhétoriqueur* influence. He can condescend to ingenious puerilities, as in *Les Regretz de la Dame infortunee*[2], and he can address Symphorien Champier as

Champier gentil, riche champ, par, entier.

He makes use too of the old allegorical machinery of the *Roman de la Rose*, though in his case it is little more than a framework, and we may say of it, as Hazlitt says of the *Faerie Queene*, that if we do not meddle with the allegory, the allegory will not meddle with us.

It is idle to ask whether Lemaire, if he had lived in a less prosaic age, or had been trained in a less detestable school, would have written great poetry. The fact remains, that charming and artistic though his verse often is, it never rises to actual greatness. He has a lively and sportive imagination, but it does not penetrate to the heart of things; his emotion is marked by delicacy rather than by warmth. Moreover, whether the cause lay in his own temperament or in the tendencies of the age, it was by a prose work that he hoped to immortalise himself, and to confer honour on the French tongue. When in the year 1500, at the age of twenty-seven, he made up his mind to undertake the task of giving a true account of the Trojan heroes and of the descent from them of the great princes of Europe he had written very little verse. It was as a disciple of *Labeur historien* that he proposed to qualify himself for admission to the Temple of Minerva.

This historical aim of his *magnum opus* must not be lost sight of, for, as a matter of fact, there is very little real history in it, and Lemaire excels rather as a story-teller than as a historian. The wonderful genealogies of the early kings of Gaul, from the good prince Noah downwards, rest on the

[1] *Op. cit.* p. 648 and see the following pages for the details. See also Ph. Martinon, *Les Strophes*, 1912, pp. 6–7.

[2] *Œuvres*, III. 187–193.

authority of the forged writings of Berosus and Manetho, recently imposed on a credulous world by Annius of Viterbo (1498)[1]. The rest of the First Book is occupied with the story of Paris, taken chiefly from Ovid's *Heroides*. In the Second Book this merges into the general account of the siege and fall of Troy, the chief authority being Dictys Cretensis, with some help from Dares Phrygius, both of whom were believed by Lemaire and his contemporaries to have lived in the days of the siege.

It is only in the Third Book that we come to the actual history of France, or *Les Illustrations de France Orientale et Occidentale*. This book is divided into three parts, of which the main narrative is occupied with tracing the descent of Pepin the Short, the founder of the Carolingian dynasty, from Francus the son of Hector. In this book Lemaire's leading authorities are more numerous. Among them are his countryman Jacques de Guise[2], from whose Annals of the princes of Hainault he culled the statement that his native Bavai was the capital of a kingdom founded by Bavo, a cousin of Priam; a mysterious unknown author of a Chronicle of Tongres, of which all traces have now disappeared; Juvencus Coelius Calanus, a Hungarian Bishop of the twelfth century, who wrote a life of Attila[3]; Flavio Biondo; the compilers Sabellicus and Raffaelle of Volterra[4]; and the Neapolitan, Michele Ricci[5]. Other Italian humanists who figure in the list of authorities for the earlier books are Pius II, Beroaldo, Landino, Perrotti, Platina, and Marsilio Ficino. French Humanism is represented only by Robert Gaguin. Of classical authors Lemaire gives about twenty-eight Latin names, and sixteen Greek. The latter he knew only through Latin translations, of which he expressly mentions that of Euripides by Erasmus, and that of Homer by Niccolò Valla. Before relating the episode of the combat between Menelaus and Paris he declares his intention of

[1] In his *Antiquitates*.
[2] Died 1399.
[3] Printed at Venice in 1502. The Bishop was a Dalmatian by birth.
[4] See above, pp. 229–230. [5] See above, pp. 180–181.

"translating Homer nearly word for word," but he begins
his account with "Or dit iceluy noble prince des poetes
Grecz mys en latin par Laurens Valle[1]."

Though he depends on a few chief authorities for the
main portions of his narrative, it is evident that he has really
consulted the authors whom he enumerates. The range of
his learning is not inconsiderable for his day, and if he has
no claim to rank with the leading Italian scholars, he com-
pares favourably with the majority of humanists north of
the Alps. Nor was his learning mere pedantry. Frequent
allusions to classical history and mythology in his poetry,
made in a perfectly natural way, shew that he was a true
humanist, a free citizen of the kingdom of the Renaissance[2].

The influence of the *rhétoriqueur* school is even more
apparent in Lemaire's prose than in his verse. Here is a
specimen:

> Venus doncques ainsi aornee dune voix doulcement organisee
> procedant du creux de sa poictrine aimable fit resonner la circonference
> de lair en ceste maniere. "O fleur fleurissant de nayfve beaulte,
> gentil prince de jeunesse, le plus acomply des dons de formosite
> corporelle qui jamais marcha ne marchera sur terre[3]."

And so on for several pages. No wonder Paris was dumb-
founded by so much eloquence. But it is only when
Lemaire wishes to be eloquent or impressive that he indulges
in bombast of this description[4]. His ordinary narrative
style is clear, simple, and nervous. His periods are short
and well-balanced. As we have seen, he excels in descrip-
tion, for he has an eye for picturesque details, and he knows
the value of an epithet that appeals to the imagination.

The description of the three goddesses as they appear
before Paris is perhaps his masterpiece. But the whole

[1] Cp. cc. XVI and XVII with Homer, *Iliad*, III. Lemaire has confused
Niccolò with Lorenzo.

[2] A good example of his use of mythology will be found in the second
Epistre de l'Amant Vert.

[3] *Les Illustrations de Gaule*, I. 32.

[4] Brunetière, *Hist. de la litt. française classique*, I. 63, unfairly quotes a
passage from the speech of Pallas to Paris as if it were an average specimen
of his style.

story of Paris is admirably told, and, in spite of some inevitable moralising, with a due appreciation of its interest as a human drama.

Lemaire's literary career, from the publication of *Le temple d'honneur et de vertus* to the time of his disappearance from our view, covers only a period of ten years. But during that period he achieved a great reputation which lasted till the end of the first half of the century. His works were frequently reprinted down to 1524; less frequently, but still fairly often, between that date and 1550. His influence on his successors has been compared to that of Chateaubriand[1], and the comparison, which does not imply that it was equal to that of the father of Romanticism, is a just one. He encountered Marot at Blois just after the latter, then a lad of fifteen, had written his first poem, a translation of Virgil's First Eclogue, and he pointed out to him his faulty use of the *coupe feminine* after the caesura. Marot repaid him with the flattery of imitation, for *Le Temple de Cupidon*, dedicated to Francis I in 1515, contains numerous reminiscences of the elder poet's Temple of Venus in *La concorde des deux langages*, and he always regarded him with reverence and admiration. But Lemaire's true descendant is Ronsard, who by temperament and training, by his love of nature and art, and his knowledge of classical literature, had a closer affinity with him than Marot[2]. It is worth noting, though it is only a coincidence, that the stately and beautiful folio, with which the Lyons printer, Jean de Tournes, honoured Lemaire, appeared in the same year 1549[3] as *La Deffence et Illustration de la Langue*

[1] "Par ses idées nouvelles, par l'étendue de ses connaissances, par son imagination, par sa prose abondante, ample, colorée, poétique, il a exercé sur la génération de Cl. Marot et celle de Ronsard une influence comparable (quoique très différente) à celle de Chateaubriand sur nos Romantiques et nos Parnassiens" (Laumonier, *op. cit.* p. 647). The same comparison has been made by Becker.

[2] Ronsard's love of diminutives is probably derived from Lemaire.

[3] There are three copies in the Brit. Mus. It omits certain works— *L'amant vert, Le temple d'honneur, La pompe funeralle de Phelipe de Castille*, and *Les chansons de Namur*.

Française. In that manifesto of the new school Ronsard's lieutenant, Joachim Du Bellay, speaks of Lemaire as the first to give lustre to France and the French language[1], and in a later chapter he copies a whole passage from *Les Illustrations de Gaule*[2]. Binet, Ronsard's biographer, tells us that the French poets whom he most often read were Jean Lemaire de Belges, the authors of the *Roman de la Rose*, Coquillart, and Clement Marot.

Yet it was of inestimable benefit to French poetry that Marot and not Ronsard was Lemaire's immediate successor. For Lemaire was a Hainaulter by birth, a Burgundian by training, and a disciple of the Italian Renaissance by temperament, and it needed one who was a Frenchman by birth, training, and temperament, and who possessed tact and common sense in a high degree, to eradicate from French poetry the vices of the *rhétoriqueur* school and to re-endow it with its true national elements. Ronsard at first turned his back on Marot and wrote poetry in which classical and Italian influences played too large a part. But soon, recognising that this exotic growth would never flourish on French soil, he returned to the true path, and henceforth grafted his poetry on the hardy native plant which Marot had so successfully reared.

If Marot and Ronsard were Lemaire's pupils in verse, he had an even more illustrious student of his prose in Rabelais. The author of *Pantagruel* has many varieties of style and in his higher flights far surpasses Lemaire. But between the narrative styles of the two writers there is a strong similarity, so that often in reading Lemaire one seems to hear the more familiar tones of his great successor. Compare, for instance, two chapters of the Second Book of *Les Illustrations de Gaule*, the fourteenth and the fifteenth, in which Lemaire relates the preparations of the Greeks for the war against Troy and the first incidents of the campaign, with Rabelais's account of the war between Grandgousier and Picrochole. We have the same straightforward business-

[1] Part IV. c. ii. [2] Part II. c. viii.

like narrative, the same economy of words—for Rabelais,
when he chooses, can be as succinct as Thucydides—the
same short unencumbered periods. And when we look a
little closer, we see that the charm of this narrative style
in both writers comes mainly from two causes, the choice of
the right word and an unfailing ear for harmony. Another
point of resemblance is that Lemaire, like Rabelais, in his
more descriptive passages is fond of enumerating material
objects, apparently for the pure pleasure of calling them
by their names. A good instance of this is the following
passage from the description of the valley where Paris
tended his sheep:

> Car icelle vallee de Mesaulon est humble et coye se baissant
> doulcement entre les deux cruppes des montaignes. Lesquelles
> seslievent hautement dung coste et dautre et sont richement reves-
> tues de pins, sapins, cedres, cyprez, ifs, buissets, houx, genoivre,
> galles, terebinthes et cocques qui portent la graine descarlate: et
> maintz autres petiz arbustes aromatiques. Et au fondz de la vallee
> le plaisant fleuve nomme Xanthus ou Scamander couloit ses undes
> aval qui sont verdes et bleues par la reverberation du ciel et des
> terres prochaines avec bruit taciturne entre ses rives. Lesquelles
> sont bien peuplees de cannes, roseaux, joncs fluviaux et autres
> herbes aquatiques. Entre lesquelz nidifient cignes, plouviers, malars,
> cercelles, fuliques, louchiers, poulles deaue et autres oyseaux de
> riviere. Et dessus les haulx arbres disposez au long du rivage: cest
> assavoir chesnes, faulx, fresnes, tilleux, allemarches, ormes, planes,
> saux, poupliers, myrtes et lauriers. Habitent maintes nouvelles
> especes doyseaux. Dont les plumettes painctes de diverses couleurs
> sont eparses par dessus lherbe poignant. Si comme faisans, herons,
> pellicans, poulles dinde, becquasses, grues, butors, cicoignes, corbeaux,
> cormorans, chauvettes, tourterelles et coulombz ramiers[1].

Here we have in a more modest form the strings of names
in which Rabelais delighted, and which he developed with
such amazing learning and gusto. Lemaire makes use of
them in his verse as well as in his prose, as for instance in
the second *Epistre de l'Amant Vert*, where Mercury enu-
merates all the snakes, beasts, birds, and insects[2] that are
to be found in Hades.

[1] I. 28.

[2] Cp. Rabelais's very much longer list of snakes, insects and other
noxious animals in *Pant.* IV. lxiv.

It may be said that these points of similarity between Lemaire and Rabelais are merely accidental, or are at most due to affinity of temperament. But there is a chapter in the Fifth Book of *Pantagruel*—a chapter which nearly everyone acknowledges is by the hand of the master— which puts Rabelais's acquaintance with *Les Illustrations de Gaule* beyond the possibility of doubt. The description of the mosaic in the temple of the Bottle, which represents the victory of Bacchus over the Indians, is taken chiefly from Lucian, but the vigorous portraits of Bacchus and Pan owe a few touches to the older writer's account of the marriage of Peleus and Thetis, in which the same deities are most graphically depicted[1]. It is from Lemaire that Rabelais borrows the idea of representing Bacchus with a young face, "as a sign that all good drinkers never grow old." It is from the same source that he depicts Pan with hairy legs (*cuisses velues*), a red face (*visage rouge et enflambé*), and a long beard.

Lemaire's influence was not confined to literature. The tapestries in the Cathedral of Beauvais, representing the fabulous kings of Gaul, which were executed for one of the Canons in 1530, were inspired by *Les Illustrations de Gaule*, and M. Mâle points out resemblances to some of Lemaire's poems in the famous Flemish tapestries of the Virtues and Vices at Madrid, especially in those of Faith and Honour to his *Temple d'honneur et de vertus*[2].

III

The importance of Jean Lemaire de Belges is now recognised by all careful students of French literature, but the only name among the writers of our period that is known to the general reader is that of Philippe de Commynes[3].

[1] I. 29. See A. Tilley, *Rabelais et Jean Le Maire de Belges* in *Rev. du seizième siècle*, II. 30–33.

[2] See E. Mâle, *L'art religieux de la fin du moyen âge en France*, 1908, p. 370 and pp. 367 ff.

[3] The most recent and best edition of the *Memoirs* is that of B. de Mandrot, 2 vols. 1901–1903, with copious notes and index, printed from a

The most important part of his work, that which relates to the reign of Louis XI (Books I–VI) was written from 1489 to 1491[1], before our period opens, and was not printed till some years after its close, namely in 1524[2]. The rest (Books VII and VIII), which contains the expedition of Charles VIII to Italy, was written in 1497 and 1498, and was first printed in 1528. Thus Commynes's book was unknown during our period and cannot be said to have influenced either its thought or its literature. Nevertheless it must not be omitted from our inquiry, for it affords evidence as to the condition of thought, especially of political thought, in France at the time it was written. How far does it reflect the spirit of the Renaissance?

Sainte-Beuve calls Commynes "the first really modern writer," and says that he was "a political philosopher like Machiavelli and Montesquieu." Similarly M. Faguet, who claims him for the sixteenth century, in spite of the fact that

hitherto unknown manuscript, that of Anne de Polignac, Commynes's niece. This is the only manuscript that contains books VII and VIII. The edition of Mlle. Dupont, edited for the Société de l'hist. de France, 3 vols. 1840–1847, with an excellent life upon which that prefixed to M. de Mandrot's edition is based, is now very rare: There is also an edition, with illustrations, by R. Chantelauze, 1881. For appreciation and criticism, see Sainte-Beuve, *Causeries du Lundi*, I. 241 ff.; E. Faguet, *Seizième siècle*, pp. 1 ff. and *Hist. de la litt. française*, I. 247 ff.; Lanson, *Hist. de la litt. française*, 5th ed. p. 121; G. Saintsbury, *A short history of French literature*, 5th ed. p. 133; C. Whibley's introduction to *The history of Comines, Englished by Thos. Danett*, 2 vols. 1897 (Tudor Translations); W. Arnold, *Die ethischen Grundanschauungen des P. von Comynes*, Dresden, 1873. Comines (as it is now spelt) is a small town on both sides of the Lys, and is therefore partly French and partly Belgian. It is about eight miles from Ypres, and about thirteen from Lille.

[1] I give M. de Mandrot's conclusions, which are more precise than those of previous editors.

[2] The date of the first edition is sometimes given as 1523: but the privilege is dated February 3, 152¾, and the printing was finished on April 26. The publisher was Galiot Du Pré. This original edition was entitled *Cronique et histoyre*. The title of *Mémoires* first appears in an edition of 1552, published by Jean de Roigny and Galiot Du Pré in co-partnership. The editor, Denis Sauvage, justifies the innovation on the ground that the term *Mémoires* is frequently applied to the work by its author. The same editor introduced the division into books and chapters.

he was about fifty-five when that century opened[1], speaks of him as "the first in date of our modern writers," and as "the first of the great French historians." M. Lanson, who has a full account of him, says that both he and Villon are moderns, because their work is an expression of their own personality. This is also Professor Saintsbury's view, though he qualifies it by the remark, that "to a certain extent the mediaeval influence is still strong in Commines, though it shews itself in connection with evidences of the modern spirit." But surely the strong individuality, which is characteristic alike of Villon and Commynes, is a sign of their genius rather than of their modernity. We find the same personal element in Charles d'Orléans and Froissart, and, to go back further, in Rutebeuf. To estimate how far Commynes was affected by the new spirit we must rather consider the nature of his personality, and what were his tastes and his general intellectual equipment.

According to the German historian, Johann Sleidan, who was born in 1506, five years before Commynes's death, and who prefixed to his Latin translation, greatly abridged, of the second part of the *Memoirs* a short notice of the author's life, Commynes often expressed his regret that he had not learnt Latin[2]. And though Sleidan puts it elsewhere less absolutely, saying that he had small knowledge of Latin (*latine leviter doctus*), it is abundantly clear that Commynes was at any rate no humanist. In only two places does he refer to ancient history, and both these references are in the second part of the *Memoirs*. In one he mentions the defeat of the Romans by the Samnites at the Caudine Forks[3], and in the other he makes some interesting comparisons between Venice and ancient Rome, adding that the Venetians "well knew from Titus Livius what mistakes the Romans made, for they possess his histories, and moreover they have his bones in their palace at Padua[4]." Commynes himself

[1] He was born about 1445, certainly before 1447, as his mother died on October 12 of that year, and he was the *eldest* son. (Mandrot. 1. 4, n.[1].)

[2] Strassburg, 1548, p. 95 r°. [3] VIII. 21.

[4] VII. 18. The reference is to the discovery of Livy's supposed bones at Padua in 1413. See above, p. 16.

possessed Livy's histories, but in a French translation[1].
According to Sleidan, he was a great reader of history,
especially of Roman history[2]. He was also interested in
geography and had a map of the world sent him from
Italy[3]. Nor was he devoid of artistic tastes. He rebuilt
the châteaux on his estates at Argenton and Villentras, and
by order of Louis XI enlarged the château of Chinon, of
which he was "captain," adding to it the *Tour d'Argenton*.
He also built at Chinon the church of Saint-Etienne[4]. For
the decoration of his château at Dreux he employed a painter
named Olivier Chiffelin[5], and he possessed some fine illu-
minated manuscripts—a Froissart[6], a *De civitate Dei* in
French[7], and a Book of Hours made for him by Fouquet[8].
After the fashion of his day he ordered in his lifetime his
tomb in the Grands-Augustins at Paris, and the work was
probably completed before his death[9]. The ornamentation
of both chapel and tomb is evidently the work of Italian
artists, and the realistic half-length figures of Commynes
and his wife have, as M. Vitry points out, all the character-
istics of the Modenese sculptor, Guido Mazzoni, whom
Charles VIII brought with him to France[10].

It may be that in all this Commynes was following
the fashion rather than his own taste, but it was at any
rate a fashion that was inspired by the Renaissance, by its
love of beauty and its craving for posthumous fame. On
the other hand the two visits which Commynes paid to
Italy do not point to any deep enthusiasm for art. His
first visit was in 1478, when he spent two months at Florence
as ambassador, but in the first part of his *Memoirs* he is

[1] Mandrot, II. 213. [2] *op. cit.* p. 95 r°.
[3] Kervyn de Lettenhove, *Lettres et Négociations de P. de Commynes*,
2 vols. Brussels, 1867, 1868. I. 322.
[4] Dupont, I. cxxvii. [5] Kervyn de Lettenhove, II. 280.
[6] Brit. Mus. Harley MSS. 4379, 4380.
[7] Vol. I. is at the Hague, and vol. II. at Nantes (Kervyn de Lettenhove,
II. 277).
[8] E. Giraudet, *Les artistes tourangeaux*, Tours, 1885, p. 170. This is
unfortunately lost.
[9] The date of 1506 occurs on a fragment.
[10] See *post*, chap. XIII.

wholly silent as to the beauties of that city[1]. Sixteen years
later, when he accompanied the expedition of Charles VIII,
his mind appears to have been more open to aesthetic
impressions. He says of the Certosa of Pavia that it was
"the finest church that he had ever seen, all of rich marble,"
and of the Medici palace at Florence that it was "the finest
merchant's house that he had ever seen[2]." And when he
describes the pillage of the palace by the Seigneur de Balsac
and others after the flight of Piero de' Medici, he speaks with
enthusiasm of the cameos and medals which he had seen
on his former visit[3]. But it is Venice, where he spent
eight months as envoy from Charles VIII, that fills him
with the warmest admiration. The Grand Canal he thinks
the finest street in the world, and lined with the finest
houses. He admires the façades of white marble, and the
interiors with their gilded ceilings and rich marble mantel-
pieces and painted screens. "It is the most triumphant
city that I have ever seen." He visits the Ducal Palace,
and is again lost in wonder, and St Mark's, where he admires
the mosaics and the great rubies which formed part of the
treasure[4]. This simple open-mouthed admiration does not
imply any deep artistic sentiment, but we may take it as
a fair example of the impression which Italy made on the
average French noble who accompanied Charles VIII on his
expedition.

Similarly Commynes's religion is the simple, inconsistent,
unspiritual religion of the ordinary mediaeval man. We get
a good idea of it from the two curious and interesting
chapters in the fifth book, in which he expounds his theory
of the balance of power, and the ways of Providence towards
unjust princes[5]. He can only account for their oppressions
and spoliations on the hypothesis that they have no true
faith in the Christian religion. For if they really believed
in the pains of hell, and that he who wrongfully seizes the
possessions of another will never enter Paradise unless he

[1] VI. 4. By a strange slip he says that he was a whole year at Florence.
[2] VII. 9. [3] VII. 11.
[4] VII. 18. [5] cc. 18, 19.

make satisfaction and restitution, is it conceivable that they
would act as they do[1]? In practice, however, Commynes
was no better than these princes, for he stoutly resisted for
the space of six years the restitution of the La Trémoille
estates which had been given him by Louis XI. *Ouster
aux ungs pour enrichir les aultres (qui est plus commun
mestier qu'ilz facent).* As for Louis XI, who took every-
thing and gave back nothing, but who made so devout an
end, he is confident as to his future. Indeed he goes so far
as to hope that the pangs of mind and body which his
master endured so patiently before "God removed him from
the toil of this miserable world" had shortened his time in
Purgatory, and that God had already received him into His
kingdom of Paradise[2]. "This miserable world" is a common
phrase in Commynes's book. His conclusion at the close
of his narrative of the reign of Louis XI is that "man is of
little account and that this life is brief and miserable[3]."
This is a mediaeval and not a Renaissance sentiment.
The men of the Renaissance believed in the dignity of
human nature, and though they might complain that life
was short, they found it anything but miserable.

But, after all, it is on Commynes's character as a historian
and a political thinker that his claim to be a modern man
principally rests. His book, indeed, is not a regular history
in form. It is very different, for instance, from the Latin
history of France, founded on the pattern of the classical
historians, of which Paolo Emilio produced the first instal-
ment in 1517. It modestly professes to be merely a record
based on personal knowledge—*seulement vous diz grosse-
ment ce que j'ay veu et sceu*[4]. But it is just this personal

[1] v. 19. [2] VI. 11.

[3] VI. 12 and cp. VIII. 25. Que c'est peu de chose de nostre miserable
vie, que tant nous donnons de peyne pour les choses du monde, et que les
roys n'y peuvent resister non plus que ung laboureur.

[4] Prologue. And cp. the following lines from Ronsard's *Epitaphe de
Philippes de Commines (Œuvres,* VII. 218 ff.);
PASSANT. Fut-il present au faict, ou bien s'il l'oüit dire?
PRESTRE. Il fut present au faict, et n'a voulu rescrire
 Sinon ce qu'il a veu.

knowledge that gives it its historical value. For it is the knowledge not merely of an eyewitness, but of one who, first in the service of the Duke of Burgundy (1464–1472) and then in that of Louis XI (1472–1483), had played a leading part in affairs, and who, in his own words, "had as much knowledge of great princes and as frequent intercourse with them as any Frenchman of his time[1]." Moreover he brought to his task great veracity, a singular freedom from prejudice and passion, and a penetrating insight into character.

His portraits are all the more convincing, because they do not pretend to be complete full-length portraits. It is rather from a series of sketches by this shrewd observer that the portrait gradually emerges. His treatment of his central figure, Louis XI, is too well known to need comment. But it may be pointed out that his admiration is tempered with pity, and that though he is unduly reticent as to some of his misdeeds, he is by no means blind to the darker shades of his character. The portrait of his former lord, Charles of Burgundy, is developed by no less masterly touches. He notes his vaulting ambition—"the half of Europe would not have contented him"—his lack of intelligence—"without great intelligence, the rest is nothing[2]"—his activity, his courage, his depression and general deterioration under the reverses of his last years[3]. His portrait of our Edward IV is less complete, because his personal knowledge of him was less. But he puts his finger at once on the weakest spot in his character as a monarch, his absorbing love of pleasure[4].

As M. Faguet has pointed out, he has an eye for national character as well as for that of individuals[5]. He notes of the Italians that it is their nature to take sides with the strongest[6], of the Flemings that they are very turbulent, but very ready to sue for pardon, of the English that they

[1] See note 4, p. 357.

[2] Book III. c. 3. [3] Book V. cc. 5 and 9.

[4] III. 5 and cp. IV. 10 and VI. 1 (C'est un homme pesant, et qui fort aimoit ses plaisirs).

[5] *Seizième siècle*, p. 8. [6] VII. 7.

are very choleric by nature, like all inhabitants of cold countries. The truth of this last observation may be disputed, but it is followed by one relating to France which is as true as it is important. "Our country," says Commynes "is situated between the warm and the cold countries.... Thus we belong both to the warm and to the cold region, and for this reason we have people of both temperaments[1]." This character of France, this mingling of North and South, is the key to the French Renaissance.

Commynes's interest in character, joined with his skill in detecting its hidden springs, is more or less of a modern quality, and it seems all the more modern if you call it psychology. But it was certainly not a Renaissance characteristic. The men of the Renaissance were too much interested in themselves to take much interest in others. They enjoyed life too keenly to look below the surface. It was Montaigne who first introduced into French literature the habit of psychological and moral observation, but it was not till that habit had been strengthened and systematised by various treatises on the human passions, culminating with Descartes's *Traité des passions*, that the psychology of the soul, if we must call it so, became the glory of French literature. But if the Renaissance writers were not students of character, they furnish ample material for its study. At no period in French literature have personal memoirs been more numerous or more remarkable. Even in those writings which are impersonal in form, personal reminiscences abound. Very different from the egotism of Renaissance literature is the impersonal tone of Commynes's *Memoirs*. Whether from modesty[2], or whether, as M. Lanson suggests, from prudence, he gives us singularly little information about himself. One would hardly suspect from his book that he played a leading part in the public affairs of the kingdom. He is present on important occasions, he assists at interviews between princes, but for all the credit he takes to himself he might be a humble secretary instead of a powerful minister.

But there are other characteristics besides this interest

[1] IV. 6. [2] See Whibley, *Introduction*, p. x.

in character which give something of a modern air to Commynes's book, and which entitle him to be regarded as at least a forerunner of the modern historian. Unlike the older chroniclers, especially unlike Froissart, he does not care for battles or pageants or other occasions for picturesque description. His interest is purely intellectual. He loves to trace cause and effect, to unravel the coil of statecraft, to deduce lessons of political conduct. He was in the first place a practical statesman, and he aspired to make his book useful to princes and other statesmen. This was no vain aspiration. The Emperor Charles V called it "his breviary," and it might well have been entitled "A manual of statecraft for Princes."

But was Commynes more than a practical statesman and diplomatist who passed judgment on the men and events which had come under his observation with unrivalled detachment and sagacity? Was he also a political philosopher? Had he, to use Flint's words, formed any "general and so far philosophical conception of history[1]"? Sainte-Beuve, as we have seen, likens him to Machiavelli. But it is by comparing him with that master of political thought that we learn to estimate his true proportions. Largely owing to his ignorance of classical history he lacks the wide outlook and the broad basis of generalisation which Machiavelli's Humanism gave him, and which make *The Prince*, written though it was with a particular object, the union of Italy, a world-wide classic of universal application. One has only to compare the concluding chapters of Commynes's fifth book, where he deals most in general reflexions, with the finest chapters of *The Prince* to realise the difference. While Machiavelli applies with a sure hand the general principles of government which he had formed as the result of experience and study to the criticism of contemporary successes and failures, Commynes tries vainly to deduce from the facts that had come under his observation some general laws as to God's government of the world. For whereas Machiavelli eliminates God from the conduct of

[1] R. Flint, *History of the Philosophy of History*, 1894.

human affairs in favour of the pagan conception of Fortune—
"a capricious deity with human passions and attributes[1],"
who, being a woman must be treated with audacity rather
than with respect[2]—Commynes believes in the government
of the world by God as fervently as Bossuet or Rabelais.
But with naïve anthropomorphism he invests Him with
human attributes, if not with human passions. Thus he
regards the balance of power, which for Machiavelli was
merely a temporary political expedient, as an eternal
ordinance of God. It is worse when his belief in success
as the test of political action drives him into making God
an accomplice, as it were, with the violence and injustice
of princes. This attitude is not surprising in a pre-
Machiavellian writer, but it marks the gulf that separates
Commynes from Machiavelli. It was by separating politics
from religion and morals that Machiavelli laid the founda-
tions of modern political science.

Another test that we may apply to Commynes as a
political thinker is his attitude towards the chief political
phenomenon of the Renaissance, the formation of the modern
state. With the resignation of the last anti-Pope, Felix V,
and the dissolution of the Council of Basle in 1449, absolute
monarchy triumphed in the Papacy[3]. In the following
year Francesco Sforza established himself as Duke of Milan,
and gave on a small scale a notable example of the efficiency
of personal government. Eleven years later his friend and
political pupil, Louis XI, began the work of welding into
a strong and united kingdom the various quasi-independent
and insubordinate fiefs of which he was nominally suzerain.
Of this work Commynes was one of the principal agents, but
there is little or nothing in his book to shew that he really
understood the nature of the political change that was
taking place under his eyes, the formation of a great national
kingdom as a self-contained independent unit, and the
development of absolute monarchy. Well may Arnold say

[1] L. A. Burd in the *Cambridge Modern History*, I. 210.
[2] *Il Principe*, c. xxv.
[3] See J. N. Figgis, *From Gerson to Grotius*, Cambridge, 1907, p. 42.

that his "*Memoirs* are striking from their perfect unconscious-
ness: the knell of the Middle Ages had been already sounded,
yet Comines has no other notions than such as they had
tended to foster; he describes their events, their characters,
their relations, as if they were to continue for centuries[1]."
Arnold judges Commynes with the eye of a historian, and
it may be noticed that historians generally are not so ready
to claim him for the modern world as literary critics.
M. Lemonnier, for instance, warns us against exaggerating
his merits as a political thinker. "We must neither consider
them as essentially personal to him, nor must we ascribe
them to a vague contact with Italy and the Renais-
sance[2]." Brunetière is not far wrong when he declares that
Commynes has nothing in him of the Renaissance[3].

Nor when we come to consider Commynes's style is the
result different. Montaigne wrote in the margin of his copy
of the *Memoirs* that "you will find the language pleasant,
agreeable, and of a naïve simplicity, the narrative pure
and revealing the evident good faith of the author[4]." This
is just praise, but some modern critics have gone further
and have exalted Commynes into a modern writer, or at
least into a literary artist[5]. He is neither. For the purposes
of simple narrative his style is excellent, being wholly
without affectation. The story of the three men who sold
the bear's skin before they had caught the bear, which he
puts in the mouth of the Emperor Frederic IV, is admirably
told[6]. M. Faguet is right in citing it to Commynes's
advantage. His praise too of the description of Venice is
not undeserved. But Commynes is before all things a
thinker, and it is for purposes of reflexion that his style is

[1] *Lectures on Modern History*, Oxford, 1842, p. 153.

[2] In Lavisse, *Hist. de France*, v. 1, p. 171.

[3] *Hist. de la litt. française classique*, p. 59.

[4] *Essais*, II. 10. Florio translates *agréable* by "gently-gliding" and
generally improves upon Montaigne.

[5] Comme artiste littéraire Commynes est très digne d'attention (Faguet).
On the other hand, Commynes n'est pas un artiste: il écrit convenable-
ment, rien de plus (Lanson).

[6] IV. 3.

inadequate. It is embarrassed by hesitations and parentheses and digressions, so that it is often difficult to arrive at his exact meaning[1]. In a modern writer one would say that this is due to confusion of thought, but in Commynes it rather comes from want of experience, from the lack of good models in the style proper to thought and reflexion. It was only after a long schooling and the intelligent study of classical Latin that French prose acquired the lucidity and logical precision that we now associate with it. Commynes's style is still mediaeval.

On the death of Louis XI there were signs of reaction against his policy and his ministers. The nobles began to intrigue, and the common people hoped for a diminution of taxation. But when the Estates met at Tours in January 1484, proving the most representative assembly that France had ever seen, every province except Brittany being represented, it soon became evident that the monarchy would emerge with undiminished strength. The three Orders were divided in their aims, and there was jealousy between the different provinces. The Regent and her supporters had little difficulty in eluding most of the demands. The only real concession was a considerable reduction of the *taille*. A promise to re-assemble the Estates at the end of two years was not kept. Thus the attempt to limit the power of the monarchy by making the Estates periodical failed at the outset, and the *taille* was soon raised again without any consultation of them[2].

Commynes points to the docility shewn by the Estates in 1484 as confirming his statement that the King of France was the best obeyed Prince in the world[3]. But he omits

[1] Cp. E. Gebhart, *Rabelais*, 1877, p. 150, "La langue de Comines, longue et lente, surchargée d'incidentes, coupée de parenthèses maladroites, embarrassée de redites."

[2] For the Estates of Tours see G. Picot, *Hist. des Etats généraux*, 4 vols. 1872, I. 354–542; Thierry, *Essai sur l'histoire du Tiers Etat (Œuvres, IX.)*, pp. 95–101; Lavisse, *Hist. de France*, IV. 2, 420–430. Both Thierry and Picot have misunderstood the purport of Philippe Pot's speech; he was a strong partisan of Pierre and Anne de Beaujeu.

[3] v. 18.

to mention the intrigues of the Duke of Orleans and other nobles against the government, in which he took part. For his punishment he had to pass eight months in one of the late king's iron cages[1]. In 1489 he was banished to his estates, and it is to this banishment, which lasted till 1492, that we owe the first part of his *Memoirs*.

The movement towards national and absolute monarchy had gathered too much impetus in France to be lightly arrested. In purely mediaeval times the idea of a national sovereignty was limited by three adverse forces, the Church, the Empire, and Feudalism[2]. But the king of France had held the Head of the Church in tutelage, not to say in captivity, and the authority of the Emperor, though it might be recognised in theory, had long been disregarded in fact. As for the great Feudatories they had been effectually crushed and absorbed by Louis XI, and the coalitions against the central authority of the sovereign which were formed after his death were destined to ignominious failure. Meanwhile theory as well as fact was ranging itself on the side of absolute monarchy. The one and undivided *imperium* with which the mediaeval jurists invested the Emperor as the temporal head of Christendom was transferred to the sovereign of the national state. Since the days of Philip the Fair or even earlier the French lawyers had done much to strengthen the royal power. The phrases which Ulpian had used of the Roman Emperor—*Quod principi placuit legis habet vigorem*, and *Princeps legibus solutus est*[3]—were now applied to the King of France, who was said to be *imperator in regno suo*[4].

The attempt to limit his power by means of the Estates General had proved a failure. The only barrier against

[1] Plusieurs l'ont maudit (*i.e.* the inventor, Cardinal de la Balue) et moy aussi, qui en ay tasté huict mois (VI. 12). The cages were about eight feet square and less than seven in height. Commynes's abode is still shewn at Loches.

[2] See G. Jellinek, *Allgemeine Staatslehre*, Berlin, 1900, pp. 399–413.

[3] Dig. I. 4. 41 ; I. 3. 31.

[4] See C. N. S. Woolf, *Bartolus of Sassoferrato*, Cambridge, 1913, pp. 368–381.

despotism was the lawyers' own body, the *Parlement* of Paris, the supposed guardian of the national traditions and institutions[1]. But this barrier was wholly illusory, for though the *Parlement* could refuse to register the king's laws, he could compel them to submit by holding what was called a *lit de justice*.

However, the government of Charles VIII and Louis XII was patriarchal rather than despotic. It kept in touch with the people, and veiled its autocracy under an outward semblance of popular bearing[2]. Though the Estates were only called together once after 1484, both monarchs often consulted informal assemblies of their subjects. Louis XII, especially, was exceedingly popular till the last years of his reign, and the phantom Estates of 1506, which he summoned for a particular purpose, conferred on him the title of Father of the People. He endeavoured, though with far from complete success, to secure the prompt and impartial administration of justice, and he succeeded to some extent, as we have seen, in giving his country, what it needed more than anything, order and repose. Thus absolute monarchy became established in France because it satisfied the wants of her people. After the Hundred Years War she demanded before all things an efficient government, and as an acute modern writer has pointed out, "the ideal of efficiency, if it be exclusive, will almost invariably tend to become an apology for tyranny[3]." But to contemporary observers the moderation of the French monarchy gave it a constitutional air. Machiavelli, who visited France in 1510, says that "it was ruled by laws more than any other country of his day that he knew[4]."

Another foreigner, far inferior to Machiavelli as a political thinker, but who, being domiciled in France, had a more

[1] See Imbart de La Tour, *op. cit.* 1. 33–43, and especially the notes on pp. 39 and 40 where he cites the absolutist doctrines that were enunciated by French lawyers from 1491 to 1501.

[2] See Maulde La Clavière, *Histoire de Louis XII, La diplomatie,* pp. 91–94, 101–102.

[3] J. N. Figgis, *op. cit.* p. 82.

[4] *Discorsi sopra la prima deca di Tito Livio,* 1. 58.

intimate knowledge of the country, has left us his views on the French monarchy in a little work written just after the death of Louis XII. Its author, Claude de Seyssel[1], was a native of Savoy and a professor at Turin, whom Charles VIII in the last year of his reign invited to France and made a member of the Great Council. He was high in favour with Charles's successor, who employed him on various missions, and made him Bishop of Marseilles in 1509. We hear of him at Blois in 1504, when he visited the royal library in company with his friend Lascaris. With the help of the same friend and of Latin versions he translated at this time some of the Greek historians into French, but they were not printed till several years after his death. This shews that he recognised at this early date the importance of translating the masterpieces of classical literature into the vernacular, and of thus diffusing a real knowledge of antiquity among a wider circle of readers. He also translated the Latin historian, Justin, and in a remarkable preface, written in 1509, advocated the claims of the French language.

Besides these posthumous works he published in his lifetime *Les louenges du roy Louis XII*, and the work referred to above, which he entitled *La grande monarchie de France*. The former, which he first wrote in Latin and then translated into French, was printed in 1508; it is little more than a panegyric. The latter, which was written early in 1516, though not printed till 1519, is of some interest as a contribution to political thought[2]. The writer reveals his humanistic sympathies by taking his examples chiefly from Greek and Roman history, but he also refers to Thomas Aquinas, and to his disciple Egidio Colonna (Aegidius

[1] See C. Dufayard, *De C. Seisselii vita et operibus*, 1892 (Thesis); A. Jacquet, *Rev. des questions historiques*, Apr. 1895; E. Picot, *Les français italianisants*, 1906, pp. 1–25; A. Tilley, *The Literature of the French Renaissance*, Cambridge, 1904, I. 35 f.; F. Brunot in *Hist. de la langue et de la littérature française*, III. 664 ff.

[2] I have used an edition published by Galiot Du Pré in 1541. When Francis I made his entry into Marseilles in January 1516 (*Actes de Francis I*, I. 70), he was met by the Bishop at the head of his clergy. A month later Seyssel offered his book to the King (A. de Ruffi, *Hist. d Marseille*, 2nd ed. Marseilles, 1696, II. 34; Dufayard, p. 26).

Romanus)[1], whose *De regimine principum* was first printed
at Augsburg in 1473 and had been reprinted twice at Rome
and once at Venice when Claude de Seyssel wrote[2]. After
passing in review the governments of ancient Rome and
Venice he comes to the conclusion that neither aristocracy
nor democracy is so perfect and durable a form of government
as monarchy, and that of all monarchies of which we have
any knowledge the best is that of France. His treatise
would have been more valuable had he distinguished more
clearly between the French monarchy as it actually was
and the ideal monarchy of his own conception. He finds
that the absolute power of the King of France is limited by
three checks (*freins*), religion, justice, and police, meaning
by the latter the laws and regulations made by the king and
confirmed by the *Parlement*. But before discussing these
limitations in detail, as well as the functions of councils, he
frankly recognises "that in a monarchy there is no other
remedy for the correction of abuses and no other means for
the maintenance of good government than the goodness and
wisdom of the monarch[3]."

If the development of the state was greatly helped by
certain forces which we associate with the spirit of the
Renaissance, the discovery of the New World was the
direct outcome of the same spirit. It was on the faith of
classical texts as well as on the prophet Isaiah, and it was
above all on the assurances of Toscanelli, the Florentine
geographer and astronomer, that Columbus based his
confidence in the success of his great undertaking[4]. It
was Renaissance science which made that undertaking
possible[5].

Naturally some time had to elapse before the full
importance of Columbus's discovery was realised in Europe.

[1] In France known as Gilles de Rome.

[2] It appeared in a French translation in 1517.

[3] Part II. chap. ii. p. 24 r⁰. A Latin translation of Seyssel's treatise by
Sleidan was printed at Strassburg in 1562, and again at Frankfort in 1578
with the same writer's translation of Commynes.

[4] See above, p. 47.

[5] Acton, *Lectures on Modern History*, 1906, p. 63.

Columbus himself at first believed he had carried out his purpose of reaching Cathay by the west, and, though there is evidence that before his death he realised the truth, he still professed to adhere to his original belief[1]. His famous letter to Isabella of Castile, announcing his discovery, was printed at Paris in 1493, soon after its first publication at Rome[2]. A decade later Fra Giocondo's Latin version of Vespucci's letter to Lorenzo di Pierfrancesco de' Medici describing his third voyage obtained, under the title of *Mundus Novus*, a far wider circulation than any other narrative of recent geographical discovery. It was printed five times in France during the years 1503–1505[3]. There was also a French version (now lost) of Vespucci's letter to Piero Soderini, Gonfalonier of Florence, in which he gives an account of all his four voyages[4]. In 1507 the first collection of voyages was printed at Vicenza under the title of *Paesi novamenti retrovati e Novo Mondo da Alberico Vesputio Florentino intitulato*. It included besides the voyages of Columbus and Vespucci those of Vasco da Gama and Cabral. Though it was not translated into French till the reign of Francis I, the Latin version, which appeared at Milan in 1508, may well have been known in France[5].

Interest in the new discoveries was also stimulated by the voyages of French sailors. From the early years of the sixteenth century expeditions were sent out from Norman,

[1] Acton, *op. cit.*

[2] *Epistola de insulis de novo repertis* (a) In campo Gaillardi [by Guy Marchand], 1493. Reprinted 1865; (b) Guy Marchand [*circ.* 1493–4]. See Proctor, 7988.

[3] See H. Harrisse, *Bibliotheca Americana vetustissima*, New York, pp. 55–74, and *Additions*, Paris, 1812, pp. 16–20.

[4] The letter was written on Sept. 10, 1504 and printed at Florence from a certified copy made on Feb. 10, 1505. From the French translation was made the Latin version printed as an appendix to Waldseemüller's *Cosmographiae Introductio* in 1507. See J. Fiske, *The Discovery of America*, 2 vols. 1892, II. 132–135.

[5] *Le nouveau Monde et Navigations faites par Emeric de Vespuce Florentin. . . .Translate de italien en langue francoyse par* Mathurin de redouer licencie es loix. . . .Galiot du Pré [1517]; *Itinerarium Portugallensium e Lusitania in Indiam et inde in Occidentem et demum in Aquilonem*, Milan, 1508.

Breton, and Basque ports, from Dieppe and Honfleur, from Saint-Malo and Bayonne. The most interesting of these expeditions is that of the *Espoir*, a vessel of 120 tons carrying sixty men, which under the command of Capitaine de Gonneville sailed from Honfleur for the East Indies on Midsummer's Day, 1503. But instead of rounding the Cape, they found themselves in January 1504 off an unknown land, which proved to be the southern part of Brazil. Here they remained for six months, and then turned homewards, taking with them the young son of an Indian chief. They had many adventures, and many deaths from sickness and encounters with pirates, but at last the thirty-one survivors, including the young Indian, reached Honfleur on May 20, 1505[1]. In 1509 Thomas Aubert brought back to the same port some inhabitants of Newfoundland, who were exposed to the public gaze at Rouen[2]. The year before, when Louis XII visited the Norman capital, a savage, who had been picked up with six companions on the coast of Brittany, was presented to him[3].

It was not till long after the close of our period that new ideas suggested by the new discoveries began to find expression in French literature, but it may be recalled that the second edition of More's *Utopia*, the framework of which is based on the discovery of the New World, was published at Paris in 1517, and had considerable popularity and influence in France.

[1] La Roncière, *Hist. de la marine française*, III. 132–137.

[2] N. Périaux, *Hist. sommaire et chronologique de la ville de Rouen*, Rouen, 1874, p. 238. The same fact, with a detailed description of the men, is recorded by Henri Estienne in his edition of the *Chronicon* of Eusebius published in 1512 (G. Chinard, *L'exotisme américain dans la litt. française au XVIᵉ siècle*, 1911, p. 6).

[3] Périaux, *op. cit.* p. 237.

APPENDIX TO CHAPTER VII

BIBLIOGRAPHY OF THE FIRST EDITIONS OF LEFÈVRE'S WORKS
ON ARISTOTLE AND THE OTHER SUBJECTS OF THE ARTS
COURSE AT PARIS

Lefèvre's works were frequently reprinted and re-edited, often under slightly different titles. The following list is confined to the first editions; I have endeavoured to make it as complete as possible, but certainly in one case, and possibly also in others there was an earlier edition of which I have not been able to trace a copy. By far the fullest bibliography of Lefèvre's works is that of Graf. I have marked with an asterisk those editions that are not recorded by him.

1. In Aristotelis octo Physicos libros Paraphrasis.
4to. Higman. 1492.
[Col.] Debetis grates Alemano et adusque Iohanni
Higman qui propriis sumptibus egit opus.
Collation: a–y⁸z¹⁰, A–O⁸P⁴; 310 leaves.
Brit. Mus.
Proctor 8131. Hain 6839. Pellechet 4720.

2*. Introductio in metaphysicos libros Aristotelis.
Fo. [Higman.] February 16, 149¾. Collation: a–d⁸e¹⁰; 42 ll.
Brit. Mus. Bodleian.
Proctor (who assigns it to Trepperel's press) 8219. Pellechet 4721.

The contents of 1 and 2 with the addition of a commentary by Josse Clichtove were printed by Hopyl in 150½ under the title of Aristotelis totius philosophiae naturalis paraphrases adiecto ad litteram familiari commentario.

3. Ars moralis.
Fo. [Antoine Caillaut.] 1494. Collation: a–b⁸; 16 ll.
Pellechet 4717.
This is an introduction to the *Magna Moralia*.

4*. Textus De Sphera Iohannis de Sacrobosco Cum additione (quantum necessarium est) adiecta: Nouo commentario nuper edito Ad utilitatem studentium Philosophice Parisiensis Academie illustratus.
Fo. Hopyl. February 12, 149⅘. Collation: a⁸b⁶c¹⁰; 24 ll.
Bib. Nat. mR 55, mR 58 (2). Bib. Mazarine. Bib. Geneviève. Albi (*Cat. Portal* 28). Hain-Copinger 14119.

5*. Artificiales nonnulle Introductiones per Iudocum Clich-thoveum in unum diligenter collecte.

4to. [Guy Marchand.] 1496. Collation: a–c⁸d⁶; 30 ll.
Albi (*Cat. Portal* 29).
Pellechet 4723.
These introductions are to the logical works only.

6. Artificialis introductio in decem libros morales Aristotelis.
Fo. Higman and Hopyl. 1496. Collation: a¹⁰; 10 ll.
Camb. Univ. Lib. (bound up with 8).

7. Arithmetica decem libris demonstrata. Musica libris demon-trata quattuor. Epitome in libros arithmeticos diui Seuerini Boetii. Rithmimachie ludus qui et pugna numerorum appellatur.
Fo. Higman and Hopyl. July 22, 1496. Collation: a–i⁸; 72 ll.
Camb. Univ. Lib. (2 copies, of which one is imperfect). Brit. Mus. (2 copies, of which one is imperfect). Bodleian.
The *Rithmimachiae ludus* is probably by John Shirwood, Bishop of Durham (d. 1494). See D. E. Smith, *Rara Arithmetica*, Boston, 1908, pp. 62–63.

8. Decem librorum Moralium Aristotelis tres conversiones. prima Argyropuli Byzantii secunda Leonardi Aretini tertia vero antiqua per Capita et numeros conciliata: communi, familiarique commentario ad Argyropulum adiecto.
Fo. Higman and Hopyl. 1497. Collation: a–p⁸q⁶, a–d⁸e⁴, A–D⁸E⁶; 200 ll.
Camb. Univ. Lib. (wants a1; bound up with 6).
Pellechet 1239.

9. Ars suppositionum adiectis passim Caroli bouilli viromandui annotationibus.
4to. Baligault for Jean Petit. 1500. Collation: a–g⁸; 56 ll.
Camb. Univ. Lib.
Pellechet 4719.

10. Libri Logicorum ad archetypos recogniti cum novis ad litteram commentariis.
Fo. Hopyl and H. Estienne. 1503. Collation: a–z⁸,A–O⁸P⁴; 300 ll.
Bib. Nat. Rés. R. 655. Schlettstadt (see Knod, p. 70).
Graf had not seen a copy.

11. Epitome Compendiosaque introductio in libros Arithmeticos diui Seuerini Boetii: adiecto familiari commentario dilucidata. Praxis numerandi certis quibusdam regulis constricta. Introductio in geometriam:...Liber de quadratura circuli. Liber de cubi-catione sphere. Perspectiva introductio. Insuper astronomicon.

Fo. Hopyl and H. Estienne. 1503. Collation: a–o⁸; 112 ll.
Brit. Mus. Bodleian.
See no. 6 for Boethius's *Epitome*. The "familiar commentary"
and the *Praxis numerandi* are by Clichtove, the three geometrical
treatises and the *Perspectiva introductio* by Bovelles, and the
Astronomicon by Lefèvre.

12. Politicorum libri Octo. Commentarii. Economicorum Duo.
Commentarii. Hecatonomiarum Septem. Economiarum publi-
carum Unus. Explanationis Leonardi in œconomica Duo.
Fo. H. Estienne. 1506. Collation: A⁶a–x⁸y¹⁰; 184 ll.
Bodleian (from the Bywater collection).
Bib. Nat. Rés. R. 342 and Vélins 968.
The *Commentarii* are by Lefèvre.

13. Introductiuncula in Politica Aristotelis et Oeconomica
Xenophontis a Raphaele Volaterano translata.
Fo. H. Estienne. 1508. Collation: a⁸b⁸; 16 ll.
Bib. Nat. Rés. R. 344.
On the title page is a letter from the editor, Volgatius Pratensis,
to Joannes Solidus of Cracow.

14. Georgii Trapezunti Dialectica.
8vo. H. Estienne. 1508. 32 ll.
Schlettstadt (see Knod, p. 83).
This edition is very rare, and I only know of the Schlettstadt
copy, which I have not seen. Beatus Rhenanus had it reprinted at
Strassburg in 1509, and twelve editions were published from that
date to 1536.

15*. Aristotelis castigatissime recognitum opus metaphysicum
a Clarissimo principe Bessarione Cardinale Niceno latinitate feliciter
donatum xiiij libris distinctum: cum adiecto in xij primos libros
Argyropyli Byzantii interpretamento rarum procul dubio et hactenus
desideratum opus. Theophrasti metaphysicorum liber I. Item
metaphysica introductio: quatuor dialogorum libris elucidata.
Fo. H. Estienne. 1515. Collation: a–p⁸q⁴r–t⁸v⁶x⁸ (x7, 8 cut
away, qu. blank?); 160 ll. + 2 blank leaves.
Brit. Mus. Merton College, Oxford.
Lefèvre's *introductio* is a reprint of no. 2.

I have to thank M. Louis Polain for the collation of 4, M. Léon
Dorez for that of 10 and 13, and Mr Madan for that of 12.

PART III

THE RENAISSANCE IN ART

375

CHAPTER XI

ARCHITECTURE I[1]

I. *Introductory*

As in England after the Wars of the Roses, so in France after the Hundred Years War there was a great revival of architectural activity. Even while France was still a prey to foreign conquest and internal dissension, even during the terrible years of pillage and famine that elapsed between the peace of Arras (1435) and the expulsion of the English

[1] The two surest guides for our period are Baron de Geymüller, *Die Baukunst der Renaissance in Frankreich*, Stuttgart, 2 vols. 1898–1901 (vol. III, which was to deal with the details of civil architecture, never appeared), and W. H. Ward, *Architecture of the French Renaissance*, 2 vols. [1911], vol. I. There is also an excellent summary account by M. Paul Vitry in Michel, *Hist. de l'Art*, IV. (ii.), 491–522. L. Palustre, *La Renaissance en France*, 3 vols. 1879–1889, never completed, deals only with the Northern and Western provinces. The same writer's handbook, *L'Architecture de la Renaissance*, 1892, in the *Bibliothèque de l'enseignement des beaux-arts*, has much information in a compact form, but like his larger work is marked by a strong national bias. The same bias is shewn in Marius Vachon, *La Renaissance française* [1910]. R. Blomfield, *A History of French Architecture from the reign of Charles VIII till the death of Mazarin*, 2 vols. 1911, deals only in a cursory fashion with the reigns of Charles VIII and Louis XII. The later volumes of the *Congrès Archéologique de France* and the *Bulletin Monumental* contain several papers of interest relating to our period and are well illustrated. Architectural plans and drawings of several important buildings will be found in A. de Baudot and A. Perrault-Dabot, *Archives de la Commission des Monuments historiques*, 5 vols. (cited as *Mon. Hist.*), and there are various illustrations of interest in Ch. Brossard, *Géographie pittoresque et monumentale de la France*, 6 vols. 1901–6. The more special authorities will be referred to in their appropriate places, but it may be noted here that the excellent series of *Villes d'art célèbres* includes F. Bournon, *Blois, Chambord et les châteaux du Blésois*; P. Vitry, *Tours et les châteaux de Touraine*; H. Prentout, *Caen et Bayeux*; M. Reymond, *Grenoble et Vienne*; L. Morel-Payen, *Troyes et Provins*; C. Enlart, *Rouen*; G. Hardy and A. Gandilhon, *Bourges*; J. Locquin, *Nevers et Moulins*; A. Hallays, *Nancy*; and G. Desdevises du Dézert and L. Bréhier, *Clermont-Ferrand*.

from Normandy (1450), the building of churches did not entirely cease. At Rouen during the English domination (1419–1449) Saint-Laurent was begun (1444), while the Cathedral, Saint-Ouen, Saint-Maclou, Saint-Patrice, all made progress, though none of them was completed till the sixteenth century[1]. At Tours the work on the Cathedral was resumed in earnest in 1425, and the nave was completed in 1430. Caudebec, famous for its spire, was built chiefly between 1435 and 1480[2]. The Cathedral at Nantes was begun in 1434, Notre-Dame de Cléry in 1445, the magnificent choir of Mont Saint-Michel in 1452. After the final expulsion of the English came Moulins (1468), Saint-Riquier (1475), Abbeville (1488), and Auch (1489). In 1489 Martin Chambiges was summoned from Paris to build transepts for Sens. The façade of La Trinité at Vendôme was begun in 1492, the south porch of Louviers in 1493, the façade of Coutances and the cloisters of Cahors in 1494, the Cathedral of Mézières, an entirely new structure, in 1499. In the last year of the century Martin Chambiges began the north transept of Beauvais.

During the first third of the sixteenth century church-building was carried on with undiminished ardour. To the first decade belong Condom, Péronne, Brou, Saint-Jacques de la Boucherie at Paris, the two northern portals and the façade of Bourges, the nave of Pont-Audemer, the north-western spire of Chartres, Rodez, and Mende (Lozère), the façade of the Cathedral and the rood-screen of La Madeleine at Troyes. Of a later date still are the south porch of Albi (1519–1535), the transepts of Limoges (1517–1530) and Senlis (1532), the southern transept of Beauvais (1530) and the churches of Saint-Merri (begun *circ.* 1520–1530) and SS. Gervais et Protais at Paris.

[1] The Cathedral (except for the spire) in 1530, Saint-Ouen (except for the façade) in 1519, Saint-Maclou in 1521, Saint-Vincent in 1530. La quantité d'édifices religieux élevés à Rouen dans une période de 80 à 100 ans, c'est-à-dire à partir de 1450 environ, jusque vers 1540, est prodigieuse. Toutes nos églises paroissiales, au nombre de trente-six ont été reconstruites dans cet intervalle. (Delaquérière, *op. cit.* 1. 75.)

[2] The spire was begun in 1426.

All this building, whether it consisted of wholly new structures or of additions to those already existing, was, with hardly an exception, Gothic. It included, indeed, most of the typical examples of late Flamboyant architecture— Abbeville, Saint-Riquier, the Chapel of Saint-Esprit at Rue, Saint-Maclou and the lantern of Saint-Ouen at Rouen, the tower of Saint-Jacques at Dieppe, the façade of the north transept at Evreux, the spire of Caudebec, the south porch of Louviers, the north portal of Gisors, the transepts of Beauvais and Senlis, the façade of the Cathedral and the rood-screen of La Madeleine at Troyes, Notre-Dame de l'Épine (Marne), and the transepts of Sens. All these, it will be observed, are included within an area formed by drawing a line from the mouth of the Seine to Sens, another from Sens to Troyes, and a third from Troyes to the mouth of the Somme. But the Flamboyant style in its latest phase was not confined to these limits. Outside them will be found such typical examples as La Trinité at Vendôme, the great church at Brou (designed by a Flemish architect), Saint-Michel at Bordeaux, Saint-Nicolas-du-Port (near Nancy), the towers of Rodez and Mende, the cloisters of Cadouin, the south porch and the rood-screen of Albi.

In the face of all this activity and of so many brilliant examples of architectural art, it seems at first sight a misnomer to speak of this period as the declining age of Gothic. But as a matter of fact Gothic architecture in France had long since reached maturity. Its apogee is represented by the exquisite church of Saint-Urbain at Troyes (begun in 1261), with which the genius of Jean Langlois and the liberality of Urban IV endowed their native town. After this no further real progress was made. There were changes in window-tracery, changes in stained glass, changes in decoration, but construction remained unchanged. Thus when the peace which followed the Hundred Years War brought about a revival of architectural activity, all the brilliant technique, all the fantastic ingenuity of the builders could not atone for their lack of creative imagination. They

could raise churches of noble proportions, for they had noble examples before them, they could carve stone into patterns which rivalled lace, but they could not invent a single new principle of construction. Architecture, in short, was suffering from the same malady as philosophy and literature—a passion for ingenuity. Just as philosophy was given over to dialectical puzzles, and poetry to juggling with words and rhymes, so architecture was largely occupied with elaborate feats of decorative detail.

Yet it would be grossly unfair to suggest that architecture was in no better plight than philosophy or literature. The hair-splitting logic of the last schoolmen, the mechanical verse of the *grands rhétoriqueurs*, were symptoms of dull decrepitude; French Gothic was glorious even in its decline. Its chief faults were restlessness and over-elaboration. It did not know when to stop. The western façade of Rouen Cathedral, to take a well-known example, lacks the repose and dignity of the earlier Gothic. But the Flamboyant style produced much brilliant work, and some of its smaller monuments, such as the organ-staircase in Saint-Maclou, are real gems. If it clung to the old traditions, these traditions were magnificent.

How stubborn was the resistance that it offered to the new style may be judged by the fact that even at the close of the sixteenth century France did not possess a single large ecclesiastical building that was Renaissance in design as well as in detail. The great church of Saint-Eustache at Paris, though it was almost certainly designed by the Italian architect, Domenico da Cortona, and though all its details are Italian, is in plan and structure a Gothic mediaeval cathedral. The contemporary Parisian church of Saint-Étienne-du-Mont is similar in plan, but the choir, which was begun in 1517, has no Renaissance features. These first appear in the crossing and transepts (finished in 1537), and become prominent only in the nave (1538–1560). It is only in small church buildings of the sixteenth century that we find examples of pure Renaissance construction. The earliest, the chapel of St Ursula in Toul Cathedral,

belongs to the fourth decade. The Mausoleum chapel of Anet was built probably between 1560 and 1566; the Valois mausoleum at Saint-Denis (now destroyed) did not approach completion—it was never really completed—till about 1590, and its designer, who did not live to see the foundations laid, was the Italian Primaticcio[1]. Both these mausoleums were roofed with domes, but throughout the sixteenth century the use of the dome was confined to relatively small chapels. The earliest French church in which this characteristic feature of Italian Renaissance architecture is the determining factor of the design is the Church of the Visitation in the Rue Saint-Antoine at Paris, which François Mansard built in 1632–4 for the convent of the Visitandines[2].

The explanation of this slow advance is not far to seek. Gothic church architecture had on its side tradition, prestige, organisation, and technical skill. Also, it was deeply rooted in the affections and religious sentiment of the nation. The tide of discontent with lazy priests and worldly bishops might rise, but the venerable cathedrals, which the pence of the people, whether as fees for dispensations or as voluntary contributions, had helped to rear, appealed not only to their sense of romance and mystery, but fostered with their wealth of shrines and images that worship of the Virgin and the Saints which was nine-tenths of the popular religion.

In domestic architecture the Gothic tradition was less persistent than in ecclesiastical. While the chapter or bishop had to build in conformity with popular sentiment, the king, or great noble, or powerful minister, could to some extent consult his own tastes. But even so at the close of the reign of Louis XII there is no domestic building that is wholly Renaissance in character. It has been said by Willis that "the Renaissance is nothing more than a compromise between the desire to reproduce the forms of classical architecture and the necessity of retaining the structural

[1] See for the above, Ward, I. 197–203.

[2] *Ib.* pp. 263–4.

arrangements which were too intimately connected with the building-arts and the habits and customs of society to be abandoned[1]." This is especially true of domestic architecture. Thus in the middle of the fifteenth century, a noticeable change began to take place in the character of domestic architecture. The mediaeval fortress began to be transformed into a country-house—the *château fort* into the *château de plaisance*. Castles were no longer built chiefly for defence, but as places of residence.

The house of Jacques Cœur at Bourges, town house though it was, may be said to have inaugurated the new style. Soon after its completion (*circ.* 1455) Louis XI built between 1463 and 1472 his palace of Plessis-lès-Montils, or, as it was afterwards called, Plessis-lès-Tours. There was nothing of the fortress about it, nothing grim in its appearance. Built of light red brick relieved by stone dressings, with windows which admitted plenty of light, and with galleries resting upon open cloisters, it must have been a bright and cheerful residence. The dormers were richly decorated, and niches on the façades facing the court were filled with sculptured figures[2].

It was part of Louis XI's policy in his contest with the feudal nobility to raze their strongholds, and it was on the site of a fortress destroyed by his order that Charles d'Amboise, chief of his illustrious house, began to erect about 1475 his château of Chaumont[3]. Towards the end of the century Montreuil-Bellay, between Saumur and Loudun, was built by a member of another illustrious family, Guillaume d'Harcourt[4]. But under Louis XI there were

[1] Willis and Clark, *The Architectural History of the University of Cambridge*, Cambridge, 1886, III. 526.

[2] Only one side now remains. Sir Walter Scott's description in *Quentin Durward* is purely imaginary, and gives a totally wrong impression.

[3] J. de Foville and A. Le Sourd, *Les Châteaux de France* [1913], arranged by departments, with a miniature photograph of every château, is a convenient handbook of the subject.

[4] The original fortress, which stood a memorable siege by Geoffrey of Anjou, father of our Henry II, was built by Fulk Nerra; nothing remains of it but a round tower much altered.

many *bourgeois* as well as great nobles who could indulge
in the luxury of princely houses. Jean Cottereau, a
Treasurer of France, built Maintenon[1], Jean Bourré, the
favourite of Louis XI, built Plessis-Bourré (1468–1472)[2]
and Jarzé (*circ.* 1500) in Anjou, and Jacques Lepelletier, a
Rouen merchant, built Martainville (1485) in the neighbour-
hood of his native city. On the other hand, the château Du
Moulin at Lassay, near Romorantin, which, like Martainville,
is of brick and stone, was built by a noble, Philippe Du
Moulin, who fought in the battle of Fornovo and was a
member of the royal council. Carrouges in Normandy[3] was
visited by Louis XI in 1473. A specially characteristic
château of the late fifteenth century is Jumilhac le Grand,
overlooking the river Isle between Périgueux and Coutras[4].
In fact the whole department of Dordogne is rich in châteaux
of this period; one passes several on the picturesque railway-
line between Limoges and Périgueux, notably château
l'Évêque, the summer residence of the Bishop of Périgueux.

The change from fortress to country-house was, after all,
a gradual one. The new châteaux still presented, at least
on their outer sides, the appearance of a military and feudal
stronghold. They still had huge towers, battlemented and
machicolated walls, moats, and drawbridges. This is the
character of Chaumont and Carrouges. Langeais, too, has
a severe and formidable aspect, with its scarcity of windows,
its dormerless roof (except on the side towards the court),
its machicolations, and its entrance between two frowning
towers. Plessis-Bourré is very similar in character. More-
over, here and there, castles were still built for real defence,
and when this was the case, the introduction of artillery
necessitated greater strength in the walls. We have an
example of this in Bonaguil (Lot et Garonne), now a noble

[1] See above, pp. 158–9.

[2] Brossard, *Ouest*, p. 346. Bourré bought the land from Charles de
Sainte-Maure in 1462. He also transformed the royal château of Langeais,
of which he was governor.

[3] Brossard, *Nord*, pp. 617, 618; M. Fouquier, *Les grands châteaux de
France*, 2 vols. 1907, II. 101.

[4] Brossard, *Sud-Ouest*, p. 357.

ruin, which Béranger de Roquefeuil, a powerful lord of Quercy, built in 1480 on a promontory where two branches of the Thèze meet.

We can mark the development from *château fort* to *château de plaisance* by comparing Langeais with Coudray-Montpensier in the same neighbourhood[1], which was reconstructed about a quarter of a century later (1489–1491) for Louis de Bourbon, Comte de Montpensier. The battlements and machicolations and towers remain, but rather as traditional survivals than for any practical purpose, while the windows in the outer walls are larger and more numerous. The château of Nantes faces you with the huge towers added by Duke François II (1466–1473), but within the court the *corps de logis* has a cheerful and picturesque aspect. The two small châteaux of Molières near Angers, and Perche near Segré[2], both of which date from the reign of Louis XII, have nothing feudal about them, even in appearance.

Thus domestic architecture kept pace with the customs and social conditions of the nation, changing as they changed, but otherwise not departing from the old traditions. The next step was taken under the influence of the Italian Renaissance. The king and his nobles returned from Italy full of admiration for the palaces of Naples and Rome and Florence, and anxious to introduce into their own homes the same combination of stately grandeur and tasteful elegance. It was by greater symmetry in the planning of the house, and by the frequent use of loggias that the influence of Italy first made itself felt. More gradually came the introduction of Renaissance forms of decoration, and more gradually still that of Renaissance forms of construction.

The various channels through which this infiltration took place have been carefully enumerated by Geymüller[3]. But he has omitted to point out that France was not wholly dependent on Italy for her knowledge of classical architecture. She had in her own land some admirable examples of classical buildings, some of which belonged to the best Roman period.

[1] About 20 miles from Langeais.
[2] Palustre, III. 196. [3] I. 34.

She had the *Maison carrée* at Nîmes, and the similar temple, less well preserved, and less pure in style, at Vienne. Bordeaux, too, in the sixteenth century possessed in the *Piliers de Tutèle* the remains of a classical temple dedicated to the tutelary genius of the city[1].

Of more importance as object-lessons in the principles of Renaissance construction are the triumphal arches. The south-east of France is particularly rich in them. The finest of all is at Orange; there are others, less well preserved, but more or less remarkable at Saint-Remy and Cavaillon; and there are two, beautifully proportioned, at either end of a triumphal bridge, at Saint-Chamas. Outside this Provençal region are the Porta Martis at Reims with its three openings, which must once have been magnificent, and the double arches of Saintes and Langres[2]. To the same type of structure belong the two fine gateways at Autun. Amphitheatres are represented by those at Nîmes, Arles, and Saintes, and in the sixteenth century there was one at Bordeaux[3]. Orange can boast of a noble theatre, and there is an exquisite sepulchral monument, very well preserved, at Saint-Remy.

But the majority of these relics of Roman rule in Gaul are confined to a small corner of France, and in the district of the Loire and the Seine, where Renaissance art found its first welcome, they are conspicuously absent. Whatever instruction classical buildings may have furnished to French architects at a later period, it was through Italy that Frenchmen first became familiar with the forms and decorative details of Renaissance architecture. We shall see how, in the middle of the fifteenth century, Jean Fouquet introduced classical buildings, such as he had seen in Italy, into

[1] See Dom Agneaux Devienne, *Hist. de la ville de Bordeaux*, Bordeaux, 1771, pp. xviii, xix. Eighteen columns were standing when Élie Vinet wrote his *L'Antiquité de Bordeaux* in 1565.

[2] The arch at Carpentras is in a poor state of preservation and the Porte Noire at Besançon is late and much defaced. See an excellent article by P. Graef in *Denkmäler des Klassischen Alterthums*.

[3] The amphitheatre at Lillebonne in Normandy was not uncovered till recent times.

his miniatures[1]. But here again we must guard ourselves against attaching too much importance to this channel of information. The miniatures can have had no wide publicity. At most, they were seen only by a small circle of disciples and fellow-craftsmen, and perhaps a few amateurs, while they were being painted, and by the owner and his friends after they were completed. It was rather by the work of Italians themselves that the taste for Renaissance architecture was disseminated, and that chiefly through drawings and engravings in the possession of Italians who were settled in France. Such an engraving, for instance, as the Judgment Hall of Pilate, with its Corinthian columns, its barrel vault over the central portico and its flat coffered vaults over the side porticoes, which Sir Sidney Colvin attributes to Maso Finiguerra[2], would have been a revelation to an artist wholly ignorant of classical architecture. Equally inspiring would have been the Temple of Solomon[3], and the splendid St George and the Dragon with the arch of Constantine in the background[4], both by Florentine engravers of the last quarter of the fifteenth century. From similar sources artists might have derived a knowledge of Renaissance ornament—from such examples, for instance, as the Twelve Arabesques by Zuan Andrea[5].

A far less likely source of inspiration is that of the illustrated books which were issued by Italian presses, chiefly by those of Venice. For the rough and simple execution of the woodcuts in the earlier books is not well suited to the rendering of architectural details, and it is improbable that many copies of expensive works like the famous

[1] See c. xv.

[2] See A. M. Hind, *Catalogue of Early Italian Engravings in the British Museum* (Text 1910, Illustrations 1909), Text, pp. 39–40; *Andrea Mantegna and the Italian Pre-Raphaelite Engravers* 1911, pl. xix. The engravings of Finiguerra are assigned to the last ten years of his life (1454–1464). The earliest date on an Italian engraving is 1461.

[3] *Catalogue*, Text, pp. 124–5, pl. A ii. 11; *Mantegna*, pl. xxix.

[4] *Cat.* pl. B iii. 11; *Mantegna*, pl. xxxiii.

[5] *Cat.* Text, pp. 382–391; *Mantegna*, pl. lviii–lx. He worked *circ.* 1475–1505, first at Mantua under Mantegna, and afterwards probably at Milan.

Hypnerotomachia Poliphili (1499), which has some remark-
able representations of Renaissance buildings, or the Latin
Herodotus printed at Venice in 1494, the title-page of which
has a magnificent border of candelabra and other forms of
Renaissance ornament[1], would find their way across the
Alps.

II. *Châteaux*

The definite introduction of Renaissance architecture
into France begins with the installation by Charles VIII
after his Italian expedition of a small colony of Italian
artists and workmen at Amboise. They were twenty-one in
number[2], including two women, and among them were
represented a considerable diversity of trades and professions,
such as a keeper of parrots, and an *ouvrière de chemises à la
façon de Catelogne*. The sculptors and workers in wood may
be reserved till the next chapter. Architecture is represented
by Fra Giocondo, Domenico da Cortona, and Messer Luc
Becjeame, who is described as *jollier [jouailler] et inventeur
subtil a faire couver et naistre poulets, chevalier, deviseur de
bastiments*. Their names and rates of pay are all set forth
in a document signed by Charles VIII on February 26, 1498
(N.S.), which states the wages of each for the year ending
December 31, 1498. Presumably they had been established
at Amboise since the end of 1495, but the accounts for the
years 1496 and 1497 are missing. The rate of pay in the
majority of cases was 240 *livres* a year, but Fra Giocondo
received 562½ *livres*, and Messer Luc Becjeame and a famous
landscape gardener, Dom Pacello da Mercoliano, 375 *livres*
each[3].

Domenico Bernabei of Cortona, surnamed Il Boccadoro,
who afterwards achieved considerable distinction, was pro-
bably quite a young man when he came to France, for he

[1] See Prince d'Essling, *Les livres à figures Vénitiens*, 2 tom., Florence,
1907–1909, I (2), 197.

[2] I have not included the Greek scholar, Janus Lascaris.

[3] A. de Montaiglon, *État des Gages des ouvriers Italiens employés par
Charles VIII* in *Archives de l'art français*, I. (1851–2), 94 ff.

lived till 1549[1]. He is described as *faiseur de chasteaux* (probably wooden towers employed in attacks on fortresses) *et menuisier de toutes ouvrages de menuiserie*. He was a pupil of Giuliano da San Gallo, who was equally eminent as an architect, a military engineer, and a wood-carver[2]. His pay was at the normal rate of 240 *livres* a year. Of the first twenty years of his residence in France few records have been preserved. When the Pont Notre-Dame collapsed in 1499, he was among the architects consulted with regard to its rebuilding. In 1510 he was employed on the furniture at Blois, and in 1512 he bought two adjoining houses in that town and resided there for eighteen years[3]. But Louis XII's addition to the château had been completed nine years before this, and there is nothing to connect Domenico da Cortona with any architectural work during the reigns of Charles VIII and Louis XII[4].

It is otherwise with Fra Giocondo[5], who, during the ten years that he remained in France, played an important part not only as an architect but generally as a promoter of Italian influence in artistic matters. Gifted with that versatility which is so remarkable a feature of the Italian Renaissance, he was not only an architect but a distinguished humanist, and during his stay in France he rendered good service to classical scholarship by copying *in extenso* a manuscript of Pliny's *Letters* which he found at Paris. This he sent to the printer Aldus, who, having subsequently received from the Venetian ambassador the manuscript itself, published in 1508 a more complete edition of the letters than had hitherto appeared[6]. Fra Giocondo himself published

[1] Among Luca Signorelli's pupils was Tommaso d'Arcangelo Bernabei of Cortona.

[2] In 1498 both Giuliano and his brother Antonio described themselves as *legnaiuoli*. (Gaye, *Carteggio*, I. 342).

[3] In the Rue Chemonton, near the Hôtel de Guise.

[4] See Geymüller, I. 74–7. [5] See Vasari, ed. Milanesi, v. 261 ff.

[6] In 1502 Avantius, a fellow-townsman of Fra Giocondo, had published the *editio princeps* of two-thirds of Pliny's correspondence with Trajan, omitting letters 1–40, from a mutilated and imperfect copy of the same manuscript. (See E. G. Hardy, *C. Plinii epistulae ad Traianum*, 1889, pp. 65–7.)

editions of Vitruvius, upon whom he lectured at Paris in 1502[1], Frontinus, and other Latin authors[2]. His lectures were attended by Budé, who in his *Notes on the Pandects* warmly acknowledges the help he had received from the eminent architect and scholar[3]. It was probably the stimulus thus given to the study of classical architecture which led Geofroy Tory in 1512 to publish an edition of Alberti's *De re aedificatoria*.

But it is with Fra Giocondo's work as a practical architect that we are now concerned. His fame in this capacity has been firmly established by Baron von Geymüller, who having discovered over a hundred of his architectural drawings in the Uffizi, and over a thousand in the Destailleur collection, and having found the key to his hitherto unintelligible design for St Peter's, proclaimed him to be the greatest Italian architect of his day after Bramante and Leonardo da Vinci. Certainly there are few buildings of the Renaissance or any other time that shew greater originality or are better suited to their particular purpose than the Palazzo del Consiglio at Verona.

The colony at Amboise also included Girolamo Pachiarotti, who is described as *maistre ouvrier de maçonnerie*, and whose annual pay was 240 livres. He did much excellent work as a decorative sculptor, as will be noticed in a later chapter. His description implies that he also worked as a mason, but taken with the rate of his pay it does not suggest that he was in any sense an architect.

Charles VIII planted his Italian colony at Amboise in order that they might assist in the great building operations that he was carrying on at his château. As early as 1488 he had begun to make extensive additions, and by 1494, before the Expedition to Italy, the little chapel of Saint-Blaise and several other important buildings were completed[4]. On his return from Italy, under the influence of his new experiences,

[1] Delaruelle, *G. Budé*, p. 89, n.[1], quoting from Lefèvre d'Étaples's commentary on the *Organon* (1503).

[2] Tiraboschi, VI. 1144–1500.

[3] *G. Budé*, p. 90, n.[1]. [4] Geymüller I. 115–116.

and with Fra Giocondo to advise him, he continued the work. Unfortunately the château has suffered so much from successive demolitions and alterations that at the present day it is not easy to make out exactly what was executed during his lifetime. But apparently it comprised the greater part of the southern tower (Tour Hurtault), the lower portion of the northern tower (Tour des Minimes)[1], the Pavillon des Vertus with the adjoining buildings, and the block to the west of the northern tower[2]. The building was continued after Charles's death. In 1500 François de Pontbriant, seigneur de La Villate, who had been sent on a mission to Ferrara in 1476, was appointed overseer of the works. At the end of 1502 the keystone of the vault of the Tour Hurtault was put in its place, but the Tour des Minimes, on the side towards the Loire, was not completed till the reign of Francis I. It is in these two towers— in their round windows, and in the spiral sloping ways up which a horse could be ridden[3]—that the influence of Italy is chiefly to be traced. There are also signs of it in the ornamentation of the pendants of the vault in the Tour Hurtault.

The first noble to rebuild his château after the return of Charles and his army from Italy was Pierre de Rohan, Maréchal de Gié[4]. In 1482 he had bought the estate of Le Verger, situated about thirteen miles north-west of Angers, and in the château which then stood on it he received the

[1] The Tour Hurtault was begun in October, 1495. See L. de Grandmaison, *Comptes de la construction du château d'Amboise* in *Congrès archéologique de France*, 1910 (2), 284 ff.

[2] See J.-A. Du Cerceau, *Les plus excellents bastiments de France*, 2 vols. 1576, vol. II.; *French châteaux and gardens in the Sixteenth Century*, by J.-A. Du Cerceau, ed. W. H. Ward, 1909, p. 9 and frontispiece; Ward, I. 7 (fig.), 16 and 17; J. de Croÿ, *Nouveaux documents sur les résidences royales des bords de la Loire*, Blois, 1894, pp. 8–25 and p. 189; L'Abbé Bossebœuf, *La Touraine historique et monumentale. Amboise*, 1897; P. Vitry, *Tours*, pp. 363–6; G. Eyries, *Les châteaux historiques de la France*, 2 vols. 1877–79, I. 67–98. All that is left standing are the two chapels, the great towers, and two blocks adjoining the Tour des Minimes.

[3] Et se peuvent veoir les tours par où lon monte a cheval (Commynes, *Mémoires*, VIII. c. 18).

[4] See above, pp. 155–6.

young king on two occasions, in July and August, 1491. The first visit was paid two days after the battle of Saint-Aubin-du-Cormier; on the second, Charles signed a treaty of peace, to which formal shape was given at Sablé on the following day[1]. On his return from Italy Pierre de Rohan pulled down this old château, and having cleared the site proceeded to build a new one. By February 1499 it was sufficiently far advanced to enable him to receive a visit from Louis XII and his court.

If Amboise has suffered in the course of the ages, Le Verger has fared far worse, for in 1778 its last owner Cardinal de Rohan, now chiefly remembered for his share in the diamond necklace scandal, in order to gratify his family pride, destroyed the château previous to selling the estate, and we have practically nothing but two seventeenth century engravings[2] from which to form an idea of one of the earliest of the great châteaux of France to shew the influence of the Renaissance.

It had, at any rate, the advantage over its rivals of a clear site and level ground. This made a symmetrical plan possible. As was natural so near to the Breton border, which had only recently been the scene of serious disturbance, it was designed for defence, as well as for pleasure. This is shewn by the two huge round towers standing well in advance of the entrance gateway, and by the battlemented and machicolated wall on either side of them, which is unpierced save by four loopholes and a single small window. The wing parallel to this at the far end of the second court with its lofty Flamboyant dormers seems to be purely Gothic. That between the two courts has more of a Renaissance character, for the arrangement of the windows is governed by that principle of symmetrical alternation to which Geymüller has called attention as a

[1] *Lettres de Charles VIII*, III. 184 ff. and 210 ff.; R. de Maulde, Introduction to *Procédures politiques du règne de Louis XII* (Doc. inédits sur l'hist. de France), 1885.

[2] Geymüller, I. 49 (by Isaac Silvestre) and Michel, p. 504. See also Geymüller, I. 69, and Piganiol de La Force, *Nouvelle description de la France*, VI. 120.

characteristic of Italian Renaissance architecture. In the first storey, small square windows without balconies alternate either with similar ones which have balconies or with niches for statues; in the second, dormers alternate with small windows. In the centre the entrance is surmounted by an equestrian statue of the owner, above which again is a large dormer of two storeys. This equestrian statue, another Italian feature, is generally regarded as earlier than that of Louis XII at Blois. This, however, seems to be merely an inference from the fact that the château of Le Verger was begun before the new wing at Blois. The evidence points the other way, for in the Latin verses, bristling with false quantities, inscribed beneath the statue, reference is made to Pierre de Rohan's second marriage, which took place in 1503[1], and Blois was completed in that year. In either case it may be conjectured that Pierre de Rohan employed the same artist as Louis XII, namely Guido Mazzoni.

There is no direct evidence as to whom are due the symmetrical plan and the other Renaissance elements of Le Verger. But Geymüller sees in them the hand, or at least the influence of, Fra Giocondo[2]. This is highly probable, for in the first place so important a person as the Maréchal de Gié would naturally have found the services of the royal architect at his disposition, and in the second it is almost impossible to suppose that any French master-mason could have made such a plan unaided. M. Vitry, indeed, says that the château "was enlarged under Louis XII by the architect, Colin Biart[3]," but all we know about Nicolas or Colin Biart, who was a master-mason of Amboise, in connexion with Le Verger is that he was summoned by Pierre Rohan "to inspect and execute certain works there," and that this was after the year 1500, by which time a considerable portion of the château had been built[4].

[1] See Gaignières's drawing $\frac{Oa}{15}$ T 96; H. Bouchot, *Inventaire des Gaignières*, I. no. 807, reproduced by Delaborde, *Expédition de Charles VIII*, p. 627.

[2] Geymüller, I. 69. [3] Michel, p. 503.

[4] Colin Biart...a été à conduire le commencement des ponts Notre-

When Pierre de Rohan's public career was closed by his disgrace in 1506, he retired to this magnificent palace, and spent the remaining seven years of his life in its embellishment. He had, at any rate, one advantage over his successful rival, Cardinal d'Amboise; he lived to enjoy the fruits of his great work. Moreover, though Gaillon might surpass Le Verger in size and splendour, in the opinion of one who visited both in 1517 Le Verger was more comfortable and better arranged[1]. Pierre de Rohan was as enthusiastic a connoisseur of art as the Cardinal. He was a diligent collector of works of sculpture, and brought back from Florence in 1499 seven marble busts and two of bronze. He had a special love of tapestries, and had some made to his order[2]. A remarkably fine one, which probably represents him with his second wife, Anne d'Armagnac, is preserved in the museum of the Archevêché at Angers.

Though Louis XII continued the work at Amboise after his predecessor's death he was chiefly interested in his ancestral château of Blois, to which he added the wing bearing his name[3]. Its chief features, besides the *corps de logis* containing the royal apartments, are an entrance gateway with the king's statue in a niche above it, and on the court side two rectangular stair-towers and a loggia. The whole building was completed in 1503[4]. It is of red brick patterned with bricks of dark blue arranged diamond-wise and relieved with stone dressings, a combination of brick and stone which was to become very popular in France during the next hundred years. Geymüller is inclined to accept Choisy's

Dame de Paris [this was in 1500]. Depuis fut appelé par le seigneur de Gié, à voir, faire et visiter quelques œuvres du château du Verger et au château d'Amboise, et depuis au château de Blois. (Quoted by Deville, *Comptes de Gaillon*, p. cviii from *Bull. Arch.* for 1843, p. 469.)

[1] E molto megliore inteso e de piu commode habitatiune (*Die Reise des Kardinals Luigi d'Aragona*, ed. L. Pastor, Freiburg, 1905, p. 130).

[2] See Bouchot, I. nos. 808–812; J. Guiffrey, *Les Tapisseries* (vol. VI. of *Hist. Gén. des arts appliquées*), pp. 88–9.

[3] See Du Cerceau, vol. II.; *id.* ed. Ward, pll. III.–v.; Ward, pp. 17–19; F. Bournon, *Blois, Chambord et les châteaux du Blésois*, 2nd ed. revised by P. Vitry, 1911; Croÿ, *op. cit.* pp. 26–43.

[4] Croÿ, pp. 191–194.

view[1] that the revival of the use of brick in France, which, except in the south, had been almost entirely given up in the Middle Ages, was due to the influence of Italy[2]. But we have examples of brick in Martainville, which dates from 1485, in the château Du Moulin, near Blois, which was begun before the Expedition to Italy, and in the manor-house of Le Clos-Lucé close to Amboise, where Leonardo da Vinci spent his last days, which was built about 1490[3]. This much, however, is certainly true, that the French learnt from Italy —especially from Milan and other North-Italian towns— the admirable effects of colour and pattern that were to be obtained from brick. A charming example is to be seen in a dovecot at Boos near Rouen, where the bricks, dressed with stone, are most ingeniously and picturesquely arranged in various patterns[4]. The French also learnt from Lombardy the use of terra-cotta; a workshop of that material was set up at Amboise by an Italian named Girolamo Solobrini, and fragments have been found near the château of terra-cotta pilasters decorated with characteristic Renaissance motives[5].

To return to Blois, except for the equestrian statue over the entrance, the design of the outer façade shews no trace of Renaissance influence. In its modest, but picturesque and not undignified, homeliness, it is in striking contrast to the building of Francis I, which soars above the place Victor Hugo. The square-headed windows, indeed, combine with the beautiful balustrade and the emphasis laid on the string-course between the storeys to produce a certain horizontal effect which suggests the Renaissance, but this is counteracted by the perpendicular line of the windows in the three storeys, by the lofty dormers, and the high-pitched roof. It is much the same with the façade on the court side (Plate I); only here

[1] *Hist. de l'Architecture,* II. 703.

[2] See Geymüller, I. 439–445.

[3] The houses on the new Pont Notre-Dame (1502–1512) were of brick and stone (Corrozet, *Les Antiquitez de Paris,* 1562, p. 150).

[4] Geymüller, I. 440 (ill.).

[5] In a letter to Octovien de Saint-Gelais mention is made of seven dishes ordered of "Jérôme Solobrin, potter of Amboise." See Vitry, *M. Colombe,* pp. 190–192.

Plate I

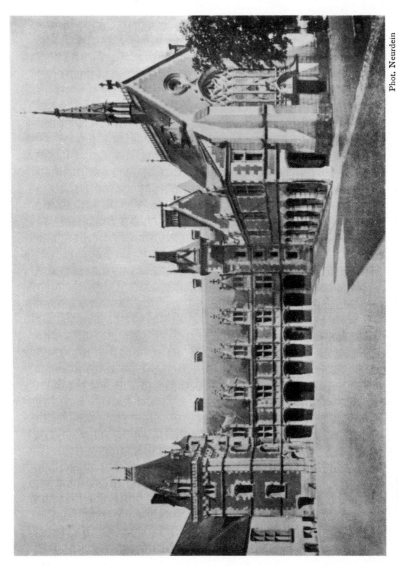

Château of Blois : East side of court

the horizontal effect is increased by the broad band of stone-work, decorated chiefly with acanthus, which takes the place of a string-course below the windows of the first storey. The arches of the loggia are supported by alternate round and four-sided columns, the round ones being decorated with fleur-de-lys (for France) and ermine's tails (for Brittany), and the others with arabesques. The capitals are not classical, but are decorated with fantastic ornament. The columns are short, and stand on very high bases. The arches are three-centred, and spring ungracefully from the capitals. Thus the general effect of the loggia is not very pleasing. Far more effective is the rectangular stair-turret. With its high-pitched roof, rich dormers, and Flamboyant doorway, it is Gothic in general appearance, but at the top of the brick-work there is an egg and dart moulding, and the acanthus makes its appearance under the sills of the dormers.

As regards the Renaissance details, it may be noted that the arabesques on the columns of the loggia are decidedly less fine in execution than those on the spiral staircase of Francis I. They may well have been executed by a French workman with a pattern before him. One thoroughly Italian feature of the château was its terraced garden laid out by Dom Pacello, who made a similar pleasaunce, surrounded by a cloister, at Amboise. In the middle was a domed pavilion, the work of Il Boccadoro.

Here, again, we can only speculate as to the author of the general design. We know, indeed that Colin Biart had some share in the work, but not till it was more than half completed, and probably his share chiefly consisted of inspection and advice. It might possibly have included a design for some portion of the building, such as the loggia[1], but this is mere conjecture. Of Fra Giocondo's connexion with Blois there is no trace. It would be natural, indeed, to suppose that as royal architect, drawing an annual salary, he would be consulted

[1] The *maître des œuvres* for the County of Blois was Simon Guischart; he had the title from *circ.* 1500, but acted before this. Jacques Sourdeau was also employed as master-mason (Croÿ, *op. cit.*).

without a special payment, and the fact that the Renaissance
enters so little into the design does not make this impossible.
Fra Giocondo was an architect of genius, not necessarily
wedded to any particular style, but one who in designing a
new building would take into account conditions and sur-
roundings and previously existing structures. But he seems
to have been busy at Paris at this time. When the Pont
Notre-Dame collapsed on October 25, 1499, he was among
those who were consulted with regard to the new bridge.
The discussions lasted till near the close of 1502, and the
work was entrusted to him as chief architect[1]. He was
engaged on the work in July 1504[2]. We also know that
during these years he was employed on the decorations of
the Grand' Chambre of the Palais de Justice, while the
Chambre des Comptes is generally regarded as his work.

With the outer façade of Louis XII's wing at Blois may
be compared the noble wing which was added to Châteaudun,
the palace of the Orléans-Longueville branch, some eight
years later[3]. The celebrated Jean d'Orléans, the bastard
son of Louis d'Orléans, better known as Dunois, had made
considerable additions to the château[4]. In particular, he
had built the left wing and the chapel adjoining it. On his
death in 1468, he was succeeded by his son François I, who
married Agnes of Savoy, sister-in-law of Louis XI, and it is
to these owners that the Flamboyant stair-tower on the
extreme left of the north wing is with great probability
ascribed. François I died in 1491 and his widow in 1508.
It was under their eldest son, François II, that the north wing
was begun in 1510. He died in 1512[5], and as his daughter

[1] Iocundus geminum imposuit tibi, Sequana, pontem;
 Hunc tu iure potes dicere pontificem.
 Sannazaro, *Epigr.* lib. i. liii.

[2] See Geymüller, i. 83–4.

[3] See L.-D. Coudray, *Histoire du Château de Châteaudun*, 3rd ed. 1893;
Ward, i. 9, 11. 21–2; *Mon. Hist.* iii. 58–9; L. Serbat in *Bull. Mon.*
LXXVI. (1912), 531 ff.

[4] He was invested with the County of Dunois, of which the château
formed part, by his brother, Charles d'Orléans, in 1441.

[5] February 12, 1512 (N.S.). When he married in 1505, his cousin and
guardian, Louis XII, erected the estate of Longueville into a duchy.

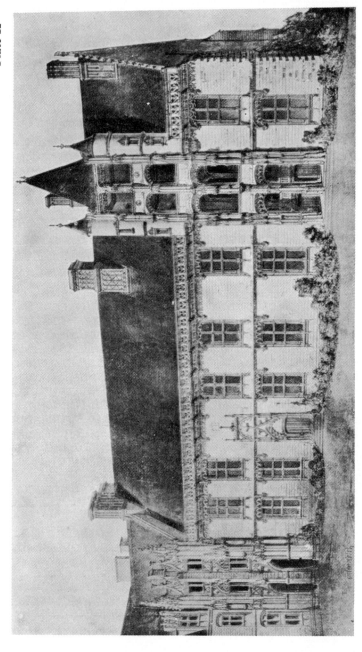

Plate II

Châteaudun : north wing

(From Ward, *The Architecture of the Renaissance in France*)

Renée who succeeded him was a child of four, the work was carried on by her uncle, Jean d'Orléans-Longueville, Archbishop of Toulouse[1]. He seems to have continued his supervision and co-operation during the ownership of his brother, Louis I, who succeeded Renée in 1515 and died in the following year, and that of his nephew Claude, who was killed at Pavia in 1525[2]. The work was finished in 1518.

Though in its general lines this north wing of Châteaudun (Plate II) resembles Blois, it differs naturally in certain details. In the first place, it is built of stone instead of brick. Secondly, the windows in both stories are considerably larger and more richly ornamented. In fact, the only criticism that one is inclined to make is that the ornamentation over the windows is too florid. A noticeable feature is the absence of the traditional dormers. The exquisite balustrade surpasses in delicacy even those at Blois, and gives a special air of distinction to the whole building. Below it a classical egg and dart moulding contrasts pleasantly with the mediaeval gargoyles. This moulding, indeed, is the only purely Renaissance feature in the *corps de logis*. On the other hand the beautiful stair-tower, with its four-storied loggia of coupled arches and the wonderfully delicate arabesques of its newel, contains very distinct Renaissance elements, but this was no doubt the last part of the work to be taken in hand.

Château d'O in Normandy was rebuilt by Charles d'O about 1505. It suffered from drastic alterations in 1770, but a considerable portion of the sixteenth century work still remains. Most of it is essentially Gothic, but here and there Renaissance details appear, as in the doorway of the

[1] Père Anselme is no doubt wrong in inferring from the absence of his name in a certain document that he was a posthumous child. The date of his birth is generally given as 1484; he was made Archbishop of Toulouse in 1502.

[2] The exact part which the Cardinal de Longueville—he was made a Cardinal shortly before his death in 1533—took in the building is not clear. M. Coudray (p. 117) speaks of him as the uncle of Louis I, but he was really his brother.

stair-tower which is framed by pilasters and has a medallion
above it. The chief interest is in the loggia of seven arcades,
which alike in the awkward spring of the arches, in the
fantastic capitals, and in the decoration of the shafts bears
a close similarity to that of Louis XII at Blois[1].

A château which owes its inspiration more directly to the
Maison de Jacques Cœur than to Blois is that of Meillant in
Berry, which having been added to by Charles II de Chaumont
d'Amboise, the governor of Milan, gave rise to the saying,
"Milan a fait Meillant[2]." The older portion was built by
his father, Charles I, and is a purely Gothic building.
Charles II added (*circ.* 1503) the Tour du Lion, an octagonal
tower, which contains the usual spiral staircase, and the *corps
de logis* immediately to the left of it. The lower half of the
tower is still Gothic, but the upper half has Renaissance
features, such as pilasters at the angles and shell canopies
below the balustrade, and it is crowned by a lantern which
terminates in a little dome. Within the tower the staircase
is adorned with marble medallions. In the *corps de logis*
the cornice of the third storey has an egg and dart moulding,
and the left of the two dormers displays shell ornament.
But on the whole one is struck by the general adherence to
Gothic traditions in this new part of the château, built though
it was for a man who, as nephew of the great Cardinal and
governor of Milan, was probably a strong partisan of the
Italian Renaissance. Just as the builders of the north-west
tower of Bourges Cathedral were dominated by the style of
the existing structure, so the addition to Meillant continues
faithful to that type of Gothic architecture which is so well
exemplified in the house of Jacques Cœur and the old *hôtel
de ville* (now the *petit lycée*) at Bourges, and in the neigh-
bouring château of Ainay-le-vieil[3]. In this latter, which has
in the *grande salle* a chimney-piece with the monograms of

[1] See *Country Life* for Feb. 24, 1912 (text by T. A. Cook); Palustre,
II. 275; Brossard, *Nord*, pp. 623-4.

[2] See Hardy and Gandilhon, *Bourges*, pp. 143-150. Meillant is five
miles south-west of the station of Saint-Amand-Montrond, from which it
is a charming drive through wooded and undulating country.

[3] See *ib.* pp. 149-150.

Louis XII and Anne of Brittany, we see the same emphasis laid on horizontal lines as at Blois[1].

A somewhat similar mixture of Flamboyant and Renaissance elements is found in the château of Fontaine-Henry, about nine miles north of Caen[2]. It is chiefly known for the fine Renaissance pavilion with its inordinately steep roof, which was added in the middle of the reign of Francis I, the date of 1535 being on one of the windows. But among the older parts of the château, which at this time belonged to the family of Harcourt, are a Flamboyant *corps de logis* flanked by two square stair towers, of which the northern one shews some trace of Renaissance influence. To the north of this again is a wing evidently built, or perhaps rather transformed, at a slightly later date, in which the Renaissance elements are much more conspicuous. Though it retains a good many Gothic features[3], this was probably not begun till after the beginning of the reign of Francis I.

III. *Gaillon*

If at Amboise and Blois, at Châteaudun and Meillant, the architectural character of the new buildings was influenced by those already existing, at Gaillon Cardinal Georges d'Amboise had practically a free hand. The original château, which had been ceded to the Archbishop of Rouen by Louis IX in 1262, was destroyed by order of the Duke of Bedford in 1424, and Cardinal d'Estouteville, having cleared the ground of the ruins, began in 1456 to build a new episcopal palace. But the work was stopped in 1463, when only a small portion was above ground. Amboise, who had been elected to the see of Rouen in 1494, determined to build on a much larger scale than that contemplated by his

[1] I only know this château from a small photograph in Foville and Le Sourd.

[2] See Marcel Fouquier, *Les grands châteaux de France*, 2 vols. 1907, II. 114; Michel, IV. ii. 531; J. S. Cotman, *Architectural Antiquities of Normandy*, 2 vols. 1822, II. 62. The château came into the Harcourt family in 1380 through the sister of Jean de Tilly, the last of the male line of the former proprietors.

[3] The accounts give the names of three master-masons.

predecessor. But, instead of selecting a perfectly new site on level ground, he used, as far as was possible, the old foundations, and even, to some extent, the existing buildings. After five years of preliminary preparations the actual work of construction was begun in 1502, and by the end of 1509 it was practically completed. When the Cardinal died in May 1510, it was nearly ready for habitation[1].

Its plan (Plate III), owing to the hilly ground, was unsymmetrical. The great gatehouse, which was reached by a drawbridge over the moat, led into the first or base court. This was of irregular shape, but measured roughly 280 feet by 110. On the side opposite the gatehouse was a cloister or loggia—the French term is *galerie*,—consisting of a long gallery resting upon open arcades. Through these you entered the great court, which was rectangular on three sides, the rectangular portion measuring about 280 feet by 200. On the right or north-east side were the state-apartments, called the Grant' Maison[2]. Facing these, but set obliquely to the loggia, was a block of buildings known as the Maison Pierre Delorme. The fourth side was formed by Cardinal d'Estouteville's building, which was, apparently, like the wing opposite to it, a loggia with a gallery above[3]. A large tower was pulled down, and on its site was erected a second gatehouse or pavilion, which gave access by another drawbridge to the garden. The court was paved with stone of different colours so as to form a regular pattern, and in the centre was a magnificent marble fountain which had been sent from Genoa as a present from the Republic of Venice to the Cardinal.

Adjoining the Grant' Maison were two stair-towers, of which the smaller one gave access to the state apartments,

[1] See A. Deville, *Comptes de dépenses de la construction du château de Gaillon* (Doc. inédits sur l'hist. de France), 1850, with a separate volume of plans and drawings; Du Cerceau, *Les plus excellents bastiments*, vol. I.; *id.* ed. Ward, pp. 9–11 and plates II. and XVI. (*b*); Geymüller, I. 70–1, 96–101; Ward, pp. 19–20; M. Vachon, *op. cit.* pp. 97–112.

[2] For a description of these apartments see *Mémoires du Duc de Luynes,* ed. Dussieux and Soulié, 1861, VII. 35 (written in 1745).

[3] See Deville, pl. IX.

Plate III

A

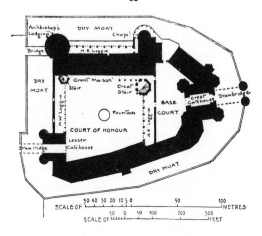

B

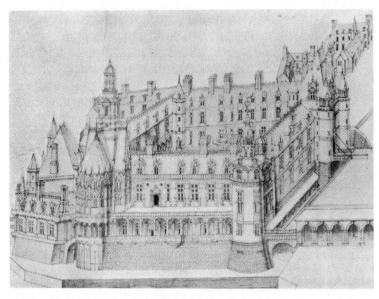

Gaillon : A, Plan ; B, Drawing of château from N.E. by Du Cerceau
(From Ward, *The Architecture of the Renaissance in France*)

and the larger one to the chapel. This latter, which, though of small proportions, was magnificently furnished with stained glass, stall-work, sculpture, and painting, was at right angles to the Grant' Maison at its south-east end. At the other end was a tower, projecting, like the choir of the chapel, well beyond the main line of buildings, which contained the Archbishop's private apartments, and between the tower and the chapel, on the outer side, ran a loggia, with a terrace at the top, upon which the windows of the Grant' Maison opened. The ornamental garden, which was reached by a bridge from the private apartments as well as by the draw-bridge from the smaller gatehouse, was laid out in formal beds in the Italian fashion by Don Pacello. In the centre was another Italian fountain, and along the north-west side ran a closed gallery, 153 feet in length, which was used for exercise. The tennis-court was in the moat under the north-east loggia.

Of this splendid palace nothing is left *in situ* but the great gatehouse, the lower chapel, one stair-turret, and the sub-structures of the Grant' Maison[1]. Some fragments, however, which were preserved by the care of Alexandre Lenoir, have been set up in the courts of the École des Beaux Arts. They consist of (i) a composite fragment of which the central part probably belongs to the south-east loggia and the two sides to the Grant' Maison; (ii) another fragment of the same loggia (in the second court of the École); (iii) part of the north-west loggia. With the help of these fragments, Du Cerceau's drawings, and the accounts published by Deville we are able in some measure to trace the development of the new style at Gaillon.

In the Grant' Maison and its external loggia, which was the first portion to be built (1502–1507), there is little or no trace of Renaissance work. The arches of the loggia are of the same flattened type as those at Blois and Château d'O. The next block in point of date, the contract for which was

[1] For descriptions of the château before its destruction at the Revolution, see *Die Reise des Kardinals Luigi d'Aragona*; *Mémoires du Duc de Luynes*, VII. 34–39; A. Ducarel, *Anglo-Norman Antiquities* [1677].

made on January 1, 1507, is the south-west wing; in this, so far as can be judged from Du Cerceau's drawing, the Renaissance element, if it exists at all, is confined to decorative details. The chapel and the great stair-tower leading to it, the south-east loggia, the lesser gatehouse, and the alterations to Cardinal d'Estouteville's building were begun almost simultaneously, namely at the end of 1507 and the beginning of 1508, and were all practically completed by the end of 1509[1]. Of these portions the chapel itself is Gothic, but its lantern is almost pure Renaissance. The lesser gatehouse, or pavilion of Pierre Delorme, is mainly Gothic, but it has pilasters on either side of the entrance on the court side[2].

It is in the south-east loggia with its gallery that the Renaissance makes itself most strongly felt. The central portion of this loggia, which now forms the centre of the composite fragment in the École des Beaux Arts[3], and the entrance gateway (*in situ*)[4] are, as Deville says, evidently by the same hand, or at any rate they proceed from the same inspiration. The designer was clearly one who was well acquainted with the practice of Italian architects. Both entrance portals have flat arches, which spring from imposts and are surmounted by lintels, the windows are framed in pilasters and crowned by shell canopies, the shafts of the pilasters are enriched with arabesques, and the divisions of the entablatures have their classical proportions. But the most interesting fragment of the south-east loggia is that in the second court of the École des Beaux Arts, the arches of which spring alternately from piers and pendants[5] (Plate IV). The treatment of these piers is highly original, but the special interest lies in the external decoration of the gallery over the loggia. For with its combination of medallions and pilasters, its candelabra and arabesques, it bears a strong resemblance to

[1] Over 44,000 *livres* were spent in 1507–8, and over 33,000 in 1508–9.
[2] Deville, pl. IX. [3] *Ib.* pl. VII.
[4] *Ib.* pl. V. Deville supposes that this was part of the work contracted for by Pierre Fain and his associates. This may be so, but we have not got the contract.
[5] *Ib.* pl. VIII.

Plate IV

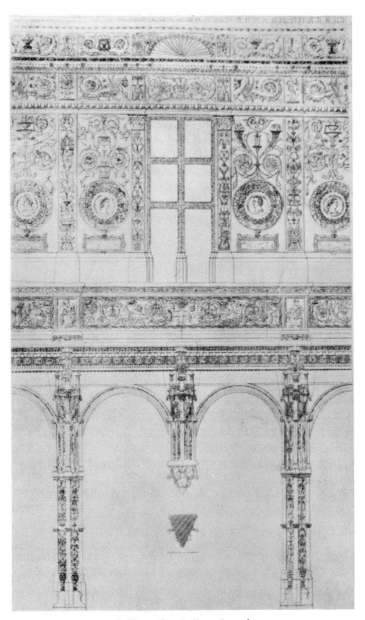

Gaillon : South East Loggia
(From Deville)

Fra Giocondo's Palazzo del Consiglio at Verona[1]. Now this brings us to a once hotly debated question, for there was an old traditional belief that Fra Giocondo was the architect of Gaillon, and when Deville published the accounts, and it appeared that Fra Giocondo's name was not mentioned in them, French patriots exclaimed in triumph that here was an end of the Fra Giocondo legend. But before we enter on this controversy, it will be well clearly to understand under what conditions building operations were carried on in mediaeval times, and particularly at the opening of the sixteenth century. Considerable light is thrown on the subject by the published accounts for the north-west tower of the Cathedral of Bourges.

About the close of the fifteenth century the Archbishop of Bourges, Guillaume de Cambrai, began to push on the building of this tower, which had been suspended for a long time. But in 1504 the foundations shewed signs of sinking, and in spite of the remedies which the chapter adopted on the advice of the leading experts in France, the tower fell on the last day of the year 1506. Undismayed by this disaster, the chapter again summoned well-known master-masons from other towns, who in consultation with the master-masons of Bourges drew up a written opinion with regard to the re-building. The first stone was laid on October 19, 1508, and the work was carried on under the supervision of two master-masons, Colin Biart of Amboise[2], and Jean Cheneau of Tours, who had been employed for sixteen years on the Cathedral at Auch. They were assisted by Guillaume Pelvoysin, master-mason to the chapter of Bourges, and Bernard Chapuzet, master-carpenter to the same chapter. Biart and Cheneau were paid ten *sous* a day, and Pelvoysin five. The greatest number of masons employed at one time was forty-three, that of ordinary labourers fifty-nine. Add

[1] The resemblance is pointed out by Geymüller (p. 70); he reproduces an engraving by Israel Silvestre, which cannot, however, be correct as regards the position of the building.

[2] See above, p. 390.

carpenters, sawyers, carters, plasterers (*bauchetons*), etc., and you get a total of about a hundred and fifty workmen. The pay of the labourers was two and a half to three *sous* in summer, and two in winter; that of the masons and carpenters four *sous* in summer and three in winter. They worked only five days a week. In the accounts of 1511 figure-sculptors (*imagiers*) appear for the first time, chief among them being Marsault Paule, a native of Bourges. But many of the masons were also sculptors, and quite capable of doing decorative work. In 1512 one of the canons was appointed overseer of the works with a salary of thirty crowns a year[1].

There is no record in these accounts of any payment for a plan, but, as M. Vitry has pointed out, the building accounts that have come down to us are not always complete. Either Colin Biart or Jean Cheneau may have made a design for the tower without a special payment being made, or without there being any record of it, or they may have merely given verbal instructions to the masons in accordance with the written opinion of the committee. On the other hand in the accounts of the Hôtel de Ville at Bourges, which was rebuilt after the great fire of 1487, we find that a mason named Jacques Gendre receives forty-five *sous* for a specification (*devis*), and two others a hundred *sous* for drawing a plan on parchment[2]. It is clear that on the one hand we are not justified in describing a master-mason as the architect of a

[1] See Baron de Girardot, *Les artistes de Bourges* in *Archives de l'art français*, 2^me série, I. 1861, 209 ff. It is interesting to compare these accounts with those of King's College Chapel, where after an interval of twenty-four years the work was resumed in 1508, that is to say, in the same year as the north-west tower was begun at Bourges. At King's from 140 to 150 workmen were employed. In the fortnight, for instance, from July 23rd to August 6th the number was 150, composed chiefly of masons (89) and labourers(41). The masons received 3s. 4d. a week or 8d. a day, the labourers 4d. (Willis and Clark, *The Architectural History of Cambridge*, 4 vols. 1886, I. 475.) Two master-masons were paid each £13. 6s. 8d. per annum, a master-carpenter £18. 5s., and the surveyor or overseer of the works (Thomas Lark, Archdeacon of Norwich and Master of Trinity Hall) £20. (Building accounts of King's College Chapel, 1509–1515.)

[2] Girardot, *loc. cit.* p. 240.

building because he contracted for the work, or inspected it while it was in progress, and that on the other we have no right to deny his claim to be so described on the ground that he did not make a design, and still less on the ground that no special payment for it is recorded in the accounts[1]. The architect in the modern sense of the term did not exist in mediaeval times either in name or in substance, but we can point to several master-masons of our period who have a good claim to be regarded as the architects of the buildings with which their names are associated. Such are Martin Chambiges of Paris, who built the transept at Sens and the choir at Beauvais, and who was consulted with regard to the Cathedral at Troyes; Jacques Le Roux, who submitted to the Cathedral Chapter of Rouen a design for the façade, and his nephew Roulland Le Roux, who made a fresh design and was entrusted with the execution of the work; and Jean Texier of Beauce who added the wonderful spire to the north-west tower of Chartres[2]. On the other hand, in the case of many buildings of the period, it is impossible to say that there was an architect in any sense of the term for the whole work. This, as we shall see, was the case with Gaillon, to which we may now return.

It appears from the accounts that various Rouen masons undertook different portions of the work, Guillaume Senault[3] the Grant' Maison, Pierre Fain the chapel, the great stair-tower, and the loggia between the two courts, Pierre Delorme the south-west wing, the lesser gatehouse, and the reparation and alteration of Cardinal d'Estouteville's wing (*le viel corps d'Hostel*). But while Fain and Delorme contracted for their

[1] It was the same in this country. There is, for instance, no mention of a design in the accounts of King's College Chapel; on the other hand we find in the accounts of Eton College that Humphrey Coke made a design for a new building, probably the Cloister, and was paid in advance for executing part of it. (Willis and Clark, I. 415.)

[2] See Geymüller, I. 101–103. Practically the master of the works of masonry, when there was one, took the place of the modern architect. It was his business to make plans and to superintend the execution of the work.

[3] Senault was employed at Amboise from October 1495 to September 1496, at the rate of 6 *sous* 3 *deniers* a day (L. de Grandmaison, *op. cit.*).

portion of the work, receiving a certain sum down, Senault
was paid, like the other workmen, every Saturday, his
pay being at the rate of 7½ *sous* a day. We also find him
receiving payment for taking his plans (*pourtraictz*) to Rouen,
evidently in order to submit them to the Cardinal. In
addition to these three, we find mention of Colin Biart
of Amboise, who is here described as "master-mason in
the town of Blois[1]," and Pierre Valence, a master-mason of
Tours. Biart, unlike the three Rouen masons, was not
employed continuously, nor did he work with his hands. He
either inspected the buildings, or visited quarries to choose
stone, and his name only appears in the accounts between
May 1504 and September 1506, that is to say, before either
Pierre Fain or Pierre Delorme had contracted for their
portion of the building. He had, as we have seen, done
similar work at Amboise, Le Verger, and Blois[2]. Pierre
Valence, who is often called Jean in the accounts, was a man
of versatile talent, being not only a mason but a carpenter
and an hydraulic engineer. Like Biart, he was employed
to inspect the buildings, but being nearer at hand—he was
engaged on the Archbishop's palace at Rouen—he inspected
them more frequently. In 1507 he worked at the wains-
coting for the great gallery along the garden, for which he
was paid six *sous* a day, and in 1508, when his headquarters
were at Tours, he was exclusively occupied during the months
of April and May with the hydraulic works in connexion with
the fountain in the great court. For this he received twenty
livres a month[3].

Thus there are no traces of what we should call an
architect for the whole building. Apparently Senault made
plans for the Grant' Maison; he was evidently a man of
some distinction in his profession, for he was consulted both
at Bourges and Rouen as to the building operations. Fain
and Delorme were master-masons, and Delorme, at any rate,
seems to have done a certain amount of carving, but their

[1] He was at this time in the service of the Bishop of Blois.

[2] See above, p. 390, and Vachon, *op. cit.* pp. 169–176.

[3] For the above see Deville, *op. cit.* pp. xcii–cxv and his references to the
accounts.

main business was that of contractors. Apart from his work at Gaillon Delorme is quite unknown, and we only hear of Fain as overseer of the works for the Archbishop of Rouen and the Abbot of Saint-Ouen. To speak of Delorme or Fain as joint-architects with Senault of Gaillon is to go far beyond the evidence.

But may Fra Giocondo be so described? To the objection that his name appears nowhere in the accounts Montaiglon answered that we do not possess all the accounts, and Geymüller added that Fra Giocondo, who was receiving a salary as the King's architect, might well have furnished a design gratis for the King's minister, or might have been recompensed for it in some way or other without his name appearing in the accounts. But he also adduces a positive argument in favour of his intervention, and that is the striking similarity already noticed between the decoration of the south-east loggia and that of the Palazzo del Consiglio at Verona. The foundations of this loggia were not laid till September 1505, the year in which Fra Giocondo left France, but he may have made a design for it before his departure, and we may fairly suppose that this design included the central portion. At any rate it is clearly the work of an Italian architect. There is nothing to suggest that it was within the capacity of Pierre Fain, the contractor. As a drawing for the chapel signed with Biart's initial has been preserved[1], he may be credited with this portion of the work. On the other hand we must in all probability look elsewhere for the designer of its Renaissance lantern.

There is one structural feature of Gaillon that calls for special notice. The round towers at the angles of the great court, even the gatehouse towers, were no longer formidable defences. One of them formed part of the chapel; in another were the archbishop's private apartments. Twenty years later round towers disappeared entirely, and their place at the angles of the court was taken by square pavilions, as at Écouen, Fontainebleau, and Ancy-le-Franc.

[1] Deville, pl. XIV.

As regards the execution of the details we may probably accept Geymüller's view that part of it was due to Italians and part to Frenchmen working from North-Italian designs. The arabesques, for instance, on the pilasters of the portion of the south-east loggia which stands in the second court of the École des Beaux-Arts and the classical mouldings on the entablature are very fine work, while the arabesques on the gallery above the loggia and on the pilasters of the windows are much coarser. Again, in the central portion of the composite fragment, which probably formed part of the same loggia, much of the ornamentation, according to Geymüller, was designed and executed by Italians; four of the ornaments, he points out, recall San Satiro at Milan, and one Santa Maria delle Grazie. The capitals of the lower pilasters are, he thinks, the work of Italians, those of the upper ones of Frenchmen after Italian models[1].

We read in the Duc de Luynes's *Memoirs* that the *cour d'honneur* at Gaillon was *fort ornée de sculptures et de médaillons*[2]. We have seen that the practice of decorating blank surfaces with marble, stone, or terra-cotta medallions was much in vogue at Milan as well for ecclesiastical as for civil buildings. In the Sacristy of San Satiro (Plate V) the circular frame sometimes takes the form of a garland. The heads sometimes represent Roman emperors or other distinguished Romans, sometimes the Dukes of Milan, as in the doorway of the Old Sacristy at the Certosa. It was doubtless from Milan that the fashion was introduced into France.

In the Gaillon accounts reference is made under the date of August 1509 to "the medallions (*médailles*) furnished by *messire* Paguenin (Guido Mazzoni)[3]." One of these, on which is carved in high relief a bust in profile of the Emperor Caldusius—an imaginary person—is now in the Louvre. Other medallions from Gaillon are preserved in the courts of the École des Beaux-Arts. They seem to belong to two series, one in which the heads are very finely modelled, and

[1] Geymüller, I. 99. [2] *Op. cit.* p. 35.
[3] Deville, p. 405. This does not necessarily imply that they were made by Mazzoni himself.

Plate V

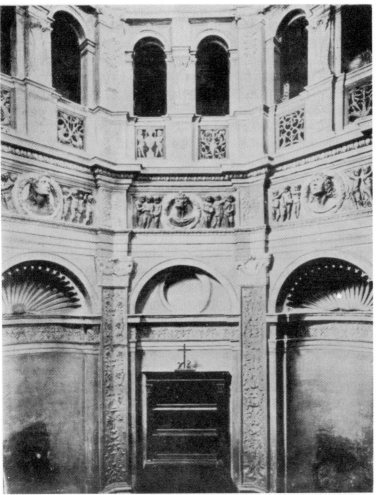

Milan : Sacristy of San Satiro

the other in which they are larger and coarser. To this second series belong two medallions of Vespasian and Hadrian, one on either side of the composite fragment[1].

From this time the practice of using medallions for decorative purposes became very common in France, and we find numerous instances in the buildings of our period. The material was sometimes stone, sometimes marble, sometimes terra-cotta. Heads of the Caesars are common; they are to be found in the Hôtel d'Alluye at Blois (terra-cotta), and in the Hôtel de Beaune at Tours, and they once adorned the palace of the Dauphins at Grenoble[2]. In the Hôtel d'Alluye the twelve Caesars are accompanied by Aristotle, whose medallion is sometimes described as that of Robertet's patron, Cardinal d'Amboise. We have a real example of a contemporary portrait in the medallion of Antoine de Lannoy, a fine work in marble, with his name, followed by CAPPI DU PALAIS DE GENES LAN 1508, inscribed in the exergue[3]. He was a nephew of Raoul de Lannoy, the Governor of Genoa for Louis XII.

These earliest examples of medallions in France were imported ready made from Italian *botteghe*, where they were turned out in hundreds. But soon the French workmen learnt to make them for themselves. We find them in the Hôtel des Pénitentes at Angers, in the Hôtel de Ville at Vendôme, in the Bureau des Finances at Rouen, in Tristan de Salazar's addition to the episcopal palace at Sens, the framework in these last two cases taking the favourite form of a garland. They were even, as in Italy, used for the external ornamentation of churches, as we may see in the Church of Saint-Pierre at Dreux. The Louvre possesses two interesting examples from the Château de Bonivet[4], which

[1] Lenoir is said to have recovered 42 medallions from Gaillon. There are over a dozen in the École des Beaux-Arts, from seven of which the heads are missing.

[2] These are now in the Museum at Grenoble; they are in part the work of Lorenzo Mugiano, who in 1508 made a statue of Louis XII for Gaillon. (See Reymond and Giraud, *Grenoble*.)

[3] Now in the Museum at Amiens; there is a cast in the Trocadéro (F. 5). See *Bull. Mon.* LXX. (1906, 387–8).

[4] Fig. Michel, IV. 645.

are much more realistic and individual in treatment than the conventional Italian heads. Of about the same date (*circ.* 1515–1520) are those of the Hôtel Lallemand and the Hôtel Cujas at Bourges. The heads have disappeared from the latter hôtel, but the inscriptions, though now defaced, could once be read as Romulus, Remus, Lavinia, Lucretia. Three, heads still remain *in situ* in the upper court of the Hôtel Lallemand. Of greater interest is an oval medallion over the door of the stair-tower, in which is set the head in profile of a warrior. It is clearly of French workmanship, and though it nominally represents Paris the son of Priam, it is really the portrait of some French cavalier[1]. After 1530 this form of decoration became general; we find it at Riom in the Maison des Juges-Consuls (1527–1531) and the Hôtel Guimonneau; at Montferrand, where a house has medallions of Brutus, Tarquin, and Lucretia; at Valence in the Maison des Têtes; at Caen, where they decorate the Tour des Gens d'Armes (*circ.* 1535) and other houses of the same period; and above all at the château of Montal in the department of Lot (1527–1534), where the court was adorned with seven large stone medallions containing portrait-busts of members of the family. They are very striking, and their robust execution shews no trace of Italian influence[2].

The vanished château of Bury[3] does not belong to our period, but it comes so near to it, and has such interesting

[1] The inscription runs PARBIUS· FILI· PRIAM· REX· TRECENCEN· MAGNAM· (i.e. *Paris filius Priami regis Troianorum magni*). See Hardy and Gandilhon, *Bourges*, p. 81; and Plate VII.

[2] Casts in the Trocadéro (F. 125–131). The originals were dispersed, but the present owner of the château has recovered those which had not left France. There is a fine dormer from the château in the Victoria and Albert Museum, which is decorated with two smaller medallions.

[3] Du Cerceau, *Les plus excellents bastiments*, vol. II.; Fergusson, *History of the Modern Styles of Architecture*, 3rd ed. 1891, I. 251–2 (reproduces a drawing from Mariette's *Architecture française*, which differs rather from Du Cerceau's); Du Cerceau, ed. Ward, pl. VI (a drawing from the side of the garden); Ward, p. 48 (plan); Geymüller, I. 73 (reproduction of part of Du Cerceau's drawing of the loggia); H. de La Vallière, *Bury en Blaisois*, Blois, 1889; P. Dufay, *Le château de Bury à l'époque des Rostaing*, Blois, 1901 (reprint of a poem written by Henri Chesneau in its honour in the middle of the seventeenth century); F. Bournon, *Blois*, pp. 135–6.

features, that it may be included in our survey. Florimond
Robertet, who on the death of Cardinal d'Amboise be-
came Louis XII's chief minister, bought the land in
January 1511 (N.S.), and, having cleared the site of what
was left of a mediaeval fortress, began his new building about
1515. Its *cour d'honneur* is remarkable for the symmetry
of its design; it fronts you with a solid unpierced wall on
either side of the gatehouse, but on the court side of this
wall is a loggia of a purely classical type. The principal *corps
de logis*, which faces the entrance, also shews symmetrical
treatment. It has early Renaissance dormers, of the same
type as those at Chambord and Blois (wing of Francis I),
the string-course between the two storeys is strongly
emphasised, and each storey is faced with equally spaced
pilasters, every third bay containing a window. Beyond the
court is a patterned garden in the Italian style. The four
round towers at the angles of the court are nearly detached;
there are three other towers on the far side of the formal
garden[1].

The principal block has close affinities with the north
wing at Blois, which was built from 1515 to 1519 and is
therefore almost exactly contemporary. The chief master-
mason employed upon this latter building was Jacques
Sourdeau, but there is nothing to shew that he made the
design. Now, we know that Domenico da Cortona made a
wooden model for Chambord which did not differ very
materially from the design that was actually carried out,
and between Chambord and the earliest of Francis I's
additions to Blois there are certain points of resemblance. It
is therefore a not unreasonable conjecture that Il Boccador,
who was living at Blois at this time, designed both Bury and
Blois, which are only between five and six miles apart[2].

[1] Charles de Neufville, Marquis de Villeroy, who inherited Bury from
the Robertets—his grandmother was sister to Jacques de Beaune—sold
it to the family of Rostaing, in whose hands it fell rapidly into decay.
In 1682 it was already a partial ruin; now there is nothing left but the
remains of two towers.

[2] See Geymüller, I. 75–6. A story of Bury having been built by an
Italian architect, who was afterwards employed at the Vatican, is told in

This conjecture is further supported by the similarity between the loggia at Bury and the ground storey of the old Hôtel de Ville at Paris, of which Il Boccador is known to have been the architect.

There is one château whose wanton and capricious destruction by order of its last proprietor rouses the strongest indignation and regret[1]. This is Bonivet, which Guillaume Gouffier, better known as the Admiral de Bonivet, built near Chatellerault in Poitou from 1513 to 1525[2]. All that is left of it are a few fragments preserved in various museums— twenty-one medallions and a few other fragments in the Cluny Museum, two medallions in the Louvre, and other fragments at Oiron and Poitiers[3]. These testify to the richness of its decorative details[4].

The province that clung most pertinaciously to Gothic traditions was Brittany. Abandoned by the Romans in the fourth century, overrun by the Celts of Britain in the fifth, under the Carolingian and the early Capetian kings it remained a separate nation. When it emerges into the light of history in the ninth century, it appears, like Catholic Ireland of the present day, as a land ruled by priests. It was in fact a land of monks and powerful abbots, who exercised an episcopal jurisdiction and suffered little interference even from the Pope. Their monasteries became the centres of dioceses which formed the real territorial divisions of the country[5]. The churches date largely from the

the "inventory" of Robertet's widow, published by Henri Chesneau in his *Bury-Rostaing* (1640) (reprinted in *Mém. Soc. Ant. de France*, xxx. 1–64), but the whole "inventory" is a fabrication (see H. Clouzot in *Rev. des études rabelaisiennes*, ix. 462 ff.).

[1] The miserable egotist who, following the example of the Cardinal de Rohan, ordered its destruction in 1788, was Charles-Louis-Henri de Chasteigner.

[2] Bonivet was killed at the battle of Pavia, and his château was not finally completed till 1649.

[3] Casts of the fragments in the Musée des Antiquaires de l'Ouest are in the Musée du Trocadéro (F. 199–206).

[4] Rabelais says of his Abbey of Thelema that it was "a hundred times more magnificent than Bonivet." (*Gargantua*, i. 53.) This was written in 1533; in the edition of 1542 he adds "Chambord or Chantilly."

[5] A. Luchaire in Lavisse, *Hist. de France*, ii. (ii), 43.

fifteenth century, and are strongly Flamboyant in character, especially in their furniture. But when one speaks of Brittany, it must be remembered that there was a marked distinction between the western and eastern halves of the province, between *la Bretagne bretonnante* and *la Bretagne française*. Nowadays a line drawn from Saint-Brieuc to Lorient roughly marks the boundary between the two divisions; but in the fifteenth century the line was more to the east, and while Rennes and Nantes were the chief centres of French influence, Vannes, Quimper, and the famous ecclesiastical city of Saint-Pol-de-Léon fostered the traditions of the Celtic west. The castle of Josselin, therefore, which lies about seven miles to the north-west of Ploërmel and is thus barely within the French sphere of culture, has a special interest for the purpose of our inquiry. It once belonged to the famous Constable de Clisson, but by the marriage of his only child with Alain VIII, Vicomte de Rohan, it passed into the hands of that quasi-royal Breton family. Rohan, the cradle of the race, is only distant some ten or eleven miles. It is not certain which of its owners began the reconstruction of the château, but it was finished by Jean II[1] in the first decade of the sixteenth century (before 1511), the latest work being represented by the inner façade. This portion is still thoroughly Gothic in spirit and design, and is remarkable for its want of symmetry, its huge slate roof, and its splendid dormers, which resemble those of the Palais de Justice at Rouen. But amidst all this mediaeval work, the tall pilasters on the façade and the scroll-work of the balustrade, from which the water runs off through immense gargoyles, shew that even this Breton château was touched by the finger of the Renaissance[2].

[1] Son of Alain IX; he died in 1516. The initials A. V. with a coronet, which frequently occur in the decoration, are puzzling. They cannot stand for Alain Vicomte. Alain IX, son of Alain VIII, died in 1462.

[2] See Eyriés, *op. cit.* I. 99–133 and *Country Life* for May 4, 1907 (both with excellent illustrations); also P. Mérimée, *Notes d'un voyage dans l'ouest de la France*, 1836, pp. 227–231.

CHAPTER XII

ARCHITECTURE II

I. *Hôtels*[1]

THE large town-house or hôtel differed very little in plan and character from the château or great country-house. We have already seen this in the case of Jacques Cœur's palatial mansion at Bourges. And as the château came to be built less and less for purposes of defence the difference tended to disappear altogether. Two important examples of hôtels on a large scale still exist at Paris—the two solitary representatives of mediaeval domestic architecture in that city. These are the Hôtel de Sens, which the Archbishop Tristan de Salazar built during the earlier half of his episcopate (1475–1519)[2], and the well-known Hôtel de Cluny, which contains the noble art collections of its last proprietor, M. de Sommerard. The foundations of the latter building were laid by Jean de Bourbon[3], Abbot of Cluny, who died in 1485, but it is practically the work of his successor, Jacques d'Amboise, a brother of the Cardinal. Except for the same tendency to horizontality that we noticed in Louis XII's wing at Blois, it does not in any way foreshadow the new style. On the other hand, the now vanished Hôtel de La

[1] For this and the following section P. Vitry, *Hôtels et maisons de la Renaissance française* (1910), a collection of photogravures with explanatory text, is of the greatest value. Two volumes are published, and a third, which does not concern our period, is in process of publication.

[2] An illegitimate son of Jean I, Duc de Bourbon.

[3] What there is left of it may be seen at one end of the Rue du Figuier, just behind the Quai des Célestins. See for an illustration T. Okey, *The Story of Paris*, opp. p. 114.

Trémoille[1], which Louis de La Trémoille, the "Chevalier sans reproche," began about 1490, shewed in its principal entrance, with its medallions of Roman emperors and great commanders—a tribute to the victor of Saint-Aubin-du-Cormier —its pilasters and canopies of dolphins, decided signs of Renaissance influence[2].

A little earlier in date is the old palace of the Comtes de Nevers—now the Palais de Justice—at Nevers[3]. It was built by Jean II (d. 1491), whose devices were once visible in the stair-tower, but this latter, which shews some Renaissance features, can hardly have been completed before the early part of the reign of Louis XII, under Jean's grandson and successor, Enguilbert of Cleves[4].

Nancy, beyond the borders of France, may also be included in our survey, for the court of Lorraine was, as we have seen, a not unimportant focus of French culture[5]. The ducal palace, begun by René II in 1502 and completed by his son, Antoine in 1512, is Flamboyant Gothic, but the extremely rich entrance gateway is an interesting example of transitional work[6]. The niche in which the equestrian

[1] It stood between the Rue de Rivoli and the Quai de la Mégisserie; the principal entrance was in the Rue des Bourdonnais.

[2] Ward, I. 24; Geymüller, I. 94; Viollet Le Duc, *Dictionnaire de l'architecture française*, VI. 282–4; A. Verdier and F. Cattois, *Architecture civile et domestique au moyen âge et à la Renaissance*, 2 vols. 4to, 1885, II. 19–28 and plates. The latter writers quote an eloquent description of the hôtel from *L'Artiste* by Didron, who, with Viollet Le Duc, protested in vain against its destruction. It was demolished in 1840. Some fragments are preserved in the outer court of the École des Beaux-Arts. La Trémoille commanded the French troops in the final defeat of Il Moro, held high commands at Agnadello and Marignano, and was killed at Pavia. His portrait, ascribed to Benedetto Ghirlandaio, much repainted, is at Chantilly. See Winifred Stephens, *From the Crusades to the French Revolution. A History of the La Trémoille family*, 1914; see p. 274 for an illustration of the hôtel and p. 60 for the Chantilly portrait.

[3] J. Locquin, *Nevers et Moulins*, 1913.

[4] The succession was disputed by Enguilbert's aunt, and the estate was sequestrated during the rest of Charles VIII's reign. The suit continued till 1505 (*L'art de vérifier les dates*).

[5] See above, p. 146.

[6] Fig. Ward, p. 5; *Mon. Hist.* III. plates 65, 66; Trocadéro (F. 138–142).

statue of the owner is placed, after the manner of Blois and Le Verger, is surmounted by a complicated structure composed of a strange medley of Gothic and Renaissance elements. The general effect is Gothic, prominent features being the pinnacles which frame the whole structure and an ogee arch with crockets of fantastic animals and cabbage leaves. But the shafts of the pinnacles are decorated with arabesques, and the crowning member is a blind dormer set between pilasters, which carry an entablature, the whole being surmounted by a canopy with the usual shell-ornament. On the face of the dormer are two medallions, which are supposed to represent René II and his son Antoine. The whole shews a combination of French, Italian, and even Flemish influence. The general effect is more curious than pleasing.

An analogous but more harmonious structure is a doorway in the wing which Tristan de Salazar added to his palace at Sens (*circ.* 1500–1505). The original portion consists of a Gothic arch between corbelled pinnacles, but this was surmounted later by a Renaissance entablature after the manner of an attica[1]. On its face are two medallions in the form of stone garlands, from which the heads have disappeared[2]. The whole is crowned by a fantastic structure consisting of a shell between pilasters with pinnacles on the top. This portion, as well as the two figures at either end of the cornice, suggests Flemish influence, an influence which also appears in the retable opposite the tomb erected by Tristan de Salazar in the Cathedral to his parents.

At Beauvais the Bishop's palace (now the Palais de Justice), originally built at the beginning of the fourteenth century, was largely altered in 1500 by Louis Villiers de l'Isle-Adam, who held the see from 1497 to 1521, but it shews little or no trace of Renaissance influence[3]. The

[1] See Ward, p. 28; Vaudin, *Fastes de la Sénonie*, pp. 201–3; Vitry, *Hôtels*, II. 26–7, plates LVI, LVII.

[2] These are shewn in an old engraving reproduced by Vaudin, as also a statue, presumably of the Virgin, in front of the shell.

[3] See L'Abbé L. Pihan, *Beauvais*, pp. 107–9.

Plate VI

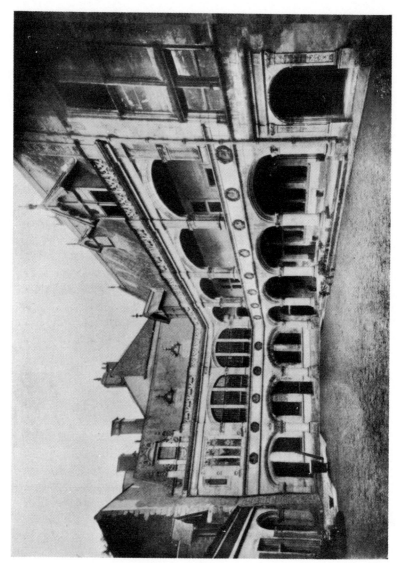

Blois : Hôtel d'Alluye

Palais de Justice at Grenoble, formerly the palace of the Dauphins, has a façade of about 1515. It is essentially Gothic in design, but the decoration includes niches for statues with shell-canopies, and medallions of the Caesars and the Dauphins[1].

Of the celebrated Hôtel du Bourgtheroulde at Rouen the earliest portion—the block on the street and that parallel to it—was built by Guillaume Le Roux[2], a Councillor of the Exchequer of Normandy, during the last decade of the fifteenth century, and is wholly Gothic, while the gallery added by his son, with its splendid bas-reliefs representing the Triumphs of Petrarch and the Field of the Cloth of Gold (1520), was not begun till after the close of our period[3].

Passing from the hôtels of great prelates and nobles to those of wealthy financiers and merchants, we may begin with that of the successful minister, Florimond Robertet, whose château at Bury has already been described. His town-house at Blois, which he called the Hôtel d'Alluye after the barony conferred on him in 1510 by Louis XII, presents to the street a front of brick and stone—it has been a good deal restored—which is mainly Gothic[4]. But on entering the court you find on two sides of it a beautiful loggia in two storeys (Plate VI). The arches in the upper storey are supported upon rectangular columns, and those in the lower storey upon round ones. The columns are massive and rather short, the span of the arches being unusually wide. The frieze between the two storeys is decorated with thirteen terra-cotta medallion heads, representing the twelve

[1] See M. Reymond and Ch. Giraud, *Le palais de justice de Grenoble*, 1897.

[2] He married in 1486; there does not appear to be any relationship between his family and that of the architects, Jacques and Roulland Le Roux. He purchased the estates of Bourgtheroulde, Tilly, Lucy, and Sainte-Beuve.

[3] Alterations were made in 1770 in consequence of a fire. The drawing in Jacques Le Lelieur's *Le Livre des Fontaines* (drawn in 1525) shews that the street-façade has been much mutilated.

[4] It is now Rue Saint-Honoré, no. 8. See *Une visite à l'Hôtel d'Alluye* [by H. de La Vallière], Blois, 1878; Bournon, *op. cit.* pp. 91–94; Vitry, *Hôtels*, II. pp. 1–3, plates I–VI.

Caesars and Aristotle. They are framed in garlands like those in San Satiro at Milan.

Other Renaissance features which strike the eye are a fine dormer on the east side, and the still finer portal immediately to the right of the loggia. The arabesques on the pilasters and the frieze above are exquisite examples of Renaissance decoration. In the Grande Salle, formerly the Salle des Gardes, is a magnificent Renaissance chimney-piece, which has been well restored[1]. The Greek inscription on either side of the lintel[2] and the owner's device with an Italian motto above the mantel[3] remind us that Robertet's knowledge of languages was one of his passports to success. Another interesting, but older, feature is the brick stair-turret with a newel of stone and a vault shaped like a palm-tree with eight branches.

There is, so far as I know, no documentary evidence to determine the date of this interesting hôtel. All one can say for certain is that, with the possible exception of a small portion of the western half, the whole was constructed during the reign of Louis XII. His arms and device and those of Anne of Brittany frequently appear, but never those of Francis I. The façade to the street is apparently contemporaneous with Louis XII's wing at Blois, and the supposition that it was begun in 1498 cannot be far wrong. The Italian loggia and the Renaissance portal are evidently of later date, and the position of the portal in the Gothic portion of the building shews that an alteration must have been made here. Various dates are given for the completion of the whole work. M. de La Vallière, the local authority, says 1510; M. Vitry, "before 1508." M. Bournon, another local archaeologist, gives no dates, but he suggests Domenico da Cortona as the designer of the loggia. We have already seen that the plan of Robertet's château of Bury may with considerable plausibility be ascribed to him. It is

[1] See E. Rouyer and A. Darcel, *L'art architectural en France depuis François I jusqu'à Louis XIV*, 2 vols. 1863–1866, I. 3–5.

[2] Μέμνησο τῆς κοινῆς τύχης (Remember the common lot) and Πρὸ παντων σέβου τὸ θεῖον (Before all things honour God).

[3] Chi ogni pena compensa col beneficio ben merita servizio.

true that he did not take up his abode at Blois till 1512, nor, so far as the evidence of the accounts goes, was he employed at the château before 1510, and then only on the furniture. But he may have done work for Robertet at an earlier date, or the hôtel may not have been completed until near the close of Louis XII's reign. M. Bournon's hypothesis is certainly worth consideration, though the only conclusion justified by the available evidence is that the court of the Hôtel d'Alluye is the work of an Italian.

Close to the Hôtel d'Alluye is the hôtel built for Denis Du Pont[1], the distinguished advocate, who was appointed by Louis XII with two colleagues to draw up a list of the customs and usages of the county of Blois with a view to codification. Little of the original building is now visible except the stair-tower with a remarkable portal, which closely resembles that of the Casa dei Castani at Milan. At Blois also we may see in the Hôtel Sardini[2] a little loggia of the date of Louis XII, two pilasters of which are in fairly good condition. One is fluted diagonally, and the other is decorated with arabesques and grotesques. In the neighbouring house the doorway of the stair-turret terminates in a Flamboyant ogee with pilasters on either side. The original date is marked by the letters L (Louis) and A (Anne), but the pilasters, which cut into the older work, are a later addition.

At the same time that Robertet was building his hôtel at Blois, Jacques de Beaune de Semblançay was enlarging his family-house at Tours. In 1507 Guillaume Besnouard, *maître des œuvres de maçonnerie de Tours*, contracted to build for him a pavilion and, at right angles to it, a two-storied building comprising a loggia below and a chapel above. The pavilion, or what is left of it, is purely Gothic, but the other building shews marked Renaissance characteristics[3]. The columns which support

[1] 2 Rue Saint-Honoré. See Vitry, *Hôtels*, ii. 3, plate vii.

[2] 7 Rue du Puits-Châtel.

[3] See Spont, *op. cit.* pp. 106–7 (with illustrations opp. pp. 105, 107, and 111); Vitry, *Tours*, pp. 86–88, and *Hôtels*, ii. 6, plate viii. Access may be

the entablature of the loggia have Ionic capitals, and the cornice is decorated with medallions of Roman emperors. In the first storey the windows have mullions and Gothic tracery, but they are symmetrically designed and are separated by pilasters with composite capitals. In 1517 Semblançay was presented by Louise of Savoy with the hôtel Dunois (at the corner of the Rue Colbert and the Rue Jules Favre), and this he connected with the rest by a new wing parallel to the Rue Colbert, part of which still exists with the date of 1518. Its Renaissance character is, as one would expect, more pronounced than that of the loggia and the chapel.

The Hôtel Gouin[1], unlike that of Jacques de Beaune, is in an excellent state of preservation, but it has undergone so many alterations and restorations that its architectural history is difficult to decipher. The oldest part of it was built apparently during the last third of the fifteenth century, but some time about 1510–1520 it is supposed that a certain René Gardette, whose family possessed it in the middle of the sixteenth century[2], made extensive alterations in the front facing south[3]. The Gothic ornamentation of the dormer-windows was almost completely superseded by Renaissance work, and the building was prolonged to the west by additions thoroughly Italian in character.

Further up the Loire, at Orleans, where the old houses are fast disappearing, a charming house is still preserved in the Rue du Tabour, and serves as the Museum of Jeanne d'Arc[4]. It is known as the Maison d'Agnès Sorel, but it is really the hôtel of the Compaing family. Originally given, it is said, by Charles VII to his councillor and advocate of

obtained at 5 Rue Colbert; the Gothic pavilion is parallel to the Rue Nationale, and the loggia to the Rue Colbert.

[1] Vitry, *Tours*, pp. 82–84.

[2] The Gardette family lived there till 1621. In 1738 it passed into the hands of the Gouin family, who still possess it.

[3] See L.-A. Bossebœuf, *Les rues de Tours*, 1888.

[4] See Verdier and Cattois, *op. cit.* I. 165–171; *Mon. Hist.* III. 87; Ward, pp. 24–26 (with an elevation and a plan); Vitry, *Hôtels*, II. 13–14, plates XXVI–XXVIII.

that name, it was rebuilt at the close of the fifteenth century, or early in the sixteenth, and afterwards received other additions. It consists of three blocks grouped together in an irregular fashion round three courts. The older part includes the street-front, which has undergone a drastic restoration. Here the influence of the Renaissance is shewn in the elegance and symmetry of the design, in the accentuation of horizontal lines, such as the string course and the rectangular hood-moulds, and in the delicate coquetry of the ornamentation, which is used very sparingly. The gallery and loggia, which run along one side of the middle and largest court, connecting two of the blocks, are of later date, being a beautiful example of the style of Francis I[1]. Mr Ward suggests that they were built in the place of older wooden galleries. This is very probable, for fifteenth-century houses often consisted of two separate blocks, one containing the master's apartments, and the other those of the servants, and these were connected by simple wooden galleries.

Descending the Loire we find at Angers an example of Renaissance elements introduced into an essentially Gothic building in the Hôtel des Pénitentes[2], where the central window of the first storey of the main *corps de logis* is set between Renaissance pilasters with a medallion above. Also in the left wing two little turret windows are surmounted by a shell. On the other hand, the Hôtel Barrault in the same city (now the Museum), built by the royal treasurer, Olivier Barrault, from 1486 to 1495, is wholly Gothic.

Within easy communication with the Loire we have a remarkably interesting specimen of a wealthy *bourgeois's* town-house in the Hôtel Lallemand at Bourges[3]. As has been said already, it was begun by Jean II Lallemand after

[1] H. H. Statham, *A Short Critical History of Architecture*, 1913, p. 471 (fig.).

[2] 23 Boulevard Descaizeaux.

[3] See Hardy and Gandilhon, *Bourges*, pp. 78–87; Vitry, *Hôtels*, II. 9–12, plates XVII–XXIV.

the great fire of 1487. After his death in 1494 it was added
to and considerably altered by his two sons, Jean III and
Jean IV[1]. The building was completed by the former about
1518, but the decoration of the interior went on under
Jean IV. The site which Jean II acquired by the purchase
of several houses was irregular and uneven. In consequence
the buildings are arranged round three courts, each of which
is at a different level.

Entering the lowest court from the Rue Bourbonnoux,
you have on your left the oldest portion of the hôtel, which
is severe and wholly Gothic. Next in point of date ap-
parently are a loggia and gallery which form the west wing
of the middle court. The loggia has three bays, of which two
have a parapet, and the other is open to the ground. In
the spandrels are circular spaces for medallions, which have
disappeared. Here again, except for these medallions,
which may be of later introduction, there is little or nothing
to suggest the influence of Italy.

It is otherwise with the highest court, the façade of
which is towards the Rue Hôtel Lallemand (formerly Rue des
Vieilles Prisons). Here we have the same blending of Gothic
and Renaissance details that we have met with elsewhere.
There is a doorway with a three-centred arch under a
straight lintel which rests on pilasters with fantastic
capitals, while the ornamentation shews in one place a cornice
of egg and dart pattern, and in another a niche with delicate
pinnacles. In the court itself (Plate VII) the Renaissance
element predominates. The pilasters on either side of the
staircase windows have Corinthian capitals, and on the blank
walls which form two sides of the court are Italian circular
medallions, in which are set terra-cotta heads[2]. In the
angle formed by the *corps de logis* and one of their walls is
a Gothic turret, the windows of which are set between
balusters and are surmounted by a pediment in the form of
a shell. The treatment is different in the circular stair-
tower at the south-east angle of the Court, for here we find a

[1] See above, pp. 159–160.
[2] These were doubtless imported from Italy.

Plate VII

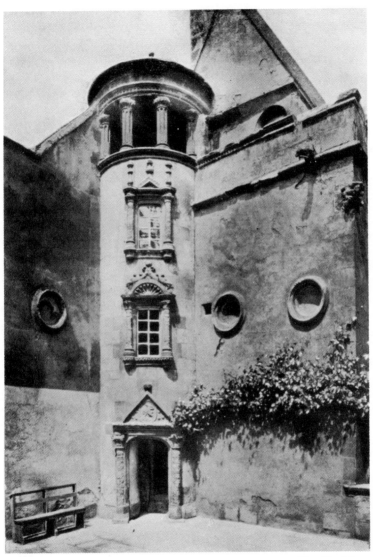

Bourges : Hôtel Lallemand

French workman trying to produce Italian forms which he has evidently never seen. The shell canopy over the lower window is correctly rendered, but he crowns it with a Gothic accolade. The doorway has a three-centred arch and lintel; but the latter rests upon columns with fantastic capitals and arabesques on their shafts, and above it is a triangular pediment. It is the delightfully naive work of a native sculptor, full of invention, but trying to work in a style of which he has no experience[1]. Finally, this most interesting tower, instead of being walled up to the roof like those in Jacques Cœur's palace and the old Hôtel de Ville, and in the château of Meillant, is crowned with a little classical temple, the entablature of which rests upon four fluted columns (two free and two engaged) with fantastic capitals[2].

The *corps de logis* of the upper court is linked with the gallery and loggia of the middle court by a narrow building of two storeys over a passage. The façade on the side towards the middle court shews a mixture of Gothic and Renaissance. The large window of the first storey has three lights of Gothic tracery, but is set between engaged columns with Renaissance capitals and Renaissance ornamentation on the shafts. Above it, immediately under the cornice, is a small double window framed in balusters. The façade on the side towards the lowest court is more or less pure Renaissance, and may be regarded as the latest portion of the main structure of the hôtel.

On the whole it may be said that, though the design of the whole building with its disregard of symmetry—to a certain extent necessitated by the nature of the site—and its fidelity to old traditions is thoroughly Gothic, its execution shews the gaiety, the individuality, and, so to speak, the humanism of the Renaissance. And this execution is all the more interesting because it is evidently the work

[1] For the interesting medallion on the face of the pediment, which proves conclusively that the workman was a Frenchman, see above, p. 408.

[2] Compare the beautiful sepulcral monument at Saint-Remy.

of men who are expressing Renaissance forms in their own language.

The Hôtel Cujas[1], which bears the name of the great jurist whose property it became in 1585, barely falls within our period, being built about 1515 by the master-mason, Guillaume Pelvoysin[2], for Durante Salvi, a Florentine merchant. Of less extent, and less richly decorated than the Hôtel Lallemand, this charming hôtel is far less instructive for our purpose, for the only part which shews decided Renaissance features in the ornamentation is the façade towards the Rue des Arènes, and this was not added till after the middle of the sixteenth century[3].

It has been suggested by M. Vitry that Durante Salvi, being an Italian, and the Lallemand family, having both business and matrimonial relations with Italy, probably employed Italian workmen. But this idea is not borne out by either of their hôtels, which rather point to the absence of Italian workmanship, at least during our period. We do, indeed, know of one Italian, Jean Chersale of Genoa, who was employed on the Cathedral as a sculptor from 1511 to 1515, and it is possible that the later portions of the Hôtel Lallemand may owe something to hints either from him or from other Italians—if there were others. The few Renaissance details that are to be found amongst the sculptures on the northernmost portal of the Cathedral may also have been of service, but on the whole there is very little direct imitation of Italian work in the Hôtel Lallemand, while the Hôtel Cujas, except in its later addition, is practically pure Gothic.

Passing from the region of the Loire to the capital of Languedoc we find in the Hôtel Bernuy an example of a house which was begun in the Gothic style and completed in that of the Renaissance[4]. The owner was Jean de Bernuy,

[1] See Hardy and Gandilhon, *Bourges*, pp. 73–77; Vitry, *Hôtels*, I. plates xv–xviii. It is now the Municipal Museum.

[2] See above, p. 401.

[3] Either by Bernardin Bochetel, Bishop of Rennes in 1565, or by his brother Jacques.

[4] See Vitry, *Hôtels*, II. 38–9, plates lxxxiii, lxxxiv.

a native of Toledo, who had made his fortune at Toulouse as a merchant of woad, and had filled the office of *Capitoul* or town-councillor. The older portion, which consists of two detached blocks—one fronting the street, and the other forming the only remaining side of the second or inner court—the vaulted passage connecting them, and the lofty stair-tower, was begun in 1504, and is practically pure Gothic[1]. The Renaissance only appears in the four medallions above the main entrance. On the other hand, the outer court, which has buildings on two sides and which was added in 1533 to connect the two blocks, is pure Renaissance[2]. There is a charming open gallery on the first storey, which recalls the Hôtel d'Alluye at Blois, and indeed the whole style of the architecture resembles that with which we have become familiar in the district of the Loire and the Seine. A more indigenous form of Renaissance architecture was developed at Toulouse a little later, beginning with the portal of Notre-Dame de la Dalbade (1537), and manifesting itself in such admirable specimens of domestic architecture as the Hôtel Maynier-Burnet[3] (*circ.* 1550) and the Hôtel d'Assézat (1555).

At Pamiers, forty miles from Toulouse, in a house opposite the Cathedral, known as the Hôtel des Fiches, there is a doorway in a stair-turret which resembles the entrance portal to the Hôtel de Bernuy, especially in the use of medallions in combination with Gothic decoration[4].

[1] The Hôtel de Jean Catel (*Capitoul* in 1498) where Monluc, the author of the *Commentaries*, once stayed, has a very similar brick stair-tower.

[2] In 1533 a master-mason, named Louis Privat, undertook the work, but apparently it was begun before this, for the date of 1530 occurs on a column.

[3] Also known as the Hôtel de Lasbordes and the Hôtel du Vieux-Raisin. Both this and the Hôtel d'Assézat have been attributed to Nicolas Bachelier (1485–*circ.* 1572), the chief figure of the Toulouse Renaissance. The son of an Italian architect who had settled in Toulouse, he studied in Italy under Michelangelo, and returned to Toulouse about 1515. His only really authenticated works are the Porte de la Commutation (1545), and the Porte du Collège de l'Esquile (1557).

[4] *Congrès archéologique*, 1891, pp. 255–6.

II. *Smaller town-houses*

It is naturally impossible to draw a hard and fast line between the *hôtel* of a rich merchant or financier and the *maison* of an ordinary tradesman or professional man. But it may be said that even the more important houses of this humbler type had only a single court, and that whereas in an hôtel the street front was generally occupied either by a screen-wall or by the servants' apartments, in the ordinary house the servants' block was as a rule at the back, and the master's in the front. The smaller houses consisted only of a single block occupying the whole street frontage, and in northern and western France, where stone was expensive, were generally made of wood, either throughout, or above the ground floor.

The evolution of the town-house, as distinguished from the hôtel, during our period may be studied fairly well at Clermont-Ferrand and Riom in Auvergne[1]. It is true that some of the houses to be noticed are dignified with the name of hôtel and are perhaps important enough to be so called, but they all belong to the same type, that of the single court, and they all have an open spiral staircase instead of an enclosed stair-turret. They represent various stages of architectural development. Thus we have pure Gothic in a house at Clermont, dated 1513, which belonged to the family of Savaron[2], and the first dawn of the Renaissance in a house near the Cathedral, which has a doorway in the court between pilasters with rude classical capitals[3]. At Montferrand the Hôtel de Montorcier has a Gothic doorway and an open gallery on the first storey, which is decorated with medallions of Brutus, Tarquin, and Lucretia[4]. In the Maison du Sire de Beaujeu, or Hôtel d'Albiat, in the same

[1] At Clermont itself the old houses are fast disappearing under the pickaxe, but Montferrand and Riom are left unmolested in their modest obscurity.

[2] 3 Rue des Chaussetiers. See Vitry, *Hôtels*, I. 31, plate LXII.

[3] 2 Rue des Grand-Jours. Over the door is the device TOUT VIENT DE DIEU.

[4] Vitry, *Hôtels*, I. 31, plate LXIII.

town a similar gallery is supported by columns, the capitals of which are a fair imitation of Doric. Somewhat larger, and perhaps rather deserving the name of hôtel, is the charming Maison des Consuls at Riom[1], the construction of which (1527–1531) is attributed to the Confraternity of the Holy Ghost. The façade towards the street is decorated with equally spaced pilasters, and with four medallions. But along with these Renaissance features the old traditions are represented by the high-pitched roof, the dormer windows, and the corbelled turret. The entrance is in a side street by a Gothic doorway which is very similar to that of the Hôtel de Montorcier at Montferrand, but with this difference, that the crockets are formed of curled acanthus leaves and the pinnacles are supported by pilasters with pseudo-Ionic capitals. A later stage of development is represented by the Hôtel du Montat or Guimonneau at Riom, the galleries and staircase of which belong to the Renaissance. Its date must be about 1530[2].

There are also some interesting houses at Périgueux. One in the Rue Limogeanne (no. 5), which in all other respects conforms to the fifteenth century pattern, has a Renaissance doorway and windows between pseudo-classical pilasters, while the house next to it has a shell ornament. The latter appears also, rudely executed, in a house, dated 1518, at the corner of the Rue Saint-Louis[3]. On the quay is a house known as the Maison du Quai or the Maison des Consuls, which really consists of two houses of different dates[4]. That on the left (Maison Cayla) is pure Gothic, while the smaller one on the right has transitional windows and a stone verandah with classical columns. Unfortunately for the purpose of our inquiry we do not know the precise date of either house.

[1] Vitry, *Hôtels*, II. 31, plates LXV, LXVI. The origin of the name is uncertain.

[2] *Op. cit.* II. 31–32, plate LXVII.

[3] Known as the Maison Tenant. It belonged to Cardinal de Périgord, Archbishop of Paris, who bequeathed it to his nephews, Talleyrand and his two brothers. See Vitry, *Hôtels*, II. 34, plate LXXIV.

[4] Ward, p. xxvi (fig.); Vitry, *Hôtels*, I. 33, plate LXVII.

The same must be said of some sixteenth-century houses at Rodez. One of these however, situated in the Place d'Estaing, shews so slight a trace of Renaissance influence that it may be assigned to an early period in the century. Another, called the Maison d'Armagnac, is evidently later than 1515; it bears a certain similarity to the Maison des Consuls at Riom.

At Tours there are several houses which belong to the early years of the sixteenth century, but they are all Gothic. The so-called House of Tristan Lhermite, which has nothing to do with the famous hangman of Louis XI, but was almost certainly built for one Pierre Du Puy, who was the proprietor in 1495, is a very interesting and well preserved example of a typical fifteenth-century house[1]. Noteworthy is the stair-turret with its spiral staircase of brick. Another good example, at 10 Rue Paul-Louis Courier, has two open balustrated wooden staircases leading to a gallery at the back of the wall which separates the court from the street[2]. There is another wooden staircase at 22 Rue Bretonneau; no. 33 in the same street is a Gothic building with early Renaissance ornament.

Wooden houses are naturally more subject than those of stone or brick to destruction by fire or other contingencies. One is, therefore, on the whole surprised at the relatively large number, mostly of the fifteenth or sixteenth century, that still exist in France. They are more common in the north and west than in the east and south. Normandy is particularly rich in them. There are several at Caen[3], Louviers, Gisors, and Lisieux[4]; there is a celebrated one, now the Hôtel du Grand Cerf, at Le Grand Andely, and, in spite of the wholesale destruction that has taken place, there are still a great many at Rouen, especially in the picturesque Rue Eau de Robec and the streets leading out of it, that is to say in the quarter between the Churches of Saint-Ouen

[1] Vitry, *Tours*, pp. 77–79; *Hôtels*, I. plates xxv–xxviii.

[2] Vitry, *Tours*, p. 79.

[3] Rue Montoir-Poissonnerie and Rue Saint-Pierre.

[4] Rue aux Fèvres, Rue au Char, Grande Rue. See *Congrès archéologique*, 1909, pp. 322–330; Vitry, *Hôtels*, I. 35–6, plates lxxiii–lxxvii.

and Saint Maclou[1]. Outside Normandy, there are a few at Bar-sur-Seine and Châlon-sur-Saône, several of much charm and interest at Beauvais, a town which was almost entirely rebuilt after its siege by Charles of Burgundy in 1472[2], a fine one at Abbeville, called Maison de François I[3], a few at Angers and at Morlaix and Saint-Brieuc in Brittany[4], and a remarkably fine one at Gallardon, near Chartres, the rich façade of which, with its free use of pilasters for ornamental purposes, resembles that of the old Hôtel de Ville at Orleans[5]. The Angers examples include the Maison Adam, a much decorated house of the fifteenth century[6], and two smaller ones with carved figures[7]. At Le Mans there is an interesting house, known as the Maison de la Reine Bérengère (1490–1515), with the ground-floor of stone, and the upper storeys, richly ornamented, of wood[8]. There is also a house of stone and wood at Châteaudun, on the façade of which are wooden medallions[9].

The majority of the timber houses enumerated above are pure Gothic, but some represent various stages of the Renaissance. Not a single one, however, of these latter can be shewn to belong to our period. The majority are certainly later. Thus the presence of the well-known emblem of Francis I in the Manoir de la Salamandre at Lisieux[10], which is transitional in style, dates it as belonging to his reign. Again, there is a beautiful house at Joigny in

[1] Other streets which are fairly rich in wooden houses are the Rue de Vicomté, the Rue de l'Épicerie, and the Rue aux Ours.

[2] For wooden houses at Rouen, Caen, Gisors, Beauvais and Abbeville, see A. W. Pugin, *Details of antient timber houses of the 15th and 16th centuries*, 1836.

[3] Vitry, *Hôtels*, I. plate XCVI.　　　　[4] *Ib.* plates XCII–XCIV.

[5] *Ib.* II. 43, plates XCII, XCIII; *Mon. Hist.* III. pl. 82; Brossard, *Ouest*, p. 441. It is said to have been built at the beginning of the sixteenth century, but I do not know that there is any documentary evidence for this.

[6] Vitry, *Hôtels*, I. 39–40, plates LXXXVII, LXXXVIII.

[7] In the Rue de la Costellerie. A similar house to these is represented on an engraving, dated 1514, of the old Hostellerie du Cheval Blanc, which has been an inn for four hundred years.

[8] Vitry, *Hôtels*, I. 40–41, plate XC.　　　　[9] *Ib.* II. 43–4, plate XCIV.

[10] 19 Rue aux Fèvres.

Champagne, in which Gothic and Renaissance details are harmoniously blended, but the treatment is so skilful that one has no hesitation in pronouncing it to be later than 1515[1].

The two exquisite houses which once stood in the Rue de la Grosse-Horloge, the chief thoroughfare of old Rouen, are both Renaissance[2]. The facade of one has been preserved and set up in a little square behind the tower of Saint-André, and Delaquérière infers from its projecting storeys that it is earlier than 1520, when that method of building was forbidden. But the projection is only slight, and we do not know whether the law was rigidly inforced.

III. *Municipal buildings*

It is in public buildings of a civil character that we should best be able to study the changing fashions in architecture. In the first place they reflect the prevailing taste of the day rather than that of any individual. Secondly, being generally built in one piece, and within a comparatively short period of time, they follow the style of that period, and not, as so often is the case with additions to great Cathedrals, the style of an earlier day. Thirdly, they have not suffered in France, like the châteaux of princes and nobles, from the fury of the Revolutionary mob, nor, like the town-houses of the middle classes, have they been sacrificed in the name of modern hygiene to the interests of municipal ambition. Their worst enemy is the restorer.

Of the chief public buildings that were erected in France during our period the Palais de Justice at Rouen, one of the finest buildings of its kind in Europe, is built in the same Flamboyant style as the Hôtels de Ville of Arras (completed in 1510) and Saint-Quentin (completed in 1509), neither of

[1] Ward, p. 12 (fig.).

[2] Delaquérière, *op. cit.* I. 140 and 142, II. 179; C. Enlart, *Rouen*, p. 127. The finest remaining timber house at Rouen, the Hôtel Caradas (29–31 Rue de la Savonnerie), a house at the corner of the Rue du Bac and the Rue des Fourchettes, and the Maison de l'Annonciation (early sixteenth century) are all Gothic.

which belonged at that time to France. But the left wing,
built in 1493, is less florid than the central block, which was
added six years later by Roulland Le Roux, and which shews
signs of Flemish influence[1]. The only trace of Italjan
influence in the whole building is in the splendid oak ceiling
of the Grand'Chambre—inaugurated in 1506—the pendants
of which have Renaissance enrichments[2].

If this sumptuous building reflects the ecclesiastical
architecture of the period, the Hôtels de Ville of Compiègne
(1502–1510)[3] and Saumur (begun in 1508[4]) follow the more
sober style of the contemporary château. At Compiègne,
as at Blois, there was an equestrian statue of Louis XII,
now replaced by a modern substitute, but it was not over
the entrance[5]. The old Hôtel de Ville at Bourges (now the
Petit Lycée), with its richly ornamented stair-tower, which
was built in 1488 after the great fire, is pure Gothic.

The Chambre des Comptes at Paris, which was built in
the reign of Louis XII[6] to the west of the Sainte-Chapelle,
and was burnt in 1737, is traditionally ascribed to Fra
Giocondo. It was wholly Gothic in its general aspect, but
contained certain Renaissance elements, such as a frieze of
dolphins and fleur-de-lys. Mr Ward points out that its most
conspicuous features, an external staircase of nearly fifty

[1] The left wing was built as a sort of Exchange for merchants to meet
in, but when the central block was added in 1499 as a home for the Échiquier
de Normandie, the ancient supreme tribunal of the duchy, its great hall
became the Salle des Procureurs. It is now the Salle des Pas Perdus.
For an engraving before its alteration in the nineteenth century see Enlart,
Rouen, p. 109. Francis I converted the Échiquier into a Parlement in
1515.

[2] Enlart, *Rouen*, p. 108; Ward, p. 30.

[3] Verdier and Cattois, *op. cit.* I. 172–176.

[4] Much restored. The Hôtel de Ville at Étampes retains a pavilion
and turrets of 1514, but the rest is modern.

[5] There was a similar statue of Francis I over the entrance of the
Hôtel de Ville at Paris.

[6] Aussi fit faire ledict roy le logis pres son palais quon appelle la
chambre des Comptes contre le quel sont assises les ymages dudict seigneur
et des quatre vertus cardinalles lequel est un tressingulier et triumphant
ediffice. G. Corrozet, *La Fleur des Antiquitez de Paris*, 1532 (reprinted
1874).

steps[1] in one straight flight in an open loggia, is not necessarily an Italian idea[2].

Another traditional work of Fra Giocondo's at Paris is the sumptuous decoration of the Grand'Chambre in the Palais de la Cité, or Palais de Justice. So lavish was the use of gold that it acquired the name of the *Chambre dorée*[3]. Geymüller points out that the decoration of the lunettes, in which shields shewing the royal arms and Louis XII's porcupine are supported by Centaurs and Sirens, has the character of the school of Verona and Padua, and that the hanging arches which form part of the decorative system of the oak ceiling resemble those at Gaillon[4].

There are rather more signs of the Renaissance in the old Hôtel de Ville[5] at Riom, for the Gothic doorway of one of the two spiral stair-towers is set between classical pilasters with small classical columns above them, and the windows above are also flanked by rude classical columns. There is no evidence that the building is earlier than 1515. At Dreux, on the other hand, we know from the records that the Hôtel de Ville was begun in 1512 and finished in 1537[6]. The building, with its roof "like the side of a cliff[7]," is Gothic alike in design and aspect, but the decoration shews an intermingling of Gothic and Renaissance details. As, however, this only appears in the second storey, where an entablature with a frieze of scroll work is surmounted by pinnacles and crocketted ogee arches, and in the corbelled

[1] *Pantagruel*, v. 16.

[2] Ward, I. 29. There are several old engravings of the building. That by Silvestre is reproduced by Geymüller, p. 72.

[3] Regnant ledict roy Loys douxiesme fut sumptueusement enrichy et decore dor et dazur le grant parquet de la court de Parlement, avecques plusieurs antiques ouvrages, ausquelz sont inserez maintz personnages et les armes et devises du roy. Corrozet, *op. cit.* The Grand'Chambre still exists, opening out of the present Salle des Pas Perdus. It has been reduced in size and partially restored.

[4] Geymüller, I. 69–70. This ceiling was covered by a plaster one at the Revolution, and destroyed by fire in 1871 (Ward, p. 30).

[5] No. 23 Rue de l'Hôtel-de-Ville.

[6] Ward, opp. p. xx (fig.); *Mon. Hist.* III. plate 81.

[7] This is William Morris's graphic description.

Plate VIII

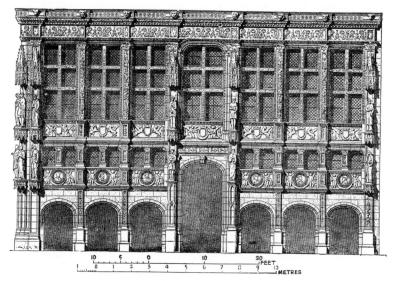

Rouen : Bureau des Finances
(From Ward, *The Architecture of the Renaissance in France*)

tourelles, we may infer that the Renaissance element was not introduced till the reign of Francis I.

Passing into Normandy we find at Rouen the most perfect and most instructive example that France has to offer of a transitional building of our period. This is the Bureau des Finances[1] at the corner of the Rue du Petit-Salut and the *parvis* of the Cathedral, which was begun by Roulland Le Roux, the architect of the Palais de Justice and the central portal of the Cathedral, in 1510. It is now grievously mutilated. The arcades have been entirely destroyed and their place taken by modern shops. In 1823 the only window which still preserved its mullions with their delicate sculptures was totally transformed; in 1827 the noble entrance portal was destroyed, and about the same time a charming oriel with mullioned windows on three sides suffered the same fate[2]. Even in its present unhappy mutilated state it has great charm, but one must turn to M. Sauvageot's re-construction (Plate VIII) and to Delaquérière's pages to form an idea of its pristine elegance and grace.

It consists of two storeys resting on arcaded arches, the lower storey forming what we should now call an entresol. A special feature is the large proportion of window space. There are seven large windows in the upper storey, and twelve small ones in the lower, only separated from one another by a single pilaster. All the windows are square-headed except the central one in the upper storey, which is rather wider

[1] It was originally known as Les Généraux, its full title being Hôtel des Généraux des Finances.

[2] The building was already considerably damaged when Delaquérière wrote his first description of it in 1820 (I. 87–89). In his second volume he records the later and more disastrous mutilations (II. 129). See also Enlart, *Rouen*, p. 110 (l'entresol est encore déshonoré par des enseignes, dont la laideur et la bêtise s'étalent avec impudence sur des frises délicieuses —this is happily no longer true). Ward, I. 29, and Geymüller, I. 19, reproduce a re-construction from C. Sauvageot, *Palais, Châteaux, Hôtels et Maisons de France du XVᵉ au XVIIIᵉ siècle*, 4 vols. 1867. See also Vitry, *Hôtels*, II. 22–3, plates XLVIII, XLIX. Oriels in France are nearly always at the angles of buildings. They are in fact the old corbelled turret with large windows. Cp. the Hôtel Marisy at Troyes (1520–1531) and the House of Cardinal Jouffroy at Luxeuil-les-bains.

than the rest and has a three-centred arch. Immediately below it the lower range of windows is intercepted by a noble entrance arch. Exceedingly interesting is the treatment of the pilasters and their entablature, for it shews us how the French architects dealt in their own way with the classical ideas of the Renaissance. While Alberti and the other Italian architects of the second half of the Cinquecento used the orders solely for purposes of decoration, without any attempt to establish relations between them and the constructive divisions of the building[1], the French architects of the early Renaissance, that is to say, roughly down to the close of the reign of Francis I, treated the classical forms in a more logical spirit. Thus in the Bureau des Finances the architrave marks the ceiling and flooring between the two storeys, the frieze marks the wall below the window, and the cornice the window-sill. It results from this treatment that the classical canons of proportion are violated. The frieze is too wide, the architrave and the cornice are too narrow[2]. But this defect, if defect it is, has its compensations in the structural sincerity. Moreover, in the building we are now considering it is amply redeemed by the beauty of the friezes. That above the arcade consists of a row of medallions framed in stone garlands and supported by a pair of genii; that above the lower storey is formed by escutcheons supported either by angels or by heraldic animals; that above the upper storey by delicately carved arabesques[3]. Equally delicate are the arabesques on the shafts of the pilasters.

But Gothic also has its share in the decoration of this façade. On either side of the central window above the entrance the pilaster is masqued by a niche for a statue, which terminates in a Gothic canopy, its base forming a canopy for another niche on the level of the lower storey.

[1] *E.g.* Alberti in the Palazzo Rucellai at Florence.

[2] In the so-called House of Agnès Sorel at Orleans the frieze is still wider in proportion (see above, pp. 418–419).

[3] All the heads of the medallions and most of the rest of this decoration have been destroyed. For the garlands, cp. above, pp. 407–8.

The same treatment is repeated at the entrance in the Rue du Petit-Salut and there are also three double niches at the north-west and south-west angles of the building. Such was the hôtel in which Thomas Bohier, General of the Finances of Normandy, transacted his business. It must have been completed just about the time that he began to build his château in the middle of the Cher.

Going from the Seine to the Loire we find in the old Hôtel de Ville at Orleans another building of great interest. Completed as it was in 1498, it claims consideration as the first attempt by a Frenchman, so far as our knowledge goes, to apply to French architecture the ideas of the Italian Renaissance. When the city fathers of Orleans determined to give a permanent home to their administrative labours, they selected a building in the centre of the town[1], which had once been the home of a feudal proprietor, but had since descended to the baser uses of an inn. It was known as the Auberge des Créneaux. A belfry tower, square and lofty, symbol of municipal liberties, was erected in 1453, and other alterations and improvements were doubtless made at the same time. But the municipal authorities of the next generation grew more ambitious, and the erection of a new building was entrusted to Charles Viart[2]. It has shared the usual fate of decay and restoration, but it is substantially the same as it was four hundred years ago[3].

It is the façade that principally demands our attention. It is evidently the work of a man who had a naive admiration for Renaissance ornament, but who was ignorant of the principles of Renaissance construction. He had probably never seen a Renaissance building in his life, and he had certainly never heard of the canons of Vitruvius. The pilasters which he so freely uses appear at first sight to

[1] In the Rue Saint-Catherine; it is now the home of the Museums of Painting and Natural History.

[2] How far the old building was utilised I do not pretend to say. The history of what actually took place is obscure, and even the name of the architect is not definitely certain. The date of 1443 which occurs in connexion with the building must refer to the old one.

[3] See Verdier and Cattois, ii. 60–72 and 4 plates; *Mon. Hist.* iii. pl. 67.

be treated as mere decorative bands. But though he violates all the classical rules of proportion between the different members of an order, he has a regard for structural realities, and it will be seen on examination that in a fashion of his own he makes his pilasters correspond to them. In many respects his use of Renaissance ornament is ingenious and artistic. The long frieze of shells over the windows of the first storey, the arabesques and candelabra on the shafts of the pilasters, the little urns on the tops of the dormers, the ornament of egg and acanthus, all testify to his naive delight in these new forms of decoration. His capitals make no pretence at being classical, but like the rest of the decoration they have the true Renaissance spirit in their exuberant playfulness and joyous creative fancy. But this partisan of the new style has not wholly abandoned the old. He puts dormer windows in the high-pitched roof, and simple hood-moulds over the windows of the ground floor, and he introduces niches for statues with Gothic canopies between the windows of the first storey. Thus the two elements are intermingled without being fused. It is the same with the design. The square-headed windows of the two lower storeys and the emphasis laid on the division between them, the frieze and cornice above the first storey, all give a horizontal aspect to the building. But this is counteracted by the vertical divisions formed by the pilasters, and by the triangular gables which crown the dormer windows.

Twenty miles from Orleans, on the right bank of the Loire, the Hôtel de Ville at Beaugency is also attributed to Charles Viart. It was built before 1526, but probably not much before. If both buildings are by the same man, the later one is of special interest as shewing the progress that he had made in Renaissance architecture in the course of a quarter of a century. A common feature of the two buildings which supports the current attribution is the charming pair of corbelled turrets at either end of the balustrade below the roof. Except for these turrets, which were dear to French tradition, and for the high-pitched roof,

which the French never wholly abandoned, the Hôtel de Ville at Beaugency is pure Renaissance. Completed as it was at least six years before the Hôtel de Ville at Paris was begun by Il Boccador, at least four years before the château of Madrid was begun by another Italian, Girolamo della Robbia, and at least two years before Il Rosso came to Paris, it stamps its architect as the first Frenchman in France to adopt whole-heartedly the new style. We can therefore readily believe that he is the same man who shewed in his youth such naive enthusiasm for it a little lower down the Loire.

The only remaining Hôtel de Ville that calls for notice is that of Vendôme. Built over the gate of St George, it is pure Gothic on the side towards the town. But on the side towards the country there is a Renaissance cornice decorated with ten small medallions and supported on corbels with Renaissance mouldings.

IV. *Ecclesiastical architecture*

We must now turn to ecclesiastical architecture and see how far that was affected by Renaissance influences during our period. The story is a very brief one. We may begin by noticing the few examples in which, while the design remains wholly Gothic, Renaissance elements are introduced into the decorative details. For instance in the Flamboyant façade of Saint-Pierre at Dreux two medallions appear by way of ornament on either side of the rose-windows over the central portal, and two over the door in the tower, while the *tourelle* on the right of the tower is decorated with a band of scroll-work[1]. Similarly in the façade of Saint-Pierre at Avignon two Renaissance wreaths are introduced into a late Gothic design. These two are examples of what Mr Ward calls the first stage of the Renaissance in Church architecture. The second stage is represented by the façade of the chapel belonging to the château of Ussé (Indre-et-Loire) which

[1] In the interior of this church a doorway in the south aisle shews a mixture of Gothic and Renaissance details—crockets of cabbage leaves, a frieze of scroll-work, a shell, and semi-classical columns.

Jacques d'Épinay, chamberlain to Charles VIII, built about 1510–1520. Here again the general design is Gothic; in fact the designer has "emphasised the soaring effect by group-ing the door and window into a single tall feature crowned by a pointed arch under a canopy of Flamboyant outline[1]." But the details are rendered in Renaissance forms; classical pilasters frame the door and window, and over the door is a semicircular arch with a shell ornament. In the great central doorway of Rouen Cathedral (1509–1514) by Roulland Le Roux the Renaissance element is represented by occasional pilasters decorated with arabesques, and in the Chapel of the Saint-Esprit at Rue the ribs and pendants of the elaborate shell or vault are enriched with Renaissance ornament[2]. Even that *tour-de-force* of Gothic virtuosity, the rood-screen of La Madeleine at Troyes (1518–1577), contains some insignificant Renaissance work, but the rudeness of its execution is in marked contrast with the brilliant dexterity of the rest.

The only example of Renaissance construction, as dis-tinguished from Renaissance decoration, that can be posi-tively assigned to our period is the crowning structure of the north-west tower of the Cathedral of Tours, which was completed in 1507. It was the result of a determination to complete the towers with lanterns in the Italian style instead of spires[3]. The work was entrusted to Pierre Valence, *maître-fontainier*, the distinguished engineer, of whom mention has already been made[4], and with him were associated Bastien François, great-nephew by marriage to Michel Colombe, and his brother Martin[5]. The work, when

[1] Ward, pp. 38, 39 (fig.). [2] *Ib.* p. 36.

[3] The south-west tower was not completed till many years later (1534–1547).

[4] See above, p. 404, and Ch. L. Grandmaison, *Doc. inédits pour servir à l'histoire des arts en Touraine*, 1870 (reprinted from vol. XX of *Mém. de la soc. archéologique de Touraine*), pp. 143–146.

[5] Their names figure in the municipal accounts from 1510 to 1523. Martin died between 1523 and 1527; in documents of 1505 and 1515 he is qualified as "master of the works of masonry of the Church of Tours." See Grandmaison, *op. cit.* pp. 141–2, and E. Giraudet, *Les artistes*

Plate IX

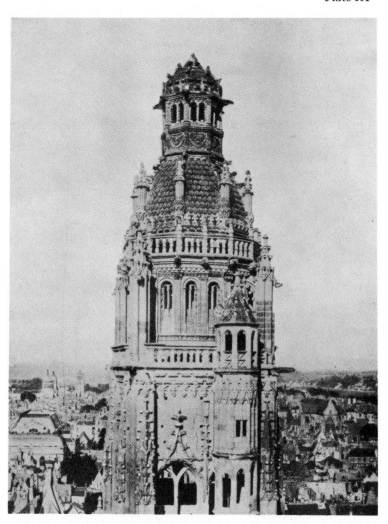

Tours : North West tower of Cathedral

Plate X

Phot. Comm. des Mon. Hist.

Tours : Cloisters of Saint-Martin

completed, consisted of an octagonal structure with an imbricated roof surmounted by an open lantern (Plate IX). The ornamentation is mainly Renaissance in character—classical mouldings above the windows of the octagon, scroll-work, dolphins, and other classical *motifs*—but Gothic has its share in numerous gargoyles and in sundry crockets and pinnacles. This new departure in the construction of church-towers in France had considerable influence. Mr Ward gives as examples of similar treatment Loches (1519–1530), Bressuire in Poitou, Coutances, and the Cathedral of Saint-Louis at Blois (completed 1609), and Geymüller adds Saint-Germain at Argentan in Normandy[1].

To the cathedral tower we may add as an example of novelty in construction the single remaining side of the cloisters of Saint-Martin (Plate X)—all that is left, with the exception of two out of the five towers, of the vast Abbey-church dedicated to the great Bishop, who in death as in life had so profound an influence on the history of the French nation[2]. The church itself with most of its dependences was completed by the middle of the thirteenth century, but the *belles galleries* on the south side were added from 1508 to 1519[3], presumably by Bastien François, who in a document of 1511 is qualified as "master-mason to the church of Saint-Martin[4]."

We cannot fix the precise date of the construction of the existing or eastern side of the cloisters, for we do not know in what order the sides were built, but at the latest it must have been begun quite at the beginning of the reign of Francis I. It consists of nine massive semicircular arches, resting upon imposts, from which also spring transverse double-arches[5]. These latter support the vault, which is

Tourangeaux, 1885, pp. 177–182. The monograms of the brothers are inscribed on the lantern (Giraudet, p. 178).

[1] II. 462–3.

[2] The church was destroyed in 1797–1799.

[3] Grandmaison, *op. cit.* p. 141. [4] *Ib.*

[5] Vitry, *Tours*, pp. 66–68; Ward, p. 91. By a door in the Rue Descartes (no. 3) the visitor passes from the twentieth century to this charming and reposeful relic of the sixteenth, now a convent of the nuns of Le Sacré Cœur.

divided into square compartments by longitudinal and trans-
verse ribs, and which is thus intermediary between the Gothic
ribbed vault and the coffered barrel-vault of the Renaissance,
such as we see at Chambord over the spiral staircase[1]. As
for the decoration it is almost entirely Renaissance. Above
each arch is an exquisite frieze of scroll-work and other Re-
naissance ornament. This from the delicacy of its execution
is probably Italian work, as also is the ornamentation of
the groins of the roof. On the other hand, the cornice
on the side towards the court, which is coarser work, may
be ascribed to the prentice hands of French workmen.
Certainly the medallions which fill the spandrels of the
arches are French work; the heads are modelled in low
relief, and in two cases their place is taken by a group.
We shall see in the next chapter that at about this time there
were Italian sculptors established at Tours, who were
unrivalled in decorative work. Such were the Giusti who
set up an *atelier* in 1509 or thereabouts, and Girolamo
Pachiarotti, who resided there from 1503 to 1507, while he
was working at the tomb of François II, Duke of Brittany.
In 1508 and 1509 he was employed at Gaillon, but we find
him again at Tours in 1513.

At any rate, neither Bastien François nor his brother
Martin were as skilful as the Italians in the execution of
Renaissance details. We see this in the charming Fontaine
de Beaune, which they made in 1510–11[2] for the financier,
Jacques de Beaune, and which was set up near his hôtel at
Tours[3]. In the centre of an octagonal tank of grey Volvic

[1] According to Dom de La Tremblaye (*Solesmes*, 1892, p. 122, cited by
Geymüller, I. 554), Simon Hayneufve or Simon du Mans, whom Tory ir his
Champfleury (1529) praises as a second Vitruvius, and who had studied
art in Italy—he was a sculptor and a painter, as well as an architect—
vaulted the chapel of the Bishop's palace at Le Mans with an Italian dome
(*circ.* 1510). At Châteaudun, about 45 miles from Le Mans, the so-called
Maison des Architectes has a small octagonal stair-turret vaulted by a dome
and crowned by an open lantern, but it may be considerably later in date.
See *Bull. Mon.* LXXVI. (1912), 538; Vitry, *Hôtels*, II. p. iii, fig. v.

[2] Grandmaison, p. 204. Jacques de Beaune ordered the marble at
Genoa in August 1509.

[3] Trocadéro, F. 284; Vitry, *Tours*, p. 55 (fig.). See also Vitry, *M.*

lava, with classical pilasters at the angles and ribbons and dolphins on the sides, rises a pyramidical structure of white Carrara marble in five receding tiers. It was originally crowned by a Calvary in gilded medal, but this with the greater part of the basins which formed the pyramid has disappeared, so that it is rather difficult to judge of the true proportions of the monument. The ornamentation is thoroughly Italian in character, and is executed with considerable skill, but it has not the exquisite delicacy of the best Italian work.

The brothers François had no lack of models for fountains of this Renaissance type. The workshops of the Giusti and the other Italian sculptors at Tours carried on a regular industry for the production of stoups, baptismal fonts, fountains, and other similar monuments. Their work is still to be found in various churches, especially at Tours. Examples are the font in the Cathedral, the stoup for holy water in Sainte-Radegonde, which came from the Abbey of Marmoutier, and that in the chapel of the *lycée*, which may have come from the church of the Minims at Plessis-les-Tours[1]. The fountains have been destroyed or mutilated, but some may be traced by fragments or drawings. We have seen that there were two Italian fountains at Gaillon, one in the centre of the great court, which was presented to the Cardinal by the Republic of Venice, and which came direct from Genoa, and another in the gardens. We know nothing of the *provenance* of the latter, but from the presence of *fleurs de lys* and ermines on the edge of the basin M. Vitry plausibly conjectures that it was made by Italian artists in France. This basin with its pedestal, both of white marble, which must have formed the upper portion of the fountain, is now in the Louvre, an exquisite example of delicate and artistic workmanship[2].

Colombe, pp. 364–5; Spont, *op. cit.* p. 104, n.[2]. The fountain was removed when the Rue Royale (now the Rue Nationale) was made in the eighteenth century, and, after being stored away for some years, was set up again in the Place du Grand-Marché.

[1] Vitry, *M. Colombe*, pp. 198–201. [2] *Ib.* pp. 146–150.

From a drawing by Du Cerceau we know that a fountain with a cupola surmounted by a lantern stood in the centre of the court of Bury, and fragments are still to be seen at Blois of one which Louis XII erected in the garden of his château[1]. They consist of part of the octagonal basin and of the principal circular basins, and are sufficient to shew that the fountain was of the same Italian type as those at Gaillon[1]. There is also at Blois a fountain, which dates from the same reign, but which is purely mediaeval in character. It is a rectangular structure without any basins, and with its massive proportions and Flamboyant ornament forms a striking contrast to the Italian type with its elegant tiers of basins and classical details.

But it was the Italian type which prevailed in France. At Clermont-Ferrand there is a fountain of Volvic lava, bearing the date of 1515, the arabesques and general decoration of which are superior in execution to those of the Fontaine de Beaune[2]. It differs from the usual type in having two octagonal tanks and one basin. On the other hand, the slightly later fountain at Mantes (1519–1521), which is beautifully proportioned, follows the customary Italian fashion of one large and two small receptacles[3].

To return to our subject, this brief record of the few examples of Renaissance work, whether structural or decorative, to be found in French ecclesiastical architecture before 1515 may be usefully supplemented by an instance in which the change from the old to the new style was deliberately made by a distinguished architect a few years after the close of our period. In 1514 Jean Texier, the architect of the north-western spire of Chartres, began the *pourtour* or screen round the choir. The first two bays on each side, which he completed by 1520, are pure Gothic. But when he came to the third bay, except for the canopies over the sculptures, which remained Gothic, he adopted an equally pure Renaissance design, decorating it with the usual

[1] Vitry, p. 202.

[2] Palustre, *L'architecture de la Renaissance*, p. 239 (fig.).

[3] Palustre, *La Renaissance en France*, p. 61 (fig.).

Renaissance ornaments, and even adding medallions of Hector, Titus, and Vespasian, in spite of their incongruity in a Christian church. In the same year, 1520, he built, also in the Renaissance style, the charming little Pavillon de l'Horloge, at the foot of the north-western tower.

V. *Stained Glass*

If Architecture was the mistress Art of the Middle Ages, her chief handmaids were Sculpture and Stained Glass. The revival of Architecture after the close of the Hundred Years War therefore naturally brought with it a corresponding activity in these two arts. Sculpture demands a separate chapter, but Stained Glass may be conveniently dealt with here. During the second half of the fifteenth century the chief centres of its production were Normandy, Moulins with Riom and Ambierle in the territory of the Dukes of Bourbon, Bourges, Avignon, Marseilles, and Toulouse, but as regards the three latter places our knowledge is derived chiefly from the records, for most of the glass has vanished from the churches.

The evolution of stained glass from the twelfth to the fifteenth century was, so to speak, from pattern to picture. The glazier of the twelfth and thirteenth centuries sought first and foremost to fill the spaces between the tracery with patterns of glowing colour, and to this aim he entirely subordinated the drawing of the human form and other natural objects. The fourteenth century is a period of transition, in which pictorial ambition begins to assert itself, but in which the glass has neither the superb colour of the earlier centuries nor the masterly drawing of the later ones. Before the close of the fourteenth century glass begins to imitate not only painting but also architecture and sculpture. The typical window of the fifteenth century is one in which each light is filled with the figure of a Saint, "grave and motionless as a statue," standing on a pedestal beneath an architectural canopy[1]. Such are the Prophets and

[1] Michel, IV. 774.

Apostles which once adorned the famous Sainte-Chapelle of
the Duc de Berry at Bourges (dedicated in 1405), and are now
preserved in the crypt of the Cathedral.　Such too are the
Evangelists and the Latin Fathers of the Church (1465) in
the same Cathedral.　But already before this date a window
at Bourges had shewn the way to a more pictorial treatment.
The Annunciation in the Chapel of Jacques Cœur (1448–1450)
is designed like a picture, but though the drawing is correct
and beautiful, the general effect, partly owing to the crudeness
of the colour, is very inferior to that of thirteenth century
glass.　Though the architectural framework is spread over
the whole window, each figure occupies a single light.　In
some Norman windows of a quarter of a century later[1]
the pictorial tendency shews itself rather differently.　Each
light represents a scene of several figures, but each scene is
confined within its architectural frame.

　　The next stage is well represented in the Collegiate
Church of Moulins.　Here are windows, dating from about
the last twelve years of the fifteenth century, in which
neither separate figures nor separate scenes are isolated,
but which represent a single and complete picture.　The
earliest, given by Cardinal Charles de Bourbon, who died in
1488, represents the Crucifixion.　The latest (to judge from
the treatment) is a fine window of three lights, which has
for its subject the presentation of two donors by their
patron saints to the Virgin and a choir of angels.　The
architecture is common to the whole picture, imitating not
the canopies of niches for statues but the fan-vault of a
building; so also are the angels, who thus serve to connect
the several lights[2].　Thus the treatment of the window in the
Chapel of Jacques Cœur at Bourges and that of the windows
at Evreux, Verneuil, and Pont-Audemer are combined.

　　[1] Pont-Audemer (Saint-Germain), Evreux (Cathedral), and Verneuil
(La Madeleine).
　　[2] This window has been badly restored, and in place of the female
donor the figure of a man, which belongs to another window, has been
inserted.　The donors have not been really identified, though the name
of Cadier is sometimes given to them.　The patron saints are St Peter
and St Barbara.　See Michel, IV. 783 (fig.).

Similar treatment is shewn in the central window of the clearstorey of the choir (much restored in 1842), which represents the death of the Virgin. An interesting feature is the Renaissance character of the architecture.

But the finest window of all is the one at the west end of the north aisle, known as the window of St Catherine[1]. The figure of the Saint, which occupies the middle of the five lights, is later than the rest, having been introduced in the sixteenth century, probably in the place of an earlier figure. On her right hand kneel Catherine d'Armagnac, wife of Jean II de Bourbon, and Pierre and Anne de Beaujeu with their son and daughter, on her left Jean II and Cardinal Charles de Bourbon. Behind Catherine stands St Anne, who is teaching the Virgin to read, behind Jean II, Charlemagne and John the Baptist. From the central position assigned to St Catherine it is inferred that the window was a memorial to Catherine d'Armagnac. The presence of Pierre and Anne de Beaujeu's little son fixes the date as between 1496 and 1498, for he died in the latter year and he was younger than his sister Suzanne, who was born in 1491.

About this time the school of Champagne began its flourishing career. The splendid windows in the nave of the Cathedral of Troyes date from 1498 to 1504. They nobly represent the story-telling phase of the glazier's art, in which he breaks with the old traditions by omitting the architectural framework. One of them, the History of the Cross, is an exact reproduction of an anonymous engraving of the French school. To copy engravings became a common practice with glass-painters in the sixteenth century. Martin Schongauer and Dürer were especially popular, and Italian masters also furnished subjects[2].

Thus the art of stained glass became the art of painting pictures on glass. The artist, freed from the control of the architect, became a painter. He no longer confined his subjects within a framework of imaginary architecture; he

[1] See J. Locquin, *Nevers et Moulins*, 1913, pp. 116–17 (fig.).

[2] Michel, IV. 789–90; L. Morel-Payen, *Troyes e Provins*, 1910, pp. 28–9.

did not even take account of the real architecture of the window. He painted pictures with blue skies, landscapes, foregrounds and distances[1]. But this was but the final consummation of an evolution which had been going on ever since the beginning of the fourteenth century, and it can only be regarded as a manifestation of the Renaissance spirit in so far as it meant greater freedom for the artist. Technically the artist in glass remained for a little time longer a glazier. The old traditions, which had been definitely abandoned as regards design, were still maintained in technique. The artist still put together a mosaic with pieces of coloured pot-metal glass; it was not till the middle of the sixteenth century that he painted on white glass with vitreous enamel[2]. In fact it is usual to describe the stained glass of the early sixteenth century as Gothic or Renaissance, not with reference to the treatment or the technique, but according as the architecture that it represents is Gothic or Renaissance in character. Thus for the purpose of our inquiry stained glass is important, not so much as an art in itself, as for the evidence it affords of the development of Renaissance architecture in France.

From this point of view the magnificent series of windows in the Cathedral of Auch are of the greatest interest, for they are not only superb examples of their art, but they are both signed and dated[3]. Begun in 1509, on the invitation of the Cardinal de Clermont-Lodève, who was Bishop from 1507 to 1538, they were completed, as an inscription in

[1] Mâle, op. cit. p. 789. The Church of Saint-Patrice at Rouen is full of early Renaissance glass. Whatever the merit of the individual windows—and it is considerable—the general effect is not altogether harmonious. The absence of any connexion between these pictures on glass and the structural divisions of the windows gives the effect of pictures without frames hung on a wall in close proximity. Moreover the brilliant colouring, which is so delightful when glass is treated as a true mosaic, is too crude and glaring for a picture.

[2] L. F. Day, Stained Glass, 1913, p. 70.

[3] Abbé F. Canéto, Sainte-Marie d'Auch, Auch, 1893; N. H. T. Westlake, A History of design in painted glass, IV. (1894), 73–78; Mâle, op. cit. pp. 807–8.

Gascon on the last window tells us, on June 25, 1513[1].
A little lower the artist has signed his name—Arnaut de
Moles. He was born at Saint-Sever (Landes), ten miles
south of Mont-de-Marsan, and there he married and died.
There are windows by him at Lombez and Fleurance, and
he worked at Toulouse, where the corporation of painters
on glass revived their statutes in 1506, both as a glazier
and a figure-sculptor. His windows at Auch, eighteen
in number, fill ten of the eleven chapels which surround
the choir, one chapel, which formerly abutted on the
Archbishop's palace, having no glass. The subject of the
windows is the Bible story from the Creation to the
Resurrection. But the story is told with more regard to
the structural features of the windows than is shewn in some
of the glass that we have been considering. The treatment
is by no means uniform, but it may be said that in the great
majority of the windows the central portion of each per-
pendicular light is occupied by a single figure, either a
Patriarch, a Prophet, an Apostle, or a Sibyl. These
figures, however, are not entirely isolated. Even when they
are confined within separate architectural niches, they turn
to one another in greeting or conversation[2]. Sometimes
a scene is spread over three lights, as in the Temptation of
Adam and Eve[3], and the Crucifixion[4]. In most of the
windows below the large central figures is a scene or scenes,
on a smaller scale, from the life of one of the figures above.
In the three-light windows a single scene is spread over all
three lights, in the four-light windows a pair of scenes fill
two lights each. Some of the windows have also small
scenes or figures above the large central figures. Eight
Sibyls are represented, all French in their attributes and
general treatment[5]. The noble dignity of the drawing in

[1] Lo XXV DE IHUN M V CENS XIII FON ACABADES LAS PRESENS VERINES
EN AUMOUR DE DIEU DE NOTR [Dame].

[2] No. 5 (beginning from the chapel to the east of the north door),
Canéto, opp. p. 28.

[3] No. 1, Canéto, opp. p. 17.

[4] No. 11, Canéto, opp. p. 24.

[5] See chapter xv for Sibyls in French art.

the larger figures, the skilful perspective of some of the smaller scenes, the variety of treatment in the architectural framework, and the harmonious richness of the colouring proclaim Arnaut de Moles as a great artist. In technique he is true to the old traditions: his colour is in the pot-metal glass, and thus has the luminous depth which painted white glass can never give; the only paint that he uses is the brown pigment that glaziers had used from the first for the purpose of defining details. It is in the architecture alone that we see the influence of the Renaissance, and this only in some of the windows. It is most conspicuous in the fifth window (the right-hand window of the chapel of Notre-Dame de Pitié), the central figures of which are framed in classical niches with shell canopies: these latter also occur in the eighth and fourteenth windows, and in one or two others. Renaissance structure, sometimes of a rudimentary or unorthodox type, is also to be found in a few other windows, while here and there appear Renaissance details, such as dolphins and garlands. But "the spirit of the work is Gothic[1]."

It is to the Church of Saint-Vincent at Rouen and the famous Vitrail des Chars that we must go for the first clear manifestation of the Renaissance spirit in French stained glass. Its subject is an allegory of the Fall and Redemption of Man, represented in three scenes—the Triumph of Adam and Eve, the Triumph of Sin, and the Triumph of the Virgin[2]. Each Triumph fills four lights. The whole treatment with its feeling for composition and pictorial effect, its energy and rhythm, its actual reminiscences of Italian painting, is eloquent of the Renaissance. We know both the date and the artists. On one of the wheels of the Virgin's triumphal car is inscribed 1515[3], and in the two lower corners of the

[1] Day, *op. cit.* p. 67, but he over-estimates the amount of Renaissance detail.

[2] Fig. Michel, IV. 797.

[3] This has not been noticed either by Palustre who dates it *circ.* 1550, or by M. Mâle (in Michel), who gives the date as *circ.* 1515 or 1520. Dr M. R. James told me of the date before I had seen the window; it is clearly visible.

window, as in three other windows of the same church, the monograms of Engrand Le Prince and his son Jean.

The introduction of the Roman triumph with the triumphal car into Christian art is an interesting and characteristic feature of the Renaissance[1]. It was largely due to the illustrations to Petrarch's *Triumphs*, the last· of which, the Triumph of Divinity or Eternity[2], represents Our Lord, either on the Cross or in Glory, in a car drawn by the four Evangelists with their symbols. The Triumphs thus illustrated had immense popularity. They appear in painted panels[3] and illuminated manuscripts[4], in engravings on copper[5] and woodcut illustrations to books[6]; they furnish subjects for marriage coffers[7] and tapestries[8]; and only two hundred yards from the Church of Saint-Vincent they may be seen in bas-relief as a frieze to the Renaissance gallery (1530) of the Hôtel du Bourgtheroulde[9]. A fresh impetus was given to this use of the Triumph as a Christian symbol by Savonarola's *Triumphus Crucis* (1497)[10], in which, under the inspiration of the later Florentine engraving of the Triumph of Eternity, he portrays Christ as a conqueror seated in a triumphal car. His description furnished in turn the subject for a lost engraving by Botticelli, and for

[1] See Mâle, *op. cit.* pp. 307–310.

[2] In questo Trionfo, che dovrebbe intitolarsi piuttosto dell' Eternità.... It usually bears the latter title.

[3] Lady Wantage; Marquis of Lothian.

[4] Mr H. Yates Thompson (*Twenty Manuscripts*, no. XCII.), *circ.* 1470–1480; Mr A. H. Huth (Burlington Fine Arts Club, *Exhibition of Illuminated Manuscripts*, 1908, no. 193), *circ.* 1490.

[5] British Museum, (*a*) Florence, *circ.* 1450–1460; (*b*) Florence, *circ.* 1470-1480. (See H. Boyd, *Triumphs of Petrarch*, 1906.)

[6] See below. [7] Victoria and Albert Museum, room 87.

[8] V. and A. Museum and Hampton Court (Flemish, 1507). I have only noted here some examples, existing in this country, of fifteenth and early sixteenth century representations of the Triumph. See for the whole subject Prince d'Essling and E. Müntz, *Pétrarque*, 1902, where over a thousand examples from the fifteenth to the eighteenth century are recorded.

[9] See above, p. 415.

[10] It was printed three times by Badius Ascensius; without a date, in 1523, and in 1524.

one of great power by Titian (*circ.* 1508–1510) which had a wide influence and was often copied or imitated[1]. But the chief source of the immense popularity of the Triumph as a subject for artistic representation must have been the numerous editions of Petrarch's *Triumphs* with woodcut illustrations which appeared at Venice from 1488 onwards, and also at Florence and Milan[2].

VI. *Summary*

We are now in a position to summarise the results of this and the preceding chapter. But first of all we must ask ourselves how far the work of destruction, which from various causes has been going on ever since the sixteenth century, has rendered our evidence incomplete. As far as regards the châteaux, probably to no appreciable extent. It is true that there is little left of Gaillon, the most important of all for our purpose, and nothing of Le Verger. But though we can only imagine what they looked like, we know enough from plans and drawings, and in the case of Gaillon from actual fragments, to judge with tolerable accuracy of the share which Gothic and Renaissance had in their structure and decoration. Of the other châteaux that were built or added to during our period probably not more than one or two are unaccounted for—none of any renown. Much the same may be said of public buildings; they have been restored in most cases with more zeal than wisdom, but they are still standing. It is otherwise with private houses. Of these the demolition has been wholesale. Entire towns, Marseilles, Bordeaux, Amiens have been so thoroughly modernised, that we cannot even tell what they once possessed. Rouen has suffered grievously, and there is enough left to make us realise what we have lost. Even places like Riom and Montferrand, where the march of

[1] It was copied in one of the windows of Notre-Dame de Brou.

[2] Venice, 1488; 1490; 149$\frac{2}{3}$; 1508. Milan, 1494. Florence, 1499. See Prince d'Essling, *op. cit.* I. 80–109.

civilisation has been less ruthless, can have retained only a small percentage of their fifteenth and sixteenth century houses. Some allowance also must be made for the imperfect information of the present writer. I have only been able to visit some thirty French towns since I planned this work, and though the study of texts and illustrations has added considerably to my knowledge, it is inevitable that I should have missed some examples of early Renaissance houses.

So far, however, as the evidence that has come under my notice goes, there are not more than one or two small town-houses of a date earlier than 1515 which shew any sign of Renaissance influence. It is true that as a rule neither documents nor inscriptions are available in the case of such houses. But the few dates that can be fixed help to support the above conclusion. Thus the so-called house of Tristan Lhermite at Tours (1495), the house of the Savaron family at Clermont (1513), the maison de la Reine Bérengère at Le Mans (1490–1515) and the hôtel of Pierre Morin at Amboise, which after his death in 1506 was completed by his widow, are all pure Gothic. On the other hand the old Bishop's Palace at Noyon[1], which is almost entirely Gothic, but which has a cornice of a Renaissance type and a shell-ornament over one of the windows, though begun in 1501, was not completed till 1528. So too the maison de la Salamandre at Lisieux, the maison d'Adam et d'Ève (1520–1525) at Le Mans, the maison des Consuls (1527–1531) at Riom, and the maison Duprè-Latour (1522) at Valence, of which M. Reymond says, *c'est comme un résumé de toutes ces formules de Florence et du nord de l'Italie*[2], all belong to the reign of Francis I. The only exceptions that I know of are two houses at Beauvais; one, the maison du Pilier, which was altered between 1505 and 1508, shews some faint traces of Renaissance influence; in the other, at 14 Rue de l'Abbé Gellée, once a canon's house, a panel decorated with

[1] Vitry, *Hôtels*, I. 22–3, plate XLVII.
[2] *Ib.* II. 40–1, plate LXXIX, and M. Reymond in *Grenoble*, pp. 52–3. The artist was either an Italian, or a Frenchman who had visited Italy.

arabesques has been introduced into a pinnacle of the porch, which was added under Louis XII[1].

This evidence is of course very scanty, but even if we enlarge the field and take in every kind of town-house, large as well as small, the result is not very different. It is only in the hôtels of great nobles and wealthy financiers— the ducal palaces at Nevers and Nancy, the Hôtel de La Trémoille at Paris, the Hôtel de Beaune at Tours, and the Hôtel d'Alluye at Blois—that Renaissance work makes a definite appearance before 1515. It is otherwise with the hôtels of the leading *bourgeois*. For instance, at Bourges the Hôtel Lallemand was built between 1494 and 1518, but it is only the later portions that shew Renaissance influence. At Orleans the earlier block of the maison d'Agnès Sorel which was built at the end of the fifteenth century, is Gothic, while the Renaissance block belongs to the reign of Francis I. At Toulouse the Gothic portion of the Hôtel Bernuy is dated 1504, and the Renaissance building not till 1533. Moreover in the case of Orleans and Toulouse, both of which became of considerable importance as centres of Renaissance art, the whole evidence, as well from written records as from the houses which still exist, is fairly conclusive that in neither city did Renaissance architecture begin to make a decisive appearance before about the middle of the reign of Francis I.

Similarly at Poitiers the earliest existing Renaissance house is the Hôtel Berthelot, which was begun in 1529, while the Hôtel Fumée, which François Fumée built in the latter half of the reign of Louis XII, except for the columns of a small loggia, probably later than the rest, is entirely Gothic[2]. It is much the same at Troyes. It was only after the great fire of 1524, when a large part of the town had to be rebuilt, that, so far as our knowledge goes, the new style began to be adopted. The Hôtel des Ursins, for instance, built in 1520, burnt in 1524, and rebuilt in 1526, has an oriel that is half Renaissance, half Gothic, and a dormer

[1] Vitry, *Hôtels*, I. 21, plate XLV.
[2] Robuchon, *Paysages et monuments de Poitou*, pp. 148–9, plate XXVII.

that is wholly Gothic[1]. The Hôtel de Marisy, on the other hand, with its beautiful oriel, which dates from 1528 to 1531, is pure Renaissance[2].

There is not enough left of old Lyons to make its evidence of much value. But it is noteworthy that of the late fifteenth century and early sixteenth century houses that remain—they are to be found at the base of the hill of Fourvières—not one shews any Renaissance elements, and this in a city with a large Italian population. The Hôtel de Gadagne, which perpetuates the name of the Florentine family of Guadagni[3], the Hôtel du Gouverneur, and several houses in the Rue Saint-Jean and the Rue Lainerie, are all Gothic[4].

If then such is the general trend of the evidence with regard to the town-houses of men of wealth and position, who had perhaps acquired a taste for Renaissance architecture in Italy itself, it is no very hazardous conjecture that, if every moderate sized house that was built in France during our period were still standing, only a very small proportion of them would shew the slightest trace of Renaissance influence. At any rate for positive evidence of the progress of Renaissance civil architecture in France we must turn to the more important structures, the châteaux, the largest hôtels, and the public buildings.

During the twelve years from the return of the Italian expedition to the close of 1507 this progress was very slight. The period includes Le Verger, Château d'O, Meillant, the additions to Amboise and Blois, the earlier portion of Gaillon, the Hôtel de la Trémoille, the ducal palace at Nevers, and the Chambre des Comptes at Paris. Now in all these the Renaissance element is comparatively small. It is largest at Le Verger, where we see the influence of the Renaissance

[1] L. Morel-Payen, *Troyes et Provins*, p. 80.

[2] *Ib.* p. 81.

[3] Rue de Gadagne, nos. 10, 12 and 14. See Brossard, *Est*, p. 572.

[4] For two remarkable courts with open staircases connected by galleries see Vitry, *Hôtels*, I, plates LVII and LVIII, and for a house with a façade richly adorned with sculptures see Brossard, *Est*, p. 564.

in the general design, shewing itself chiefly in a greater feeling for symmetry and artistic composition. In the other buildings of these years the Renaissance element is mostly confined to decorative details, such as pilasters as a framework to the windows, and the use of Renaissance motives in the ornamentation. We also see the introduction of certain Italian features, such as medallions, a niche over the entrance gateway for an equestrian statue of the owner, and a loggia or arcaded cloister.

Earlier than any of these buildings, at any rate· completed before them, is the old Hôtel de Ville at Orleans (1498), where we see a Frenchman, without any assistance from Italian architects, introducing into a building, three-quarters Gothic in design and half Gothic in ornamentation, his own conception of the leading features of Renaissance details.

During the period from 1508 to 1512 the later portions of Gaillon and the Hôtel de Beaune at Tours were built, while the north wing of Châteaudun, the cloisters of St Martin at Tours (though possibly not the existing side) and the Bureau des Finances at Rouen were begun. Of these buildings, the south-east wing at Gaillon is thoroughly Renaissance in character, but, as we have seen, the greater part of the decorative details was executed by Italians, and the design was probably Fra Giocondo's. With regard to the cloisters of St Martin it is impossible either to fix the exact date of the side that is left, or to say how far Bastien François was responsible for the work; apart from the decoration, much of which is evidently Italian, the construction of the vault shews a distinct advance in the direction of the Renaissance. The Hôtel de Beaune too is remarkable for the classical sobriety of its treatment, while in the Bureau des Finances we have a most interesting example of a French master-mason working out his own scheme of Renaissance decoration.

In 1512, when some of these buildings were completed and the others were in process of construction, Geofroy Tory published his edition of Alberti's treatise on architecture.

His preface has so much bearing on our subject that it is worth quoting the first part of it:

> Our ancestors, as everybody knows, were content with good work, and built with little art and elegance. Their aspirations were moderate and they lived in houses of no great luxury and magnificence[1]. But at length we have woken up, and our buildings are now renowned everywhere. Indeed since that magnanimous king, the terror of all Italy, Charles VIII, returned as a glorious conqueror from Naples, the art of building in the beautiful Doric and Ionic style, which is also that of Italy, has begun to be practised among us with great success. At Amboise, Gaillon, Tours, Blois, Paris, and a hundred other important places, you will now see public and private buildings built in a classical style. You may see, I say, buildings so beautiful and so perfect that the French architects are judged to surpass, not only the Italians, but their teachers the Dorians and Ionians[2].

It is needless to point out how much exaggeration there is in this blast of the patriotic trumpet, but it shews that at this date, rather more than two years before the close of the reign of Louis XII, Renaissance architecture had taken a real hold in France. The majority of the French mastermasons, true to the traditions of their craft, might still offer a stubborn resistance to the new style, but some of them were already beginning to accept it, at least as regards decorative details, and were attempting, though at first with unpractised hand, to execute the favourite motives of Renaissance ornament.

Tory's preface is addressed to his fellow-citizens, Philibert Babou and Jean Lallemand the younger. The dedication to the latter was appropriate, for at this very time were being carried on the additions to his family hôtel which have been described above[3]. It was doubtless owing to the Italian connexions of the owner that the later portions shew strong Italian influence. As we have seen, their great interest

[1] We may assume that Tory is thinking only of civil architecture; he could hardly speak of the cathedral of his native town as built "with little art and elegance."

[2] A. Bernard, *G. Tory*, p. 105.

[3] Jean Lallemand the younger is evidently Jean IV; his elder brother, Jean III, was still alive. See above, p. 420.

consists in the fact that they are an attempt by French workmen to express Renaissance forms in their own fashion, with little or no help from Italian models. On the other hand the master-mason, Guillaume Pelvoysin, when he built the Hôtel Cujas about 1515, practically introduced no Renaissance element, although he was building for an Italian patron.

To the buildings that were in process of construction in the year 1512 we should perhaps add the Renaissance portion of the Hôtel d'Alluye at Blois. It was at any rate completed before the close of the reign of Louis XII. But as we have seen, it is, like the south-eastern wing of Gaillon, almost certainly the work of Italians. The same must be said, at least so far as the design is concerned, of Robertet's château of Bury. This, however, was not begun till after the accession of Francis I.

Viewing the movement as a whole, we see that the patronage of the new style was the work of a few individuals, of Charles VIII and Louis XII (both to a very limited degree), of powerful ministers like Cardinal d'Amboise, the Maréchal de Gié, and Florimond Robertet, of a wealthy financier like Jacques de Beaune. To their châteaux and hôtels must be added a very few public buildings, such as the Bureau des Finances at Rouen, the Hôtel de Ville at Orleans, the cloisters of Saint-Martin at Tours, and the lantern of one of the Cathedral towers. In the earlier of these examples, those before 1508, the Renaissance element is very small and confined to the decorative details. The lantern at Tours, which was finished in 1507 is, it is true, Renaissance work, but it is only a single feature, and that a small one, of the whole building. After 1508, chiefly owing to Cardinal d'Amboise and his successor Robertet, progress was more rapid, and designs made by Italian architects, or at least with their help, were carried out by native masons.

Even after 1508, except for a few isolated attempts of no great importance, the movement was confined to a small area, to Rouen and Gaillon on the Seine, to Blois and Tours on the Loire. At Paris it made at first little progress. In

the Chambre des Comptes, in spite of its attribution to Fra Giocondo, the Renaissance element is very small. It is larger in the Hôtel de La Trémoille, but even there it appears almost solely in the decoration of the outer façade.

The reasons for this slow advance of Renaissance architecture are fairly obvious. The king might import competent Italian architects like Fra Giocondo and Il Boccadoro, but they could do very little when confronted by masters of the works and master-masons who had neither the inclination nor the ability to carry out their designs. The leading master-masons, those who were capable of performing some of the functions of a modern architect, such as Jean Texier and Martin Chambiges, had been brought up in the great traditions of Gothic architecture, and they were naturally unwilling to go to school again with foreigners. The ordinary mason could execute a Gothic design with little aid from drawings, and he could chisel a crocket or a finial with marvellous skill. But when it came to a pilaster or a classical moulding, his hand lost its cunning, and he became a bungling apprentice. When Fra Giocondo left France, after ten years' service, in 1505, the only Italian architect left was Il Boccadoro, and at first he was employed rather as an organiser of pageants, a builder of temporary structures, and a maker of furniture, than as an architect of important buildings[1]. But there was now growing up a new generation of native master-masons, who shewed more goodwill to the Renaissance style, and who were ready to adapt it as far as they could to the old conditions. Such were Roulland Le Roux and Charles Viart. There were also older men, like Bastien and Martin François and Jean Texier, who rallied to the new style, though the latter did not do so till 1520.

It has been said that the style of Louis XII, as it is called, continued during the first five years of the next reign. That is true so far as regards results. But from the very outset of his reign, Francis I shewed his predilection for Italian artists in architecture as in other forms of art.

[1] See Ward, I. 61; he compares his position to that of Inigo Jones at the English Court.

The impulse was definitely given at his accession, though it did not bear fruit till about 1520. In 1530 the Italian influence was strengthened by the arrival of Il Rosso. He was followed in 1531 by Primaticcio, and in 1541 by Serlio, who as the chief authority on classical architecture had great weight as a writer, if not as an architect. In the early forties five great French architects, Jacques Androuet Du Cerceau, Philibert de L'Orme, Jean Bullant, Pierre Lescot, and Jean Goujon, of whom certainly the first three and probably also the other two, had studied in Italy, all began their professional career. Before the close of the reign a type of architecture was established in France, which with some modifications in detail to suit changing conditions of society remained essentially the same for more than three hundred years[1]. In spite of these repeated infiltrations of Italian influence, certain national traditions were never lost. The French remained faithful to their large mullioned windows, high dormers, and steep-pitched roofs[2]. Beneath its parade of classical and Italian forms the architecture of De L'Orme and Lescot and Bullant, like the poetry of Ronsard and Du Bellay, was French at heart.

[1] Ward, I. 133.

[2] Ward, *The Architecture of the Renaissance in France* in *Journal of the Royal Institute of British Architects*, 3rd ser. vol. XIX. no. 10, p. 360.

CHAPTER XIII

SCULPTURE I[1]

I

To trace the first promptings of the Renaissance spirit in sculpture and painting is a far more delicate task than it is in architecture. Renaissance architecture is a definite thing. It has certain well-defined characteristics, about which there can be no dispute. But the characteristics of Renaissance sculpture or Renaissance painting are vague and difficult to define, and probably no two men would agree to the same definition. Thus although it can be at once said of certain works of sculpture or painting that they are mediaeval, and of certain others that they are Renaissance, there are others again which either shew both mediaeval and Renaissance characteristics, or in which these are so subtly and inextricably blended that it is impossible to distinguish them.

[1] The chief authorities are A. Michel, *Histoire de l'Art*, IV. (ii.) 573–645; P. Vitry, *Michel Colombe et la sculpture française de son temps*, 1901; E. Mâle, *L'art religieux de la fin du moyen âge en France*, 1908 (all three with numerous illustrations); L. Courajod, *Alexandre Lenoir, son journal et le Musée des Monuments français*, 3 vols. 1878–1887 (esp. vol. II.), *La Sculpture française avant la Renaissance classique* (*Leçon d'ouverture*), 1891, and *Leçons professées à l'école du Louvre* (1887–1896), ed. H. Lemonnier and A. Michel, 3 vols. 1899–1903, vol. II. *Origines de la Renaissance*, 1901; L. Gonse, *La sculpture française depuis le XIV⁰ siècle*, 1895, pp. 37–69 (inadequate and out of date for our period).

Casts of several of the monuments will be found in the *Musée du Trocadéro*, of which there is an illustrated *catalogue raisonné* (to the end of the fifteenth century) by Courajod and Marcou (1902).

In France the development of sculpture and painting was practically contemporaneous with that of architecture. In both arts as in architecture the full Renaissance may be said to begin about the year 1545; in sculpture with the work of Jean Goujon, in painting with that of François Clouet[1]. In all three arts alike the reign of Francis I (1515–1547) represents the early Renaissance, the period during which the two elements, Mediaeval and Renaissance, are struggling for mastery, and often appear side by side in the same work without being completely fused. Finally, there is the period with which we are specially concerned, a period of transition for sculpture and painting as well as for architecture, but in which the first beginnings of the new style are far more intangible and consequently far more difficult to detect than in architecture.

As regards French sculpture during this period of transition different views have been held. According to one view, of which Courajod was the chief exponent, French sculpture in 1495 was in a condition of decadence. The Solesmes Entombment, the Vierge d'Olivet, and the work of Michel Colombe mark the beginning of a new movement, which drew its inspiration from the Italian Renaissance. M. Vitry, on the other hand, believes that French sculpture after the revival of 1450 was, like French architecture, full of life and vigour, that it developed spontaneously without any help from Italian influence, and that it reached its culminating point in the works enumerated above. For M. Vitry these represent a *point d'arrivée* and not a *point de départ*, and he holds that the school which produced them, and which he calls the *École de Loire*, was at its maturity (*en pleine floraison*) from 1480 to 1512. After the latter date, which is that of the presumed death of Michel Colombe, sculpture in the region of the Loire began to suffer from the influence of Italian art. Finally, M. Vitry objects to the use of the word Renaissance in connexion with French

[1] Jean Goujon was paid for his work for the rood-screen of Saint-Germain l'Auxerrois (Deposition and Evangelists) in 1545; François Clouet was appointed painter to the king in 1540.

art, on the ground that the different and contradictory meanings attached to it are the source of much confusion and misunderstanding[1].

For the purpose of his own undertaking, which is the study of French sculpture from the artistic rather than from the historical point of view, M. Vitry is probably wise in avoiding the term Renaissance. But in this inquiry, which is very different in scope and character, we must perforce face the question to what extent, whether independently or not of Italian influences, the Renaissance spirit makes its appearance in the French sculpture of our period. The difficulties of the inquiry are considerably increased by the dispersion and the incompleteness of our material. M. Vitry testifies that in each of the contiguous departments of Maine-et-Loire, Indre-et-Loire, and Loir-et-Cher he has visited over a hundred communes. And it is only in one or two places that the rich material which once existed has been preserved more or less intact. The agencies of destruction have been chiefly four. First, the Wars of Religion, when the iconoclastic zeal of the Huguenots mutilated wholesale the images of the Virgin and the Saints. Next, the so-called "taste" of the eighteenth century, which destroyed works of art that seemed to it barbarous and Gothic. Thirdly, the Revolution, when the fury of the mob was directed chiefly against the tombs of royal personages, great nobles, and ecclesiastical dignitaries, and when a considerable number of monuments were methodically destroyed by the government on the report of a solemn Commission that "it was not of much merit[2]." Lastly, in the nineteenth century, the more insidious but not less effective raids of art-dealers and art-collectors.

But in spite of all this destruction enough remains to shew beyond dispute that, whatever the value of French sculpture during the second half of the fifteenth century

[1] See Vitry, *op. cit.* introduction, and esp. pp. xiii, xvii, xviii, xx, xxi.

[2] *Ce n'est point un ouvrage très précieux* was the verdict on the tomb of Jean de Salazar in the Cathedral of Sens (E. Vaudin, *Fastes de la Sénonie,* 1862, p. 166).

may be, there was abundance of it. The revival of archi-
tectural activity which followed the close of the Hundred
Years War brought with it a corresponding activity in the
sister art. The new cathedrals and churches, and the
façades with their portals and towers which were added to
those that were unfinished, required sculptures for their
external decoration, while the interiors were enriched by
the piety of corporations or individuals with countless
Pietàs and Entombments and statues of the Virgin and the
Saints. Of the character of this art some account must
now be given.

After the death of Philip the Good (1467) the Burgundian
school, which had for so long been dominant in sculpture,
began to decline. The tomb of John the Fearless and his
Duchess, which was completed in 1470, was merely a replica
of the great tomb of Philip the Bold[1]. In the tomb of
Philippe Pot, Seigneur de La Roche-Nolay, and Grand
Seneschal of Burgundy, which he ordered in his life-time,
probably between 1477 and 1483, for the Abbey-church of
Cîteaux, the theme of the *pleureurs* or mourners, which is
so characteristic of the ducal tombs, is greatly developed[2].
Whereas in the earlier tombs they are small figures standing
in niches round the sarcophagus, here they support on their
shoulders the slab upon which the effigy lies. Outside the
funeral monuments by far the most considerable example,
now existing, of the Burgundian style in the second half of
the fifteenth century is the great series of fifty statues which
adorn the screen round the choir at Albi, and which were
probably executed between 1485 and 1500[3].

The chief characteristic of this Burgundian sculpture is

[1] Ordered of Juan de la Huerta in 1443, it was completed by Antoine
Lemoiturier, a native of Avignon, in 1470. Though the latter lived till
nearly the close of the century, no later work of his is known. (See Michel,
III. (i.) 395–400; Courajod and Marcou, pp. 121–2.)

[2] Philippe Pot, who delivered a famous speech at the meeting of the
Estates at Tours in 1484 (see above, p. 363), died in 1494. His tomb, the
sculptor of which is unknown, is now in the Louvre. See Michel, III.
407–8.

[3] See J. Laran, *La Cathédrale d'Albi*, pp. 76–82.

sincere religious feeling expressed in massive, vigorous, and realistic forms. But in the inferior works of the school, especially in those of later date, there is a strong tendency to heaviness and vulgarity in the forms, and to over-exaggerated expression in the features. Moreover, the draperies, which in the masterpieces of the style add by their skilful treatment to the grandeur of the whole effect, in the inferior examples cease to be expressive, and become merely complicated.

Jacques Morel, a native of Lyons, but trained in the Dijon school, who worked from 1418 to his death in 1459, modified the Burgundian style by introducing into it greater delicacy. In 1453 he completed his masterpiece, the tomb of Charles de Bourbon and his wife Agnes of Burgundy at Souvigny, which even in its present lamentable state, stripped of its ornamentation and its mourners, and with the faces of the ducal pair mutilated, gives some idea of the artist's excellence[1]. The same tendency to refinement and delicacy is found in a Virgin and Child in a private collection of Autun, which came from a church in the neighbourhood[2], and in the retable of the Tarasque in the Cathedral of Saint-Sauveur at Aix[3], the execution of which was finished in 1470. The central figure of St Anne, who has in front of her the Virgin and Child, is particularly good; on her left is St Maurice, and on her right the legendary monster of Tarascon with St Margaret rising out of its back. Another Virgin and Child of the same period—its date is 1478—is in the Musée Calvet at Avignon[4]. The drapery is too heavy, but the work is full of feeling.

The Burgundian influence in sculpture did not extend to the whole of France. In the Ile de France, where there was little artistic activity during the fifteenth century, M. Vitry points out that the sculpture of this period is not of the

[1] Michel, *op. cit.* pp. 408–413; Trocadéro, E. 145. Morel was the uncle of Antoine Lemoiturier.

[2] Figs. Vitry, p. 69; Michel, IV. 579.

[3] Trocadéro, E. 2; Vitry, p. 267 (fig.).

[4] From the church of Les Célestins.

Burgundian type. Similarly with regard to Champagne MM. Koechlin and Marquet de Vasselot have shewn that, in spite of its proximity to Burgundy, the vigorous school of sculpture which came into being at the beginning of the sixteenth century reveals little or no trace of Burgundian influence. They find the reason for this in the miserable condition of the province, which, before it had recovered from the effects of the Hundred Years War, was devastated by the struggle between Louis XI and the Duke of Burgundy. Again, in the region of the Loire, though the Burgundian influence appears here and there, as for instance at Angers, where Jacques Morel worked for King René, and at various isolated places[1], the sculpture, as a whole, preserves the characteristics of an earlier and purely French tradition.

The type which the Virgin assumed in this region in the fourteenth century may be described as that of maternal devotion. Combining homely simplicity with delicate grace, she envelops the divine Infant with a tender and often smiling look of love. A charming example may be seen in the Virgin of Notre-Dame du Marturet at Riom in Auvergne, which has always been the object of a special cult[2].

The largest collection of statues of this period, that is to say, from the death of Philip the Good (1467) to the Expedition of Charles VIII, is to be found in the Sainte-Chapelle of Châteaudun, which was begun by Dunois and his second wife, Marie d'Harcourt, in 1463. The countess died in the following year, but Dunois lived to see the chapel practically completed, and when he died in November 1468, his heart was buried within its walls[3]. The fifteen statues, which stand on columns ranged round the building, vary considerably in style and merit, but

[1] An example is the Virgin from the abbey of Beaumont-les-Tours in the *Musée de la Société archéologique* at Tours (fig. Vitry, p. 62).

[2] Fig. Vitry, p. 74. The date is not certain; Gonse assigns it to the fourteenth century, Vitry to the first half of the fifteenth century at the latest, Michel (III. 415) to the middle of the fifteenth century. It is on the central shaft of the main portal.

[3] L.-D. Coudray, *Hist. du château de Châteaudun*, pp. 101–109.

Plate XI

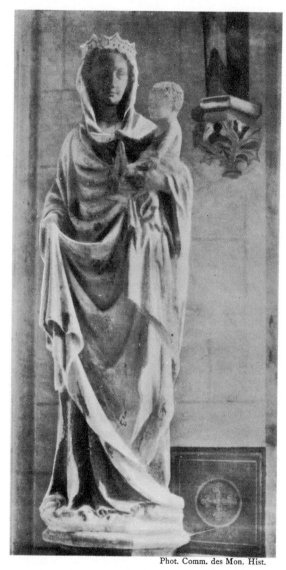

Virgin and Child (Chapel of Châteaudun)

doubtless the great majority, if not all, are of about the same date as the completion of the chapel. Two are far superior to the rest, the Virgin, and the Magdalen. The latter is at once simple and impressive. Her draperies are ample, but they do not hang in the complicated folds affected by the later Burgundian school. The whole execution shews that careful attention to details which we shall find in the Entombment of Solesmes and the work of Michel Colombe[1]. The Virgin (Plate XI) is a more radiant and more idealistic figure. Her beautiful and regular features are illumined by a charming smile; her draperies, less ample than those of the Magdalen, fall in easy natural folds. Like the Virgin of Riom, she wears a crown over her head-dress, and like the same Virgin she holds the Child on her left arm[2]. Similar in style, though very different in conception, is a statue of painted wood, representing Our Lady of Sorrows, in the *Musée archéologique* at Tours. It is approximately dated by the pointed shoe, which, according to M. Vitry, went out of fashion in the last third of the fifteenth century[3]. As regards the other statues at Châteaudun, they fall into two main groups. The one to which the Magdalen belongs includes another figure of some merit in St Barbara. The other is chiefly composed of male Saints, the best perhaps being St John the Evangelist, and is characterised by a precise realism and straight draperies after the fashion of the time.

The capitals of the columns on which these statues rest are formed by child-angels of a type peculiar to French and Flemish art. We find a somewhat similar type as early as the thirteenth century, when it appears on the voussoirs of the central portal of Bourges Cathedral, and towards the close of the fourteenth century in the Angels of the altar of

[1] Fig. Vitry, p. 81.

[2] Fig. *ib.* p. 79. It seems to me possible that this statue may be later than the rest, dating from the time (1490) when François d'Orléans and his wife, Agnes of Savoy, began to occupy themselves with the palace and chapel.

[3] Fig. *ib.* p. 77.

Notre-Dame la Blanche in the Sainte-Chapelle of the same
city[1]. But the type that became so popular in the fifteenth
century, slightly older than the earlier type and not so
distinctively boyish, makes its first appearance, so far as
I know, in the two Angels at the head of the recumbent
effigy on the tomb of Philip the Bold, which was completed
in 1411. The fame of this tomb served to fix this type, not
only as a theme for funeral monuments, but wherever Angels
were employed. A good example may be seen in the northern
portal of the façade of the Cathedral at Vienne, where, either
in couples as choristers, or crowded together like birds with
their wings folded round them, they fill the two voussoirs
of the arch[2]. Another delicious example is the bronze Angel
of the château of Le Lude (Sarthe), now in the Pierpont
Morgan collection, which served originally as a weather-
cock, the forefinger pointing in the direction of the wind[3].
An inscription on one of the wings gives the date—March 28,
1475 (O.S.)—and the name of the maker—Jean Barbet of
Lyons[4].

The child-angel was one of the numerous types by which
French sculpture in the latter half of the fifteenth century
interpreted the devotional sentiment of the people. Of
single figures by far the most popular was naturally the
Virgin. Her statues were to be seen, enshrined in niches on
the wall, at the corner of nearly every street[5]. As M. Vitry
has pointed out, she is almost invariably represented in
a standing position, with the Child on one arm, seated
or half-length figures of the Virgin, so dear to Donatello
and Luca della Robbia, being almost unknown in France.
Many of these statues were regarded with peculiar vene-
ration, as for instance the one at Riom. The mutilation

[1] Fig. Michel, III. 401.
[2] Fig. Michel, IV. 577. There are similar angels by Lemoiturier in the façade of Saint-Antoine-en-Viennois (1461–1463).
[3] Trocadéro, E. 89.
[4] The statuette did not belong originally to the château of Le Lude, but was bought at Paris in the middle of the nineteenth century. See Vitry, pp. 84–86; Michel, IV. 580; Courajod and Marcou, p. 134.
[5] There are still some left at Avignon.

of a favourite Madonna at Paris in 1528 was made the
occasion for a great expiatory procession, and nothing did
more harm to the cause of Reform than outrages on these
cherished objects of the popular worship. The devotion
of the French people to the outward symbols of their religion,
and especially to the statues of the Virgin and the Saints,
is a force which every historian of the Reformation must take
into account.

Only less popular than the Virgin were the Saints.
Above the city-gates, on the towers of châteaux, over the
doorways of public buildings and private houses, they kept
watch and ward, and gave protection to their clients.
Among the most popular, besides the chief Apostles, St Paul
and St John the Baptist, were St Denis, the patron-saint of
France, St Nicholas, the special patron of the poor, the
oppressed, and the helpless, St Martin[1], St Remy, St Quentin,
St Christopher, who protected folk against sudden death, but
who was less popular on the whole in France than in England,
St Sebastian and St Roch, both of whom warded off
the plague[2], the two physicians, St Cosmo and St Damian,
the two cobblers, St Crispin and St Crispinian, and St Éloi,
the favourite goldsmith of King Dagobert, who was adopted
by the blacksmiths as their patron and fitted with an
appropriate legend[3]. Of the female Saints the most popular
were the Magdalen, St Géneviève, St Catherine, the patroness
of young girls[4], St Barbara who, like St Christopher,
warded off sudden death, St Margaret, and St Anne, the
patroness of mothers, whose great popularity dates from the
treatise of Trithemius (1494), in which he championed the

[1] A statue of St Martin giving his cloak to the beggar at the corner of the
Rue Saint-Martin at Beauvais is reproduced in A. W. Pugin, *op. cit.* p. xii.

[2] St Roch was born at Montpellier in the twelfth century. His
European popularity as a healer of the plague dates from the Council of
Constance (1414). In France it became enormous in the sixteenth century.
In the Bourbonnais alone 114 parishes honoured him with a special devotion
(Mâle, p. 197).

[3] Mâle, p. 203.

[4] In the diocese of Amiens alone there were recently 200 churches which
possessed a statue of St Catherine.

doctrine of the Immaculate Conception[1]. Before this, probably in 1492, Robert Gaguin had written a prose oration on the same theme, but he did not publish it till after the Theological Faculty of Paris had passed a resolution (August 13, 1497), requiring from all Doctors of Theology an expression of belief in the new dogma[2]. The fact that the Queen of France and the Duchess of Bourbon were both named Anne possibly contributed to the popularity of their patron-saint[3].

Coming from single figures to groups, the favourite forms which they assumed at this time were the *Pietà* and the Entombment. The oldest *Pietà* in France of which we have any record was executed by Claus Sluter in 1390, but it has unfortunately disappeared. Of those which still exist none can be definitely assigned to an earlier date than 1460, which is the approximate date of a bas-relief at Vernou near Tours. The *Pietà* of Moissac (Tarn-et-Garonne) is dated 1476, but the great majority belong to the close of the fifteenth century and the early years of the sixteenth. As it was just at this time that the *Confréries* of Notre-Dame de Pitié began to multiply, it is natural, says M. Mâle, to suppose that the existing *Pietàs* were for the most part ordered by these societies. Among the more remarkable are those at Bayel and Mussy-sur-Seine in Champagne (Aube)[4], and at Autrèche in Touraine[5]. With few exceptions

[1] Mâle, p. 229.

[2] Thuasne, *op. cit.* I. 104. In 1477 Sixtus IV, who as a true Franciscan warmly encouraged the cult of the Virgin, instituted a special office for the Feast of the Conception on December 8. This was partly a counterblast to the treatise which the Dominican, Vincenzo da Bandello, wrote against the Immaculate Conception in 1475, followed by another from the same pen in 1481 (Pastor, *Gesch. der Päpste*, II. 538–9). Gaguin's prose oration, as well as a Latin poem which he wrote on the same subject, were by way of answer to these treatises.

[3] Among the fifteenth-century Mysteries of Saints that have come down to us either in print or in manuscript are those of St Denis (3), St Martin (2), St Christopher, St Quentin, St Nicholas, St Sebastian, St Remy, St Crispin and St Crispinian, the Magdalen, St Généviève, St Barbara (2), and St Margaret.

[4] Fig. Mâle, pp. 124 and 125.

[5] Fig. Vitry, pp. 331 and xvi.

the Virgin is represented alone with her Son. But occasionally, as at Notre-Dame de Joinville (Haute-Maine), her grief is shared with St John and the Magdalen[1], St John in this case being nearly always at the Saviour's head and the Magdalen at His feet.

This larger group forms the intermediate stage between the *Pietà* and the Entombment, or, as it was called in France, the *Sépulcre*, which from the middle of the fifteenth century became exceedingly popular. In spite of all the destruction that has taken place there still exist in France a large number of these sculptured groups. M. Deslignières has counted no less than a hundred and twenty-six in Picardy alone. Many of course are of rude workmanship, but the more important ones form an interesting and continuous series from that of Tonnerre[2], which is dated 1453 and is thoroughly Burgundian in style, to that of Saint-Mihiel (Meuse) which the Huguenot sculptor, Ligier Richier, left, barely finished, in his workshop, when he fled to Geneva in 1560[3]. There are interesting examples, all pre-Renaissance, at Avignon, Souvigny, Auch, and Poitiers, and there is one, little known, at Bulgnéville near Vittel in the Vosges[4]. The finest, perhaps of all, except the famous one at Solesmes, which will be described later, is at Chaource in Champagne, and is dated 1515[5].

The composition of these Entombments follows certain traditional lines. The two ends of the shroud are always held by Joseph of Arimathea and Nicodemus, the latter being invariably bearded, while St Joseph is sometimes bearded and sometimes beardless[6]. Facing the spectator, are the Virgin in the middle, whose drooping figure is

[1] Fig. Mâle, p. 127. See generally for these *Pietàs* Mâle, pp. 122–128.

[2] Fig. Mâle, p. 133. [3] Fig. Mâle, p. 137; Michel, p. 653.

[4] My friend, M. Abel Lefranc, kindly sent me a post-card of this. I have not seen it mentioned in any book.

[5] Fig. Mâle, p. 134, and see generally, Michel, pp. 590–598; Vitry, pp. 304–306.

[6] In Flemish and German art St Joseph is always shaven and nearly always bald. M. Mâle infers that this was the general tradition, but that it was not observed in France (*op. cit.* pp. 59–60).

supported by St John, the two other Maries, one to the right of St John, near Our Lord's head, and the other to the left of the Virgin, and the Magdalen at Our Lord's feet. This order, however, is often varied, the Virgin with St John being placed near the head of Christ, while the holy women follow in order on her left. At Auch, Solesmes, and a few other places, two soldiers, standing or sleeping, are placed near the tomb. In the sixteenth century the sculptors depart more and more from the traditional arrangement. In the Entombment of Ligier Richier fourteen persons form a highly dramatic scene, in portraying which the artist is as much concerned with the display of his own talent as with the emotion of the actors. But in the earlier Entombments it is the dumb sorrow pervading the whole group which gives unity to the composition, and which renders even the ruder representations profoundly impressive[1].

It was not only the religious Confraternities that provided work for the sculptors. The professional and trade *Confréries* were equally active. It must have been chiefly owing to the influence of these latter that the Saints were represented not only as wearing the dress of their day, but as engaged in the occupations which legend assigned to them. Thus St Crispin and St Crispinian appear as working cobblers[2], St Cosmo and St Damian in the habit of Paris physicians[3], St Éloi as a blacksmith[4], St Joseph as a carpenter[5].

Certainly the decoration of the façades and portals of cathedrals and other large churches with statues was in a large measure due to the Confraternities[6]. Much of the

[1] See for these Entombments Mâle, pp. 128–140.

[2] In the Church of Saint-Pantaléon at Troyes (Mâle, p. 161)—a late work.

[3] Hours of Anne of Brittany; Musée archéologique, Tours; fig. Vitry, p. 326.

[4] Victoria and Albert Museum, room 8.

[5] Notre-Dame de Verneuil (Mâle, p. 162); Montréal near Avallon (Yonne). In the museum at Moulins there is a delightful bust, evidently a faithful portrait of some individual, entitled St Mayeul.

[6] For the influence of the trade corporations on religious art see Mâle, *op. cit.* p. 170, and cp. Dürer's account of a procession at Antwerp on the

work dates from the closing years of the fifteenth century. The rich façade of Saint-Riquier[1] was begun in 1475, and the work went on till 1516. Its neighbour, Saint-Wulfran of Abbeville dates from 1488, and Notre-Dame d'Alençon with its highly Flamboyant porch may be a year or two later[2]. The façade of La Trinité at Vendôme was begun in 1492, and that of the Cathedral of Coutances in 1494. The portals of Saint-Pierre at Dreux and of SS. Gervais et Protais at Gisors belong to the same period. In the east of France the western front of Toul was begun in 1460, but the work went on till 1517 and the sculptures of the portals are not earlier than the last decade of the fifteenth century. Of about the same date are the Prophets and Sibyls on the voussoirs of the portal of the transept at Sens, the work of a sculptor of Auxerre, named Pierre Gramain[3]. At Tours the western portals were filled with sculptures in 1486–1488, but these have been ruined by mutilation and restoration.

Happily the three great portals of the Cathedral of Saint-Pierre at Nantes, which are only a few years earlier in date (*circ.* 1470–1480), and are possibly, M. Vitry conjectures, the work of the same sculptors[4], are in fairly good preservation. In the voussoirs of the central portals are represented scenes from the Last Judgment. Of the side portals the northern is devoted to St Peter and the southern to St Paul. M. Vitry, who has examined the sculptures of the northern portal at close quarters with the help of scaffolding, points out the skill with which they are executed. The artist has taken into account the position which some of them occupy at a considerable height above the ordinary spectator, and he manages his perspective accordingly. Above all he has grasped the importance of simplification, of the elimination of unnecessary details, in work meant to be looked at from a distance. The general character of

Sunday after the Assumption, 1520 (W. M. Conway, *Literary remains of Albrecht Dürer*, Cambridge, 1889, pp. 99 f.).

[1] Fig. Michel, opp. p. 584. 　　　　[2] Fig. Vitry, p. 319.

[3] Eight life-sized statues which he made for the niches were destroyed at the Revolution (E. Vaudin, *Fastes de la Sénonie*, 1882, p. 153).

[4] The architect of Nantes, Mathelin Rodier, was a native of Touraine.

the treatment is that of careful but unaffected realism. The natural attitudes of the figures and the simple folds of their draperies remind M. Vitry of Fouquet's miniatures[1].

In the first chapter of his great work on the Religious Art of France at the close of the Middle Ages M. Mâle lays great stress on the influence of the Mystery-plays on Christian iconography. According to him the innovations in the representations of the life of Our Lord and the Saints which began to appear at the beginning of the fourteenth century were almost entirely due to the Mysteries, while these in their turn borrowed largely from a work entitled *Méditations sur la vie de Jésus-Christ*, which was falsely attributed to St Bonaventura. Of the intimate connexion between the religious art of France in the fifteenth century and the Mysteries there can be no doubt. Though the Mysteries practically begin with the letters-patent granted by Charles VI in 1402 to the Confrères de la Passion, in which the term is first applied to a dramatic representation, it is only in the middle of the century that they enter on their most flourishing period. This was due to the same cause as the revival of sculpture and architecture, the end of the Hundred Years War. It was about 1450 that Arnoul Greban produced the Mystery of the Passion, which inaugurated a new era in the dramatic art of the Middle Ages. Embracing the whole life of Our Lord upon earth from the Nativity to the Ascension in thirty-three thousand lines, it took four long days to act, and had nearly a hundred and fifty speaking characters. Of even greater dimensions was the revision which Jean Michel, a physician of Angers, made in 1486 of that part of Greban's work which relates to the actual Passion of Our Lord, while the Mystery of the Acts of the Apostles, which Arnoul Greban composed with the assistance of his brother Simon, was nearly double the length of his earlier work, and

[1] Vitry, pp. 88–92. Similar doorways in which the voussoirs of the arch are embellished with little groups of figures are represented in Roger van der Weyden's Miraflores and St John the Baptist altar-pieces at Berlin.

provided entertainment for ten days and parts for nearly
five hundred actors[1].

Such being the vogue of the Mysteries it is not difficult
to accept M. Mâle's view, at any rate for the second half of
the fifteenth century, that they largely influenced the
sculptors, or those who gave them their commissions, in their
treatment of religious subjects. But during the earlier
period of the Mysteries, when they were still in a more or
less rudimentary stage, the influence was probably more
often in the opposite direction. Thus we learn from a
passage in the *Journal d'un bourgeois de Paris* that in 1422
the entry of Charles VI and Henry V of England into Paris
was celebrated by the representation, apparently in dumb
shew, of a Mystery of the Passion of Our Saviour *selon qu'elle
est figurée autour du cueur de Nostre Dame de Paris*[2].

In any case the frequent analogies that we find between
the Mysteries and the contemporary sculpture point to the
popular character of the latter. And it is popular in the
best sense, not only in its choice of subjects, but in its
treatment of them, in its naive realism, its homely tender-
ness, and its convincing but unaggressive sincerity. It is a
religious art expressing the religious sentiment of the nation.

On the other hand the funeral monument, confined as it
was to princes and great nobles and high ecclesiastics, was
essentially aristocratic. Moreover, it was losing its religious
aspect; it was becoming less a work of commemorative
piety than a creation of family pride or personal vanity,
the outward sign of that craving for posthumous fame
which was so marked a characteristic of the Renaissance.
The earliest mediaeval form of funeral monument was a
simple slab level with the pavement. Then, at the end of
the twelfth century, it became a tomb surmounted by a
recumbent and idealised effigy. The next step, which may
be dated from the end of the thirteenth century, was with
the help of a death-mask to make the likeness more faithful

[1] See L. Petit Julleville, *Les Mystères*, 2 vols., 1880; Gaston Paris, *La
poésie du moyen âge*, 2me série, 1895, pp. 235–248.

[2] See G. Paris, *op. cit.* p. 239.

For two centuries after this the normal tomb in France
is a simple rectangular sarcophagus surmounted by a slab,
upon which reclines an effigy of the deceased, the head
resting upon a cushion supported by two child-angels, the
feet upon some animal. Two tombs of this type, both more
or less celebrated, belong to the middle of the fifteenth
century. One is that of Jeanne de Montejean, wife of Jean
de Bueil, who died before 1456[1], and the other, which is at
Loches, is that of Agnes Sorel, who died in 1449[2].

Though this type prevailed till the close of the fifteenth
century, two important innovations were introduced during
the first half of the fourteenth century. First the tomb was
ordered by its future tenant during his life-time, and secondly
the recumbent figure became a kneeling one, an *orant* instead
of a *gisant*. Probably the former innovation suggested the
latter. A person ordering his tomb in his life-time might
well shrink from contemplating his own effigy in the attitude
of death. But the kneeling figure is rare in the fourteenth
century, and is still an exception in the fifteenth. It was
not till the middle of the sixteenth century that it triumphed
over the recumbent statue[3]. We have fifteenth-century
examples in the tomb of Cardinal de Saluces, by Jacques
Morel, in the Cathedral of Lyons[4], the contract for which is
dated 1420, and in that of Jean Jouvenel Des Ursins, now
at Versailles (much restored), but formerly in Notre-Dame
de Paris, which was ordered soon after 1431. But the most
celebrated fifteenth-century tomb with a kneeling figure was
that of Louis XI at Cléry. It was designed by Colin d'Amiens,
and executed by Conrad of Cologne, goldsmith, and Laurent

[1] At Bueil (Indre-et-Loire). See Vitry, p. 97 (fig.); Courajod and
Marcou, p. 110; Trocadéro E. 44. The lady's feet rest upon two little dogs;
the angels, which hold an escutcheon, are in the Musée archéologique at Tours.

[2] Fig. Vitry, p. 92; her feet rest on two lambs. Courajod suggests
Jacques Morel as the sculptor.

[3] Mâle, pp. 466–468. He mentions as the earliest instance the tomb of
Comtesse Mahaut in the Abbey-church of Thieuloye near Arras, which is
known from a drawing. The countess died in 1329, and documents lead
us to suppose that the tomb was made in her lifetime.

[4] It was destroyed in 1652.

Wrine, metal-founder. In a letter written to the designer on January 24, 1483, minute directions are given with regard to the effigy. The king is to be represented in a kneeling attitude and in hunting dress, his dog by his side, his hat between his clasped hands, his horn suspended from his shoulders, his two boots shewing. The artist is to make him "as handsome as he can, young and plump, with the nose rather long and somewhat high, as you well know; and do not make him bald, and let the hair be longer behind than in front[1]." Thus Louis, who had cheated a good many people in his life-time, and who had a most unkingly fear of death—*car oncques homme ne craignit tant la mort*[2]—tried to cheat his last and most powerful enemy[3].

Meanwhile a practice had been introduced at the close of the fourteenth century which expressed an idea exactly opposite to that of the kneeling effigy. The kneeling effigy ignored death; the *cadaver*, half skeleton, half emaciated body, presented death in its most grisly aspect. The earliest examples of a *cadaver* in France are those of Guillaume de Harcigny, physician to Charles VI (d. 1393), at Laon, and of Cardinal Lagrange (d. 1402) at Avignon[4]. From this time there is an almost continuous series down to past the middle of the sixteenth century[5]. It was not, however, till after the accession of Francis I that a sculptor conceived the idea of uniting the kneeling statue and the *cadaver* in the same monument. It was carried out in the great tomb erected to Louis XII and Anne of Brittany at Saint-Denis, which served as a model for all the sculptors of the sixteenth century. The work was, in part at any rate, executed by the Giusti, but whether they or a Frenchman planned the design is not known.

Such was the character of French sculpture at the time

[1] Commynes, *Mémoires*, ed. Dupont, III. 339–341. The tomb was destroyed in the Wars of Religion and was replaced at the beginning of the seventeenth century by a work of Michel Bourdin.

[2] Commynes, VI. 11.

[3] The precedence of the kneeling attitude was followed in the tombs of Charles VIII and Louis XII.

[4] Mâle, p. 376. [5] *Ib.* pp. 468–9.

of the Expedition of Charles VIII. 'We must now turn
to the sculpture executed in France by Italian artists
before and after the Expedition. We shall then be in a
position to judge how far French work before 1515 was
influenced by Italian models, and how far independently of
this influence it exhibited qualities which may be regarded
as characteristic of the Renaissance.

II

For the earliest examples of Italian sculpture in France
after the revival of 1450 we must go back to Francesco
Laurana, who was working in France for King René from
1460 to at least 1466. In 1468 he was in Sicily and from
1474 to 1477 at Urbino. Then he returned to France and
was domiciled at Marseilles till 1483. When we last hear
of him in 1502 he was still living in his adopted country[1].
Besides his medals the only existing works, authenticated by
documents, that he executed on French soil are the decoration
of the Chapel of Saint-Lazare in the old Cathedral of
Marseilles (1477–1481) and the great retable from the church
of the Célestins at Avignon, now in the Church of Saint-
Didier (1478–1481). In the former work he is barely
recognisable, the chief share in it being apparently due to
his associate Tomaso Malvito or Sumalvito of Como. It is
chiefly remarkable for the arabesques on the pilasters and
other Renaissance details, the figures being of no great
merit[2]. The Avignon retable is striking rather than

[1] He was born about 1430. See Courajod and Marcou, pp. 139–143;
F. Burger, *Francesco Laurana*, Strassburg, 1907; W. Rolfs, *Franz
Laurana*, 2 vols. (one of plates), Berlin, 1907. Michel, pp. 620 ff.;
Vitry, pp. 117–122; W. Bode, *Florentine Sculptors of the Renaissance*, 1908,
pp. 129–140; A. Venturi, *Storia dell' arte italiana*, VI. (1908), 1022–1050.
Laurana's fellow-worker at René's court, Pietro da Milano, only spent
three years in France (1461-1464) and nothing of his work, except a few
medals, now exists. See generally for the Italian work in France at this
period, L. Courajod, *La part de l'art italien dans quelques monuments de
sculpture de la première Renaissance française* in *Gaz. des Beaux-Arts*,
1884 (1), 493 ff.; 1884 (2), 250 ff.

[2] Fig. Ward, p. 2; Burger, plates XXXI–XXXV. There are casts of the
pilasters in the Trocadéro (I. 171 and 172).

attractive. The background consists of classical buildings arranged in skilful perspective. The foreground represents Our Lord on the road to Calvary, surrounded by soldiers whose brutal realism forms a strong contrast to the pathetic and refined forms of the holy women. But the composition is over-crowded, and even in the women the emotion is exaggerated. The work is executed in very high relief[1]. To Laurana also has been attributed the tomb of Giovanni Cossa, Grand Seneschal of Provence, (d. 1476), in the Church of Sainte-Marthe at Tarascon. It is in favour of the attribution that Laurana made a medal of him in 1456. Another tomb of about the same date which is assigned to him for a similar reason is that of Charles I, Comte du Maine[2], brother of King René, in the Cathedral of Le Mans. It consists of a Renaissance sarcophagus of white stone, beautifully carved, and resting partly on lions' feet. This is surmounted by a slab of black marble, on which rests the recumbent figure, noble in its simplicity, of the prince in armour, his head supported by a cushion, and his hands crossed over his breast. The design and execution are pure Italian and of high quality, and, whether the work is by Laurana or not, it is of great importance as the earliest existing example of an Italian tomb in France. Its exact date is unknown, but, if it is by Laurana, it was probably executed between 1477, when he returned to France, and the death of Charles II, Comte du Maine, in 1481[3].

[1] This retable is in a very dark corner, and it is easier to judge of it from the cast in the Musée Calvet at Avignon, or from that in the Trocadéro (I. 175).

[2] He died in 1473 (N.S.).

[3] It is just possible that it may have been executed in Italy and sent to France. The end of the nose is wanting, and in its present position the tomb is placed too high to admit of the figure being seen properly without standing on a chair. See L. Palustre in *Gaz. des Beaux-Arts*, 1886 (1), pp. 300–304; Vitry, p. 119; Courajod and Marcou, pp. 136–8; and for a cast, Trocadéro I. 170. The sarcophagus comes nearest to that of Pietro da Noceto's tomb by Matteo Civitali at Lucca (see above, p. 94), but if Laurana is the artist, his immediate source of inspiration is more likely to have been the replica of the Cardinal of Portugal's tomb at San Miniato which Antonio Rossellino

Though Laurana was still living in France in 1502, we know of no work of his later than the Avignon retable, which was completed in 1481, and it was not till after the return of Charles VIII from Italy that he was joined by another sculptor from that country. This was Guido Mazzoni of Modena, called Il Paganino (after his grandfather), whose Entombment at Naples had, as we have seen, made so great an impression on the French king that he invited him to France[1]. In the royal accounts for 1498 he is called *peintre et enlumineur*[2], but we know nothing of his painting, and it was as a sculptor that he enjoyed his considerable reputation. His importance is shewn by the fact that he received considerably higher pay than the other Italians in the service of Charles VIII[3]. We know that from 1511 to 1515 he was living in the Hôtel du Petit-Nesle at Paris with other Italian artists, but it is possible that his residence there began as early as 1507, after his return from a short visit to Italy[4]. In 1516 he returned to his native country for good, and died there in 1518.

Unfortunately the only two works which he is known to have executed in France, the tomb of Charles VIII at Saint-Denis and the equestrian statue of Louis XII at Blois, have both disappeared. Of the former, which was destroyed in 1793, we have descriptions and illustrations, from which we learn that the tomb was of black marble and that its sides were adorned with twelve medallions of half-length seated female figures representing, almost certainly, the Virtues[5].

made for Mary of Arragon in the Church of Montoliveto at Naples (see above, p. 111).

[1] See above, p. 111. In England, where he designed a tomb for Henry VII, which was rejected, he was called Pageny (L. Einstein, *The Italian Renaissance in England*, New York, 1907, p. 196).

[2] Not 1497, as M. Vitry says. The date of January 1, 1497, is old style.

[3] He received 50 ducats or 937 *livres* yearly, whereas even Fra Giocondo was paid only 30 ducats or 562 *livres*, and Lascaris only 400 *livres*. (*Arch. de l'art français*, I. 94 ff.)

[4] *Nouv. arch. de l'art franç.* VI. (1878), 238–9.

[5] They have no symbols. Examples of twelve Virtues occur in the central portals of Amiens and Notre-Dame (both thirteenth century). In a

On the top was the effigy of Charles VIII kneeling in a somewhat theatrical attitude before a *prie-Dieu*, and four child-angels, one at each corner, also kneeling. All the figures were of gilded bronze, except that the king's mantle, which falls round him in ample folds, was painted blue, probably in enamel[1]. Thus the themes were partly French and partly Italian, the kneeling figure of the king and the child-angels being French, and the medallions Italian. M. Vitry, however, is wrong in ascribing what he calls the "violent polychromy" of the gilded bronze and the blue enamel to Italian influences, for in this the sculptor was only following the precedent of the tomb of Louis XI, whose effigy was to be of gilded bronze, kneeling on a cushion of blue enamel[2].

The tomb was probably ordered by Louis XII. The same king gave Mazzoni a commission for a statue of himself for his château at Blois[3]. This is no doubt to be identified with an equestrian statue which formerly stood over the main entrance, but which is now only known from a drawing in the *Bibliothèque Nationale*[4]. We have seen that a similar equestrian statue of Pierre de Rohan, Maréchal de Gié, which adorned the principal front of his château of Le Verger, was probably by the same artist.

To the two authentic but vanished works by Mazzoni M. Vitry would add a third, which still exists, and to which

fifteenth century manuscript of *Le Champion des dames* (Bib. Nat. MS. franc. 12476 fo. 144) is a miniature of the Virgin Mary surrounded by twelve Virtues without attributes, but with their names inscribed. Besides the Theological and Cardinal Virtues we have Perseverance, Chastity, Long-suffering, Virginity, and Humility. On the vault of the choir of Albi, which is by Italian artists, there are eight Virtues, including Humility.

[1] The best description is by Dom Millet in his *Trésor sacré de Saint-Denis* (1615). It is quoted by Montaiglon in *Arch. de l'art français*, I. 129–132; Vitry (p. 169) reproduces an engraving from Félibien's *Histoire de Saint-Denis* (1706). There is also a drawing by Gaignières (*Cat. Bouchot*, no. 2020), and a rough woodcut by Jean Rabel in the *Second livre* of Corrozet's *Les antiquitez et singularitez de Paris* (1588).

[2] See above, p. 473.

[3] See Montaiglon, *Arch. de l'art français*, 2me série, 219–228.

[4] Reproduced by Vitry, p. 171.

a brief reference has been made in a preceding chapter. This is the tomb of Philippe de Commynes and his wife Hélène de Chambes, which the minister of Louis XI ordered doubtless in his lifetime, and to receive which he had a chapel prepared in the Church of the Grands-Augustins at Paris. As I have already said, the decoration of both the chapel and the tomb is certainly the work of Italian artists[1]. As for the figures, which Courajod regarded as French, M. Vitry with great probability sees in them the hand of Mazzoni. Certainly these curious half-length kneeling figures of painted stone, with their minute and almost brutal realism, remind one strongly of that sculptor's Entombment at Naples[2]. And they are powerful enough to be by the master himself rather than by a pupil[3]. Of the decorative fragments the most important are four large panels with little figures surrounded by arabesques in bas-relief, beautifully executed, especially the panel representing St Augustine.

For two other works, both of considerable interest, M. Vitry suggests Guido Mazzoni as the possible author. The first is a large marble bas-relief in the Louvre, representing the death of the Virgin, which according to Lenoir came from the Church of Saint-Jacques de la Boucherie. The arabesques on the Virgin's bed, the classical buildings of the background, which remind one of Laurana's retable at Avignon, and the small and almost naked figure of the Virgin borne up to heaven by four angel-musicians are all thoroughly Italian characteristics. But though the dramatic attitudes and violent gestures of the Apostles may be paralleled in the Modena *Pietà*, we miss the powerful, if somewhat vulgar, realism that we always find in Mazzoni's

[1] See above, p. 355. [2] See above, p. 111.

[3] Courajod in *Gaz. des Beaux-Arts*, 1884 (2), p. 256; Millin, *Ant. Nat.* III. no. xxv. pp. 40–43; Vitry, pp. 174–178. The tomb is also figured in Petit de Julleville, *Hist. de la langue et de la litt. franç.* II. 328. See also Geymüller, pp. 616–17. The figures and fragments of the tomb are in the Louvre. There are also fragments of the decoration in the court of the *École des Beaux-Arts*, and casts of the four marble panels in the Trocadéro (F. 185, 186).

work[1]. On the other hand this characteristic is strongly present in a work in the Abbey-church of Fécamp, which also represents the death of the Virgin. Here the Apostles are simply portraits, and the whole scene, as M. Vitry says, is interpreted in a spirit of rather vulgar *genre*. The careless execution and the strong polychromatic effects—the work is of painted stone—also point to Mazzoni. A feature of special interest, to which M. Vitry calls attention, is the unmistakable resemblance of one of the heads to that of the Laocoon, which was discovered in 1506, and which Mazzoni might have seen when he visited Italy in 1507. It was in the latter year that Antoine Bohier, Abbot of Fécamp, ordered at Genoa certain monuments for his church, employing the same artists as Louis XII. M. Vitry's hypothesis that on his return to France he gave a commission to the royal *atelier* at the Petit-Nesle, of which Mazzoni was head, is a very plausible one, and we shall hardly dispute his conclusion that the main portion of the work, if it is not by Mazzoni himself, is at least by one of his pupils. But M. Vitry also calls attention to certain features which point to the co-operation of some local artist. These are the Gothic framework, the two child-angels at the Virgin's head, and the two Apostles on the extreme left, whose dignified and reposeful attitude and expression is in marked contrast to those of the other figures[2].

Girolamo da Fiesole[3] did not belong to the colony at Amboise; at any rate his name does not appear in the royal accounts. But from a document discovered by Signor Milanesi we learn that early in the year 1500 he was at the Court of "the Most Christian King" for the purpose of executing tombs of the queen's father and of her two children by Charles VIII[4]. As we shall see, the tomb of the Duke of Brittany was ultimately entrusted to Michel

[1] Fig. Vitry, p. 179; see also Courajod in *Gaz. des Beaux-Arts*, 1884 (2), pp. 263–267. There is no figure like the St Joseph (or is it Nicodemus?) of the Modena *Pietà*.

[2] Vitry, pp. 180–187; fig. p. 183. [3] Vitry, pp. 193–196.

[4] *Gaz. des Beaux-Arts*, 1876 (2), p. 368.

Colombe, but it is a fair supposition, though it cannot be
said to be more, that Girolamo was one of the two Italians
employed on the decorative portions of that tomb. Further,
as we do not hear that the second tomb, that of the
children of Charles VIII, was taken out of his hands, it may
be assumed that he at least designed it. An interesting
feature of the design is that the upper portion of the base
with its concave face recalls the tomb of Sixtus IV by
Antonio Pollaiuolo[1], while the three episodes from the life
of Hercules, which form part of the frieze, suggest the
influence of the same master[2]. As M. Vitry observes, the
theme of Hercules as well as that of Samson, which is also
introduced, is quite unsuited to a tomb, especially to one
for children. It shews, as he says, "the irrational spirit of
the classical and pagan Renaissance[3]." Though the design
is good, the execution is only moderate.

Not only did Italian sculptors work in France, but
monuments were imported ready made from Italy. We
have just seen how Antoine Bohier, following the example
of Louis XII, gave an important commission at Genoa to
Girolamo Viscardo. Of the four chief centres in Italy
for the production of works of sculpture, Genoa, Milan,
Como, and Naples, Genoa was the most important. Not
only was it in close touch with the marble quarries of
Carrara and Massa, but it possessed a definitely constituted
association of sculptors. About 1498 Matteo Civitali
migrated there from Lucca[4] and associated himself with
a family of sculptors named Gaggini, who came from
Bissone on Lake Lugano[5]. They had as fellow-workers
three other Lombards, the above mentioned Girolamo
Viscardo, Michele d'Aria, who made realistic statues of the

[1] See above, p. 107.

[2] See the small panels of Hercules and the Hydra and Hercules and
Antaeus in the Uffizi. Antonio painted three large pictures (now lost) of
Hercules's labours for Lorenzo de' Medici, which were very famous.

[3] Fig. Michel, p. 631, and see Geymüller, p. 612. [4] See above, p. 121.

[5] For the Gaggini see Venturi, *op. cit.* VI. 838 ff. In the Victoria and
Albert Museum (East Hall) are two characteristic Genoese lintels with reliefs
of St George and the Dragon, one of which is ascribed to Giovanni Gaggini.

leading Genoese bankers, and Antonia della Porta, surnamed Tamagnino, who had been employed at the Certosa of Pavia[1].

As early as 1499, the year in which Genoa placed herself under the French king, we find Anne of Brittany negociating for the purchase of Carrara marble for her father's tomb[2]. In 1502 Louis XII gave a commission to four sculptors for a monument to the Dukes of Orleans. The work was to be executed at Genoa, one half by Michele d'Aria and Girolamo Viscardo, and the other half by Donato di Battista Benti and Benedetto di Bartolommeo, both Florentines[3]. The last named (1474–1556), who is better known as Benedetto da Rovezzano, was with Andrea Sansovino the chief representative, after Michelangelo, of Florentine sculpture during the first quarter of the sixteenth century[4]. The tomb was finished in 1504 and set up early in the following year in the Church of the Celestines at Paris[5], where it remained till the Revolution. Two of the sculptors, presumably the two Florentines, accompanied the monument to Paris. It is now at Saint-Denis[6]. The design, which was probably not more than a rough sketch, was prepared in France. Owing to the necessity of providing space for four effigies a new type of tomb was evolved. At the corners of a square base four columns support a platform, upon which are placed the recumbent figures of Louis d'Orléans and his wife, Valentina Visconti. Those of Charles d'Orléans and his brother Philip repose upon the base itself. All the

[1] See Courajod, *Leçons*, II. 633–647; Michel, IV. 119.

[2] A. de Montaiglon in *Gaz. des Beaux-Arts*, 1876 (2), p. 368.

[3] For the contract see F. Alizeri, *Notizie dei professori di disegno in Liguria*, 6 vols., Genoa, 1870–1880 (*Sculptura*, IV. and V.), IV. 286.

[4] He was born at Pistoia, but he bought an estate at Rovezzano. There is a Cantoria by him and Donato Benti, dated 1499, in the Church of San Stefano at Genoa. He came to England in 1524 to execute Cardinal Wolsey's tomb (see A. Higgins in the *Archaeological Journal*, LI. (1894), 152–163).

[5] The remains of Charles d'Orléans were transported from Blois to the Celestine Church in February 1505 (N.S.). (Jean d'Auton, *op. cit.* III. 354.)

[6] After the Revolution it found a temporary asylum, in three pieces, in Lenoir's Museum.

figures are conventional, without any attempt at portraiture. The ornamentation of the base is pure Renaissance. It consists of an arcade of round arches supported on columns decorated with arabesques, with a fluted Corinthian pilaster between each arch. The niches are filled with the twelve Apostles, this being the first time that they were represented on a funeral monument in France. Their attitudes and gestures are highly theatrical, and the workmanship is of very moderate quality[1].

In 1504 Cardinal d'Amboise, following in the footsteps of his royal master, began to negociate for the purchase of Carrara marble, but it was not till 1507, the year in which Louis XII reconquered Genoa after its revolt, that we hear of Genoese sculptors actually working for him. In that year he employed Pace Gaggini[2], probably on decorative pieces, such as bas-reliefs, pilasters, trophies of classical armour, grotesques, of which fragments are preserved in the Louvre. In the same year he was presented by the republic of Venice with a marble fountain, which, judging from the drawing in Du Cerçeau, must have been singularly beautiful[3]. It was the work of Pace Gaggini, Antonio della Porta, and Agostino Solari[4]. It stood in the great court of the château; in the garden was another Italian fountain, the upper part of which with its basin and pedestal, beautifully decorated with arabesques, may be seen in the Louvre[5]. From Gaillon also comes a marble torso, now in the Louvre, of Louis XII as a Roman *imperator*. On the cuirass are represented warriors in combat, some naked, some wearing

[1] See Millin, *Antiquités nationales*, I. 77, pl. 15; Guilhermy, *Monographie de Saint-Denis*, pp. 293 ff.; Vitry, pp. 142–145; Michel, IV. 630; H. de Tschudi in *Gazette archéologique*, 1885, pp. 93–98. Four of the statuettes are modern. A later example (*circ.* 1520) of this type of tomb, also with figures of the twelve Apostles on the base, is that of the Bastarnay at Montrésor (fig. Michel, p. 610).
[2] Alizeri, IV. 306–7, and 313. There are pilasters and a lunette by Pace Gaggini in the Victoria and Albert Museum (room 64).
[3] Du Cerçeau, *Les plus excellens bastiments*, vol. I.
[4] Alizeri, IV. 319; fig. Vitry, p. 147.
[5] Fig. Vitry, p. 149.

Roman dress. An inscription tells us that the work was
executed by Lorenzo da Mugiano of Milan in 1508[1], and it
may be fairly identified with one of three marble *portraitures*
which arrived at Gaillon from Milan in February 1509, the
two others being statues of Cardinal d'Amboise and his
nephew Charles, the Governor of Milan[2].

We now come to the commission which Antoine Bohier,
Abbot of Fécamp, brother of Thomas Bohier, the General of
finances[3], gave to Girolamo Viscardo, one of the artists
employed by Louis XII, in May 1507. The contract, which
has been preserved, is for three pieces, "an altar, a chest,
and a tabernacle[4]." There is also mention, though not so
specific, of two statues. As the artist was given fourteen
months for the execution of his commission, it must have
been towards the end of 1508, at the earliest, that the
marbles were set up in the Abbey-church of Fécamp, where
they may still be seen[5]. The piece which has suffered most
is the altar, of which all that is left are five bas-reliefs,
somewhat mutilated. Of these, the Baptism of Christ is, as
M. Vitry says, a marble picture, in which, after the manner of
Ghiberti, the perspective is managed with most remarkable
skill. The execution is extremely delicate, and there is
considerable charm in the two Angels. The figures of Our
Lord and the Baptist are now headless, but their atti-
tudes and especially the dress of St John shew unmistakable

[1] The name of the same sculptor appears on the Grenoble medallions.
See above, p. 407; and generally for the Italian marbles at Gaillon, Courajod
in *Gaz. des Beaux-Arts*, 1884 (I), pp. 493 ff., and *Alexandre Lenoir*, II. 74–131;
Vitry, pp. 145–152, fig. p. 151.

[2] Deville, *op. cit.* p. 287. Other fragments from Gaillon in the Louvre
are the head of a young warrior, which Courajod attributes to Antonio
Giusti, two lions' heads with a cornucopia issuing from their mouths, six
pilasters decorated with arabesques, and four other fragments similarly
decorated. (See Courajod, *Leçons*, II. 645–652.) According to the Cardinal
of Aragon's secretary there were in one of the loggias colossal statues of
Charles VIII, Louis XII, Anne of Brittany, Cardinal d'Amboise, the
Cardinal of San Severino, and others; and in the chapel, statues of members
of the house of Amboise.

[3] See above, p. 152. [4] Alizeri, IV. pp. 296–298.

[5] See Leroux de Lincy, *op. cit.* pp. 47–8; Vitry, pp. 152–158.

signs of the influence of Verrocchio's well-known picture.
The marble chest, which was destined to hold the relics
of several Saints, is decorated on its sides with twelve shell-
niches, separated by pilasters covered with arabesques, in
each of which stands an Apostle. Their attitudes are less
theatrical than in the monument to the Dukes of Orleans,
but the types are equally commonplace and conventional[1].
The gem of the Fécamp marbles is the tabernacle, after the
pattern of those which were so common at Florence in the
fifteenth century, and of which the finest examples are
by Desiderio da Settignano in San Lorenzo[2] and by
Mino da Fiesole in San Ambrogio[3]. It resembles both
of these, and is a good and characteristic specimen of
much of the Italian work of this period—artistic, delicate,
accomplished, but without any real individuality[4]. This
lack of individuality makes itself felt even more in the
two statues; they are perfunctory academic productions,
without a trace of feeling[5].

In the neighbouring department (Somme) to that of
Seine-inférieure the little church of Folleville[6] contains a
tomb which is generally regarded as the finest example of
Italian sculpture introduced into France at this period. It
is the tomb of Raoul de Lannoy and his wife Jeanne de Poix,
by Antonio della Porta and his nephew, Pace Gaggini[7].

[1] Vitry, 156 f. The *motif* of shell-niches between pilasters was a
favourite one in Italy. Examples are the tomb of Bernardo Giugno by
Mino da Fiesole in the Badia of Florence, and the famous tomb of the
Doge Andrea Vendramin (*circ.* 1495) by the Lombardi and Alessandro
Leopardi, upon which Ruskin has poured the vials of his wrath (*Stones of
Venice*, I. pp. 26–29).

[2] Reymond, *La sculpture florentine*, III. 67.

[3] *Ib.* III. 109. [4] Vitry, pp. 153 f.

[5] *Ib.* pp. 157 f. [6] Thirty miles south of Amiens.

[7] See above, p. 482. On one side of the tomb is inscribed *Antonius de
Porta Tamagninus Mediolanensis faciebat*, on the other *Et Paxius nepos
suus*. The two worked together both at the Certosa (1493) and, as we
have seen, on the fountain which was sent to Gaillon. We do not know
the exact date of Antonio della Porta's death, but the last document in
which he is mentioned is dated February 1513, and he probably died soon
afterwards.

Lannoy was governor of Genoa for Louis XII from 1507 to
1508, and it is highly probable that he gave the commission
for his tomb to these Genoese sculptors during his term of
office[1]. Its date is therefore closely approximate to that of
the Fécamp marbles.

The two recumbent figures of Lannoy and his wife, which
are in low relief, partly in the cavity of the slab, are remarkable
for their sober realism, and for the exceeding delicacy with
which some of the details are executed. A ravishing garland
of fruit and leaves runs round the slab, and on the front of
the tomb two delicious pairs of winged genii lean on escut-
cheons in the attitude of mourners[2]. The tomb stands in
a niche, the three walls of which are richly decorated with
designs of a pure Renaissance type[3]. M. Vitry suggests
that these were executed by Pace Gaggini, or some other
Italian, in France. But as the chapel, which was expressly
built to receive the tomb—it practically forms the choir
of the church—was not begun till after Lannoy's death
in 1513 and was not completed till 1519, this is very
unlikely. Moreover M. Durand, who has an unrivalled
knowledge of the whole province of Picardy, declares
that he has found nothing to suggest the presence of any
Italian artist in that district before the reign of Francis I,
or even, strictly speaking, in that reign. Further, he notes
a close similarity of style between the whole decoration of
the choir of Folleville and the famous stalls of Amiens[4].
Be this as it may, there is no reason why in 1519 or

[1] Raoul de Lannoy entered the service of Louis XI in 1477 on the
death of his former master, the Duke of Burgundy. He accompanied
Charles VIII to Naples, and in 1496 was appointed *bailli* of Amiens. In
1501 he took part in the second expedition to Naples, remaining there till
1503. After his governorship of Genoa he paid a fourth visit to Italy in
1509, and in the following year he accompanied his friend, Antoine Bohier,
the Abbot of Fécamp, on a mission to England. He died in 1513. (G.
Durand, *Les Lannoy, Folleville et l'art italien dans le Nord de la France,
Bull. Mon.* LXX. (1906), 329–404 (with several illustrations).

[2] Fig. Durand, p. 370. Owing to the lowness of the relief the repro-
ductions of the tomb in Michel and Vitry give no idea of the figures.

[3] Fig. Durand, p. 374. [4] Durand, pp. 389–393.

1520, when in all probability the tomb of Raoul de Lannoy
was set up in its niche, there should not have been found
French artists capable of executing decorative work in the
Renaissance style.

In the same year 1507, in which Raoul de Lannoy was
appointed governor of Genoa for Louis XII, and in which
Antoine Bohier gave the commission for the monuments at
Fécamp, a Florentine sculptor named Giovanni di Giusti
Betti[1] completed an important work at Dol in Brittany.
This was the tomb of Thomas James, Bishop of Dol, a
prelate who had been in Italy and had there given some small
commissions to Italian artists[2]. He died in 1504, and the
order for his tomb was given by his nephews Jean and
François James[3]. It consists of a sarcophagus under a
tabernacle, set within a shrine, which is shaped like a
triumphal arch. The design is characteristically Italian.
So is the decoration, but it presents no new features except
the medallions of the Bishop's nephews on the two sides of
the sarcophagus. The Bishop's effigy has disappeared[4].

Soon after the completion of this work Antonio Giusti[5],
the elder brother of Giovanni, entered the service of Cardinal
d'Amboise at Gaillon, and in 1508 he figures in the accounts
as the sculptor of several important works—"the battle of
Genoa, a large greyhound, the head of a stag, the portraits
of Monseigneur and a child[6]." All these pieces have dis-
appeared, and the only addition that can be made to this
bare record is a statement that the Battle of Genoa was
"a long bas-relief representing a triumphal march[7]." A
little later Antonio Giusti was paid 297 livres for the "statues

[1] See for the Giusti A. de Montaiglon in Gaz. des Beaux-Arts, 1875 (2),
pp. 385 ff., 515 ff.; 1876, p. 552 ff.

[2] See above, p. 83.

[3] The date of 1507 is repeated several times on the monument.

[4] Vitry, pp. 204–207; Michel, p. 652.

[5] Antonio was born in 1479, Giovanni in 1484. M. Vitry says that
Antonio must have taken part in the Dol monument, but only Giovanni's
name appears in the inscription.

[6] Deville, op. cit. pp. 324 and 358.

[7] A. C. Ducarel, Anglo-Norman Antiquities [1767].

of the chapel[1]." These, we know, were a series of Apostles, and the rapidity with which they were executed, coupled with a statement by Lenoir that he had seen six coloured terra-cotta statues which came from this chapel[2], suggests that they were of that material. M. Vitry has, therefore, considerable justification for recognising as part of the series two life-sized terra-cotta statues, one of Christ, and the other of a male figure reading a book, apparently an Apostle, which are now in the little church of Gaillon[3]. The identification, however, is not sufficiently certain to justify us in forming from these statues an estimate of Antonio Giusti's merits as a figure-sculptor. As he died in September 1519, he can have taken little, if any, part in the great tomb of Louis XII and Anne of Brittany which Francis I erected in Saint-Denis[4]. But if his work was not very different in character from that of his younger brother, then the Frenchman, Michel Colombe, had nothing to learn from him as a figure-sculptor.

The tomb of Louis XII, at least that part of it which was entrusted to the Giusti, was executed at Tours, where it is probable that their *atelier* was established soon after 1509, when Antonio had finished his work for Cardinal d'Amboise. In the following year he was employed by Louis XII on a small work, the head of a stag in wax, for the château of Blois[5].

[1] He received payments from November 1, 1508, to October 23, 1509. (Deville, *op. cit.* pp. 419–20.)

[2] L. Courajod, *A. Lenoir*, II. 94, n.[1]. [3] Vitry, pp. 211–216.

[4] The dates of 1517 and 1518 occur on the monument, but it was not completed till 1531.

[5] Another tomb which has been attributed to the Giusti is that of Guy de Blanchefort, Abbot of Ferrières in the Gâtinais (Loiret), who died in 1506. The decoration of the base—the figure has disappeared—represents an Italian theme, the seven Virtues and St Benedict in shell-niches between pilasters, and if the tomb was erected by the deceased's brother, who died in 1508, the work may well be by one of the Giusti. (See E. Michel in *Gaz. des Beaux-Arts*, 1883 (2), pp. 225 ff.) But M. Vitry points out that the date is not certain, and he is inclined to put it as late as 1520, and to regard it as the work of a Frenchman under the influence of Italian models.

Antonio Giusti was not the only Italian sculptor employed at Gaillon. Bertand de Meynal, a Genoese, who brought the fountain presented by the Republic of Venice in 1508, worked there for some time afterwards[1]. He was pre-eminently a decorator. So was Girolamo Pachiarotti, a member of the Italian colony of Amboise[2]. We find him at Tours in 1503[3], working at the decoration of the tomb of Duke François II, which was completed in 1507. After this he went to Gaillon, and his name frequently occurs in the accounts for the years 1508 and 1509. In his special domain of decoration he was unrivalled, and he appears to have exercised a sort of general superintendence over the whole decorative work of Gaillon[4]. After the death of the Cardinal he returned either to Amboise or Tours[5]. He was at any rate at Tours in 1513, when he witnessed the letters of naturalisation granted to the Giusti, and he was still living there in 1527. Jean Chersale, who is mentioned in the accounts of Gaillon as working with him, was probably also an Italian[6].

Such briefly is the record of Italian sculpture in France during the last quarter of the fifteenth century and the first quarter of the sixteenth. Before 1495 we have nothing but the work of Francesco Laurana at Marseilles and Avignon, and the tombs of Charles d'Anjou and Giovanni Cossa, which are probably also by his hand. Of his authenticated work it is only the arabesque decoration and the classical architecture that can be supposed to have had any influence on French artists. For the period from 1495 to 1515 we have firstly the work of Guido Mazzoni and his *atelier* at the Petit-Nesle, secondly the various marble monuments executed at Genoa and transported to France, and thirdly the work of the brothers Giusti. Mazzoni was in France for

[1] The latest date of a payment to him is May 15, 1509 (Deville, p. 360).
[2] See above, p. 387. [3] Giraudet, *op. cit.* p. 315.
[4] Vitry, p. 197; Deville, p. ciii.
[5] In April 1508 he is described in the Gaillon accounts as "living at Amboise." (Deville, p. 343.)
[6] Deville, pp. 359–60.

practically the whole of our period, and was high in favour
with the Court. No authentic work by his hand now exists
in France, but with the help of descriptions and drawings
and the examples he has left in Naples and Modena we can
judge of its character; as for the monuments which have been
conjecturally attributed to him, they may at any rate be
regarded as representing his school. Here again it is only the
decorative portions of the work that are likely to have appealed
to the French sculptors. It is noticeable that Mazzoni
appears hardly ever to have been allowed a free hand, and
that in all the works that he executed in France we find
French elements—either French themes, as in the tomb of
Charles VIII, or a French setting, as in the statue of
Louis XII. And if the Death of the Virgin at Fécamp is
by him, he even had French fellow-workers. The only work
out of those attributed to him which, so far as we can
judge from the existing fragments, was Italian throughout,
is the tomb of Philippe de Commynes and the decoration
of the chapel which contained it[1].

The second phase, the importation of marble monuments
executed at Genoa by Italian sculptors, may be said to
have begun in 1504, in which year the tomb of the
Dukes of Orleans was completed and set up in the Church
of the Celestines at Paris. Next in date come the various
objects sent to Gaillon, of which the chief were a fountain
(1507) and three statues representing Louis XII, Cardinal
d'Amboise, and his nephew (1508). Thirdly we have the
monuments at Fécamp (end of 1508), and fourthly the
tomb of Raoul de Lannoy at Folleville, which was
probably ordered in 1507, but which may not have been
set up in its place till a few years later. In the execu-
tion of the monument destined for the Church of the
Celestines, we have seen that the sculptors had more
or less to conform to a design sent from France. The
only important feature of the work, so far as Italian
influence on French sculpture is concerned, is the decora-
tion of the base, with its classical architecture and its

[1] Yet, as we saw, Courajod regarded the two figures as French work.

figures of the twelve Apostles, the latter being a novelty
in France as a theme for funeral monuments. On the
other hand Girolamo Viscardo was given a perfectly free
hand by his new patron, Antoine Bohier. The result was
that he produced works, purely Italian in character, and
remarkable alike for the taste and skill in the composition,
and for the delicacy of the execution. The commonplace
character, however, of his larger figures, and the want of
individuality in his whole work, shew that he was greater as
a decorator than as a figure-sculptor. It is otherwise with
Antonio della Porta, who made effigies of Raoul de Lannoy
and his wife for their monument at Folleville. In the
opinion of competent judges these are of high merit and are
even superior to that of Charles d'Anjou at Le Mans. But
neither Fécamp, which is on the coast between Dieppe and
Havre, nor Folleville, which lies east of the road between
Amiens and Beauvais, are very accessible, and neither of
them can have been an important centre of influence. At
most Fécamp can have affected Dieppe, where, as we have
seen, an Italian colony established itself in the reign of
Francis I[1], and possibly Rouen, while the monuments at
Folleville can hardly have been known beyond Amiens and
Beauvais.

The third phase of Italian influence is represented by the
work of Antonio and Giovanni Giusti. Dol, where Giovanni
executed his first commission in France, is even more remote
than Fécamp, but in 1508 and 1509 the elder brother,
Antonio, was working at Gaillon in the midst of a large
colony of French sculptors. It was, as we have seen,
probably soon after this that he and his brother set up an
atelier at Tours, where the *doyen* of French sculptors, Michel
Colombe, now a very old man, was head of a flourishing
school. At Tours also about this time the accomplished
decorator and worker in marble, Girolamo Pachiarotti,
pitched his tent, and did a considerable business, not only
in the decoration of large works, but in the production of
smaller monuments, such as fonts and fountains.

[1] See above, p. 174.

At Bourges too there were Italian workmen, brought there either by the Lallemand family, which had, as we have seen, both marriage and business relations with Italy, or by the Florentine merchant, Durante Salvi, who built the hôtel Cujas[1]. Among the numerous sculptors who worked on the two northern portals of the west front of the Cathedral from 1511 to 1515, we find the name of the presumed Italian, Jean Chersale, the associate of Pachiarotti at Gaillon[2]. In essentials the work is purely mediaeval in character, but here and there, as for instance in the relief of Christ before Pilate, occur architectural and other decorative details which are inspired by the Renaissance[3].

At Lyons with its large colony of wealthy Italian merchants and bankers there must have been plenty of employment for Italian sculptors, and the names of some of them have come down to us[4]. Doubtless also a certain number of marbles were imported from Italy, and Vasari tells us that Lyons possessed a work of Antonio Rossellino's. But all traces of this or similar examples of the Italian Renaissance have vanished from the city.

Finally mention must be made of another lost work, the bronze David of Michelangelo, which once stood in the courtyard of Florimond Robertet's château of Bury. It was originally destined by the Signoria for the Maréchal de Gié, who had greatly admired the bronze David of Donatello—"probably the first free-standing nude statue made in Italy for a thousand years"—and wanted something like it. The commission for a similar work was given to Michelangelo in 1502, but by the time it was completed (1508), the Maréchal had fallen into disgrace, and Florimond

[1] See above, p. 422.

[2] Girardot, *Les artistes de Bourges* in *Archives de l'art français*, 1861, pp. 226–234.

[3] A. Boinet in *Rev. de l'art chrétien*, LX. (1910), 13–24, cp. pp. 21–2; Vitry, pp. 219–20. The latter is wrong in supposing that Marsault Paule was an Italian; he was born, says Boinet, at Châteauroux, and was the son of a goldsmith at Bourges.

[4] See N. Rondot, *Les sculpteurs de Lyon du 14ᵐᵉ au 18ᵐᵉ siècle*, Lyons, 1884.

Robertet was rapidly becoming a person of the first import-
ance. So the prudent Signoria, as has been mentioned in
an earlier chapter[1], gave the statue to Robertet, who set
it up on a column in the centre of the court of his new
château[2].

[1] See above, p. 156.

[2] Michelangelo was helped in the casting by Benedetto da Rovezzano,
who received a final payment for his work in January 1509. (See Gaye,
Carteggio, II. 58–61 and 102–107; L. Courajod, *Le David du château de
Bury*, 1885.) Its position is shewn in Du Cerçeau's engraving, *Les plus
excellens bastiments*, II. last plate. There is a small wax model of a David
in the Victoria and Albert Museum (room 64), ascribed to Michelangelo,
which Courajod conjectures may have been the model for this work.

CHAPTER XIV

SCULPTURE II

I

HAVING now cleared the way by a record of the achievements of Italian sculpture in France, we may return to native art, and consider how far it was affected by these Italian influences, and how far it developed on its own lines. At the very beginning of our period comes the famous Entombment of Solesmes (Plate XII), which bears the date of 1496 inscribed on a pilaster[1]. The monument of which it forms part was begun, apparently in 1494, by the Prior of the Benedictine Abbey of Solesmes, Guillaume Cheminart, who resigned in 1495, and as his arms, and not those of his successor, appear on an escutcheon, it may be inferred that by 1496 it was nearly finished. Dom de La Tremblaye, on the authority of an ancient manuscript, gives 1498 as the probable date of its final completion[2]. The whole monument consists of two storeys, the Entombment being placed in the *enfeu* or recess of the lower storey. Except for the two pilasters on either side of this recess, it is Gothic throughout. Besides the principal group, there are half-length

[1] Vitry, pp. 274–298 (with numerous illustrations); Michel, pp. 596–598; Geymüller, *op. cit.* 640–643; Trocadéro, E. 141–143. Solesmes is on the Sarthe, barely two miles above Sablé. Its monks have found a refuge at Quarr Abbey in the Isle of Wight.

[2] *Les sculptures de l'Église abbatiale de Solesmes*, fo. 1892. I have not seen this finely illustrated work.

figures of David and Isaiah, five Angels, of which three crown the lower storey, and two the upper, and figures of the penitent and the impenitent thief on crosses. The central cross, which is supported by an Angel and which dominates the whole work, is empty. Thus the monument, embracing, as it does, the Old Testament prophecies, the Crucifixion, and the Entombment, is a representation of the Bible story down to the Resurrection.

The Entombment itself differs in two details from the two most usual arrangements of the scene[1]. First the Magdalen is represented as seated in front of the tomb—this departure from the ordinary tradition is not without precedent—and her place behind the tomb is taken by a bearded figure holding a vase of perfumes. Secondly outside the recess stand two soldiers, a not uncommon addition to the group. The two figures that at once attract our attention are those of the Magdalen and Joseph of Arimathea. The Magdalen is a touching and sincere picture of silent grief. The dramatic attitude and gestures, dear to the Italian artists who worked in France, are here wholly absent. She sits in absolute repose, save that her body is gently agitated by suppressed sobs and her lips just move in silent prayer. St Joseph is a striking and vigorous figure. He is beardless and wears the rich dress of a civilian, with the collar of an order round his neck[2]. There is nothing to confirm the tradition that identifies him with Jean d'Armagnac, Seigneur de Sablé, but we evidently have before us a life-like portrait[3]. Fine though it is, this robust figure with its air of prosperous worldliness strikes a discordant note, which jars with the deep and tender pathos of the whole scene.

Of the other figures, those of the Virgin and St John are

[1] See above, pp. 467–8.

[2] The emblem which once hung from the collar has disappeared.

[3] We may dismiss the idea that it is an ostensible portrait of a donor, and that the unknown disciple behind the tomb is Joseph of Arimathea. In the picture of the Deposition in the Louvre, which is about ten years later in date, the donor supports Our Lord's head, but, according to the invariable practice, he is kneeling.

Plate XII

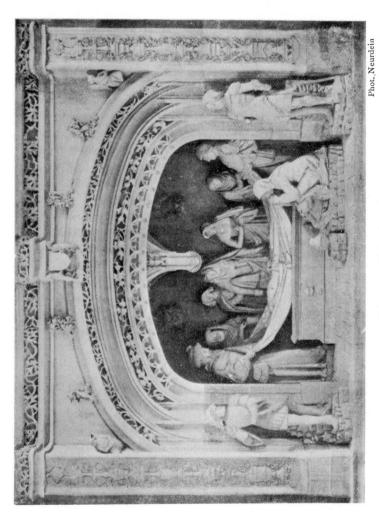

Solesmes : Entombment

of considerable merit and beauty. The two other Maries are rather commonplace, especially the one next to the Virgin. The attitude of the Mary at Our Lord's feet may seem affected if looked at alone, but in relation to the whole group it is quite natural, as is that of the other Mary with her clasped hands. The Nicodemus is a dignified, if conventional, figure, but the Christ again is commonplace. The draperies of all the figures hang in natural folds, and the whole execution is marked by a scrupulous attention to details.

In spite of some obvious defects, the Entombment of Solesmes is a noble work, and in criticising it one must bear in mind the great difficulty of treating a group of figures in sculpture, especially when the sculptor is hampered by a traditional arrangement. Here the unity necessary to a work of art is obtained by making Our Lord's face the focus to which the eyes of the whole group are directed. In spite of some rash conjectures, there can be no manner of doubt that all the figures are by the same hand, and the unity of the work conclusively proves it to be the conception of a single brain. The same unity shews that the sculptor, in so far as he has grasped this great principle of art, is on the threshold of the Renaissance. But he is still too much dominated by the model. The Joseph of Arimathea is a life-like and vigorous portrait, but is out of keeping with the whole scene. The two Maries at Our Lord's feet are mere transcripts of models, neither sufficiently individualised to be portraits, nor sufficiently generalised to be types.

Geymüller is of opinion that the classical armour of the two soldiers indicates Italian workmanship, and he compares them with two similar figures on the portal of the Medici Bank at Milan[1]. But whereas in the latter case the armour is of a strictly classical pattern, that of the soldiers at Solesmes is very far from being archaeologically correct. On this ground M. Vitry is doubtless right in suggesting for

[1] See above, p. 133.

them a French origin; as he points out, soldiers wearing very similar armour are of frequent occurrence in the miniatures of Fouquet and his school[1].

There is, however, one portion of the Solesmes monument which beyond question is the work of an Italian artist, and that is the decoration of the two pilasters. It is composed of tiers of candelabra of different patterns, crowned by two naked *amorini*; the whole rests upon claws of a classical form. It is clear that we must look to North Italy for similar work, and Geymüller furnishes examples in S. Maria delle Grazie at Milan and S. Maria de' Miracoli at Brescia. The same motive occurs in one of the terra-cotta fragments discovered at Amboise, which, as we saw, may be regarded as a product of the workshop of Girolamo Solobrini, "potter of Amboise[2]." The name of the artist can only be a matter of conjecture, but one naturally thinks of Girolamo Pachiarotti, a member of the original colony of Amboise, who, as we have seen, was especially skilful in architectural decoration[3]. Some support is lent to this conjecture by the fact that the escutcheons of Charles VIII and Anne of Brittany are introduced immediately above the pilasters, indicating perhaps that they took a special interest in the monument.

In each of the angles formed by the pilasters with the outermost voussoir of the recess-arch is an Angel, half-kneeling and half-standing, who is as characteristically French as the decoration of the pilaster is Italian. Five other Angels, all standing, appear in the upper portion of the monument. All belong to that type to which attention has been called in the preceding chapter, but the two between the voussoir and the pilasters have a peculiar charm.

[1] Vitry, pp. 289–292, and see Fouquet's *Josephus*, esp. plate 19.

[2] Fig. Vitry, p. 191, and see above, p. 392.

[3] See above, pp. 488 and 491. M. Vitry thinks that Pachiarotto's habitual style is more elegant than that of the pilasters. Palustre attributed the work to Girolamo da Fiesole, but there s no evidence of his presence in France before 1499.

In default of any documentary evidence various hypotheses have been put forward as to the authorship of this
important work, and in particular the name of Michel
Colombe has been suggested. But most of the arguments
in his favour are more ingenious than convincing, and the
evidence of style, which is the only serious evidence available,
is on the whole against him[1]. It is true that the Virtues
round the tomb of Duke François II furnish our only
adequate standard of comparison, and that the repose
proper to a funeral monument is very different to the
emotional drama of an Entombment. But after making
due allowance for this consideration, it is difficult not to
agree with M. Vitry's conclusion that there are inherent
differences of style between the two works. If the art of
the Master of Solesmes is, as M. Vitry says, more robust,
that of Michel Colombe is more learned, more finished,
more secure of itself. Above all, it is a step nearer to the
Renaissance. And this difference is not to be accounted for
merely by the interval of time which separates the two works,
for at the date of the Entombment (1496) Colombe's style
must in all probability have reached its full development.

We should be able to speak with greater certainty on
this point, were it not that the few examples that we possess
of Michel Colombe's art all belong to his old age, and that
of his earlier career we know exceedingly little[2]. The year
of his birth is unknown. In a letter written from Tours to
Margaret of Austria in 1511 Jean Lemaire says that he was
then about eighty[3], but people in those times were very
vague as to their own age, and at all times old persons are
prone to make themselves out older than they really are.
It would not be surprising to find that Michel Colombe was
born not much before 1440. On the evidence of a mural
inscription, not however quite contemporary, relating to
the tomb of François II, it is generally accepted that

[1] See Vitry, pp. 293–298, for a discussion of the arguments.

[2] See, besides M. Vitry's great work, L. Palustre, *Michel Colombe*, in
Gaz. des Beaux-Arts, 1884 (6), pp. 406 ff., 525 ff.

[3] Le Glay, *Analectes hist.* pp. 9–12.

he was a native of Brittany[1]. In 1474 he was sufficiently
celebrated to be entrusted with an order from Louis XI to
make a model for his tomb[2]. This is the earliest notice of
his work that is authenticated by a contemporary document.
But an alabaster relief in the Church of Saint-Michel-en-
l'Herm, near Luçon, which represented St Michael piercing
with his lance a wild boar, and which is said to have
commemorated a hunting accident that happened to
Louis XI in 1473[3], is attributed to him in a statement
made in 1569. He himself says, writing in 1511, that his
nephew Guillaume Regnault had assisted him "for forty
years or thereabouts in all his commissions, large or small[4]."
In 1480 he was commissioned to make a model for the
tomb of Louis de Rohault, Bishop of Maillezais, the see
adjoining that of Luçon[5]. In both this case and in that
of the model for the tomb of Louis XI he was associated
with a Tours painter— n 1474 with no less a person than
Jean Fouquet—whose business it was to colour the model,
but there is no direct proof that he was living at Tours
at this time. The most that can be said is that this
association with Tours painters and his relations with
Louis XI make the supposition very probable. It is not,
however, till 1491 that an official document confirms his
residence in the capital of Touraine; in that year his name
appears on the register of the Confraternity of Saint-
Gatien[6]. When Louis XII made his entry into Tours in
November 1500, after his return from Italy, it was Colombe
who made the model for the medal which was struck on
the occasion[7]. He was also called upon at the same time
to furnish a design for an antique cuirass to be worn by

[1] It no longer exists, but it was copied by Gaignières (1. f. 108). In it
Colombe is described as *originaire de l'évêché de Léon en Bretagne*. Saint-
Pol de Léon is between Morlaix and the coast.

[2] He received 13 *livres* 15 *sous* for the model (Laborde, *La Renaissance
des arts à la cour de France*, 1. 159); the project did not go any
further.

[3] Vitry, p. 346. [4] *Ib.* p. 488.
[5] *Ib.* p. 348. [6] *Ib.* p. 349.
[7] See below, p. 526.

Turnus, the local hero of Tours, in the Mystery of that name
which was performed in front of Notre-Dame la Riche[1].

At last we come to the only two important works of
importance executed by our sculptor that have escaped
destruction, the tomb of François II of Brittany and the
relief of St George and the Dragon. We have seen that in
1499 Anne of Brittany began to negociate for the purchase
of marble at Genoa for her father's tomb. It is quite likely,
as M. Vitry suggests, that it was her original intention to
employ Italian sculptors, as Louis XII did a little later, and
that she changed her mind after the royal visit to Tours in
November 1500[2]. At any rate soon after this visit the
commission was given to Michel Colombe, and in 1502 he
began the work. Most of the marble had come from
Genoa, having been brought by sea and river to Lyons,
thence by land to Roanne, and so down the Loire to Tours.
Colombe was paid at the considerable rate of twenty crowns
a month, and his two assistants at the rate of eight crowns.
One of them, we may be sure, was his niece's husband,
Guillaume Regnault, and the other was very probably Jean
de Chartres, whom Colombe describes in his letter to Margaret
of Austria as "my pupil and assistant (*serviteur*), who has
been with me for eighteen or twenty years[3]." There were
also associated with him two *tailleurs de maçonnerie antique
italiens*, generally identified as Girolamo Pachiarotti and
Girolamo da Fiesole, who were also paid eight crowns
monthly[4]. The work was under the general supervision of
Jean Perréal of Lyons, who had designed and executed the
model.

The monument was finished in 1507 and set up under
the personal superintendence of Perréal in the choir of the
Carmelite Church at Nantes. The church was sold in 1791
and pulled down, and in 1817 the tomb was placed in the
Cathedral, where it may now be seen in the transept,

[1] Vitry, pp. 350 f. [2] *Ib*. pp. 352 f.

[3] *Ib*. p. 489.

[4] See *Gaz. des Beaux-Arts*, 1876 (2), p. 368 (documents furnished by
Sig. Milanesi).

practically intact[1] (Plate XIII). Round the four sides of the
tomb, which rests on a plinth of black marble, are sixteen
niches separated by pilasters ornamented with arabesques. In
the niches of the long sides are statues of the twelve Apostles,
in those of the short sides St Francis and St Margaret,
patrons of the Duke and Duchess, and St Louis and
Charlemagne, patrons of France. Below is another row of
niches, circular in shape and separated by candelabra, in
which sit or crouch sixteen figures of mourners. Upon a slab
of black marble are the recumbent figures of Duke François
and his wife. Their hands are folded, their feet rest upon a
lion and a greyhound, with the escutcheons in their paws,
while their heads are supported by cushions held by three
child-angels. At the four angles of the tomb stand detached
figures representing the four Cardinal Virtues. Justice holds
a book and a sword, Temperance a bit and a clock. Prudence,
who has a double face, that of a young woman in front
and of an old man behind, holds a mirror and a compass,
while a serpent lies at her feet. Force, in helmet and
cuirass, bears a tower, from which she plucks a struggling
dragon.

It will be seen that we have here a mixture of French
and Italian themes. The recumbent figures with the Angels
at their heads and the animals at their feet follow the old
French tradition. French too are the mourners, but these
are relegated to a lower row of niches, while the upper row
is occupied by the Italian theme of the twelve Apostles,
which, as we have seen, made its first appearance in France on
a funeral monument in the tomb of the Dukes of Orleans[2].
Purely Italian too is the introduction of the four Cardinal
Virtues, a form of glorification, which, as M. Mâle points
out, is highly characteristic of the Italian Renaissance.
They had already been introduced in the tomb of
Charles VIII, but without any symbols, and their treatment
was purely conventional. Here the symbols are partly

[1] There is a cast in the Trocadéro (F. 143). See Vitry, pp. 382–410;
Michel, pp. 602–3; Geymüller, pp. 613–14.

[2] See above, p. 482.

Plate XIII

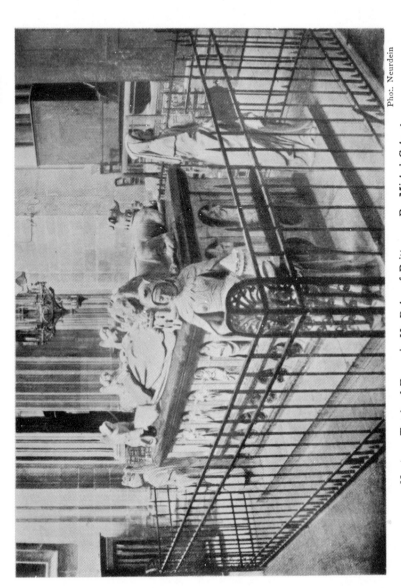

Nantes : Tomb of François II, Duke of Brittany. By Michel Colombe

French, and partly Italian. Temperance with her bit and clock is entirely French; in Italian art she is represented as pouring the contents of one vessel into another, evidently water into wine[1]. The sword and balance of Justice are common to both countries. Force is French in her symbols, the Italian Force having a column or a shield, but Italian in her costume. Prudence is almost entirely Italian; the compass indeed is a French attribute, and the mirror is common to France and Italy, but the serpent at her feet and the double face are found only in Italy[2].

We have seen that the general design was due to Jean Perréal, who had visited Milan, and perhaps other Italian cities, in 1499 and 1501, and who, as we shall see in the next chapter, played no inconsiderable part in the introduction of Italian influences into French art. It cannot be said that he is altogether successful. The recumbent figures are too high above the ground to admit of their being properly seen, and the detached Virtues at the corners of the tomb seem out of place. There is no real connexion, either in thought or in construction, between them and the tomb itself. The design, in short, as M. Vitry points out, though rich in new and ingenious ideas, is from the architectural point of view of no great merit. On the other hand M. Vitry calls attention to a merit which it undoubtedly possesses, that of harmonious colouring. The black marble

[1] As in the vault of the Cardinal of Portugal's chapel in San Miniato by Luca della Robbia, and in a beautiful medallion in the Musée de Cluny by the same artist.

[2] On Balducci's tomb of Peter Martyr in S. Eustorgio at Milan (1339) Prudence is triple-faced and has a mirror and a serpent. The tomb of François II made the theme of the Virtues in connexion with funeral monuments very popular in France. They appear in the tombs of François de Bourbon (fragments in the Musée at Vendôme), of Pierre de Roncherolles at Écouis (fig. Vitry, p. 504 from an engraving of Millin), of the two Cardinals of Amboise at Rouen (eight in number, including Chastity), of Cardinal Hémond de Denonville at Amiens, and of François de Lannoy at Folleville. See generally for the treatment of the Virtues in the religious art of this period Mâle, pp. 331–352. Vitry (p. 400) points out that in the Flemish tapestry of the Vices and Virtues at Madrid (see above, p. 352) Temperance has a clock, and Force holds a dragon in her hands.

of the slab, the green marble below the two rows of niches,
the white Apostles and patron-saints against their red back-
ground, the dark-green mourners against their white back-
ground, are blended in a happy combination of rich and
varied colour, of which photographs and the cast in the
Trocadéro give no idea[1].

To come from the design to the execution, it seems
pretty clear that the Apostles and patron-saints are of
Italian workmanship, partly on account of their style, and
partly because they are for the most part too big for their
niches. They give one the idea of having been made to
order, without sufficient care being taken to ensure their
being of the right size. Had they been executed by Michel
Colombe or his French assistants, this would surely not
have happened. To these assistants may be conjecturally
ascribed the sixteen mourners in the circular niches. But
the figures of the Duke and Duchess, the three delightful
Angels at their heads, the two heraldic animals, and the four
Virtues are, we may confidently conjecture, mainly the work
of Michel Colombe himself.

As regards the two recumbent figures, the sculptor had
behind him a long national tradition which he worthily
upholds. We have seen that the type of effigy which he
adopts had been the normal one in France since the close
of the thirteenth century[2]. The folded hands, the Angels at
the head, the animals at the feet, are all in accordance with
this tradition. It is also in accordance with it that the faces
of the Duke and Duchess are to some extent idealised, that
they do not shew the pitiless, almost brutal, realism of some
of the Burgundian effigies[3]. How far they are faithful
portraits it is impossible to say. The pair had been dead
for some years, but doubtless death-masks and other forms
of likeness were available. The dominant note in both is
one of calm placidity; if in the Duke it verges on coldness,

[1] I was unfortunately prevented from going on to Nantes from Angers,
and only know the tomb from the cast in the Trocadéro.

[2] See above, p. 472.

[3] Vitry, pp. 388–9.

in the Duchess it is pervaded by a seductive charm. The Angels are among the happiest renderings of that characteristically French type in which French intelligence and French kindliness are equally blended.

With the four Virtues Michel Colombe is on less sure ground, and he has only achieved a partial measure of success. His figures are those of modest and dignified women, but except by their attributes they hardly suggest the Virtues which they are supposed to represent. They are portraits rather than the realisation of ideals conceived in the artist's brain. But they have individuality and charm. Temperance, who is older than the others and wears a widow's wimple, is a most sympathetic figure, full of grace and gentle dignity. But she suggests a benign Sister of Charity rather than the special Virtue for which she stands. Justice is of a severer aspect and represents fairly well the idea of that Virtue. There is a tradition that she has the features of the sculptor's patroness, Anne of Brittany, but she does not resemble the portraits of that princess. Prudence is less attractive, barely escaping insignificance. Force is spoilt by having her mouth open, but otherwise is an impressive figure, serious and thoughtful.

Whatever fault may be found with the conception of the Virtues, their execution, no less than that of the recumbent figures, reveals the hand of a master. Its most marked feature is the careful attention to details. But there is no parade of skill; all is subordinated to the general effect. The draperies hang in natural but rhythmical folds; the head-dresses, which are those of the day, have a peculiar charm. It is only in the casque and cuirass of Force, which are no more archaeologically correct than the armour of the soldiers at Solesmes, that the sculptor draws upon his imagination.

After the completion of the tomb of François II Michel Colombe executed several important works of which unfortunately only one has come down to us. They included a Crucifix and statues of St Francis and St Margaret, which formed part of a large retable for the altar behind the tomb

of François II[1], an Entombment for the church of Saint-Sauveur at La Rochelle, which was ordered in 1507 and completed in 1510[2], and a recumbent statue of Guillaume Guegen, bishop of Nantes, who died in 1506 or 1507[3].

The one work that has survived is the bas-relief of St George and the Dragon (Plate XIV) now in the Louvre, but once part of the retable in the chapel of Gaillon, for which Michel Colombe received on February 25, 1509 (N.S.) the sum of three hundred *livres*[4]. Like the monument at Nantes it is remarkable for the very careful rendering of all the details, down to the sword-hilt, the boots, the bridle, and even the horse's hoofs[5]. St George wears the armour of the time, and the dress of the Princess is also contemporary. The treatment of St George as he charges the dragon, lance in rest, is marked rather by spirit and animation than by intimate knowledge of horses and their riders, and in spite of his size the dragon is not a very terrifying beast[6]. The marble framework, which consists of two pilasters supporting an entablature, deserves special attention. Executed at Gaillon by Pachiarotto with the assistance of Bertrand

[1] *Arch. de l'art français*, I. 429.

[2] See Vitry, pp. 359–60. In the document giving the order (May 2, 1507) reference is made to an earlier work by Colombe, a retable in Saint-Saturnin at Tours, representing the Death of the Virgin, which was destroyed by the Protestants in 1562. Both these works were of stone, and the figures of the Entombment were painted. Had the latter work survived it would have furnished an instructive comparison with the Entombment of Solesmes.

[3] This statue has disappeared and we only know it from a drawing by Gaignières, Pe lh f. 163; Bouchot, no. 2924. The arabesque decoration of the *enfeu* in which the tomb was placed is of inferior quality. See L. Palustre, *M. Colombe, loc. cit.* and for Guegen above, p. 154.

[4] Deville, p. 419; Vitry, pp. 378–382 (fig.) and xvii (fig.).

[5] It is difficult to conceive this minute work being executed by a man of seventy-seven. M. Vitry, who apparently accepts Lemaire's statement as to Colombe's age, conjectures that Regnault or some other pupil may have assisted him.

[6] For the general composition M. Vitry compares a relief by Donatello in Or San Michele, and a miniature of the Grimani Breviary, but in the relative positions of St George, the dragon, and the Princess, Colombe's work comes nearest to a relief ascribed to Giovanni Gaggini in the Victoria and Albert Museum.

Plate XIV

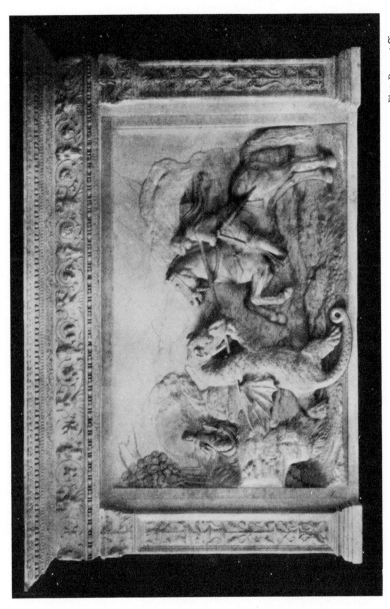

St George and the Dragon (Louvre). By Michel Colombe

de Meynal and Jean Chersale[1], and including nearly every variety of classical and Renaissance ornament, there is no better example of the skill and taste which the Italian sculptors brought to bear on the decorative side of their art.

In the spring of 1511 Colombe accepted through Jean Perréal a commission from Margaret of Austria to make a model for the tomb of her late husband, Philibert of Savoy, which she proposed to erect in her memorial church of Brou. In the summer of the same year he set to work, and on December 3 he signed a provisional contract, in which he undertook to make the model with the assistance of his three nephews, Guillaume Regnault, sculptor, Bastien François[2], master-mason, and François Colombe, miniaturist. The recumbent figure, which was to be in terra-cotta, was to be made with his own hands. If the Duchess were satisfied with the model, he would make the monument itself with the help of Regnault and Bastien François, and send it to Bourg under their charge and that of another of his assistants, Jean de Chartres. For, owing to his age and bulk, he could not undertake the journey in person[3]. We learn also from this document that the material for the monument was to be alabaster from a certain quarry in Burgundy, in which Jean Lemaire, who had come to Tours to conduct the negociations on Margaret's behalf, had an interest as superintendent[4].

The execution of the model did not proceed fast enough to please Margaret. On May 28, 1512, Michel Colombe wrote to excuse himself for the delay, alleging illness and old age. He says he will finish the work if his *compère* Jehan (Perréal)

[1] Deville, pp. 358–360.

[2] Son-in-law to Regnault. Jean Lemaire had reported to Margaret in a letter of Nov. 22, 1511, that "les deux neveus (Regnault and Bastien François) sont ouvriers en perfection...l'un en taille d'ymaigerie, l'autre en architecture et massonnerie." (C.-J. Dufaÿ, *L'église de Brou et ses tombeaux*, Lyons, 1867.)

[3] Lemaire describes him to Margaret as *fort ancien et pesant* and adds that he is *goutteux et maladif*.

[4] The whole document is printed by Vitry, pp. 487–490, from the original text. It differs very slightly from that published by Le Glay, *Anal. hist.* pp. 13–21. For Lemaire's visit to Tours see above, p. 342.

does not desert him, and he speaks of Regnault as the *baston de sa vieillesse*[1]. Later in the same summer the model was completed; it was coloured by Perréal in the place of François Colombe, who had died. It included figures of ten Virtues, but these, instead of being life-size, like those of the Nantes tomb, were reduced by a third[2]. The model was never used. Perréal and Lemaire fell into disgrace, and Margaret entrusted her church to Louis van Boghem of Malines, and her husband's tomb to sculptors chosen by him.

The mention of Michel Colombe in a letter of Perréal dated July 20, 1512, is the last we hear of the old man. The date of his death is unknown. All that can be said for certain is that his name does not appear in the list of members of the Confraternity of Saint-Gatien for 1519.

At his death the direction of his famous *atelier* in the Rue des Filles-Dieu passed into the hands of his niece's husband, Guillaume Regnault[3], who lived till near the close of 1532. Seeing that in 1511 he had been Colombe's assistant for about forty years, he must have been between seventy and eighty at the time of his death. Besides his share in the tomb at Nantes, the only work that can be attributed to him with certainty is the tomb of Louis de Poncher and his wife, Roberte Legendre, now in the Louvre, which he executed in association with Guillaume Chaleveau, also of Tours, in 1523 and the following years[4]. The work lies outside the limits of our inquiry, but it may be noted here that the two recumbent figures, of which the woman is the most successful, are thoroughly French, being conceived and executed with the dignified simplicity and delicate precision characteristic of Michel Colombe and his

[1] This is the only letter of Michel Colombe's that has come down to us. It was discovered in the archives at Lille by C. Cochin with other unpublished letters relating to Brou. From one of these we learn that the price of the monument was fixed at 800 crowns. (*Comptes rendus* of the *Académie des inscriptions* for Nov. 21, 1913 (pp. 653–656).)

[2] Lemaire to Margaret (Le Glay, *Anal. hist.* pp. 25 ff.) and Perréal to Margaret (Le Glay, *Nouv. anal. hist.* pp. 42–3; Lemaire, *Œuvres*, IV. 387).

[3] Vitry, pp. 414–416.

[4] The contract was discovered by M. Louis de Grandmaison. For illustrations see Vitry, pp. 444–447.

school. On the other hand the decoration of the base,
though apparently the work of Frenchmen, shews, alike in
its general scheme—shell-niches, separated by pilasters, con-
taining figures of the three Theological Virtues[1]—and in
the pose and drapery of the figures, clear traces of Italian
influence.

We have seen that the design for the base of the royal
children's tomb at Tours and the decoration of its sides
may with some confidence be attributed to Girolamo da
Fiesole. But the recumbent figures of the two children and
the child-angels at their head and feet are evidently French,
and as the tomb was ordered by Anne of Brittany at the
same time and under the same conditions as that of her
father, it is a natural assumption that the order for the
figures was given to Colombe's *atelier*. Moreover the style
of the work bears out this assumption. The four Angels are
exquisite, but the figures of the children are generally
regarded as not quite worthy of Michel Colombe himself,
and are therefore assigned to his chief assistant, Guillaume
Regnault. The argument is plausible, but it rests upon
three unproved hypotheses.

From the style of the work, and from the connexion of
the famous Tours *atelier* with the Court, critics are led to
assign to the same source the admirable kneeling figures of
Louis XII and Anne of Brittany which surmount their
monument at Saint-Denis. That of the king impresses
one as a singularly faithful portrait. There is no attempt
at pose, as in Mazzoni's figure of Charles VIII. Louis kneels
in a reverent, almost devout, attitude, as one awaiting the
judgment of a just and merciful God.

Another assistant of Michel Colombe's who may with
considerable probability be connected with existing work is
Jean de Chartres, the assistant whom he proposed to send to
Bourg-en-Bresse with the completed monument of Philibert of
Savoy. "He is at present," he says in his letter to Margaret of
Austria, "sculptor (*tailleur d'images*) to Madame de Bourbon."
Now between 1504 and 1514 Anne de Beaujeu was restoring

[1] Only two, Faith and Hope, are preserved.

her château of Chantelle in the Bourbonnais, and on its three
towers she placed statues of the patron-saints of her husband
(St Peter), her daughter (St Suzanne) and herself (St Anne
with the Virgin). The château was demolished by order of
Richelieu, and it was not till 1845 that the three statues
were unearthed from the ruins. They are now in the Louvre,
and on the strength of Jean de Chartres being sculptor to
the Duchess about the time when they were executed and
of the style being in close conformity with that of Colombe's
atelier, the attribution of them to Jean de Chartres, which
was first made by M. André Michel, is a legitimate and
tempting hypothesis[1]. The modelling of all the figures,
especially of St Suzanne, is rather feeble; the most success-
ful is certainly St Anne.

Another statue that has been confidently claimed for the
famous Tours *atelier* is the well-known Vierge d'Olivet in the
Louvre (Plate XV), which takes its name from the modern
château where it found a home after the Revolution[2]. Its
original *provenance* is unknown, but Montaiglon conjectures
with some plausibility, arguing from its size and condition,
that it once stood against the central pillar of a church
portal, where it was partially protected against the weather
by a canopy[3]. The Virgin is a beautiful figure of a severe
but sweetly simple type. The Child is on her right arm, a
departure from ordinary custom which is perhaps to be
accounted for, as Montaiglon suggests, by the position of
the statue and the exigencies of the light. The sculptor was
certainly justified in placing the Child so as to shew off to
the best advantage the delicate modelling of his back.
But a mother at any rate would make the criticism that his
back has not sufficient support. The Virgin's draperies
may be compared with those of Temperance in the Nantes
monument. They hang in a somewhat similar fashion,

[1] See Michel, pp. 610–612; Vitry, pp. 662–665.

[2] A. de Montaiglon in *Gaz. des Beaux-Arts*, 1876 (1), pp. 665–670;
Vitry, pp. 426–431. lt was bought by the Louvre from the painter,
Charles Timbal.

[3] Cp. the Vierge de Marturet at Riom referred to above, p. 462.

Plate XV

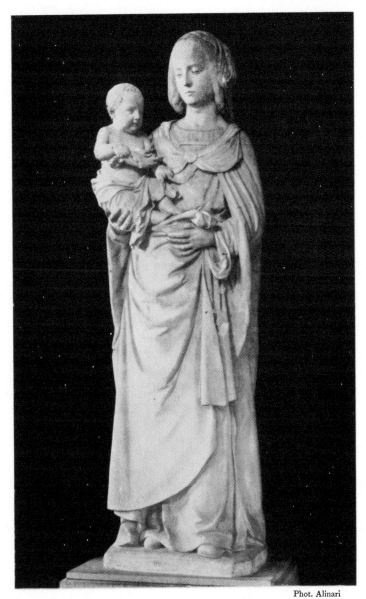

La Vierge d'Olivet (Louvre)

especially as they near the ground. But the folds seem heavier, and at the point where they are gathered up by the hand a little clumsy.

On the whole from the point of view of material treatment and technique the work lacks the accomplishment and certainty of touch that we find in Michel Colombe. But in the highest quality of art—the inner vision, the spiritual appeal—it marks a decided advance. The artist has taken for his model in all probability a young mother of Touraine, but he has selected his model well, and he has idealised her by the help of his imagination into a type of simple and divine motherhood. Is not this the secret of Renaissance art?

Round the Vierge d'Olivet M. Vitry has grouped together three works closely akin to it, if not immediately inspired by it. The two earliest, the Vierge de la Bourgonnière, of painted stone, in the chapel of the Angevin château of that name, which may be dated about 1510–1515[1], and the Vierge de Mesland, a marble statue in the church of a priory, formerly dependent on the great Abbey of Marmoutier near Tours[2], shew the same simplicity of conception and treatment that we noted in their prototype[3]. But in the Virgin d'Écouen[4], which formerly adorned the chapel of the Montmorency château and is now in the Louvre, we see alike in the features and the pose of the Virgin the signs of that mannerism, the result of Italian influence, which we noticed in the figures of the Virtues on the tomb of Louis de Poncher. Unfortunately we do not know its date. It was at Écouen before the Revolution, but there is nothing to shew that it had always been there, or that it was ordered by the Constable of Montmorency for his château, which was not begun till about 1532[5].

Finally, this brief notice of the *atelier*, or at least the school, of Michel Colombe may be completed by the mention

[1] Vitry, pp. 432–434 (fig.). [2] *Ib.* pp. 434–5 (fig. p. 432 and p. xix).

[3] The pose of the child and the treatment of the draperies are very similar. I have not seen either of these statues.

[4] Vitry, p. 436 (fig.). [5] *Ib.* pp. 431–2.

of the charming little terra-cotta figure of the Virgin and
Child which formerly stood above the portal of the Chapel
of La Carte, and is now safely preserved in the interior[1].
As Jacques de Beaune began to build his château about
1500 and ceased to live there about 1515[2], we may infer
that the date of the statuette falls within these limits.

We may now leave the valley of the Loire, and see what
signs of the coming Renaissance we can discover in other
districts in France. In Normandy, owing to the influence of
Cardinal d'Amboise and the presence of Italian sculptors
at Gaillon, we should naturally expect to find an influx of
Italianism, and it is interesting to learn that when Pierre des
Aubeaux was working with three associates on the Death of
the Virgin, which comprised more than twenty colossal figures,
for the Church of St Gervais and St Protais at Gisors, he was
sent to Fécamp to see that representation of the same
scene which has been mentioned above as mainly Italian[3].
In the work which the same sculptor executed in 1513 and
the following years for the central portal of Rouen Cathedral,
so far as can be judged from its present mutilated condition,
he remained faithful to the old Gothic tradition[4]. But in
the tomb of the two Cardinals of Amboise in the same
Cathedral, of which he was the principal sculptor, though
with numerous fellow-workers, including Italians, the
influence of Italian models is clearly visible. If we compare
the figures of the Virtues with those of Michel Colombe, we
get a good idea of the evolution that was taking place in
French sculpture during the years from 1515 to 1525[5].

On the other hand, the considerable group of sculptures
at Verneuil (22 miles west of Dreux and 17 miles south of
Evreux), comprising an Entombment and a Madonna of

[1] Vitry, pp. 422–426 (fig.). [2] See above, p. 157.

[3] See above, p. 479, and L'Abbé F. Blanquart in *Congrès Arch.* 1889,
pp. 378–391. That writer is clearly wrong in regarding the work at Fécamp
as a replica of that at Gisors.

[4] See above, p. 173.

[5] Cp. the figure of Temperance (fig. Michel, IV. 616) with that of the
Nantes tomb, and see C. Enlart, *Rouen*, p. 56, for a reproduction of the
whole monument.

painted stone in the Church of La Madeleine, and a *Pietà*
and numerous Saints in the Church of Notre-Dame, most of
which belong to our period, shews no traces of Italian
influence. In some of the figures, as for example the St
Christopher of Notre-Dame, there is a decided appearance
of Flemish influence, but the majority are executed in that
spirit of mitigated realism, though with less accomplishment
and less individuality, which we have seen to be characteristic
of the thoroughly French school of the Loire[1].

At Chartres, about thirty miles from Verneuil, an
important series of sculptures representing scenes from the
lives of the Virgin and Jesus Christ, was begun in 1519 by
Jean Soulas, under the direction of Jean Texier, for the
screen round the choir of the Cathedral. Completed about
1525, his work, which fills the first bay on the south side, has
the homeliness, the simplicity, and the love of detail
characteristic of French pre-Renaissance sculpture, and it is
not till we come to the third group of the second bay, which
was executed by an unknown artist[2] between 1525 and about
1540 that we find in the Angel of the Annunciation traces
of Italian influence[3].

South of the Loire there is nothing which points to any
school of sculpture that was active during our period. At
Toulouse, the only important art-centre at this time in south-
western France, Nicolas Bachelier, as has been already men-
tioned, returned to his native city from Italy in 1510, but
his work in sculpture, so far as it is definitely known, dates,
like his work in architecture, from a later period. Lyons
is equally disappointing for our purpose. We have seen that
a gild was formed there in 1496 for painters, sculptors, and
painters on glass, and the names of several sculptors have
come down to us, among them, Hugues Légier dit Favier

[1] See Vitry, pp. 316–319; Michel, p. 614; and generally for the sculpture
of Normandy, Le Chanoine Porée in *Bull. Mon.* LXIV. (1899), 381 ff.
(printed also in *Bull. de la société des antiquaires de Normandie*, XXI.
(1900), 193 ff.)

[2] The unknown artist may be Jean Soulas himself. See Vitry, pp. 477–
479.

[3] See R. Merlet, *La Cathédrale de Chartres*, pp. 80–1.

(fl. 1486–1516), Poncet Escoffier (fl. 1493–1512), Jean Barbet (fl. 1475–1514), Nicolas Leclerc (fl. 1487–1507), and Jean de Saint-Priest (fl. 1490–1516)[1]. But nothing remains, so far as we know, to bear witness to their skill, save the Angel of Lude by Jean Barbet[2], and a medal of Louis XII, to be noticed later, for which Leclerc and Saint-Priest furnished the model.

From Lyons we may pass to La Forez, the southernmost province of the ample domain of the Dukes of Bourbon, situated between the upper waters of the Loire and the Allier. Here are to be seen four early sixteenth century statues of considerable merit, which M. Thiollier has grouped together under the title of *sculptures Foréziennes*[3]. They range in date, however, from perhaps 1500 to 1530, and shew considerable differences of style. The two earliest are the Vierge de l'Hôpital-sous-Rochefort[4], of wood, and the Vierge de la Chira, of white alabaster, in a chapel of Saint-Marcel d'Urfé, which was founded in 1508[5]. Both of these are purely Gothic. The other two shew decided Italian influence. One is a white marble statuette of St Catherine in the church of Champoly (Loire), brought there from Saint-Étienne-d'Urfé[6]. The material, the small size, and the treatment of the drapery, have led M. Vitry to suggest that it is of Italian workmanship, and that it was imported from Italy[7]. But the face is thoroughly French and has the appearance of a portrait. M. Thiollier conjectures that it was the gift of Catherine de Polignac, the first wife of Pierre II d'Urfé, Grand Écuyer of France and Brittany, who died in 1493. But it may equally well have been presented by her husband as a memorial[8]. The latest of the four statues—

[1] N. Rondot, *Les sculpteurs de Lyon du 14me au 18me siècle*, Lyons, 1884. He gives the names of about twenty-five sculptors, including one Fleming, for our period.

[2] See above, p. 464. [3] *Gaz. des Beaux-Arts*, 1892 (1), 496 ff.

[4] Trocadéro, F. 109; Vitry, p. 311 (fig.). [5] Vitry, p. 469 (fig.).

[6] Trocadéro, F. 299; Mâle, p. 164 (fig.). [7] Vitry, p. 469.

[8] In 1494 Pierre d'Urfé was sent to Genoa to equip ships (Commynes, VII. c. 4). He went to Naples, and fought at Fornovo and, in the next reign, at Novara, so that he might easily have bought the statuette or the marble for it in Italy. (See A. Bernard, *Les d'Urfé*, 1839, pp. 33–44.)

M. Vitry suggests 1515–1530 for its date—is probably the Vierge du Pilier in the church of Saint-Galmier[1] (Loire). It is made of limestone, and a certain affectation in the pose and the elaborate treatment of the draperies, with a view to shewing off the sculptor's skill, point to the influence of north-Italian models.

Further north, in Burgundy, we see a similar example of inferior Italianism in the retable of the Cathedral of Autun, which may be dated soon after 1511[2]. The decoration is Gothic, but a Renaissance niche is introduced above the lintel, and the new influence reveals itself in the two figures of Christ and the Magdalen. The dignified gesture with which Our Lord re-assures the agitated Magdalen denotes a praiseworthy attempt to realise the scene as a whole, but there is an obvious pose in the attitude of both figures, and the Magdalen's drapery is arranged in too elaborately flowing lines[3]. The same lack of simplicity marks the Vierge d'Arbois, now in the Musée de Cluny, which comes from the same region[4].

It is greatly to be regretted that the splendid monument which Tristan de Salazar[5] erected for his parents in his Cathedral of Sens exists only in fragments. All that is left are the beautiful Gothic retable, which faced the tomb, and two statues of the Virgin and St Stephen, both of mediocre merit[6]. The two kneeling figures of Jean de Salazar and his wife, which rested on a platform of black Dinant marble, supported by four columns, have disappeared[7].

[1] Fig. Vitry, pp. 471 and xxi.

[2] In February 1511 the Chapter gave permission to Jean Charvet to construct a chapel for his tomb; he was buried there in 1515 (Michel, IV. 612).

[3] Fig. Michel, IV. 611. [4] Vitry, p. 481 (fig.).

[5] See above, p. 152.

[6] Vitry, p. 473 (fig.). M. Vitry connects the statue of the Virgin with the Vierge d'Olivet, which it certainly resembles; but it is of ruder workmanship.

[7] Our knowledge of the monument is derived from a drawing of Gaignières, Pe 1m. ff. 60 and 70; Bouchot, nos. 3464 and 3475; see also

The province of Champagne, as a whole, has been more fortunate. Thanks to the insight and industry of MM. Koechlin and Vasselot[1] there is no provincial school of French sculpture in which it is easier to observe the rising tide of Italianism than that of Troyes. Unlike the *atelier* of Michel Colombe of Tours, which executed a select number of important works, but of which, judging from the few works that have come down to us, the output was not large, the workshops of Troyes turned out statues, retables, *Pietàs*, and Entombments by the hundreds[2]. Their clients were not princes and great nobles, but the clergy, *bourgeoisie*, and Confraternities of Troyes. As an almost inevitable consequence, the leading sculptors were in the first place *atelier*-directors and only in the second place artists. Their chief business was to conduct an important industry, and it was only on rare occasions that they executed a work entirely with their own hands[3].

Owing to the devastated condition of Champagne and the consequent paralysis of its artistic life the Burgundian school never gained a foothold in that province, so that, when peace and the arts returned, the new school of sculpture that sprang up at Troyes was of purely native growth[4]. One of its earliest productions, the Madonna of the Hôtel-Dieu presented by Nicolas Forjot, Abbot of Saint-Loup, between 1508 and 1512, is a fine and dignified figure, absolutely free from affectation, but without any trace of the Renaissance spirit[5]. Rather later, perhaps as late as 1520,

Vaudin, *op. cit.* p. 166, and A. de Montaiglon in *Gaz. des Beaux-Arts*, 1880 (2), pp. 241 ff. There were probably also two recumbent figures on the tomb itself. A similar tomb, also destroyed, was erected to Card. Dupont (d. 1535) in the same Cathedral. (See Michel, IV. 643.)

[1] R. Koechlin and J.-J. Marquet de Vasselot, *La sculpture à Troyes et dans la Champagne méridionale au XVIme siècle*, 1900.

[2] See Vitry, p. 418.

[3] Koechlin and Marquet de Vasselot, p. 97. [4] *Ib.* pp. 6–7.

[5] *Ib.* pp. 93–4, plate 18. Two stone statues in the Victoria and Albert Museum, St Barbara and the Virgin, belong to the Troyes school and are assigned to the early sixteenth century. The Virgin is not without charm, but the draperies of both are too heavy. The retable of Lirey in the same

is the masterpiece of the earlier Troyes school, the Martha of the Church of La Madeleine[1], which nobly expresses the idea of a woman "cumbered with much serving." But the art is still pre-Renaissance, and so is that of the fine Entombment of Chaource (1515)[2], and of the noble figure of St Bonaventura in the Church of St Nicholas[3]. On the other hand the influence of the Renaissance is shewn in the Entombment of Villeneuve-l'Archevêque near Sens (1528) as well by its pyramidical composition as by certain features in its execution[4]. It is from 1520 to 1535 that MM. Koechlin and Marquet de Vasselot place the transformation of the Troyes school from Gothic—to use their term— to Renaissance[5]. It was about the year 1535 that the *atelier* of the Juliots, which was impregnated with Italianism from the first, began to make a decisive appearance.

The effect of this Italianism upon the school of Troyes was almost wholly injurious. Troyes produced no sculptors capable of understanding what was really helpful in Italian art, or who were even able to distinguish third-rate work from the work of genius. The decadence of this local school does not concern us, but the causes of its decline before it had really come to maturity have been well explained by the authors of *La sculpture à Troyes*, and are of such universal application, that it is worth while to refer to them here. It appears that the sources of decay which the influence of Italian models introduced into the sculpture of the Troyes school were three in number. The first was virtuosity, or the display of technical skill and knowledge for their own sakes. The draperies were either made to fall in unnaturally complicated folds in order to shew off the

Museum with its tumultuous emotion is an example of Troyes sculpture in its decadence.

[1] *Ib*. pp. 100–102, plate 20.
[2] Mâle, p. 134.
[3] Fig. Vitry, p. 322.
[4] Koechlin and Marquet de Vasselot, plates 23, 24, and 26.
[5] The Visitation (*ib*. p. 140; Trocadéro, F. 293) is an example of bad realism. Elizabeth and the Virgin are two over-dressed *bourgeoises* meeting after Mass in the market-place.

sculptor's skill with the chisel, or were drawn tight over the knee or some other convenient part of the body for the purpose of calling attention to his knowledge of anatomy. This is simply bad art. The second was affectation, or the adoption of certain tricks of style, chiefly also for the purpose of attracting the spectator's attention. This again is simply bad art. But to these two sources of decay there was added later a third, which was all the more dangerous, because the principle from which it proceeded was good. This was "the tendency to generalisation[1]." Now to rise from the particular to the general, from the particular to the universal, from the temporal to the eternal, from the portrait to the type, is the highest aim of the artist. But few achieve it. You must study details before you can generalise. You must realise the individual before you can create the type. You must live with your own times, if you would speak to the ages. You must stand firm upon the earth, if you would proclaim eternal verities. Now the "grand style," as it was called, recognised to the full the generalising principle. It was by eliminating everything that was not typical that Michelangelo attained to the universal. But he was able to do this because he beheld with his inner eye a concrete embodiment of his idea. Men with more commonplace souls and less powerful imaginations have no such vision. They think that the mere omission of characteristic details produces the grand style. The result is that their art, lacking creative force, becomes cold, conventional, and academic.

We have seen how in other parts of France the contact with Italian art produced the same tendency to virtuosity and affectation. It was a misfortune for French sculpture that the Italians who settled in France were, at any rate in figure sculpture, only of the second or third rank. It was a further misfortune that during the generation which elapsed between the death of Michel Colombe and the rise to fame of Jean Goujon no sculptor appeared in France who had at once the opportunity of studying the masterpieces of Italy and the genius to understand them.

[1] Koechlin and Marquet de Vasselot, pp. 201 ff.

II

In some parts of France the spirit of conservatism was very strong, and sculpture retained its mediaeval characteristics till far into the sixteenth century. Indeed in remote Brittany there may be seen at Plougastel and Pleyben, not far from Brest, Calvaries, dated 1602 and 1650 respectively, which alike in conception and execution belong wholly to the Middle Ages. But, apart from such extreme examples, we find that in Picardy, for instance, the sculptors preferred the old ways. When the stone screen which separates the choir of Amiens from its aisles (*le pourtour*) was continued in 1527—it was begun in 1490—no change was made in the style. The stories of St Firmin and St John the Baptist were told with all the naive and popular realism which is so characteristic of French fifteenth-century sculpture[1]. It is just the same with the rich façades of Abbeville, Saint-Riquier, and Rue.

This conservatism of Picardy is partly to be accounted for by its proximity to the Flemish border. The Flemish influence on French sculpture at the close of the fifteenth century was a declining one, but it still made itself felt in certain regions. The spirited relief on the lintel over the double entrance doorway of the little Chapel of St Blaise at Amboise shews decided Flemish influence. In the principal composition, which represents the Vision of St Hubert, this appears in the thick-set, though expressive, figure, of the saint, and in a similar robustness in the horse, dogs, and stag. Further, as M. Vitry points out, the St Christopher is treated in accordance with Flemish traditions, while we have a Flemish rendering of the Italian Renaissance in the little chapel on the extreme left of the relief. M. Vitry infers that it is the work of a French artist under Flemish influences. Similar

[1] There is some Renaissance architecture in the Sellers of the Temple in the transept (Durand, plate LIII).

work is to be found elsewhere, at Amboise, at Blois, and in Anjou[1], and there is evidence of Flemish sculptors living at Tours and executing work for French patrons in 1520 and 1522[2]. The existence of this Flemish influence had at any rate this effect, that it tended to stiffen the resistance to Italian innovations. For the French and Flemish sculptors had been brought up in the same traditions, especially as regards religious types and iconography. The Flemings were particularly expert as carvers in wood. Statuettes and retables in that material were imported in abundance from the workshops of Brussels and Antwerp[3]. Notable examples are to be seen at Thenay[4], between the Loire and the Cher, at Ambierle near Roanne, and, still further south, at Saint-Galmier. They are partly carved and partly painted[5], the central portion being carved and gilded and the wings painted. The largest and most celebrated is the one at Ambierle, which has three compartments of wood-work, representing scenes from the Passion with the Crucifixion in the centre, and six painted wings[6]. We know that it was bequeathed in 1476 to the Church of Ambierle by Michel de Chaugy, a high official of the Court of Burgundy, but it is said that the date of 1466 could once be deciphered on it[7].

Flemish wood-carvers, as well as their imported work, were greatly in demand. They were employed in considerable numbers on the choir-stalls of Rouen Cathedral, among them being Paul Mosselmann, who was also a sculptor in stone of considerable distinction[8]. These stalls with their carved ends and poppy-heads, their elbow-rests and hand-rests, and above all their misericordes, on which are represented an infinite variety of realistic, grotesque, and often amusing scenes, established a tradition which it was not

[1] Vitry, pp. 242–246. [2] *Ib.* p. 237.
[3] *Ib.* pp. 232–237. [4] *Ib.* p. 235 (fig.).
[5] There is an example in the Musée des Antiquités at Rouen.
[6] Vitry, p. 233 (fig.).
[7] E. Jeannez in *Gazette archéologique* for 1886, pp. 221–234.
[8] See E. Molinier, *Hist. générale des arts appliquées à l'industrie*, II. (1892), 20 ff.

easy to dislodge. The fine and spirited Flamboyant stalls
of La Trinité at Vendôme, with their notable misericordes,
which were executed at the end of the fifteenth century for
Louis de Crevant, and the equally fine ones at Beaulieu-lès-
Loches, the gift of Hardouin La Fumée, who was Abbot
from 1494 to 1521, shew no sign of departure from the
accepted model[1]. The same may be said of those in the
chapel at Blois. At Amiens, indeed, where the work is of
rather later date (1508–1519), the Renaissance begins to
make an appearance in the beautifully executed frieze of
arabesques and figures which adorns the elbow-rests, and
in the ends of the sub-stalls. There are also Renaissance
and semi-Renaissance buildings in some of the scenes with
figures[2]. But except for these details the whole work is
executed in a purely mediaeval spirit.

The stalls at Amiens were executed by a local gild of
wood-carvers, which in the year 1494 numbered two
hundred members. For the French workers in wood—
huchiers, as they were called in mediaeval times, the term
menuisier not being used till the end of the fifteenth century
—were no less skilful than their Flemish rivals[3]. There is
a fine example of the work of Rouen *huchiers* in a retable
from the church of Pasquienne in the Musée des Antiquités
of that city. At Paris they formed an important *confrérie*,
with St Anne for their patron-saint[4]. In the south of France

[1] The abbatial chair presented by the same abbot shews a mixture of
Gothic and Renaissance.

[2] See Durand, *op. cit.* III. plates LXXIX and LXXXII and II. 279–80;
A. Maskell, *Wood-sculpture*, 1911, pp. 324–330.

[3] The stalls on the right at Amiens were entrusted to Alexandre Huet,
those on the left to Arnould Boulin, both *huchiers*. Boulin had three
assistants. A *menuisier*, named Breton, also took part in the work, and
Antoine Avernier, *tailleur d'images*, made the misericordes. A workman,
named Jean Turpin, has carved his name twice. During the work Boulin
went to study the stalls at Rouen, Beauvais, and Saint-Riquier, of which
the two latter have been destroyed. Those at Saint-Riquier were begun
in 1507 by Huet and two other *huchiers* of Amiens (see Durand, *op. cit.*
vol. II.).

[4] R. de Lespinasse, *Les métiers et corporations de la ville de Paris* (*Hist.
générale de Paris*), 2 vols. 1884–1892, II. 634.

the most famous school was that of Toulouse, and it was doubtless Toulouse workmen who executed, from designs attributed to the ubiquitous Nicolas Bachelier, the magnificent choir-stalls in the Cathedral of Auch. They were begun in 1515, and the first portion, comprising forty-four stalls, was completed during the episcopate of the Cardinal de Clermont-Lodève (1507–1538). It is only in one of the very latest of this series, that a subject taken from pagan mythology— Hercules and Cacus—finds a place, but in the general scheme of decoration Renaissance details play a prominent part. In the combination of energy of conception with delicacy of execution these stalls are unrivalled[1].

It was in the chapel at Gaillon that a distinctively Italian art, namely *tarsia*, was first introduced into French stall-work. The term *tarsia* or *intarsia* was sometimes used to denote any kind of inlaid wood-work, but it was generally confined to that form of it which represented figures or landscapes by means of coloured wood, and in which skilful effects of perspective were often a conspicuous feature[2]. From about 1460 *tarsia* became very popular in Italy, and among its earliest masters were the well-known architects and sculptors Giuliano and Benedetto da Maiano[3]. When the French crossed the Alps there were few cities in Italy which did not possess some notable specimen of the art. But it was probably at Milan that Cardinal d'Amboise was inspired by the desire to introduce it into his chapel at Gaillon. In that city he might have seen the fine stalls of Santa Maria delle Grazie (1470) or those of Santa Maria della Scala (now in San Fedele), while in the Certosa of Pavia was the most recent example of the art, completed by Pietro da Vailate in 1498.

[1] The material is heart of oak, which has taken a splendid colour, almost like bronze. Other stalls of this date are those of Brou, begun by Terrasson of Bourg and completed by Anne le Picard, and of Notre-Dame de Bourg, which were begun in 1512 or 1513.

[2] See Molinier, *op. cit.* pp. 61–78.

[3] The stalls in S. Giustina at Padua with *intarsia* work by Domenico Piacentino and Francesco Parmigiano date from 1460.

The Italian colony at Amboise comprised an *ouvrier de planches et menuisier de toutes couleurs* named Bernardino of Brescia, but no record of his work in France has been preserved. Among the names of twenty-one *menuisiers* which occur in the accounts of Gaillon are those of Michellet Guesnon, who is qualified as *marquetier*, Colin or Nicolas Castille, and Richard Guerpe or Carpe. Castille, who was of Rouen, was at the top of his profession, and was employed later as *maître-menuisier* of the Cathedral, where he executed the central door of the great portal[1]. It has been plausibly suggested that Guerpe or Carpe was an Italian from Carpi near Modena, but there is nothing to confirm the conjecture, nor is there any payment in the accounts which connects him with the *intarsia* of the chapel stalls. This, which is confined to the lower tier of the upper part of the stalls, consists of figures of the Virtues and the Sibyls, enthroned, as in the nave of a church, at the end of a double row of columns, which with the tessellated pavement give an opportunity to the craftsman to display his skill in perspective[2]. In other ways the stalls present an interesting mixture of Gothic and Renaissance. The general design with its horizontal lines is almost Renaissance. Above the *intarsia* are scenes from the New Testament, framed by architecture which by the use of candelabra and similar ornamentation shews its Milanese origin[3]. In the Musée de Cluny may be seen another portion of the same stalls, consisting of Gothic panels separated by pilasters which are decorated with arabesques.

[1] He began to work for the Cardinal at his Rouen house apparently in 1504. In connexion with the chapel of Gaillon he is paid separately for wood for the stalls, but otherwise he is paid weekly with the other *menuisiers* who worked at the stalls from December 1508 to September 1509. The average pay was a *livre* a week (Deville, *op. cit.* pp. 391–395).

[2] Temperance and Force have French, not Italian, attributes. Temperance a bit and bridle, Force a dragon and tower (see above, pp. 500–1). Geymüller (1. 98) thinks that the *intarsia* is from the design of a Frenchman who is trying to work in the Italian fashion.

[3] Geymüller, *ibid.* See W. H. Ward, *op. cit.* p. 34 (fig.); Deville, plates XIX and XIII; Molinier, II. 94–97, plate VII.

Other examples of wooden church-fittings of this period in which Gothic and Renaissance appear side by side are a font-cover at Bueil, in which the Renaissance element is only slight, and another at Saint-Riquier, which is ornamented with medallions and other forms of Renaissance decoration. The font itself has classical pilasters.

For an example of transitional church-doors we must go to the other end of France, to the Cathedral of Aix in Provence, the doors of which were executed by Jean Guiramand of Toulon from 1505 to 1508 (Plate XVI). There are three rows of figures, the twelve Sibyls above, and the four major Prophets below. Each figure stands under a Flamboyant canopy, but the Prophets are separated by pilasters richly decorated with arabesques, and the canopies are supported by classical columns. Round the top and sides of each division of the doors runs a beautiful garland of fruit and leaves[1].

Geymüller mentions a door of 1513 in the Church of St Gengoult at Toul, famous for its fine Flamboyant cloister, which is Renaissance in general design but has Gothic ornamentation, and the doors of the right transept of the Church of St Gervais and St Protais at Gisors (circ. 1515), which are decorated with medallions and arabesques[2].

Finally the doors of the north portal of Limoges are interesting as shewing a rude attempt by a Frenchman to execute a Renaissance design. We have a shell canopy, attempts at classical capitals, and medallions, all of inferior workmanship. The date inscribed is 1510, but the left door is apparently earlier than the right, the work being poorer and the Renaissance characteristics less marked; it has for instance only three medallions, while the right door has seven.

[1] Fig. Mâle, p. 293 (only the upper portion of the right-hand door) and Molinier, op. cit. II. pl. VI.

[2] Geymüller, II. 600.

Plate XVI

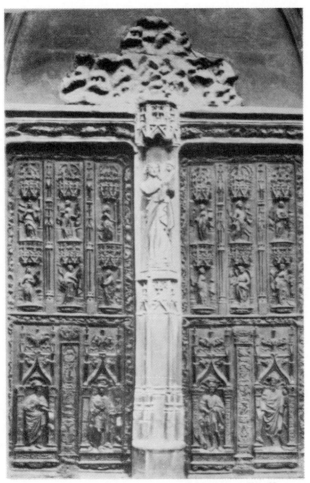

Aix : Doors of Cathedral

III

The word *médaille*, which was used for large medallions in marble, stone, wood, or terra-cotta, also denoted another variety of the sculptor's art, the small medal[1] of silver, or more generally, bronze. This characteristic art of the Renaissance made its first appearance in France under the patronage of King René, who employed Pietro da Milano and Francesco Laurana, both imitators of the great Pisanello[2]. During the years 1461 and 1462 Pietro da Milano made medals of René and his wife, René alone (three), his daughter Margaret of Anjou[3], and his son-in-law, Ferry de Lorraine, Comte de Vaudemont. That of René and his wife shews on the reverse a Renaissance building, which reveals the experienced architect. Laurana's work includes medals of Giovanni Cossa (1466), Charles of Anjou, Comte du Maine (brother of René), Louis XI, and King René with his wife. The reverses of the last two are closely imitated from Roman coins, that of Louis XI shewing a seated figure of Concord, with the inscription CONCORDIA AVGVSTA, and that of René a *Spes Augusti*. The workmanship of both these medallists is exceedingly rough and careless, and the composition of their medals is devoid of artistic feeling. Some of their portraits, however, have considerable character. Pietro da Milano's head of King René in the Museum at Aix is particularly vigorous[4]. Neither had any influence on the medallist's art in France.

[1] The word *médaille* first appears in this sense in a document of 1494.

[2] See A. Heiss, *Les médailleurs de la Renaissance, P. da Milano et F. Laurana*, 1887 (ill.); A. Armand, *Les médailleurs italiens des quinzième et seizième siècles*, 2nd ed. 3 vols. 1883–1887, I. 38–42; C. von Fabriczy, *Medaillen der italienischen Renaissance*, Leipsic (no date; English trans. by Mrs Hamilton, 1904); H. de La Tour, *P. da Milano* in *Rev. numismatique*, 1893, pp. 85 ff.; F. Burger, *Francesco Laurana*, Strassburg, 1907; and W. Rolfs, *Franz Laurana*, 2 vols. (one of plates), Berlin, 1907.

[3] The only known specimen of this medal is in the Salting collection at the Victoria and Albert Museum. See L. Forrer, *Biographical Dictionary of Medallists* (1902–), IV. 74, and *Cat. of Early English Portraiture* (Burlington Fine Arts Club), 1909, plate XXXI.

[4] See Heiss, *op. cit.* plate IV. I.

Of far greater importance than either of these slovenly followers of Pisanello was Giovanni di Candida, whose influential position at the French Court has been pointed out in an earlier chapter[1]. He was a pupil of the medallist who called himself "Lysippus junior," a Mantuan working at Rome under Paul II and Sixtus IV[2], and this master's influence is plainly visible in his earlier medals. Of those which he executed while he was at the Court of Burgundy perhaps the finest are the second one of Mary of Burgundy and her husband Maximilian, and those of Jean de La Gruthuyse and Jean Miette[3]. To his later period belong two fine medals of Robert Briçonnet (1492 or 1493; 1494), equally fine ones of Cardinal Giuliano della Rovere (probably executed in 1494), and Guillaume Des Perriers, Auditor of the Rota (*circ.* 1495–1500)[4]. Another group is formed by those of Pierre Briçonnet, Thomas Bohier, Francis I in his tenth year, and Louise of Savoy with her daughter Margaret on the reverse[5]. All these, which are of great charm, belong to the years 1503 and 1504, and as we hear no more of the artist or his work after the latter date, it may be presumed that he died in that year or soon afterwards[6].

Giovanni di Candida was essentially a portraitist. His reverses often shew a second portrait, otherwise only arms

[1] See above, pp. 85–6. The chief authority for his work is H. de La Tour, *Jean de Candida*, 1895.

[2] See G. F. Hill in *The Burlington Magazine*, XIII. (1908), 224 ff. "Lysippus's" real name is not known. Mr Hill thinks that the charming medal of Candida, sometimes attributed to "Lysippus," is by Candida himself.

[3] La Tour, pl. VII, 5 and 6.

[4] *Ib.* plates VII, 7, 8, 9, and XII, 12. There is a specimen of the medal of G. Des Perriers in the Victoria and Albert Museum (Salting collection). Heiss in *Rev. numismatique*, 1890, p. 477, assigns this to 1491, the year in which Candida went as ambassador to Rome. But he may equally well have made it in 1495. Des Perriers, who died in 1500, is represented as a very old man. For Robert and Pierre Briçonnet, see above, p. 158, n.[3].

[5] La Tour, plates XIII, 15; XII, 13; XIII, 14 and 16. There are specimens of the medals of Pierre Briçonnet, Louise of Savoy, and Francis I in the Victoria and Albert Museum.

[6] La Tour, pp. 136–138.

or a device. An interesting example of the latter is the salamander on the medal of Francis I, an invention, conjectures M. de La Tour, of the artist. In his later work, from the first medal of Robert Briçonnet onwards, Candida adopts a freer and larger style, more in the manner of Niccolò Fiorentino. He simplifies considerably, indicating unimportant details in a summary fashion, and dwelling, but without exaggeration, on those features which make for character. Thus, though his medals lack the fire, the grace, the imaginative beauty of Pisanello's, they give us a convincing and monumental portrait.

His influence on the medallist's art in France was less than might have been expected. It is seen to some extent in certain medals of Lyons, executed in 1518 and ascribed to Jerôme Henry of that city[1], in the far better work of Jacques Gauvain, surnamed Le Picard, who worked from 1501 to 1545[2], and in two medals by an unknown master, both with a man's portrait on the obverse and a woman's on the reverse, which date from about 1520[3]. But on the whole the reign of Francis I was an unfruitful period for the medallist's art.

The first medal with a portrait, that of Aymar de Prie, dated 1485, which is incontestably French, shews no trace of Italian influence. It is made of silver, and is struck, not cast, the portrait, which is full of character, being

[1] See F. Mazerolle, *Les médailleurs français* (Doc. inédits), 3 vols. (one of plates), 1902–1904, II. 12, III. plate v.

[2] Mazerolle, *op. cit.* I. xvii–xxi, III. plate v. Mazerolle regards the medal of Margaret of Austria, executed at Brussels in 1502, as doubtful (II. 14). Gauvain is found at Lyons, where he chiefly worked, in 1515.

[3] See J. de Foville in *Rev. numismatique*, 1910, pp. 392 ff. (fig. p. 394). He conjectures that the artist is the Court goldsmith, Regnault Danet, who is represented on one of the medals. The portraits on the other, which has the motto *Faire ou bien dire* on the obverse and *Sans varier* on the reverse (Mazerolle, III. plate VI, 86), are conjectured by Armand (II. 143), to be those of Pierre Briçonnet and his wife, but the male portrait does not represent the same individual as Candida's medal of Pierre Briçonnet. There is a specimen in the Victoria and Albert Museum (Salting collection).

executed with the delicate precision of a goldsmith[1]. On the other hand an oval medal of Cardinal Charles de Bourbon, which was executed at Lyons in the following year (1486) is cast after the Italian fashion, and is the work either of an Italian or of a Frenchman under Italian influence[2]. But the example reproduced by Rondot is in so bad a state of preservation that it is not easy to form an opinion as to this latter point.

In any case this medal is an exception, and we return to the old type in the medal struck in 1494 by the three goldsmiths, Louis Lepère, his son Jean, and his son-in-law, Niccolò of Florence[3], to commemorate the entry of Charles VIII and Anne of Brittany into Lyons[4]. It is only in the more or less decorative design, which was furnished by Jean Perréal, that we can detect any trace of Italian influence. In the low relief, in the feebleness of the portraits of Charles and Anne, in the fleur-de-lys and ermines with which these portraits are surrounded, as well as in the careful execution essential to goldsmith's work, we have still the mediaeval coin-like medal of the reign of Charles VII. To the same type belongs the celebrated gold medal offered by the city of Tours to Louis XII in 1500. It was engraved by a goldsmith of Tours, Jean Chapillon, from a model made by Michel Colombe[5]. The reverse shews a porcupine with a crown and the inscription VICTOR TRIVMPHATOR SEMPER AVGVSTVS, but apart from this tribute to classical

[1] Fig. Michel, p. 685. For the French medals generally see besides Mazerolle, op. cit., N. Rondot, Les Médailleurs en France, ed. H. de La Tour, 1904, and Michel, IV. 679 ff.

[2] Rondot, pl. XII, 5.

[3] This obscure goldsmith was formerly confused with Niccolò Forzore di Spinello, or Niccolò Fiorentino, who in 1494 made medals of Charles VIII and some of the Frenchmen who accompanied him to Italy. Herr Bode's suggestion that these medals were made in Florence is almost certainly right.

[4] Ib. pl. XII, 3; Mazerolle, III. pl. II.

[5] Fig. Michel, p. 685, and Vitry, p. 377. See also Vitry, pp. 350–352 and 376–378 and Mazerolle, I. pp. 3–4 (documents). Sixty-one specimens were struck, but only one survives, now in the Bib. Nationale.

antiquity[1] and from the fact that on the obverse a realistic portrait of the king in profile takes the place of the traditional enthroned or equestrian figure of the monarch, there is nothing Italian about it. The uncompromising fidelity of the royal effigy, executed with a delicate precision which does credit to Jean Chapillon, the highly decorative reverse, and the treatment of the inscription in the manner customary to coins, are all thoroughly French.

Italianism plays a much larger part in the medal which the city of Lyons offered to Louis XII and Anne of Brittany in the same year 1500. Though it comes from the workshop of the same goldsmith, Jean Lepère, who had been employed on the medal of Charles VIII, it is not struck but cast[2]. The model was furnished by two *imagiers* of Lyons, Nicolas Leclerc and Jean de Saint-Priest, and the profile busts— almost half lengths—of the king and queen betray by their bold relief the sculptor's hand. They are good and conscientious portraits, carefully executed, with a nice but not undue regard for details. But they lack the energy and vitality which mark the portraits on the best Italian medals, and which redeem the careless execution of Niccolò Spinelli's later work. They have a too ceremonious air, and the background of fleur-de-lys and ermines is not so effective as the plain field of Italian medals. Still the medal is a fine one, artistically conceived and artistically executed.

At Bourg-en-Bresse, which is not more than a hundred miles from Lyons, Jean Marende executed in 1502 a medal, bearing on the obverse portraits of Philibert of Savoy and his wife, Margaret of Austria, which is closely similar in treatment to that of Louis XII and Anne of Brittany. The plain features of the Duchess are faithfully represented, and

[1] The inscription on the obverse is LVDOVIC XII FRANCORV REX MEDIOLANI DVX.

[2] Lepère had the assistance of his brother Nicolas, and of a caster. The medal—4 inches in diameter—was cast in silver, bronze, and bronze-gilt. There is a bronze specimen in the Fitzwilliam Museum, Cambridge, which is reproduced in the frontispiece to this work. See Mazerolle, 1. pp. 4–5 for the documents.

are in marked contrast to those of her husband, who was known as Philibert the Fair[1].

We have seen that ducats and testons were struck at Milan with the head of Louis XII. But it is a strongly idealised, or rather conventionalised, portrait. In a less degree this is also the case with the Asti coins. The reverses of both mints sometimes shew a porcupine with a crown, similar to that of the Tours medal[2]. Testons were also struck at Lyons and Paris with the king's head on the obverse, but they are greatly inferior to Colombe's medal[3]. France had to wait till the reign of Henri II for a really artistic coinage.

[1] See Mazerolle, *op. cit.* I. xiii, II. 10, III. plate IV. The original medal, which was of gold, has disappeared, but there are several replicas of silver or bronze in existence. Those in the Brit. Mus. and the Victoria and Albert Museum (Salting collection) are both of bronze.

[2] See Hoffmann, *op. cit.* plates XLVI, 59; XLVII, 52–54; 59–62; XLVIII; XLIX; and D. Promis, *Monete del Piemonte*, 2da parte, *Monete della zecca d'Asti*, Turin, 1853, plate V, 1, 2, 4.

[3] Hoffmann, *op. cit.* plate XIV, 17–19.

CHAPTER XV

PAINTING[1]

I

WHEN, after the expulsion of the English in 1453, France had leisure to return to the arts of peace, painting continued to shew for a considerable period the strong Flemish influence which the genius of the Van Eycks had impressed on it. A glance at the most important existing pictures painted in France during the third quarter of the fifteenth century will make this clear. Take the admirable portrait in the Louvre, so full of individuality, of the Man with the glass of wine. It is, as M. Hulin de Loo has pointed out, the work of an immediate disciple of Jan van Eyck[2]. Take the Angels of Bourges, the fresco on

[1] The best general account is that by Comte Paul Durrieu in Michel, *Histoire de l'Art*, IV. (ii), 701–771. See also C. Benoit, *La peinture française à la fin du xvᵉ siècle* in *Gazette des Beaux-Arts*, 1901 (2), 90 ff., 318 ff., 368 ff., and 1902 (1), 65 ff., 239 ff.; G. Lafenestre, *L'Exposition des primitifs français*, 1904 (reprinted from *Gaz. des Beaux-Arts*); R. Fry, *Exhibition of French Primitives* in *Burlington Magazine*, V. (1904), 356; *Œuvres exposées à la Bibliothèque Nationale, Manuscrits à peintures* [1904]. The exaggerated claims made by too patriotic critics on behalf of French painting on the occasion of this exhibition naturally provoked controversy, and L. Dimier in *Les Primitifs français* [1904] and *French Painting in the Sixteenth Century*, chap. 1, ably, but with pronounced bias, contests these claims.

[2] Michel, IV. 730 (fig.); Leprieur in *Gaz. des Beaux-Arts*, 1907 (1), 8–17 (fig.). A portrait in the collection of Prince Liechtenstein at Vienna is generally regarded as the work of the same painter. Mr Fry thinks it is by Fouquet, but it is difficult to resist M. Hulin's argument that both portraits follow Jan van Eyck's practice of making the light come from the foreshortened side of the face, while Fouquet invariably adopts the contrary and more usual method.

the vault of Jacques Cœur's chapel, which must have been completed shortly before his downfall in 1453, a work remarkable, not only for the graceful forms of the Angels, but also for the technical knowledge displayed in the distribution of the light and the management of the draperies. Here again we see a marked Flemish influence[1]. So too the retable of the Crucifixion, formerly in the Palais de Justice, and now in the Louvre (which, as shewn by the buildings, was clearly painted at Paris), is evidently by a follower of Roger van der Weyden[2].

Then there is the brilliant little diptych in the Musée Condé at Chantilly, which represents on one panel the Crucifixion and, on the other, Jeanne de France, sister of Louis XI and wife of Jean II de Bourbon, kneeling before the Virgin in glory. Painted in France, and presumably at Moulins, it is Flemish in its delicate execution and in the position of the patron-saint, behind and not in front of the princess, while the Oriental dress of the soldier on horseback is suggestive of both Flanders and northern Italy[3]. It is an interesting conjecture of Comte Durrieu's, but nothing more, that it was painted by Zanetto Bugatto, portrait-painter to the Duke of Milan, and a pupil of the great Roger, when he came to France in 1468 to make a portrait of the king's sister-in-law, Bona of Savoy, for her proposed husband, Galeazzo Maria Sforza[4].

There were also at this time Flemish painters settled

[1] The decorative effect obtained by the floating scrolls of the Angels may be paralleled in French miniatures from the beginning of the fourteenth century onwards, but it is especially characteristic of the Maître de Flémalle and of his Dijon Nativity in particular.

[2] The dresses, says Comte Durrieu (Michel, III. 732), indicate 1450–1475 as the date. It was formerly attributed to Hugo van der Goes.

[3] Fig. F.-A. Gruyer, *Musée Condé*, pp. 127 and 131. It was formerly attributed to Memlinc. Note the floating scrolls.

[4] Michel, IV. 751–2. The proposed date of 1468 is a little late to suit the apparent age of the Duchess, who was born in 1435. Comte Durrieu also suggests Bugatto as the author of the Crucifixion from the Palais de Justice, but the two pictures can hardly be by the same artist. For Bugatto see F. Malaguzzi-Valeri, *Pittori lombardi del Quattrocento*, Milan, 1902; *Chronique des Arts*, 1904, pp. 226 (S. Reinach), 231 (P.

permanently in France. For instance, King René had in his service Barthélemy de Cler, who died in 1476 after working for him for thirty years, and Coppin Delf, who painted in Anjou and Touraine from 1459 to 1488. They were still honoured, at any rate in Lorraine, at the beginning of the sixteenth century, when René's grandson René II was Duke. For Jean Pélerin, in the dedicatory poem prefixed to the third edition of his *De artificiali perspectiva* (Toul, 1521), names them among the chief painters of France, Germany, and Italy, coupling them with Fouquet and Poyet[1]. In the next line he mentions another Northerner, Colin d'Amiens, who, as we have seen, was ordered to make a model of a kneeling statue of Louis XI for his tomb in Notre-Dame de Cléry, and whom that monarch afterwards employed as a painter[2].

In a similar enumeration of celebrated painters, made by Jean Lemaire de Belges about the same date, the Netherlands are represented by Roger van der Weyden, Hugo van der Goes, and Jan van Eyck. By the middle of the fifteenth century Roger rivalled Jan van Eyck in fame, and surpassed him in influence. For without being a consummate artist

Durrieu), and 320 (L. Dimier). In 1460 he was sent by Francesco Sforza to study under Roger van der Weyden at Brussels. We know from the royal accounts (Laborde, *La Renaissance des arts à la cour de France*, I. 65, n.[1]) that Louis XI bought from him *un tableau où sont tirés auprès du vif le feu duc de Milan et son fils.* This was doubtless in 1468. He died in 1476, and was succeeded as portrait-painter to the Duke of Milan by Antonello da Messina. There is a close similarity between the Angel who supports the shield of the Duchess and the Angels who perform a similar function in the topmost pair of shutters of the retable of Ambierle (see above, p. 518), which is only distant about fifty miles from Moulins. M. Jeannez attributes the shutters to Roger van der Weyden, who died in 1464, but the style is not like his. Whoever was the artist, they were executed, with the rest of the retable, in the Netherlands. If therefore there is a connexion between the retable and the diptych, the diptych must be the later work of the two. We have seen that the date of 1466 (on the strength of a once decipherable inscription) has been assigned to the retable.

[1] See A. de Montaiglon, *Notice sur Jean Pélerin*, 1861. Pélerin was chaplain to Philippe de Commynes.

[2] See above, pp. 472–3.

like his predecessor, he appealed to popular taste by his
love of violent emotion and dramatic action. His visit
to Italy for the jubilee of 1450 set the seal on his reputation.
A Flemish master who is not mentioned by Lemaire, but
whose works were copied and imitated hardly less often
than Roger's, is the painter whom Herr von Tschudi made
known to the world under the provisional name of the
Maître de Flémalle, and whom the more recent researches
of M. Hulin have identified with Robert Campin[1]. Hugo
van der Goes, the third name in Jean Lemaire's list, was
admitted to the Guild of St Luke at Ghent the year after
Roger's death, that is to say, in 1465. He worked there
for the next ten years, retired to a cloister in 1478 and died
in 1482. Many of his pictures were once to be seen at
Bruges[2], but the two finest of his surviving works are
an Adoration of the Shepherds at Berlin and the well-
known altar-piece (formerly in the hospital of Santa Maria
Nuova at Florence and now in the Uffizi) which he painted
in 1476 for Tommaso Portinari, the Medici's agent at
Bruges.

To these four masters must be added Hans Memlinc,
a pupil of Roger, who worked at Bruges from 1465 till his
death in 1494, and Gerard David, whose career in the
same city lasted from 1483, when he was received as a
master-painter, to 1523. Both had a great vogue far
beyond the Flemish border, the younger man being a special
favourite with Ferdinand and Isabella of Spain and with
Dom Manoel of Portugal.

These six may be regarded as the most famous representa-
tives of Flemish painting in the second half of the fifteenth
century. Moreover, it is possible to point to certain of
their pictures as having been especially popular. Such
were Jan van Eyck's Van der Paele altar-piece at Bruges

[1] See H.von Tschudi in *Jahrbuch der k.k. preussischen Kunst-Sammlungen*,
XIX. (1898), 8 ff., 89 ff.; G. Hulin de Loo in *Burlington Magazine*, XV.
(1909), 202 ff. and XIX. (1911), 218 ff.

[2] Albert Dürer saw some in St Jacob's Church in 1521 (*Literary Remains*,
ed. W. M. Conway, Cambridge, 1889).

(1436), Robert Campin's Nativity at Dijon (before 1432), Roger's Descent from the Cross at the Escorial (1440), and the retable (now in the Prado) which he painted for the Abbey-Church of Saint-Aubert at Cambrai between 1455 and 1459[1], the Chatsworth triptych which Hans Memlinc made for Sir John Donne in 1468[2], and Hugo van der Goes's great altar-piece at Florence.

We must now turn to the one really great French painter of the fifteenth century. If the foundations of his art were laid in the Flemish school, he developed it in a thoroughly original, and above all, in a thoroughly French spirit. It would be presumptuous on my part to attempt a complete estimate of Jean Fouquet, nor is it necessary for the purpose of this inquiry. I need only refer briefly to the few known facts of his career, and to the general character of his art[3]. He was born at Tours, and throughout his life his home was in that city. Between 1443 and 1447 he went to Italy, probably in the suite of some ambassador, and painted at Rome that portrait of Pope Eugenius IV to which reference has been made in a previous chapter[4]. He was employed by Charles VII and Louis XI, and in 1475 he figures in the royal accounts with the title of *peintre du roi*. His death took place between 1477 (when he was still living at Tours) and November 1481. His illuminated work, which has endeared him to all lovers of art, consists principally of four volumes, of which one is authenticated by documentary evidence, while the other three, at least in part, are unanimously

[1] There are numerous copies of the Descent from the Cross, and at least seven copies are known of the picture at Madrid.

[2] A large portion of the central subject including the landscape is repeated in a panel in the Uffizi, and the two St John's on the wings appear in a triptych at Vienna. Both may be by Memlinc, who often repeated himself. Another triptych, belonging to Mrs Alfred Morrison, which was exhibited at the Guildhall in 1906, is, except for the omission of some of the figures, a mere variant of the Chatsworth picture. It is said to be the work of a Frenchman. For copies of Campin's work see H. von Tschudi, *op. cit.*

[3] The best account of Fouquet's life and work is that by Comte Durrieu, *Les Antiquités Judaïques et le peintre Jean Fouquet*, 1908.

[4] See above, p. 101.

ascribed to him by competent critics. These are the *Hours* of Étienne Chevalier (*circ.* 1455–1460), the Munich Boccaccio (*circ.* 1458), the *Grandes Chroniques de France*, and the first volume of Josephus in French, at the end of which it is recorded by François Robertet, secretary to Pierre de Beaujeu, that the "histories," with the exception of the first three, are "by the hand of the excellent painter and illuminator of Louis XI, Jehan Foucquet, native of Tours." This volume belonged first to Jean, Duc de Berry, for whom the first three miniatures were made, and then to Jacques d'Armagnac, Duc de Nemours, who was beheaded by order of Louis XI in 1477[1]. To these four volumes must be certainly added a miniature representing Louis XI presiding over a Chapter of the Order of St Michael[2], and with hardly less certainty four superb examples from *Les faits des Romains*, three of which were exhibited by Mr Yates Thompson at the Burlington Fine Arts Club in 1908[3].

It was almost inevitable that Fouquet, who was barely out of his apprenticeship when the final touches were put to the Adoration of the Lamb, should have studied in the new school, which was spreading its fame to all

[1] Robertet says, "En ce livre a douze histoires," but there are really fourteen. The first miniature of the second volume, which contains books xv.–xx. of the *Antiquities* and the whole of the *Judaic Wars*, is generally recognised as being also by Fouquet, but the others, which are considerably smaller in size, are clearly the work of another and decidedly inferior hand. Comte Durrieu thinks that he recognises this hand in the artist of the Versailles Livy (Bib. Nat. *fonds franç.* 273–4). Some of the miniatures too in the *Grandes Chroniques* and the Munich Boccaccio are inferior in quality and evidently the work of pupils. For the Josephus and the *Grandes Chroniques* see the reproductions issued by the *Bibliothèque Nationale*. The Boccaccio miniatures have been reproduced under the editorship of Comte Durrieu (Munich, 1909).

[2] Identified by Comte Durrieu (fig. Michel, IV. 725). It must have been executed between 1469 and 1472.

[3] The fourth, the Crowning of Alexander, was sold to the Louvre. All four have been beautifully reproduced in colour. Mr S. C. Cockerell has no doubt about their being by Fouquet; Mr Fry thinks they are not. The Crossing of the Rubicon is in any case a magnificent piece of work, full of imagination.

countries. But if he learned lessons of the greatest value
from the Flemish masters, his work, as I have said,
is thoroughly French in spirit. Even his visit to Rome
did not affect the essential character of his art. He
may, indeed, have profited, as Mr Fry suggests, by the
frescoes (now vanished) of Masaccio at San Clemente,
and by those of Gentile da Fabriano and Pisanello in
St John Lateran[1], and he may owe to Fra Angelico, who
was in the service of Eugenius IV, the idea of representing
the crucified Christ and the two thieves without any trace of
pain on their features[2]. Certainly, he made studies of classical
architecture, and reproduced them in his miniatures[3], where
they appear side by side with the old Romanesque Basilica
of St Peter's[4], the Gothic Cathedrals of France[5], and the
smiling landscape of his own Touraine[6]. For Fouquet was
an observer and lover of all beautiful and interesting things,
and so with naive impartiality he puts France and Italy,
Gothic and Renaissance, into the same picture. Thus in
one of the Chantilly miniatures we see the Church of the
Innocents and the Châtelet at Paris in combination with
a lofty tower which is an evident reminiscence of the
Palazzo Vecchio at Florence[7].

Fouquet was not only a great miniaturist, but he had
a very considerable reputation as a portrait-painter. Unfor-
tunately not one of the portraits which are generally
attributed to him is authenticated by documentary evidence.
Nor do they command the same unquestioned admiration

[1] *Burlington Magazine*, v. 358. Gentile da Fabriano painted, in
1427–8, five Prophets, the Pope with ten Cardinals, and the history
of St John the Baptist. This last work, which was unfinished at his death
in 1428, was completed by Pisanello, who also did other work in the same
church. See G. F. Hill, *Pisanello*, pp. 48–9.

[2] *Hours of É. Chevalier*, no. 214.

[3] *Hours of É. Chevalier*, 201, 203, 225; Josephus, 11.

[4] *Grandes Chroniques*, 8, 19; Josephus, 14, 15; *Hours*, 203.

[5] *Grandes Chroniques*, 3, 20, 25; Josephus, 8, 10; *Hours*, 202,
210.

[6] *Grandes Chroniques*, 45; Josephus, 5; *Hours*, 229.

[7] *Hours*, 239.

as the miniatures[1]. They lack the solidity and the impressiveness of Jan van Eyck's work. The Charles VII in the Louvre is full of character, but the modelling is a little hard and lacks subtlety, and on the whole it is more suggestive as a portrait than satisfying as a picture. Fouquet had undoubtedly a real genius for portraiture, but in the handling of a large picture he lacked the technical skill that he shews in his delicate miniatures. His fame as a portrait-painter would stand higher if he could be proved to be the author of the fine drawing of a Papal legate, remarkable for its broad massive style, formerly in the possession of Mr J. P. Heseltine[2]. As it is, we get perhaps the best idea of his skill in this line from the portrait of himself on enamel, now in the Louvre, which is generally recognised as being by his hand.

Of his other pictures, as distinguished from his miniatures, nothing now remains. The paintings with which he adorned the walls of Notre-Dame-la-Riche, and which greatly excited

[1] The "Agnes Sorel" Madonna at Antwerp is generally regarded as one half of a diptych, formerly at Melun, of which the portrait of Étienne Chevalier with St Stephen at Berlin is the other half. The tradition which ascribes to the Madonna the features of Agnes Sorel is a fairly old one.

[2] Un Roumain legat de notre St Pere en france (see Max Friedländer in *Jahrbuch der k.k. preussischen Kunst-Sammlungen*, XXXI. (1901), 227 ff.). M. Hulin de Loo (*L'Exposition des primitifs français*, pp. 29–31) cites "as having all the characters of his art" the portrait of Louis de Laval in the *Hours* (Bib. Nat. *ms. latin*, 920), made for that nobleman. It is certainly a very fine portrait, and far superior in quality to the other miniatures of the volume. These are very numerous, and are by various hands, shewing various influences—Flemish, Italian, and occasionally that of Fouquet or Bourdichon. The landscape, however, is always French. As regards the date of the volume, Louis de Laval bequeathed it in his will to Anne de Beaujeu, so that it must be earlier than 1489, the date of his death. Further, some of the miniatures, those which represent the Sibyls, must be later than 1481, for they shew a knowledge of Barbieri's treatise (see below) which was printed in that year. The portrait of Louis de Laval, however, may have been executed before the Sibyls; it represents him as a man of about 55, which, as he was born in 1411, would give 1466 as the approximate date. The frontispiece of the volume is said to have Fouquet's signature. (See F. de Mély, *Les Primitifs et leurs signatures*, 1913, pp. 398–408.)

the admiration of Francesco Florio[1], have vanished with the other mural decorations of which Tours boasted—with those of Saint-Martin by Coppin Delf (1482)[2], of the old Hôtel de Ville by Allard Follarton (1479)[3], and of the chapel of Plessis-lès-Tours by Pierre André. After Fouquet's death his school was carried on by his two sons, Jean and François. There is nothing to connect the latter with the miniaturist whom Robert Gaguin calls *egregius pictor Franciscus* and who completed in 1473 for Gaguin's friend, Charles de Gaucourt, the illustrations for a fine manuscript of St Augustine's *Cité de Dieu*[4]. The pronounced individuality of his style has enabled critics to assign to him several other works, all of considerable merit. Among them are a Valerius Maximus in French, which belonged to Philippe de Commynes and is now in the British Museum[5], a tiny *Book of Hours* also in the British Museum[6], a *Book of Hours* of René II belonging to Mr Yates Thompson, executed soon after 1476[7], a miniature of the Crucifixion surrounded by six smaller miniatures in the Musée de Cluny, and one of the Last Judgment in the possession of Mr S. C. Cockerell[8].

The Tours painter who had the highest reputation after Fouquet's death was Jean Poyet, whom we find working for the Court in 1483, and who in 1497 received from Anne of Brittany 153 *livres* for 23 full-paged miniatures (*histoires riches*) and 271 smaller illustrations (*vignettes*), which he had made for a small *Book of Hours*[9]. He is

[1] See above, p. 85, and *Arch. de l'art français*, VII. 168.

[2] E. Giraudet, *Les artistes tourangeaux*, 1885, p. 117. [3] *Ib.* p. 164.

[4] Bib. Nat. *mss. franç.* 18 and 19. One page is reproduced in Michel, IV. 736. The manuscript passed into the hands first of Jean Bourré, and then of Louis Malet de Graville. See Thuasne, *op. cit.* I. 34, and 225 ff.

[5] Harley MSS. 4374, 4375. See the reproduction made for Mr Yates Thompson, with an introduction by Dr G. F. Warner, 1907.

[6] Egerton MSS. 2045.

[7] Formerly in the Didot collection. See *Cat. Didot*, p. 58.

[8] Exhibition of Burlington Fine Arts Club, No. 225. It is a leaf from Jean Chappuis's *Les Sept articles de la Foi*.

[9] *Nouv. archives de l'art français*, VI. (1878), 197–199.

termed in the accounts *enlumineur et historieur*, but it is almost certain that, like Fouquet, he was also a painter of large pictures. Jean Lemaire in his *La plainte du desire* (1504) names him immediately after Fouquet, and so does Jean Pélerin[1], while Jean Brèche, a Tours lawyer, speaks of him in his *De verborum significatione* (Lyons, 1556) as "far superior even to the Fouquets in the knowledge of perspective and painting." Unfortunately no example of his work, so far as we know, has come down to us.

Another Tours painter, Jean Bourdichon, has been in a sense more fortunate, for we have the *Book of Hours* which he illustrated for Anne of Brittany[2]. We find him settled at Tours and employed by the Court as early as 1479. In the royal accounts for 1483–4 he appears with the title of *peintre du roi*. He did much work for Charles VIII and Anne of Brittany and he continued in favour under Louis XII and Francis I. His death took place before July 29, 1521[3]. His famous *Hours*, for which he received six hundred gold crowns in 1508, have not maintained the high reputation in which they were once held. The more one studies them in the various reproductions[4], the more one realises Bourdichon's inherent defects,

[1] See above, p. 531.

[2] Bib. Nat. *ms. latin*, 9474. M. Mély contends ingeniously, but far from convincingly, that these *Hours* are by Jean Poyet (*Gazette des Beaux-Arts*, 1909 (2), 177–197.

[3] For the documentary evidence of his career see *Archives de l'art français*, VII. 1–23 and *Nouv. arch. de l'art français*, VI. 194–197. More recently there has come to light a document (letters-patent) of Louis XII recording the payment to Bourdichon in 1498 of 300 *livres* on account, part of a sum of 1000 *livres* given to him by Charles VIII *pour marier ses filles* (*Comptes rendus* of the *Acad. des inscriptions* for Dec. 27, 1912, p. 690). In 1507 Bourdichon painted a portrait of St François de Paule just after his death at Plessis-lès-Tours (F. de Mély in *Bull. des Antiquaires de France*, 1913, pp. 192–3).

[4] Curmer, 2 vols. 1841 (in colour); ed. H. O[mont] for the *Bibliothèque Nationale* (in reduced size, and without the borders of flowers round the text). Five photogravures of some of the borders and of several of the full-page miniatures will be found in L. Delisle, *Les Grandes Heures de la Reine Anne de Bretagne et l'atelier de Jean Bourdichon*, 1913.

the lack of decision in his drawing, especially of architecture, the superficial prettiness of his faces, and the monotonous conventionality of his gestures and attitudes. He is fairly successful in single figures[1]; but he cannot combine them in a common action. His crowds are conspicuously wanting in that energetic vitality which makes those of Fouquet so impressive. Even his flowers, which he uses so freely for the borders of his *Hours*, in spite of the care with which they are drawn, shew little real appreciation on his part either of their aesthetic or their botanical interest.

There is a distinct Italian element in Bourdichon's work, which shews itself in two ways, in the architecture and in the treatment of the figures. Roman Corinthian columns and pilasters appear much more frequently than they do in Fouquet's work, while in one miniature there is a whole Corinthian portico[2]. In at least four miniatures a shell-niche is introduced[3], and in two we have rectangular pillars ornamented with arabesques[4]. As for the figures, they are for the most part idealised after a more or less conventional pattern, which becomes monotonous in its sweetness. Two figures, St John the Evangelist (no. 16) and St Sebastian (no. 40), are strongly reminiscent of Perugino. Now, as regards the decorative element, Bourdichon, even before the Expedition of Charles VIII, might have found patterns in drawings or engravings in the possession of some Italian living at Tours, or he may have borrowed the Corinthian columns from Fouquet. At a later date he had close at hand examples of the niche with a shell ornament and of candelabra arabesques in the tomb of Duke François II, which, as we have seen, was executed in the *atelier* of Michel Colombe from 1502 to 1507. It is otherwise with his figures. The idealised types of their faces and the self-consciousness of some of their poses

[1] St John (no. 16), St Sebastian (no. 40), St Lifard (no. 45), St Mark (no. 19), and St Cosmo with St Damian (no. 39).

[2] The raising of Lazarus (no. 30).

[3] Nos. 18, 23, 27, and 39.

[4] Nos. 24 and 26.

suggest an acquaintance with Italian painting which can only have come from a visit to Italy. We have no record of such a visit, but, as painter to the king, Bourdichon might have accompanied Charles VIII in 1494, and Louis XII in 1499 and 1502. In the reign of Louis XII he had a colleague in Jean Perréal, who went to Milan in 1499, and possibly also in 1502. But in 1494 Bourdichon was, so far as we know, the only *peintre du roi*, and it is therefore highly probable that in the expedition of that year he formed part of the royal suite[1], while he may also have done so in 1499 and 1502.

Intellectually indolent, Bourdichon had little invention and never hesitated to repeat types and poses or even whole miniatures. There are in existence at least three replicas of the *Hours* of Anne of Brittany, of which the miniatures are either his own work or that of his pupils. One is in the British Museum[2], a second is in the possession of Baron Edmond de Rothschild, while a third, incomplete, belongs to Colonel Holford[3]. They all differ from the original in certain particulars, but they have this in common, that the miniatures are set in frames of classical architecture with plenty of arabesque decoration, which sometimes takes the form of candelabra[4]. In the Holford example there is a noticeable superiority in the drawing of the flowers, the pistils and stamens, which are absent in the original *Hours*, being more or less correctly represented. The marked increase of the Renaissance element in the replicas is specially interesting, but unfortunately for our purpose we cannot assign a definite date to them.

[1] The prettiness which is characteristic of his work suggests Milanese influence. Moreover, he could have seen no more characteristic example of Perugino's work than the great altar-piece which was set up in the Certosa of Pavia towards the close of 1499.

[2] Add. MSS. 18855.

[3] *Burlington Fine Arts Club Exhibition of Illuminated Manuscripts*, no. 169.

[4] See the Presentation in Col. Holford's manuscript and the Crucifixion in that of Baron E. de Rothschild.

Besides these replicas there are other illuminated manuscripts the resemblance of which to the *Hours* of Anne of Brittany stamps them as coming from the same *atelier*. These are; (1) a Tours Missal with the arms of the Fumée family, probably made for Hardouin Fumée, who was Abbot of Beaulieu near Loches from 1494 to 1521[1]; (2) a *Book of Hours* made for Ferrante I, king of Naples, who died in 1494[2]; (3) a small *Book of Hours* made for Charles VIII[3]; (4) a *Book of Hours* made for his confessor, Jean Bourgeois[4]; (5) a *Book of Hours* in the library of the Arsenal[5]; and lastly (6) two single miniatures in a *Book of Hours* belonging to Charles, Comte d'Angoulême, the father of Francis I, who died in 1494[6]. In the *Hours* made for Ferrante I, which is the only one of these *atelier* productions that I have seen, great use is made of the candelabra ornament, which appears on nearly every page. On the title-page are mermaids and dolphins. The miniatures consist for the most part of single figures of Saints, some framed in classical architecture. The St Catherine closely resembles the same Saint in the *Hours* of Anne of Brittany. M. Léon Dorez suggests that the manuscript was executed at Naples by a Frenchman who had worked in Bourdichon's *atelier*[7]. In any case this manuscript and the two miniatures made for the Comte d'Angoulême shew that several years before Bourdichon began to work on the famous *Hours* (probably about 1500) some of the figures which he introduced there, and even whole miniatures, were already in existence. His *atelier* was evidently organised on sound commercial lines.

[1] Bib. Nat. *ms. latin*, 886.
[2] *Ib. ms. latin*, 10532.
[3] *Ib. ms. latin*, 1370.
[4] University of Innsbruck.
[5] *Ms.* 417.
[6] These were discovered by Comte Durrieu. See *Chronique des arts*, 1908, p. 57, and Michel, IV. 744 (fig.). There is nothing to connect these miniatures with the payment of 10 *livres* made to Bourdichon by the Comte d'Angoulême between 1482 and 1485.
[7] For all these productions of the Bourdichon *atelier* see Mâle in *Gaz. des Beaux-Arts*, 1902 (1), pp. 185 ff. and 1904 (2), pp. 441 ff. and especially Delisle, *op. cit.*

We learn from the royal accounts that Bourdichon also painted portraits and large pictures. For instance, his work for the Court in the years 1490–1 included a portrait of the king, another of the king and queen—they were married on December 6, 1491—and seven pictures, of which some, judging by the description, must have been of considerable importance. None of them, however, so far as we know, survive. There is no real reason for attributing to him, partly on the strength of the letters F.I.B. (*Fecit Joannes Bourdichon*), a triptych of the Crucifixion in the Church of Saint-Antoine at Loches, with the date of 1485[1]. All that can be said for certain of this picture is that it belongs to the school of Fouquet, for there is considerable resemblance between the central panel and Fouquet's miniature of the Crucifixion in the Chantilly *Book of Hours*. M. Dimier is clearly mistaken in recognising the influence of Ghirlandaio and Mantegna. There is nothing Italian in the picture, with its overcrowded composition, except the placid aspect of the three crucified figures. But this, as we have seen, is found in Fouquet[2].

For two other pictures the name of Bourdichon has been suggested. They are both portraits of children, one representing Charles-Orland, the eldest son of Charles VIII, who died on December 16, 1495, aged three years and two months[3], and the other possibly representing his younger brother Charles, who died on October 2, 1496, twenty-five days after his birth[4]. As M. Leprieur has pointed out,

[1] Fig. Dimier, *Les primitifs français*, p. 116. The letters have also been interpreted as referring to Jean Bourgeois, the confessor of Charles VIII, who was represented in one of Bourdichon's lost pictures (Durrieu in Michel, IV. 741). The triptych almost certainly comes from the Chartreuse de Liget near Loches.

[2] Similarly the white horse, strongly foreshortened from behind, is borrowed from Fouquet, who may have seen it in Italy. It appears in Altichiero's fresco of the Crucifixion in St George's Chapel at Padua, and in his follower Pisanello's fresco of St George and the Princess at Verona (*circ.* 1438).

[3] In the collection of M. Beistegui.

[4] Louvre. For their ages see the inscription on their tomb in Tours Cathedral.

Plate XVII

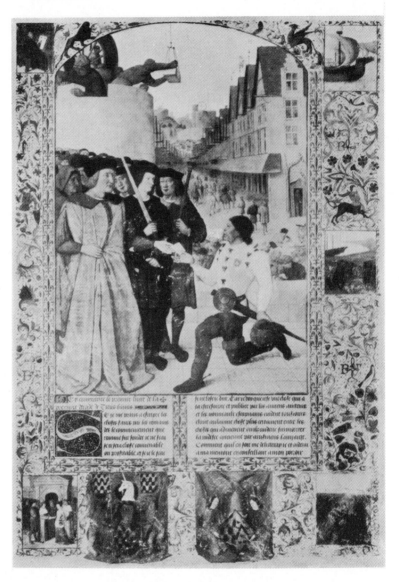

Miniature from the Livy of François de Rochechouart (Bib. Nat.)

there is considerable similarity of treatment in the two portraits[1], but that treatment is not Bourdichon's. In the case of the younger brother (if M. Leprieur's conjecture is correct), there is no question of a likeness, for the portrait is that of a much older child, but the portrait of Charles-Orland, which is dated December, 1494, has all the appearance of a faithful study from life. If so, it was painted at Amboise, where the child lived, apart from his mother, during his father's absence in Italy. One may therefore conjecture that the painter came from Tours, or at any rate from the region of the Loire. But the work is too realistic for Bourdichon, who would have given us a more conventional child, prettier doubtless, but with less individuality.

The finest miniatures that proceeded from the school of Tours during our period, or at any rate not long after, are to be found in a manuscript of the French translation of Livy by Pierre Bersuire, now in the possession of the Bibliothèque Nationale[2]. It was made for François de Rochechouart, governor of Genoa from 1508 to 1512, in which post he succeeded Raoul de Lannoy[3]. The first volume contains four full-page miniatures, and a large number of smaller ones. The finest is the miniature on leaf v r⁰ (Plate XVII), which represents a messenger presenting a letter to François de Rochechouart, whose arms, supported by two Angels, with those of his wife, Blanche d'Aumont, are at the bottom of the picture. The figure of the Governor is magnificent, the pose of his head and the expression of his face being superbly rendered. Round the page runs a beautiful border of foliage, flowers, and fruit,

[1] *Gazette des Beaux-Arts*, 1911 (1), pp. 204–8.

[2] *Fonds franç.* 20071–2 (two vols. in one).

[3] François de Rochechouart, Seigneur de Champ-Denier, was Seneschal of Toulouse. He went as ambassador to the Emperor Maximilian in 1506, and accompanied Louis XII to Genoa in the following year (see J. d'Auton, *op. cit.* IV. 51 ff. and 228). Comte Durrieu exhibited at a meeting of the antiquaries of France a manuscript adorned with vignettes which was executed for him at Genoa in 1511 (*Bull. de la Soc. des Antiquaires de France* for 1913, p. 193).

with little scenes interspersed. In one of these a classical building is introduced; on the other hand, the picture itself shews a Gothic doorway. Another of the large miniatures (leaf LI v⁰), brilliant in colouring, has classical triumphal arches. There is also a purely classical building in one of the smaller miniatures, while another shews a mixture of classical and Gothic architecture. The painter is evidently fond of crowds, as in the fine composition on leaf LXXVII r⁰, and of fighting, but his figures are inclined to be stumpy, and his horses are clumsier than Fouquet's. The second volume has only its illuminated borders, blank places being left throughout for the pictures. Though we do not know the exact date of these miniatures they were probably executed, at the latest, soon after the termination of François de Rochechouart's governorship. It is indeed possible that they may have been painted at Genoa during his tenure of office by some French artist who accompanied Louis XII to Italy in 1509.

In marked contrast with the broad and vigorous treatment, the power of rendering gesture and movement, and the pictorial sense of this last miniaturist is a page from a Rouen manuscript of 1503, which represents Louis XII, Anne of Brittany, Cardinal d'Amboise and numerous gentlemen and ladies of the Court before the goddess Fortune[1]. The subject is suggestive of the Renaissance, but the execution is thoroughly mediaeval. The minute and careful work, the determination to get as much as possible into the picture, the irrelevant details, the charming little plants in the foreground, the monkey, the curious animal with a bushy tail and an almost human face, the vast map-like landscape, the children which resemble little men and women, the faithful and not unsuccessful likeness of the king, and the stiffness of his gait—all this combination of naive delight in imitation, of conscientious workmanship, of admirable drawing, and pictorial incapacity, makes this a typical example of the average mediaeval miniaturist.

[1] Michel, IV. 749 (fig.).

II

Next to Tours the most active centre of painting during the second half of the fifteenth century was the Papal city of Avignon. But before we notice its productions, it will be convenient to mention three works from different parts of France which were painted during the first half of the reign of Louis XII. The first is a Deposition from Saint-Germain-des-Près[1], in which are represented Montmartre, the Louvre, and the Abbey of Saint-Germain. It was painted for Guillaume Briçonnet, Cardinal of Reims, who was Abbot of Saint-Germain from 1504 to 1507. It is thoroughly French in character, recalling in its naive simplicity and devout tenderness the sculptured Pietàs and Entombments noticed in the preceding chapter. The usual figures are represented. In the centre is the Virgin with the Saviour's Body across her knees. On her right kneels one of the Maries and, beyond her, the donor supporting the Saviour's Head, while at the extreme left of the picture is the charming seated figure of another Mary. On the Virgin's left are first St John, next a bearded man, richly dressed, who may be either Nicodemus or St Joseph of Arimathea, and last the Magdalen. The execution is not that of a master, but the composition is simple and good ; there is expression, along with a certain stiffness, in the figures and faces, and the colouring is bright and not inharmonious.

The other two works are both mural paintings, one at Le Puy, and the other at Amiens. The former is in the Chapter library adjoining the Church of Notre-Dame, and was painted for Pierre Odin, one of the Canons, who was employed by Louis XI on various missions to the Pope and in the next reign was *official* to Jean II de Bourbon, Governor of Languedoc. It represents the seven Liberal Arts, but three have perished. The four that remain—Grammar, Logic, Rhetoric, and Music—are represented as female figures seated in high-backed chairs, while below them on stools, in the attitude

[1] Now in the Louvre. See C. H. Caffin, *The story of French painting,* 1911, 26 ff. and p. 20 for a reproduction.

of disciples, sit Priscian, Aristotle, Cicero, and Tubal-Cain. Aristotle and Cicero are particularly fine and are probably portraits of real persons. All the figures wear the dress of the day, that of the men being academical and that of the women having a certain fantastic element. The landscape which forms the background is mountainous, and is probably an idealistic rendering of the scenery round Le Puy. The composition is classical in its almost perfect symmetry, and the backs of the chairs have classical pilasters and, in the case of the two middle ones, shell-canopies. This classical element points to the date of the work being not much earlier than the close of the fifteenth century. It was at any rate begun before 1502, the date of Pierre Odin's death[1].

The other mural painting, only a few years later in date, is the series of Sibyls painted in 1506 on the wall-arcading of the Chapel of St Éloy in the Cathedral of Amiens[2], at the expense of the Dean, Adrien de Hénencourt[3]. The painter is unknown, but in all probability he was a local artist, a member of that Confraternity of St Luke which, as we have seen, received its charter about the year 1500[4]. These paintings, so far as can be judged from their present condition, have considerable artistic merit, but they have also an interest arising from their subject-matter.

The appearance of the Sibyls in Christian art was an expression of that sense of a mysterious harmony between Paganism and Christianity which was felt by the mediaeval Church. The thirteenth century knew ten Sibyls, but the only two who were recognised in art were the Erythraea in France and the Tiburtina in Italy. It was not till the second half of the fifteenth century that they began to be really popular, and that we meet with collective representations of them. In the celebrated stalls of the Cathedral of Ulm, which were carved by Jörg Syrlin from 1469 to 1474, nine Sibyls appear. The prophetic oracles

[1] See P. Mantz in *Gaz. des Beaux-Arts*, 1887 (1), pp. 120 ff.
[2] See G. Durand, *Notre-Dame d'Amiens*, II. 345–354.
[3] See above, p. 153.
[4] See above, p. 171.

which accompany them are, for the most part, borrowed
from Lactantius, whose *Divine Institutions*, the first book
printed in Italy, had appeared a few years before
(1465). On the authority of Varro he enumerates ten
Sibyls[1]. But in 1476 there appeared at Naples a short
treatise by a Dominican named Filippo Barbieri, which,
in Italy at any rate, quite superseded Lactantius, and which
had an extraordinary influence on the art of all Europe[2].
In this treatise, which is entitled *Duodecim Sibyllarum
Vaticinia,* Barbieri adds two new Sibyls, Agrippa, and
Europa, and gives the age, appearance, costume, and
attributes of nearly every Sibyl. Moreover, the prophecies
which he assigns to them differ completely from those of
Lactantius. As the result of this treatise the Sibyls had
a very great vogue in Italian art, culminating with the
stupendous figures of Michelangelo in the Sixtine Chapel.

In France Barbieri did not altogether displace Lac-
tantius; the French Sibyls, which differ considerably from
the Italian ones, are the result of a compromise between
the two authorities. They first appear, says M. Mâle, in the
Hours of Louis de Laval, which he bequeathed in his will—
he died in 1489—to Anne de Beaujeu[3], and they soon
became popular through the agency of the illustrated
Books of Hours which Vôstre and Verard issued in such
abundance[4]. Sometimes, however, a French artist followed
Barbieri exclusively, as in a missal of the Sainte-Chapelle,
executed about 1495, and as in the frescoes at Amiens.
In this latter case M. Mâle suggests that the painter had
before him a manuscript of Barbieri's treatise, and that

[1] Book I (*De falsa religione*), c. vi.
[2] In *Opuscula*, printed by Sixtus Riessinger [Naples, 1476]. There
is a copy of this rare edition, which is not known to M. Mâle, in the
Rylands Library, Manchester. The earliest Roman edition is of 1481.
The first of the *Opuscula* is *Discordantiae inter SS. Hieronymum et
Augustinum*; that on the Sibyls is the second.
[3] See above, p. 536, n.[2].
[4] In the Cathedral at Auch the twelve Sibyls in the stalls and the
nine in the windows belong to this new French cycle.

possibly he may also have been inspired by the well-known engravings attributed to Baccio Baldini[1].

We may now return to Avignon, where the researches of the Abbé Réquin have shewn that painters were drawn from all quarters to execute the orders of numerous patrons, so that the Papal city became an art-centre for the whole of Provence[2]. King René had an hôtel there, but the patrons chiefly consisted of confraternities and monasteries, ecclesiastics, and merchants. Prominent among individual patrons were Cardinal Alain de Coëtivy[3], who was Bishop of Avignon from 1440 to 1474, and Jean de Mareuil, Bishop of Uzès (1463–1483) and Abbot of Saint-Gilles. He was succeeded as Abbot by Giuliano della Rovere, afterwards Pope Julius II, who was already Archbishop of Avignon. We have seen that he was active in promoting the intellectual interests of his see, and as he was a keen lover of art, he was doubtless also one of its foremost art-patrons.

The painters included Enguerrand Quarton or Charonton (the Provençal form of his name) from Picardy, and Pierre Villatte[4] from the diocese of Limoges, who collaborated with him in painting the Virgin of Compassion, now at Chantilly, for the Cadart family (1452). Charonton also painted the interesting Triumph of the Virgin (1454), the contract for which has been discovered by the Abbé Réquin, and he was still at Avignon in 1461. Pierre Villatte worked there till at least 1497. Rather later we have Jean Grassi from Ivrea in Piedmont (1487–1502)[5]. Other painters came from Germany, Alsace, and the Netherlands.

Thus Avignon became an international market for the production and sale of pictures. But this is a different

[1] There are only eight Sibyls at Amiens, four having been omitted for want of space. For the Sibyls generally see Mâle, *op. cit.* pp. 267–296; Bartsch, *Le peintre engraveur*, XIII. 172–175; Schreiber, *Manuel*, IV. 351 ff.; and for the engravings attributed to Baldini, Hind, *Catalogue* (see above, p. 384), pp. 135–142. He dates them *c.* 1465–1470, and says that they were possibly designed by Botticelli; Mr Horne thinks not.

[2] *Doc. inédits sur les peintres d'Avignon au xv^e siècle*, 1889.

[3] See above, p. 69.

[4] Réquin, pp. 22 ff. [5] *Ib.* pp. 43 ff.

thing from a school of painting, and the evidence for an
Avignon school rests chiefly upon two pictures. One of
these is a Pietà from Villeneuve-lès-Avignon, now in the
Louvre, in which the archaic treatment and unequal
execution are redeemed in part by the vigour of its realism
and the intensity of its pathos. It shews no trace of either
Flemish or Italian influence[1]. The other picture, painted
half-a-century later, is an Adoration of the Infant Jesus
in the Musée Calvet at Avignon. M. Hulin sees an affinity
with the earlier picture in the figure of the kneeling donor
and his patron-saint. This is extremely doubtful, but the
beautiful Provençal type of the Virgin points to the picture
having been painted in Provence. Equally marked are
the Flemish and Italian elements. In the conspicuous
part assigned to the kneeling donor and in the position
of his patron-saint the picture conforms to Flemish traditions.
Moreover, the awkward gesture of the Saint, who is about
to take off his mitre, is imitated, as both M. Hulin and
Mr Fry have pointed out, from the St George in the Van
der Paele altar-piece[2]. On the other hand the design is
Italian in its simplicity and feeling for space[3]. It is this
conflict between the rival influences of the two great schools
of painting which dominated Europe during the fifteenth
century that makes this fine and attractive picture a typical
example of French art at this period of transition[4].

Another picture painted in France, apparently by a
Frenchman, which shews the same combination of Italian
and Flemish influences, is a Virgin and Child with two
Angels and the kneeling figures of St Margaret and Louis XII,
now in the possession of Mr Charles Weld-Blundell of Ince
Blundell Hall (Plate XVIII). Mr Weale assigns it to the
close of Louis XII's reign, and sees in it the influence both

[1] Hulin, op. cit. pp. 47–50.
[2] Hulin, op. cit. pp. 50–52; R. Fry in Burlington Magazine, v. 379.
[3] M. Hulin says that the Madonna's net-like head-dress is Milanese,
but a similar head-dress is worn by the Duchess of Brittany on her tomb
at Nantes.
[4] M. Hulin calls it an exemple typique de la lutte des influences.

of the Van der Paele altar-piece and of Gerard David[1].
Neither influence, especially the latter, is at all obvious, but
the picture has at any rate Flemish affinities in the careful
painting of the rich draperies and the dorsel behind the
Madonna. It has also a not uncommon Flemish defect,
a want of proportion between the figures and the building.
If the king and St Margaret were to stand upright, they would
knock their heads against the roof. The drawing too is
feeble, and the king bears only a fanciful likeness to Louis
XII. But both he and St Margaret have an air of grave
and impressive dignity, which suggests to Mr Fry a north-
Italian influence[2]. He particularly refers to Bartolommeo
Montagna of Vicenza, and the king's figure certainly recalls
that of St Sigismund in his noble picture in the Brera.
Another Italian work that presents analogies is the Madonna
with four Saints by Lorenzo Costa in San Giovanni in Monte
at Bologna (1497), for we have the same peculiar treatment
of the Renaissance capitals, which instead of conforming to
one of the classical orders are fantastically decorated with
little sculptured figures. In the picture at Ince Blundell
Hall Mr Weale thinks these were copied from second-rate
ivories. Mr Fry has no doubt that this and the Avignon
picture are by the same painter. But there must have
been more than one French painter at this time who borrowed
from both Flemish and Italian models. The same blending
of influences, though without any direct borrowing, appears
in yet another work of about the same date as the two
last, which was apparently painted in the neighbourhood
of Paris. But, before discussing it, it seems worth while
to try and point out what were the qualities which the
Flemish painters lacked and the Italians possessed, and
why it was so essential to the development of French art
that it should acquire these qualities[3].

[1] *Burlington Magazine*, IX. 239 (fig.). Waagen (*Art Treasures in Great
Britain*, III. 249) believed it to be by an "old French master."

[2] *Burlington Magazine*, IX. 331.

[3] See Jacques Mesnil, *L'art au Nord et au Sud des Alpes à l'époque
de la Renaissance*, Brussels, 1911, for an interesting and valuable appreciation
of the differences between Flemish and Italian art.

Plate XVIII

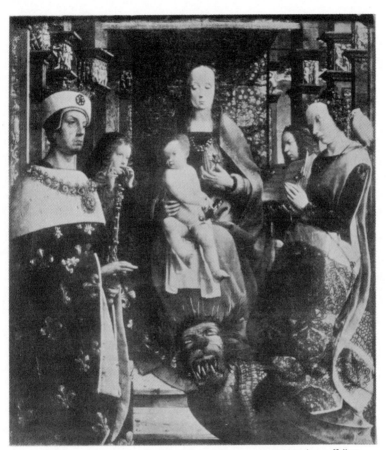

Virgin and Saints with Louis XII
(Charles Weld-Blundell, Esq., Ince Hall)

We cannot do better than start from a highly suggestive remark by Mr Fry, who, speaking of the painter of the Moulins triptych, says, "that he is the first modern French painter, in that he has the air of painting in order to produce a picture rather than to express an idea." The mediaeval painter did not set out "to produce a picture" but "to express an idea," or to tell a story, imposed upon him from without. Often his contract contained numerous conditions as to the details and execution of his work. We have a remarkable instance of this in Charonton's Triumph of the Virgin[1]. The picture is to include St Peter's at Rome, with the famous bronze fir cone in front of it, the Castle of St Angelo, and the Tiber starting from Rome and entering the sea; Jerusalem, the valley of Jehoshaphat, and a Carthusian monk praying at the foot of the Cross; Abraham and the three Persons of the Trinity; Moses and the Burning Bush; Paradise, Purgatory, and Hell "with a devil very hideous." The painter is not to use German blue, but "fine blue of Acre," i.e. ultramarine. The astonishing thing is that the painter, in spite of all these incongruous details that were forced upon him, should have produced so successful a picture, and by the date appointed[2]. Thirty years later (circ. 1482) we have a similar contract made with Coppin Delf for the decoration of the Chapel of the Dauphin in St Martin at Tours. The prescribed subject is the presentation of the Dauphin (the future Charles VIII) to the Virgin by St Martin. Above this episode the painter is ordered to represent the Trinity between Cherubim and Seraphim, the Father and Son seated on two chairs, the Holy Ghost as a dove. There are to be two Angels, one holding the King's shield and the other the Dauphin's. The Cherubim are to be red, the Seraphim and the four Evangelists blue. The colours are also prescribed for some of the other figures[3].

[1] See above, p. 548.
[2] The contract is dated April 14, 1453, and the picture had to be finished by Michaelmas 1454. See Réquin, op. cit. pp. 15–17 and 57 ff.; T. Okey, The Story of Avignon, 1911, pp. 377 ff.
[3] Archives de l'art français, XI. 73 ff.

But, even when he was unhampered by conditions, a mediaeval painter was not in the habit of conceiving a picture as a whole, or of considering the total impression that it would make on the beholder. He planned it carefully with his intelligence, but he did not create it with his imagination. We have a characteristic example in Pisanello, who, though in his glorious medals he is a true child of the Renaissance, as a painter is purely mediaeval. "The first criticism which occurs to one," says Mr Hill of his Vision of St Eustace in the National Gallery, "is that it is entirely lacking in unity....Working like a miniaturist on details he loses all sense of the composition as a whole[1]." A similar criticism is made by Mr Berenson, who also compares him to a miniaturist. For the average miniaturist in his naive delight in the imitation of material objects and the accumulation of details took no thought for the composition of his picture, and often indeed seemed to forget its subject. We see the same defect in most of the pictures of the Flemish school. Except when the composition is exceedingly simple, as in Jan van Eyck's Virgin and Chancellor Rollin, or Roger van der Weyden's Virgin and St Luke, it generally suffers from the accumulation of details. There are too many figures or too many buildings; sometimes two subjects or even stories are combined in the same picture. In any case there is no true sense of composition of the relations of one part of a picture to another. Typical instances of these defects are Robert Campin's Adoration of the Shepherds at Dijon, Roger van der Weyden's Descent from the Cross at the Escorial, Memlinc's Shrine of St Ursula at Bruges, and Seven Joys of the Virgin at Munich.

This inability of the Flemish painters to compose a picture of many figures was due not only to their failure to conceive the picture as a whole, but also to their want of knowledge. They did not know how to bring the different parts of the picture into relationship with each other, how to give prominence to the central idea, how to differentiate

[1] G. F. Hill, *Pisanello*, pp. 65 and 67.

the planes of vision by means of aerial perspective. Even when handling only a few figures they shew distinct limitations. Their strength is concentrated on the expression of character, in which they succeed admirably, but it is, as a rule, character in repose, and not character in action. Roger van der Weyden is fond of portraying vehement emotion, but the gestures of his figures are either violent and theatrical, or stiff and awkward. His Beheading of John the Baptist in the Berlin altar-piece is almost comic. Contrast his rendering of an animated and impressive scene with the dignified energy of Masaccio's Tribute-money and you realise the difference between Flemish and Italian art of the Quattrocento. Memlinc's Seven Joys of the Virgin, in which several incidents are introduced into the same picture, is painted with the naive indifference to grouping and arrangement of a miniaturist. In his famous Shrine of St Ursula he is far more successful than Roger van der Weyden in representing life and movement, and there is nothing stiff or ungraceful in his figures. But in the closing scene, the Martyrdom of the Saint, neither Ursula nor the soldiers shew any sign of emotion. On the other hand the three shepherds in Hugo van der Goes's masterpiece are instinct with a feeling of passionate adoration, but the picture is overcrowded and ill-arranged.

In the art of composing a picture the French painters had a far superior teacher to any Fleming in Jean Fouquet. If, like all miniaturists, he sometimes puts too much into a single picture, he has a true feeling for the total effect. His work is not merely an accumulation of details, but the details are arranged in the light of a preconceived whole. He handles crowds like a master, and he gives figures and buildings their proper relationship. It is especially the feebleness of the composition that marks the second volume of the Josephus as the work of an inferior hand. But Fouquet was after all a miniaturist, employing the methods proper to that branch of painting. For knowledge how to compose a panel-picture containing many figures the French painters had to seek inspiration

from Italy. Masaccio's Tribute-money and Raising of the King's son, Filippo Lippi's Funeral of St Stephen, Perugino's Christ giving the keys to St Peter and the same painter's Entombment (1495), and above all Leonardo's Adoration of the Magi—to keep within the limits of the fifteenth century—are all notable examples of the sense of freedom and space, of the feeling for life and movement, of the power of composing a picture so as to give due emphasis to the central idea, that we find as a rule in the paintings of the Italian Renaissance, and that we miss so frequently in the pre-Renaissance work of Frenchman and Fleming.

With these considerations in view we may now return to our picture. It forms part of a retable, of which four panels only are known to be in existence. Of these the one in question, which is in the National Gallery, and its companion, formerly in Lord Dudley's collection, represent episodes in the life of St Giles[1], and the other two, both in private hands, episodes in the life of St Remy. The subject of the National Gallery picture (Plate XIX) is the well-known story of the Saint's tame hind being hunted by the king of the Goths and taking refuge with her master. The king and an ecclesiastic—the Archbishop of Nimes according to the legend—kneel before the Saint, who caresses the hind. His hand is pierced by an arrow. This has been shot by an archer in a striped jerkin, who with other attendants occupies the middle distance. In the background on the left is a group of buildings, including three churches, while beyond these and to their right stretches a wide landscape of wood and river and hills. Some picturesque rocks on the same plane with the buildings represent the Saint's abode. In the foreground are plants, of which the most conspicuous are irises and a tall mullein. A tree, which has considerable character, but which it is difficult to recognise, forms a prominent feature in the very centre of the picture, and serves to give emphasis to the main group.

The care and skill with which the plants are drawn

[1] They both measure 24 inches by 18.

Plate XIX

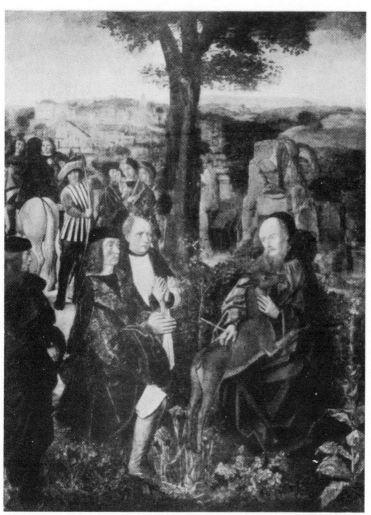

The Legend of St Giles (National Gallery)

and the richly embroidered cloak of the kneeling prince
are decidedly Flemish. So are the faces, full of character,
of the principal figures, especially of the Saint and the
ecclesiastic. Further, the wide landscape is not dissimilar
in treatment from those of Gerard David; indeed, it bears
a certain resemblance, particularly in colour, to a panel by
David's follower, Joachim de Patinier, which hangs, or did
hang, beside it, in the National Gallery. As a composition,
our picture has some of the defects that we have noticed
in the Flemish school. The management of the different
planes of vision leaves much to be desired; the archer,
for instance, appears in unnatural proximity to his quarry.
His striped jerkin gives him undue prominence, distracting
the spectator's attention from the central point of interest,
which is the Saint with the hind and the two kneeling
figures. And, though the faces of these three are full of
character, they fail to express the emotions suitable to
the incident. On the other hand, the freedom and dignity
of their attitudes, the stately figure of the courtier, who,
wrapped in voluminous draperies, stands behind the prince,
the clever way in which the two groups, one mounted
and the other on foot, are arranged on either side of the
archer, the admirable drawing of the hind, and the white
horse, all suggest some knowledge of Italian methods. It
is doubtless no more than a coincidence, but the tree, which
is abruptly terminated by the top of the picture, recalls
the two trees in Leonardo's Adoration of the Magi, and
serves the same purpose of emphasising the central group.

The subject of the companion picture is St Giles cele-
brating Mass before Charles Martel and his suite[1]. This
event is said to have taken place at Orleans, but the
church here represented is Saint-Denis, and the picture has
an historical interest in that it represents the vanished
altar of St Louis with the reredos given by Charles the

[1] Exhibited with its companion at the Burlington Fine Arts Club
in 1892. See *Illustrated Catalogue of Early Netherlandish Pictures*, 1892,
plate xvi. It was lent by Mr E. Steinkopf; former owners were Mr T.
Emmerson and Lord Northbrook.

Bald. The Flemish elements are even more obvious than in the companion panel. The dresses, the carpet, the altar with its retable, the architecture and sculpture of the church, are all rendered with marvellous delicacy and precision. But the figures shew more freedom and ease of gesture than in most Flemish work. St Giles with his hands raised in the act of consecration, the ecclesiastic who is kneeling immediately behind him, and Charles Martel with his suite on the left of the picture, give the impression of a scene from real life that you do not get from Roger van der Weyden or Memlinc[1]. Moreover, the refined and delicate beauty of St Giles and the ecclesiastic behind him is not Flemish.

The careful minuteness with which the chapel and its altar are rendered makes it certain that at any rate this part of the retable was painted at Saint-Denis, and it seems therefore natural to regard the whole work as proceeding from a Paris *atelier*. If there were only the National Gallery panel to go upon, one would be inclined to substitute Avignon for Paris, for the landscape has a strong look of Provence, and Saint-Giles, where the noble Abbey-church is supposed to mark the site of the Saint's cave, is only about thirty miles from Avignon, while Saint-Remy is at less than half that distance. At any rate the work was executed in France, but experts have not made up their minds as to whether the artist was a Fleming or a Frenchman. The Flemish influence is, as we have seen, very apparent, but the general impression that both panels, and more especially that in the National Gallery, leave on my mind is that they were painted by a Frenchman, who, if he was familiar with the methods of the Flemish school, preserved undiminished his national sympathies and outlook on life. Further, I venture to suggest that the comparative breadth of treatment, alike in the general composition and in the individual figures of St Giles with the Hind, points, not

[1] Note the admirable drawing of the hand of the acolyte, who is holding back the curtain.

indeed to any direct imitation, but to an intelligent study of Italian masterpieces.

At Lyons we come upon the names of four Flemish and two Italian painters who were working there during our period[1], and it may be taken as a sign that art was in a flourishing condition that, as already noticed, the king granted in 1496 a Charter to the painters, sculptors, and painters on glass of the city. The statutes are a formidable document of fifty-three clauses, and the rules which they lay down for the practice of the three arts seem to us intolerably stringent. But they really mark an advance in the direction of freedom, and at any rate they are framed with a view to the promotion of good workmanship[2]. Among the fifteen signatories to the petition for the Charter, all apparently Frenchmen, are Jean Perréal, whose name heads the list, and the sculptors, Nicolas Leclerc and Jean de Saint-Priest, who designed the medal of Louis XII and Anne of Brittany.

The proportion of Flemish to Italian painters at Lyons does not represent the relative importance of the two influences, for throughout our period the Flemish influence in art was decreasing and the Italian increasing. During the eleven years that elapsed between the death of Mary of Burgundy (1482) and the return of her daughter, Margaret of Austria, after her repudiation by Charles VIII, to the Netherlands (1493), there was a French party in most of the Flemish towns, and close relations were kept up between the two countries. The peace of Senlis, which was concluded shortly before Margaret's return, put an end to the disputes between Maximilian and the French king with regard to the Burgundian heritage, but the Expedition of Charles VIII changed the current of France's foreign policy, and with it that of her artistic sympathies. The fashion in art turned sharply in the direction of Italy. Moreover by this time Flemish art, though still highly popular, had,

[1] N. Rondot, *Les artistes et les maîtres de métier étrangers ayant travaillé à Lyon* in *Gaz. des Beaux-Arts*, 1883 (2), pp. 157 ff.

[2] *Ordonnances des rois de France*, xx. 562 ff.

except in its treatment of landscape, long ceased to be
progressive. Roger van der Weyden, to whom the wide
popularity of Flemish art was mainly due, had left it on
a lower plane than he had found it in the hands of Jan van
Eyck. Memlinc was a greater painter than Roger. His
technique, if less solid, was as sure and as conscientious
as Jan van Eyck's, and he had an inward vision to which
the older master was a stranger. But he was not the man
to make new discoveries or win fresh conquests. He kept
to the old themes and the old treatment‚ of them. He did
not trouble himself much with invention. When he had
once hit upon a type that pleased him, he repeated it again
and again even to the identical pose and attitude. He was
content to express his own ideal, the ideal of a refined,
religious, almost mystical, spirit, aloof from the strife and
violence of the world. He died in the year in which Charles
VIII returned from Italy, untouched by the Renaissance[1],
the last great mediaeval painter.

Before the Expedition of Charles VIII the art of the
leading painters of the Quattrocento was little known in
France. We can only point to two pictures by Italians
of any note, of which one certainly, and the other possibly,
was in France at the time of that event. Both till quite
recently were in the Church of Notre-Dame at Aigueperse,
the capital of the Duchy of Montpensier, but while the
Nativity of Benedetto Ghirlandaio, a brother of Domenico,
still hangs in its original home, Mantegna's St Sebastian
has passed to the Louvre. As Gilbert, Comte de Mont-
pensier married Clara di Gonzaga, grand-daughter of
Mantegna's patron, Ludovico di Gonzaga, it is natural to
infer that it was through him or his wife that Mantegna's
picture came to France. It may have possibly been given
to them on the occasion of their marriage in 1481[2]. The

[1] The common Renaissance *motif* of *putti* holding a garland is found
in the panel ascribed to him in the Uffizi, and in the triptych (by an
imitator) belonging to Mrs Alfred Morrison. See above, p. 533, n.[2].

[2] Herr Kristeller points out that the picture could not have been
painted at this time, for it belongs to a much earlier period of Mantegna's
career. Gilbert de Montpensier died at Naples in 1496.

other picture has an inscription in French verse by the artist, which says that he painted it at Bourbon (l'Archambault) in the house of the Constable. This must be Jean II de Bourbon, who was appointed to that office in 1483[1]. As we have seen, the inventory of Anne of Brittany's possessions included pictures both from Naples and Milan, and we may conclude that those which came from Naples were the result of her first husband's expedition. But no traces of any of them exist, and they are described so briefly and baldly that it is impossible to form any conjecture as to what they were like or who painted them. A mosaic of the Virgin and Child with two Angels by David Ghirlandaio, another brother of Domenico, which Jean de Ganay, First President of the Parliament, brought from Italy in 1495 and presented to the Church of St Merri at Paris, has been more fortunate, for it has found a resting-place in the Musée de Cluny.

The occupation of Milan gave the French king and his courtiers the opportunity to become better acquainted with Italian art, especially with the masters of northern Italy. Cardinal d'Amboise thought Mantegna the greatest painter in the world, and asked Isabella d' Este to get him to paint a picture for him (1499)[2]. She was not, however, successful. Florimond Robertet was more fortunate with Leonardo da Vinci, who painted for him in 1501 a small picture representing the Madonna with a spindle and the Child playing with a reel. Judging from this brief description, it must have been of infinite charm[3]. Cardinal d'Amboise would gladly have persuaded Leonardo to come to Gaillon to decorate the chapel, but the great painter was too busy even to paint a picture for the King of France. So Charles d'Amboise sent in his place Andrea Solario, who passed two years in the Cardinal's service (1507–1509), painting the walls of the chapel and an easel-picture of the Nativity.

[1] See P. Mantz in *Gaz. des Beaux-Arts*, XXXIV. (1886), pp. 375 ff.
[2] *Rev. historique*, XLVIII. (1892), p. 57, n.[3].
[3] See a letter from Fra Pietro da Novellara to Isabella d' Este (J. Cartwright, *Isabella d' Este*, I. 321).

The wall-paintings and the picture have alike disappeared, but the charming *Vierge au coussin vert*, which hangs in the Louvre, was painted either in France or just before the painter left Italy. Besides a considerable number of pictures of which the painter is not recorded, Cardinal d'Amboise also possessed a Deposition by Perugino[1], but this too has vanished.

Just after Solario had finished decorating the chapel of Gaillon, the Cathedral of Albi was similarly treated by Italian artists from Bologna and Modena for the Cardinal's nephew (1509–1514). More fortunate than Gaillon it was spared by the revolution, and the paintings which cover the vault of the choir are as fresh as when they were first executed. The whole work speaks of the verve and facility of these Italian decorators. Finally, the Louvre possesses a picture of the Marriage of Saint Catharine painted by Fra Bartolommeo in 1511, which Jacques Hurault, Bishop of Autun, presented to the Chapter of his Cathedral. Originally painted for the Convent of San Marco, it had been given to him by the Signoria of Florence, when he was Ambassador to the Republic.

There were doubtless other pictures by eminent Italians in France, but all record of them has vanished. Even so, the list is respectable as a beginning. The three living painters who had the greatest reputation at the opening of the sixteenth century, Leonardo, Perugino, and Mantegna[2], are all represented, though only by a single picture. It was of more importance that a painter as able as Andrea Solario, who combined Venetian colouring with Milanese science, should have spent two years in France. As nothing but easel-pictures by him exist, we can only speculate as to the quality of his wall-paintings, but he doubtless shewed a freedom and facility in the treatment of large surfaces which was unknown in France.

[1] See Deville, *op. cit.* pp. lxxi and 540.

[2] Jean Pélerin in 1521 mentions "Leonard, Le Pelusin, and André Montaigne" as the chief Italian painters (see above, p. 531).

III

Finally we come to a remarkable group of pictures which have been assigned with more or less agreement to one and the same hand. The principal picture of the group is the great triptych in the sacristy of Moulins Cathedral, which represents in the central panel the Virgin in Glory, and on the inner panels of the shutters portraits of Pierre and Anne de Beaujeu, with their patron-saints. It is from this picture that the unknown painter is provisionally styled the Maître de Moulins. The other pictures which are generally ascribed to him are: (1) A pair of panels representing Pierre and Anne de Beaujeu with their patrons (parts of a triptych—Louvre). (2) The Magdalen with a donatrix (part of a diptych—Louvre). (3) Portrait of a girl (part of a diptych—Mme de Yturbe, Paris). (4) Nativity with Cardinal Rolin as donor (episcopal palace, Autun). (5) St Maurice with a donor (part of a diptych—Glasgow). To these Comte Durrieu would add a full-page miniature from a manuscript of the *Statutes of the Order of St Michael*, which represents St Michael appearing to Charles VIII[1], and Mr Roger Fry an Annunciation, which was exhibited at the Dowdeswell Gallery in 1908.

Comte Durrieu's arguments in favour of the former attribution are not strong, but it is difficult to resist the reasoning of Mr Fry[2]. He points to the open palms of the Virgin's hands, the bright but rather crude colouring, especially the peculiar strident shade of green, the slightly obliqued eyes, and the traces of *pentimenti*, as being all special characteristics of the Maître de Moulins. Against this it may be said that in Robert Campin's Dijon Nativity one of the midwives shews the palm of the hand, and that so does one of the

[1] Bib. Nát. *ms. français*, 14363. See Comte Durrieu in *Le Manuscrit*, I. (1894), 19 ff., and (with a far better reproduction) *Bull. de la Soc. française de reproductions de manuscrits à peintures*, I. (1911), 22 ff. The date of the miniature is the end of 1493 or the beginning of 1494. Comte Durrieu thinks that St Michael is a portrait of Anne of Brittany, and compares the medal struck at Lyons in 1494 from the design of Jean Perréal.

[2] *Burlington Magazine*, IX. 331 (fig.).

shepherds and one of the angels in the Nativity of Van der Goes, and that we find the obliqued eyes in Bourdichon. On the other hand the colouring is certainly suggestive of the Maître de Moulins. The peculiar shade of green, for instance, is noticeable in the panels of 1488 (which, however, are probably copies), and in that of the Magdalen with a donatrix. Mr Fry also says, with perfect truth, that the composition of the picture recalls that of the miniaturists, and particularly that of Bourdichon. He further notes that the treatment of the architecture betrays a very superficial acquaintance with classical forms. We are thus led to infer firstly that the painter was not familiar with Fouquet's work, in which correctly drawn classical columns occur, and secondly, that he was either a fellow-pupil with Bourdichon, or possibly his disciple. But if he is to be identified with the Maître de Moulins, it is difficult to agree with Mr Fry that the picture is later than the Autun Nativity, for it shews evident signs of immaturity, especially in the awkward attitude of the Angel, who is not even looking at the Virgin.

The Autun Nativity (Plate XX) must have been painted at the latest in 1483, the year in which Cardinal Rolin, the donor, died at the age of seventy-five. He looks in the picture not more than seventy[1]. The general conception of the picture is Flemish. In the triptych which Roger van der Weyden painted soon after 1450 for the church at Middelburg to the order of Peter Bladelin of Bruges, treasurer of the Order of the Golden Fleece, and finance-minister to the Dukes of Burgundy, we have the same five kneeling figures of the Virgin, St Joseph, two Angels, and the donor. This may be a mere coincidence, but the resemblances to Van der Goes's Portinari altar-piece are evidently designed. Mr Fry points out that the figure of the Virgin recalls that of the Magdalen on the right shutter of the triptych, and that the two shepherds looking in at the open bay of the building resemble those

[1] He was born in 1408, made Bishop of Autun in 1436, and Cardinal in 1449. See above, p. 70.

Plate XX

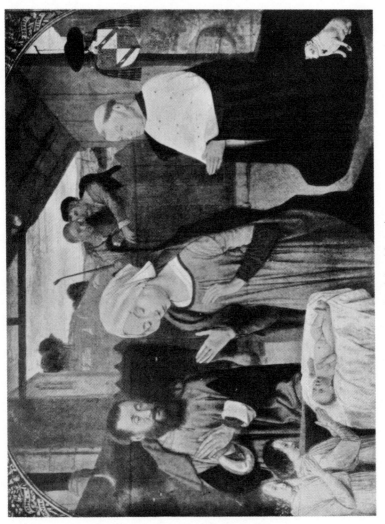

Nativity (Autun)

(From *The Burlington Magazine*)

of Van der Goes[1]. The Virgin too holds her right hand so as to shew very plainly the lines of the palm, just as one of the Angels and one of the shepherds do in the Portinari altar-piece. Moreover the whole composition, in spite of its omissions and simplifications, recalls that of the earlier picture. Now this latter was, as we have seen, painted in 1476, and presumably sent to its destination at Florence soon afterwards, and it is tempting to infer from this that the painter of the Autun Nativity saw it at Bruges, where Portinari resided, and where Van der Goes did a good deal of work, in that year. But the picture was a highly popular one and we cannot be sure that one or more copies of it were not made before it left Flanders.

The Autun Nativity, says Mr Fry, is "not the work of a novice," and I cordially agree. There is nothing timid or hesitating about it. The artist has clearly seen his goal from the first, and he has reached it with a considerable measure of success. The composition is far from perfect, but setting out, as he apparently did, from that of the Portinari altar-piece, he has greatly improved upon it. By omitting several of the figures, that is to say, all the Angels except two, and by bringing the remaining figures together, he has produced a unity which is entirely lacking in his model. The relegation of the shepherds to the middle distance, thus connecting the principal figures with the landscape, is a masterly stroke. It is this feeling for balance and unity in the composition, combined with the character and treatment of the landscape, that point to the painter being a Frenchman and not a Fleming.

The panel in the Louvre which, according to an inscription

[1] Van der Goes probably got the idea of treating his shepherds as realistic studies of peasants from Campin's Nativity at Dijon, but he has given them much more dramatic force than his predecessor. The notion of making them look in at the building which the Maître de Moulins has adopted is of fairly frequent occurrence. It occurs, for instance, in Bourdichon, *Hours of Anne of Brittany*, no. 24, in a manuscript of about 1500, said to have been executed at Bruges (British Museum, *Exhibited Illuminated Manuscripts*, no. 79), and in Vostre and Pigouchet's cut of the Nativity (set no. 3).

at the bottom of the frame, represents Pierre de Beaujeu
in 1488, after his accession to the Duchy of Bourbon, closely
resembles the Autun picture in the treatment of the land-
scape, especially in its relation to the kneeling figure of the
Duke[1]. The similar picture of a lady of high rank, which
is of the same height, and doubtless would have been of
the same breadth if a portion of it had not been cut away,
is naturally supposed to represent the Duchess and to have
once formed, with the companion panel, part of a triptych
of which the centre is lost[2]. It should be noticed that the
Duchess's patron is not St Anne, as we should expect, and
as is the case in the Moulins triptych, but St John the
Evangelist. The Duke is the better portrait of the two,
but both panels are so manifestly inferior in quality to the
Moulins triptych that one is glad to accept Mr Fry's view
that they are workshop replicas.

Closely related to them, but superior in quality, is another
panel in the Louvre, which represents an exceedingly plain
lady in a plum-coloured dress of the same style as that of
Anne de Beaujeu, kneeling in prayer under the protection of a
more youthful and more attractive Magdalen, evidently also a
portrait[3]. Both figures have considerable character and indi-
viduality. The right hand of the Magdalen shews the clearly
defined lines of the palm. In Mme de Yturbe's charming
portrait of a young girl in a maroon dress (Plate XXI) we
have the same treatment of the landscape and the same
relations between the landscape and the figure as in the
Autun Nativity and in the panels of 1488. The landscape,
however, is grey-green instead of the bright green of the
panels. The picture originally formed one half of a diptych,

[1] Fig. *Gaz. des Beaux-Arts*, 1901 (2), p. 321.

[2] Fig. *ib.* p. 325. The Duchess was twenty-seven in 1488. The
buildings in the landscape may be a fanciful representation of the
château and Abbey-Church of Moulins.

[3] Fig. *ib.* p. 376. Formerly in the Somzée collection at Brussels and
afterwards in the Agnew collection. Can the lady be Madeleine de France,
sister of Louis XI, who was born in 1443, married Gaston de Foix, was left
a widow in 1470, and died in 1486? The age of the lady in the picture is
between forty and forty-five.

Plate XXI

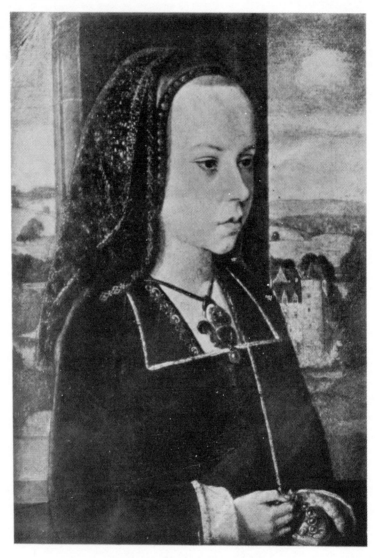

Portrait of a young girl (Mme de Yturbe)
(From *The Burlington Magazine*)

as is shewn by the traces of alteration at the top of the
canvas. The girl wears round her neck a jewel in the form
of a fleur-de-lys, and this coupled with the similarity of
her dress to that of Anne de Beaujeu in the panel of 1488
makes it tolerably certain that the portrait represents
Suzanne de Bourbon, the only daughter of the Duke and
Duchess, who was born in 1491[1]. If this is the case, the
picture must have been painted between 1499 and 1501,
for the girl's age is apparently from eight to ten. "It
belongs," says Mr Fry, "to the new world of the Renais-
sance." But to appreciate this remark we must look back
at the portraiture of the fifteenth century not only in France
but in Italy and the Low Countries.

In the great revival of art which began at Florence
about the year 1400, portraiture, whether in painting or
sculpture, had at first a subordinate place. An art which
conferred prominence and distinction on individual citizens
at their own pleasure was possibly regarded with apprehen-
sion by an oligarchy of *bourgeois* families who looked on
one another with suspicion and jealousy. The republic,
indeed, commissioned Masaccio to paint a fresco of con-
temporary Florentines (1426–1428), but portraits of single
individuals during the first thirty years of the fifteenth
century were comparatively rare. That of Giovanni de'
Medici, father of Cosimo, by an unknown artist, was painted
shortly before his death in 1429, and the terra-cotta bust
of Niccolò da Uzzano by Donatello is perhaps a little earlier.
To the same decade belong the Prophets which the same
sculptor made for the Cathedral, and which, as we have
seen, were for the most part portraits of well-known citizens.
But in this case the portraiture was not avowed, any more
than it was in the numerous Magdalens and St John the
Baptists which reproduced the features of living Florentines.

In the Courts of Northern Italy portraiture met with a

[1] The picture came from the collection of a Spanish Bourbon, but
this of course may be only a coincidence. It was formerly called
Jeanne .a Folle (the mother of Charles V) and attributed to Holbein.
See C. Benoit in *Gaz. des Beaux-Arts*, 1901 (2), p. 328.

more ready and a more open patronage. At Ferrara
especially it received great encouragement from Leonello
d' Este, who succeeded to the Marquisate in 1441. Between
that year and his marriage in 1444 the great medallist,
Pisanello, made for him at least six medals, while three
painted portraits, by Jacopo Bellini, Oriolo[1], and Pisanello
himself, belong to the same period. The painted portraits
resemble the medals in being in profile, but they are inferior
to them in energy and character[2]. The same remark applies
to Piero de' Franceschi's Sigismondo Malatesta (1451),
whose kneeling figure in its devotional attitude hardly
corresponds to our idea of that masterful and unscrupulous
condottiere. It is otherwise with Mantegna's full-face
portrait of Cardinal Scarampo (1459) in which the character
of "this wolf in sheep's clothing[3]" is revealed with profound
and uncompromising sincerity[4]. But portraits of this
quality, and indeed portraits of any kind, were still an
exception in Italy. The first Italian painter who made
his reputation chiefly as a portrait-painter, and whose
portraits may be compared for energy and expressive-
ness with Mantegna's Scarampo, was Antonello da Messina,
who settled at Venice in 1474, and who painted in that
year the Berlin portrait of a young man[5] and in the
following year the wonderful bust of a man in the
Louvre. With his hard glittering eyes and resolute
contemptuous mouth, he is as much a type of the un-
scrupulous man of action of the Renaissance, as Man-
tegna's Cardinal is of its ambitious intriguer. In 1476
Antonello, who was regarded as the first portrait-painter
in Italy, succeeded Zanetto Bugatto as painter to the
Duke of Milan. He died at Messina in 1479 at the age

[1] National Gallery.
[2] B. Berenson, *The Venetian Painters of the Renaissance*, p. 35.
[3] *Ib.*
[4] Now at Berlin.
[5] Formerly in the Duke of Hamilton's collection. In the same year
Mantegna completed his great group of the Gonzaga family for the Camera
degli sposi at Mantua.

of forty-nine[1], and after his death portrait-painting became general in Italy.

The fact that Antonello was only ten years old at the time of Jan Van Eyck's death disposes of Vasari's well-known story that he learnt the secret of oil-painting from that master in Flanders. As has been pointed out he might have seen examples of his work either at Naples or at Palermo. But it is true that he was in a sense Van Eyck's disciple. For his portraits are all constructed after Van Eyck's favourite formula; that is to say, they are three-quarter busts with the light coming from the foreshortened side of the face[2]. Antonello could not have chosen a better model. With the exception of Mantegna's Cardinal Scarampo, which would have seemed hard in modelling and unattractive in colour to a follower of the Vivarini and Bellini, there were no Italian portraits at this time to compare with those of the great Fleming. Physically they give a complete picture of the man, such as only a painter of penetrating vision, unbiassed observation, and unfaltering execution can give. But they lack the energy and expressiveness of Antonello's work; they portray the sitter in mental repose, and they reveal his character with discretion. The few portraits that we have of Roger van der Weyden are superficial and subjective. Memlinc painted numerous portraits, but not more than half-a-dozen of these are portraits pure and simple, that is to say portraits which do not form part of a votive picture. He gives us, indeed, the soul as well as the body, but it is his own soul. It is strange that the portrait of a young man holding a medal in his hand at Antwerp should for so long have passed under the name of Antonello da Messina. Can anything be more unlike the expressive energy of the Sicilian painter's

[1] See H. Stein in *Gazette des Beaux-Arts*, 1909 (1), pp. 34 ff. Vasari gives his age at the time of his death correctly.

[2] National Gallery, Louvre, Berlin, Milan (Castello). See the illustrations to H. Stein's article. Waagen, *op. cit.* III. 302, in speaking of the Berlin portrait, formerly at Hamilton House, notes the influence of Jan van Eyck.

work than this placid meditative countenance, which
breathes the very spirit of Memlinc[1]?

Of the few portraits painted in France between 1450
and 1500 that have come down to us more than half are
devotional in character. Such are Fouquet's portraits
of Guillaume Jouvenel des Ursins and Étienne Chevalier,
and Froment's portraits of King René and his second
wife, Jeanne de Laval[2]. The defect of this class of portrait
is that it represents a man engaged in an act which is
possibly not at all characteristic. It is true that the
painter, unless he be a Memlinc, does not always impart
a particularly spiritual or devout look to his model, but he
must perforce represent him in repose, and wearing at least
an air of restraint and decorum. It is not from King René
at his prayers that we should expect to get a true idea of
his character. On the other hand we have non-devotional
portraits in Fouquet's Charles VII, in his portrait of himself
on enamel, and in the drawing of the Papal legate ascribed
to him. To these should be added the Man with a glass
of wine, and the Liechtenstein portrait, which, though, as
we have seen, they are probably by a follower of Jan van
Eyck, are at any rate portraits of Frenchmen. But in the
reigns of Charles VII and Louis XI it was rare for persons
of lesser rank than the king, or possibly a prince of the blood,
to have his portrait painted, except as part of a religious
picture. In the matter of portraiture, sculpture was ahead
of painting. In the fifteenth century, says M. Mâle, the
"habit of taking a mould of the face of the dead became
general," and this, he points out, explains the increasing
realism of funeral statues[3]. It also became more and more
common in the course of the fifteenth century for great
persons to order their tombs in their life-time, and so to
ensure as far as possible a faithful likeness.

Another impulse to portraiture came, as it had done

[1] It will be noted too that the light comes from the full side of the face.
[2] On the shutters of the triptych in Aix Cathedral.
[3] *Op. cit.* p. 460.

in Italy, from the medallists. We have seen that the Italian
medallists Francesco Laurana and Pietro da Milano were
employed by King René between 1460 and 1470, and that
the former made a medal of Louis XI in 1469. We have
seen too that Giovanni di Candida worked first in Flanders
(*circ.* 1476–1482) and then in France, and that among his
earliest medals of Frenchmen were those of Pierre de
Courthardy and Robert Briçonnet, both distinguished
members of the Paris *Parlement*[1].

Of the group of pictures that we are now considering
all, except the Annunciation, contain portraits. Indeed it
may be said that they were all painted principally for the
sake of the portrait. But in each case the portrait is part
of a devotional picture. In the Autun Nativity the donor
kneels before the Virgin, but without his patron-saint.
In all the other pictures, except one, the patron-saint
presents the donor to the Virgin. The exception is the
presumed portrait of Suzanne de Bourbon, which none the
less, however, once formed part of a devotional diptych, of
which the missing half must have represented either the
Virgin or a Saint. How far is Mr Fry justified in claiming
it as a work of the Renaissance? He sees in it the refine-
ment and polish characteristic of Renaissance portraits.
But may we not go a little further? The portraits of the
Italian Renaissance, especially those of women, have an air
of serene composure and self-reliance, which, while it baffles
curiosity, seems to indicate a soul bent on exploring, frankly
and unreservedly, the mysteries of life. It is of course
impossible to see all this in the portrait of a child, but
Mme de Yturbe's princess, young though she is, has a
resolute and masterful look, as of one prepared to assert
her own individuality and to give free play to the spirit
of inquiry. In spite of the fact that the Ambrogiana portrait
of a Sforza princess by Ambrogio de Predis is of a young
woman instead of a child, and is in profile instead of

[1] For portraits in illuminated manuscripts see C. de Couderc in *Gazette
des Beaux-Arts*, 1907 (1), pp. 469 ff. (Charles VIII and Anne of Brittany,
Louis XII, Louis de Laval, Louis de Bruges).

presenting a three-quarters view, one is subtly reminded of that charming example of Lombard art. It is therefore worth recalling that, from 1482 to the final downfall of Il Moro, Ambrogio was the official portrait-painter of the Court, and that when the French took possession of Milan his portraits in that city must have been fairly numerous, while there must have been many examples by other painters who, like himself, had come under the influence of the great Leonardo[1]. It would be rash to assert that the painter of Mme de Yturbe's princess must have visited Milan, or even Italy, but at any rate he is informed by the same spirit as the Italian portrait-painters. If this is not "the new world of the Renaissance," it is at least its threshold.

The Glasgow picture of St Maurice with a donor (Plate XXII)[2] was formerly ascribed to Hugo van der Goes,

[1] The great majority of Ambrogio's portraits are in profile, but exceptions are Francesco Sforza, son of Il Moro, at the age of five, painted in 1498 (Mr William Beattie of Glasgow; reproduced by C. M. Ady, *A History of Milan*, p. 169); Bona of Savoy and a Young Man (both in the National Gallery); a Musician in the Ambrosiana; and a Girl in the Dreyfus collection at Paris.

[2] The identity of the Saint seems to be established by the arms which he bears on his shield—gules, an escarbuncle fleurdelisé or. In those of St Victor, which are in other respects identical, the field is azure. They occur in a Missal made for the Abbey of St Victor at Paris about 1500 (*Catalogue of Manuscripts of J. Pierpont Morgan*, 1906, by Dr M. R. James, who kindly called my attention to this instance), and in a *Diurnale* for the use of the same House (*circ.* 1480), in the possession of Mr S. C. Cockerell, ff. 52 and 130. The arms of St Maurice appear on the banner borne by that Saint in the triptych by Nicolas Froment in the Cathedral of Aix in Provence; on the cuirass of his statue (with S. Mauricius inscribed on the pedestal) in the retable of the Tarasque in the same Cathedral; and on one of the panels of a volume, *Pragmatica sanctio*, printed by Pigouchet for himself and Jean Petit in 1510 and bound by Clément Alexandre of Angers (of which city St Maurice was the patron), son of Jean Alexandre (see above, p. 305). See for the last example *Catalogue of a Collection of Early French Books in the Library of C. Fairfax Murray*, compiled by H. W. Davies, 1910, II. no. 455 (fig.). In the same volume (p. 731) will be found a reproduction of a cut of St Victor from Hugues de Saint-Victor's *Larve de lame*, printed about 1525. M. Hulin de Loo, *Exposition des tableaux flamands des xiv^e, xv^e et xvi^e siècles*, Bruges, 1902, p. 22, points out that the Saint is St Maurice, but he does not comment on the similarity of his arms with those of St Victor.

but the position of the patron-saint in front of instead of
behind the donor points to its being the work of a French-
man. Mr Fry claims it without hesitation for the Maître
de Moulins. He points out that we have the same fresh
landscape with its brilliant greens, the same bright blue sky
and white clouds, that we have in the Autun Nativity and
Mme de Yturbe's portrait. He notes further that, as in this
portrait, the tip of the donor's nose is slightly twisted away
from the spectator, and with a painter's eye he detects a
certain handling of the paint which he declares to be
characteristic of the work of our master. One may add
to this that the kneeling figure of the donor recalls that
of Cardinal Rolin in the Autun picture. M. Hulin is equally
confident in attributing the Glasgow picture to the Maître
de Moulins[1]. Comte Durrieu records the attribution, but
expresses no opinion as to its correctness.

The picture is in the first place remarkable for its colour-
ing, which is at once rich and harmonious. The pink banner,
the red shield, the blue of the Saint's armour, and the
deeper blue of his breastplate, the donor's cope of crimson
velvet and gold brocade over his white alb, his almuce of
brown fur, the blue and white sky, the blue hills, and the
green landscape all blend together with impressive effect.
The attitude of the patron-saint claims attention. As in
Fouquet's picture of Étienne Chevalier with St Stephen,
he has one hand on the donor's shoulders, but he has a
far more protective air than St Stephen, or indeed than
any of the patron-saints in our group except those of the
Moulins triptych. The painter has selected his model
with care and has portrayed a noble and stately figure,
the dignity of whose pose is emphasised by bringing the
head well above the horizon, so that it stands out against
the clear sky. It is an intellectual face, serious with
a touch of melancholy, but one which hardly represents
the ideal of a warrior-saint. The painter has given us in
fact a portrait, not a type created by his imagination.
But it forms an effective contrast to the plain and stolid

[1] *Op. cit.*

countenance of the donor, who is presented with un-varnished truth.

The almuce on the right arm of the latter indicates that he is a Canon, the rings and the jewel on his breast that he is of noble birth, and the diadem round his forehead that he is a *jubilaire*, that is to say, that he has held his Canonry for fifty years. As his age appears to be between fifty and sixty, he must have been appointed when he was a child. One critic sees in him a likeness to King René, and conjectures that he is his nephew, Charles of Anjou. But this prince died in 1481, a date far too early for the picture if it was painted by the Maître de Moulins. Another suggestion is that the unknown belongs to the house of Cleves, but there is nothing to support this[1].

Though there are clear traces of Flemish influence in the picture—it is not for nothing that it was once attributed to Hugo van der Goes—there is no suggestion of that of Italy, and though in some respects it is a more impressive work than either the Moulins triptych or Mme de Yturbe's portrait, it lacks the idealism of the former, and the secular feeling, if I may call it so, of the latter. It is in a word pre-Renaissance. In the order of the painter's work I should put it certainly before the triptych, and more hesitatingly before the portrait[2].

The date of the Moulins triptych (Plate XXIII) may be approximately determined. It cannot be later than 1503, for Pierre de Beaujeu died in that year. It cannot well be earlier than 1498, for in that year the Duke and Duchess lost their only son, who was younger than Suzanne. Had he been alive when the picture was painted, he would almost certainly have figured in it, as he does in one of the Cathedral windows. It is difficult to estimate Suzanne's age in the picture, but she looks about ten or eleven. This would make the date 1501 or 1502.

[1] The arms of Cleves were *gueules à un rai pommeté fleuronné d'or de 8 pièces percé d'argent* (Père Anselme, I. 208), but the arms in the picture are certainly those of the Saint, and not of the donor.

[2] M. Hulin, however, gives *circ.* 1510 as the probable date.

Plate XXII

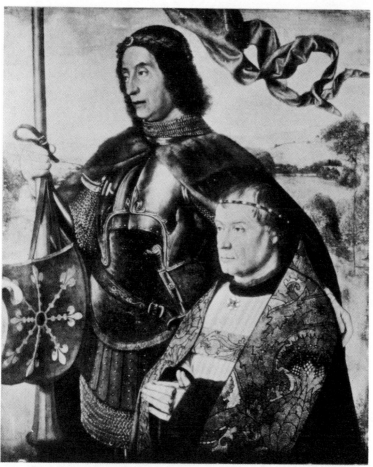

St Maurice with a donor (Glasgow Gallery)

Plate XXIII

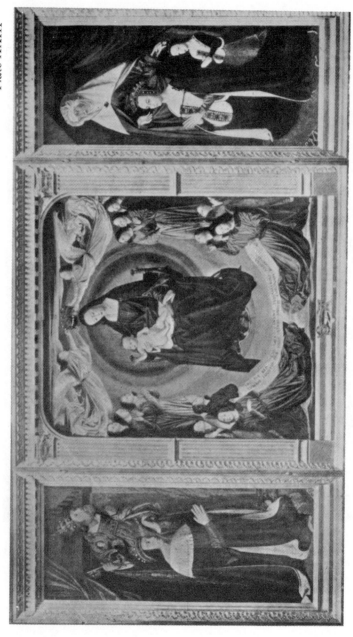

Triptych (Collegiate Church of Moulins)

(From *The Burlington Magazine*)

For the subject of its central panel the painter has chosen the Virgin in Glory, taking as his model, as Mr Fry points out, the Chantilly diptych, then presumably at Moulins[1]. In both pictures the Virgin is seated on a fald-stool, with her feet resting on the crescent-moon[2] and her draperies falling over it, and in both she has for a background a glory with rainbow-like edges. There is also a very close similarity in the attitude of the Holy Child, while the Angels in both pictures are of the same child-like type that we have noticed as the prevailing one in France at this period[3]. We have seen a notable and almost contemporary example in the tomb of François II at Nantes[4].

With their long floating draperies these Angels recall more especially those of Bourges. But the treatment of the central panel, with its soft contour-lines and its carefully graduated colouring, points unmistakably to the influence of Italy. The same influence is shewn in the composition

[1] See above, p. 530.

[2] About the beginning of the fifteenth century French artists began to represent the Virgin rising out of the crescent-moon or standing on it as a symbol of the Immaculate Conception, the idea being derived from the "woman clothed with the sun and the moon under her feet" of the Revelation (Mâle, op. cit. pp. 219–220). The earliest known instance of this symbolism occurs in a *Book of Hours* in the Fitzwilliam Museum, Cambridge (*Cat.* no. 62), which once belonged to Isabella Stewart, second wife of Francis I of Brittany, the date being about 1400. The conception of this representation of the Virgin in Glory, says Mr Fry, clearly due to Jean de Limbourg (*Burl. Mag.* VII. 442 ff.). It is worth noting that a French translation by Antoine de Leves from a Latin treatise on the Immaculate Conception, entitled *Le défenseur de l'originale innocence de la glorieuse Vierge Marie* (Bib. Nat. *ms. franç.* 989), is dedicated to Jeanne de France, the princess of the Chantilly diptych. For engraved representations of the Madonna standing on the moon see W. L. Schreiber, *Manuel de l'amateur de la gravure sur bois et sur métal au xve siècle*, 5 vols., Berlin and Leipsic, 1891–1911, I. 322 ff., III. 107 ff. In Murillo's numerous Immaculate Conceptions the Virgin is almost invariably represented as standing on the crescent-moon. In Perugino's pictures of the Virgin in Glory and in Mantegna's one representation of this subject (Trivulzio Collection) there is no moon, but the Virgin is surrounded by a *mandorla*. It is the same in Quintin Matsys's picture in the Hermitage gallery.

[3] See above, pp. 463–4.　　　　[4] See above, p. 503.

of the whole triptych. The artist has set out "to produce a picture," not merely to tell a story, or "to express an idea." Especially noteworthy is the way in which he has brought the wings of the triptych into close connexion with the central panel. This will be seen by comparing his treatment of the donors and their respective patron-saints with that of Fouquet, and with that of his own earlier pictures.

While in Flemish pictures the Saint stands invariably behind the donor in a respectful attitude, in Fouquet's Étienne Chevalier with St Stephen he is placed in front of him with one hand on his shoulder[1]. But the expression of St Stephen does not correspond to this protecting attitude, nor has he the air of presenting the donor to the Virgin. In the panel of the Magdalen with a donatrix the Maître de Moulins makes the Saint point with one hand to the kneeling figure behind her, while she looks in front of her towards what we may conjecture was a seated figure of the Virgin with the Child. This arrangement is not quite satisfactory, for the gesture of the pointing hand is a little awkward. In the panels of 1488 the Saints stand well in front of the donors, but they look backwards at them, and not towards the Virgin, who presumably was the principal figure of the missing central panel.

In the Moulins picture St Peter and St Anne stand neither behind nor in front of their clients, but above them. This position not only emphasises the idea of protection, but has the effect of bringing both patron and client into closer relation with the central subject, and thus of giving greater unity to the picture. It was possibly suggested by the presence of Suzanne de Bourbon. For had St Anne been placed in front of the Duchess the child would have been practically left out of the composition. As it is, the protecting attitude of the Saint happily embraces both mother and daughter, and connects the latter as well as the former with the central theme. The only possible

[1] Hulin, *op. cit.* p. 27. For the general question of patron-saints see Mâle, *op. cit.* pp. 164–170.

criticism that can be brought against the composition is
that it is too symmetrical, but this very symmetry is a sign
of the classical spirit which has inspired the painter. Already
in the Autun Nativity, painted from twenty to twenty-five
years earlier, he had shewn a decided aptitude for composi-
tion, and now under the influence of Italian models and
of a growing feeling for classical order and symmetry he
designs and executes a perfectly harmonious work, which
is not merely the expression of an idea, but a true picture.
In another way, too, the Moulins triptych reveals the inspira-
tion of Italian models. It has been conceived and executed
under the influence of the imagination not only as a shaping
but as an idealising process. The Virgin is a true type of
glorified womanhood—gentle, mild, loving, but glorious;
the Angels are a true heavenly choir; the Child is divine.
Even in the wings, the execution of which is more vigorous
but less learned and artistic than that of the central panel,
the figures of the donors as well as the Saints are brought
into harmony with the theme and spirit of the Virgin in
Glory. St Anne with her widow's wimple is especially
beautiful and gracious, and the Duke and Duchess, without
losing their individuality, are raised into types of devout
worshippers[1].

We may now attempt a tentative reconstruction of our
unknown painter's career. From the fact that the Autun
Nativity was painted not earlier than 1476 and not later

[1] It is interesting to compare with this picture two of the windows
in the Cathedral, that of St Catherine with the Bourbon family, and that
of St Peter and St Barbara with the unknown donor and his wife (see
above, pp. 442–3). The former, which, as we saw, must be dated
between 1496 and 1498, seems to me the earlier of the two, representing
a less successful attempt to give unity to the picture. In the so-called
Cadier window the task was rendered easier by there being only three
lights instead of five, and only two kneeling figures instead of seven.
The result is a more compact composition, which in its balanced symmetry
and in its choir of Angels offers a certain analogy to the great triptych
in the sacristy. The donors kneel at faldstools, and the patron-saints
stand behind them, pointing to them with one hand, and with a sufficiently
protective air. The floating Angels in the small lights above recall those
of Bourges.

than 1483—probably nearer 1476—and that it presents the appearance of not being the work of a novice, we may infer that the artist was born in 1463 at the latest, but in all probability some five to eight years earlier. If Mr Fry is right in claiming for him the Annunciation, it may be conjectured that he was a fellow-pupil of Bourdichon's, probably in some miniaturist's *atelier* at Tours[1]. But before he painted the picture for Cardinal Rolin, he must have visited the Low Countries and studied the great Flemish masters. During the years 1488 to 1502 he executed some important works for Pierre and Anne de Beaujeu. About the close of the fifteenth century he visited Italy, either independently or, more probably, in the train of Louis XII. As regards his artistic personality, we should infer that he was not so much a great original genius as a true artist, always striving towards improvement, a student even while he was a master, thinking much about the problems of his art, planning his pictures with forethought and executing them with deliberation, ready to learn from Italian or Fleming, but always retaining his own individuality, which was that of a true Frenchman.

The only name, so far as I know, that has been suggested for this anonymous painter is Jean Perréal, who has figured in these pages in connexion with various activities. His claim is warmly supported by M. Hulin de Loo in his notes on the Exhibition of the Flemish Primitives at Bruges, but he only gives a bare outline of his argument, which, as it stands, is far from convincing[2]. The best way, as it seems to me, of approaching the subject is, first to give an account of Jean Perréal's career, so far as we know it, and an estimate, so far as we can form it, of his artistic personality, and then to see whether these fit in with the career and personality of the Maître de Moulins.

[1] We only know for certain that Bourdichon was settled at Tours in 1479 (see above p. 538).

[2] *Op. cit.* pp. xlviii–lvi. I do not know whether M. Hulin has returned to the subject in a later publication.

We have a good deal of scattered information about Jean Perréal—entries in the royal accounts, letters from him to various persons, and notices of him by contemporaries. But in spite of this he remains somewhat of an enigma. We know that he designed the tomb of François II at Nantes and the Lyons medal of Charles VIII and Anne of Brittany, but otherwise we cannot connect him with any authenticated work. His life and his artistic career have been related more than once with considerable detail, but, when we have eliminated the share of fancy and speculation, little that is really significant is left[1]. Considerable confusion has arisen from the fact that he was called and called himself Jean de Paris, a *soubriquet* which was also borne by several individuals who were his contemporaries and who, like him, were connected with the royal household.

The first authentic notice of Jean Perréal occurs in 1483, when he was employed on a small piece of work by the municipality of Lyons[2]. Three years later (1486) he was entrusted with the organisation of the entry of the Cardinal of Bourbon as Archbishop[3], and in 1489, 1490, and 1494 he performed the same duty for the respective entries of the Duke of Savoy[4], Charles VIII[5], and Anne of Brittany[6]. It was on the last occasion that he designed the medal of Charles and Anne, the decorative character of which shews, as I have said, some trace of Italian influence. Some time before this he had entered the service of Pierre de Beaujeu as *fourrier* or quartermaster, and in 1487 we find him executing a confidential commission for Anne de

[1] The most trustworthy account is that by E. J. G. Charvet, *Jehan Perréal, Clément Trie, et Edouard Grand*, Lyons, 1874; that of Maulde La Clavière in the *Gazette des Beaux-Arts*, 1895 (2), 254 ff., and 1896 (1), 58 ff., 240 ff., 367 ff. (also published separately), may be depended on for the facts and dates of his life, but as regards the construction of his artistic career it is largely fantastic. The references to him in the royal accounts are collected in *Archives de l'art français*, 2me série, I. 15–142.

[2] *Archives*, p. 89.　　　[3] *Ib.* p. 88.　　　[4] *Ib.*

[5] *Ib.* pp. 15–41.　　　[6] *Ib.* pp. 45–92.

Beaujeu[1]. Although his name appears at the head of the petition which the painters and sculptors of Lyons presented to the king in 1496, he had at that time no special position at the Court[2]. But we are told in a story of the *Heptaméron* which is generally accurate in matters of fact, that Charles VIII sent "his painter named Jehan de Paris" to Germany to paint the portrait of a lady. This implies that he was appointed *peintre du roi* before the king's death in April 1498[3]. His name, however, does not figure in the royal accounts till the next reign, when he is paid a stipend of 240 *livres* for the year ending September 30, 1499[4]. In the same year he organised the entry of the king and queen into Lyons on July 10[5], when the former was on his way to Milan. The purchase of an hôtel and a *vigne* at this time shews that his affairs were prospering.

He accompanied Louis XII to Milan, and an interesting letter has been preserved, in which, writing from that city on November 14, 1499, to the Marquis of Mantua, he apologises for not being able to paint the "head," as the Marquis desired, but says that he will make a portrait of the king for him if he wishes it. The letter was dispatched to Mantua with two portraits by the writer, one of Cardinal d'Amboise, and the other of a girl[6]. It was during this sojourn at Milan that Perréal made the acquaintance of Leonardo da Vinci. In the latter's note-books we find a memorandum to get from Jean de Paris the method of painting in tempera and various information about painting on paper, *i.e.* illumination[7]. We hear of him again at Milan in August 1501[8], and it was about this time that he made for Anne of Brittany the

[1] Maulde La Clavière, p. 268. [2] *Ib.* p. 274.
[3] *Nouv.* XXXII. [4] Laborde, I. 182.
[5] *Archives*, pp. 92–111.
[6] *Notices et documents publiés pour la Société de l'histoire de France*, 1884, p. 295.
[7] Piglia da Gian di Paris îl modo de colorire a secco; il modo del sale bianco, e del fare le carte impastate; folie in molti doppi; e la sua cassetta di colori (*The Literary Works of L. da Vinci*, II. 421–2). See also Solmi, *Leonardo*, pp. 181 ff. Leonardo left Milan in December 1499.
[8] Jean d'Auton, II. 102–104.

design for her father's tomb, which, as we have seen, shews in various ways the influence of the Italian Renaissance[1]. In 1503 he organised the entry of the Archduke Philip into Lyons, in 1506 that of the new Archbishop, François de Rohan[2], and in 1507 that of Louis XII. He may have accompanied the king to Italy in that year, as he certainly did in 1509, when, according to his friend Jean Lemaire de Belges, he painted scenes from his campaigns and was saved from death by the physician, Symphorien Champier[3].

On his return to France in August he received instructions from Lemaire to prepare designs for the three tombs which Margaret of Austria, from whom he had been receiving a pension since 1504, was proposing to erect in her memorial Church of Brou. During the next three years he was much occupied with various negociations in connexion with this work, but in 1512 he fell into disgrace with his art-loving but capricious patroness, and the work was put into other hands[4]. In January 1514 he was employed on the funeral ceremonies of Anne of Brittany, and in the following August he was sent to England by Louis XII to paint the portrait of her successor, Mary Tudor[5], and to supervise the preparation of her trousseau, which in accordance with etiquette had to be in the French fashion[6]. In the next reign he retained his appointment, but there is no record of his having received any important commission from Francis I. He continued to live at Lyons, where he was employed from time to time on entries and other public works, and he died there in 1529.

The one clear impression that we get of Jean Perréal's artistic personality is his versatility. He was not only

[1] See above, pp. 500–1. [2] *Archives*, pp. 112–114.

[3] Preface to *La Légende des Vénitiens*; Laborde, *op. cit.* I. 182–191.

[4] See C. J. Dufaÿ, *L'église de Brou et ses tombeaux*, 2nd ed. Lyons, 1879; he prints in an appendix the correspondence between Jean Perréal and Margaret and her secretary, some of which had already been published by Le Glay, *Nouveaux analectes*, 1852. See also P. Vitry, *Michel Colombe*, pp. 490 ff., for a summary of the whole correspondence relating to Brou.

[5] *Fasciculus temporum.*

[6] See a letter from Louis XII to Wolsey (to whom the French alliance was due), printed in Rymer's *Foedera*.

a painter, employed like the other painters of his day upon very diverse forms of his art, but he painted on glass, designed medals and monuments, organised pageants, and was even consulted by the Lyons authorities as to the reconstruction of the bridge over the Rhone[1]. This very versatility has injured his reputation, and one writer speaks of him contemptuously as *ce brasseur de travaux*. But versatility was a characteristic of the Renaissance and may just as well have been accompanied by real genius in the case of Jean Perréal as it was in that of Leonardo and Alberti. Unfortunately there is nothing to testify to his genius. Judged as a composition, the design for the tomb at Nantes is not of striking merit, for it lacks the essential quality of unity. Its chief excellence is its feeling for colour. Evidently Perréal was in the first place a painter. But what sort of a painter? So far as the evidence goes, it was chiefly as a portrait-painter that he made his reputation. It was to paint a portrait that he was employed by Charles VIII, it was for portraits that he was most in demand when he first went to Italy. Here, as we may see by the Italian ideas which he introduced into the tomb of Duke François II, he came under the spell of a new influence. It was under this influence that he "revised his designs" for the monument at Brou "in the light of the antiquities which he had seen in Italy[2]."

But this adoption of Renaissance ideas and motives does not necessarily imply that he modified his style as a painter under the same influence. It is going far beyond the evidence to say, as M. Vitry does, that "he is the type of the artist of transition." All we can fairly say is, that, judging from his correspondence and other evidence, he represents a type of humanity which was not uncommon at the time of the Renaissance, that of the pushing, resourceful, and versatile adventurer, prone to take offence, intriguing, and treacherous.

[1] *Archives*, 115–117.
[2] Letter from Perréal to Margaret of Austria, dated Nov. 15, 1509 (quoted by Vitry, *M. Colombe*, p. 386).

xv] PAINTING

Such was the man who, according to contemporary testimony, was the most renowned French painter of the reign of Louis XII. Unfortunately not a single authenticated picture can be ascribed to him. On the other hand we have a remarkable group of pictures of the same period by an unknown painter. It seems a simple and natural solution to bring together pictures and painter, and to identify the Maître de Moulins with Jean Perréal. The argument that our Unknown must be Jean Perréal, because there is no other known painter of the time of sufficient eminence to have painted these pictures, is a perfectly legitimate one. But it loses sight of the fact that there is also Jean Poyet, of whose work we have no specimen, but who is mentioned by Jean Lemaire and his contemporary, Jean Pélerin, and later by a writer of the middle of the sixteenth century, as one of the leading French painters of his day. On the other hand we only know of him as a miniaturist, and we know nothing of him after 1497. As regards the date of Perréal's birth, the known dates of his life seem to put it about 1460, so that it more or less agrees with the conjectural date adopted for the Maître de Moulins. On the whole, however, the evidence points to his being rather a younger man than our Unknown. For instance in 1483, when at the very latest the Autun Nativity was painted, he is employed on an unimportant piece of work at Lyons. M. Hulin thinks that he was a native of that city. Rather, his *soubriquet* of Jean de Paris implies that he was not, but that he came to Lyons from Paris[1]. It is quite possible that in 1483 he had only just arrived at Lyons, seeking work, and that his previous training had been in Flanders.

Stress has been laid on the fact that both painters were in the service of the Duke of Bourbon. But there is no record of Jean Perréal being employed by him as a painter, or in any artistic capacity. During the years 1483 to 1496 his chief relations, so far as we know them, are with the city of Lyons, where he definitely settled; later he is

[1] Similarly the humanist Olivier, who was born at Montluçon, was called at Paris Olivier of Lyons (see above, p. 284).

employed by the Court. He was at Milan in 1499 and 1501, dates which perfectly agree with those of Mme de Yturbe's portrait and the Moulins triptych. But the latter picture was painted at the latest in 1503, while Jean Perréal lived till 1529, and was in high favour with the Court till 1515. If in 1503 he painted so fine a picture as the altar-piece of Moulins, it is curious that no work by him painted after that date survives.

On the whole, the external evidence would seem to impose upon us the conclusion, that, while there is no inherent impossibility in the identification of our unknown painter with Jean Perréal, the balance of probabilities inclines in the other direction. We are led to the same conclusion, if we compare the artistic personality of the Maître de Moulins, as inferred from his pictures, with that of Jean Perréal, so far as we can gather it from our knowledge of his career. The latter was apparently first and foremost a painter, and especially a portrait-painter, but he also practised other branches of art, and shewed considerable energy and aptitude in business matters. Now, it may be a wrong impression, but this versatility seems to be inconsistent with the artistic temperament of the Maître de Moulins, which appears to be rather that of a patient and thoughtful student, absorbed in the practice and development of a single art[1].

Lastly, while all the portraits of the Maître de Moulins form part of a devotional picture, those which Jean Perréal was commissioned to paint for Charles VIII, Louis XII, and the Marquis of Mantua were evidently portraits pure and simple. Indeed the mention of a "head," which the Marquis of Mantua desired from him, suggests that he made a speciality of small portraits of this description. M. de Maulde La Clavière, indeed, claims for him the

[1] M. Hulin points to the fact that the head-dress of Temperance in the tomb of Duke François II is identical with that of St Anne in the Moulins triptych. But (a) there is nothing to shew that Perréal, and not Michel Colombe, designed the individual figures for the tomb; (b) the head-dress is the wimple ordinarily worn by widows, and almost invariably by St Anne in French representations of her which date from this period.

miniatures of Francis I and his six companions, known as the "Preux de Marignan," which figure in the second volume[1] of the *Commentaires de la guerre gallique*, painted for Francis I in 1519–1520, but there is no evidence for this attribution. A better-informed opinion sees in them, as in the drawings upon which they are certainly based, the hand of Jean Clouet.

The earliest of these drawings date from 1515, so that in any case Clouet's work—for nothing of earlier date has been assigned to him—falls outside our period. But it is worth noting that the one French painter who really attained to eminence during the reign of Francis I was a painter of portraits, and a Fleming by birth[2]. The painting of large compositions under the patronage of the new king was dominated by Italian masters. The Maître de Moulins founded no school. The great triptych, in which for the first time we behold the spirit of the Renaissance triumphantly embodied in a French work of art, had no successor.

IV

A kindred branch of art to that of painting in which the rise of the Renaissance in France may be followed with some precision is that of book-illustration, especially as exemplified in the *Books of Hours* which the Paris printer and bookseller, Philippe Pigouchet, printed for Simon Vostre[3]. His earliest illustrations, which belong to the last decade of the fifteenth century, are purely Gothic, but in a *Book of Hours* printed about 1502 he enlarged some

[1] Bib. Nat. *ms. franç.* 13429.

[2] He was certainly not a Frenchman, as on his death his property fell by *droit d'aubaine* to the Crown, and almost certainly a Fleming; the name is common in Flanders. He settled at Tours, where we find him established in 1522. The first dated receipt of a picture painted by him is of 1518.

[3] The best guides are *Catalogue of Early Printed Books in the Library of J. Pierpont Morgan*, 3 vols. 1907, III. (*Horae* described by A. W. Pollard), and *Catalogue of the Library of C. Fairfax Murray*, I. 265 ff.

of his 8vo cuts to a 4to size by the addition of architectural borders, which have Renaissance features[1]. In the same *Horae* appears a new set with a *criblé* background, cut on metal, in which Renaissance architecture is shewn not only in the borders but in some of the cuts themselves, as for instance in St John before the Latin Gate, where classical buildings are substituted for the Gothic ones of the earlier cut[2], in David and Uriah, which has a Renaissance doorway[3], and in Augustus and the Sibyl, in which Renaissance architecture is mixed with Gothic[4]. Further we have three coarsely drawn cuts in which the Renaissance influence is still stronger[5]. These are the first cuts of a new set which appeared in full about 1508 in a *Horae* published by Vostre and probably printed by Pigouchet[6].

But before this Jean Pychore[7] and Remy de Laistre issued, in 1503, a *Book of Hours*, in which several cuts of this last new set were included, as well as some of Pigouchet's earlier ones. Use was also made of his architectural frames. In fact the whole book has a more pronounced Renaissance character than any illustrated book that had yet appeared in France[8].

It cannot be said that the influence of the Renaissance upon the illustrated books produced by Vostre and Pigouchet was a fortunate one. Under it the charm and refinement of the earlier work gradually disappears. This is partly due to the fact that the engraver did not get his Renaissance

[1] The Almanack is from 1502 to 1520 (*Fairfax Murray*, no. 257). See the cut of Bathsheba, *ib.* p. 276.

[2] Cp. the cut figured in *Pierpont Morgan*, III. 27 with that of Claudin, *Hist. de l'imprimerie*, II. 51.

[3] *Fairfax Murray*, I. 277.

[4] *Ib.* II. 1062.

[5] *E.g.* the Annunciation (*Pierpont Morgan*, III. 26), and the Adoration of the Magi (*Fairfax Murray*, I. 275).

[6] In a *Horae* for the use of Chartres (*ib.* no. 259) Other cuts of this set are David harping and Job (*ib.* II. pp. 1074 and 1071), both with Renaissance architecture, and a new Shepherds in the Fields (*ib.* 1079).

[7] Printed from 1503 to 1520; nothing more is known of his associate.

[8] Brit. Mus. c. 29, k. 21. See *Pierpont Morgan*, III. 26–29, no. 583. Mr Davies points out that the plates probably belonged to Vostre and not to Pigouchet. Four of the cuts were used by Kerver in a *Horae* of 1511 (*Fairfax Murray*, no. 267).

ideas directly from Italy, but at second hand from the Netherlands or Germany. A new set, which Vostre published about 1514 in a rare *Horae* for the use of Chartres, shews strong German influence[1].

Other active publishers of *Books of Hours* were Gillet and Germain Hardouyn, with whom was sometimes associated Guillaume Anabat. A *Horae* which he printed for them about 1507 contains seventeen pictures in the Renaissance style, and five pieces of Renaissance ornament for borders. The work is exceedingly poor and decidedly inferior even to Pigouchet's later work[2]. The Hardouyns sometimes adapted his cuts, as in a *Horae* printed in 1510[3]. Almost the only one of their own cuts which has any interest is that of Hercules, Nessus, and Deianira, which they used for their device.

This brief account of the development of Renaissance element in book-illustration at Paris during our period has this interest, that it indicates the trend of public taste. As a man of business, Simon Vostre, whatever his personal inclinations, was chiefly concerned in catering for the wants of a considerable public, and it was with this aim that he introduced Renaissance elements into the cuts of the *Horae* that were printed for him by Pigouchet. These elements are at first confined to architecture, and they begin to appear about 1502—the Almanack dates from that year—the

[1] *Fairfax Murray*, no. 260; two of the cuts are figured on p. 284, one of which, the Presentation, shews a romanesque basilica, and one on p. 287. These three cuts are signed, one with a G and two with an F encircled by a G. They have been attributed to Geofroy Tory, but bear no resemblance to his later and authenticated work. Two other cuts of the same set, the Visitation, and the Nativity, are similar in style, and the former of these suggests to Mr Davies that the artist lived by the Lake of Zurich. Another, the Martyrdom of St John, is based on a design of Dürer's. There are new borders, German in style. The book is printed partly from Pigouchet's type and partly from a new type which is apparently identical with that used by Pychore and Laistre. No book printed by Pigouchet with a date later than 1512 is known.

[2] Brit. Mus. c. 29, h. 8. See *Pierpont Morgan*, no. 591, pp. 36–39.

[3] March 8, 15$\frac{09}{10}$. See *Fairfax Murray*, no. 270 (from the collection of Prof. J. H. Middleton). See also no. 273 (*circ.* 1514), and *Pierpont Morgan* (nos. 586 and 593).

year, it may be noted, in which Fra Giocondo lectured on Vitruvius at Paris. In 1503 we have a definitely dated *Horae*—published indeed not by Vostre, but with type which he afterwards used and with cuts printed from plates which he either possessed at the time, or soon afterwards acquired—in which the Renaissance makes a decisive appearance. It reveals itself not only in the architectural backgrounds and borders, but in the whole character of some of the new cuts. Sacrificing the delicacy and the decorative feeling of the earlier work, they try to rival painting with their large figures and ambitious composition. But their inspiration is drawn, not from Italian masterpieces, but from the works—possibly not even at first hand—of Flemish or German imitators of the Italians. It was not till 1525 that Geofroy Tory, who had returned from a two or three years' visit to Italy about 1518, illustrated a *Book of Hours*, published by Simon de Colines, with engravings which worthily reflect the spirit of the Renaissance. About the same time Jean de Gourmont, whom we have encountered as a printer at Paris, produced at Lyons from 1522 to 1526 a series of vignettes, classical in style and otherwise shewing the influence of Italian engraving.

Finally, two other arts of design may be noticed, one of which remained entirely unaffected by the Renaissance till twenty years after the close of our period, while in the other the Renaissance influence was confined to the choice of subjects and had no effect upon the style. These two arts are enamelling and tapestry.

Towards the end of the fifteenth century painting on copper took the place of champlevé, which is a form of carving, and Limoges which had been the principal home of the old art became also that of the new. Léonard or Nardon Pénicaud, the first member of his distinguished family who made a name as a worker in enamel, flourished from 1495, by which date he had attained his majority, to 1530. He therefore belongs to our period in point of date, but there is nothing in his extant work to suggest the Renaissance. The only piece of his that is signed and dated,

the Calvary, dated 1503, in the Musée de Cluny, is purely Gothic[1], and the same may be said of all the other pieces which, with this for a guide, have been assigned to him. One of these—in the Victoria and Albert Museum—is a triptych of the Annunciation with figures of Louis XII and Anne of Brittany accompanied by their patron-saints on the wings[2]. The attitude of the Saint in each case is very similar to that of St Maurice in the Glasgow picture, one hand being on the shoulder of the kneeling figure, and the other advanced in front. Equally Gothic are the numerous works[3], dating from about 1475 to 1500, ascribed to an unknown *atelier* for which at present no more distinguishing name has been found than that of "the pseudo-Monvaerni." It is not till we come to Jean Pénicaud II, whose earliest dated work is of 1534, that the influence of the Renaissance begins to affect the enamelling art[4].

So far as style goes French tapestry did not feel the effects of the Renaissance any earlier than French enamelling. "Down to 1530 at least," says M. Jules Guiffrey, "French artists and in their train French tapestry-weavers remain faithfully attached to the old traditions[5]." But as regards subject, the influence of the Renaissance on tapestry begins to be apparent before the close of the fifteenth century. While the enamellers till almost the middle of the sixteenth century continued to take their subjects almost exclusively from sacred history and legend, in tapestry, as was natural in an art that was chiefly used for the decoration of châteaux and smaller houses, portraits and profane scenes, though

[1] Fig. Michel, v. (1), 451.

[2] Fig. H. H. Cunynghame, *European Enamels*, 1906, p. 116.

[3] Including twelve large plaques in the Louvre (see J.-J. Marquet de Vasselot in *Gaz. des Beaux-Arts*, 1910 (1), pp. 299–316). There are three examples in the Victoria and Albert Museum (see H. P. Mitchell in the *Burlington Magazine*, XVII. (1910), 37–39).

[4] See generally E. Molinier, *Dict. des émailleurs*, 1885, and *L'émaillerie*, 1891; J.-J. Marquet de Vasselot in Michel, v. (1), 448–452, and *Musée de Louvre: Orfèvrerie, Émaillerie et Gemmes* [1914]; H. H. Cunynghame, *op. cit.* and *On the Theory and Practice of Art-Enamelling upon Metals*, 1906.

[5] *Op. cit.* p. 79.

they did not become common till after the reign of Francis I,
began to take a larger place. Here, as in the other arts
of design, the portrait became more and more popular[1].
One of Charles VIII, woven after 1495, is in the possession
of Baron Schickler. It is characteristic of the Renaissance
that in the inscription Charles is compared with Hannibal[2].
A similar portrait, now lost, once existed of Pierre de Rohan,
whose love of tapestries has been noticed in a former chapter.
The beautiful specimen with his arms, which represents a
lady playing an organ with a cavalier, is, as has been
said, probably a portrait of himself and his second wife,
Anne d'Armagnac[3]. Another tapestry of the same period
in the Museum of the Archevêché at Angers has for its
subject Penthesilea, the Queen of the Amazons[4]. Besides
scenes inspired by classical mythology we have rustic scenes
and idylls, while the Musée de Cluny has a famous tapestry
of about 1500, representing a lady with a unicorn[5].

[1] See Léon Deshairs in Michel, v. (ii.) 889–898.
[2] *Exposition des primitifs français*, no. 263.
[3] *Primitifs*, no. 268, Michel, p. 897 (fig.).
[4] *Primitifs*, no. 270.
[5] Michel, p. 896 (fig.). The unicorn is a symbol of virginity. Cp.
Moretto's fine picture of St Justina at Vienna.

CHAPTER XVI

RETROSPECT

IT remains to gather up the threads of this inquiry, to attempt some general summing up of its results, and to estimate the progress made by the Renaissance in France during the twenty years which elapsed between the return of Charles VIII from his Italian Expedition and the accession of Francis I. We have seen that such premonitions of the Renaissance as were visible in France at the close of the fourteenth century were almost entirely confined to the princes of the House of Valois. Charles V and his brothers, the Duc de Berry and the Duc de Bourgogne, and his younger son, the Duc d'Orléans, were all liberal patrons of art and literature. They loved extravagance and display, they were great builders, and above all they cared for books. With their art-collections and libraries and the encouragement that they gave to artists and men of learning they formed nuclei of culture at their various courts.

But all this was swept away by the long period of misrule and anarchy, of civil war and foreign conquest, which followed the murder of the Duc d'Orléans by Jean *sans-Peur* in 1407 and desolated the country for nearly forty years. Then France, her soil at last freed from the invader, began slowly and painfully to rebuild her national life, to heal the wounds inflicted by foreign foes and domestic brigands, to restore discipline and order, to develope afresh the great natural resources of the country. Much was done during the reign of Charles VII, who, if not over-wise himself, was served by wise ministers, but much still

remained to be done. It was Louis XI who meeting violence with violence and fraud with fraud gave unity to the kingdom, who laid the foundations of material wealth and prosperity, who made France once more a rich and powerful nation, and by so doing prepared her soil for the reception of the Renaissance.

Louis XI was by no means indifferent to the claims of learning and literature and art, but he was too much occupied with other things to give them more than friendly encouragement. A movement, however, of far-reaching importance was inaugurated with his approval during his reign. This was the establishment in the Sorbonne of the first French printing-press (1470). It was established in the interests of Humanism, but the original impulse was short-lived. Other presses were set up in Paris and other French towns, but after 1477 the books ceased to be of a humanistic character. It was not till the very eve of our period that the Paris press became once more an agent for the diffusion of humanistic literature.

Another movement of the reign of Louis XI which helped to prepare the way for the introduction of the Renaissance was the resumption of friendly relations with Italy. During the period of disruption and anarchy, intercourse between the two countries had been almost wholly intermitted, and under Charles VII it had been rendered fitful by cross-currents of shifting diplomacy. But the conciliatory policy which Louis XI adopted towards all the leading Italian states promoted its steady increase. Missions constantly passed between France and the Italian Courts; French Bishops travelled to Rome and Italians were appointed to French bishoprics; French students sought degrees in Italy and Italian humanists found careers in France; Italian bankers at Lyons, Italian silk-workers first at Lyons and then at Tours, Italian artists at the Court of King René, all helped to spread the influence of their country of origin.

For the first eleven years of the reign of Charles VIII, thanks to the firmness and capacity of Anne de Beaujeu

and her husband, the policy of Louis XI was continued and consolidated. Then came a change in the relations of France with Italy. The young king, romantic and undisciplined, nursing vague dreams of empire and conquest, listened to the advice of Étienne Du Vesc and Guillaume Briçonnet and crossed the Alps with Naples for his objective.

Hazardous though his enterprise may have been from a political point of view, it was fraught with momentous consequences for the intellectual life of the nation. France was now ready for the Renaissance. Among her nobler spirits there was a growing feeling of dissatisfaction with mediaeval ideals and practice, with mediaeval learning and literature and art. They were weary of the eternal round of disputations in the schools, of the metrical jugglery which passed for poetry, of the virtuosity in stone-carving which took the place of construction in architecture, in a word of the restlessness without movement which marked the exhaustion of the mediaeval world.

To these dissatisfied spirits, seeking an escape from their prison, Humanism offered the prospect of a freer and larger life. It opened to them a new world of knowledge, new impulses to critical inquiry, new standards of conduct. Before, however, the treasures of classical literature could be fully explored, much preliminary spade-work had to be done. Thus Humanism in its first phase in France was chiefly concerned with the study and practice of Latin rhetoric and with the dissemination through the printing-press of the Latin classics. The recognised leader of the movement was Robert Gaguin, and we have seen how much it owed to his capacity for affairs, his high character, and his wide sympathies. If he exaggerated the value of writing Latin verse and prose, he did not disdain his native language, and his interest in rhetoric was equalled by his interest in theology, philosophy, and history.

The centre of French Humanism was Paris, and this fact imparted what may be called a northern character to the movement. Gaguin himself was a Fleming by birth. So were his friends Pierre de Bur and the brothers Charles

and Jean Fernand. He had correspondents not only in
the Low Countries—Arnold Bost and Roger de Venray—
but in Germany—Trithemius and Wimpheling—and in
England—William Tilley. The University of Paris drew
its students mainly from the north and north-east of France,
and if the University as a whole was not too well-disposed
towards the new studies, it had warm supporters among
individual professors. Here again we find natives of the
Low Countries joining hands with Frenchmen, such as
Petrus de Ponte (who like the Fernands came from Bruges),
and the Dutchmen, Gilles and Martin of Delft. Moreover,
after Gaguin's death (1501) it was a Fleming, Josse Badius,
who played the most active part in the development of
French Humanism, while about the same time the great
Dutchman, Erasmus, began to exercise a growing influence
over the Paris humanists. His friendly rival, Budé, the
founder of Greek studies in France, was a native of Paris.
Finally, Jacques Lefèvre d'Étaples, whose name, at any
rate in the University, stood higher than that of any of
these men, not excepting Gaguin, was a native of Picardy
beyond the Somme, while of his two chief lieutenants,
Charles de Bouelles was also from Picardy, and Josse
Clichtove was a Fleming.

The result of this large northern element in French
Humanism, this comradeship of northern Frenchman,
Fleming, and Dutchman, was to impress upon the movement
from the first a distinctive character, which clearly differen-
tiated it from Italian Humanism. This character was
theological, religious, moral, educational. Gaguin and most
of his friends were ecclesiastics. Lefèvre d'Étaples, whose
work in the University was confined to the faculty of arts,
and who was not a member of either the Sorbonne or the
College of Navarre, began in middle life to devote himself
more and more to theological studies. Badius, a layman,
took an active part in the printing of the great Christian
writers. Budé, another layman, was well read in these
writers. Moreover, he applied his critical powers to the text
of the Vulgate, and he was keenly alive to the need of reform

in the Church. Another feature of French Humanism,
though this it shared with Italian Humanism, was its
recognition of the need for reform in education. Gaguin,
before he was absorbed by the affairs of his Order and
of the State, published a text-book on Latin versification.
But it was Lefèvre d'Étaples who by his text-books and
commentaries on Aristotle and the other subjects of the
Arts curriculum, and Badius, an old pupil of the Brethren
of the Common Life, who by the publication and editing of
treatises on grammar and rhetoric were the real reformers
of education in France. And it was a marked feature
of their educational aims that, like the earlier Italian
humanists, like Vittorino da Feltre and Guarino da Verona,
they had in view a moral as well as an intellectual purpose.
It was this moral purpose that guided them in their choice
of classical writers for young students, and led them to
regard with suspicion the amatory poets and other perverters
of youth. Thus the seed sown by their friend Erasmus,
whose views were similar to their own, fell on soil ready
to receive it.

It agrees with this serious character of the French
humanists, that we do not find among them men like
Politian, whose morals were in inverse ratio to his scholarship,
or like Pontano, who, destitute of all patriotic feeling,
betrayed his sovereign and benefactor to the French. Gaguin,
Lefèvre d'Étaples, Budé, and Badius, led exemplary lives;
they were alike honourable and honoured, good citizens and
true Christians. In marked contrast to them were the Italian
adventurers, Balbi and Andrelini, who, having obtained a
footing in the University of Paris, lost by the scandal of
their lives whatever reputation they had gained from their
showy but superficial scholarship.

Another feature of early French Humanism which
contrasts with that of Italy is the absence of anti-Christian
thought among its leaders, even in the somewhat superficial
form which it assumed with many Italian humanists.
There were, no doubt, a certain number of young humanists
at Paris and other Universities who, "intoxicated by the

novelty of their studies, troubled by the bold independence
of ancient thought, found in the systems of the Greek
philosophers theses more satisfying to the aspirations of
their restless intellect than the traditional dogmas." But
they kept their opinions to themselves, or only discussed
them with intimate friends. The case of Haymon de la
Fosse, a young student of Picardy, who entered the College
of Cardinal Lemoine in 1493, and was burnt ten years
later for open sacrilege and persistent denial of the truth
of the Christian religion, was most exceptional[1].

If a sceptical attitude towards the Christian religion
was exceedingly rare among the first French humanists,
they found an attraction in that generous but chimerical
attempt to reconcile paganism with Christianity which was
initiated at Florence by Marsilio Ficino and Pico della
Mirandola, and which was glorified in the Camera della
Segnatura of the Vatican at the bidding of Pope Julius II[2].
The writings of Ficino and Pico were received with favour
at Paris; the Sibyls took their place in French art by the
side of the Prophets; Christ and the Virgin were depicted
in stained-glass windows as riding in triumphal cars like
the Roman Imperators. But during our period that sym-
bolical use of pagan mythology which is so frequent in the
poetry of the Pleiad, and which finds such characteristic
expression in Ronsard's essentially Christian poem of the
Hymne de la Mort, was far from common. Such a tomb,
for instance, as that erected to Guillaume Du Bellay in
1557—a year after the publication of Ronsard's Hymn—
which in its present condition shews nothing but purely
pagan ornamentation, the kneeling Angels and the Virtues
having disappeared, would have been impossible in the
reigns of Charles VIII and Louis XII. You can detect
a materialistic and non-Christian note in some of the tombs

[1] See Marcel Godet, *Tragique histoire d'Haymon de la Fosse,* in *Rev.
du seizième siècle,* II. (1914), 168–190. The author of this remarkable
contribution to the history of the French Renaissance was killed in action
at Pervyse on October 14, 1914.
[2] See F. X. Kraus in *The Cambridge Modern History,* II. 5–8.

of the period, but the use of pagan mythology and pagan symbols is still infrequent.

It was owing to this reverence of the French humanists for Christian dogma and Christian morals that they looked at first with favour on the new religious doctrines. As Churchmen they welcomed the prospect of Church reform, and as humanists they applied the principle of free criticism to the domain of theology. Badius warmly sympathised with Erasmus's publication of Valla's *Annotations*, Budé found room in his voluminous notes on the *Pandects* to criticise certain passages of the Vulgate, and Lefèvre d'Étaples shewed equal boldness in his commentary on St Paul.

Such was the general character of French Humanism in its initial phases. I have already attempted to estimate the extent of its progress[1]. I pointed out that at the death of Gaguin in 1502, Latin rhetoric, or the study of Latin authors and the practice of Latin composition, had taken a firm foothold at Paris and had found sympathisers in some of the colleges of the University; and that after Gaguin's death this work was largely developed by Josse Badius, who united to his activities as a publisher and printer of classical authors the writing of "familiar commentaries" for young students and the editing of improved grammars and manuals of rhetoric. I further pointed out that work similar to that of Gaguin and Badius for Latin rhetoric was carried out by Lefèvre d'Étaples for Aristotle, but that the value of his reforms, in many respects notable, was lessened by his imperfect Greek scholarship. At the opening of the sixteenth century it is probably the literal truth that there was only one Frenchman who was a really competent Greek scholar, namely, Guillaume Budé. Six years later (1507) a Greek press was set up at Paris, and in the following year the arrival of the distinguished Italian humanist, Girolamo Aleandro, gave a real impetus to Greek studies. It is true that the general enthusiasm which Aleandro aroused by his lectures died

[1] See above, pp. 318–323.

down after his departure and that the real devotees of Greek scholarship at Paris were a small, if select, band. But their leader, Budé, was a host in himself, and the publication of his *De Asse* in the third month of the reign of Francis I proclaimed him one of the chief humanists and Greek scholars of Europe. I further pointed out that outside Paris, Humanism made little progress during our period, and that, save for an isolated scholar or two, it was only at the Universities of Orléans and Poitiers that even the study of classical Latin can be said to have reached more than an elementary stage.

I have laid stress on the northern character of French Humanism, on the fact that most of the early leading humanists came from the north of France, or even from beyond the Flemish border. But we must not lose sight of the debt to Italy. Frenchman and Fleming alike looked towards Italy as the centre of humanistic studies. Gaguin and Budé travelled there as members of diplomatic missions; Lefèvre d'Étaples paid two visits there of some duration; Pierre de Bur, the distinguished Latin poet, resided there for seven years, Germain de Brie for six, Jean de Pins for ten. We have seen how Gaguin was attracted to the mystical philosophers, Pico and Ficino, and how probably at his instigation their writings were printed in France. We have seen too how the grammars, aids to composition, letters, and speeches of the Italian humanists were published and edited by Badius, and how the coming of Aleandro gave an invaluable stimulus to the study of Greek. This Italian element in French Humanism was greatly strengthened by the increased importance given to the half-Italian city of Lyons by the forward policy of Charles VIII and Louis XII. During the last half of the latter's reign Lyons almost took the place of Paris and the châteaux on the Loire as the chief residence of the Court. If Paris continued to be the chief focus of the intellectual life of the nation, a new focus was established in the southern city, which in the next reign rivalled the capital as an intellectual centre.

The importance of Lyons for the development of the French Renaissance is shewn when we pass from Humanism to the vernacular literature. Jean Lemaire de Belges, the one French writer of our period who was really touched by the Renaissance spirit, was a Hainaulter by birth, but he spent at least five years, from 1498 to 1503, at Villefranche in the Beaujolais, twenty miles from Lyons, and he had close relations with the literary and artistic movement of that city. Even after he had entered the service of Margaret of Austria he was employed by the city authorities to organise the entry of Louis XII on his return from Italy in 1509. This intercourse with Lyons, with its strong Italian element, made him all the more susceptible to the influence of Italy herself. The sensuous character of his writings and the strong feeling that he shews in them for pictorial effect are doubtless an affair of temperament, but his chief prose work, *Les Illustrations de Gaule*, and his most important poem, *La concorde des deux langages*, are a striking testimony to the strong impression he had received from his visits to Rome and Venice, and to the extent to which he was penetrated by the spirit of the Italian Renaissance. In these works he reveals himself as a true humanist, versed in classical legend and mythology as no French writer had been before him, handling the stories that he had read in Virgil and Ovid not only in the same romantic spirit, but with an appreciable measure of their transforming magic. He has caught too from his contact with the Italian Renaissance that sympathy with pagan modes of thought and expression and that disrespect for the discipline and dogmas of the Church which find such free expression in the poetry of Lorenzo de' Medici and his circle.

If at the opening of our period Paris was the centre of the intellectual life of France, the centre of her artistic life was Tours[1]. Fouquet was dead, but his *atelier* was carried on by his sons and other disciples, and the Tours school of painting was also represented by Bourdichon and Poyet, both of whom were in high repute. The name of Michel

[1] See above, pp. 161–2.

Colombe stood even higher, for he had no rival among French sculptors, and his school, which included not only sculptors, but architects and painters, retained its preeminence after the Italian Expedition. Moreover, the Italian sculptors and decorators who were invited to France, having to work in co-operation with Colombe and his assistants, set up their *ateliers* in the same city.

This importation of Italian craftsmen was an important factor in the spread of the Renaissance in France, but its progress varied according to the character of each art, its existing condition, and the proficiency of the Italians who represented it.

Gothic architecture had at its back all the force of a long tradition and strong popular sentiment. The French master-masons, if lacking true originality, were thoroughly competent, and the workmen were extraordinarily proficient in a highly specialised technique. The introduction of a new and fundamentally different style was bound to encounter much opposition and be slow of accomplishment. An Italian architect might produce an admirable design for a Renaissance building, but it would be difficult for him to carry it out without the co-operation of a sympathetic native master-mason, or of a considerable Italian element among the workmen. On the other hand it was in architecture that the Italian colony was strongest. For it included Fra Giocondo, who was an architect of the first rank, Domenico da Cortona, who, though only a young man when he came to France, afterwards achieved high distinction in the same profession, and Girolamo Pachiarotti, a master-mason who was a highly skilled decorator and who helped to familiarise French artists with the technique of Renaissance ornament.

This contact of the old style with the new, of French master-masons and workmen supported by tradition and public sentiment with Italian architects and decorators under royal patronage, resulted in a blending of the two styles, in which at first Gothic had by far the larger share. Thus down to the year 1508 the Renaissance made very little

progress. Its influence appears in the symmetrical plan of Le Verger, but there is only a suggestion of it in the design of Blois and the other châteaux of the period. The one exception is the lantern of the north-west tower of the Cathedral of Tours, which is Renaissance in construction, but which combines Gothic with Renaissance details in the decoration.

From 1508 there is a decided advance. In the south-east wing of Gaillon, with its loggia and gallery, and in the court of the Hôtel d'Alluye at Blois with its loggia, we have examples of work which, alike in construction and decoration, is pure Renaissance. The Hôtel was possibly not begun before 1512, and in the case of both buildings it is almost certain that the architect was an Italian. On the other hand the Hôtel de Beaune, and the cloisters of St Martin at Tours, the Bureau des Finances at Rouen, and the Hôtel Lallemand at Bourges, are the work of French master-masons, though possibly with some assistance, in the form either of advice or of manual labour, from Italian decorators. The Bureau des Finances is especially instructive as being the not unsuccessful attempt of a French architect to work out on his own lines the principles of classical architecture.

But when we look at the net result, we find that, when the reign of Louis XII closes, the Renaissance movement in architecture is still virtually confined to a few centres— to Blois, Tours, Paris (where it makes a very limited appearance), and Gaillon with Rouen—that the movement in these centres is due to the influence of the king and a few powerful ministers, and that no complete Renaissance building has been built. Indeed, as regards church architecture, the movement has not gone beyond the introduction of a few Renaissance details into two or three Gothic designs, the crowning of a single tower by a Renaissance lantern, and the construction of a single cloister with a transitional vault and with a scheme of decoration which is almost wholly Renaissance. Of that feeling for space and light which is so marked a characteristic of Italian churches,

even when they are nominally Gothic, there is not a sign in French ecclesiastical architecture. It is otherwise in domestic buildings, for it is just in the direction of more space and more light that we find the château and the large town-house advancing. It was a natural movement, stimulated indeed by what the French nobles saw in Italy, but originating and progressing independently of Italian influence. Consequently it found expression in structural changes, such as the use of lower buildings and larger windows, both of which had begun to make their appearance some years before the Expedition of Charles VIII.

Sculpture and painting were in a very different position from architecture as regards their susceptibility to the influence of the Renaissance. In the first place, as has been already noted, there is no such obvious difference between the two styles in these arts as there is in architecture. In a transitional building such as those that were erected during our period we can see at once what are the Gothic, and what the Renaissance elements. But in a picture or work of sculpture of the same period there is nothing positive, so far as the style goes, to guide us. If it is a composition of several figures, we may take as a criterion the presence or absence of a thought-out design, of a conscious feeling for unity. But in the case of single figures, whether they are painted portraits of men and women, or sculptured images of the Virgin and the Saints, no such test is possible. We can only fall back on the vague distinction between the realism of the art of Fouquet and Michel Colombe, and the idealism which was becoming more and more a feature of Italian art.

But "realism" and "idealism" are terms capable of a wide interpretation, and we must try to be more precise. As we have seen, two characteristics of the art of Colombe and his fellow-sculptors are a careful rendering of details, and a too faithful subservience to the model. The artist depicts not only all that he sees of his subject, but all that he knows of it. He uses his sight and his intellect, but not his imagination. His Madonnas and Saints are

portraits of individuals, not imaginative types. It is the
same with painting, of which the most flourishing branch
at the close of the reign of Louis XI was the illumination of
manuscripts. A loving care for details is inherent in the
miniaturist's art, and constitutes in fact one of its greatest
charms. It is not less conspicuous in Fouquet than in artists
who lack his breadth of vision, his feeling for crowds and
wide stretches of landscape. The Coronation of the Virgin
in the *Hours* of Étienne Chevalier is a miracle of sumptuous
detail. The marbles, precious stones, and tessellated pave-
ment are rendered with faithful accuracy, but the artist's
conception of the Persons of the Trinity is almost comic
in its want of imagination. It is the same in some of the
other pages of these wonderful *Hours*. Étienne Chevalier
is portrayed with far greater vigour and sympathy than
the angelic choir among which he kneels. Charles VIII
is a more impressive figure than that of the Virgin. For
Fouquet had no spiritual vision of the Virgin either as the
Mother of Jesus or as the Queen of Heaven. In his only
representation of her apart from his illuminated pages she
appears—so runs tradition—with the features of Agnes
Sorel.

But the difference between realism and idealism, between
the particular and the general, between the individual and
the type, is after all no radical one. Between an uncom-
promising realism and a highly imaginative idealism there
are infinite degrees, which shade off into one another
imperceptibly, and the detection of these finer shades of
difference must depend in no small measure on the idio-
syncrasy, as well as on the competence, of the critic.

In the second place, sculpture and painting differ from
architecture in being far more individualistic. The sculptor
or painter who seeks to introduce new principles of art
or new methods of execution has not to encounter the
interested opposition of a powerful corporation, or the
inability of subordinates to carry out his ideas. His subject
may be prescribed for him by his patron, but his style in
the last resort depends only on himself.

Among the Italians who came to France at the invitation of Charles VIII, sculpture was less adequately represented than architecture. In the place of Fra Giocondo there was Guido Mazzoni, whose craftmanship was decidedly inferior to Michel Colombe's, and who was equally a realist, though of a coarser and more dramatic type. Pachiarotto and Girolamo da Fiesole were decorators rather than figure sculptors, nor was Giovanni Giusti—we cannot speak with certainty of his brother Antonio—of more than secondary importance in the nobler branch of his art. On the other hand sculpture had this advantage, that finished works by Italian artists could be imported from Italy. The sepulchral monuments that came into France in this way numbered two of first-rate merit, the tomb of Charles d'Anjou at Le Mans, and that of Raoul de Lannoy and his wife at Folleville; but Folleville lay off the main road in one of the most northern provinces of France, while the capital of Maine, though connected by main roads with Tours, Rouen, and Paris, was not in close affinity with any of these important art-centres.

If the Italian sculptors whom Charles VIII and other patrons invited to France were not of the first rank, France herself possessed in Michel Colombe a sculptor who was at least their equal in dexterity of execution, and who in the treatment of the human figure was very decidedly their superior. Moreover when Charles VIII returned from Italy, Colombe was, as age was reckoned in those days, an old man, nearer sixty than fifty, perhaps older. It is therefore not surprising to find that in the only two examples, apart from a medal, that have come down to us of his work, there is not the faintest trace of Italian influence[1]. Colombe, in fact, represents at its highest point the French tradition in sculpture—as it was on the eve of the Renaissance. In his art the crude and naive realism of an earlier period is softened by his artistic temperament and his accomplished craftsmanship. But he was deficient in imagination and

[1] The design for the tomb of Duke François II, it will be remembered, was made by Jean Perréal.

spiritual vision, or, at least, he had not discovered the vitalising influence of these faculties upon art. The raising of the particular to the general, of the portrait to the type, the realisation of the idea that springs from the artist's imagination, these were the re-discoveries of the Renaissance.

Less accomplished in execution than Colombe's Virtues, the Vierge d'Olivet, by some unknown artist of the same school, shews more of this inward vision, of this striving towards the ideal. Equally with Colombe's work it shews no trace of Italian influence, and may therefore be said to mark in a sense the furthest advance made by French sculpture in the direction of the Renaissance without any help from Italian models. Unfortunately there is no external evidence to fix its precise date.

The first effect of Italian influence upon French sculpture was by no means beneficial. It produced a tendency to mannerism and affectation, as in the Vierge du Pilier (? 1515–1530), the Vierge d'Écouen, the retable of Autun (soon after 1511), and the Virtues of the tomb of Louis Poncher (1523 and following years), or else to academic conventionalism, as in the Virtues of the tomb of the two Cardinals d'Amboise (1518–1525). In the school of Troyes from 1525 onwards we see the same defects in a more pronounced form. In fact, during almost the entire reign of Francis I French sculpture seems to have suffered rather than gained from the contact with Italy.

It would, however, be rash to infer from this that French sculpture had nothing to learn from the country in which the Renaissance had borne such admirable fruit. That it did not at first profit by its opportunities was due to a variety of causes. In the first place the Italian sculptors who were invited to France were, as we have seen, greater as decorators than as figure-sculptors. Secondly, just at the time when, owing to the occupation of Milan and Genoa, French intercourse with Italy was becoming more intimate and more continuous, a new movement was beginning to develop in Italian sculpture. This was classicism, or, to be more

precise, the conscious imitation of classical models. Its first eminent exponent was Andrea Sansovino, whose statue of the Virgin and Child, with its evident pagan inspiration, was set up in the Cathedral of Genoa in 1504, when the French were masters of that city[1]. Now Sansovino, and still more the lesser artists who were influenced by him, did not clearly comprehend what they imitated. They slavishly reproduced. the ideals of a bygone age, instead of creating ideals of their own. Moreover, under the influence of the newly-discovered Laocoon (1506), they were ensnared by the dangerous attractions of emotional energy and over-emphasised technique. Lastly, between Michel Colombe and Jean Goujon there was no French sculptor of sufficient originality to grasp the true principles of Renaissance sculpture and to interpret them in accordance with his own and the national genius.

So far as we can judge from the examples that have come down to us, painting in France at the opening of our period was on the whole less flourishing than sculpture. It was less productive, and, illumination apart, it was in a lower stage of development. Fouquet was first and foremost a miniaturist, and he had been dead for more than a dozen years when Charles VIII invaded Italy. There was no individual who occupied the same position in painting as Michel Colombe in sculpture. Even supposing that Jean Perréal was the painter of the pictures that have been grouped together under the name of the Maître de Moulins, he was not, like Colombe, the head of a large and prosperous school. Further, Italian painting was represented in France only by Andrea Solario, who, though of high merit at his best, is remarkably unequal, and by the North-Italians who decorated the Cathedral of Albi. The Italian pictures that were brought into France were even fewer than the works of sculpture, and being in private hands were even less likely to have any influence on the national art.

On the other hand, painting was more in a position

[1] On p. 121 I have implied that the statue was already there in 1502; this is incorrect.

to lend itself to new developments than either architecture or sculpture. It was not hampered by a long and great tradition, nor had it as its chief representative an artist like Michel Colombe whose advanced age kept him to the old paths. Moreover, painting, being more individualistic than either of her two sisters, is pre-eminently the Renaissance art. We see this not only in its own triumphs, but also in the influence that it exercised on arts like stained glass and enamelling, both of which began to adopt methods analogous to those of painting. Under these conditions it is not surprising that the one work of art produced during our period which may be claimed unreservedly for the Renaissance is the triptych of Moulins.

It was only natural that the minor arts, being practised by a smaller band of craftsmen and having on the whole a more highly specialised technique, should have been slower to feel the influence of the Renaissance. We have seen that the most flourishing and most widely practised of these arts, that of stained glass—which, indeed, can hardly be regarded as a minor art—did not produce a work in which the Renaissance spirit is clearly manifested till the year 1515. As for the medals and coins struck during the reign of Louis XII they only shew faint traces of Renaissance influence. There is more of it in the engraved illustrations of books, but it is chiefly confined to architectural details, and its results are far from promising. Apart from a new method, which approximates to painting, the art of enamelling remains purely mediaeval in spirit, while tapestry reveals the influence of the Renaissance only in a growing inclination for portraiture and for classical and other secular subjects.

But if during our period the Renaissance achieved no signal victories in the domain of French art, its first advances extended over a wide area. It penetrated from Amiens in the north to Pamiers in the south; from the château of Josselin in the west to Grenoble in the east. These, however, were more or less isolated points. The centre of the movement was Touraine and from there it

radiated to the neighbouring provinces of Anjou, Maine, Orléanais, Berry, and Poitou. After Touraine, mainly owing to the encouragement of Cardinal d'Amboise and the work promoted by him at Gaillon and Rouen, the most receptive province was Normandy. Paris was naturally involved in the movement, but in spite of the presence of Fra Giocondo and of the Italian colony at the Petit-Nesle, little seems to have been accomplished in the way of domesticating Renaissance art in the capital. It must be borne in mind, however, that the work of destruction inevitable in a great progressive city has doubtless swept away buildings on which the first advance of the Renaissance had left its mark. The same reservation applies to other large towns, such as Lyons, Marseilles, and Bordeaux. Over the rest of France, other than the provinces mentioned above, the spread of Renaissance art was extremely sporadic. In a few places, Moulins, Nevers, Sens, its appearance is to be accounted for by the influence of some prince or wealthy ecclesiastic. In others, such as Chartres, Clermont, Toulouse, Troyes, its first beginnings, so far as we can trace them, fall outside our period.

It is needless to insist on the importance of the part played by Italy in this diffusion of the Renaissance through France. The contact of the countries had two distinct phases. First, the Expedition of Charles VIII awakened in the king and his courtiers an eager but undiscriminating enthusiasm for what they saw in Italy, for her palaces and gardens and works of art. But, except at Naples, they had no time for more than hurried glances. The artistic fruits of the Expedition were a considerable amount of booty, of which part was lost, and a small band of Italian artists and craftsmen. The second phase of the contact is represented by the French occupation of Milan under Louis XII and the voluntary cession of Genoa to the same monarch. It was evidently the intention of Louis and his advisers to make his new acquisitions a permanent part of his kingdom. Regular government was established in the Duchy of Milan, with a governor to represent the king,

and a small senate of Italians and Frenchmen, the latter
being in the majority. As a result of this more or less
peaceful occupation the newcomers had leisure and oppor-
tunity to observe the many admirable examples of Renais-
sance art with which the Visconti and the Sforzas had
adorned their capital. Moreover, the two Italian rulers
who after Ludovico Sforza were the most munificent and
discerning patrons of Italian art, the Duke of Ferrara and
the Marquis of Mantua, had joined the French alliance.
To these centres of art must be added Brescia and Cremona,
which the French were allowed to occupy after the defeat
of the Venetians at Agnadello (1509). The influence of Milan
was felt mainly in architecture; that of Genoa in sculpture;
that of Ferrara and Mantua, the home of Mantegna, in
painting.

Apart from the lessons peculiar to each art which these
North-Italian cities had to impart to French artists, there
are certain characteristics common to all Renaissance art.
These may be briefly summed up as plan, unity, and
idealism. Did French art develop these of itself, or did it
owe them to the teaching of Italy? We will try to answer
the question for each of the three arts separately.

As regards sculpture, the practice of making a preliminary
design seems to have been common in France in the case
of funeral monuments, and it was probably the same for
the favourite Entombments. But in both cases the design or
plan was largely determined by tradition, without adequate
regard for artistic unity. As far as mere composition
goes, this unity is successfully attained in the Entombment
of Solesmes, but the unity of treatment is marred by the
figure of St Joseph, the robust realism of which clashes
with the rest of the group. The same deficiency in the
idealising faculty, though less striking, is noticeable in the
Virtues of Michel Colombe's great tomb. It is only in the
Vierge d'Olivet, where the task is much simpler, that the
artist's imagination has transformed the individual portrait
into the appropriate type. Now in all these three works
there is no trace of Italian influence. They serve to shew

how far French sculpture could develop unaided in the direction of the Renaissance.

In painting, the highest achievement of our period is represented by the triptych of Moulins, in which the influence of Italy is plainly visible. Whether the earlier work of the same artist, the portrait of the presumed Suzanne de Bourbon, shews the same influence is more doubtful.

It is in architecture that France's debt to Italy is most apparent. The radical change in the principles of construction and in the details of execution which the transition from Gothic to Renaissance involved could hardly have been carried out without the assistance of Italian architects and workmen. Even with this assistance the rate of progress was at first very slow. For the first twelve years after the return of Charles VIII from Italy, that is to say, down to the close of 1507, in spite of the presence of Fra Giocondo, and of other Italians, most of whom were highly skilled as decorators, little was accomplished. All the help that the strangers were permitted to give was an occasional design for a new building, or a few hints and lessons in the execution of Renaissance details. During the last seven years of the reign of Louis XII the opposition to the new style perceptibly weakened. Buildings are now constructed from a pure Renaissance design made by an Italian architect, and ornamental details are entrusted to Italian decorators. Finally, at the very close of our period, we have French mastermasons working out Renaissance principles on their own lines, and French workmen trying their hands at Renaissance ornament.

Passing from the domain of Art to that of Letters, we find on the one hand the study of Greek in France powerfully stimulated by the lectures of the Italian humanist, Girolamo Aleandro, and scholars like Germain de Brie and Jean de Pins spending several years at Italian Universities, and on the other Guillaume Budé attaining to the primacy of Greek learning in France with practically no help from Italy, except in the way of books. As for Latin scholarship in France, it owed much to the grammars, manuals of rhetoric,

and collections of letters and speeches by Italian humanists which Josse Badius Ascensius was so active in introducing into France. But he did not confine himself to this work of republication; he wrote on his own account treatises adapted to the needs of French students. The only writer of French poetry or prose during our period who can be said to belong to the Renaissance is Jean Lemaire de Belges. He does so by virtue of his sensuous and artistic temperament, his curiosity and learning, his semi-pagan ideals. But the thorough sympathy that he shews in his later poems and in his chief prose work with the spirit of classical literature may in part be ascribed to the two visits that he paid to the fountain-head of the Renaissance.

It is one of the glories of France that she is ever ready to welcome new ideas, whether they have sprung from her own soil or whether they have come to her from without. So it was at the dawn of the Renaissance. When Charles VIII led his troops across the Alps the condition of France, both material and spiritual, was favourable to the reception of the new movement. Sixty years of patient labour and wise government had healed her wounds and given her the blessings of order and unity. She was now in a position to take her place in the intellectual advance of western civilisation, to feel the mysterious current that was flowing through men's veins, stirring them to fresh conquests of the mind and fresh aspirations of the soul. The soil was ripe for the seed. France saw, at first vaguely, and through the eyes of a few, what Italy had to offer her. Then, as her vision became clearer, she began to discern how she could make the new ideas subservient to her own purposes. Henceforth, though she welcomed practical lessons in the execution of details and other matters of mere technique, she followed the promptings of her own genius in every form of intellectual activity, and she stamped her Renaissance with the visible impress of her own spirit.

INDEX